European Paintings in The Metropolitan Museum of Art

by artists born before 1865

A SUMMARY CATALOGUE

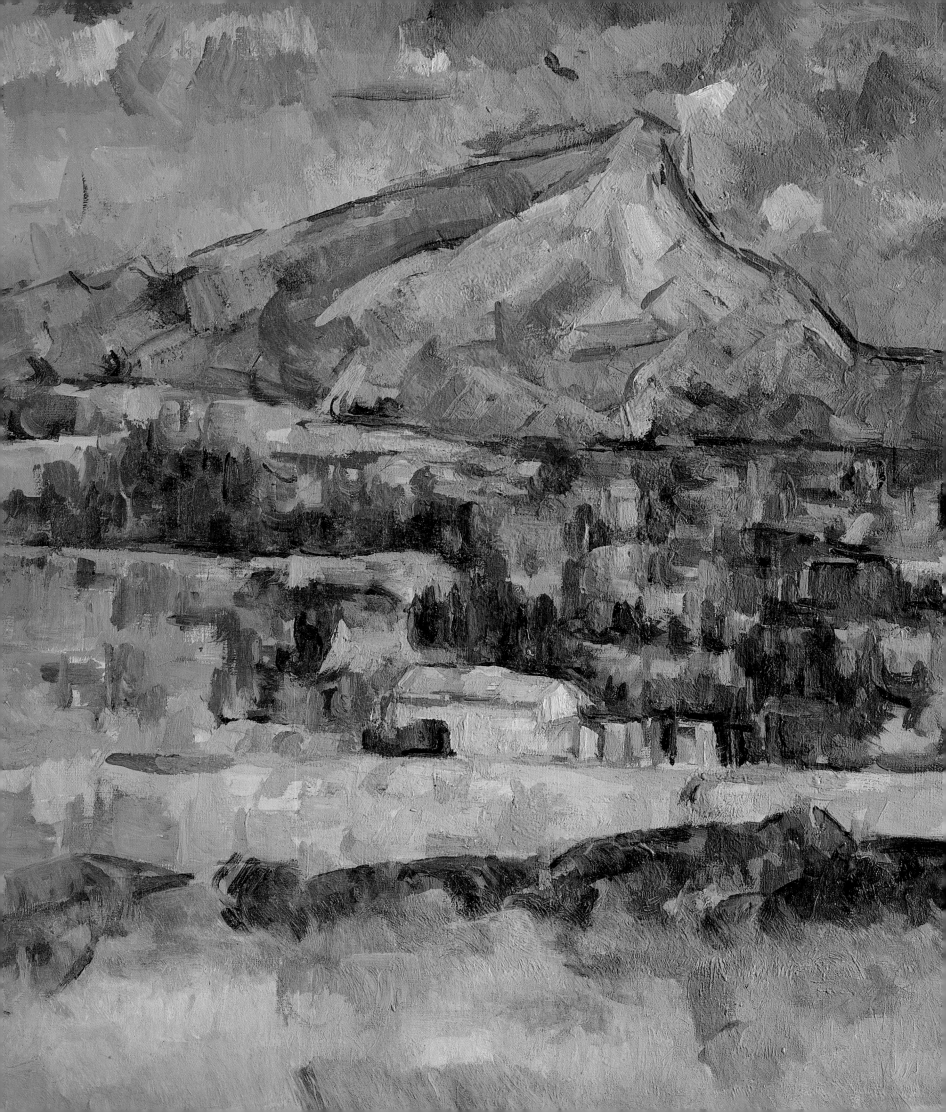

European Paintings in
The Metropolitan Museum of Art
by artists born before 1865

A SUMMARY CATALOGUE

Katharine Baetjer

The Metropolitan Museum of Art, New York

DISTRIBUTED BY HARRY N. ABRAMS, INC., NEW YORK 1995

This book has been generously supported by the Samuel I. Newhouse Foundation.

Published by The Metropolitan Museum of Art, New York
Copyright © 1995 by The Metropolitan Museum of Art
All rights reserved

John P. O'Neill, Editor in Chief
Kathleen Howard and Ellen Shultz, Editors
Bruce Campbell, Designer
Jay Reingold and Gwen Roginsky, Production

New photography by Joseph Coscia Jr., Oi-Cheong Li, and Bruce Schwarz, The
Photograph Studio, The Metropolitan Museum of Art

Set in Centaur by Sarabande Press, New York
Printed on Dune Art dull 128 gsm
Separations by Professional Graphics, Rockford, Illinois
Printed and bound by Toppan Printing Company, Singapore

JACKET ILLUSTRATION: Jacques-Louis David, French, *Antoine-Laurent Lavoisier and His Wife,* 1788 (see page 386)
FRONTISPIECE: Paul Cézanne, French, *Mont Sainte-Victoire* (detail) (see page 468)

Library of Congress Cataloging-in-Publication Data

Metropolitan Museum of Art (New York, N.Y.)
 European paintings in The Metropolitan Museum of Art by artists born
before 1865 : a summary catalogue / by Katharine Baetjer.
 p. cm.
 Includes index.
 ISBN 0-87099-734-3—ISBN 0-8109-6431-7 (Abrams)
 1. Painting, European—Catalogs. 2. Painting—New York (N.Y.)—
Catalogs. 3. Metropolitan Museum of Art (New York, N.Y.)—Catalogs.
I. Baetjer, Katharine. II. Title.
ND450.M47 1995
759.94'074'7471—dc20
 94-39136
 CIP

Contents

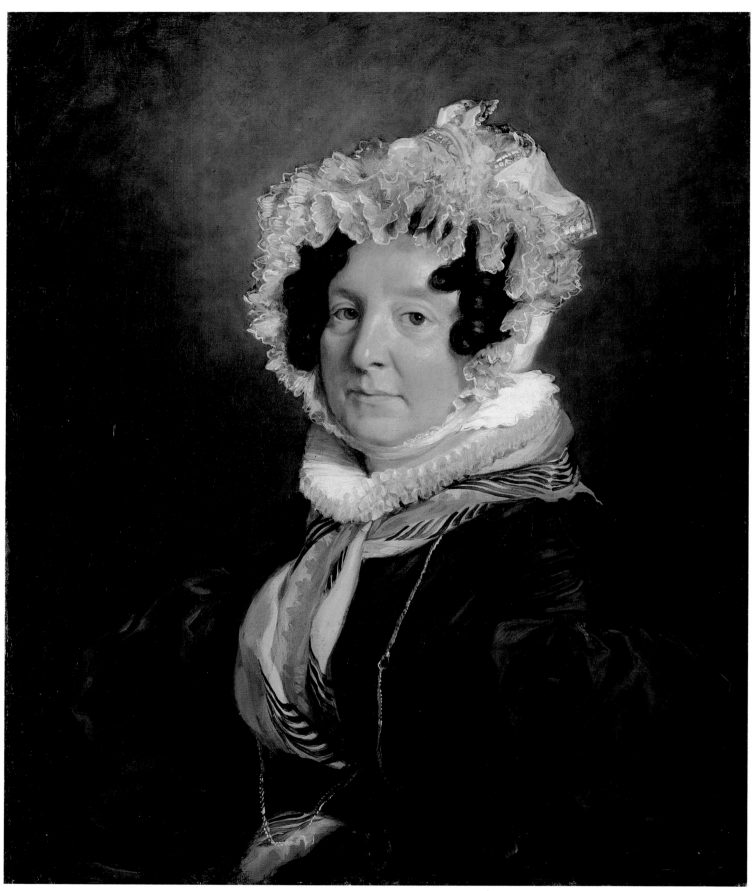

Eugène Delacroix. French, 1798–1863. *Madame Henri François Riesener* (Félicité Longrois, 1786–1847). Oil on canvas, 29¼ x 23¾ in. (74.3 x 60.3 cm). Gift of Mrs. Charles Wrightsman, 1994 (1994.430)

Director's Foreword

I am pleased to introduce this summary catalogue of the Metropolitan Museum's collection of European paintings, which replaces that published in three volumes in 1980. The Metropolitan is a dynamic institution, committed to the augmentation and refinement of its holdings, and the process of change can be charted in this up-to-date listing, which is so up to date, in fact, that we include our most recent acquisition—made in March 1995—an important secular work of the Renaissance: the birth tray commissioned in 1449 for Lorenzo the Magnificent (overleaf). In this catalogue are recorded the phenomenal gifts and the purchases of the last fifteen years, and new research findings, most notably about attributions, are incorporated. The new edition, made possible in part by the generosity of the Samuel I. Newhouse Foundation, gave us the opportunity to adopt a more useful single-volume format, which allows image and text to appear together.

The publication of an overview of the European paintings collection encourages reflection on the Metropolitan's great debt to its donors. Two recent benefactions—those of Jayne Wrightsman and Walter Annenberg—must be remarked. On the facing page is an illustration of Delacroix's portrait of Madame Riesener, one of many magnificent gifts from the collection formed by Jayne and Charles Wrightsman. The Wrightsmans' extraordinary generosity, primarily in the field of old master paintings, has a counterpart in Walter Annenberg's anticipated bequest and partial gifts of French Impressionist and Postimpressionist paintings, a detail of one of which, *Mont Sainte-Victoire* by Cézanne, appears as the frontispiece of this volume.

On this occasion we are struck once again by the remarkable quality and quantity of the Museum's holdings—the exceptional assemblages of works by Giovanni di Paolo, Vermeer, Tiepolo, and a number of Impressionist painters. We must, however, acknowledge some critical gaps: there is no painting by Saenredam, no signal High Renaissance or Mannerist altarpiece, no work by Caspar David Friedrich, Pontormo, or Le Nain. We look forward to the next edition of this catalogue, where we trust that some of these failings will have been corrected.

Philippe de Montebello
Director

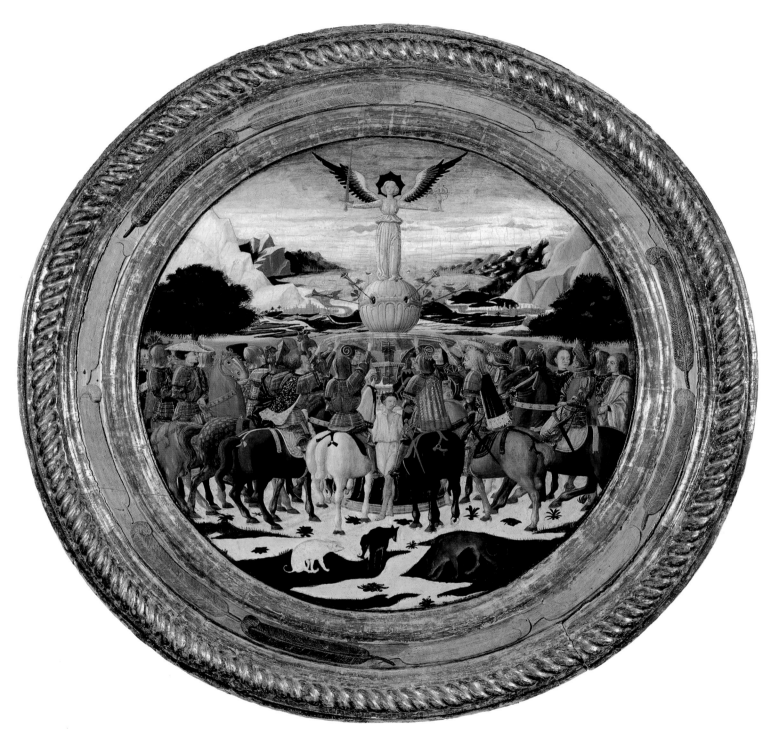

Giovanni di Ser Giovanni di Simone (called Scheggia). Italian, Florentine, 1407–1487. *The Triumph of Fame*
(birth tray of Lorenzo de' Medici). Tempera, silver, and gold on wood; overall, with engaged frame, diam. 36½ in.
(92.7 cm); recto, painted surface, diam. 24⅝ in. (62.5 cm); verso, painted surface, diam. 29⅝ in. (75.2 cm). Arms
(verso) of the Medici and Tornabuoni families. Purchase in memory of Sir John Pope-Hennessy: Rogers Fund,
The Annenberg Foundation, Drue Heinz Foundation, Annette de la Renta, Mr. and Mrs. Frank E. Richardson,
and The Vincent Astor Foundation Gifts, Wrightsman and Gwynne Andrews Funds, special funds, and Gift of
the children of Mrs. Harry Payne Whitney, Gift of Mr. and Mrs. Joshua Logan, and other gifts and bequests,
by exchange, 1995 (1995.7)

Preface

This catalogue is intended to supply essential information on all paintings, oil sketches, and finished pastels by European artists born before 1865 (not, as in the 1980 edition, in or before 1865) belonging to The Metropolitan Museum of Art. It also includes entries for thirty-five paintings and pastels from the anticipated bequest of Walter H. Annenberg; for twelve paintings and pastels that are the partial and promised gifts of Mr. and Mrs. Douglas Dillon, Janice H. Levin, Mr. and Mrs. Walter Mendelsohn, and an anonymous donor; for one painting that is the partial gift of Joanne Toor Cummings; and for six paintings that are the partial gifts of Walter H. and Leonore Annenberg.

The Department of European Paintings has custodial responsibility for most of the pictures. Also included here are works given, bequeathed to, or acquired for the departments of American Decorative Arts, American Painting and Sculpture, Arms and Armor, European Sculpture and Decorative Arts (ESDA), Medieval Art and The Cloisters, Musical Instruments, and—most importantly—the Robert Lehman Collection. The entries for Italian paintings in the Robert Lehman Collection follow John Pope-Hennessy's 1987 catalogue and incorporate a few subsequent changes; other Lehman entries appear largely as they did in the 1980 edition. Oil sketches and finished pastels, many of which are housed in the Department of Drawings and Prints, have been added. Some painted woodwork belonging to European Sculpture and Decorative Arts has been omitted. Paintings by European artists born in or after 1865 are the responsibility of the Department of Twentieth Century Art, and since 1980 we have made a more rigorous chronological division.

The size of the Metropolitan Museum's holdings of European paintings has not changed significantly over the past fifteen years, but as can be construed from the activity in these years, it has improved in quality. We acquired no fewer than 135 paintings by gift or bequest. We purchased forty-nine paintings. The trustees authorized the deaccession and sale of 193 paintings, and additionally six paintings have been turned over to other New York state museums, for a total of 199. During the same period there have been close to 150 major changes of attribution. Our greatest strengths are in the areas of French painting, roughly 800 works; and Italian painting, roughly 700 works; with the balance—approximately 1,000—represented in declining numerical order by the Dutch, British, Netherlandish, German, Spanish, and Flemish schools, and a small number of icons varying as to country of origin but primarily Russian. It should be noted that it is more difficult than it may at first appear to provide a total. A complete Spanish retable is counted as a single work, for example, whereas three related panels apparently from the same banco must count as three. Bearing this in mind, we use 2,500 as the number of works in the collection at this writing.

The arrangement of this catalogue differs from that published in 1980: it is one volume rather than three, and the texts as well as the photographs are presented chronologically and by national and regional school. Entries by artist are ordered in accordance with their known or implied birth dates. To the best of our present knowledge, the works of individual artists are also arranged chronologically; however approximate dates are supplied only when there is relatively firm evidence, such as Salon entries. The chronological order is occasionally altered to accommodate the size of images. While artists are always identified by nationality, their works may be catalogued by school (for example, portraits by and attributed to Corneille de Lyon, born in The Hague, will be found among the sixteenth-century French paintings). Accordingly, we have supplied an index by artist as well as an index by accession number. The latter can be used as a guide to recent changes of attribution, and consecutive gifts and bequests of many major donors can be singled out. The manuscript is complete as of March 1, 1995.

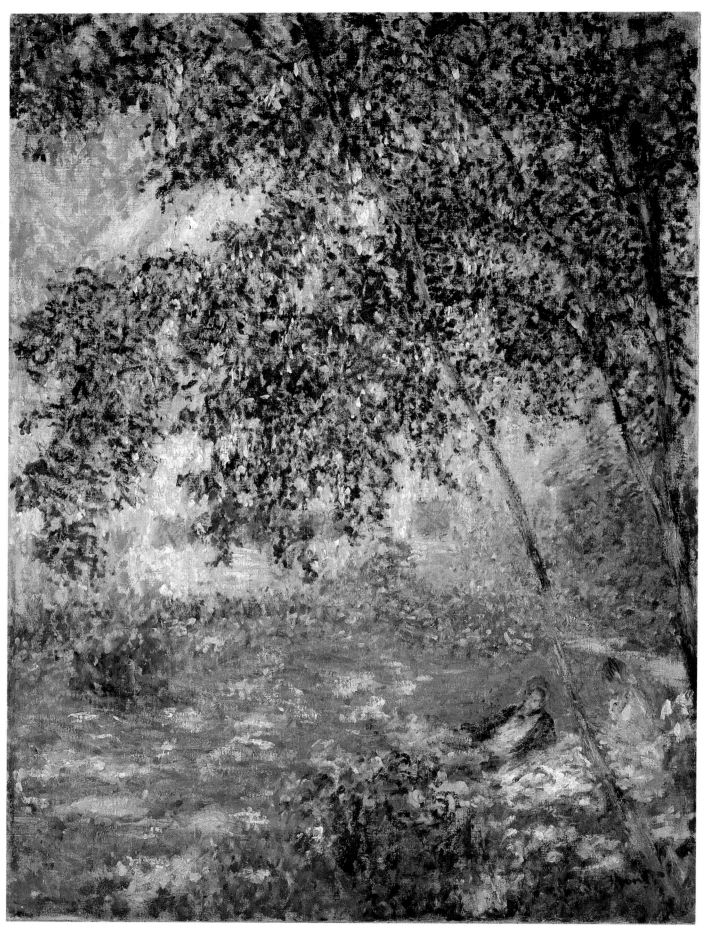

Claude Monet. French, 1840–1926. *The Garden of Monet's House at Argenteuil.* Oil on canvas, 31⅞ x 23⅝ in. (81 x 60 cm). Signed (lower right): Claude Monet. Gift of Mrs. Charles Wrightsman, 1994 (1994.431)

ACKNOWLEDGMENTS

As work on summary catalogues is cumulative, I should like to acknowledge those who helped me with the 1980 edition: Patricia Pellegrini, Alan E. Salz, and Elizabeth E. Gardner. I am much indebted to Mary Sprinson de Jésus, who is in charge of the old master paintings records, and to Gretchen Wold, who for several years assumed comparable responsibility for the nineteenth-century paintings. Guy Bauman gave generously of his knowledge during his all-too-brief tenure as Assistant Curator of Netherlandish Paintings. Everyone in the European Paintings Department —particularly Walter Liedtke, whose Dutch catalogue is forthcoming—has contributed from his or her ongoing scholarly work.

Jacob Bean, Curator Emeritus of Drawings, kindly agreed to the inclusion of oil sketches on paper and finished pastels from the holdings of his department; until shortly before his death he continued to offer advice and encouragement. Helmut Nickel, Curator Emeritus of Arms and Armor, assisted with armorial matters. Laurence B. Kanter,

Monique van Dorp, James Parker, James David Draper, William D. Wixom, Timothy Husband, Barbara Drake Boehm, and Stuart W. Pyhrr have verified information on material belonging to their respective departments. All credit lines have been reviewed by the Museum's Archivist, Jeanie James. Barbara Bridgers of the Photograph Studio was unfailingly helpful and Bruce Schwarz made new negatives of more than two hundred paintings. Summary catalogues defy completion, and this one has been in preparation for fully five years, during which time Kathleen Howard and Ellen Shultz, friends of long standing, have served alternately as editors: by now I should commend them not only for their critical intelligence and tact but for their endurance. Bruce Campbell, of whose gifts as a designer I stand in awe, has imposed an elegant and orderly design on an unyielding body of highly complex material. Philippe de Montebello and Everett Fahy, joined by John O'Neill and Barbara Burn in the Editorial Department, have always given this project their unstinting support.

CATALOGUES

Catalogues of European paintings in The Metropolitan Museum of Art were published regularly in nine editions between 1904 and 1931. This early series was then discontinued in favor of more complete, critical catalogues encompassing one or several national or regional schools. Eleven such volumes, two summary catalogues, and a catalogue of The Jack and Belle Linsky Collection have been published since 1940:

Harry B. Wehle. *A Catalogue of Italian, Spanish and Byzantine Paintings.* New York, The Metropolitan Museum of Art, 1940.

Harry B. Wehle and Margaretta Salinger. *A Catalogue of Early Flemish, Dutch and German Paintings.* New York, The Metropolitan Museum of Art, 1947.

Josephine L. Allen and Elizabeth E. Gardner. *A Concise Catalogue of the European Paintings in The Metropolitan Museum of Art.* New York, The Metropolitan Museum of Art, 1954.

Charles Sterling. *A Catalogue of French Paintings XV–XVIII Centuries.* Cambridge, Harvard University Press, 1955.

Charles Sterling and Margaretta M. Salinger. *French Paintings II: XIX Century.* New York, The Metropolitan Museum of Art, 1966.

Charles Sterling and Margaretta M. Salinger. *French Paintings III: XIX–XX Centuries.* New York, The Metropolitan Museum of Art, 1967.

Federico Zeri with the assistance of Elizabeth E. Gardner. *Italian Paintings: Florentine School.* New York, The Metropolitan Museum of Art, 1971; reprinted, 1979.

Federico Zeri with the assistance of Elizabeth E. Gardner. *Italian Paintings: Venetian School.* New York, The Metropolitan Museum of Art, 1973.

Federico Zeri with the assistance of Elizabeth E. Gardner. *Italian Paintings: Sienese and Central Italian Schools.* New York, The Metropolitan Museum of Art, 1980.

Katharine Baetjer. *European Paintings in The Metropolitan Museum of Art by artists born in or before 1865: A Summary Catalogue.* 3 vols. New York, The Metropolitan Museum of Art, 1980.

Walter A. Liedtke. *Flemish Paintings in The Metropolitan Museum of Art.* 2 vols. New York, The Metropolitan Museum of Art in association with The J. Paul Getty Trust, 1984.

John Pope-Hennessy, Katharine Baetjer, Guy C. Bauman, Keith Christiansen, and Walter Liedtke, in *The Jack and Belle Linsky Collection in The Metropolitan Museum of Art,* New York, The Metropolitan Museum of Art, 1984, pp. 11–12, 20–125. Supplemented by Katharine Baetjer, Guy C. Bauman, and Mary Sprinson de Jésus, in "The Jack and Belle Linsky Collection in The Metropolitan Museum of Art: Addenda to the Catalogue," *Metropolitan Museum Journal* 21 (1986), pp. 154–63.

Federico Zeri with the assistance of Elizabeth E. Gardner. *Italian Paintings: North Italian School.* New York, The Metropolitan Museum of Art, 1986.

John Pope-Hennessy assisted by Laurence B. Kanter. *The Robert Lehman Collection I: Italian Paintings.* New York, The Metropolitan Museum of Art in association with Princeton University Press, 1987.

NOTE TO THE CATALOGUE

When preceding the name of an artist:

Attributed to
indicates that although the painting is probably by the artist a certain degree of caution is required: the painting may be in poor condition, for example, or present knowledge about the extent or nature of the artist's work may be insufficient.

Workshop of
indicates that the painting was executed in the artist's studio, and therefore probably within his lifetime, by an unidentified collaborator or pupil.

Style of/Follower(s) of
indicates similarity to the work of the artist but may imply a significant distance in time or place of origin. The nationality and date to the quarter century are supplied where possible.

Copy after
indicates that the original work is known or may be postulated. The nationality and date are supplied where possible.

Particular attention has been given to the verification of signatures, dates, and inscriptions. Excepting those in Russian and Greek, all have been transcribed in full. Most have also been translated in full, though there are a few commonly used phrases and abbreviations whose meaning is assumed to be understood: AETATIS SVAE and a date, for the age of a sitter; INRI, identifying Christ as King of the Jews; AVE MARIA, Hail Mary, for the Virgin; and EGO SVM, I am [the way, the truth, and the life: no man cometh unto the father but by me. John 14:6]. Whether effaced or deliberately elided, letters and numerals that can be supplied from biblical or other sources appear in square brackets, and in the interest of clarification, truncated phrases may also be expanded and bracketed in translation.

The works of each artist are arranged in approximate chronological sequence, but no attempt has been made to supply dates for undated paintings.

Paintings by unknown masters are listed under the country—and, as appropriate, school—of origin.

The designations Dutch and Flemish are used for artists active by or born in or after 1579, when the Union of Utrecht established what became the permanent boundary between the north and south Netherlands.

In general, hyphens are used for the names of French artists and sitters born after 1775.

Measurements are given in inches (to the ¼ in.) and centimeters, height preceding width; a chart has been used to achieve consistent conversions.

European Paintings in The Metropolitan Museum of Art

by artists born before 1865

A SUMMARY CATALOGUE

Berlinghiero

Italian, Lucca, active by 1228, died by 1236

Madonna and Child

Tempera on wood, gold ground; overall
31⁵/₈ × 21¹/₈ in. (80.3 × 53.7 cm); painted
surface 30 × 19¹/₂ in. (76.2 × 49.5 cm)
Gift of Irma N. Straus, 1960
60.173

Master of the Magdalen

Italian, Florentine, active 1265–1295

Madonna and Child Enthroned (triptych)
Central panel: Madonna and Child
Enthroned with Saints Paul and Peter and
(above) the Annunciation; left wing: Christ in
Glory, Last Supper, and Betrayal of Christ;
right wing: Crucifixion, Way to Calvary, and
Flagellation
Tempera on wood, gold ground; central panel
16 × 11¹/₈ in. (40.6 × 28.3 cm); left wing
15 × 5⁵/₈ in. (38.1 × 14.3 cm); right wing
15 × 5¹/₂ in. (38.1 × 14 cm)
Inscribed (top of central panel): [illegible]
Gift of George Blumenthal, 1941
41.100.8

Madonna and Child (fragment)
Tempera on wood, irregular, 29¹/₂ × 18¹/₄ in.
(74.9 × 46.4 cm)
Gift of Irma N. Straus, 1964
64.189.1

60.173

41.100.8

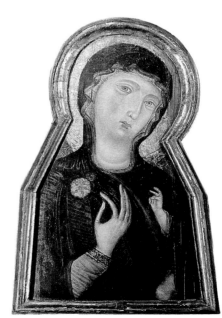

64.189.1

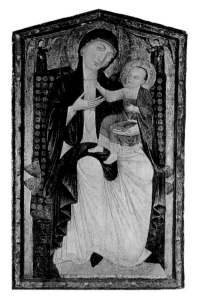

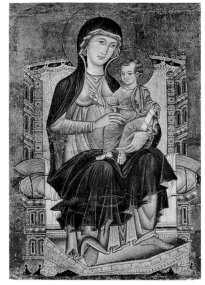

Italian (Florentine) Painters

late 13th century

Madonna and Child Enthroned
Tempera on wood, gold ground,
60¹/₂ × 36 in. (153.7 × 91.4 cm)
Inscribed (on each side of Madonna's halo, in Greek): Mother of God
Gift of George Blumenthal, 1941
41.100.21

fourth quarter 13th century

Madonna and Child Enthroned
Tempera on wood, gold ground,
32³/₄ × 21⁷/₈ in. (83.2 × 55.6 cm)
Gift of Mrs. W. Murray Crane, 1969
69.280.4

41.100.21

69.280.4

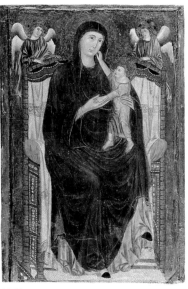

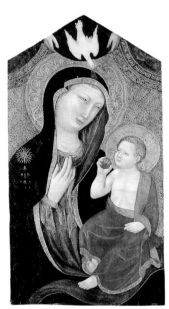

Master called Pseudo-Master of Varlungo

Italian, Florentine, active fourth quarter 13th century

Madonna and Child Enthroned with Angels
Tempera on wood, silver ground; overall
51¹/₄ × 32⁵/₈ in. (130.2 × 82.9 cm); painted surface 50¹/₄ × 28 in. (127.6 × 71.1 cm)
Gift of Robert Lehman, 1949
49.39

Lippo di Benivieni

Italian, Florentine, active 1296–1327

Madonna and Child (fragment)
Tempera on wood, gold ground,
67¹/₄ × 33³/₄ in. (170.8 × 85.7 cm)
Inscribed (on border of cloth of honor): [A]UE
. MARISTELLA . DEI MAT̄[ER]/ALMA . ATQUE
SEMPER VIRGO. (Hail, Star of the Sea, beloved Mother of God, and ever virgin [From Ave maris stella, a hymn to the Virgin].)
Gift of Robert Lehman, 1963
63.203

49.39

63.203

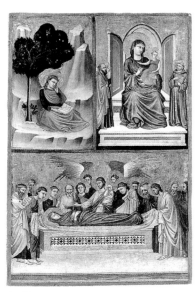

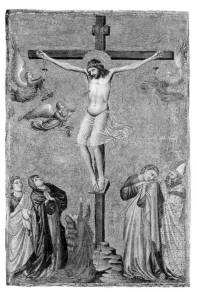

Pacino di Bonaguida

Italian, Florentine, active 1303–1320 or later

Saint John on Patmos, Madonna and Child Enthroned, and Death of the Virgin; The Crucifixion (diptych)
Left wing: Saint John on Patmos, Madonna and Child Enthroned with Saints Paul and Francis, and Death of the Virgin; right wing: Crucifixion with Saint John the Baptist, the Virgin, Saints Mary Magdalen and John the Evangelist, and a bishop saint
Tempera on wood, gold ground; left wing
24³/₈ × 16 in. (61.9 × 40.6 cm); right wing
24³/₈ × 15³/₄ in. (61.9 × 40 cm)
Gift of Irma N. Straus, 1964
64.189.3ab

64.189.3a

64.189.3b

Giotto di Bondone

Italian, Florentine, 1266/76–1337

The Epiphany

This scene from the life of Christ is from a
series to which six others belong:
Presentation (Isabella Stewart Gardner
Museum, Boston), Last Supper and
Crucifixion (both Alte Pinakothek, Munich),
Entombment (Berenson collection, Villa I
Tatti, Florence), Descent into Limbo (Alte
Pinakothek, Munich), and Pentecost (National
Gallery, London).
Tempera on wood, gold ground,
17³/₄ × 17¹/₄ in. (45.1 × 43.8 cm)
John Stewart Kennedy Fund, 1911
11.126.1

Italian (Tuscan) Painter

first quarter 14th century

Madonna and Child; Pietà (diptych)

Tempera on wood, gold ground; left wing,
overall, with engaged frame, 6³/₈ × 4⁵/₈ in.
(16.2 × 11.7 cm); left wing, painted surface
4⁷/₈ × 3¹/₂ in. (12.4 × 8.9 cm); right wing,
overall, with engaged frame, 6¹/₄ × 4⁵/₈ in.
(15.9 × 11.7 cm); right wing, painted surface
4³/₄ × 3³/₈ in. (12.1 × 8.6 cm)
Robert Lehman Collection, 1975
1975.1.3–4
ROBERT LEHMAN COLLECTION

Maso di Banco

Italian, Florentine, active 1320–1346

Saint Anthony of Padua

This panel belonged to a polyptych that
included a Madonna and Child
(Gemäldegalerie, SMPK, Berlin) and Saints
Anthony Abbot and John the Baptist (both
destroyed, 1945).
Tempera on wood, gold ground, arched top,
29¹/₄ × 16 in. (74.3 × 40.6 cm)
Maitland F. Griggs Collection, Bequest of
Maitland F. Griggs, 1943
43.98.13

Biadaiolo Illuminator

Italian, Florentine, active second quarter 14th
century

*The Last Judgment; Madonna and Child
with Saints; The Crucifixion; The
Glorification of Saint Thomas Aquinas;
The Nativity*

Tempera on wood, gold ground; overall
26³/₈ × 18⁵/₈ in. (67 × 47.3 cm); painted
surface 23¹/₄ × 16⁵/₈ in. (59.1 × 42.2 cm)
Inscribed: (on scroll held by angel at left in
Last Judgment) VENITE BENEDITT/PATER MEI
EPOSIDETE (Come, ye blessed of my Father,
inherit [the kingdom] [Matthew 25:34].); (on
scroll held by angel at right in Last Judgment)
GITE.MALLADITTI.INI/NGNAM ETTERNA
(Depart [from me], ye cursed, into everlasting
fire [Matthew 25:41].); (on scroll held by

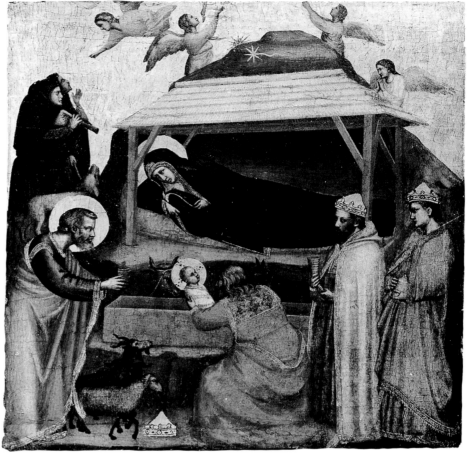

11.126.1

1975.1.3

1975.1.4

Saint Peter in Glorification) ASCULTA OFILII
P[RE]C/ETTA MAGISTRI (Hear [my] sons the
precepts of the master)
Robert Lehman Collection, 1975
1975.1.99
ROBERT LEHMAN COLLECTION

Master of the Codex of Saint George

Italian, Florentine, active second quarter 14th
century

The Crucifixion; The Entombment

These panels, and the Noli Me Tangere and
the Coronation of the Virgin (both Bargello,

43.98.13

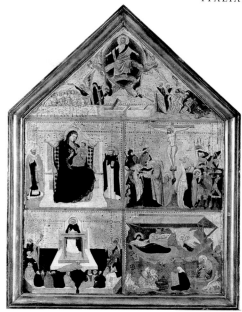

1975.1.99

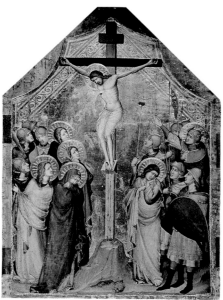

61.200.1

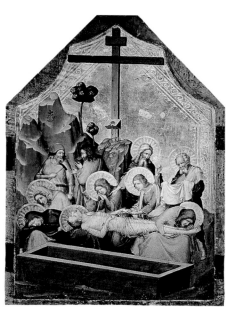

61.200.2

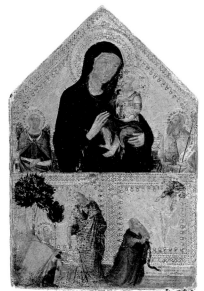

1982.60.2

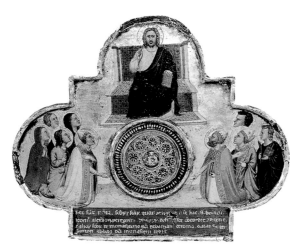

1974.217

Florence), probably belonged to a portable altarpiece.

Tempera on wood, gold ground, shaped top; overall (1) 18 × 11³/₄ in. (45.7 × 29.8 cm), (2) 18¹/₈ × 11³/₄ in. (46 × 29.8 cm); painted surface, each 15⁵/₈ × 10⁵/₈ in. (39.7 × 27 cm) Inscribed: (on cross) ·I·N·R·I·; (on banner) SPQR
The Cloisters Collection, Bequest of John D. Rockefeller Jr., 1960
61.200.1–2
THE CLOISTERS

Italian (Pisan) Painter

second quarter 14th century

Madonna and Child with Saints Michael and John the Baptist; The Noli Me Tangere; The Conversion of Saint Paul
Tempera on wood, gold ground; overall, with additions 18 × 11⁵/₈ in. (45.7 × 29.5 cm); without additions 17¹/₂ × 11 in. (44.5 × 27.9 cm); painted surface 17¹/₄ × 10⁷/₈ in. (43.8 × 27.6 cm) Inscribed: (upper right, on Saint John's scroll) Ec[c]e ag[nu]s dei. Ecce / qui tollit pecc[atum mundi. [John 1: 29]; (lower right, on Christ's scroll) [Sau]le qu[i]d me / persequeris [?] (Saul, why persecutest thou me? [Acts 9:4]); (bottom right) . . . / . . . girenus qu . . . / . . . / . . . et . . . / ingre . . . / quid . . .
The Jack and Belle Linsky Collection, 1982
1982.60.2

Bernardo Daddi

Italian, Florentine, active by 1327, probably died 1348

Christ Enthroned with Saints
Tempera on wood, gold ground, irregular, 7¹/₂ × 9 in. (19.1 × 22.9 cm) Inscribed (bottom): hec s͞u[n]t n͞o[m]i[n]a. s[an]c̄[t]orum & s[an]c̄[t]arum quoius reliq[uia]e s͞u[n]t hic. S[ancti]. [se]bostia[n]i̅. / leonis. alex͞a[n]dri. peregrini. phil[i]ppy. rufi[nianus]. [iu]ste. c͞o[n]cordie. & dece͞[n]tie. / & aliorum s[an]c̄[t]orum de monasteerio s[an]c̄[t]i sebastian[i] deroma. Quas frater / Simon abbas d[i]c̄[t]i monasterii dedit (Here are the names of the saints, male and female, whose relics are here: of Saints Sebastian, Leo, Alexander, Peregrine, Philip, Rufinianus, Justa, Concordius, Decentius, and other saints of the monastery of Saint Sebastian of Rome which Brother Simon, the abbot of said monastery, gave)
Bequest of Harriet H. Jonas, 1974
1974.217

43.98.3

41.190.15

43.98.4

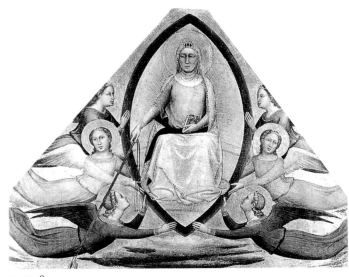

1975.1.58

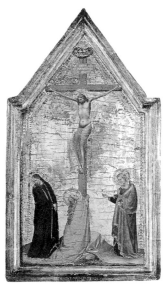

41.190.12

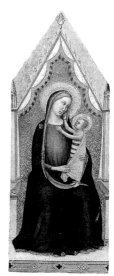

1975.1.59

Saint Reparata before the Emperor Decius
This panel and the following two (41.190.15, 43.98.4), together with Saint Reparata in Prison (private collection), Saint Reparata in a Furnace (private collection), and the Beheading of Saint Reparata (location unknown), constituted the predella of an unidentified altarpiece.
Tempera on wood, 12⅝ × 15⅞ in. (32.1 × 40.3 cm)
Maitland F. Griggs Collection, Bequest of Maitland F. Griggs, 1943
43.98.3

Saint Reparata Tortured with Red-Hot Irons (predella panel)
Tempera on wood, gold ground (tooled pattern added possibly in the late 19th century), 13 × 16½ in. (33 × 41.9 cm)
Bequest of George Blumenthal, 1941
41.190.15

Saint Reparata Being Prepared for Execution (predella panel)
Tempera on wood, gold ground, 9⅝ × 13⅝ in. (24.4 × 34.6 cm)
Maitland F. Griggs Collection, Bequest of Maitland F. Griggs, 1943
43.98.4

Bernardo Daddi
and
The Assistant of Daddi
Italian, Florentine, active in the 1340s

The Assumption of the Virgin (fragment of an altarpiece)
Tempera on wood, gold ground, 42½ × 53⅞ in. (108 × 136.8 cm)
Robert Lehman Collection, 1975
1975.1.58
ROBERT LEHMAN COLLECTION

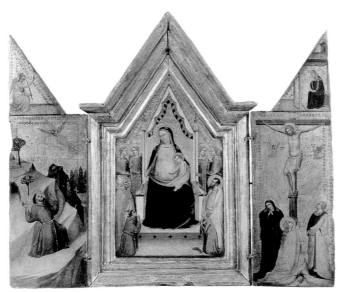

32.100.70

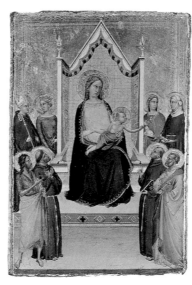

41.100.15

1975.1.60 (recto)

1975.1.60 (verso)

Workshop of Bernardo Daddi

The Crucifixion (central panel of a portable altarpiece)
Tempera on wood, gold ground, arched top, 18³/₄ × 10¹/₄ in. (47.6 × 26 cm)
Inscribed (on cross): HIC EST IHS /[NA]SARENVS/REX [JV]DEO[RVM]
Bequest of George Blumenthal, 1941
41.190.12

Madonna and Child Enthroned

Tempera on wood, transferred to canvas and laid down on wood, gold ground, 10¹/₈ × 3³/₄ in. (25.7 × 9.5 cm)
Robert Lehman Collection, 1975
1975.1.59
ROBERT LEHMAN COLLECTION

Madonna and Child Enthroned with Saints (triptych)
Central panel: Saints Nicholas(?) and Bartholomew with donors, one a Franciscan monk; left wing: Saint Francis Receiving the Stigmata and (above) Angel of the Annunciation; right wing: Crucifixion and (above) Virgin Annunciate
Tempera on wood, gold ground; central panel, overall 19¹/₂ × 11¹/₄ in. (49.5 × 28.6 cm); central panel, painted surface 13¹/₄ × 7³/₄ in. (33.7 × 19.7 cm); left wing 18¹/₈ × 5¹/₂ in. (46 × 14 cm); right wing 18¹/₄ × 5⁵/₈ in. (46.4 × 14.3 cm)
The Friedsam Collection, Bequest of Michael Friedsam, 1931
32.100.70

Madonna and Child Enthroned with Saints
This painting is the left wing of a diptych and was paired with a Crucifixion (art market, 1965). The saints are John the Baptist, Francis, Louis of Toulouse, Catherine of Alexandria, Agnes, Elizabeth of Hungary, Anthony of Padua, and an Evangelist.
Tempera on wood, gold ground; overall 13¹/₄ × 8¹/₂ in. (33.7 × 21.6 cm); painted surface 13 × 8¹/₈ in. (33 × 20.6 cm)
Gift of George Blumenthal, 1941
41.100.15

Follower of Bernardo Daddi

Italian, Florentine, painted about 1335–40
The Nativity
This panel is probably the left wing of a diptych. The verso is painted in four quadrants with alternating fields of red and green bordered in yellow; at the center of each field is a quatrefoil interlaced with a rosette.
Tempera on wood, gold ground; overall, with engaged frame, 11⁵/₈ × 8³/₈ in. (29.5 × 21.3 cm); painted surface 8¹/₂ × 6⁷/₈ in. (21.6 × 17.5 cm)
Robert Lehman Collection, 1975
1975.1.60
ROBERT LEHMAN COLLECTION

Taddeo Gaddi

Italian, Florentine, active by 1334, died 1366
Madonna and Child Enthroned with Saints
This altarpiece may be tentatively identified with one mentioned by Vasari as on the high altar of the church of Santo Stefano al Ponte Vecchio, Florence. Originally composed of five panels with pointed tops, it was reframed in the early 16th century; the pilasters and the Evangelists in the spandrels, by David Ghirlandaio (1452–1525), were painted at that time. The saints (left to right) are Lawrence, John the Baptist, James the Greater, and Stephen.
Tempera on wood, gold ground; overall 43¹/₄ × 90¹/₈ in. (109.9 × 228.9 cm); Lawrence 43¹/₄ × 15¹/₂ in. (109.9 × 39.4 cm); John 43¹/₄ × 13¹/₂ in. (109.9 × 34.3 cm); Madonna and Child 43¹/₄ × 28¹/₂ in. (109.9 × 72.4 cm); James 43¹/₄ × 15³/₄ in. (109.9 × 40 cm); Stephen 43¹/₄ × 16³/₄ in. (109.9 × 42.5 cm)
Inscribed (on frame): S.LAVRENTIVS S.IOHANES S.MARIA: MATER·DEI S.IACOBVS S.STEFANVS (Saint Lawrence; Saint John; Holy Mary, Mother of God; Saint James; Saint Stephen)
Rogers Fund, 1910
10.97

Puccio di Simone

Italian, Florentine, active about 1340, died 1362

The Nativity

This panel formed part of a predella, other parts of which are a Pietà (Gemäldegalerie, SMPK, Berlin) and Three Marys at the Tomb (Statens Museum for Kunst, Copenhagen).
Tempera on wood, gold ground,
7⁷/₈ × 15 in. (20 × 38.1 cm)
Robert Lehman Collection, 1975
1975.1.105
Robert Lehman Collection

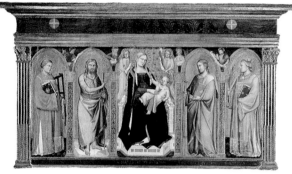

10.97

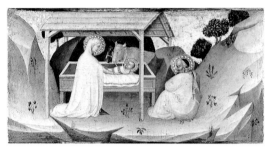

1975.1.105

Niccolò di Tommaso

Italian, Florentine, active 1343–1376

The Man of Sorrows

Fresco, transferred to canvas, 65 × 70 in.
(165.1 × 177.8 cm)
Inscribed (on cross): inri
The Cloisters Collection, 1925
25.120.241
The Cloisters

Giovanni da Milano (Giovanni di Jacopo di Guido da Caversaio)

Italian, Florentine, active 1346–1369

Madonna and Child with Donors (lunette)

Tempera on wood, gold ground,
27¹/₈ × 56³/₄ in. (68.9 × 144.1 cm)
Rogers Fund, 1907
07.200

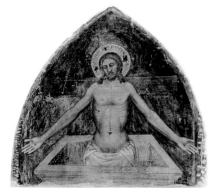

25.120.241

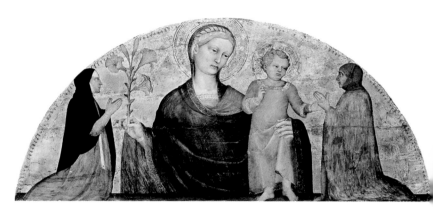

07.200

Master of the Orcagnesque Misericordia

Italian, Florentine, active second half 14th century

Head of Christ

The verso is decorated with a white-bordered purple quatrefoil design on a green ground; within the quatrefoil are squares and triangles of white, purple, and black.
Tempera on wood, gold ground; overall, with engaged frame, 11⁵/₈ × 8¹/₈ in. (29.5 × 20.6 cm); painted surface 9⁵/₈ × 6¹/₈ in. (24.4 × 15.6 cm)
Inscribed (on Christ's collar): ⫶ pacem ⫶ meam ⫶ dovobis (My peace I give unto you [John 14:27].)
Gift of The Jack and Belle Linsky Foundation, 1981
1981.365.2

Crucifix

Terminals: (recto) Virgin and Saints John the Baptist, Francis of Assisi, and Bonaventura; (verso) four Evangelists. The recto and verso have been separated.
Tempera on wood, gold ground,
18 × 13¹/₄ in. (45.7 × 33.7 cm)
Inscribed (recto): inri
Gift of Samual H. Kress, 1927
27.231ab

1981.365.2 (recto)

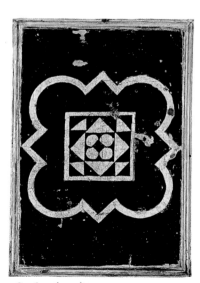

1981.365.2 (verso)

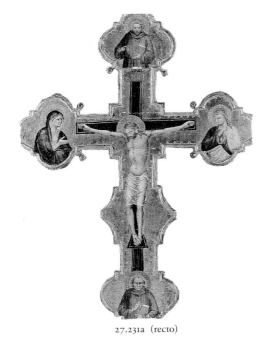

27.231a (recto)

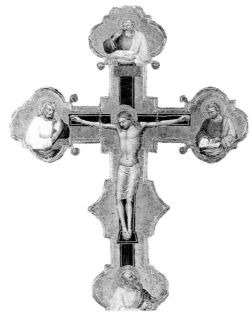

27.231b (verso)

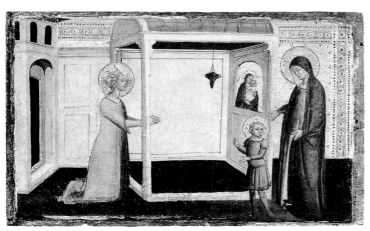

1975.1.62

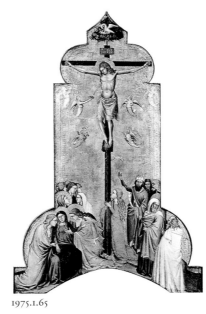

1975.1.65

The Vision of Saint Catherine of Alexandria

This panel formed part of a predella, other panels of which are the Disputation of Saint Catherine (private collection) and the Martyrdom of Saint Catherine (Worcester Art Museum, Massachusetts). It is possible that the central panel of the altarpiece is a Mystic Marriage of Saint Catherine (private collection).

Tempera on wood, gold ground; overall 8¼ × 13½ in. (21 × 34.3 cm); painted surface 7⅞ × 12⅞ in. (20 × 32.7 cm)
Robert Lehman Collection, 1975
1975.1.62
ROBERT LEHMAN COLLECTION

Don Silvestro de' Gherarducci
Italian, Florentine, 1339–1399

The Crucifixion

This panel may be the central pinnacle of an altarpiece of 1372 from the Sala del Capitolo of the Convento degli Angeli, Florence, which also included wings with saints (private collection and Musée d'Histoire et d'Art, Luxembourg), a left gable with the Noli Me Tangere (National Gallery, London), and a predella panel with the Man of Sorrows (Denver Art Museum).

Tempera on wood, gold ground, 54⅛ × 32¼ in. (137.5 × 81.9 cm)
Robert Lehman Collection, 1975
1975.1.65
ROBERT LEHMAN COLLECTION

Jacopo di Cione
Italian, Florentine, active about 1360–1400

Six Angels

Since before 1836 these panels have been framed with the preceding one (1975.1.65).
Tempera on wood, gold ground; top left 9¾ × 3⅞ in. (24.8 × 9.8 cm); center left 11⅛ × 5¼ in. (28.3 × 13.3 cm); bottom left 9⅞ × 3⅞ in. (25.1 × 9.8 cm); top right 9¾ × 3⅞ in. (24.8 × 9.8 cm); center right 11⅛ × 5¼ in. (28.3 × 13.3 cm); bottom right 10 × 3⅞ in. (25.4 × 9.8 cm)
Robert Lehman Collection, 1975
1975.1.65a–f
ROBERT LEHMAN COLLECTION

1975.1.65a

1975.1.65b

1975.1.65c

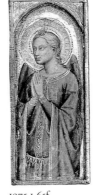

1975.1.65d

1975.1.65e

1975.1.65f

Giovanni di Bartolommeo Cristiani
Italian, Florentine, active 1367–1398

Saint Lucy and Her Mother at the Shrine of Saint Agatha
This panel and the following three (12.41.3, 1, 2) are from a series that also included the Last Communion and Martyrdom of Saint Lucy (private collection) and, as the central panel, Saint Lucy Enthroned (Yale University Art Gallery, New Haven).
Tempera on wood, gold ground,
9³/₄ × 15¹/₈ in. (24.8 × 38.4 cm)
Rogers Fund, 1912
12.41.4

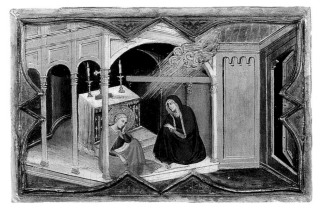

12.41.4

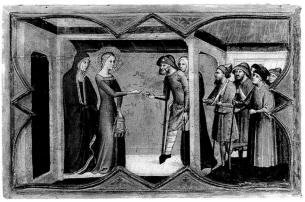

12.41.3

Saint Lucy Giving Alms
Tempera on wood, gold ground,
9³/₄ × 15¹/₈ in. (24.8 × 38.4 cm)
Rogers Fund, 1912
12.41.3

Saint Lucy before Paschasius
Tempera on wood, gold ground,
9¹/₂ × 15¹/₄ in. (24.1 × 38.7 cm)
Rogers Fund, 1912
12.41.1

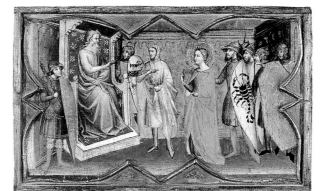

12.41.1

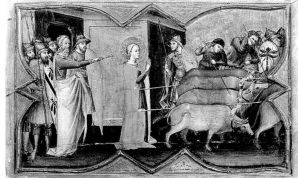

12.41.2

Saint Lucy Resisting Efforts to Move Her
Tempera on wood, gold ground, 10 × 15 in. (25.4 × 38.1 cm)
Rogers Fund, 1912
12.41.2

Agnolo Gaddi
Italian, Florentine, active by 1369, died 1396

The Trinity
It seems likely that this panel was the center of a triptych. The predella may have been made up of scenes from the Legend of the True Cross by the Master of the Straus Madonna—Christ Descending into Limbo (National Gallery, Prague), Saint Helen Discovering the True Cross (private collection), and the Beheading of Cosroe and the Entry of Heraclius into Jerusalem (originally one panel, now divided between a private collection and the National Gallery, Prague).
Tempera on wood, gold ground, arched top; overall 53¹/₂ × 28³/₄ in. (135.9 × 73 cm); painted surface 51¹/₈ × 27⁷/₈ in. (129.9 × 70.8 cm)
Gift of George Blumenthal, 1941
41.100.33

Workshop of Agnolo Gaddi

Saint Margaret and the Dragon (fragment)
Panels representing a Franciscan saint, possibly Francis of Assisi himself, and Saint Elizabeth of Hungary (both art market, about 1955) may

be from the predella of the same unidentified altarpiece.
Tempera on wood, gold ground, 9¹/₈ × 8 in. (23.2 × 20.3 cm)
Bequest of George Blumenthal, 1941
41.190.23

Cenni di Francesco di Ser Cenni
Italian, Florentine, active by 1369, died 1415

Saint Catherine Disputing and Two Donors
Tempera on wood, gold ground; overall, with engaged frame, 22³/₄ × 18¹/₄ in. (57.8 × 46.4 cm); painted surface 21¹/₄ × 16³/₄ in. (54 × 42.5 cm) [cut at top; the frame is not original]
Bequest of Jean Fowles, in memory of her first husband, R. Langton Douglas, 1981
1982.35.1

Niccolò di Pietro Gerini
Italian, Florentine, active by 1368, died 1414/15

An Episode from the Life of Saint Giovanni Gualberto
Tempera on wood, gold ground, arched top, 57³/₄ × 28¹/₂ in. (146.7 × 72.4 cm)
Inscribed (on cross): I·N·R·I·
Gwynne Andrews Fund, 1958
58.135

Master of 1416
Italian, Florentine, early 15th century

Ameto's Discovery of the Nymphs
This panel and the following (26.287.1) are the recto and verso of a marriage salver.
Tempera on wood, twelve-sided,
21¹/₈ × 22¹/₈ in. (53.7 × 56.2 cm)
Rogers Fund, 1926
26.287.2

A Contest between the Shepherds Alcesto and Acaten
Tempera on wood, twelve-sided,
21¹/₈ × 22¹/₈ in. (53.7 × 56.2 cm)
Rogers Fund, 1926
26.287.1

Tommaso del Mazza
Italian, Florentine, active late 14th century

Madonna and Child Enthroned with Saints (triptych)
Central panel: Madonna and Child Enthroned with Saints Peter, Bartholomew, Catherine of Alexandria, and Paul, and (below) the Nativity; left wing (top to bottom): Annunciatory Angel, Crucified Christ with the Virgin, Saints Mary Magdalen and John, and Christ as the Man of Sorrows; right wing (top to bottom): Virgin Annunciate, Saints Onophrius and Paphnutius, and Saint Onophrius buried by

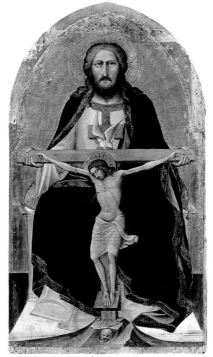

41.100.33

41.190.23

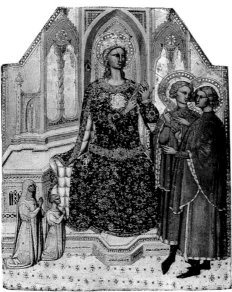

1982.35.1

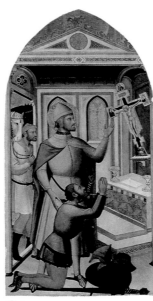

58.135

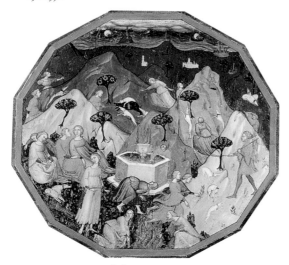

26.287.2

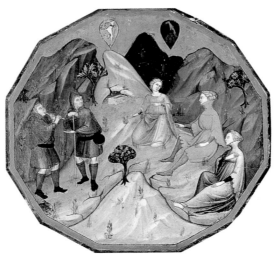

26.287.1

Saint Paphnutius. The verso is painted red with black trim on the shutters. The hinges appear to be original.

Tempera on wood, gold ground; central panel 17¹/₂ × 8 in. (44.5 × 20.3 cm); left wing 16⁷/₈ × 4¹/₂ in. (42.9 × 11.4 cm); right wing 17¹/₈ × 4⁵/₈ in. (43.5 × 11.7 cm)

Robert Lehman Collection, 1975

1975.1.69

ROBERT LEHMAN COLLECTION

Spinello Aretino (Spinello di Luca Spinelli)

Italian, Tuscan, active by 1373, died 1411

Saint Philip

This panel and the following (1975.1.64) formed part of an altarpiece from the monastery church of Monte Oliveto Maggiore. Other surviving panels are: Coronation of the Virgin and Dormition of the Virgin (both Pinacoteca Nazionale, Siena); Saints Nemisius and John the Baptist with scenes from their lives (Szépmuvészeti Múzeum, Budapest); Saints Benedict and Lucilla with scenes from their lives (Fogg Art Museum, Cambridge, Massachusetts); and a pilaster panel of Saint James the Lesser (art market, 1982).

Tempera on wood, gold ground; overall, excluding 1¹/₈ in. (2.9 cm) of frame at bottom, 20³/₄ × 7³/₈ in. (52.7 × 18.7 cm); painted surface, excluding ⁵/₈ in. (1.5 cm) of titulus, 18¹/₈ × 5³/₈ in. (46 × 13.7 cm)

Inscribed (in gilt gesso): S:PHILLIPPS:.

Robert Lehman Collection, 1975

1975.1.63

ROBERT LEHMAN COLLECTION

A Saint, Possibly James the Greater

Tempera on wood, gold ground; overall 20⁵/₈ × 7¹/₈ in. (52.4 × 18.1 cm); painted surface 18¹/₄ × 5³/₈ in. (46.4 × 13.7 cm)

Robert Lehman Collection, 1975

1975.1.64

ROBERT LEHMAN COLLECTION

Processional Banner

This banner represents (recto) Saint Mary Magdalen with a Crucifix and (verso) the Flagellation of Christ. It was apparently painted for the confraternity of Saint Mary Magdalen in Borgo Sansepolcro. The missing face of Christ is in the Camposanto Teutonico, Vatican City.

Tempera on canvas, gold ground, 69¹/₂ × 47¹/₄ in. (176.5 × 120 cm)

Gift of the family of Francis M. Bacon, 1914

13.175

The Conversion of Saint Paul

Tempera on wood, gold ground, 11⁷/₈ × 11⁵/₈ in. (30.2 × 29.5 cm)

Robert Lehman Collection, 1975

1975.1.11

ROBERT LEHMAN COLLECTION

Giovanni di Tano Fei
Italian, Florentine, active 1384–1405

The Coronation of the Virgin, and Saints
This triptych is from the Brunelleschi chapel in the church of San Leo, Florence. Central panel: Christ Crowning the Virgin (above, bust of Christ); left panel: Saints Bernard and Silvester (above, bust of a prophet); right panel: Saints Nicholas and Julian the Hospitaler (above, bust of a prophet); predella panels: Emperor Constantine's Dream, Saint Silvester Raising the Bull, Saint Silvester Binding the Dragon's Mouth; between panels: kneeling donors
Tempera on wood, gold ground, shaped top; overall, with engaged frame, 78³/₈ × 76 in. (199.1 × 193 cm)
Inscribed and dated: (frame, at base of central panel) HANC·TABVLAM·FIERI·[FECIT] ALDEROT[T]VS·DEBRVNEL[L]ESCHIS·QVE· DIMISSIT·/SILVESTER·PATRVVS·SVVS· P[RO]REMEDIO·ANIME SVEE[T]SVORVM ·A·D·M·CCC·L·XXXX·IIII (Alderottus Brunelleschi had this altarpiece made with what his paternal uncle Silvester left for the redemption of his soul and the souls of his family in the year of our Lord 1394); (bottom, central panel) DIE VIIII MENSIS NOVENBRIS (ninth day of the month of November); (frame, at base of left panel) S[AN]C[TV]S· BERNARDVS·ABB[AS] / S[AN]C[TV]S· SILVESTER·P[A]P[A] (Saint Bernard, abbot; Saint Silvester, pope); (frame, at base of right panel) S[AN]C[TV]S·NICCHOLAVS ·EP[ISCO]P[VS]/S[AN]C[TV]S IVLIANVS M[ARTY]R (Saint Nicholas, bishop; Saint Julian, martyr); (on open book held by Christ) AUU (Alpha and Omega); (on scrolls held by prophets, in pseudo-Kufic)
Arms (at base of each colonnette) of the Brunelleschi family of Florence
Gift of Robert Lehman, 1950
50.229.2

Lorenzo Monaco (Piero di Giovanni)
Italian, Florentine, active 1390–1423

The Crucified Christ between the Virgin and Saint John the Evangelist
This panel was probably the central pinnacle of an altarpiece of 1404, the Madonna and Child between Saints Donnino and John the Baptist and Saints Peter and Anthony Abbot (Museo Diocesano, Empoli).
Tempera on wood, gold ground; overall, including gable, 33⁵/₈ × 14¹/₂ in. (85.4 × 36.8 cm)
Robert Lehman Collection, 1975
1975.1.67
ROBERT LEHMAN COLLECTION

The Nativity
This panel and three others—the Visitation and the Adoration of the Magi (both Courtauld Institute Gallery, London) and the Flight into Egypt (Staatliches Lindenau-Museum, Altenburg)—may be from the

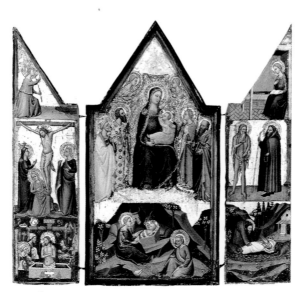

1975.1.69

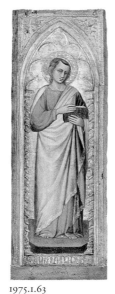

1975.1.63

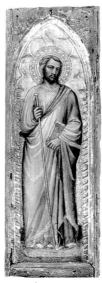

1975.1.64

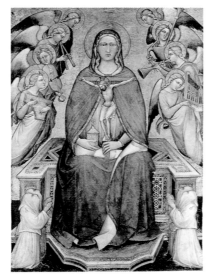

13.175 (recto)

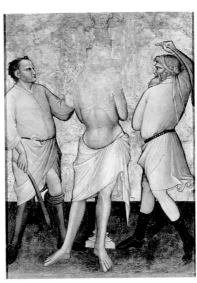

13.175 (verso)

1975.1.11

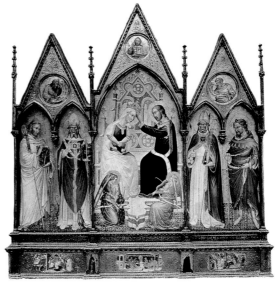

50.229.2

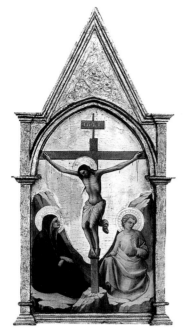

1975.1.67

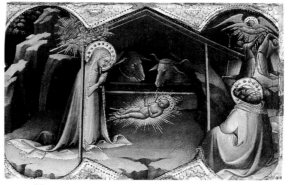

1975.1.66

predella of the Madonna and Child Enthroned with Four Saints (Accademia, Florence).
Tempera on wood, gold ground,
8³/₄ × 12¹/₄ in. (22.2 × 31.1 cm)
Robert Lehman Collection, 1975
1975.1.66
ROBERT LEHMAN COLLECTION

Abraham

This panel and the following three (65.14.2–4) belonged to the same ensemble.
Tempera on wood, gold ground; overall 26 × 16⁷/₈ in. (66 × 42.9 cm); painted surface 22⁷/₈ × 16⁵/₈ in. (58.1 × 42.2 cm)
Gwynne Andrews Fund, and Gift of G. Louise Robinson, by exchange, 1965
65.14.1

Noah

Tempera on wood, gold ground; overall 25⁷/₈ × 17³/₈ in. (65.7 × 44.1 cm); painted surface 22⁷/₈ × 17 in. (58.1 × 43.2 cm)
Gwynne Andrews Fund, and Gift of Paul Peralta Ramos, by exchange, 1965
65.14.2

Moses

Tempera on wood, gold ground; overall 24¹/₂ × 17¹/₂ in. (62.2 × 44.5 cm); painted surface 22⁵/₈ × 17⁵/₈ in. (57.5 × 44.8 cm)
Inscribed (on tablets): [illegible]
Gwynne Andrews Fund, and Bequest of Mabel Choate, in memory of her father, Joseph Hodges Choate, by exchange, 1965
65.14.3

David

Tempera on wood, gold ground, arched top, 22³/₈ × 17 in. (56.8 × 43.2 cm)
Gwynne Andrews and Marquand Funds, and Gift of Mrs. Ralph J. Hines, by exchange, 1965
65.14.4

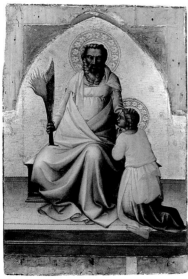

65.14.1

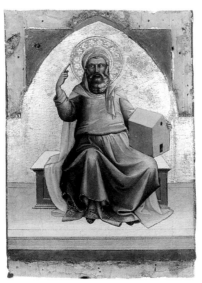

65.14.2

Attributed to Lorenzo Monaco

The Intercession of Christ and the Virgin

From the chapel of the Santissima Trinità, cathedral of Santa Maria del Fiore, Florence
Distemper on canvas, 94¹/₄ × 60¹/₄ in. (239.4 × 153 cm)
Inscribed (center): PADRE MIO SIENO SALVI CHOSTORO PEQUALI TU / VOLESTI CHIO PATISSI PASSIONE. (My Father, let those be saved for whom you wished me to suffer the passion.); DOLCIXIMO FIGLIUOLO·PELLAC:/TE CHIO TIDIE·ABBI M̄IA [MISERICORDIA] DI CHOSTORO (Dearest Son, because of the milk that I gave you have mercy on them)
The Cloisters Collection, 1953
53.37
THE CLOISTERS

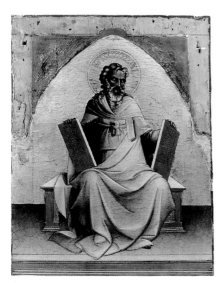

65.14.3

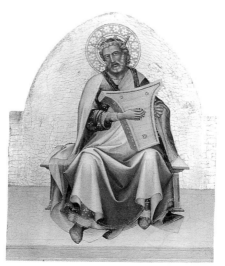

65.14.4

Workshop of Lorenzo Monaco

Madonna and Child with Angels
Tempera on wood, gold ground,
35¼ × 22⅛ in. (89.5 × 56.2 cm) [top
slightly truncated]
Rogers Fund, 1909
09.91

Bicci di Lorenzo

Italian, Florentine, 1373–1452

Saints John the Baptist and Matthew
This lateral panel and the two predella panels
(88.3.89, 16.121) are from an altarpiece painted
in 1433–35 by Bicci di Lorenzo and Stefano di
Antonio for San Niccolò in Cafaggio,
Florence. The central panel is the Madonna
and Child Enthroned with Four Angels
(Pinacoteca Nazionale, Parma). Another lateral
panel is Saints Benedict and Nicholas (Badia,
Grottaferrata); other predella panels are the
Birth of Saint Nicholas (private collection),
Saint Nicholas Rebuking the Tempest
(Ashmolean Museum, Oxford), and Pilgrims
at the Tomb of Saint Nicholas (Wawel Castle,
Kraków).
Tempera on wood, gold ground, 48⅝ × 29
in. (123.5 × 73.7 cm)
Inscribed (on John the Baptist's scroll):
ECCE.AGN.
Robert Lehman Collection, 1975
1975.1.68
ROBERT LEHMAN COLLECTION

*Madonna and Child with Saints Matthew
and Francis*
Tempera on wood, gold ground, shaped top;
overall, with engaged frame, 44⅝ × 22¼ in.
(113.3 × 56.5 cm); painted surface
32¾ × 18¾ in. (83.2 × 47.6 cm)
Inscribed (on halos): SCS·MATTEVS·
AP[OSTOLVS]; AVE·MARIA·GRATIA·PLE[NA]; SCS·
FRANCISCHV[S]
Gift of George Blumenthal, 1941
41.100.16

Saint Nicholas Providing Dowries (predella
panel)
Tempera and gold on wood, 12 × 22¼ in.
(30.5 × 56.5 cm)
Gift of Coudert Brothers, 1888
88.3.89

Saint Nicholas Resuscitating Three Youths
(predella panel)
Tempera and gold on wood, 12 × 22¼ in.
(30.5 × 56.5 cm)
Gift of Francis Kleinberger, 1916
16.121

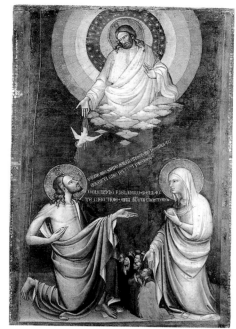

53.37

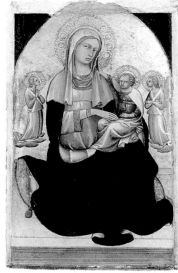

09.91

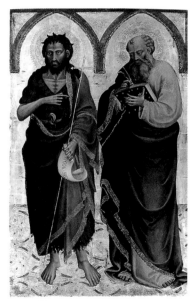

1975.1.68

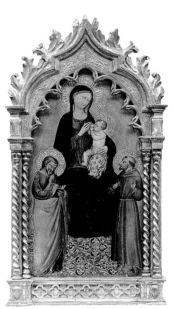

41.100.16

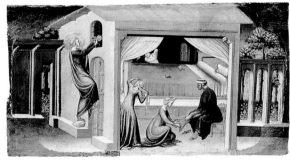

88.3.89

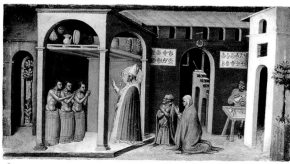

16.121

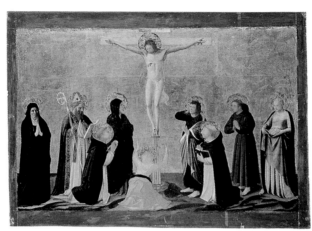

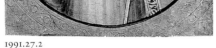
1991.27.2

14.40.628

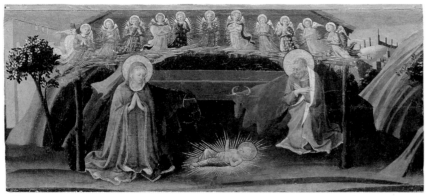

1983.490

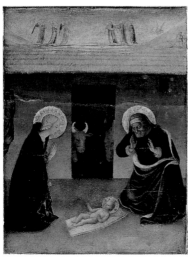

24.22

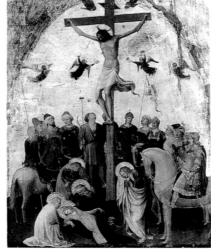

43.98.5

Fra Angelico (Guido di Pietro)

Italian, Florentine, active by 1417, died 1455

A Bishop Saint

This panel and a martyr bishop or abbot (National Gallery, London) may be from the frame or predella of an altarpiece at San Domenico, Fiesole.

Tempera on wood, gold ground; overall 6¹/₄ × 6¹/₈ in. (15.9 × 15.6 cm); diameter of roundel 5⁷/₈ in. (14.9 cm)

Bequest of Lucy G. Moses, 1990

1991.27.2

The Crucifixion

The figures (left to right) are Saints Monica, Augustine, and Peter Martyr, the Virgin, and Saints Mary Magdalen, John the Evangelist, Dominic, Francis, and Elizabeth of Hungary.

Tempera transferred to canvas, laid down on wood, gold ground; 13³/₈ × 19³/₄ in. (34 × 50.2 cm); set in panel 15³/₄ × 21¹/₄ in. (40 × 54 cm)

Bequest of Benjamin Altman, 1913

14.40.628

Workshop of Fra Angelico

The Nativity

The panel is from a predella that may have included the Temptation of Saint Anthony (Museum of Fine Arts, Houston), Saint Romuald Appearing to the Emperor Otto III (Musée Royal, Antwerp), Saint Benedict in Ecstasy (Musée Condé, Chantilly), and the Penitence of Saint Julian(?) (Musée Thomas-Henry, Cherbourg). A panel representing Saint Anthony (location unknown) may have belonged to the same altarpiece.

Tempera and gold on wood, 7³/₈ × 17¹/₈ in. (18.7 × 43.5 cm)

Gift of May Dougherty King, 1983

1983.490

The Nativity

The verso is painted to imitate porphyry.

Tempera and gold on wood; overall, with engaged frame, 15¹/₄ × 11¹/₂ in. (38.7 × 29.2 cm); painted surface 13 × 9¹/₈ in. (33 × 23.2 cm)

Inscribed (top, the beginning illegible): . . . TER[R]Ā PAX HŌ[MIN]ĪB[VS] BON[A]E / VOLV[NTATIS] (. . . [on] earth peace, good will toward men [Luke 2:14].)

Rogers Fund, 1924

24.22

Master of the Griggs Crucifixion

Italian, Florentine, active second quarter 15th century

The Crucifixion

Tempera on wood, gold ground, 25¹/₈ × 19 in. (63.8 × 48.3 cm)

Inscribed: (lower right, on breast strap of horse) . . . hone; (on cross) INRI

Maitland F. Griggs Collection, Bequest of Maitland F. Griggs, 1943

43.98.5

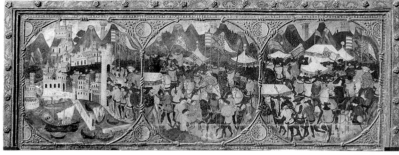

07.120.1

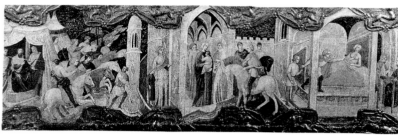

32.75.2a

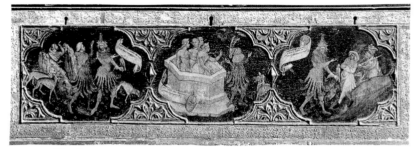

41.190.129 (detail)

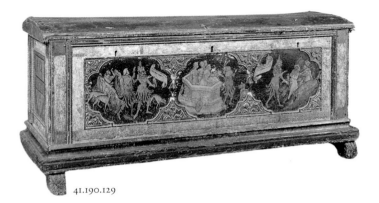

41.190.129

41.190.130 (detail)

41.190.130

Master of Charles of Durazzo

Italian, Florentine, early 15th century

The Conquest of Naples by Charles of Durazzo (cassone panel)
Right: Charles wages war against Otto of Brunswick; center: Otto submits to Charles; left: Charles enters the city of Naples as victor. The events depicted took place on June 28, 1381.
Tempera on wood, embossed and gilt ornament; overall 19³/₈ × 50³/₄ in. (49.2 × 128.9 cm); each painted surface 15³/₄ × 15 in. (40 × 38.1 cm)
Arms (on standards and trumpet flags) of the Guelph party, of the gonfaloniere of the church, of Durazzo, and of Brunswick
Rogers Fund, 1906
07.120.1

Scenes from a Legend (cassone panel)
The pair to this panel was on the art market in 1989.
Tempera on wood, embossed gilt and silver ornament; (a) 15¹/₂ × 46 in. (39.4 × 116.8 cm); end panels, with coats of arms: (b) overall 15⁵/₈ × 18³/₄ in. (39.7 × 47.6 cm); (b) painted surface 14⁷/₈ × 18 in. (37.8 × 45.7 cm); (c) overall 15¹/₈ × 19³/₈ in. (38.4 × 49.2 cm); (c) painted surface 14¹/₂ × 18⁵/₈ in. (36.8 × 47.3 cm) [b–c not illustrated]
The Collection of Giovanni P. Morosini, presented by his daughter Giulia, 1932
32.75.2a–c

Italian (Florentine?) Painter

second quarter 15th century

The Story of Actaeon (cassone panel)
This panel and the following (41.190.130) are the fronts of chests that belonged to the same family; the ends are decorated with the same unidentified coat of arms.
Tempera on wood, embossed and gilt ornament, overall 29¹/₂ × 62¹/₄ in. (74.9 × 158.1 cm)

Inscribed (left to right, on cartouches): Como Anteon andava alla caccia / Con sua compagnia; Como Diana deve diventare / Cervio Antheon; Como licōpagni de antheo . . . / Andauano Cerc[a]ndo e no[n] / Lu poteano retrouar[e] (How Actaeon went hunting with his companions; how Diana turned Actaeon into a stag; how Actaeon's companions were looking for him and could not find him)
Bequest of George Blumenthal, 1941
41.190.129
ESDA

Three Allegorical Scenes (cassone panel)
Tempera on wood, embossed and gilt ornament, overall 29¹/₂ × 62¹/₄ in. (74.9 × 158.1 cm)
Inscribed (on cartouches in each scene): [illegible]
Bequest of George Blumenthal, 1941
41.190.130
ESDA

1971.115.4

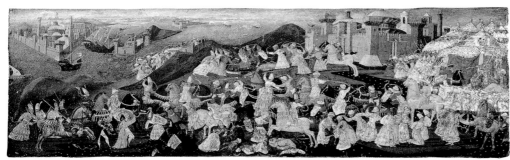

14.39 (detail)

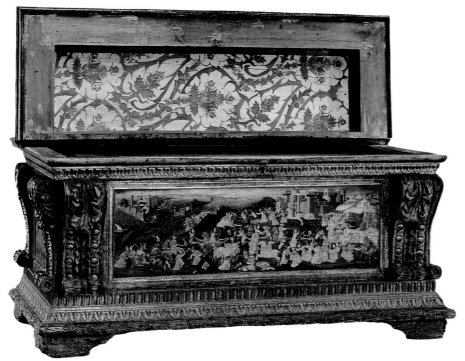

14.39

Italian (Florentine or Sienese) Painter

second quarter 15th century

The Labors of Hercules (cassone panel)
Tempera on wood, embossed and gilt
ornament; overall 18³/₄ × 69¹/₂ in.
(47.6 × 176.5 cm); each medallion, diameter
15 in. (38.1 cm)
Arms (left to right, between medallions) of
the Ginazzi and Boni families
Bequest of Edward Fowles, 1971
1971.115.4

Marco del Buono Giamberti

Italian, Florentine, 1402–1489

and

Apollonio di Giovanni di Tomaso

Italian, Florentine, 1415/17–1465

The Conquest of Trebizond (cassone panel)
This cassone comes from Palazzo Strozzi,
Florence, and is intact. The panel on the front
represents the conquest of Trebizond—on
the Black Sea, several hundred miles east of
Constantinople—by the Ottoman Turks
under Sultan Mehmed II on August 15, 1461.
This event resulted in the ouster of the
Venetians from Constantinople and the gift of
their property to the Florentines.
Tempera and gold on wood, painted surface
15¹/₄ × 49¹/₂ in. (38.7 × 125.7 cm)
Inscribed: (left, on city walls)
GO[N]STANTINOPOLI (Constantinople); left,
within city walls) S FRA[N]CES / CO
(church of San Francesco) ·$·SOFIA· (church
of Santa Sophia) DEILO·PER . . . ORI
[undeciphered]; (left center, on city walls)
PERA· (Pera / Galata); (on the Bosporus)
LOSTRETTO· (strait); (center, on city walls)
LOSCUTARIO (Scutari, now Üsküdar, on the
other side of the Bosporus); (farther back)
CHASTEL NVOVO (the new fort—that is,
Rumelihisari); (right, on city walls)
TREBIZOND[A] (Trebizond, now Trabzon, on
the south coast of the Black Sea); (next to the
conqueror) TAN[B]VRLANA (Tamerlane)
[inscriptions identifying strait, Trebizond, and
Tamerlane are recorded but no longer visible]
Imprese (on end panels) and curled scrolls
inscribed M·E·Z·Z·E· are apparently a personal
device of Filippo Strozzi (1426–1491), the
falcon referring to *strozziere* (falconer), the
caltrap to *tribolo* (tribulation), and the letters
to *mezzelune* (half-moons of crescents, three
of which figure in the Strozzi arms) [not
illustrated].
John Stewart Kennedy Fund, 1913
14.39
ESDA

The Story of Esther (cassone panel)
Tempera and gold on wood, 17¹/₂ × 55³/₈ in.
(44.5 × 140.7 cm)
Inscribed (beneath the figure of Esther): ESTER.
Rogers Fund, 1918
18.117.2

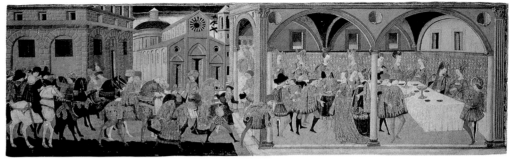

18.117.2

Alvaro Pirez
Portuguese, active 1411–1434
The Presentation in the Temple
Five other components of the altarpiece from
which this panel comes are pinnacles of the
Annunciation (both Gemäldegalerie, SMPK,
Berlin) and pilaster panels representing Saint
Jerome (Louvre, Paris), a beatified man
(Museo Nazionale, Pisa), and Saint Raynerius
(location unknown).
Tempera and gold on wood, 13³/₈ × 15⁷/₈ in.
(34 × 40.3 cm)
The Jack and Belle Linsky Collection, 1982
1982.60.3

1982.60.3

Fra Filippo Lippi
Italian, Florentine, born about 1406, died 1469
***Madonna and Child Enthroned with Two
Angels***
The side panels are in the Accademia
Albertina, Turin.
Tempera and gold on wood, transferred from
wood, arched top, 48¹/₄ × 24³/₄ in.
(122.6 × 62.9 cm)
Inscribed (left, on angel's scroll): VENI / TE·
AD / ME·O / MNE / S.Q[VI] / CON / CVPI /
SCIT / [I]S . ME / ·XAG / ENE / RAT / ION
[IBVS MEII IMPLEMINI] (Come unto me, all ye
that be desirous of me, and fill yourselves
[with my fruits] [Ecclesiasticus 24:19].)
The Jules Bache Collection, 1949
49.7.9

49.7.9

***Portrait of a Man and Woman at a
Casement***
Tempera on wood, 25¹/₄ × 16¹/₂ in.
(64.1 × 41.9 cm)
Inscribed (edge of woman's cuff): lealt[a]
(loyalty)
Arms (lower left) of the Scolari family
Marquand Collection, Gift of Henry G.
Marquand, 1889
89.15.19

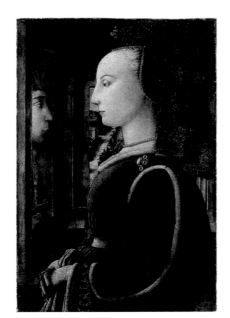

89.15.19

***Saints Augustine and Francis, a Bishop
Saint, and Saint Benedict***
Tempera on paper, laid down on canvas,
transferred from wood, 56 × 39¹/₂ in.
(142.2 × 100.3 cm)
Rogers Fund, 1917
17.89

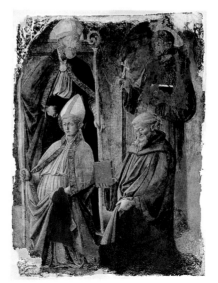

17.89

***Saint Lawrence Enthroned with Saints and
Donors***
This altarpiece is from the church of the Villa
Alessandri, Vincigliata, Fiesole. Central panel:
Saint Lawrence Enthroned, with Saints

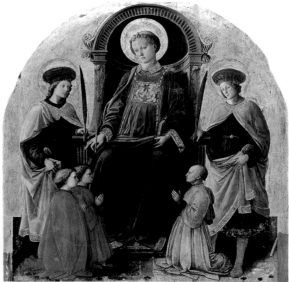

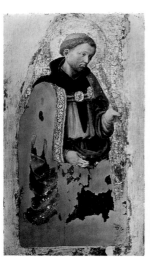

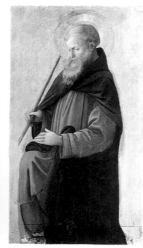

35.31.1c 35.31.1a 35.31.1b

Cosmas and Damian and Alessandro Alessandri and two of his sons; left panel: Saint Benedict; right panel: Saint Anthony Abbot.
Tempera on wood, gold ground, arched top; central panel (a), overall, with added strips, 47³/₄ × 45¹/₂ in. (121.3 × 115.6 cm); right panel (b) 28¹/₂ × 15⁵/₈ in. (72.4 × 39.1 cm); left panel (c) 28¹/₂ × 15¹/₂ in. (72.4 × 39.4 cm) [panels substantially altered in size and shape]
Rogers Fund, 1935
35.31.1a–c

Workshop of Fra Filippo Lippi

The Annunciation
Tempera on wood, 15⁷/₈ × 27¹/₂ in. (40.3 × 69.9 cm)
Maitland F. Griggs Collection, Bequest of Maitland F. Griggs, 1943
43.98.2

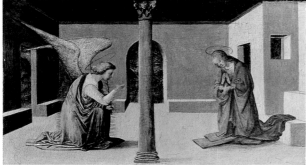

43.98.2

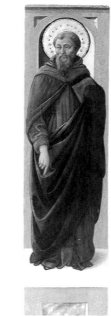

1975.1.70B 1975.1.70A

Saint Bernard of Clairvaux
This panel and the following (1975.1.70A) form part of a group of eighteen. Others are in the Courtauld Institute Gallery, London; Worcester Art Museum, Massachusetts; Fogg Art Museum, Cambridge, Massachusetts; Honolulu Academy of Arts, Hawaii; University of Georgia, Athens, Georgia; and on the art market (1985).
Tempera and gold on wood, 19 × 5 in. (48.3 × 12.7 cm)
Robert Lehman Collection, 1975
1975.1.70B
ROBERT LEHMAN COLLECTION

Male Saint
Tempera and gold on wood, 19 × 5 in. (48.3 × 12.7 cm)
Robert Lehman Collection, 1975
1975.1.70A
ROBERT LEHMAN COLLECTION

Italian (Florentine) Painters
fourth quarter 15th century

Saint Anthony Abbot (fragment)
Fresco, 20¹/₄ × 14¹/₂ in. (51.44 × 36.8 cm)
Gift of Cornelius Vanderbilt, 1880
80.3.679

second quarter 15th century

Madonna and Child Enthroned with Saint John the Baptist and Another Saint
Tempera and gold on wood; overall, with engaged frame, 29³/₄ × 17¹/₈ in. (75.6 × 43.5 cm); painted surface 17¹/₈ × 14¹/₄ in. (43.5 × 36.2 cm)
Gift of Georges Brauer, 1906
06.1048

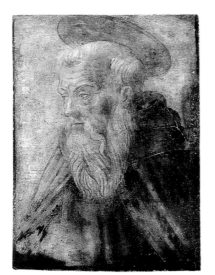

80.3.679

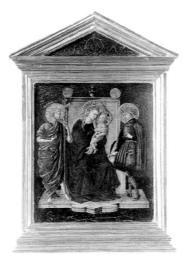

06.1048

Attributed to Paolo Uccello (Paolo di Dono)

Italian, Florentine, 1397–1475

Portrait of a Woman

Tempera on wood, 16¹/₄ × 12¹/₄ in.
(41.3 × 31.1 cm)
The Friedsam Collection, Bequest of Michael
Friedsam, 1931
32.100.98

Master of the Lanckorónski Annunciation

Italian, Florentine, second quarter 15th century

Madonna and Child

Tempera and gold on wood, 29⁵/₈ × 22¹/₄ in.
(75.2 × 56.5 cm)
Theodore M. Davis Collection, Bequest of
Theodore M. Davis, 1915
30.95.254

Master of the Castello Nativity

Italian, Florentine, active about 1445–1475

Portrait of a Woman

Tempera and gold on canvas, transferred from
wood, 15³/₄ × 10³/₄ in. (40 × 27.3 cm)
The Jules Bache Collection, 1949
49.7.6

Pesellino (Francesco di Stefano)

Italian, Florentine, born about 1422, died 1457

Madonna and Child with Six Saints

Tempera on wood, gold ground, 8⁷/₈ × 8 in.
(22.5 × 20.3 cm)
Bequest of Mary Stillman Harkness, 1950
50.145.30

Neri di Bicci

Italian, Florentine, 1419–1491

The Archangel Raphael and Tobias

Tempera and gold on wood; overall,
with engaged frame, 11⁷/₈ × 9¹/₈ in.
(30.2 × 23.2 cm); painted surface
10³/₈ × 7¹/₂ in. (26.4 × 19.1 cm)
Robert Lehman Collection, 1975
1975.1.71
ROBERT LEHMAN COLLECTION

The Archangel Raphael and Tobias

Tempera and gold on wood; overall
7³/₄ × 5³/₄ in. (19.7 × 14.6 cm); painted
surface 7³/₈ × 5¹/₂ in. (18.7 × 14 cm)
Robert Lehman Collection, 1975
1975.1.72
ROBERT LEHMAN COLLECTION

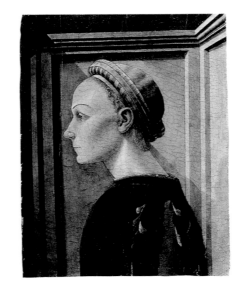

32.100.98

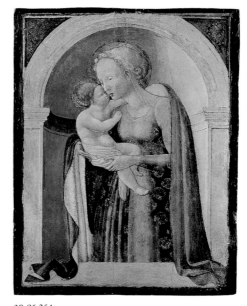

30.95.254

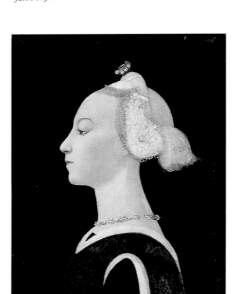

49.7.6

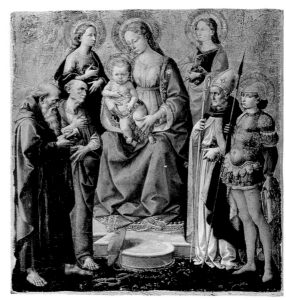

50.145.30

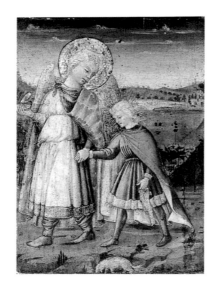

1975.1.71

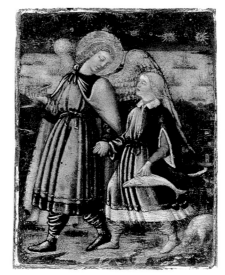

1975.1.72

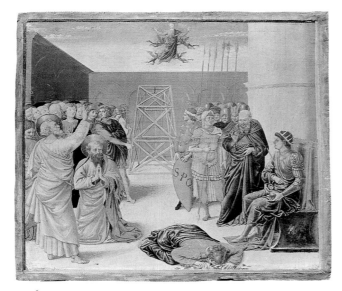

15.106.1

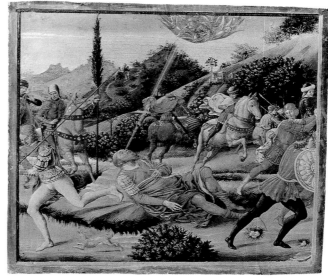

15.106.2

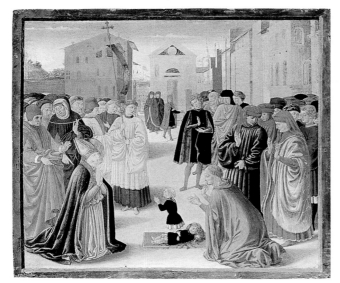

15.106.3

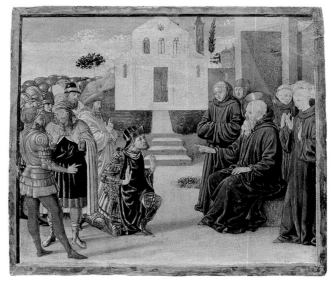

15.106.4

Benozzo Gozzoli (Benozzo di Lese di Sandro)
Italian, Florentine, born about 1420, died 1497
Saint Peter and Simon Magus
This predella panel and the following three (15.106.2–4) are from an altarpiece painted for the Alessandri family, formerly in the choir of San Pier Maggiore, Florence. The five-part polyptych (private collection) to which they belonged is by Lippo di Benivieni (Florentine, first half 14th century).
Tempera on wood, 15¾ × 18 in.
(40 × 45.7 cm)
Inscribed (on shield): SPQ[R]
Rogers Fund, 1915
15.106.1

The Conversion of Saint Paul (predella panel)
Tempera on wood, 15⅝ × 18 in.
(39.7 × 45.7 cm)
Rogers Fund, 1915
15.106.2

Saint Zenobius Resuscitating a Dead Child (predella panel)
Tempera on wood, 15½ × 18 in.
(39.4 × 45.7 cm)
Rogers Fund, 1915
15.106.3

Totila before Saint Benedict (predella panel)
Tempera on wood, 15½ × 18 in.
(39.4 × 45.7 cm)
Rogers Fund, 1915
15.106.4

Benozzo Gozzoli (Benozzo di Lese di Sandro)

Italian, Florentine, born about 1420, died 1497

Saints Nicholas of Tolentino, Roch, Sebastian, and Bernardino of Siena, with Kneeling Donors

Tempera and gold on canvas, transferred from wood; overall, with added strips, 31 × 24³/₈ in. (78.7 × 61.9 cm); painted surface 30¹/₈ × 23¹/₂ in. (76.5 × 59.7 cm)
Dated and inscribed: (center, on parapet, considerably strengthened) QVESTI IIII·SANTI D IFENSORI / DELLA PESTILENTIA A FATᴛFARE / PIETRO DIBATISTA DA RIGO DIM IÑOE / CITADINO PISANO·M̈· CCCC·LXX XI· (Pietro di Battista d'Arrigo di Minore[?], citizen of Pisa, had these four saints, protectors against the plague, made in 1481); (on halos, left to right) ·SANTVS NICHOLAVS DETOLENTINO·; ·SANCTVS ROCHVS·; ·SANCTVS SEBASTIANVS·; ·SANTVS BERNARDINVS·; (in Saint Bernardino's open book) PATER M / ANIFES / TAVI N / OMENT / VVM O / MNIB / VS· []E / []FA[] / MI[SERICORDI]AM T / VĀ[M] NOB / IS DOMI / NE CLE / MENTE / [] OSTE / NDE [] (Father, I have manifested thy name unto all men [John 17:6]; merciful Lord, show us thy compassion)
Bequest of Harry G. Sperling, 1971
1976.100.14

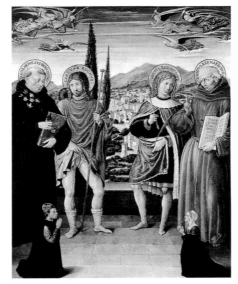

1976.100.14

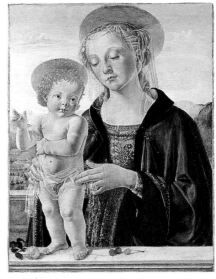

14.40.647

Workshop of Andrea del Verrocchio

Italian, Florentine, 1435–1488

(possibly Francesco Botticini)

Madonna and Child

Tempera and gold on wood, 26 × 19 in. (66 × 48.3 cm)
Bequest of Benjamin Altman, 1913
14.40.647

Master called Pseudo-Pier Francesco Fiorentino

Italian, Florentine, active about 1460–1500

Madonna and Child with the Infant Saint John the Baptist and Angels

Tempera and gold on wood, 33³/₈ × 23³/₄ in. (84.8 × 60.3 cm)
The Friedsam Collection, Bequest of Michael Friedsam, 1931
32.100.79

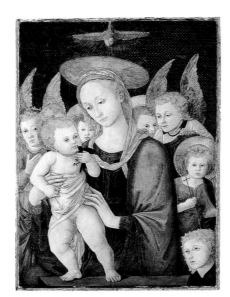

32.100.79

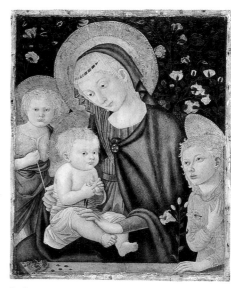

65.181.4

Madonna and Child with the Infant Saint John the Baptist and an Angel

Tempera on wood; overall 25³/₄ × 20 in. (65.4 × 50.8 cm); painted surface 24³/₄ × 19 in. (62.9 × 48.3 cm)
Bequest of Adele L. Lehman, in memory of Arthur Lehman, 1965
65.181.4

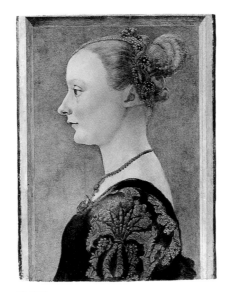

50.135.3

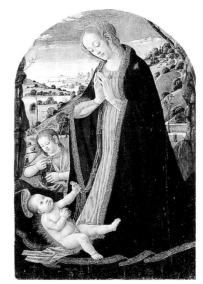

41.100.10

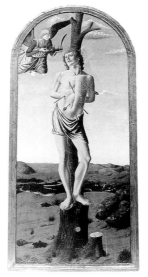

48.78

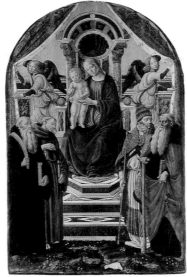

61.235

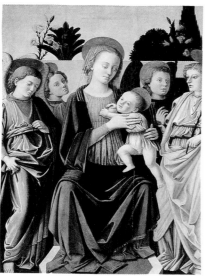

64.288

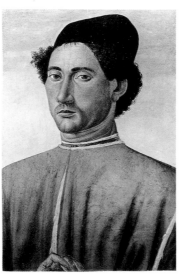

50.135.1

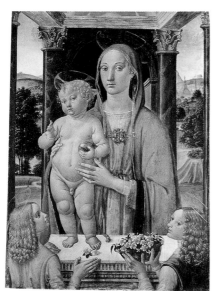

32.100.84

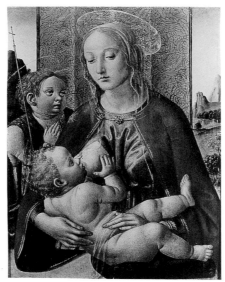

1975.1.73

Piero del Pollaiuolo (Piero di Jacopo Benci)

Italian, Florentine, born about 1441, died not later than 1496

Portrait of a Woman

Tempera on wood, 19¼ × 13⅞ in. (48.9 × 35.2 cm)
Bequest of Edward S. Harkness, 1940
50.135.3

Jacopo del Sellaio

Italian, Florentine, 1441/42–1493

The Nativity

Tempera and gold on wood, arched top, 41 × 27 in. (104.1 × 68.6 cm)
Gift of George Blumenthal, 1941
41.100.10

Francesco Botticini (Francesco di Giovanni)

Italian, Florentine, born about 1446, died 1497

Saint Sebastian

Tempera and oil on wood, arched top; overall, with engaged frame, 56¾ × 26¼ in. (144.1 × 66.7 cm); painted surface 53¾ × 23 in. (136.5 × 58.4 cm)
Gwynne Andrews, Rogers, and Harris Brisbane Dick Funds, 1948
48.78

Madonna and Child Enthroned with Saints and Angels

Tempera on wood, arched top, 110½ × 69 in. (280.7 × 175.3 cm)
Inscribed: (left, on border of Madonna's robe) AVEMARIAGRAZIA PREИA DOM[VS?]; (on hem of Madonna's robe) ·INMVLIERIBVS·EBEИ EDITVS· FRVTVS· (Hail, Mary, full of grace, the Lord [is with thee, blessed art thou] among women, and blessed is the fruit [of thy womb])
Gift of George R. Hann, in memory of his mother, Annie Sykes Hann, 1961
61.235

Italian (Florentine) Painter

third quarter 15th century

Madonna and Child with Saints

Oil on wood; overall 34 × 24⅝ in. (86.4 × 62.5 cm); painted surface 33½ × 24⅛ in. (85.1 × 61.3 cm)
Gift of Colonel C. Michael Paul, 1964
64.288

Cosimo Rosselli

Italian, Florentine, 1439–1507

Portrait of a Man

Tempera on wood, 20⅜ × 13 in. (51.8 × 33 cm)
Bequest of Edward S. Harkness, 1940
50.135.1

Cosimo Rosselli

Italian, Florentine, 1439–1507

Madonna and Child with Angels

Tempera and gold on wood, 33¹/₂ × 23 in.
(85.1 × 58.4 cm)
The Friedsam Collection, Bequest of Michael
Friedsam, 1931
32.100.84

*Madonna and Child with the Young Saint
John the Baptist*

Tempera, oil, and gold on wood; overall
17⁷/₈ × 14¹/₈ in. (45.4 × 35.9 cm); painted
surface 17¹/₄ × 13¹/₂ in. (43.8 × 34.3 cm)
Robert Lehman Collection, 1975
1975.1.73
ROBERT LEHMAN COLLECTION

**Botticelli (Alessandro di Mariano
Filipepi)**

Italian, Florentine, 1444/45–1510

The Annunciation

Tempera and gold on wood, 7¹/₂ × 12³/₈ in.
(19.1 × 31.4 cm)
Robert Lehman Collection, 1975
1975.1.74
ROBERT LEHMAN COLLECTION

Bartolomeo di Giovanni

Italian, Florentine, active by 1488, died 1501

The Trinity

This is the lunette of a gilt tabernacle frame
measuring 26³/₄ × 14³/₄ in.
(67.9 × 37.5 cm).
Tempera on wood, painted surface
5¹/₈ × 10¹/₄ in. (13 × 26 cm)
Gift of Daniel Wildenstein, 1989
1989.132

**Botticelli (Alessandro di Mariano
Filipepi)**

Italian, Florentine, 1444/45–1510

The Last Communion of Saint Jerome

The painting was commissioned by the
Florentine wool merchant Francesco del
Pugliese (died 1519); it is mentioned in his
will of 1502.
Tempera and gold on wood, 13¹/₂ × 10 in.
(34.3 × 25.4 cm)
Bequest of Benjamin Altman, 1913
14.40.642

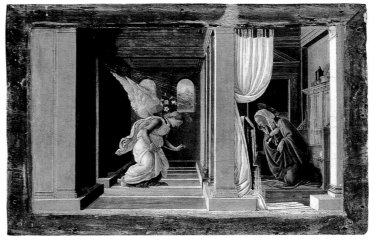

1975.1.74

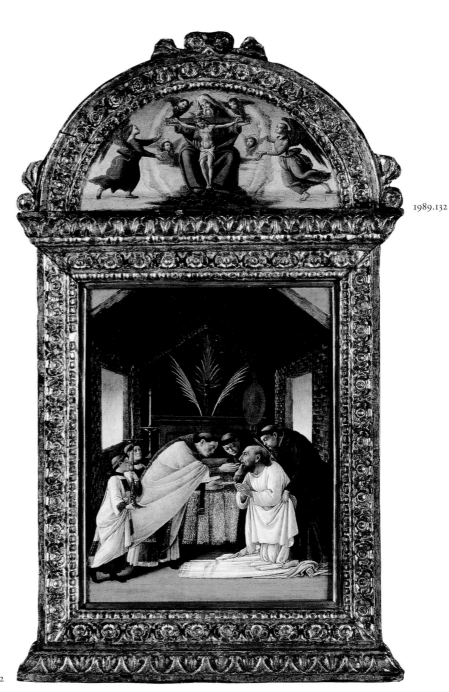

1989.132

14.40.642

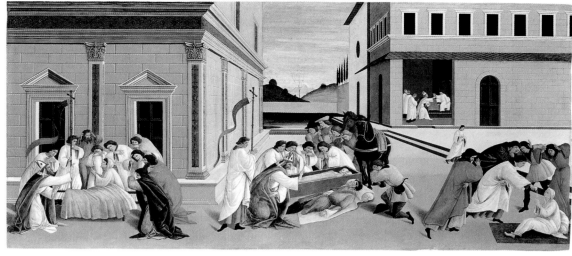

11.98

Three Miracles of Saint Zenobius
Saint Zenobius restores to life a dead youth whose funeral procession he had encountered (left); revives a messenger, killed while journeying to him from Saint Ambrose with gifts of relics (center); and hands to Saint Eugenius a cup of holy water (background), with which Eugenius revives a relative who had died without receiving the Eucharist. This panel is the third of a series of four (two in the National Gallery, London, and the fourth in the Gemäldegalerie, Dresden) showing the early life and miracles of Zenobius.
Tempera on wood, 26¹/₂ × 59¹/₄ in. (67.3 × 150.5 cm)
John Stewart Kennedy Fund, 1911
11.98

Workshop of Botticelli
The Nativity
Tempera and gold on wood, 30¹/₂ × 22¹/₂ in. (77.5 × 57.2 cm)
Robert Lehman Collection, 1975
1975.1.61
ROBERT LEHMAN COLLECTION

Followers of Botticelli
Italian, Florentine, fourth quarter 15th century
The Coronation of the Virgin
Tempera on canvas, transferred from wood, 39¹/₂ × 60¹/₄ in. (100.3 × 153 cm)
The Jules Bache Collection, 1949
49.7.4

Madonna and Child
Tempera on wood, arched top, 29¹/₄ × 16 in. (74.3 × 40.6 cm)
Given in memory of Felix M. Warburg by his wife and children, 1941
41.116.1

Attributed to Botticelli
Madonna and Child with Two Angels
Tempera on wood, oval, 39¹/₄ × 28 in. (99.7 × 71.1 cm)
H. O. Havemeyer Collection, Bequest of Mrs. H. O. Havemeyer, 1929
29.100.17

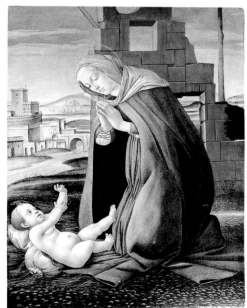

1975.1.61

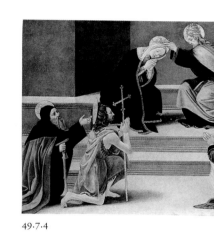

49.7.4

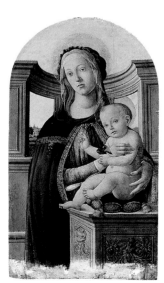

41.116.1

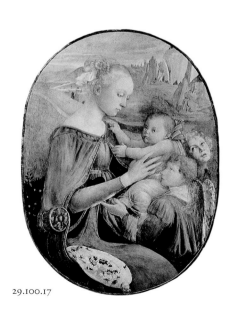

29.100.17

Domenico Ghirlandaio (Domenico di Tommaso Curradi di Doffo Bigordi)

Italian, Florentine, 1449–1494

Saint Christopher and the Infant Christ

Fresco, 112 × 59 in. (284.5 × 149.9 cm)
Inscribed (on globe held by the Infant
Christ): ASIA / AFRIHA / [E]VROPA
Gift of Cornelius Vanderbilt, 1880
80.3.674

Portrait of a Man

Tempera on wood, 21¹/₂ × 17¹/₂ in.
(54.6 × 44.5 cm)
The Friedsam Collection, Bequest of Michael
Friedsam, 1931
32.100.67

Francesco Sassetti (1421–1490) ***and His Son Teodoro***

Tempera on wood; overall 33¹/₄ × 25¹/₈ in.
(84.5 × 63.8 cm); painted surface
29⁷/₈ × 20⁷/₈ in. (75.9 × 53 cm)
Inscribed (top): FRAN[CISCV]S SAXETTVS
THEODORVS QVE·F[ILIVS] (Francesco Sassetti
and [his son] Teodoro)
The Jules Bache Collection, 1949
49.7.7

Portrait of a Woman

Tempera on wood, 22¹/₂ × 17³/₈ in.
(57.2 × 44.1 cm)
The Friedsam Collection, Bequest of Michael
Friedsam, 1931
32.100.71

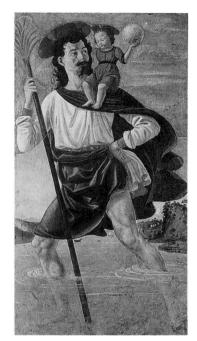

80.3.674

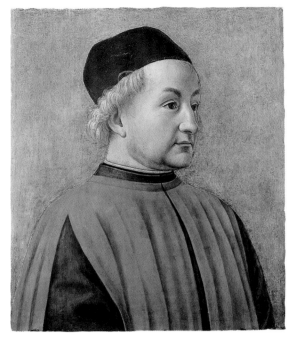

32.100.67

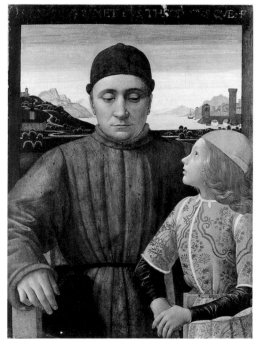

49.7.7

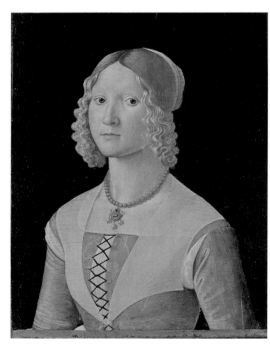

32.100.71

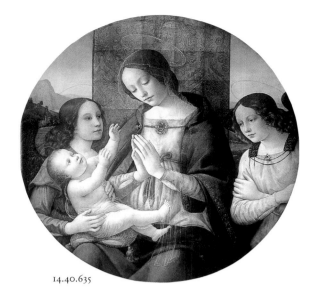

14.40.635

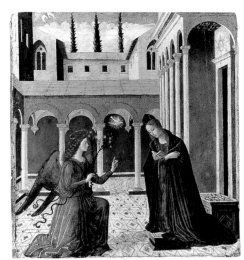

1975.1.77

Workshop of Domenico Ghirlandaio
Madonna and Child with Angels
Tempera on canvas, transferred from wood, diameter 38³/₄ in. (98.4 cm)
Bequest of Benjamin Altman, 1913
14.40.635

Alunno di Benozzo (also called Maestro Esiguo)
Italian, Florentine, late 15th century
The Annunciation
Tempera and gold on wood; overall 16¹/₄ × 14⁵/₈ in. (41.3 × 37.1 cm); painted surface 16 × 14¹/₈ in. (40.6 × 36 cm)
Robert Lehman Collection, 1975
1975.1.77
ROBERT LEHMAN COLLECTION

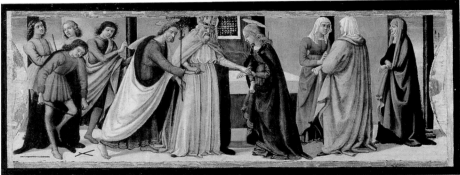

13.119.1

David Ghirlandaio (David di Tommaso Curradi di Doffo Bigordi)
Italian, Florentine, 1452–1525
The Marriage of the Virgin
The main panel (Uffizi, Florence) represents the Madonna and Child Enthroned with the Archangel Michael, Saints Justus and Zenobius, and the Archangel Raphael. This panel was the center of the predella, and the following two (13.119.2, 3) were on the right; the panels from the left side are the Fall of the Rebel Angels (Detroit Institute of Arts) and Saint Justus Distributing Bread (National Gallery, London). The altarpiece, commissioned by the Gesuati for San Giusto alle Mura, their church on the outskirts of Florence, was installed not later than June 1486.
Tempera and gold on wood, 6¹/₄ × 16¹/₄ in. (15.9 × 41.3 cm)
Francis L. Leland Fund, 1913
13.119.1

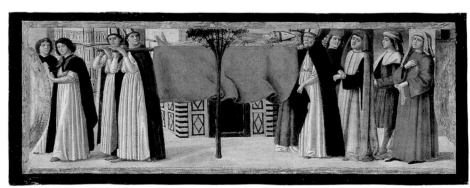

13.119.2

The Burial of Saint Zenobius (predella panel)
Tempera and gold on wood, 6¹/₄ × 16¹/₄ in. (15.9 × 41.3 cm)
Francis L. Leland Fund, 1913
13.119.2

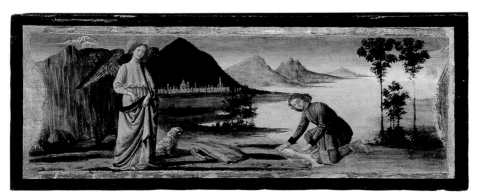

13.119.3

Tobias and the Angel (predella panel)
Tempera and gold on wood, 6¹/₄ × 16¹/₄ in. (15.9 × 41.3 cm)
Francis L. Leland Fund, 1913
13.119.3

Francesco Granacci (Francesco di Andrea di Marco)

Italian, Florentine, 1469–1543

Scenes from the Life of Saint John the Baptist

The three episodes are (left to right): an angel announcing to Zacharias the birth of his son; the visitation of Mary to Elizabeth; and Elizabeth watching from her bed as two women care for her newborn son, while Zacharias sits before the fire. This painting and the following (1970.134.2) are the first and fourth of a series that also included Saint John Carried to His Father, Zacharias (Cleveland Museum of Art) and five other scenes from the life of the saint (Walker Art Gallery, Liverpool).
Oil, tempera, and gold on wood,
31¹/₂ × 60 in. (80 × 152.4 cm)
Inscribed (in spandrels, left to right, beneath and beside sculptural vignettes): . . . ; s c (abbreviation for ex Senatu consulto [by decree of the Senate]); . . . ; VICTORIA (victory); s c; PACOS ([the establishment of] peace); ROMA (Rome); s c; FIDES (faith)
Purchase, Gwynne Andrews, Harris Brisbane Dick, Dodge, Fletcher, and Rogers Funds, funds from various donors, Ella Morris de Peyster Gift, Mrs. Donald Oenslager Gift, and Gifts in memory of Robert Lehman, 1970
1970.134.1

Workshop of Francesco Granacci

The Preaching of Saint John the Baptist

Oil, tempera, and gold on wood,
29³/₄ × 82¹/₂ in. (75.6 × 209.6 cm)
Purchase, Gwynne Andrews, Harris Brisbane Dick, Dodge, Fletcher, and Rogers Funds, funds from various donors, Ella Morris de Peyster Gift, Mrs. Donald Oenslager Gift, and Gifts in memory of Robert Lehman, 1970
1970.134.2

Master of the Argonauts

Italian, Florentine, fourth quarter 15th century

Madonna and Child

Tempera on wood, 17³/₄ × 14¹/₄ in.
(45.1 × 36.2 cm)
Gift of George Blumenthal, 1941
41.100.6

Biagio di Antonio

Italian, Florentine, active 1476–1504

Portrait of a Young Man

Tempera on wood, 21¹/₂ × 15³/₈ in.
(54.6 × 39.1 cm)
The Friedsam Collection, Bequest of Michael Friedsam, 1931
32.100.68

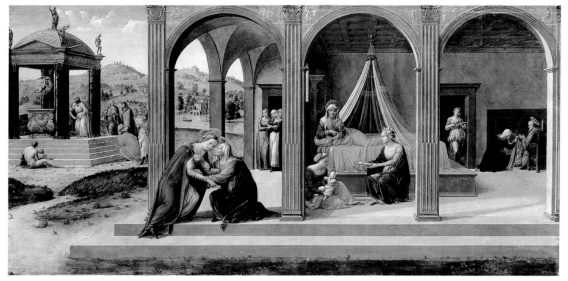

1970.134.1

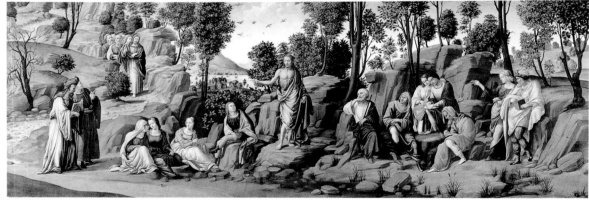

1970.134.2

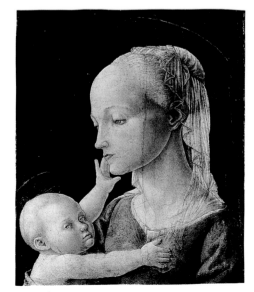

41.100.6

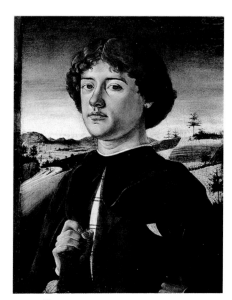

32.100.68

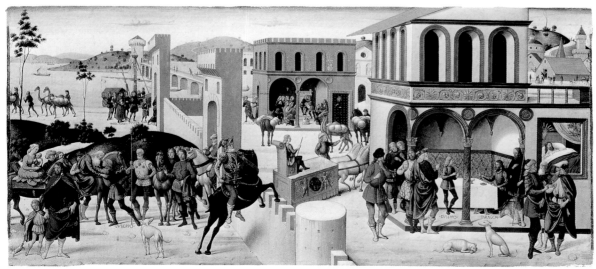

32.100.69

Biagio di Antonio

Italian, Florentine, active 1476–1504

The Story of Joseph

The companion panel (J. Paul Getty Museum, Malibu) depicts earlier episodes in the life of Joseph.
Tempera on wood, 27 × 59 in. (68.6 × 149.9 cm)
Inscribed: (with names of those represented) GVSEPPO (repeatedly), JACOB, MERCATANTI, PVLTIFR, MOGLE DIPVLTIFR, FARAGON (Joseph, Jacob, merchants, Potiphar, Potiphar's wife, pharaoh); (on triumphal cart) ·IOS / EF·; (right) ·SONGO·DIFARAGONE (pharaoh's dream)
The Friedsam Collection, Bequest of Michael Friedsam, 1931
32.100.69

Scenes from the Story of the Argonauts

In this panel and its companion (Master of the Argonauts, 09.136.2), the engaged decorative moldings are original.
Tempera on wood, gilt ornaments; overall 24¹/₈ × 60³/₈ in. (61.3 × 153.4 cm); painted surface 19⁵/₈ × 56 in. (49.8 × 142.2 cm)
Gift of J. Pierpont Morgan, 1909
09.136.1

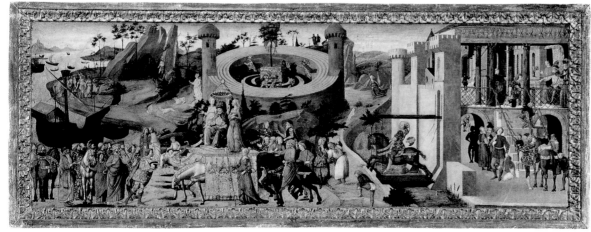

09.136.1

Master of the Argonauts

Italian, Florentine, fourth quarter 15th century

Scenes from the Story of the Argonauts

Pendant to Biagio di Antonio (09.136.1)
Tempera on wood, gilt ornaments; overall 24¹/₈ × 60¹/₈ in. (61.3 × 152.7 cm); painted surface 19⁵/₈ × 56 in. (49.8 × 142.2 cm)
Gift of J. Pierpont Morgan, 1909
09.136.2

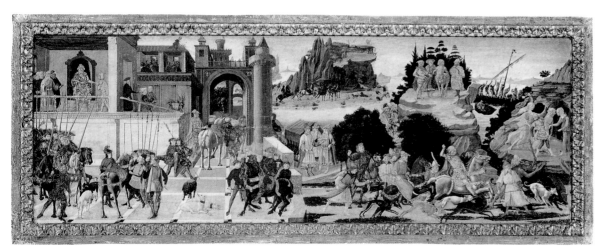

09.136.2

Filippino Lippi
Italian, Florentine, probably born 1457, died
1504

Madonna and Child
Tempera, oil, and gold on wood,
32 × 23¹/₂ in. (81.3 × 59.7 cm)
The Jules Bache Collection, 1949
49.7.10

Workshop of Filippino Lippi
The Virgin of the Nativity (fragment)
Tempera and gold on wood, 12³/₄ × 9³/₄ in.
(32.4 × 24.8 cm)
Gift of Donald S. Klopfer, 1982
1982.73

The Descent from the Cross
Tempera on wood, 22 × 16 in.
(55.9 × 40.6 cm)
Inscribed (on cross): I.N.R.I.
John Stewart Kennedy Fund, 1912
12.168

49.7.10

1982.73

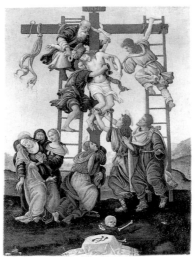

12.168

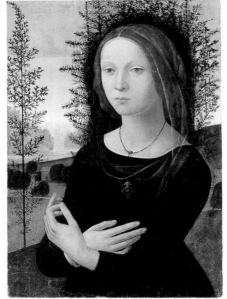

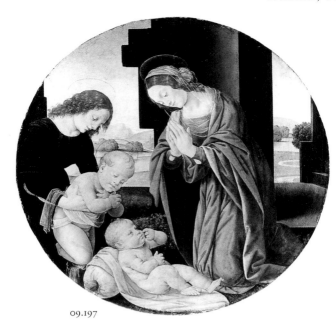

43.86.5

09.197

Lorenzo di Credi (Lorenzo d'Andrea d'Oderigo)

Italian, Florentine, 1459/60–1537

Portrait of a Young Woman
Oil on wood, 23 1/8 × 15 3/4 in.
(58.7 × 40 cm)
Bequest of Richard De Wolfe Brixey, 1943
43.86.5

Madonna Adoring the Child with the Infant Saint John the Baptist and an Angel
Tempera on wood, diameter 36 in. (91.4 cm)
Rogers Fund, 1909
09.197

Master of Marradi

Italian, Florentine, active late 15th/early 16th century

The Rape of Lucretia
A third panel, the Death of Lucretia (private collection), belonged with this one and the following (1975.1.76).
Tempera and gold on wood; overall
15 3/4 × 27 3/4 in. (40 × 70.5 cm); painted
surface 15 1/8 × 27 1/2 in. (38.4 × 69.9 cm)
Inscribed (repeatedly) with the names Lucretia and Sextus Tarquinius
Robert Lehman Collection, 1975
1975.1.75
Robert Lehman Collection

The Funeral of Lucretia
Tempera and gold on wood; overall
15 5/8 × 27 1/2 in. (39.7 × 69.9 cm); painted
surface 15 × 27 1/8 in. (38.1 × 68.9 cm)
Inscribed (on bier): LVHRETIA
Robert Lehman Collection, 1975
1975.1.76
Robert Lehman Collection

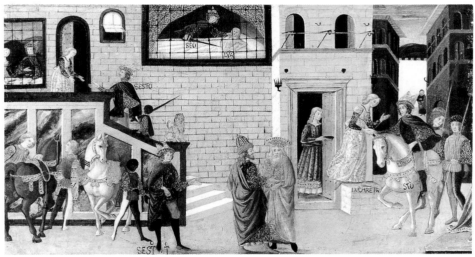

1975.1.75

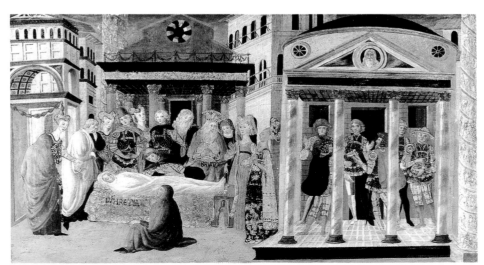

1975.1.76

Piero di Cosimo (Piero di Lorenzo)

Italian, Florentine, 1462–?1521

The Young Saint John the Baptist

Tempera and oil on wood, 11¹/₂ × 9¹/₄ in.
(29.2 × 23.5 cm)
The Bequest of Michael Dreicer, 1921
22.60.52

A Hunting Scene

This panel and the following (75.7.1) were
probably made for Francesco del Pugliese. The
Forest Fire (Ashmolean Museum, Oxford)
belonged to the series, and the Building of a
Palace (Ringling Museum, Sarasota, Florida)
may have also been part of the cycle.
Tempera and oil on wood, 27³/₄ × 66³/₄ in.
(70.5 × 169.5 cm)
Gift of Robert Gordon, 1875
75.7.2

The Return from the Hunt

Tempera and oil on wood, 27³/₄ × 66¹/₂ in.
(70.5 × 168.9 cm)
Gift of Robert Gordon, 1875
75.7.1

22.60.52

75.7.2

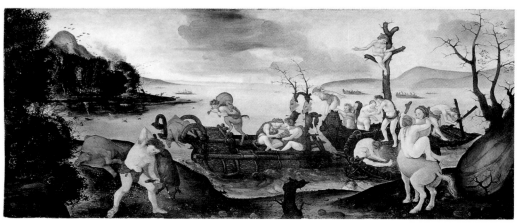

75.7.1

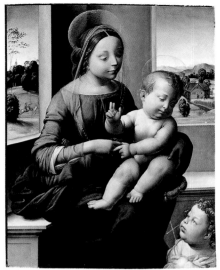

06.171

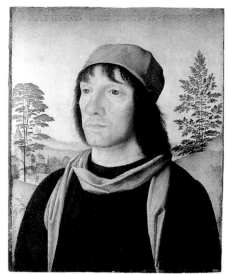

1982.60.8

Fra Bartolomeo (Bartolomeo di Paolo del Fattorino)
Italian, Florentine, 1472–1517
Madonna and Child with the Young Saint John the Baptist
Oil and gold on wood, 23 × 17¼ in.
(58.4 × 43.8 cm)
Rogers Fund, 1906
06.171

Portrait of a Man
Oil on wood; overall 15⅝ × 12⅛ in.
(39.7 × 30.8 cm); painted surface
15½ × 11¾ in. (39.4 × 29.8 cm)
Inscribed (top): MATTHAEVS·SASS T[HA]NVS·
OBIT·1506 (Matteo Sass[. . . ?] died 1506)
The Jack and Belle Linsky Collection, 1982
1982.60.8

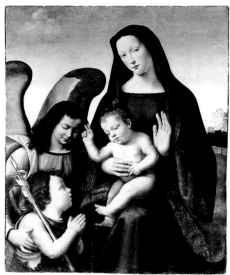

30.95.270

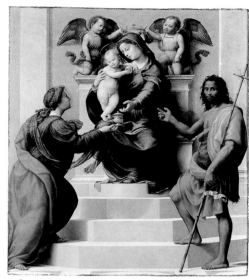

30.83

Mariotto di Bigio di Bindo Albertinelli
Italian, Florentine, 1474–1515
and
Giuliano di Piero di Simone Bugiardini
Italian, Florentine, 1475–1554
Madonna and Child with the Infant Saint John the Baptist and an Angel
Oil, tempera, and gold on wood,
38½ × 30¼ in. (97.8 × 76.8 cm)
Theodore M. Davis Collection, Bequest of
Theodore M. Davis, 1915
30.95.270

Giuliano di Piero di Simone Bugiardini
Italian, Florentine, 1475–1554
Madonna and Child Enthroned with Saints Mary Magdalen and John the Baptist
This altarpiece is from the church of Santa
Maria Maddalena all'Isola, Incisa Valdarno.
The panel has been cut down; the frame,
which nevertheless may be original, bears the
arms of the Altoviti family.
Tempera and gold on wood, 76¼ × 65¼ in.
(193.7 × 165.7 cm)
Inscribed (on scroll): ECCE·A[G]N[U]S·DEI
Fletcher Fund, 1930
30.83

1971.115.3a

1971.115.3b

Adam; Eve
Oil on canvas, each 26⅜ × 61¾ in.
(67 × 156.8 cm)
Bequest of Edward Fowles, 1971
1971.115.3ab

Andrea del Sarto (Andrea d'Agnolo)

Italian, Florentine, 1486–1530

Head of the Madonna (fragment)

The complete composition is recorded in an engraving after the painting by Cornelis Bloemaert (Dutch, born about 1603, died 1692).

Oil on wood, 15 × 11¹/₂ in.

(38.1 × 29.2 cm)

The Friedsam Collection, Bequest of Michael Friedsam, 1931

32.100.89

Portrait of a Man

Oil on canvas, transferred from wood,

26¹/₄ × 19⁷/₈ in. (66.7 × 50.5 cm)

The Jack and Belle Linsky Collection, 1982

1982.60.9

The Holy Family with the Infant Saint John the Baptist

Oil on wood, 53¹/₂ × 39⁵/₈ in.

(135.9 × 100.6 cm)

Maria DeWitt Jesup Fund, 1922

22.75

Raffaellino del Garbo (Raffaelle di Bartolommeo di Giovanni di Carlo)

Italian, Florentine, probably born before 1479, died 1524 or later

Madonna and Child with Saint Joseph and an Angel

Tempera on canvas, transferred from wood,

22 × 15 in. (55.9 × 38.1 cm)

Inscribed (on angel's halo): [A]NGELVS· GRAD[VAL]

Bequest of Benjamin Altman, 1913

14.40.641

32.100.89

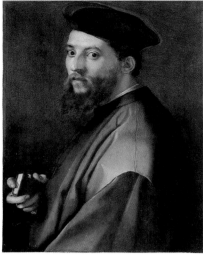

1982.60.9

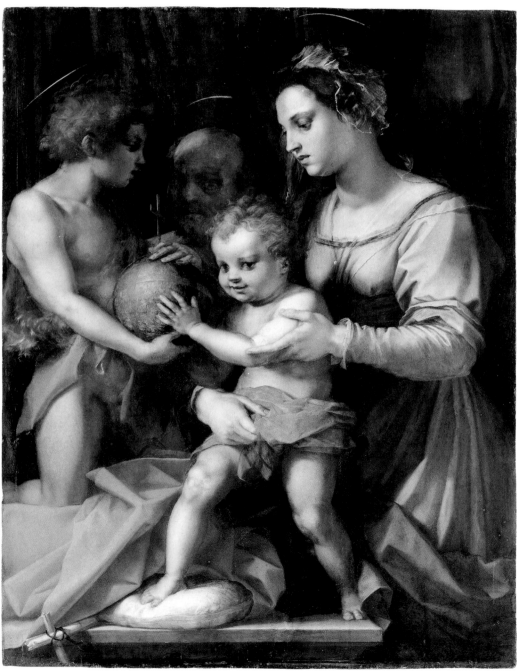

22.75

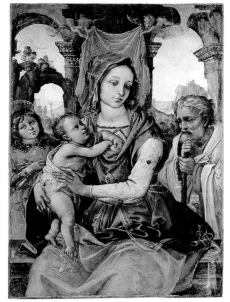

14.40.641

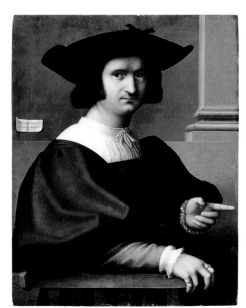

32.100.80

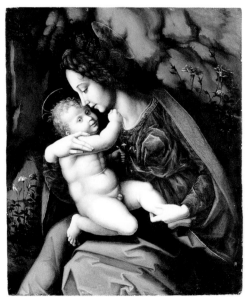

1982.60.10

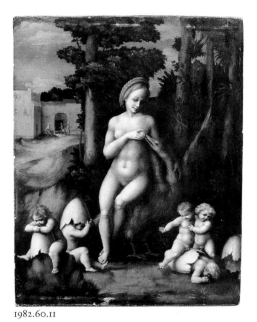

1982.60.11

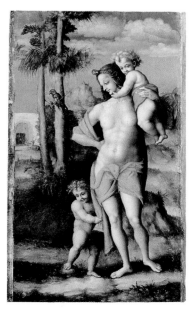

38.178

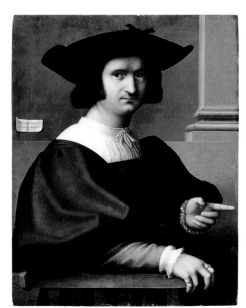

17.190.8

Ridolfo Ghirlandaio
Italian, Florentine, 1483–1561
The Nativity with Saints (triptych)
Central panel: Nativity and Saint Maurus (or Placidus); left wing: Saints Peter, Benedict, and Christine; right wing: Saints Paul, John the Evangelist, and Dorothy
Oil on wood; central panel 14 × 9 in. (35.6 × 22.9 cm); each wing 14 × 4 in. (35.6 × 10.2 cm)
The Friedsam Collection, Bequest of Michael Friedsam, 1931
32.100.80

Bacchiacca (Francesco d'Ubertino)
Italian, Florentine, 1495–1557
Madonna and Child
Oil and gold on wood, 34¼ × 26½ in. (87 × 67.3 cm)
Inscribed (on Madonna's collar): AVE MARIA
The Jack and Belle Linsky Collection, 1982
1982.60.10

Leda and the Swan
Oil on wood; overall 16⅞ × 12½ in. (42.9 × 31.8 cm); painted surface 16½ × 12½ in. (41.9 × 31.8 cm)
The Jack and Belle Linsky Collection, 1982
1982.60.11

Eve with Cain and Abel
This picture, a fragment, has been cut at the left.
Tempera and oil on wood, 15¾ × 9¼ in. (40 × 23.5 cm)
Gwynne Andrews Fund, 1938
38.178

Tommaso Fiorentino (Tommaso di Stefano Lunetti)
Italian, Florentine, born about 1495, died 1564
Portrait of a Man
Oil on wood, 32¼ × 23⅞ in. (81.9 × 60.6 cm)
Signed and dated (left, on paper): ·[O]PVS THOME FLORETINI / ·A[NNO]·S[ALVTIS]: M·D·XXI·MAII· (The work of Tommaso of Florence / May in the prosperous year 1521)
Gift of J. Pierpont Morgan, 1917
17.190.8

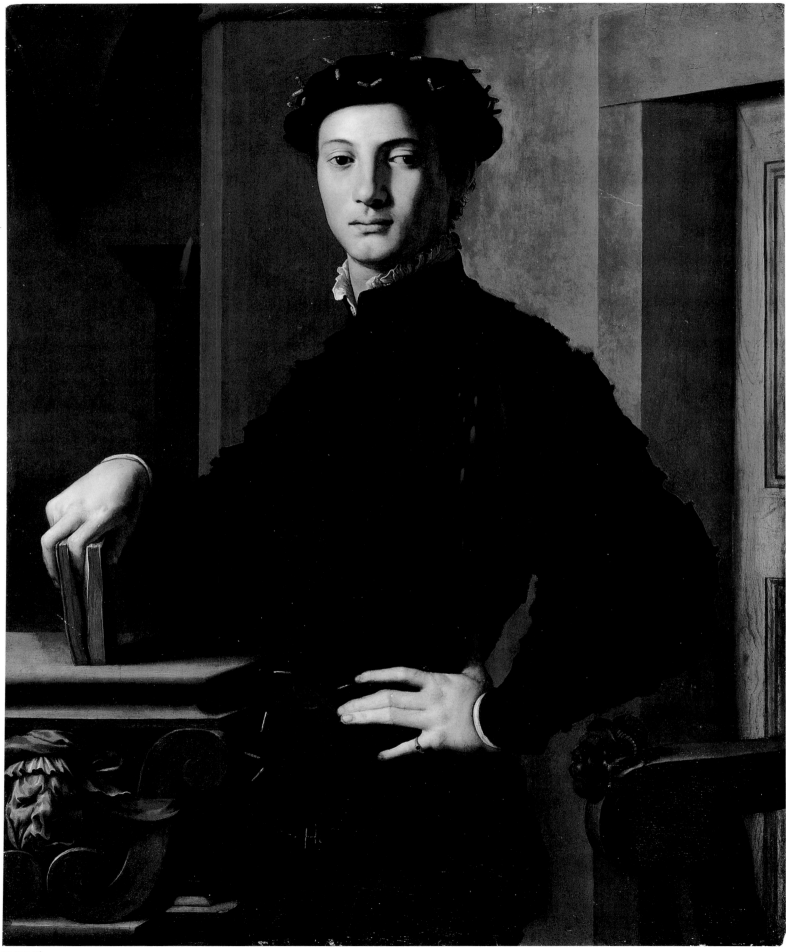

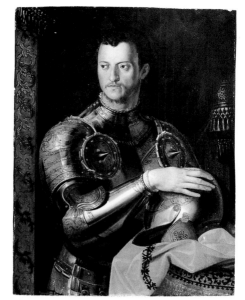

08.262

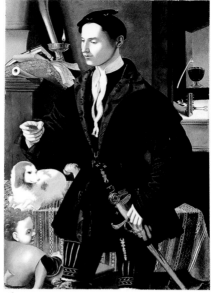

56.51

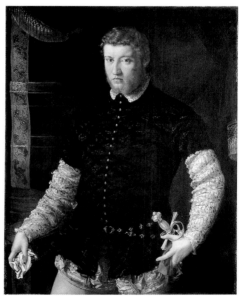

55.14

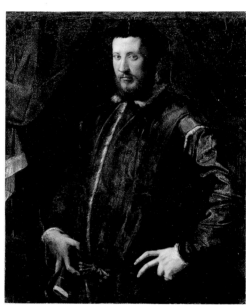

45.128.11

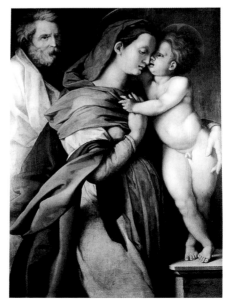

1976.100.15

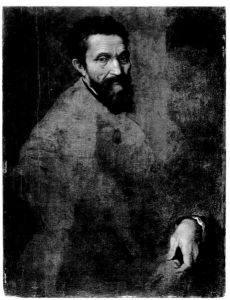

1977.384.1

Bronzino (Agnolo di Cosimo di Mariano)

Italian, Florentine, 1503–1572

Portrait of a Young Man

Oil on wood, 37⁵/₈ × 29¹/₂ in.
(95.6 × 74.9 cm)
H. O. Havemeyer Collection, Bequest of Mrs.
H. O. Havemeyer, 1929
29.100.16

Workshop of Bronzino

Cosimo I de' Medici (1519–1574)
Oil on wood, 37³/₄ × 27³/₄ in.
(95.9 × 70.5 cm)
Rogers Fund, 1908
08.262

Benedetto Pagni

Italian, Tuscan, active by 1524, died 1578

Portrait of a Young Man

Oil on wood, 46¹/₄ × 30³/₄ in.
(117.5 × 78.1 cm)
Gift of Alice Borland Wilson, 1956
56.51

Francesco Salviati (Francesco de' Rossi)

Italian, Florentine, 1510–1563

Portrait of a Man

Oil on canvas, 48¹/₄ × 36³/₄ in.
(122.6 × 93.4 cm)
Gift of Mr. and Mrs. Nate B. Spingold, 1955
55.14

Portrait of a Man

Oil on canvas, 37³/₄ × 29¹/₂ in.
(95.9 × 74.9 cm)
Bequest of Helen Hay Whitney, 1944
45.128.11

Jacopino del Conte

Italian, Florentine, 1515–1598

Holy Family

Oil on wood, 47¹/₂ × 33³/₄ in.
(120.7 × 85.7 cm)
Bequest of Harry G. Sperling, 1971
1976.100.15

Michelangelo Buonarroti (1475–1564)
Oil on wood, 34³/₄ × 25¹/₄ in.
(88.3 × 64.1 cm)
Gift of Clarence Dillon, 1977
1977.384.1

Italian (Florentine) Painters

mid-16th century

Portrait of a Woman
Oil on wood, 38¹/₂ × 30 in.
(97.8 × 76.2 cm)
The Friedsam Collection, Bequest of Michael
Friedsam, 1931
32.100.66

*Madonna and Child with the Young Saint
John the Baptist*
Oil on wood, 26⁷/₈ × 22¹/₄ in.
(68.3 × 56.5 cm)
Inscribed (on Saint John's scroll): ECCE
AGN[US DEI]
Bequest of Katherine S. Dreier, 1952
53.45.1

Jacopo Ligozzi

Italian, Florentine, 1547–1626

Allegory of Avarice
Oil on canvas, 54⁷/₈ × 33¹/₄ in.
(139.4 × 84.5 cm)
Gift of Eric Seiler and Darcy Bradbury, and
Edward A. and Karen S. W. Friedman, 1991
1991.443

Aurelio Lomi

Italian, Florentine, 1556–1622

The Gathering of Manna (monochrome)
Oil on canvas, 41¹/₂ × 42³/₄ in.
(105.4 × 108.6 cm)
Gift of Cornelius Vanderbilt, 1880
80.3.245a

Cigoli (Ludovico Cardi)

Italian, Florentine, 1559–1613

*The Adoration of the Shepherds with Saint
Catherine of Alexandria*
Oil on canvas, 121³/₈ × 76¹/₄ in.
(308.3 × 193.7 cm)
Signed, dated, and inscribed: (lower right) LC
[monogram]/1599; (top, on banderole) GLORIA
IN EXCELSIS DEO
Arms (lower left) of the Riccardi family of
Arezzo or of the Ricci family of Pistoia
Gwynne Andrews Fund, 1991
1991.7

Cesare Dandini

Italian, Florentine, 1596–1656

Charity
Oil on canvas, 47¹/₈ × 41¹/₂ in.
(119.7 × 105.4 cm)
Gift of Mr. and Mrs. Ralph Friedman, 1969
69.283

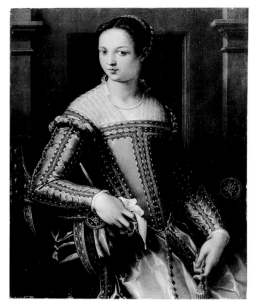

32.100.66

53.45.1

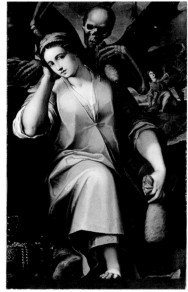

1991.443

80.3.245a

1991.7

69.283

68.162

Italian (Florentine) Painter
second quarter 17th century
Scenes and Allegories of the Virgin (ceiling)
Thirty-three painted compartments of various
sizes and shapes, framed by (modern)
embossed and gilt moldings
Oil on canvas, overall 95 × 70½ in.
(241.3 × 179.1 cm)
Gift of Mr. and Mrs. Alan S. Hartman, 1968
68.162
ESDA

Segna di Buonaventura
Italian, Sienese, active by 1298, died 1326/31

Madonna and Child; Saint Benedict; Saint Silvester Gozzolini
These three panels, the following (41.100.22), and a Saint John the Baptist (Sacro Convento di San Francesco, Assisi) are parts of a dismembered polyptych representing (left to right): Saint Benedict (with angel and apostle above), Madonna and Child (with Saint Paul, Christ, and Saint Peter above), and Saint Silvester Gozzolini (with apostle and angel above).
Tempera on wood, gold ground; overall, as joined by modern moldings, 60 × 66¹/₂ in. (152.4 × 168.9 cm); left pinnacle, painted surface 10¹/₄ × 15³/₈ in. (26 × 39.1 cm); center pinnacle, painted surface 12¹/₈ × 23 in. (30.8 × 58.4 cm); right pinnacle, painted surface 10 × 15⁵/₈ in. (25.4 × 39.7 cm); left panel, painted surface 27⁷/₈ × 16 in. (70.8 × 40.6 cm); center panel, painted surface 37 × 23¹/₈ in. (94 × 58.7 cm); right panel, painted surface 27⁷/₈ × 16¹/₄ in. (70.8 × 41.3 cm)
Signed and inscribed (on frame): (left) s. BENE[DICTVS]; (center) [HOC O]PVS PI[NXIT S]EGNA SE[NENSIS]; (right) s. SILVE[STER]
Harris Brisbane Dick Fund, 1924
24.78a–c

Saint John the Evangelist
Tempera on wood, gold ground; overall, with engaged (largely modern) frame, 35 × 22 in. (88.9 × 55.9 cm); painted surface 27¹/₄ × 16¹/₂ in. (69.2 × 41.9 cm)
Gift of George Blumenthal, 1941
41.100.22

Christ Blessing
Tempera on wood, gold ground, shaped top; overall 15¹/₂ × 9¹/₂ in. (39.4 × 24.1 cm); painted surface 14 × 8¹/₈ in. (35.6 × 20.6 cm)
Bequest of Adele L. Lehman, in memory of Arthur Lehman, 1965
65.181.2

Master of Monte Oliveto
Italian, Sienese, active about 1305–1335

Madonna and Child with Nine Angels; The Crucifixion
Tempera on wood, gold ground; left wing, overall, with engaged frame, 15¹/₈ × 10⁵/₈ in. (38.4 × 27 cm); right wing, overall, with engaged frame, 15 × 10⁵/₈ in. (38.1 × 27 cm)
Robert Lehman Collection, 1975
1975.1.1–2
ROBERT LEHMAN COLLECTION

Madonna and Child Enthroned (triptych)
Central panel: Madonna and Child Enthroned with Saints Paul, John the Baptist, Peter, and John the Evangelist and (in the

24.78 a–c

41.100.22

65.181.2

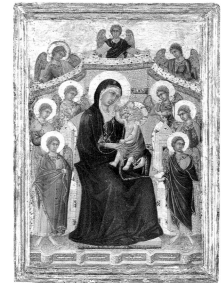

1975.1.1

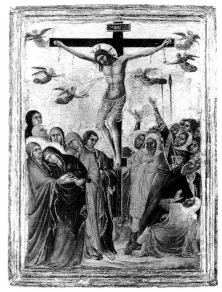

1975.1.2

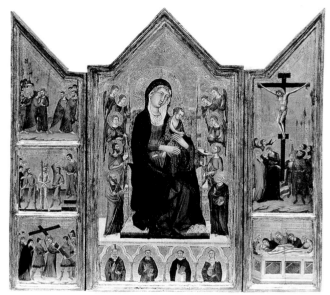

18.117.1

arches under the throne) Saints Nicholas, Francis, Dominic, and Catherine of Alexandria; left wing: Betrayal of Christ, Flagellation, and Bearing of the Cross; right wing: Crucifixion and Lamentation
Tempera on wood, gold ground, shaped top; central panel, overall, with engaged frame, 30⅝ × 16½ in. (77.8 × 41.9 cm); central panel, painted surface 27⅜ × 14 in. (69.5 × 35.6 cm); left wing, overall, with engaged frame, 30⅜ × 8⅛ in. (77.2 × 20.6 cm); right wing, overall, with engaged frame, 30½ × 8¼ in. (77.5 × 21 cm)
Rogers Fund, 1918
18.117.1

Master of Monte Oliveto
and
Italian (Sienese) Painter
active first quarter 14th century
The Crucifixion with Saints Clare and Francis of Assisi (triptych)
Left wing: Annunciation, Nativity, and Adoration of the Magi; right wing: Coronation of the Virgin and Saints John the Baptist, Stephen (or Lawrence), Peter, Mary Magdalen, Catherine of Alexandria(?), and an unidentified female saint
Tempera on wood, gold ground; central panel, overall, with engaged frame, 25¼ × 18⅝ in. (64.1 × 47.3 cm); central panel, painted surface 22¼ × 15¾ in. (56.5 × 40 cm); left wing, overall, with engaged frame, 25¼ × 9¼ in. (64.1 × 23.5 cm); left wing, painted surface 23⅜ × 7½ in. (59.4 × 19.1 cm); right wing, overall, with engaged frame, 25⅛ × 9⅜ in. (63.8 × 23.8 cm); right wing, painted surface 23½ × 7½ in. (59.7 × 19.1 cm)
Inscribed (on cross): I·N·R·I·
Bequest of George Blumenthal, 1941
41.190.31a–c

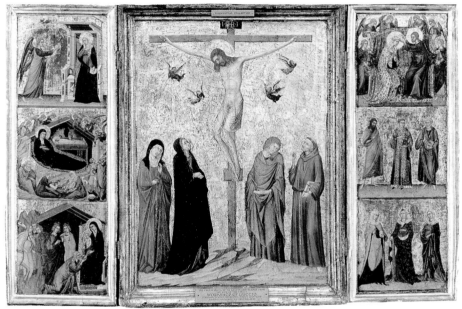

41.190.31a–c

Goodhart Ducciesque Master
Italian, Sienese, active about 1315–1330
Madonna and Child with the Annunciation and the Nativity
This panel was the left wing of a diptych. Its verso is decorated with squares and a quatrefoil of green on a background of blue (now blackened) with green and red borders.
Tempera on wood, gold ground; overall, with engaged frame, 12⅛ × 8¼ in. (30.8 × 21 cm); painted surface 10¼ × 6½ in. (26 × 16.5 cm)
Marquand Fund, 1920
20.160

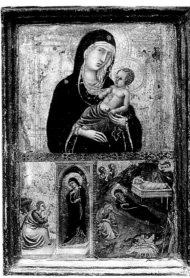

20.160

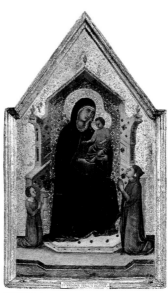

1975.1.24

Goodhart Ducciesque Master

Italian, Sienese, active about 1315–1330

Madonna and Child Enthroned with Two Donors

Tempera on wood, gold ground; overall, with engaged frame, 20³/₄ × 11³/₄ in. (52.7 × 29.8 cm)
Robert Lehman Collection, 1975
1975.1.24
ROBERT LEHMAN COLLECTION

Simone Martini

Italian, Sienese, active by 1315, died 1344

Saint Ansanus

This panel and the following two (1975.1.12, 41.100.23) formed part of a polyptych that also included Saints Peter (art market, 1992) and Luke (J. Paul Getty Museum, Malibu). The frames, separated and reworked, are original.
Tempera on wood, gold ground; overall 22⁵/₈ × 15 in. (57.5 × 38.1 cm); painted surface 22¹/₂ × 14¹/₂ in. (57.2 × 36.8 cm)
Robert Lehman Collection, 1975
1975.1.13
ROBERT LEHMAN COLLECTION

Madonna and Child

Tempera on wood, gold ground; overall 23¹/₈ × 15¹/₂ in. (58.7 × 39.4 cm); painted surface 22¹/₂ × 15¹/₈ in. (57.2 × 38.4 cm)
Robert Lehman Collection, 1975
1975.1.12
ROBERT LEHMAN COLLECTION

Saint Andrew

Tempera on wood, gold ground, 22¹/₂ × 14⁷/₈ in. (57.2 × 37.8 cm)
Inscribed (background): :s: / :Â[N]DREAS
Gift of George Blumenthal, 1941
41.100.23

Workshop of Simone Martini

Saint Thomas

This panel and the following three (43.98.10–12) belong to a series of apostles, of which six others are known (Saints Matthew, Simon, James the Greater, and Thaddeus, in the National Gallery of Art, Washington, D.C.; Saint James the Lesser, in a private collection; and Saint Philip, on the art market, 1992).
Tempera on wood, gold ground, arched top; overall, with engaged frame, 11⁵/₈ × 8⁵/₈ in. (29.5 × 21.9 cm); painted surface 10³/₈ × 7³/₄ in. (26.4 × 19.7 cm)
Inscribed (background): ·SANTVS THOMAS
Maitland F. Griggs Collection, Bequest of Maitland F. Griggs, 1943
43.98.9

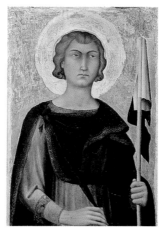

1975.1.13

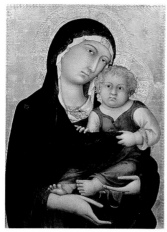

1975.1.12

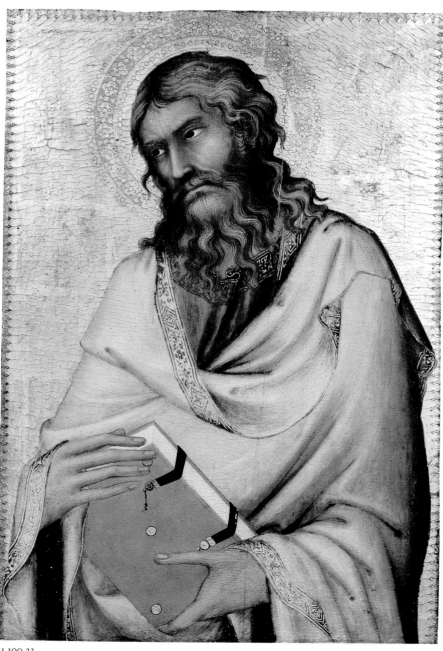

41.100.23

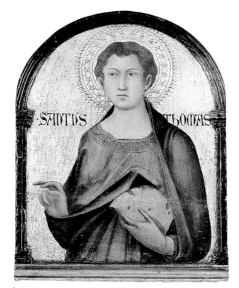

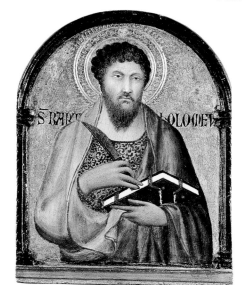

43.98.9

43.98.10

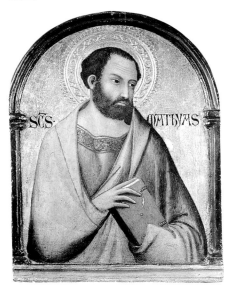

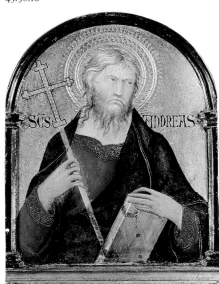

43.98.11

43.98.12

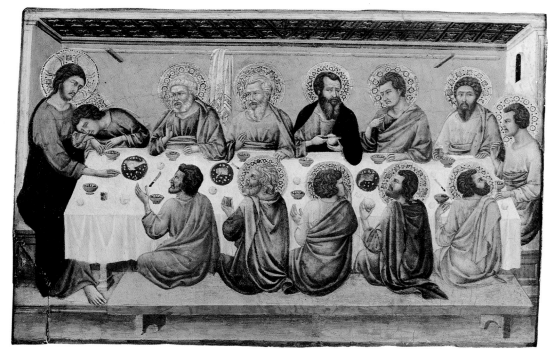

1975.1.7

Saint Bartholomew

Tempera on wood, gold ground, arched top; overall, with engaged frame, 11⁵/₈ × 8⁵/₈ in. (29.5 × 21.9 cm); painted surface 10³/₈ × 7³/₄ in. (26.4 × 19.7 cm)
Inscribed (background): s̄ BARTHOLOMEVˢ
Maitland F. Griggs Collection, Bequest of Maitland F. Griggs, 1943
43.98.10

Saint Matthias

Tempera on wood, gold ground, arched top; overall, with engaged frame, 11⁵/₈ × 8⁵/₈ in. (29.5 × 21.9 cm); painted surface 10¹/₄ × 7³/₄ in. (26 × 19.7 cm)
Inscribed (background): SCS·MATHYAS
Maitland F. Griggs Collection, Bequest of Maitland F. Griggs, 1943
43.98.11

Saint Andrew

Tempera on wood, gold ground, arched top; overall, with engaged frame, 11³/₄ × 8³/₄ in. (29.8 × 22.2 cm); painted surface 10³/₈ × 7⁷/₈ in. (26.4 × 20 cm)
Inscribed (background): SCS·ANDREAS·
Maitland F. Griggs Collection, Bequest of Maitland F. Griggs, 1943
43.98.12

Ugolino da Siena (Ugolino di Nerio)

Italian, Sienese, active 1317–1327

The Last Supper

This panel and six others—Arrest of Christ (National Gallery, London), Flagellation (Gemäldegalerie, SMPK, Berlin), Way to Calvary and Deposition (both National Gallery, London), Entombment (Gemäldegalerie, SMPK, Berlin), and Resurrection (National Gallery, London)—comprised the predella of the altarpiece on the high altar of the church of Santa Croce, Florence. Saints John the Baptist, Paul, and Peter (all Gemäldegalerie, SMPK, Berlin) are from the main register; Saints James the Greater and Philip, Saints Matthew and James the Lesser, and Saints Matthias and Clare (all Gemäldegalerie, SMPK, Berlin), Saints Simon and Thaddeus and Saints Bartholomew and Andrew (both National Gallery, London) are from the intermediate upper register.
Tempera and gold on wood; overall, with engaged (modern) frame, 15 × 22¹/₄ in. (38.1 × 56.5 cm); painted surface 13¹/₂ × 20³/₄ in. (34.3 × 52.7 cm)
Robert Lehman Collection, 1975
1975.1.7
ROBERT LEHMAN COLLECTION

Ugolino da Siena (Ugolino di Nerio)

Italian, Sienese, active 1317–1327

Madonna and Child

Tempera on wood, gold ground, arched top,
35³/₈ × 23 in. (89.9 × 58.4 cm)
Robert Lehman Collection, 1975
1975.1.5
ROBERT LEHMAN COLLECTION

Saint Matthew (fragment)

This panel is from the same polyptych as
Saint Anne with the Infant Virgin (National
Gallery of Canada, Ottawa).
Tempera on wood, gold ground,
15¹/₈ × 12³/₄ in. (38.4 × 32.4 cm)
Robert Lehman Collection, 1975
1975.1.6
ROBERT LEHMAN COLLECTION

Ambrogio Lorenzetti

Italian, Sienese, active 1319–1347

Madonna and Child

Tempera on wood, gold ground, arched top,
37 × 22¹/₈ in. (94 × 56.2 cm)
Inscribed (on halos): AVE·MARIA·GRATIA; JESV
CRIS[TVS]
Bequest of George Blumenthal, 1941
41.190.26

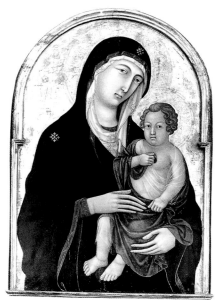

1975.1.5

1975.1.6

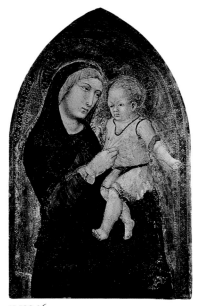

41.190.26

13.212

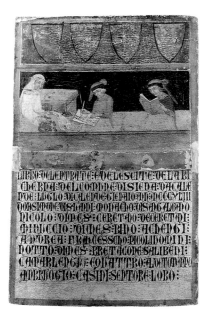

10.203.3

88.3.99

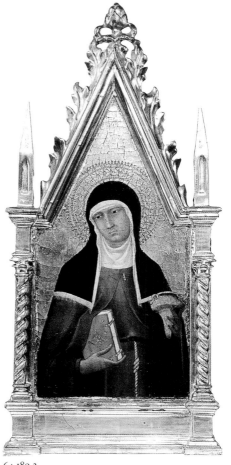

64.189.2

43.98.6

Pietro Lorenzetti
Italian, Sienese, active 1320–1344

Saint Catherine of Alexandria
This painting was part of a polyptych representing a martyr bishop (private collection), Saint Margaret (Perkins collection, Sacro Convento di San Francesco, Assisi), the Madonna and Child (Palazzo Vecchio, Florence), and, at the extreme right, a saint, probably John the Evangelist (private collection). The pinnacles included a male martyr and Saint Anthony Abbot (both National Gallery, Prague).
Tempera on wood, gold ground; overall 26 × 16¹/₄ in. (66 × 41.3 cm); painted surface 24¹/₂ × 16¹/₄ in. (62.2 × 41.3 cm)
Inscribed (above arch): S [A]GNES [or S IOHES] (Saint Agnes [or Saint John])
Rogers Fund, 1913
13.212

Italian (Sienese) Painter
dated 1343

Book Cover
Tempera on wood, 16¹/₈ × 9³/₄ in. (41 × 24.8 cm)
Inscribed: LIBRO ⫶ DELENTRATE ⫶ EDELESCITE ⫶ DELABI / CHERNA ⫶ DELCOMUNE ⫶ DISIENA ⫶

DACALE / NDE ⫶ LUGLO ⫶ DICALENDE ⫶ GIENAIO ⫶ ANN ⫶ MCCCXLIII / DONSIMONE ⫶ DISVANNI ⫶ MONACHO ⫶ DISANGALGANO / NICOLO ⫶ DIMES ⫶ CERETANO ⫶ DECERETANI / MINUCCIO ⫶ DIMES ⫶ BINO ⫶ ACHENGI / ANDREA ⫶ FRANCESSCHO ⫶ PICOLIUOMINI / NOTTO ⫶ DIMES ⫶ BRETACONE ⫶ SALIBENI ⫶ / CAMARLENGNJ ⫶ EQUATTRO ⫶ ALDETOTOTEMPO / AMBRUOGIO ⫶ CASINI ⫶ SENTORE ⫶ LORO ⫶ (Book of the income and expenses of the *biccherna* [financial administrators] of the commune of Siena from the first of July to the first of January 1343. Don Simone di Ser Vanni, monk of San Galgano; Nicolo di Messer Cerretano de' Cerretani; Minuccio di Messer Bino Achengi; Andrea Francesco Piccolomini; Notto di Messer Bretacone Salimbeni; secretary and four [purveyors]; at the said time Ambrogio Casini being their clerk)
Rogers Fund, 1910
10.203.3

Lippo Memmi (Filippo di Memmo)
Italian, Sienese, active by 1317, died 1356

Saint Paul
This is one of the main panels of an altarpiece that also included Saints Louis of Toulouse (Pinacoteca Nazionale, Siena) and

John the Baptist (National Gallery of Art, Washington, D.C.), the Madonna and Child (Gemäldegalerie, SMPK, Berlin), and Saints John the Evangelist (Yale University Art Gallery, New Haven), Peter (Louvre, Paris), and Francis (Pinacoteca Nazionale, Siena). The altarpiece may have been painted for the church of San Francesco in Colle di Val d'Elsa.
Tempera on wood, gold ground, arched top; overall, with engaged frame, 37³/₄ × 19 in. (95.9 × 48.3 cm); painted surface 35¹/₈ × 16¹/₂ in. (89.2 × 41.9 cm)
Inscribed (on book): AD / A[d] / A[d] / .Ad. ROMANOS / PAVLVS (To the Romans. Paul)
Gift of Coudert Brothers, 1888
88.3.99

Saint Clare
It is probable that this panel and Saint Margaret(?) (Museo Poldi Pezzoli, Milan), a male saint (location unknown), and Saints Anthony of Padua (Frick Art Museum, Pittsburgh), Mary Magdalen (Museum of Art, Rhode Island School of Design, Providence), and Agnes (Frick Art Museum, Pittsburgh) constituted the pinnacles of the altarpiece described in the entry for 88.3.99 above.
Tempera on wood, gold ground, shaped top; overall, with engaged (modern) frame, 19 × 8 in. (48.3 × 20.3 cm); painted surface 15¹/₂ × 7¹/₂ in. (39.4 × 19.1 cm)
Gift of Irma N. Straus, 1964
64.189.2

Madonna and Child with Saints and Angels
The Madonna is flanked by Saints John the Baptist and Francis of Assisi; in the predella (left to right) are a male martyr and Saints Clare, Lawrence, Peter, Louis of Toulouse, Catherine of Alexandria, and Cecilia. The picture formed a diptych with the Crucifixion (Louvre, Paris).
Tempera on wood, gold ground, shaped top; overall, with engaged (partially modern) frame, 26¹/₄ × 13 in. (66.7 × 33 cm); painted surface 19³/₄ × 10¹/₈ in. (50.2 × 25.7 cm); predella 1¹/₂ × 10 in. (3.8 × 25.4 cm)
Inscribed: (on neck of Madonna's dress) AVE; (on Madonna's right sleeve) GRA[TIA]
Maitland F. Griggs Collection, Bequest of Maitland F. Griggs, 1943
43.98.6

Follower of Lippo Memmi

Italian, Sienese, active mid-14th century

Saint Mary Magdalen

This panel and the following (1975.1.15) are parts of a polyptych to which Saints Catherine of Alexandria, John the Evangelist, Paul, and John the Baptist (all Pinacoteca Nazionale, Siena) also belong. The verso is painted to imitate porphyry, with a trilobe medallion of fictive marble in the center. Tempera on wood, gold ground; overall, with original side and bottom moldings, 17 × 10³/₄ in. (43.2 × 27.3 cm); painted surface 15⁵/₈ × 8³/₈ in. (39.7 × 21.3 cm) Robert Lehman Collection, 1975
1975.1.14
Robert Lehman Collection

Saint Peter

The verso is painted to imitate porphyry, with a trilobe medallion of fictive marble in the center (see 1975.1.14 above). Tempera on wood, gold ground; overall, with original side and bottom moldings, 17⁵/₈ × 10⁷/₈ in. (44.8 × 27.6 cm) Robert Lehman Collection, 1975
1975.1.15
Robert Lehman Collection

Bartolomeo Bulgarini

Italian, Sienese, active 1337–1378

Saints Matthias and Thomas

Panels apparently representing Saints Peter and Matthew (both Wallraf-Richartz-Museum, Cologne) and smaller panels representing the prophets Moses and Daniel (Keresztény Múzeum, Esztergom) are from the same altarpiece. A fragmentary Madonna (Wallraf-Richartz-Museum, Cologne) may also be from this altarpiece. Tempera on wood, gold ground; overall, exclusive of modern frame additions, 20⁷/₈ × 18¹/₈ in. (53 × 46 cm); painted surface 17¹/₂ × 16³/₄ in. (44.5 × 42.5 cm) Inscribed (bottom): S.MATTIAS S.TOMMAS Robert Lehman Collection, 1975
1975.1.8
Robert Lehman Collection

Lippo Vanni (Lippo Vanni di Giovanni)

Italian, Sienese, active 1341–1375

Madonna and Child Enthroned with Saints Peter and Paul and Angels

Tempera on wood, gold ground; overall, with engaged frame, 13¹/₈ × 8⁵/₈ in. (33.3 × 21.9 cm); painted surface 11³/₄ × 7³/₈ in. (29.8 × 18.7 cm) The Friedsam Collection, Bequest of Michael Friedsam, 1931
32.100.100

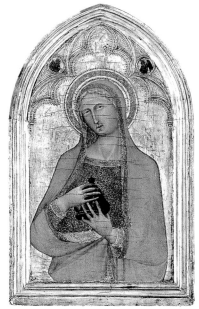

1975.1.14

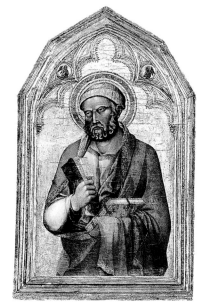

1975.1.15

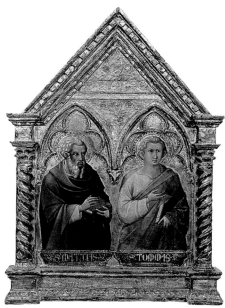

1975.1.8

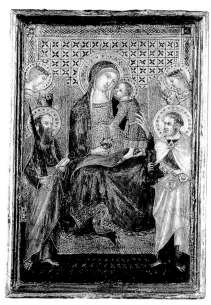

32.100.100

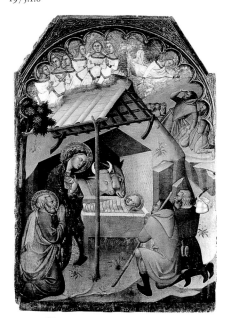

25.120.288

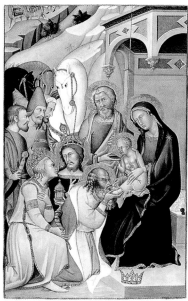

1975.1.16

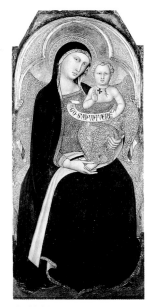

41.100.34

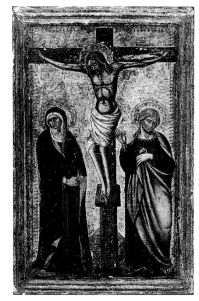

25.79

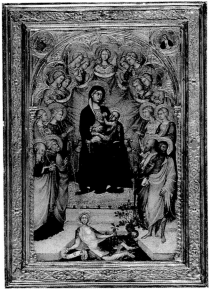

1975.1.23

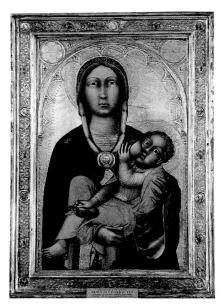

41.190.13

Bartolo di Fredi
Italian, Sienese, active by 1353, died 1410

The Adoration of the Shepherds
This panel was the center of a triptych painted in 1374 for the convent of San Domenico, San Gimignano.
Tempera on wood, gold ground, arched top; overall 69¹/₈ × 45¹/₈ in. (175.6 × 114.6 cm); painted surface 63¹/₄ × 45¹/₈ in. (160.7 × 114.6 cm)
The Cloisters Collection, 1925
25.120.288
THE CLOISTERS

The Adoration of the Magi
The Journey of the Magi (Musée des Beaux-Arts, Dijon) is a fragment of the upper part of this painting.
Tempera and gold on wood, 58¹/₂ × 35¹/₈ in. (148.6 × 89.2 cm)
Robert Lehman Collection, 1975
1975.1.16
ROBERT LEHMAN COLLECTION

Luca di Tommè di Nuto
Italian, Sienese, active 1356–1389

Madonna and Child
Tempera on wood, transferred from wood, gold ground, shaped top, 52⁷/₈ × 23¹/₈ in. (134.3 × 58.7 cm)
Inscribed (on scroll): EGO·SVM·VIA·VERI[TAS ET VITA] (I am the way, the truth, [and the life] [John 14:6].)
Gift of George Blumenthal, 1941
41.100.34

Copy after Luca di Tommè di Nuto
Italian, shortly before 1925

The Crucifixion
This painting is a reduced copy—without the gable—of Luca di Tommè's Crucifixion of 1366 (Museo Civico, Pisa). It was acquired for study purposes.
Oil on wood, gold ground, 13⁷/₈ × 8³/₈ in. (35.2 × 21.3 cm)
Administration Fund, 1925
25.79

Paolo di Giovanni Fei
Italian, Sienese, active by 1369, died 1411

Madonna and Child Enthroned with Saints and with Eve and the Serpent
The throne is flanked (left) by Saints John the Evangelist, Peter, Agnes, and Catherine of Alexandria and (right) by Saint Lucy, an unidentified female saint, and Saints Paul and John the Baptist. In the background are nine angels and in the spandrels is the Annunciation.
Tempera on wood, gold ground; overall, with engaged frame, 34¹/₄ × 23¹/₄ in. (87 × 59.1 cm); painted surface 27⁷/₈ × 17¹/₄ in. (70.8 × 43.8 cm)
Inscribed (on scroll): EVA
Robert Lehman Collection, 1975
1975.1.23
ROBERT LEHMAN COLLECTION

Madonna and Child
Tempera on wood, gold ground; overall, with engaged frame, 34¹/₄ × 23¹/₄ in. (87 × 59.1 cm); painted surface 27 × 16⁷/₈ in. (68.6 × 42.9 cm)
Bequest of George Blumenthal, 1941
41.190.13

Workshop of Paolo di Giovanni Fei

Madonna and Child Enthroned with Saints and Angels; Crucifixion (diptych)

The Madonna is flanked by Saints John the Baptist and James the Greater; the crucified Christ is surrounded by his mother and Saints Mary Magdalen and John the Baptist. In the spandrels is the Annunciation. The versos of the panels have been painted black, but some gesso and bole and traces of engraved decoration appear beneath.

Tempera on wood, gold ground; left wing, overall, with engaged frame, $17^7/8 \times 7^3/4$ in. (45.4×19.7 cm); left wing, painted surface, including gable, $15^7/8 \times 6^1/2$ in. (40.3×16.5 cm); right wing, overall, with engaged frame, $18 \times 7^3/4$ in. (45.7×19.7 cm); right wing, painted surface, including gable, $15^7/8 \times 6^1/2$ in. (40.3×16.5 cm)
Inscribed (on scroll): EGO·SVM
Robert Lehman Collection, 1975
1975.1.22
ROBERT LEHMAN COLLECTION

Naddo Ceccarelli

Italian, Sienese, active mid-14th century

Madonna and Child

Tempera on wood, gold ground; overall, with engaged frame, $24^5/8 \times 10^3/4$ in. (62.5×27.3 cm); painted surface $19^7/8 \times 8^5/8$ in. (50.5×21.9 cm)
Robert Lehman Collection, 1975
1975.1.10
ROBERT LEHMAN COLLECTION

Niccolò di Buonaccorso

Italian, Sienese, active by 1372, died 1388

The Coronation of the Virgin

The Presentation of the Virgin (Uffizi, Florence), the Marriage of the Virgin (National Gallery, London), and this panel probably constituted a portable polyptych. Like those panels, this one is silvered, punched, and painted with a pattern of diamond-shaped lozenges in blue and red on the verso; the outer edges were originally silvered and punched.

Tempera on wood, gold ground; overall, with engaged frame, $20 \times 12^7/8$ in. (50.8×32.7 cm); painted surface $17^5/8 \times 10^1/2$ in. (44.8×26.7 cm)
Robert Lehman Collection, 1975
1975.1.21
ROBERT LEHMAN COLLECTION

Saint Paul

Tempera on wood, gold ground, shaped top; overall, with engaged frame, $60 \times 16^1/2$ in. (152.4×41.9 cm); painted surface $52^3/8 \times 16^1/2$ in. (133×41.9 cm)
Inscribed (on book): adrom /anos ∴ (to the Romans)
Bequest of George Blumenthal, 1941
41.190.531

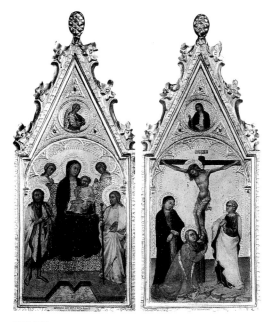

1975.1.22

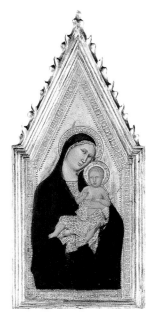

1975.1.10

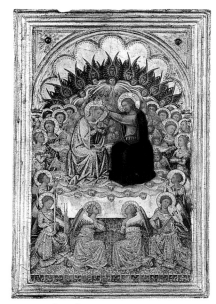

1975.1.21 (recto)

1975.1.21 (verso)

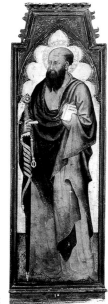

41.190.531

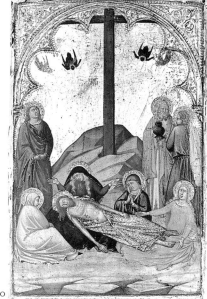

1975.1.20

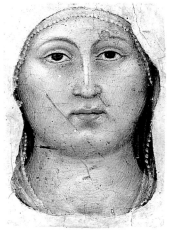

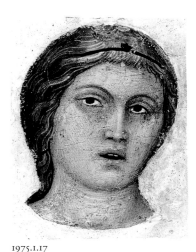

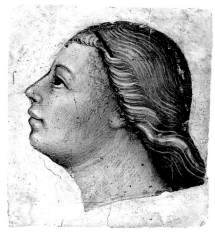

1975.1.18 1975.1.17 1975.1.19

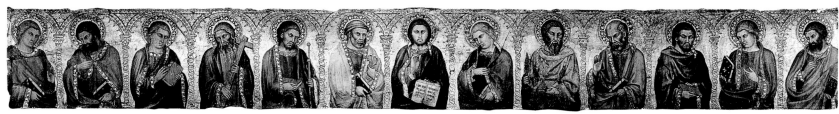

1991.27.1

Workshop of Niccolò di Buonaccorso

The Lamentation over the Dead Christ
This painting may have been associated with an Annunciation (Wadsworth Atheneum, Hartford) as a diptych.
Tempera on wood, gold ground; overall 16¹/₈ × 10¹/₂ in. (41 × 26.7 cm); painted surface 15¹/₂ × 10 in. (39.4 × 25.4 cm)
Robert Lehman Collection, 1975
1975.1.20
ROBERT LEHMAN COLLECTION

Taddeo di Bartolo
Italian, Sienese, born about 1362, died 1422

Head of the Virgin (fragment)
This panel and the following two

(1975.1.17, 19) appear to have been excised from an Assumption of the Virgin; no other fragments of this work are known.
Tempera on wood (paint around head scraped away and vacant area gessoed), 7³/₄ × 5³/₈ in. (19.7 × 13.7 cm)
Robert Lehman Collection, 1975
1975.1.18
ROBERT LEHMAN COLLECTION

Head of an Angel in Full Face (fragment)
Tempera on wood (paint around head scraped away and vacant area gessoed), 6¹/₄ × 4³/₄ in. (15.9 × 12.1 cm)
Robert Lehman Collection, 1975
1975.1.17
ROBERT LEHMAN COLLECTION

Head of an Angel in Left Profile (fragment)
Tempera on wood (paint around head scraped away and vacant area gessoed), 5⁷/₈ × 5¹/₄ in. (14.9 × 13.3 cm)
Robert Lehman Collection, 1975
1975.1.19
ROBERT LEHMAN COLLECTION

Christ and the Twelve Apostles (predella)
Tempera on wood, gold ground, 9⁵/₈ × 73¹/₈ in. (24.4 × 185.7 cm)
Bequest of Lucy G. Moses, 1990
1991.27.1

Martino di Bartolommeo di Biagio

Italian, Sienese, active by 1389, died 1434/35

Saint Stephen (with the Angel of the Annunciation)

This panel and the following three (30.95.265, 266, 264) were part of the same altarpiece. Tempera on wood, gold ground, shaped top; overall, with engaged (modern) frame, 59³/₈ × 15¹/₂ in. (150.8 × 39.4 cm); Saint Stephen, 39³/₄ × 11³/₈ in. (101 × 28.9 cm); angel, 12³/₄ × 9¹/₄ in. (32.4 × 23.5 cm)
Inscribed (bottom, on frame): SAS.STEPHANUS
Theodore M. Davis Collection, Bequest of Theodore M. Davis, 1915
30.95.263

Saint Anthony Abbot (with Saint John the Baptist)

Tempera on wood, gold ground, shaped top; overall, with engaged (modern) frame, 58⁵/₈ × 16¹/₂ in. (148.9 × 41.9 cm); Saint Anthony, 39¹/₂ × 11³/₄ in. (100.3 × 29.8 cm); Saint John, 12³/₄ × 8⁷/₈ in. (32.4 × 22.5 cm)
Inscribed: (on Saint John's scroll) Ecce agnius dei ecce quitollit p . . . ; (bottom, on frame) S. ANTONIUS. AB.
Theodore M. Davis Collection, Bequest of Theodore M. Davis, 1915
30.95.265

Saint Julian the Hospitaler (with Saint Nicholas of Bari)

Tempera on wood, gold ground, shaped top; overall, with engaged (modern) frame, 58³/₄ × 17 in. (149.2 × 43.2 cm); Saint Julian, 39⁵/₈ × 12 in. (100.6 × 30.5 cm); Saint Nicholas, 12³/₄ × 8⁷/₈ in. (32.4 × 22.5 cm)
Inscribed (bottom, on frame): S. PAULUS. APOS.
Theodore M. Davis Collection, Bequest of Theodore M. Davis, 1915
30.95.266

Saint James the Greater (with the Virgin of the Annunciation)

Tempera on wood, gold ground, shaped top; overall, with engaged (modern) frame, 59³/₈ × 15³/₈ in. (150.8 × 39.1 cm); Saint James, 39³/₈ × 11³/₈ in. (100 × 28.9 cm); the Virgin, 13¹/₄ × 9¹/₈ in. (33.7 × 23.2 cm)
Inscribed (bottom, on frame): SAS.IACOBUS
Theodore M. Davis Collection, Bequest of Theodore M. Davis, 1915
30.95.264

Andrea di Bartolo

Italian, Sienese, active by 1389, died 1428

The Crucifixion

The painting was the center of a predella illustrating the Passion of Christ, which included the Betrayal and the Way to Calvary (both Thyssen-Bornemisza Foundation), the Lamentation (Nationalmuseum, Stockholm),

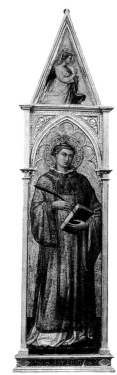

30.95.263

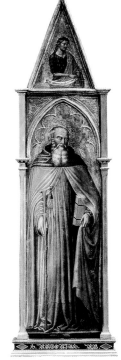

30.95.265

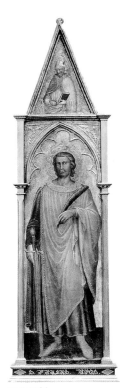

30.95.266

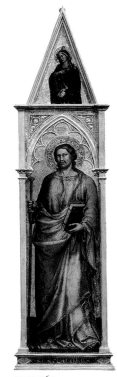

30.95.264

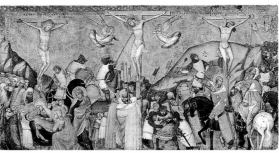

12.6

43.98.1

and the Resurrection (Walters Art Gallery, Baltimore).
Tempera on wood, gold ground, 20³/₄ × 38¹/₂ in. (52.7 × 97.8 cm)
Inscribed: (on cross) ·I·N·R·I·; (on shields) ·S·P·Q·R·
Rogers Fund, 1912
12.6

Sassetta (Stefano di Giovanni)

Italian, Sienese, active by 1423, died 1450

The Journey of the Magi

This panel formed the upper part of the Adoration of the Magi (Chigi-Saracini collection, Monte dei Paschi, Siena). Tempera and gold on wood, 8¹/₂ × 11³/₄ in. (21.6 × 29.8 cm)
Maitland F. Griggs Collection, Bequest of Maitland F. Griggs, 1943
43.98.1

The Annunciation

It is likely that this panel was the central pinnacle of the front of the altarpiece painted between 1437 and 1444 for San Francesco, Borgo Sansepolcro. Other components of the front are the Madonna and Child with Six Angels (Louvre, Paris), Blessed Ranieri Rasini and Saint John the Baptist (both Berenson collection, Villa I Tatti, Florence), Saints John the Evangelist and Anthony of Padua (both Louvre), and two predella panels with scenes from the life of Blessed Ranieri Rasini (Gemäldegalerie, SMPK, Berlin). Elements of the verso are Saint Francis in Ecstasy (I Tatti), eight scenes from his life (seven in the National Gallery, London, and one in the Musée Condé, Chantilly), and three scenes from the Passion (Detroit Institute of Arts). Among the pinnacle and pilaster panels is Saint Francis Kneeling before the Crucified Christ (Cleveland Museum of Art), the verso of the present Annunciation.

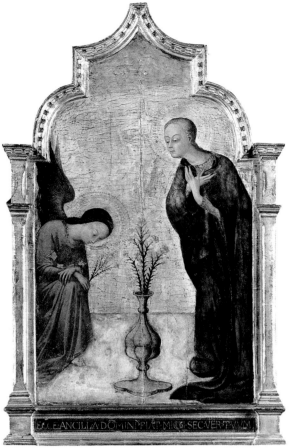

1975.I.26

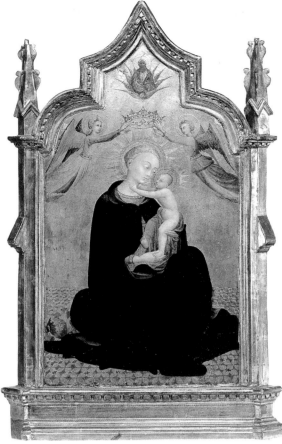

41.100.20

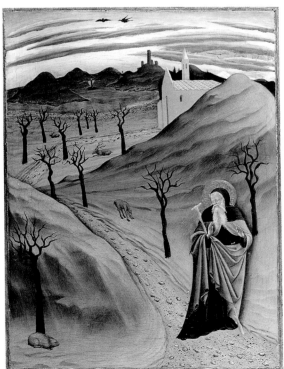

1975.I.27

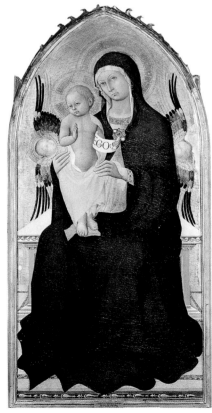

1975.I.41

Tempera on wood, gold ground; overall, with engaged (modern) frame, 30 × 17¹/₈ in. (76.2 × 43.5 cm); painted surface 28³/₄ × 16¹/₈ in. (73 × 41 cm)
Robert Lehman Collection, 1975
1975.1.26
ROBERT LEHMAN COLLECTION

Madonna and Child with Angels
Tempera on wood, gold ground, shaped top; overall, with engaged (modern) frame, 31³/₄ × 19³/₄ in. (80.6 × 50.2 cm); painted surface 25¹/₈ × 13¹/₂ in. (63.8 × 34.3 cm)
Gift of George Blumenthal, 1941
41.100.20

Osservanza Master
Italian, Sienese, active second quarter 15th century

Saint Anthony Abbot Tempted by a Heap of Gold
This panel is the sixth in a series of eight that includes Saint Anthony at Mass (Gemäldegalerie, SMPK, Berlin); Saint Anthony Distributing His Wealth and Saint Anthony Blessed by an Old Hermit (both National Gallery of Art, Washington, D.C.); Saint Anthony Tempted by the Devil in the Guise of a Woman and Saint Anthony Beaten by Devils (both Yale University Art Gallery, New Haven); and Journey and Meeting of Saint Anthony with Saint Paul the Hermit and Funeral of Saint Anthony (both National Gallery of Art, Washington, D.C.).
Tempera and gold on wood; overall 18³/₄ × 13⁵/₈ in. (47.6 × 34.6 cm); painted surface 18¹/₂ × 13¹/₄ in. (47 × 33.7 cm)
Robert Lehman Collection, 1975
1975.1.27
ROBERT LEHMAN COLLECTION

Madonna and Child Enthroned with Two Cherubim
This is the central panel of a polyptych whose predella may have comprised scenes from the Passion: Flagellation of Christ (Pinacoteca Vaticana), Way to Calvary (Philadelphia Museum of Art, John G. Johnson Collection), Crucifixion (Museum of Western Art, Kiev), Descent into Limbo (Fogg Art Museum, Cambridge, Massachusetts), and Resurrection (Detroit Institute of Arts).
Tempera on wood, gold ground, 56¹/₂ × 27³/₈ in. (143.5 × 69.5 cm)
Inscribed: (on Madonna's halo) MARIA·MATER· GRATIE·ET·MISER[ICORDIA] (Mary, mother of grace and mercy); (on Christ Child's halo) YESVS NAÇAR ENVS·R EX·IV[DAEORVM]; (on scroll) EGO:S[VM]
Robert Lehman Collection, 1975
1975.1.41
ROBERT LEHMAN COLLECTION

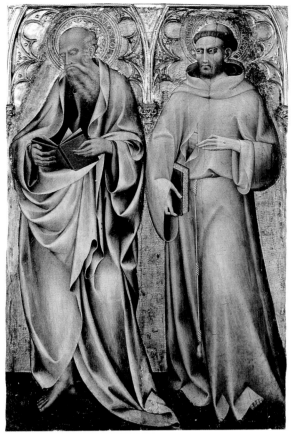

88.3.111

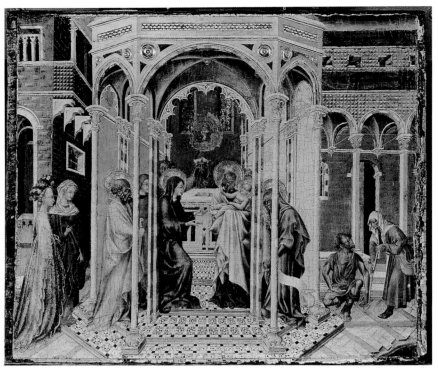

41.100.4

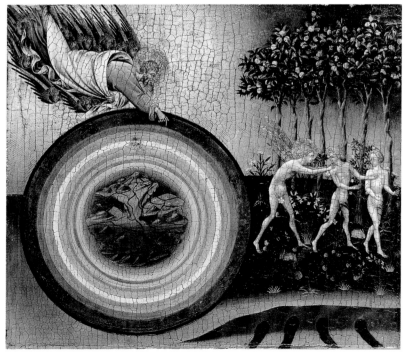

1975.1.31

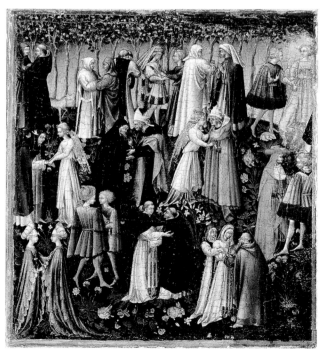

06.1046

1975.1.35

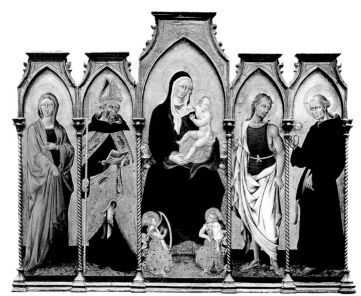

32.100.76

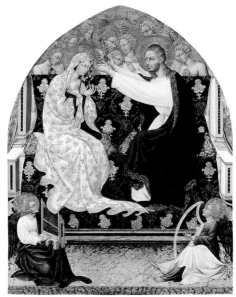

1975.1.38

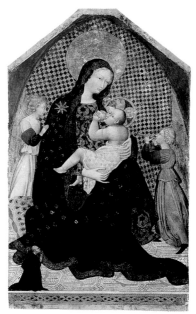

41.190.16

Giovanni di Paolo (Giovanni di Paolo di Grazia)

Italian, Sienese, active by 1417, died 1482

Saints Matthew and Francis

This panel is from an altarpiece that also included fragmentary panels representing Saints Ursula and John the Baptist (Museum of Fine Arts, Houston) at the left and the Madonna and Child (Monte dei Paschi, Siena) in the center.
Tempera on wood, gold ground; overall, with added strips, 54⁵/8 × 34³/4 in.
(138.7 × 88.3 cm); painted surface
52⁷/8 × 33¹/2 in. (134.3 × 85.1 cm) [top truncated]
Inscribed (on halos): ƧANCTVS MACTEVS APOSTOLVS; SANCTVS F[RANCISCV]S SERA[F]RIC[VS] (Saint Matthew the Apostle; Saint Francis the Seraphic)
Gift of Coudert Brothers, 1888
88.3.111

The Presentation of Christ in the Temple

This panel is the final scene in a predella that included the Annunciation and the Expulsion of Adam and Eve from Paradise (National Gallery of Art, Washington, D.C.), the Nativity (Pinacoteca Vaticana), the Crucifixion (Gemäldegalerie, SMPK, Berlin), and the Adoration of the Magi (Cleveland Museum of Art).
Tempera and gold on wood;
overall 15¹/2 × 18¹/8 in. (39.4 × 46 cm);
painted surface 15¹/4 × 17¹/4 in. (38.7 × 43.8 cm)
Gift of George Blumenthal, 1941
41.100.4

The Creation and the Expulsion of Adam and Eve from Paradise

This panel and the following (06.1046) are from the predella of an altarpiece—almost certainly the Madonna and Child with Saints

Dominic, Peter, Paul, and Thomas Aquinas, which is signed and dated 1445 (Uffizi, Florence)—from the Guelfi chapel, San Domenico, Siena.
Tempera and gold on wood, 18¹/4 × 20¹/2 in.
(46.4 × 52.1 cm)
Robert Lehman Collection, 1975
1975.1.31
ROBERT LEHMAN COLLECTION

Paradise (fragment of a Last Judgment)

Tempera and gold on canvas, transferred from wood; overall 18¹/2 × 16 in. (47 × 40.6 cm); painted surface 17¹/2 × 15¹/8 in.
(44.5 × 38.4 cm)
Rogers Fund, 1906
06.1046

The Exultation of Saint Nicholas of Tolentino

The panel's verso is painted to imitate dark porphyry with a light porphyry surround.
Tempera on wood, gold ground; overall, with engaged frame, 19¹/8 × 14¹/4 in.
(48.6 × 36.2 cm)
Robert Lehman Collection, 1975
1975.1.35
ROBERT LEHMAN COLLECTION

Madonna and Child with Saints (polyptych)

The saints (left to right) are Monica(?), Augustine, John the Baptist, and Nicholas of Tolentino; the pinnacles may perhaps be identifiable with a series of the four Evangelists and Christ Blessing (private collection).
Tempera on wood, gold ground; central panel 82³/4 × 25⁷/8 in. (210.2 × 65.7 cm); left panels 70⁷/8 × 16⁷/8 in. (180 × 42.9 cm), 70⁷/8 × 16³/4 in. (180 × 42.5 cm); right panels 70⁷/8 × 16⁷/8 in. (180 × 42.9 cm), 70⁷/8 × 16³/4 in. (180 × 42.5 cm)
Signed and dated (base of central panel): OPVS IOHANNES MCCCCLIIII
The Friedsam Collection, Bequest of Michael Friedsam, 1931
32.100.76

The Coronation of the Virgin

It is likely that this painting had a predella that comprised three panels: Saint Bartholomew, the Entombment of the Virgin, and the Mourning Virgin (Fitzwilliam Museum, Cambridge); Christ as the Man of Sorrows (private collection); and the Mourning Saint John the Evangelist, the Assumption of the Virgin, and Saint Ansanus (El Paso Museum of Art).
Tempera on wood, gold ground, shaped top, 70⁵/8 × 51³/4 in. (179.4 × 131.4 cm)
Robert Lehman Collection, 1975
1975.1.38
ROBERT LEHMAN COLLECTION

Giovanni di Paolo (Giovanni di Paolo di Grazia)

Italian, Sienese, active by 1417, died 1482

Madonna and Child with Two Angels and a Donor

Tempera on wood, gold ground (partly checkered with modern red glazes); overall 57 1/8 × 32 in. (145.1 × 81.3 cm); painted surface 54 1/4 × 32 in. (137.8 × 81.3 cm)
Bequest of George Blumenthal, 1941
41.190.16

The Adoration of the Magi

Panels from the same predella are the Nativity (Fogg Art Museum, Cambridge, Massachusetts), the Infant Christ Disputing in the Temple (Isabella Stewart Gardner Museum, Boston), and less certainly the Crucifixion (Christ Church, Oxford). The main panel may have been the Presentation of Christ in the Temple (Pinacoteca Nazionale, Siena).
Tempera and gold on wood, 10 5/8 × 9 1/8 in. (27 × 23.2 cm)
The Jack and Belle Linsky Collection, 1982
1982.60.4

Saint John the Evangelist Raises Drusiana

The predella of the altarpiece of the Venerabile Compagnia degli Artisti of Montepulciano seems to have included the present fragmentary panel, as well as the Baptism of Christ (Ashmolean Museum, Oxford), the Crucifixion (private collection), and the Attempted Martyrdom of Saint John the Evangelist at Porta Latina (private collection).
Tempera and gold on wood, 9 3/8 × 8 7/8 in. (23.8 × 22.5 cm)
Robert Lehman Collection, 1975
1975.1.36
ROBERT LEHMAN COLLECTION

Saint Catherine of Siena Receiving the Stigmata

This panel and the following four (1975.1.33, 32.100.95, 1975.1.55, 56) are among fifteen panels from a total of no fewer than seventeen that are conjecturally associated with the Pizzicaiuoli altarpiece from the church of the hospital of Santa Maria della Scala, Siena (the main panel, the Purification of the Virgin, is in the Pinacoteca Nazionale, Siena). The others are: Saint Catherine Invested with the Dominican Habit (Cleveland Museum of Art), Mystic Marriage of Saint Catherine (private collection), Saint Catherine and the Beggar (Cleveland Museum of Art), Saint Catherine Exchanging Her Heart with Christ (private collection), Saint Catherine Dictating Her Dialogues to Raymond of Capua (Detroit Institute of Arts), Saint Catherine before a Pope (Thyssen-Bornemisza Foundation),

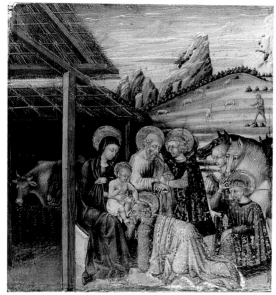

1982.60.4

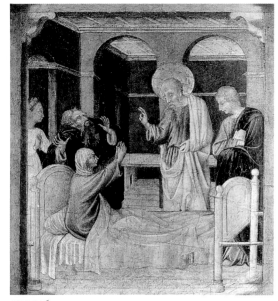

1975.1.36

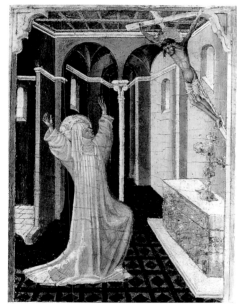

1975.1.34

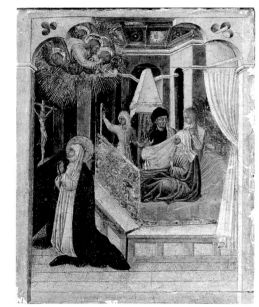

1975.1.33

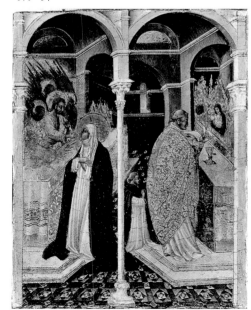

32.100.95

1975.1.55

1975.1.56

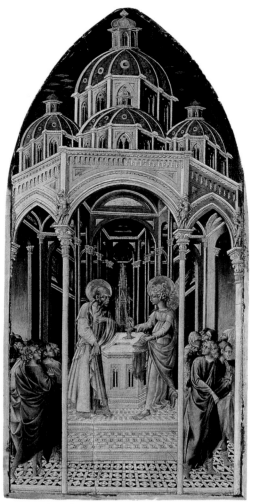

1975.1.37 (recto)

1975.1.37 (verso)

The Blessed Andrea Gallerani (died 1251)
Tempera on wood, gold ground; overall,
with engaged frame, 20¹/₄ × 7 in.
(51.4 × 17.8 cm); painted surface
19 × 4⁷/₈ in. (48.3 × 12.4 cm)
Robert Lehman Collection, 1975
1975.1.55
ROBERT LEHMAN COLLECTION

The Blessed Ambrogio Sansedoni (1220–
1286)
Tempera on wood, gold ground; overall,
with engaged frame, 20⁵/₈ × 7 in.
(52.4 × 17.8 cm); painted surface
19¹/₄ × 4⁷/₈ in. (48.9 × 12.4 cm)
Robert Lehman Collection, 1975
1975.1.56
ROBERT LEHMAN COLLECTION

The Annunciation to Zacharias; (verso) ***The
Angel of the Annunciation***
This panel is the first of twelve (eleven are
known) that may have constituted the doors
of a cupboard, or custodia, housing a
sculpture or reliquary: Birth and Naming of
John the Baptist (Westfälisches
Landesmuseum, Münster), Saint John in the
Wilderness (Art Institute of Chicago), Saint
John Preaching (Louvre, Paris), Baptism of
the Multitude (lost), Ecce Agnus Dei (Art
Institute of Chicago), Baptism of Christ
(Norton Simon Museum, Pasadena), Saint
John Preaching before Herod (Westfälisches
Landesmuseum, Münster), and Saint John in
Prison, Banquet of Herod, Beheading of the
Baptist, and Presentation of the Baptist's Head
to Herod (last four, Art Institute of Chicago).
Tempera and gold on wood, 29⁷/₈ × 17 in.
(75.9 × 43.2 cm)
Robert Lehman Collection, 1975
1975.1.37
ROBERT LEHMAN COLLECTION

Death of Saint Catherine (private collection),
Crucifixion (Rijksmuseum Het
Catharijneconvent, Utrecht, on deposit at the
Rijksmuseum, Amsterdam), and pilaster
figures representing Saint Galganus and
Blessed Peter of Siena(?) (both
Aartbischoppelijk Museum, Utrecht).
Tempera and gold on wood, 11 × 7⁷/₈ in.
(27.9 × 20 cm)
Robert Lehman Collection, 1975
1975.1.34
ROBERT LEHMAN COLLECTION

***Saint Catherine of Siena Beseeching Christ
to Resuscitate Her Mother***
Tempera and gold on wood, 11 × 8⁵/₈ in.
(27.9 × 21.9 cm)
Robert Lehman Collection, 1975
1975.1.33
ROBERT LEHMAN COLLECTION

***The Miraculous Communion of Saint
Catherine of Siena***
Tempera and gold on wood, 11³/₈ × 8³/₄ in.
(28.9 × 22.2 cm)
The Friedsam Collection, Bequest of Michael
Friedsam, 1931
32.100.95

Giovanni di Paolo (Giovanni di Paolo di Grazia)

Italian, Sienese, active by 1417, died 1482

Saints Catherine of Alexandria, Barbara, Agatha, and Margaret

These pilaster panels and two others showing Saints Mary Magdalen and Agnes (private collection) may have belonged to a triptych representing the Nativity with Saints Galganus (or Victorianus) and Ansanus (Musée du Petit Palais, Avignon).

Tempera on wood, gold ground; left to right:
(a) overall 18³/₄ × 6 in. (47.6 × 15.2 cm);
(a) painted surface 18¹/₄ × 5¹/₂ in.
(46.4 × 14 cm); (b) overall 18³/₄ × 6 in.
(47.6 × 15.2 cm); (b) painted surface
18³/₈ × 5⁵/₈ in. (46.7 × 14.3 cm); (c) overall
18³/₄ × 6 in. (47.6 × 15.2 cm); (c) painted
surface 18³/₈ × 5³/₈ in. (46.7 × 13.7 cm);
(d) overall 18³/₄ × 6 in. (47.6 × 15.2 cm);
(d) painted surface 18¹/₄ × 5⁵/₈ in.
(46.4 × 14.3 cm)
The Friedsam Collection, Bequest of Michael Friedsam, 1931
32.100.83a–d

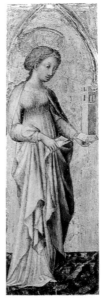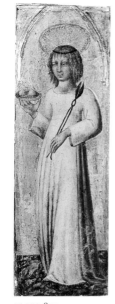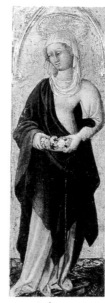

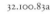

32.100.83a	32.100.83b	32.100.83c	32.100.83d

Madonna and Child with Saints Jerome and Agnes

The verso, which is painted to imitate porphyry, bears the arms of the Chiavellini-Pini (left) and of the Aldobrandeschi, counts of Santa Fiora.

Tempera on wood, gold ground,
12⁵/₈ × 9³/₄ in. (32.1 × 24.8 cm)
Robert Lehman Collection, 1975
1975.1.32
ROBERT LEHMAN COLLECTION

Saint Ambrose

This fragmentary panel and a Saint Augustine (Fogg Art Museum, Cambridge, Massachusetts) are from the same altarpiece, to which a fragmentary Saint Gregory the Great (location unknown), a fragmentary Madonna and Child with Two Angels (Mount Holyoke College, South Hadley, Massachusetts), and presumably a Saint Jerome (lost) may also have belonged. Panels with Saint Jerome Appearing to Saint Augustine (Gemäldegalerie, SMPK, Berlin) and Pope Gregory the Great Staying the Plague at Castel Sant'Angelo (Louvre, Paris) are likely to have formed part of the predella.

Tempera on wood, gold ground,
23⁷/₈ × 14¹/₂ in. (60.6 × 36.8 cm)
Robert Lehman Collection, 1975
1975.1.30
ROBERT LEHMAN COLLECTION

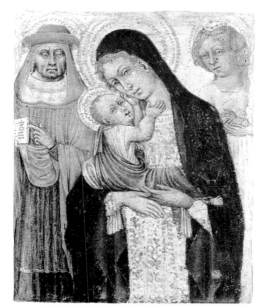

1975.1.32

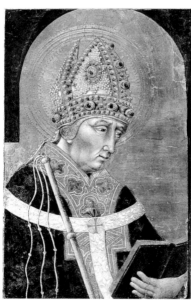

1975.1.30

Sano di Pietro (Ansano di Pietro di Mencio)

Italian, Sienese, 1406–1481

The Birth and Naming of Saint John the Baptist (predella panel)

Tempera and gold on wood; overall, with engaged (modern) frame, 9⁵/₈ × 18⁷/₈ in. (24.4 × 47.9 cm); painted surface 8¹/₈ × 16⁷/₈ in. (20.6 × 42.9 cm)
Robert Lehman Collection, 1975
1975.1.44
ROBERT LEHMAN COLLECTION

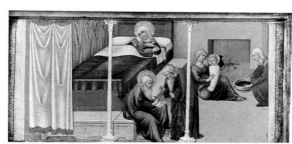

1975.1.44

1975.1.40

1975.1.51

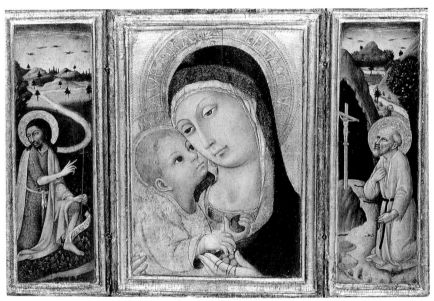

64.189.4

1975.1.46

1975.1.50

Madonna and Child
Tempera on wood, gold ground; overall, with engaged (modern) frame, diameter 7 in. (17.8 cm); painted surface, diameter 5 in. (12.7 cm)
Robert Lehman Collection, 1975
1975.1.40
ROBERT LEHMAN COLLECTION

Madonna and Child
Tempera on wood, gold ground; overall, with engaged frame, 16³/₈ × 12¹/₈ in. (41.6 × 30.8 cm); painted surface 13¹/₈ × 9 in. (33.3 × 22.9 cm)
Robert Lehman Collection, 1975
1975.1.51
ROBERT LEHMAN COLLECTION

Madonna and Child; Saint John the Baptist; Saint Jerome (portable triptych)
The exterior wings retain the original decoration on an imitation-porphyry ground.
Tempera on wood, gold ground; central panel, overall, with engaged frame, 17³/₈ × 12⁵/₈ in. (44.1 × 32.1 cm); central panel, painted surface 14³/₄ × 10¹/₈ in. (37.5 × 25.7 cm); each wing, overall, with engaged frame, 17³/₈ × 6¹/₄ in. (44.1 × 15.9 cm); each wing, painted surface 15¹/₂ × 4⁵/₈ in. (39.4 × 11.7 cm)
Inscribed: (on Madonna's halo) AVE·GRATIA PLENA·DOMIN[VS]; (on Christ Child's halo) [EGO] SVM; (on Saint John's scroll) ECCE AGNVSD[EI]
Gift of Irma N. Straus, 1964
64.189.4

Saint Bernardino
This panel and the following (1975.1.50) were part of a single work.
Tempera on wood, gold ground, 9¹/₂ × 8³/₄ in. (24.1 × 22.2 cm)
Inscribed (on tablet): YHS
Robert Lehman Collection, 1975
1975.1.46
ROBERT LEHMAN COLLECTION

Saint Francis
Tempera on wood, gold ground, 9¹/₂ × 8³/₄ in. (24.1 × 22.2 cm)
Robert Lehman Collection, 1975
1975.1.50
ROBERT LEHMAN COLLECTION

Sano di Pietro (Ansano di Pietro di Mencio)

Italian, Sienese, 1406–1481

Madonna and Child with Saints Jerome, Bernardino, John the Baptist, and Anthony of Padua and Two Angels

Tempera on wood, gold ground; overall, with engaged frame, 29¹/₈ × 20³/₈ in. (74 × 51.8 cm); painted surface 24³/₈ × 15⁵/₈ in. (61.9 × 39.7 cm)
Robert Lehman Collection, 1975
1975.1.42
ROBERT LEHMAN COLLECTION

Madonna and Child with Saints John the Baptist, Jerome, Peter Martyr, and Bernardino and Four Angels

Tempera on wood, gold ground; overall, with engaged (not original) frame, 28¹/₈ × 22¹/₈ in. (71.4 × 56.2 cm); painted surface 24³/₄ × 18⁵/₈ in. (62.9 × 47.3 cm)
Inscribed: (lower left, on scroll held by Saint John) ECCE A; (on Madonna's halo) AVE GRATIA PLENA DOMIN; (on Christ Child's halo) YHS XPO
Robert Lehman Collection, 1975
1975.1.43
ROBERT LEHMAN COLLECTION

Madonna and Child with the Dead Christ, Saints Agnes and Catherine of Alexandria, and Two Angels (portable altarpiece)

Tempera on wood, gold ground; main panel, overall, with engaged (modern) frame, 12³/₄ × 11³/₄ in. (32.4 × 29.8 cm); main panel, painted surface 10⁷/₈ × 9⁷/₈ in. (27.6 × 25.1 cm); predella, overall, with engaged (modern) frame, 3⁵/₈ × 12⁵/₈ in. (9.2 × 32.1 cm); predella, painted surface 2⁵/₈ × 11⁷/₈ in. (6.7 × 30.2 cm)
Inscribed (on Madonna's halo): AVE GRATIA PLENA
Anonymous Bequest, 1984
1987.290.2ab

The Adoration of the Magi

This panel and the following (58.189.1) are from the predella of an altarpiece that also included the Nativity and the Flight into Egypt (both Pinacoteca Vaticana). The main panel was the Presentation in the Temple (formerly Massa Marittima; destroyed).
Tempera and gold on wood, 11⁷/₈ × 18³/₄ in. (30.2 × 47.6 cm)
Gift of Irma N. Straus, 1958
58.189.2

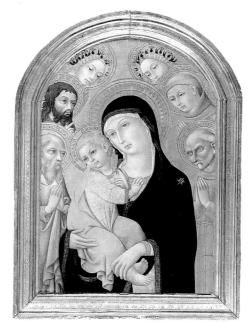

1975.1.42

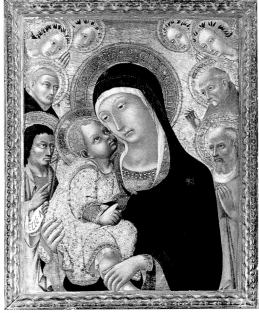

1975.1.43

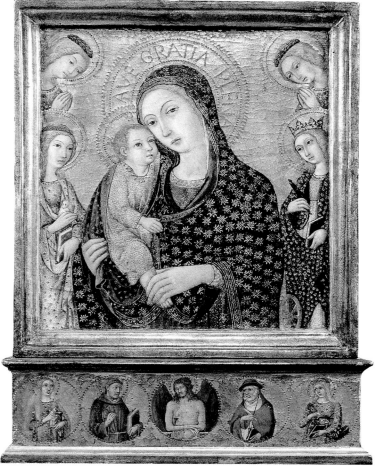

1987.290.2ab

The Massacre of the Innocents (predella panel)
Tempera on wood, 11⁷/₈ × 17³/₈ in.
(30.2 × 44.1 cm)
Gift of Irma N. Straus, 1958
58.189.1

The Burial of Saint Martha (predella panel)
Tempera and gold on wood, 5¹/₂ × 11¹/₂ in.
(14 × 29.2 cm)
Inscribed (on scroll held by Christ): i[n] memoria [a]eterna/erit giusta ospida mea (In everlasting memory shall be my righteous hostess)
Bequest of Adele L. Lehman, in memory of Arthur Lehman, 1965
65.181.7

Workshop of Sano di Pietro

Saint Bernardino
Tempera and gold on wood, 7 × 4¹/₈ in.
(17.8 × 10.5 cm)
Inscribed (on tablet): YHS / IN NOMINE YHV. / OMNE. GENV. / FLETATVR. CELESTIVM / TERESTI ET INFERNORV. (At the name of Jesus all in heaven, on earth, and in hell kneel)
Robert Lehman Collection, 1975
1975.1.45
ROBERT LEHMAN COLLECTION

Madonna and Child
Tempera on wood, gold ground; overall 24⁷/₈ × 17⁵/₈ in. (63.2 × 44.8 cm); painted surface 21⁵/₈ × 14¹/₈ in. (54.9 × 35.9 cm)
Inscribed: (on Madonna's halo) AVE.MARIA.GRACIA.PLENA.DO; (on Christ Child's halo) EGO.SVM.LVX.MV[NDI]
Robert Lehman Collection, 1975
1975.1.39
ROBERT LEHMAN COLLECTION

Pietro di Giovanni d'Ambrogio
Italian, Sienese, active by 1428, died 1449

Saint Michael; Saint Nicholas of Bari
These panels were the wings of a triptych; the central panel may have been a Madonna and Child Enthroned with Saints John the Baptist and Dorothy (Gemäldegalerie, SMPK, Berlin).
Tempera on wood, gold ground; each wing, overall, with engaged (modern) frame, 11³/₄ × 5¹/₄ in. (29.8 × 13.3 cm); each wing, painted surface 9¹/₄ × 3 in. (23.5 × 7.6 cm)
Robert Lehman Collection, 1975
1975.1.28ab
ROBERT LEHMAN COLLECTION

58.189.2

58.189.1

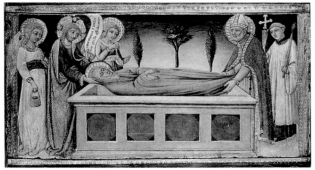

65.181.7

1975.1.45

1975.1.39

1975.1.28a

1975.1.28b

Icilio Federico Ioni

Italian, Tuscan, 1866–1946

Saints Cosmas and Damian and Their Brothers before the Proconsul Lycias

This panel and the following two (1975.1.48, 49) reproduce the first three scenes of the predella of an altarpiece by Sano di Pietro (Sienese, 1406–1481) (Pinacoteca Nazionale, Siena).
Tempera and gold on wood; overall 10⁵/₈ × 15³/₄ in. (27 × 40 cm); painted surface 10³/₈ × 12 in. (26.4 × 30.5 cm)
Robert Lehman Collection, 1975
1975.1.47
ROBERT LEHMAN COLLECTION

Saints Cosmas and Damian and Their Brothers Saved by an Angel After They Have Been Condemned to Death by Drowning

Tempera and gold on wood; overall 10⁵/₈ × 16¹/₈ in. (27 × 41 cm); painted surface 10³/₈ × 12¹/₈ in. (26.4 × 30.8 cm)
Robert Lehman Collection, 1975
1975.1.48
ROBERT LEHMAN COLLECTION

The Stoning of Saints Cosmas and Damian

Tempera and gold on wood; overall 10⁵/₈ × 16 in. (27 × 40.6 cm); painted surface 10³/₈ × 12¹/₈ in. (26.4 × 30.8 cm)
Robert Lehman Collection, 1975
1975.1.49
ROBERT LEHMAN COLLECTION

Priamo della Quercia (Priamo del Pietro)

Italian, Sienese, active 1442–1467

Madonna and Child with Adoring Angels

Tempera and gold on wood; overall, with added strips, 33¹/₄ × 21¹/₄ in. (84.5 × 54 cm); painted surface 26¹/₂ × 20¹/₂ in. (67.3 × 52.1 cm)
Bequest of Adele L. Lehman, in memory of Arthur Lehman, 1965
65.181.3

Madonna and Child with Saints (triptych)

Left wing: Saints Ursula and Michael; right wing: Saints Agatha and Lucy. The central panel has been reshaped.
Tempera on wood, gold ground; central panel 43¹/₄ × 22¹/₂ in. (109.9 × 57.2 cm); left wing 45¹/₂ × 22 in. (115.6 × 55.9 cm); right wing 45¹/₄ × 22¹/₄ in. (114.9 × 56.5 cm)
Gift of George Blumenthal, 1941
41.100.35–37

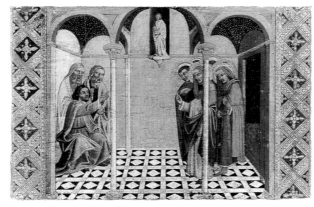

1975.1.47

1975.1.48

1975.1.49

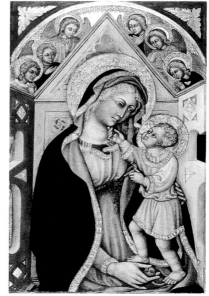

65.181.3

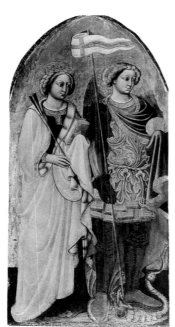

41.100.37

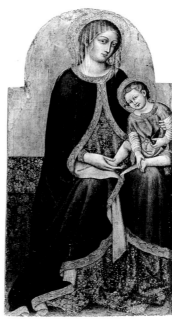

41.100.35

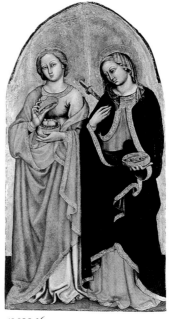

41.100.36

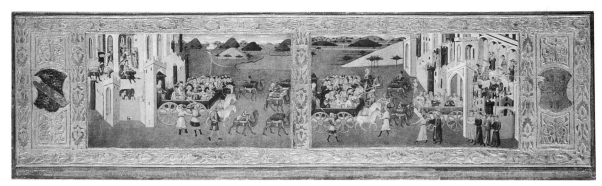

14.44

1975.1.52

65.234

41.100.17

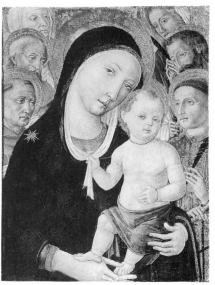

41.190.29

Master of Lecceto

Italian, Sienese, third quarter 15th century

King Solomon and the Queen of Sheba
(cassone panel)
Left: the queen departing on her journey;
right: the queen received by King Solomon
Tempera on wood, embossed and gilt
ornament; overall 20³/₄ × 70¹/₈ in.
(52.7 × 178.1 cm); left, painted surface
13⁷/₈ × 24¹/₂ in. (35.2 × 62.2 cm); right,
painted surface 14 × 24³/₄ in. (35.6 × 62.9 cm)
Inscribed (base): [QV]ESTA SIE LASTORIA
QVANDO LAREINA SABA ANDO AVDIRE
LASAPIENTIA DELRE [S]ALAMONE INGIERVSALEM
(This is the story of how the Queen of Sheba
went to hear the wisdom of King Solomon in
Jerusalem)
Arms (left) of the Insegni family and (right)
of the Spannocchi family
Rogers Fund, 1914
14.44

Matteo di Giovanni di Bartolo

Italian, Sienese, active by 1452, died 1495

***Madonna and Child with Saints Anthony
of Padua and Catherine of Siena***
Tempera on wood, gold ground,
25³/₄ × 16⁷/₈ in. (65.4 × 42.9 cm)
Inscribed: (along segmented arch)
AVE.MARIS.STELLA.DEI.MAT (Hail, Star of the
Sea, Mother of God); (on Madonna's halo)
REGINA.CELI.LETARE.ALLELV (Queen of
Heaven, rejoice, alleluia)
Robert Lehman Collection, 1975
1975.1.52
ROBERT LEHMAN COLLECTION

***Madonna and Child with Saints Jerome
and Mary Magdalen***
Tempera and gold on wood, 24¹/₄ × 17³/₄ in.
(61.6 × 45.1 cm)
Gift of Robert Lehman, 1965
65.234

**Workshop of Matteo di Giovanni di
Bartolo**

***Madonna and Child with Saints
Bernardino of Siena and Jerome and Two
Angels***
Tempera on wood, gold ground,
22 × 19¹/₂ in. (55.9 × 49.5 cm)
Inscribed (on tablet): YHS
Gift of George Blumenthal, 1941
41.100.17

Madonna and Child and Six Saints
Tempera on wood, gold ground; overall, with
engaged (modern) frame, 25¹/₄ × 19¹/₄ in.
(64.1 × 48.9 cm); painted surface
21³/₄ × 15³/₄ in. (55.2 × 40 cm)
Bequest of George Blumenthal, 1941
41.190.29

Benvenuto di Giovanni
Italian, Sienese, born 1436, died in or about
1518

Madonna and Child
The frame is of the period and may be the
original one.
Tempera on wood, gold ground;
overall 27³/₄ × 18¹/₈ in.
(70.5 × 46 cm); painted surface
24¹/₄ × 14³/₄ in. (61.6 × 37.5 cm)
Inscribed (on Madonna's halo):
AVE.GRATIA.PLENA.DOM
Robert Lehman Collection, 1975
1975.1.54
ROBERT LEHMAN COLLECTION

Saint Bernardino
This panel is from a predella that included
Christ in Benediction and Saint Dominic
(both Nelson-Atkins Museum, Kansas City),
Saint Peter Martyr (Yale University Art
Gallery, New Haven), Saint Francis (Museum
of Fine Arts, Houston), and Saint Philip(?)
(location unknown).
Tempera on wood, gold ground, pastiglia
garland of fruit, 9³/₈ × 10¹/₈ in.
(23.8 × 25.7 cm)
Robert Lehman Collection, 1975
1975.1.53
ROBERT LEHMAN COLLECTION

**Francesco di Giorgio (Francesco
Maurizio di Giorgio di Martino
Pollaiuolo)**
Italian, Sienese, 1439–1501

Goddess of Chaste Love
This panel, which must have been one of
three, was cut from the left end of a cassone
front; the corresponding panel from the right
end is the Triumph of Carnal Love (private
collection). The central panel has not been
identified.
Tempera and gold on wood, 15¹/₂ × 17¹/₄ in.
(39.4 × 43.8 cm)
Marquand Fund, 1920
20.182

The Nativity
This panel is the lower part of a larger
composition. It has been reunited with the
upper part, God the Father Surrounded by
Angels (National Gallery of Art, Washington,
D.C., Samuel H. Kress Collection, 1952.5.8).
The two-part work will be exhibited at each
museum on a rotating basis.
Tempera on wood; (41.100.2) overall
20³/₄ × 23⁵/₈ in. (52.7 × 60 cm); (41.100.2)
painted surface 20¹/₂ × 22¹/₂ in.
(52.1 × 57.2 cm); painted surface of
reassembled work 33¹/₄ in. (84.5 cm) high at
center
Gift of George Blumenthal, 1941
41.100.2

1975.1.53

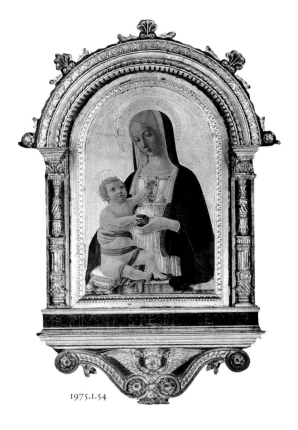

1975.1.54

20.182

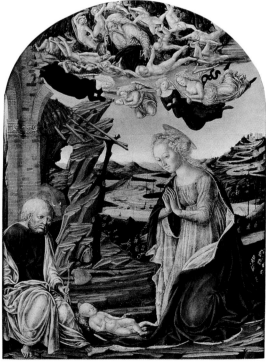

41.100.2

**Neroccio de' Landi (Neroccio di
Bartolommeo di Benedetto di
Neroccio de' Landi)**
Italian, Sienese, 1447–1500

***Madonna and Child with Saints Jerome
and Mary Magdalen***
Tempera on wood, 24 × 17¹/₄ in.
(61 × 43.8 cm)
Gift of Samuel H. Kress Foundation, by
exchange, 1961
61.43

Neroccio de' Landi and Workshop
***Madonna and Child with Saints Michael
and Bernardino of Siena***
Tempera on wood, arched top; overall,
with engaged frame, 31¹/₄ × 22³/₄ in.
(79.4 × 57.8 cm); painted surface
27¹/₂ × 19¹/₈ in. (69.9 × 48.6 cm)
Gift of George Blumenthal, 1941
41.100.18

61.43

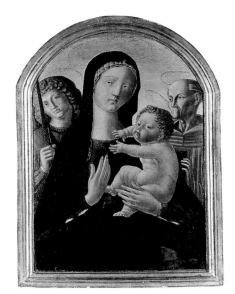

41.100.18

1975.1.57

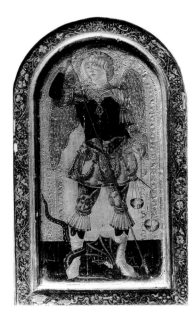

07.241

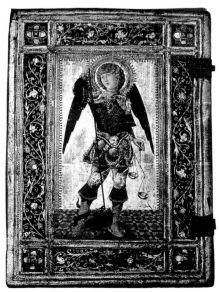

07.24.24 (recto)

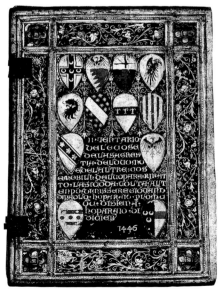

07.24.24 (verso)

Icilio Federico Ioni

Italian, Tuscan, 1866–1946

Madonna and Child with Saints Mary Magdalen and Sebastian

The painting is a forgery in the style of Neroccio de' Landi (Sienese, 1447–1500). Tempera on wood, gold ground; overall 43^1/$_8$ × 28^1/$_2$ in. (109.5 × 72.4 cm); painted surface 39^1/$_4$ × 24^5/$_8$ in. (99.7 × 62.5 cm)
Robert Lehman Collection, 1975
1975.1.57
ROBERT LEHMAN COLLECTION

Copies after Neroccio de' Landi

Italian, before 1907

Saint Michael

This panel is a reduced copy with slight variations of the left wing of Neroccio's triptych of 1476 (Pinacoteca Nazionale, Siena). It is attributable to the seller, Corrado Scapecchi, or perhaps to Icilio Federico Ioni (Tuscan, 1866–1946), and was acquired for study purposes.
Oil on wood, arched top, 19^3/$_8$ × 11^1/$_2$ in. (49.2 × 29.2 cm)
Rogers Fund, 1907
07.241

Saint Michael

This panel, the recto of a book cover intended to imitate a *biccherna* cover, is a somewhat less accurate copy (see 07.241 above) of the left wing of Neroccio's 1476 triptych (Pinacoteca Nazionale, Siena). The verso is falsely dated 1446.
Tempera on wood; overall 23^1/$_2$ × 15^1/$_2$ in. (59.7 × 39.4 cm); central field 10 × 5^5/$_8$ in. (25.4 × 14.3 cm)
Gift of Mrs. Ridgeley Hunt, in memory of William Cruger Pell, 1907
07.24.24

Liberale da Verona (Liberale di Jacomo)

Italian, Veronese, 1445–1527/29

Scene from a Novella

This panel (left) and the following (43.98.8) formed a cassone front, with a third panel (Berenson collection, Villa I Tatti, Florence) at the center.
Tempera on wood, 13 × 16^1/$_8$ in. (33 × 41 cm)
Gwynne Andrews Fund, 1986
1986.147

Liberale da Verona (Liberale di Jacomo)

Italian, Veronese, 1445–1527/29

The Chess Players (cassone panel)
Tempera on wood; overall 13³/₄ × 16¹/₄ in.
(34.9 × 41.3 cm); painted surface
13¹/₈ × 15⁷/₈ in. (33.3 × 40.3 cm)
Maitland F. Griggs Collection, Bequest of
Maitland F. Griggs, 1943
43.98.8

Guidoccio di Giovanni Cozzarelli

Italian, Sienese, 1450–1516

The Legend of Cloelia (cassone panel)
Tempera and gold on wood; overall
17³/₄ × 45¹/₂ in. (45.1 × 115.6 cm); painted
surface 15¹/₈ × 43¹/₄ in. (38.4 × 109.9 cm)
Frederick C. Hewitt Fund, 1911
11.126.2

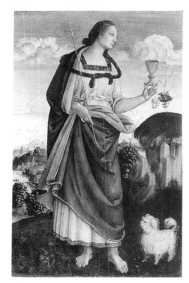

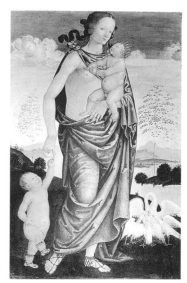

1986.147

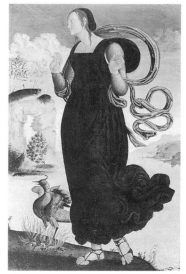

43.98.8

Bernardino Fungai

Italian, Sienese, born 1460, died 1516 or later

The Nativity
Oil and gold on wood; overall
55³/₈ × 40¹/₂ in. (140.7 × 102.9 cm);
painted surface 54⁷/₈ × 39³/₄ in.
(139.4 × 101 cm)
Rogers Fund, 1926
26.109

Italian (Umbrian) Painter

about 1500

Faith
This painting and the following two
(1982.177.2, 3) represent the Theological
Virtues; the landscape backgrounds are
continuous.
Tempera and gold on wood, 29¹/₈ × 17⁷/₈ in.
(74 × 45.4 cm)
Inscribed (on host held by Faith): INRI
Purchase, Bequest of Mary Cushing Fosburgh
and Gift of Rodman Wanamaker, by
exchange, 1982
1982.177.1

Charity
Tempera and gold on wood, 29¹/₈ × 18 in.
(74 × 45.7 cm)
Purchase, Bequest of Mary Cushing Fosburgh
and Gift of Rodman Wanamaker, by
exchange, 1982
1982.177.2

Hope
Tempera and gold on wood, 29¹/₈ × 18 in.
(74 × 45.7 cm)
Purchase, Bequest of Mary Cushing Fosburgh
and Gift of Rodman Wanamaker, by
exchange, 1982
1982.177.3

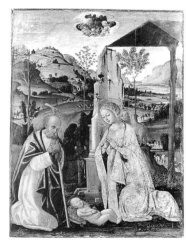

26.109

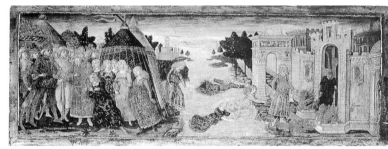

11.126.2

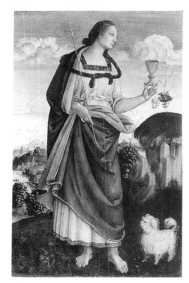

1982.177.1

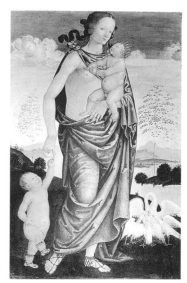

1982.177.2

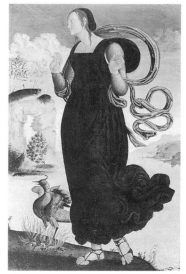

1982.177.3

41.190.22

88.3.100

Pietro di Domenico
Italian, Sienese, 1457–?1506
Madonna and Child with Two Angels
Tempera and gold on wood; overall
23³/₈ × 15¹/₄ in. (59.4 × 38.7 cm); painted
surface 23 × 14¹/₂ in. (58.4 × 36.8 cm)
Bequest of George Blumenthal, 1941
41.190.22

Italian (Sienese) Painter
late 15th century
Madonna and Child with Saints Peter and Paul
Tempera on wood, gold ground; overall
20⁵/₈ × 14¹/₂ in. (52.4 × 36.8 cm); painted
surface 19³/₄ × 13¹/₂ in. (50.2 × 34.3 cm)
Gift of Coudert Brothers, 1888
88.3.100

22.60.61 (recto)

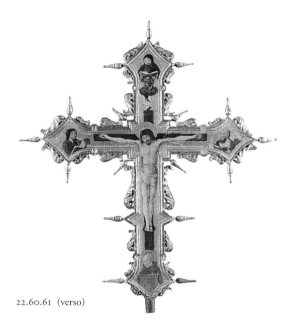

22.60.61 (verso)

Pietro di Francesco Orioli
Italian, Sienese, 1458–1496
Processional Crucifix
Terminals: (recto) the Virgin and Saints John
the Evangelist, Jerome, and Francis; (verso)
Saints Luke, Mark, Matthew, and Bernardino
of Siena
Tempera on wood, gold ground; overall
21¹/₄ × 18¹/₂ in. (54 × 47 cm); painted
surface 18⁵/₈ × 14 in. (47.3 × 35.6 cm)
Inscribed (recto and verso): ·I·N·R·I·
The Bequest of Michael Dreicer, 1921
22.60.61

Domenico Beccafumi
Italian, Sienese, born about 1486, died 1551
Saint Matthew
This painting and the following (1975.97) are
studies for two of the panels of the four
Evangelists (Duomo, Pisa); payment for the
finished works was made in December 1538.
Tempera and emulsion on paper,
15¹/₄ × 8¹/₂ in. (38.7 × 21.6 cm)
Gift of Jean Douglas Fowles, in memory of R.
Langton Douglas, 1974
1974.216
DRAWINGS AND PRINTS

Saint Mark
Tempera and emulsion on paper,
15³/₄ × 9¹/₈ in. (40 × 23.2 cm)
Gift of Jean Douglas Fowles, in memory of R.
Langton Douglas, 1975
1975.97
DRAWINGS AND PRINTS

1974.216

1975.97

Paolo Veneziano

Italian, Venetian, active by 1333, died 1358/62

Madonna and Child Enthroned

Tempera on wood, gold ground, shaped top;
overall 32¼ × 19¾ in. (81.9 × 50.2 cm);
painted surface 31½ × 18¾ in. (80 × 47.6 cm)
Bequest of Edward Fowles, 1971
1971.115.5

Guariento di Arpo

Italian, Paduan, active by 1338, died 1368/70

Madonna and Child

Tempera on wood, gold ground, arched top;
overall, with engaged (modern) frame,
32⅜ × 18⅞ in. (82.2 × 47.9 cm); painted
surface 28½ × 17 in. (72.4 × 43.2 cm)
Inscribed (bottom): BENEDICTVS·SIT·NOMEN
·DOMINI YHVXPI / ET NOMEN·MATRIS
·EIVS GLORIOSE VIRGIN IS (Blessed be the
name of the Lord Jesus Christ and the name
of his glorious Virgin Mother)
Gift of Coudert Brothers, 1888
88.3.86

Lorenzo Veneziano

Italian, Venetian, active 1357–1372

Madonna and Child Enthroned with Two Donors

Tempera on wood, gold ground,
42⅝ × 25⅞ in. (108.3 × 65.7 cm)
Robert Lehman Collection, 1975
1975.1.78
ROBERT LEHMAN COLLECTION

Master of Saint Silvester

Italian, Venetian, active third quarter 14th
century

Madonna and Child Enthroned with Saints James the Lesser and Lucy

Tempera on wood, gold ground,
12¼ × 17¼ in. (31.1 × 43.8 cm)
The Friedsam Collection, Bequest of Michael
Friedsam, 1931
32.100.87

Niccolò di Pietro

Italian, Venetian, active 1394–1427/30

Saint Ursula and Her Maidens

Tempera and gold on wood,
37 × 31 in. (94 × 78.7 cm)
Inscribed: (background) ·santa· ·ursula·; (on
saint's belt) [ave]mariagratiapl[ena]
Rogers Fund, 1923
23.64

Italian (Veronese) Painters

third quarter 14th century

The Crucifixion (tabernacle)

The angels on a blue ground have been
attributed to Turone (Italian, Veronese, active

1971.115.5

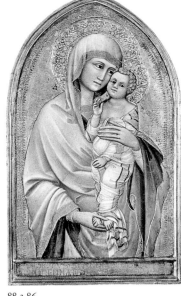

88.3.86

1975.1.78

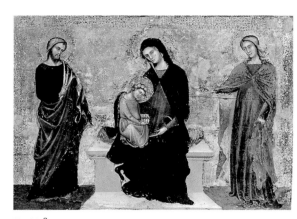

32.100.87

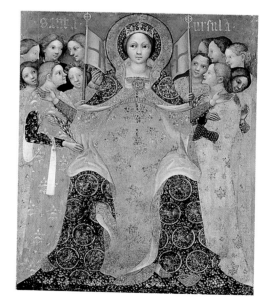

23.64

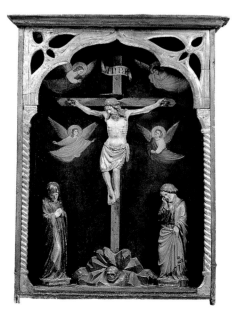

1985.229.2

09.104

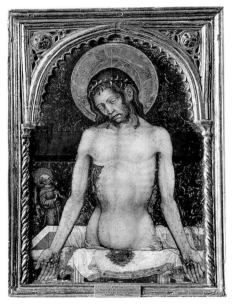

06.180

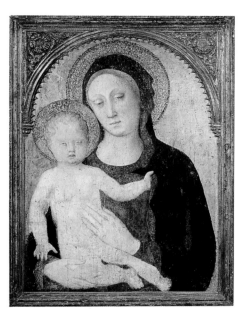

59.187

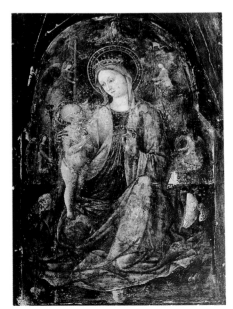

32.100.93

08.40

in 1360). The wings of the tabernacle have been lost.
Tempera on wood, 34^1/$_2$ × 25^3/$_8$ in. (87.6 × 64.5 cm)
Gift of Ruth Blumka, in honor of Ashton Hawkins, 1985
1985.229.2
THE CLOISTERS

first half 15th century
Scenes from the Life of Christ (triptych)
Center panel: Saint John the Baptist, Trinity, Saint Michael the Archangel, Flagellation, Crucifixion, Bearing of the Cross, Pietà, Man of Sorrows; left wing: Flight into Egypt, Christ among the Doctors, Last Supper, Agony in the Garden; right wing: Annunciation, Nativity, Adoration of the Magi, Presentation in the Temple
Tempera on wood, gold ground; central panel, overall, with engaged frame, 24^1/$_8$ × 16^3/$_4$ in. (61.3 × 42.5 cm); central panel, painted surface 20^5/$_8$ × 14^3/$_4$ in. (52.4 × 37.5 cm); left wing, overall, with engaged frame, 23^3/$_8$ × 8^1/$_4$ in. (59.4 × 21 cm); left wing, painted surface 21^1/$_2$ × 6^1/$_2$ in. (54.6 × 16.5 cm); right wing, overall, with engaged frame, 23^3/$_8$ × 8^1/$_4$ in. (59.4 × 21 cm); right wing, painted surface 21^1/$_2$ × 6^1/$_4$ in. (54.6 × 15.9 cm)
Inscribed: (center, on cross, and lower right) ·I·N·R·I·; (on Saint John the Baptist's scroll) Ecce \overline{agn}[us]. -d[e]i Ecce qu[i tollit peccatum mundi]. [John 1:29]; (verso of each wing) yhs.
Rogers Fund, 1909
09.104

Michele Giambono (Michele Giovanni Bono)
Italian, Venetian, active 1420–1462
The Man of Sorrows
Tempera and gold on wood; overall, with engaged frame, 21^5/$_8$ × 15^1/$_4$ in. (54.9 × 38.7 cm); painted surface 18^1/$_2$ × 12^1/$_4$ in. (47 × 31.1 cm)
Inscribed (above halo): ·IN:RI·
Rogers Fund, 1906
06.180

Jacopo Bellini
Italian, Venetian, active 1424–1470
Madonna and Child
Tempera on wood, gold ground, arched top; overall 34^1/$_2$ × 25 in. (87.6 × 63.5 cm); painted surface 30^1/$_2$ × 21^3/$_4$ in. (77.5 × 55.2 cm) [frame original though not engaged]
Gift of Irma N. Straus, 1959
59.187

Italian (Venetian) Painters

second quarter 15th century

Madonna and Child

Tempera on wood; overall, with added strips,
15³/₈ × 10 in. (39.1 × 25.4 cm); painted
surface 14¹/₄ × 9 in. (36.2 × 22.9 cm)
The Friedsam Collection, Bequest of Michael
Friedsam, 1931
32.100.93

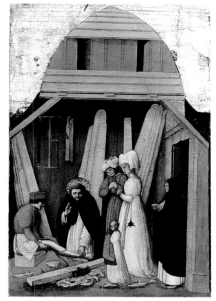

third quarter 15th century

Four Saints

These panels are the shutters of a shrine
housing a carved and gilded sculpture of the
Madonna and Child. At left are Saints Jerome
(above) and Sebastian; at right are Saints
Louis of Toulouse (above) and Roch.
Tempera on wood; left wing, overall, with
engaged frame, 49 × 14 in. (124.5 × 35.6 cm);
right wing, overall, with engaged frame,
49 × 14¹/₄ in. (124.5 × 36.2 cm)
Rogers Fund, 1908
08.40
MEDIEVAL ART

37.163.4 65.181.6

Antonio Vivarini

Italian, Venetian, active by 1441, died 1476/84

Saint Peter Martyr Healing the Leg of a Young Man

There are six related panels representing scenes
from the life of this Italian saint, who lived
from about 1205 to 1252: Peter Martyr
Received into the Dominican Order and Peter
Martyr and the Miraculous Fire (both
Gemäldegalerie, SMPK, Berlin), Peter Martyr
Exorcising a Woman Possessed by the Devil
(private collection), Peter Martyr Exorcising
the Devil Disguised as the Madonna and
Child (art market, 1962), the Virgin
Appearing to Peter Martyr (private collection),
and Funeral of Peter Martyr (private collection).
Tempera and gold on wood, 20⁷/₈ × 13¹/₈ in.
(53 × 33.3 cm)
Gift of Samuel H. Kress Foundation, 1937
37.163.4

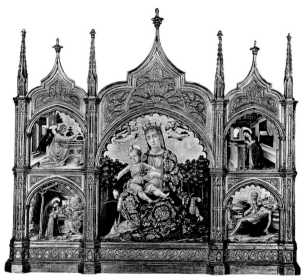

1975.1.82

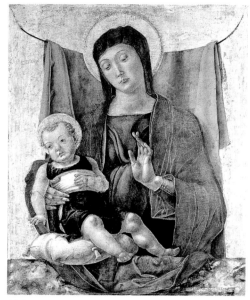

30.95.277

Workshop of Antonio Vivarini

Saint Jerome

Tempera on wood, gold ground,
10¹/₄ × 6⁵/₈ in. (26 × 16.8 cm)
Bequest of Adele L. Lehman, in memory of
Arthur Lehman, 1965
65.181.6

65.181.1

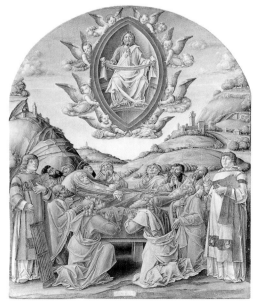

50.229.1

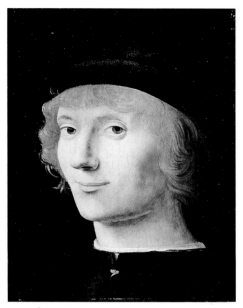

14.40.645

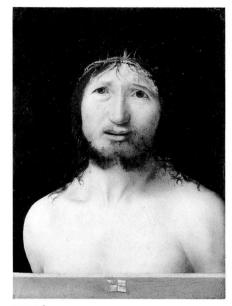

32.100.82

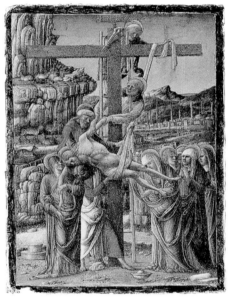

49.7.8

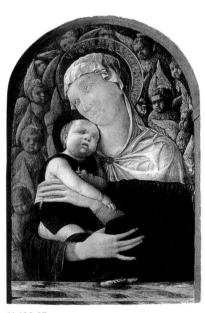

32.100.97

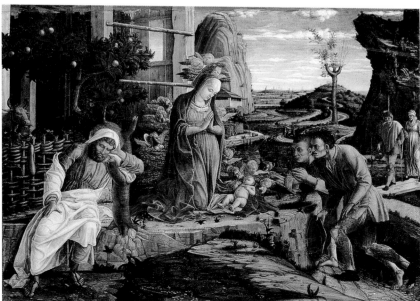

32.130.2

Bartolomeo Vivarini

Italian, Venetian, active 1450–1491

Madonna of Humility with Two Angels and a Kneeling Nun; The Annunciatory Angel and the Nativity; The Virgin Annunciate and the Pietà

Tempera on wood, gold ground; central panel, overall 23 × 18 in. (58.4 × 45.7 cm); central panel, painted surface 21¹/₄ × 17³/₈ in. (54 × 44.1 cm); left panel, overall 22³/₈ × 9¹/₂ in. (56.8 × 24.1 cm); left panel, painted surface, above 9⁷/₈ × 8¹/₂ in. (25.1 × 21.6 cm), below 9³/₄ × 8¹/₂ in. (24.8 × 21.6 cm); right panel, overall 22¹/₄ × 9³/₈ in. (56.5 × 23.8 cm); right panel, painted surface, above 9³/₄ × 8³/₈ in. (24.8 × 21.3 cm), below 9⁷/₈ × 8¹/₂ in. (25.1 × 21.6 cm)
Robert Lehman Collection, 1975
1975.1.82
ROBERT LEHMAN COLLECTION

Madonna and Child

Tempera on canvas, laid down on wood, transferred from wood, gold ground, 32³/₄ × 25³/₄ in. (83.2 × 65.4 cm)
Signed and dated (bottom right, on cartellino): OPVS·FACTVM·PER·BARTHOLOMEV[M] / M[]M·VIVA·RI[N]VM·DEMVRIANO 1472
Theodore M. Davis Collection, Bequest of Theodore M. Davis, 1915
30.95.277

A Saint (Mark?) Reading (fragment)

Tempera on wood, gold ground, 18⁵/₈ × 14³/₄ in. (47.3 × 37.5 cm)
Bequest of Adele L. Lehman, in memory of Arthur Lehman, 1965
65.181.1

The Death of the Virgin

Tempera on wood, arched top, 74³/₄ × 59 in. (189.9 × 149.9 cm)
Signed and dated (bottom center, on cartellino): [OPVS FAC]TVM·VENETIIS PE / [R BARTH]OLOMEVM·VIVA / [RINVM DE] MVRIANO.148[5]
Gift of Robert Lehman, 1950
50.229.1

Antonello da Messina (Antonello di Giovanni d'Antonio)

Italian, Sicilian, born about 1430, died 1479

Portrait of a Young Man

Oil on wood, 10⁵/₈ × 8¹/₈ in. (27 × 20.6 cm)
Bequest of Benjamin Altman, 1913
14.40.645

Antonello da Messina (Antonello di Giovanni d'Antonio)

Italian, Sicilian, born about 1430, died 1479

Christ Crowned with Thorns

Oil, perhaps over tempera, on wood,
16³/₄ × 12 in. (42.5 × 30.5 cm)
Signed (lower center): Antonellus messane /
[us] / me pin[x]it
The Friedsam Collection, Bequest of Michael
Friedsam, 1931
32.100.82

Girolamo da Cremona

Italian, Paduan, active 1451–1483

Descent from the Cross

Tempera on parchment, laid down on wood,
6¹/₄ × 4¹/₂ in. (15.9 × 11.4 cm)
The Jules Bache Collection, 1949
49.7.8

Andrea Mantegna

Italian, Paduan, born no later than 1430, died
1506

Madonna and Child with Seraphim and Cherubim

Tempera and gold on wood, arched top,
17³/₈ × 11¹/₄ in. (44.1 × 28.6 cm)
The Friedsam Collection, Bequest of Michael
Friedsam, 1931
32.100.97

The Adoration of the Shepherds

Tempera on canvas, transferred from wood;
overall 15³/₄ × 21⁷/₈ in. (40 × 55.6 cm);
painted surface 14⁷/₈ × 21 in.
(37.8 × 53.3 cm)
Purchase, Anonymous Gift, 1932
32.130.2

The Holy Family with Saint Mary Magdalen

Distemper on canvas, 22¹/₂ × 18 in.
(57.2 × 45.7 cm)
Bequest of Benjamin Altman, 1913
14.40.643

Style of Andrea Mantegna

Italian, Mantuan, about 1490–95

Rodolfo Gonzaga (1451–1495)

Tempera on wood, 4¹/₄ × 3¹/₄ in.
(10.8 × 8.3 cm)
The Jules Bache Collection, 1949
49.7.11

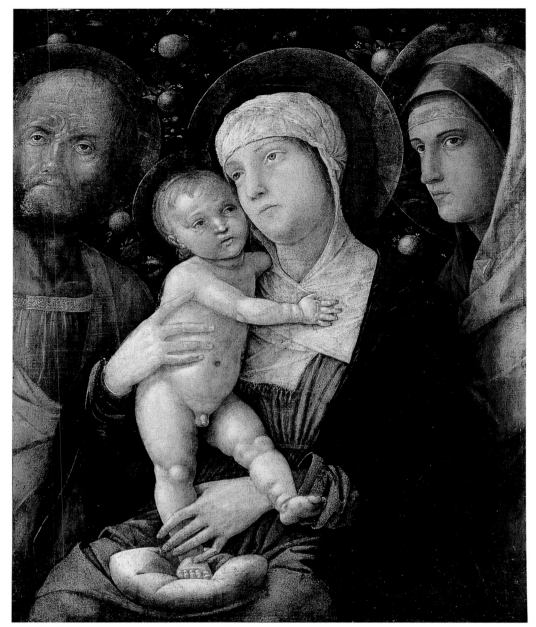

14.40.643

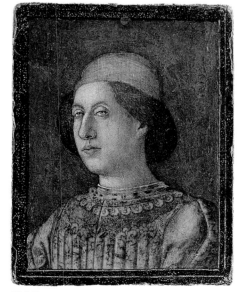

49.7.11

1975.1.109

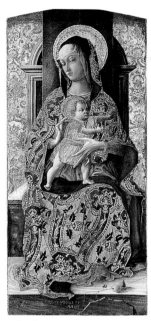

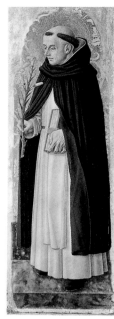

05.41.2 1982.60.5 05.41.1

of uncertain date

Judith with the Head of Holofernes
The composition is based on a number of
works by or attributed to Andrea Mantegna.
Tempera on wood, 8¹/₂ × 5³/₄ in.
(21.6 × 14.6 cm)
Robert Lehman Collection, 1975
1975.1.109
ROBERT LEHMAN COLLECTION

Carlo Crivelli

Italian, Venetian, active 1457–1493

Saint George
This panel is from an altarpiece that included
the following two panels (1982.60.5, 05.41.1)
and others depicting Saint James the Greater
(Brooklyn Museum) and Saint Nicholas of
Bari (Cleveland Museum of Art).
Tempera on wood, gold ground,
38 × 13¹/₄ in. (96.5 × 33.7 cm)
Rogers Fund, 1905
05.41.2

Madonna and Child Enthroned
Tempera on wood, gold ground,
38³/₄ × 17¹/₄ in. (98.4 × 43.8 cm)
Signed and dated (bottom left):
+CAROLVS+CRIVELLVS+VENETVS+ / 1472
PINSIT+
The Jack and Belle Linsky Collection, 1982
1982.60.5

Saint Dominic
Tempera on wood, gold ground,
38¹/₄ × 12³/₄ in. (97.2 × 32.4 cm)
Rogers Fund, 1905
05.41.1

Pietà
This panel is generally associated with the
nine panels constituting the two lower tiers of
the so-called Demidoff Altarpiece (National
Gallery, London) of 1476, which may come
from the church of San Domenico at Ascoli
Piceno.
Tempera on wood, gold ground,
arched top; overall 28¹/₄ × 25³/₈ in.
(71.8 × 64.5 cm); painted surface
28 × 25¹/₈ in. (71.1 × 63.8 cm)
John Stewart Kennedy Fund, 1913
13.178

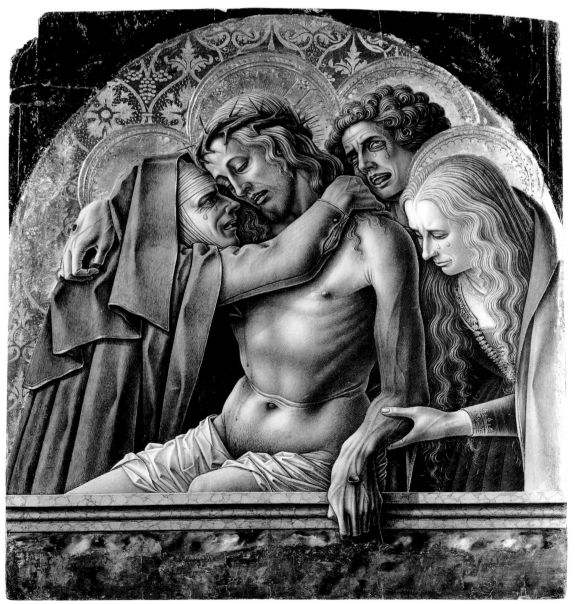

13.178

Carlo Crivelli
Italian, Venetian, active 1457–1493

Madonna and Child
Tempera and gold on wood; overall
14⁷/₈ × 10 in. (37.8 × 25.4 cm); painted
surface 14³/₈ × 9¹/₄ in. (36.5 × 23.5 cm)
Signed (lower center): OPVS.KAROLI.
CRIVELLI.VENETI
The Jules Bache Collection, 1949
49.7.5

An Apostle
The panel belongs to a series with Christ
(Clark Art Institute, Williamstown) and six
other apostles (two at the Detroit Institute of
Arts, two at the Honolulu Academy of Arts,
Hawaii, and two in the Bearstead collection at
Upton House, National Trust). Five panels
from the main tier (two in the Musées
Royaux, Brussels, and three in the church of
Santa Lucia, Montefiore) and four of the
pinnacles (one at the National Gallery,
London, and three at Montefiore) have been
identified. The altarpiece is thought to come
from Montefiore dell'Aso, near Fermo.
Tempera on wood, gold ground, arched top,
12⁵/₈ × 9¹/₈ in. (32.1 × 23.2 cm)
Robert Lehman Collection, 1975
1975.1.84
ROBERT LEHMAN COLLECTION

Attributed to Carlo Crivelli
Madonna and Child Enthroned
Tempera on wood, gold ground,
55¹/₂ × 23³/₈ in. (141 × 59.4 cm)
Robert Lehman Collection, 1975
1975.1.83
ROBERT LEHMAN COLLECTION

Giovanni Bellini
Italian, Venetian, active by 1459, died 1516

Madonna Adoring the Sleeping Child
Tempera on wood, 28¹/₂ × 18¹/₄ in.
(72.4 × 46.4 cm)
Theodore M. Davis Collection, Bequest of
Theodore M. Davis, 1915
30.95.256

Madonna and Child
Tempera, oil, and gold on wood,
21¹/₄ × 15³/₄ in. (54 × 40 cm)
Robert Lehman Collection, 1975
1975.1.81
ROBERT LEHMAN COLLECTION

Workshop of Giovanni Bellini
Madonna and Child
Oil on wood; overall 13¹/₂ × 10⁷/₈ in.
(34.3 × 27.6 cm); painted surface
12³/₄ × 10¹/₈ in. (32.4 × 25.7 cm)
The Jules Bache Collection, 1949
49.7.2

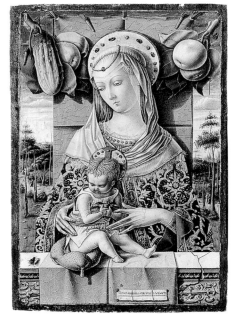

49.7.5

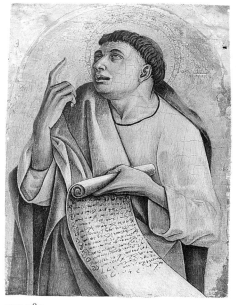

1975.1.84

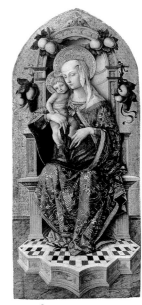

1975.1.83

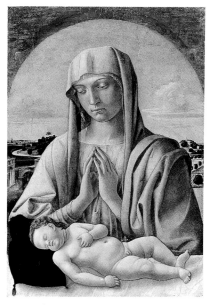

30.95.256

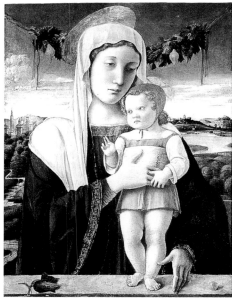

1975.1.81

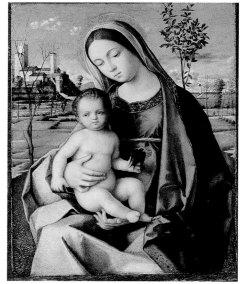

49.7.2

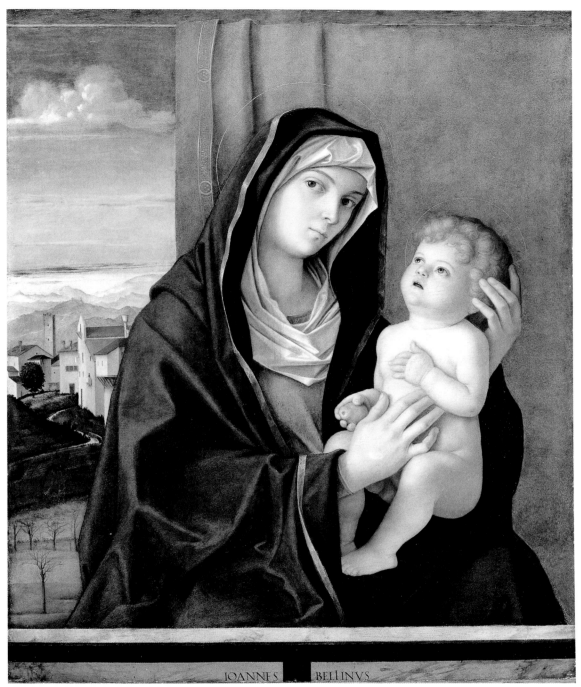

08.183.1

Giovanni Bellini

Italian, Venetian, active by 1459, died 1516

Madonna and Child

Oil on wood, 35 × 28 in. (88.9 × 71.1 cm)
Signed (lower center): IOANNES BELLINVS
Rogers Fund, 1908
08.183.1

Giovanni Bellini and Workshop

Madonna and Child with Saints

The saints (left to right) are Peter, Catherine of Alexandria, Lucy, and John the Baptist.
Tempera and oil on wood, 38¼ × 60½ in. (97.2 × 153.7 cm)
Signed and inscribed: (lower center, on cartellino) Ioannes Bellinus; (on scroll held by Saint John the Baptist) ECCE / AGNVS / DEI
The Jules Bache Collection, 1949
49.7.1

Workshop of Giovanni Bellini

The Circumcision

Oil on wood, 26¾ × 40½ in. (67.9 × 102.9 cm)
Inscribed and dated (lower center): IOANNES BELLINVS / P. MDXI
Gift of J. Pierpont Morgan, 1917
17.190.9

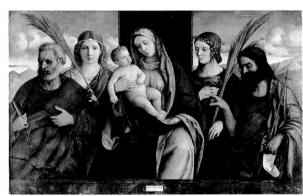

49.7.1

17.190.9

Jacometto (Jacometto Veneziano)
Italian, Venetian, active about 1472, died
before 1498

*Alvise Contarini(?); (verso) A Tethered
Hart*
Oil on wood; overall 4⁵/₈ × 3³/₈ in.
(11.7 × 8.6 cm); recto, painted surface
4¹/₈ × 3¹/₈ in. (10.5 × 7.9 cm); verso,
painted surface 4³/₈ × 3¹/₈ in.
(11.1 × 7.9 cm)
Inscribed (verso): AI EI
Robert Lehman Collection, 1975
1975.1.86
ROBERT LEHMAN COLLECTION

A Woman, Possibly a Nun of San Secondo;
(verso) *Scene in Grisaille*
Pendant to 1975.1.86
Oil (verso: oil and gold) on wood; overall
4 × 2⁷/₈ in. (10.2 × 7.3 cm); recto and
verso, painted surface 3³/₄ × 2¹/₂ in.
(9.5 × 6.4 cm)
Robert Lehman Collection, 1975
1975.1.85
ROBERT LEHMAN COLLECTION

Portrait of a Young Man
Oil on wood, 11 × 8¹/₄ in. (27.9 × 21 cm)
The Jules Bache Collection, 1949
49.7.3

Antonello de Saliba
Italian, Venetian, active 1480–1535
Madonna Adoring the Child
Tempera and oil on wood, 26⁵/₈ × 19¹/₂ in.
(67.6 × 49.5 cm)
Theodore M. Davis Collection, Bequest of
Theodore M. Davis, 1915
30.95.249

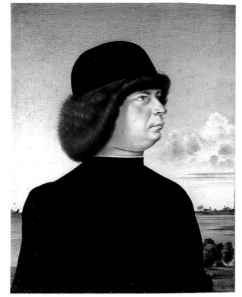

1975.1.86 (recto)

1975.1.86 (verso)

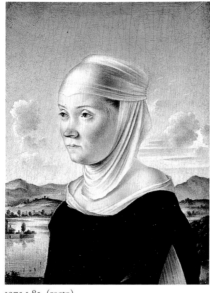

1975.1.85 (recto)

1975.1.85 (verso)

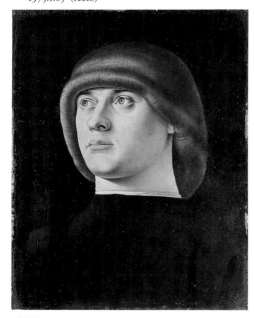

49.7.3

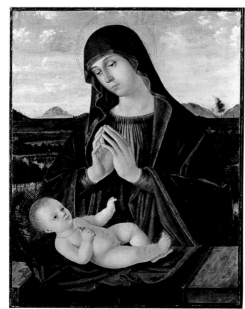

30.95.249

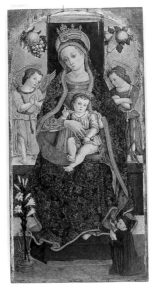

41.100.32

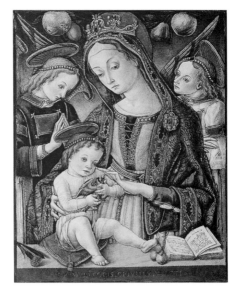

1982.60.6

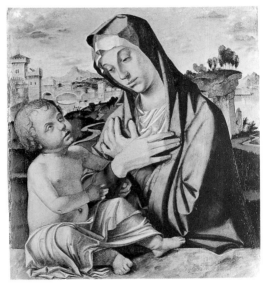

09.102

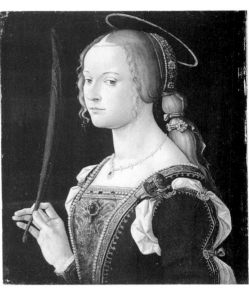

14.40.606

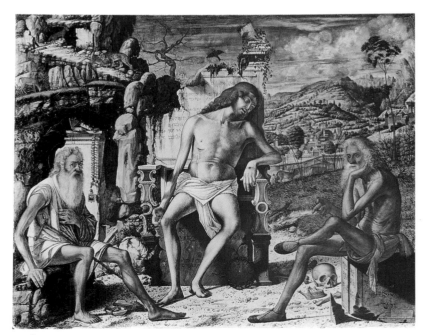

11.118

Vittore Crivelli

Italian, Venetian, active by 1465, died 1501/2

Madonna and Child Enthroned with Two Angels and a Donor

Tempera on wood, gold ground ; overall
54 × 25³/₄ in. (137.2 × 65.4 cm); painted
surface 52 × 24¹/₄ in. (132.1 × 61.5 cm)
Gift of George Blumenthal, 1941
41.100.32

Madonna and Child with Two Angels

Tempera and gold on wood, 21⁷/₈ × 16 in.
(55.6 × 40.6 cm)
Signed (on ledge): OPVS VICTORIS·CRIVELLV
·VENETI·
The Jack and Belle Linsky Collection, 1982
1982.60.6

Bartolomeo Montagna (Bartolomeo Cincani)

Italian, Vicentine, born before 1459, died 1523

Madonna Adoring the Child

Oil(?) on wood, 24³/₄ × 20¹/₂ in.
(62.9 × 52.1 cm)
Rogers Fund, 1909
09.102

Saint Justina of Padua (fragment)

Oil on wood; overall, with added strips,
19¹/₂ × 15¹/₈ in. (49.5 × 38.4 cm); painted
surface 19¹/₈ × 14³/₄ in. (48.6 × 37.5 cm)
Bequest of Benjamin Altman, 1913
14.40.606

Vittore Carpaccio

Italian, Venetian, born about 1455, died
1523/26

The Meditation on the Passion

The dead Christ is attended by Job (right)
and Saint Jerome.
Oil and tempera on wood, 27³/₄ × 34¹/₈ in.
(70.5 × 86.7 cm)
Signed (lower right, on cartellino): vjctorjs
carpattjj / venettj opus [legible only with
infrared]
Inscribed extensively with phrases in distorted
Hebrew letters; those that can be read are: (on
throne) with a cry, Israel, crown; (right, on
stone block) Israel, that my redeemer liveth,
19 (phrase and number from Job 19:25)
John Stewart Kennedy Fund, 1911
11.118

Giovanni Battista Cima

Italian, Venetian, born about 1459, died 1517/18

Three Saints: Roch, Anthony Abbot, and Lucy

Oil on canvas, transferred from wood, 50¹/₂ × 48 in. (128.3 × 121.9 cm)
Rogers Fund, 1907
07.149

Madonna and Child with Saints Francis and Clare

Oil on wood, 8 × 10¹/₂ in.
(20.3 × 26.7 cm)
Inscribed (falsely, bottom): IOANNES BELLINVS FACIEBAT.
Bequest of George Blumenthal, 1941
41.190.11

Michele da Verona (Michele di Zenone)

Italian, Veronese, 1470–1536/44

Madonna and Child with the Infant Saint John the Baptist

Tempera and oil on wood, 29 × 22³/₄ in.
(73.7 × 57.8 cm)
Anonymous Gift, 1927
27.41

Girolamo dai Libri

Italian, Veronese, 1474–1555

Madonna and Child with Saints

This altarpiece was painted for the Cartieri chapel in the church of San Leonardo nel Monte, near Verona; the saints (left to right) are Catherine of Alexandria, Leonard, Augustine, and Apollonia.
Tempera and oil on canvas, arched top, 157 × 81¹/₂ in. (398.8 × 207 cm)
Fletcher Fund, 1920
20.92

Catena (Vincenzo di Biagio)

Italian, Venetian, active by 1506, died 1531

Portrait of a Venetian Senator

Oil on canvas, 27¹/₄ × 24 in.
(69.2 × 61 cm)
Theodore M. Davis Collection, Bequest of Theodore M. Davis, 1915
30.95.258

The Adoration of the Shepherds

Oil on canvas, 49¹/₂ × 81³/₄ in.
(125.7 × 207.6 cm)
Purchase, Mrs. Charles S. Payson Gift, Gwynne Andrews Fund, special funds, and other gifts and bequests, 1969
69.123

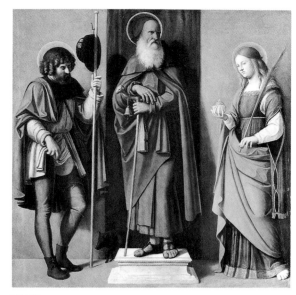

07.149

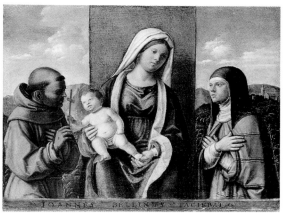

41.190.11

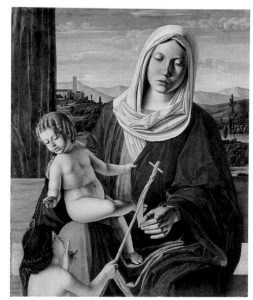

27.41

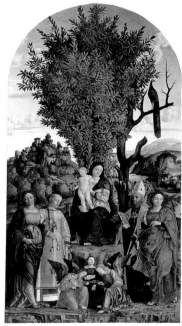

20.92

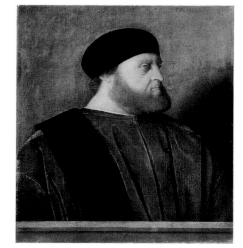

30.95.258

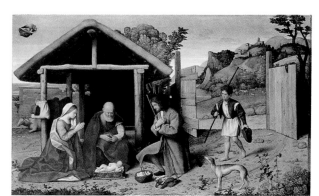

69.123

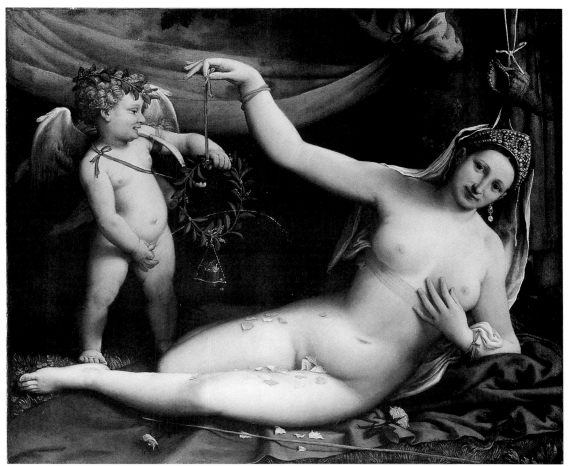

1986.138

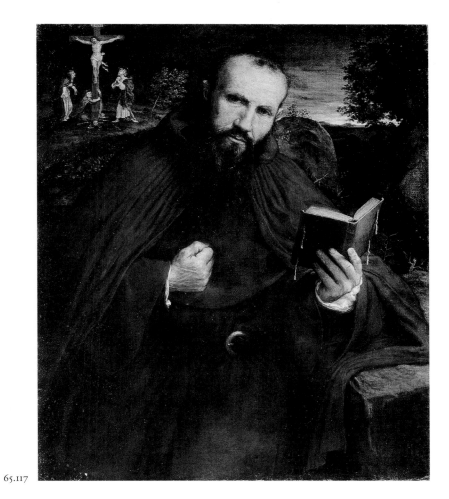

65.117

Lorenzo Lotto

Italian, Venetian, born about 1480, died 1556

Venus and Cupid

Oil on canvas, 36³/₈ × 43⁷/₈ in.
(92.4 × 111.4 cm)
Signed (lower right, on tree trunk): Laurent.°
Loto
Purchase, Mrs. Charles Wrightsman Gift, in
honor of Marietta Tree, 1986
1986.138

Brother Gregorio Belo of Vicenza

Oil on canvas, 34³/₈ × 28 in.
(87.3 × 71.1 cm)
Dated and inscribed (lower right): .F. Gregorij
belo de Vincentia / eremite in hieronimi
Ordinis beati / fratris Petri de pisis Anno /
etatis eius. LV.M.D.XLVII (Fra Gregorio Belo of
Vicenza, hermit in the Hieronymite order of
Blessed Fra Pietro of Pisa, at the age of fifty-
five, 1547)
Rogers Fund, 1965
65.117

Sebastiano del Piombo (Sebastiano Luciani)

Italian, Venetian, born about 1485, died 1547

Portrait of a Man, Said to Be Christopher Columbus (born about 1446, died 1506)
Oil on canvas, 42 × 34³/₄ in.
(106.7 × 88.3 cm)
Signed, dated, and inscribed: (center right)
SEBASTIANVS / VENETVS FACIT; (across top)
HÆC.EST.EFFIGIES.LIGVRIS.MIRANDA.
COLVMBI.ANTIPODVM.PRIMVS / RATE.QVI.
PENETRAVIT.IN.ORBEM. 1519 (This is the
admirable portrait of the Ligurian Columbus,
the first to enter by ship into the world of the
Antipodes, 1519)
Gift of J. Pierpont Morgan, 1900
00.18.2

Attributed to Sebastiano del Piombo

The Holy Family with Saints and Donors
Oil on wood; overall 26¹/₂ × 40¹/₂ in.
(67.3 × 102.9 cm); painted surface
26 × 39³/₄ in. (66 × 101 cm)
Inscribed (on scroll): [illegible]
Bequest of Josephine Bieber, in memory of her
husband, Siegfried Bieber, 1970
1973.155.5

Bonifazio Veronese (Bonifazio de' Pitati)

Italian, Venetian, 1487–1553

The Legend of the Infant Servius Tullius
As told by Livy (Book I: 39), King Tarquinius
and Queen Tanaquil witnessed the head of
the young boy bursting into flames and took
this as a portent, making him their heir. Here
they rush into the room in which the infant
lies in his cradle.
Oil on canvas, 10¹/₂ × 40¹/₄ in.
(26.7 × 102.2 cm)
The Friedsam Collection, Bequest of Michael
Friedsam, 1931
32.100.78

Titian (Tiziano Vecellio)

Italian, Venetian, born about 1488, died 1576

Madonna and Child
Oil on wood; overall 18 × 22 in.
(45.7 × 55.9 cm); painted surface
17 × 21¹/₂ in. (43.2 × 54.6 cm)
The Jules Bache Collection, 1949
49.7.15

Portrait of a Man
Oil on canvas, 19³/₄ × 17³/₄ in.
(50.2 × 45.1 cm)
Bequest of Benjamin Altman, 1913
14.40.640

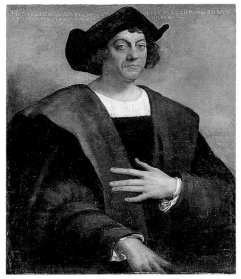

00.18.2

1973.155.5

32.100.78

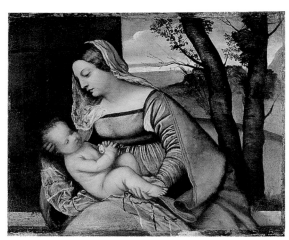

49.7.15

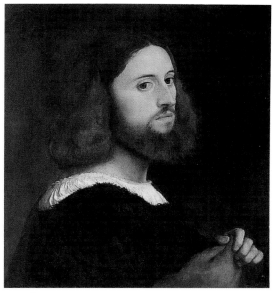

14.40.640

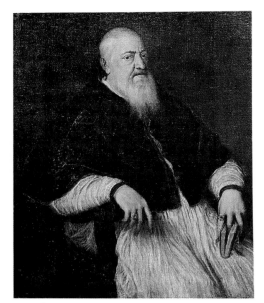

14.40.650

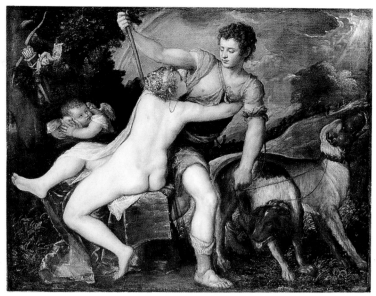

49.7.16

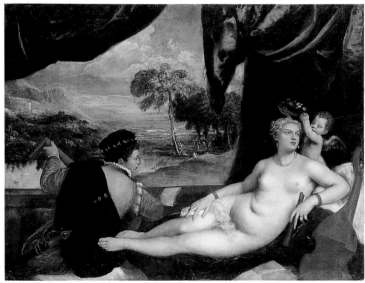

36.29

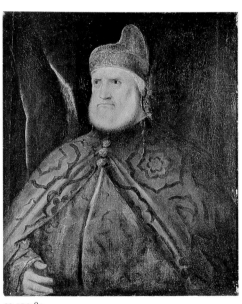

32.100.85

Titian (Tiziano Vecellio)
Italian, Venetian, born about 1488, died 1576

Filippo Archinto (born about 1500, died 1558), *Archbishop of Milan*
Oil on canvas, 46¹/₂ × 37 in.
(118.1 × 94 cm)
Bequest of Benjamin Altman, 1913
14.40.650

Venus and Adonis
Oil on canvas, 42 × 52¹/₂ in.
(106.7 × 133.4 cm)
The Jules Bache Collection, 1949
49.7.16

Titian and Workshop

Venus and the Lute Player
Oil on canvas, 65 × 82¹/₂ in.
(165.1 × 209.6 cm)
Munsey Fund, 1936
36.29

Workshop of Titian

Doge Andrea Gritti (1455–1538)
Oil on canvas, 40¹/₄ × 31³/₄ in.
(102.2 × 80.6 cm)
The Friedsam Collection, Bequest of Michael
Friedsam, 1931
32.100.85

Style of Titian

Italian, Venetian, about 1510–20

Madonna and Child

Oil on wood, 16³/₄ × 12 in.
(42.5 × 30.5 cm)
Gift of Chester D. Tripp, 1957
57.31

Copy after Titian

late 16th or early 17th century

Alfonso d'Este (1486–1534), *Duke of Ferrara*
Oil on canvas, 50 × 38³/₄ in.
(127 × 98.4 cm)
Munsey Fund, 1927
27.56

Paris Bordon

Italian, Venetian, 1500–1571

Portrait of a Man in Armor with Two Pages
Oil on canvas, 46 × 62 in.
(116.8 × 157.5 cm)
Inscribed (lower center, on ribbon): OPVS /
PARIDIS BO / RDON
Gift of Mr. and Mrs. Charles Wrightsman,
1973
1973.311.1

Lambert Sustris

Netherlandish, born 1515/20, died after 1568

Portrait of a Man
Oil on canvas, 47¹/₂ × 36¹/₂ in.
(120.7 × 92.7 cm)
The Jules Bache Collection, 1949
49.7.14

Tintoretto (Jacopo Robusti)

Italian, Venetian, 1518–1594

Portrait of a Man
Oil on canvas, 44³/₈ × 35 in.
(112.7 × 88.9 cm)
Gift of George Blumenthal, 1941
41.100.12

Portrait of a Young Man
Oil on canvas, 54¹/₂ × 42 in.
(138.4 × 106.7 cm)
Dated and inscribed: (left, on marble
pedestal) M.D.LI; (below) ÆTATIS. SVÆ /
ANNO.[X?]XX
Gift of Lionel F. Straus Jr., in memory of his
parents, Mr. and Mrs. Lionel F. Straus, 1958
58.49

The Miracle of the Loaves and Fishes
Oil on canvas, 61 × 160¹/₂ in.
(154.9 × 407.7 cm)
Francis L. Leland Fund, 1913
13.75

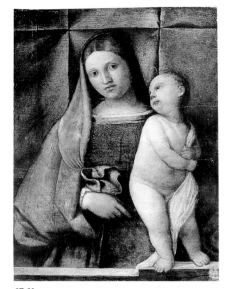

57.31

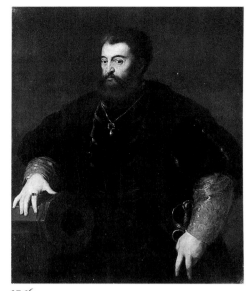

27.56

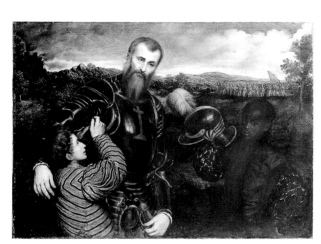

1973.311.1

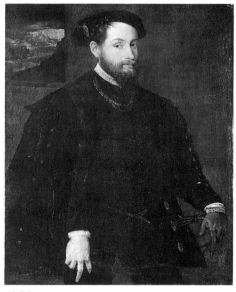

49.7.14

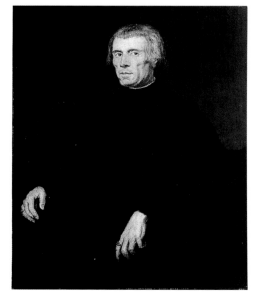

41.100.12

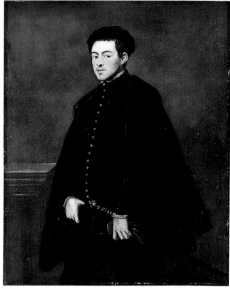

58.49

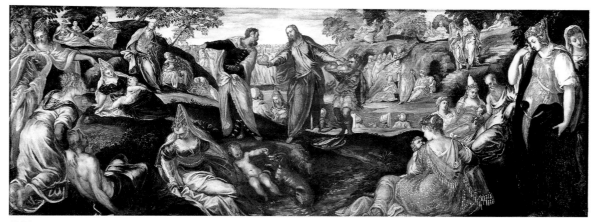

13.75

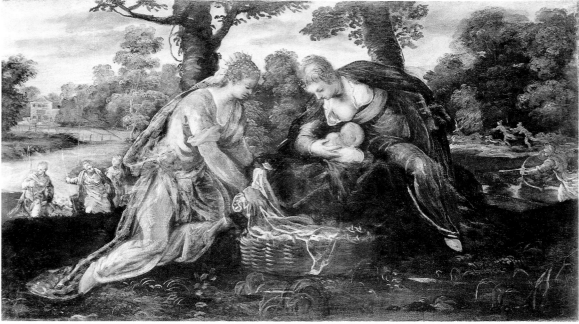

39.55

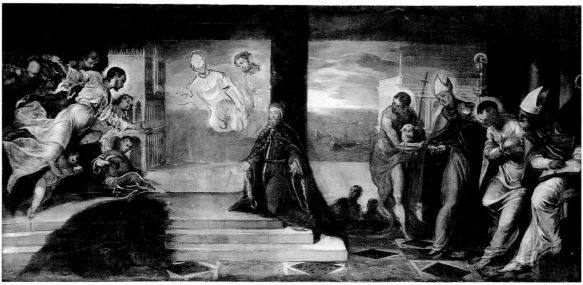

10.206

Tintoretto (Jacopo Robusti)

Italian, Venetian, 1518–1594

The Finding of Moses
Oil on canvas, 30¹/₂ × 52³/₄ in.
(77.5 × 134 cm)
Gwynne Andrews Fund, 1939
39.55

Doge Alvise Mocenigo (1507–1577) Presented to the Redeemer
This painting is a study for Tintoretto's canvas in the Sala del Collegio of the Palazzo Ducale, Venice.
Oil on canvas, 38¹/₄ × 78 in.
(97.2 × 198.1 cm)
John Stewart Kennedy Fund, 1910
10.206

Paolo Veronese (Paolo Caliari)

Italian, Venetian, 1528–1588

Alessandro Vittoria (1524/25–1608)
Oil on canvas, 43¹/₂ × 32¹/₄ in.
(110.5 × 81.9 cm)
Gwynne Andrews Fund, 1946
46.31

Boy with a Greyhound
Oil on canvas, 68³/₈ × 40¹/₈ in.
(173.7 × 101.9 cm)
H. O. Havemeyer Collection, Bequest of Mrs. H. O. Havemeyer, 1929
29.100.105

Mars and Venus United by Love
Oil on canvas, 81 × 63³/₈ in.
(205.7 × 161 cm)
Signed (lower center, on marble fragment):
PAVLVS VERONENSIS F
John Stewart Kennedy Fund, 1910
10.189

Andrea Schiavone (Andrea Medulich or Meldolla)

Italian, Venetian, 1522?–1563

The Marriage of Cupid and Psyche
Oil on wood, with corners made up; overall
51¹/₂ × 61⁷/₈ in. (130.8 × 157.2 cm); painted surface 50¹/₂ × 61¹/₂ in. (128.3 × 156.2 cm)
Gift of Mary V. T. Eberstadt, by exchange, 1973
1973.116

46.31

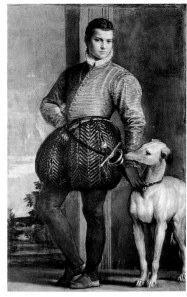

29.100.105

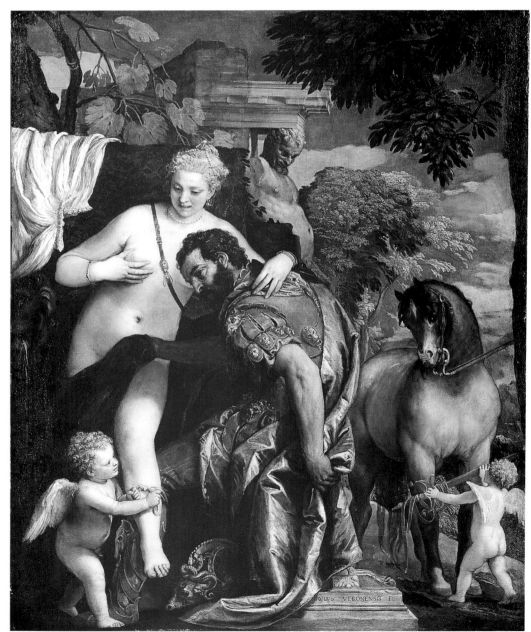

10.189

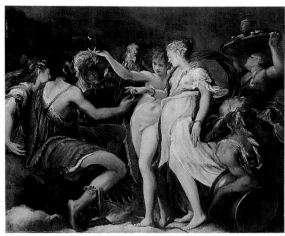

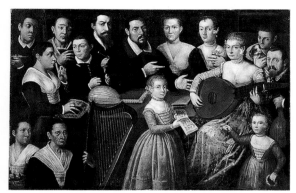

89.4.2742

1973.116

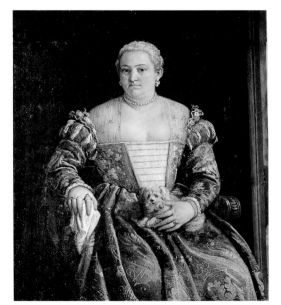

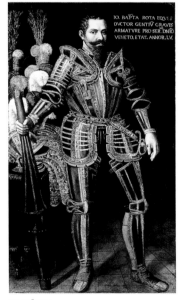

29.100.104

29.158.754

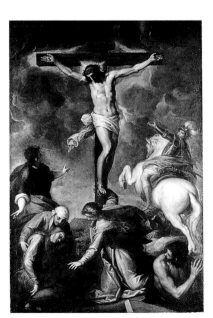

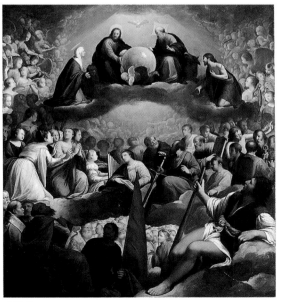

57.170

1971.93

Girolamo Forni

Italian, Vicentine, active second half 16th
century

Portrait of a Family

Oil on canvas, 52 × 79 in.
(132.1 × 200.7 cm)
Gift of Mrs. John Crosby Brown, 1889
89.4.2742
MUSICAL INSTRUMENTS

Francesco Montemezzano

Italian, Venetian, born about 1540, died after
1602

Portrait of a Woman

Oil on canvas, 46³/₄ × 39 in. (118.7 × 99.1
cm), including added strip of 5¹/₂ in. (14 cm)
at top
H. O. Havemeyer Collection, Bequest of Mrs.
H. O. Havemeyer, 1929
29.100.104

Italian (Venetian) Painter

late 16th century

Giovanni Battista Rota

Oil on canvas, 86¹/₂ × 53 in.
(219.7 × 134.6 cm)
Inscribed (upper right): IO. BAPTA ROTA
EQVES / DVCTOR GENTIV̂ GRAVIS / ARMATVRE
PRO SERᵐᵒ DNÎO / VENETO . ETAT . ANNOR .
LV . (Giovanni Battista Rota, knight,
commander of the native heavy artillery for
the most fair Venetian republic, at the age of
fifty-five)
Bashford Dean Memorial Collection, Funds
from various donors, 1929
29.158.754
ARMS AND ARMOR

Jacopo Palma the Younger

Italian, Venetian, 1544–1628

The Crucifixion

Oil on canvas, 85 × 53¹/₄ in.
(215.9 × 135.3 cm)
Signed and inscribed: (lower right) JACOBVS
PALMA. F.; (on cross) INRI
Gift of Robert Lehman, 1957
57.170

Carlo Saraceni

Italian, Venetian, 1579?–1620

Paradise

Oil on copper; overall 21³/₈ × 18⁷/₈ in.
(54.3 × 47.9 cm); painted surface
20⁷/₈ × 18³/₈ in. (53 × 46.7 cm)
Theodore M. Davis Collection, Bequest of
Theodore M. Davis, by exchange, 1971
1971.93

Sebastiano Ricci

Italian, Venetian, 1659–1734

The Holy Family with Angels

Oil on canvas, 50 × 45¹/₂ in.
(127 × 115.6 cm)
Gift of Mr. and Mrs. Piero Corsini, 1986
1986.347

The Baptism of Christ

This is one of at least three studies of this
subject (the others have been on the art
market, one in 1989). There is also a
companion piece, the Last Supper (National
Gallery of Art, Washington, D.C.), and both
are sketches for the lost decoration of the
chapel at Bulstrode House, Gerrards Cross,
Buckinghamshire.
Oil on canvas, 26 × 40 in. (66 × 101.6 cm)
Inscribed (on cartouche at top of arch): HIC
EST FILLIVS / MEVS DILECTV[S] / LVC CAPUT III
(This is my beloved Son. Luke 3 [actually
Matthew 3:17])
Purchase, Rogers and Gwynne Andrews
Funds, and Gift of Jane L. Melville, by
exchange, 1981
1981.186

Giovanni Antonio Pellegrini

Italian, Venetian, 1675–1741

Bacchus and Ariadne

Oil on canvas, 46 × 50¹/₂ in.
(116.8 × 128.3 cm)
Gift of Mr. and Mrs. Eugene Victor Thaw,
1984
1984.458

Jacopo Amigoni

Italian, Venetian, 1682–1752

Flora and Zephyr

This painting has a pendant representing
Venus and Adonis (art market, 1992). The
pair was evidently commissioned by a member
of the Ward-Boughton-Leigh family between
1729 and 1739.
Oil on canvas, 84 × 58 in.
(213.4 × 147.3 cm)
Purchase, Rudolph and Lentilhon G. von
Fluegge Foundation Inc. Gift, 1985
1985.5

Giovanni Battista Piazzetta

Italian, Venetian, 1682–1754

***Saint Christopher Carrying the Infant
Christ***

Oil on canvas, 28¹/₄ × 22¹/₈ in.
(71.8 × 56.2 cm)
Bequest of Miss Adelaide Milton de Groot
(1876–1967), 1967
67.187.90

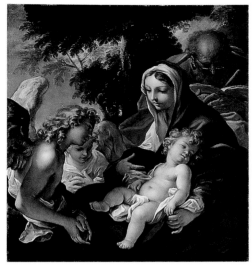

1986.347

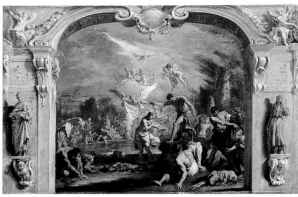

1981.186

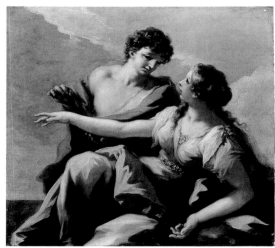

1984.458

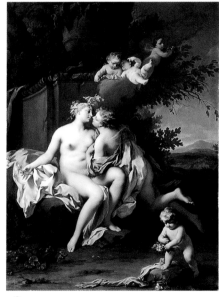

1985.5

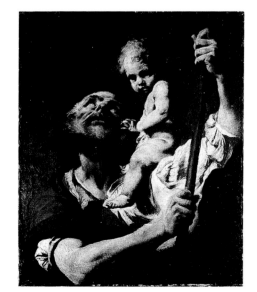

67.187.90

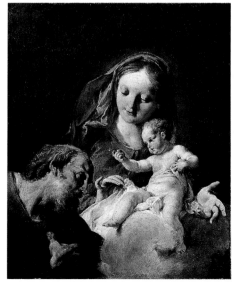

1982.35.2

1975.1.88

1975.1.90

1975.1.87

1975.1.89

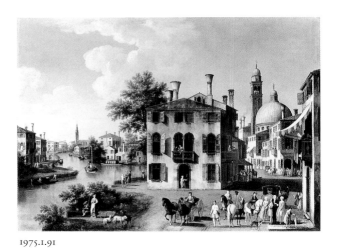

1975.1.91

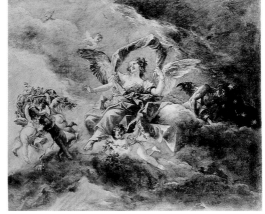

06.1335.1b

Giovanni Battista Pittoni
Italian, Venetian, 1687–1767
The Holy Family
Oil on canvas, 32¹/8 × 25³/8 in.
(81.6 × 64.5 cm)
Bequest of Jean Fowles, in memory of her first
husband, R. Langton Douglas, 1981
1982.35.2

Luca Carlevaris
Italian, Venetian, 1663–1730
*The Bacino, Venice, with the Dogana and
a Distant View of the Isola di San Giorgio*
This painting and the following three
(1975.1.90, 87, 89) form a series.
Oil on canvas, 20 × 47¹/8 in.
(50.8 × 119.7 cm)
Robert Lehman Collection, 1975
1975.1.88
ROBERT LEHMAN COLLECTION

The Molo, Venice, Looking West
Oil on canvas, 19⁷/8 × 47¹/8 in.
(50.5 × 119.7 cm)
Dated and inscribed (extreme right, on a
pillar of the Palazzo Ducale): L (for
Luca)/DCC/IX (for 1709 or 1719, the earlier
date being the more likely)
Robert Lehman Collection, 1975
1975.1.90
ROBERT LEHMAN COLLECTION

*The Molo, Venice, from the Bacino di San
Marco*
Oil on canvas, 20 × 46⁷/8 in.
(50.8 × 119.1 cm)
Robert Lehman Collection, 1975
1975.1.87
ROBERT LEHMAN COLLECTION

Piazza San Marco, Venice
Oil on canvas, 19⁷/8 × 47¹/4 in.
(50.5 × 120 cm)
Robert Lehman Collection, 1975
1975.1.89
ROBERT LEHMAN COLLECTION

Giambattista Cimaroli
Italian, Venetian, born about 1687, died after
1757
View of the Brenta, near Dolo
Oil on canvas, 32³/8 × 44¹/2 in.
(82.2 × 113 cm)
Robert Lehman Collection, 1975
1975.1.91
ROBERT LEHMAN COLLECTION

COPERTVM CATENIS
IVGHVRTAM
POPVLVS ROMANVS ASPEXIT

65.183.1

65.183.2

65.183.3

Gasparo Diziani
Italian, Venetian, 1689–1767
Dawn
This ceiling is installed in the room for which
it was originally painted: a bedroom from the
Palazzo Sagredo, Venice (MMA).
Oil on canvas, 78 × 94¹/₂ in.
(198.1 × 240 cm)
Rogers Fund, 1906
06.1335.1b

Giovanni Battista Tiepolo
Italian, Venetian, 1696–1770
The Triumph of Marius
This picture and the following two
(65.183.2, 3) are from a series of ten painted
for the salone of the Palazzo Dolfin, Venice.
The other seven are: Triumph of a Roman
General or Emperor, Volumnia and Her
Children before Coriolanus, Mucius Scaevola
before Porsenna, Quintus Fabius Maximus
before the Senate of Carthage, and
Dictatorship Offered to Cincinnatus (all
Hermitage, Saint Petersburg), and Death of
Lucius Junius Brutus and Hannibal
Contemplating the Severed Head of
Hasdrubal (both Kunsthistorisches Museum,
Vienna).
Oil on canvas, irregular painted surface,
220 × 128⁵/₈ in. (558.8 × 326.7 cm)
Dated and inscribed: (upper center, on oval
medallion) 1729; (top center, on cartouche,
first letter probably a later addition)
COPERTVM CATENIS / IVGHVRTAM / POPVLVS
ROMANVS / ASPEXIT (The Roman people
behold Jugurtha laden with chains. [Lucius
Anneus Florus, Epitome de Tito Livio
bellorum omnium annorum DCC, book 2,
36:17]); (upper left, on banner) [S]PQR
Rogers Fund, 1965
65.183.1

The Capture of Carthage
Oil on canvas, irregular painted surface,
162 × 148³/₈ in. (411.5 × 376.9 cm)
Inscribed (left, on standard): SPQR
Rogers Fund, 1965
65.183.2

The Battle of Vercellae
Oil on canvas, irregular painted surface,
162 × 148³/₈ in. (411.5 × 376.9 cm)
Inscribed (upper left, on banner): SP[QR]
Rogers Fund, 1965
65.183.3

Giovanni Battista Tiepolo
Italian, Venetian, 1696–1770

The Glorification of the Barbaro Family
This ceiling painting and four upright ovals
—Timocleia and the Thracian Commander
(National Gallery of Art, Washington, D.C.),
Tarquinius and Lucretia (Städtische
Kunstsammlungen, Augsburg), Betrothal
(Statens Museum for Kunst, Copenhagen),
and Offering to Juno (private collection)—
are from the Palazzo Barbaro, Venice.
Oil on canvas, irregular oval, 96 × 183¾ in.
(243.8 × 466.7 cm)
Anonymous Gift, in memory of Oliver H.
Payne, 1923
23.128

The Investiture of Bishop Harold as Duke of Franconia
This painting is probably a preparatory sketch
for a fresco in the Kaisersaal of the Residenz,
Würzburg, as is its presumed pendant, the
Marriage of Frederick I to Beatrice of
Burgundy (Isabella Stewart Gardner Museum,
Boston).
Oil on canvas, 28¼ × 20¼ in.
(71.8 × 51.4 cm)
Purchase, 1871
71.121

Allegory of the Planets and Continents
This sketch, for the fresco above the staircase
of the Residenz, Würzburg, may be that
presented to Prince-Bishop Carl Philipp von
Greiffenklau in 1752.
Oil on canvas, 73 × 54⅞ in.
(185.4 × 139.4 cm)
Inscribed (sides): EVROPA / AFRICÆ / AMERICA
/ ASIA
Gift of Mr. and Mrs. Charles Wrightsman,
1977
1977.1.3

Saint Thecla Praying for the Plague-Stricken
This sketch is for the painting on the high
altar of the cathedral at Este, which was
commissioned in 1758 and installed in 1759.
Oil on canvas, 32 × 17⅝ in.
(81.3 × 44.8 cm)
Rogers Fund, 1937
37.165.2

The Adoration of the Magi (sketch)
Oil on canvas, 23¾ × 18¾ in.
(60.3 × 47.6 cm)
Rogers Fund, 1937
37.165.1

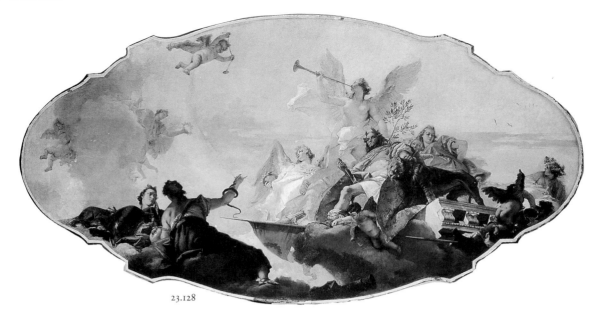

23.128

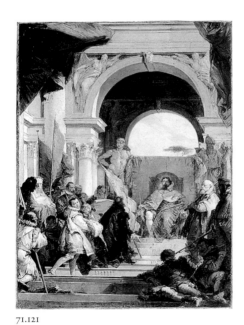

71.121

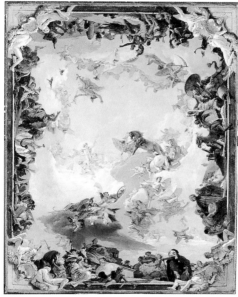

1977.1.3

37.165.2

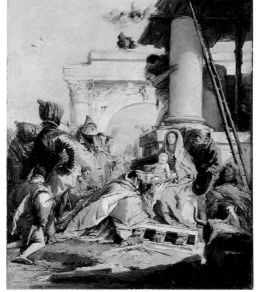

37.165.1

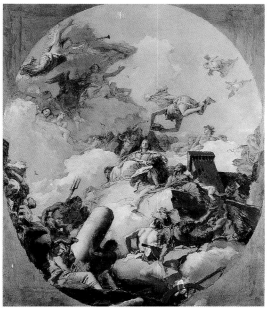

37.165.3

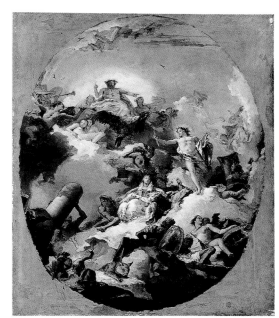

1980.363

1984.49

37.165.4

43.85.12

The Apotheosis of the Spanish Monarchy
This sketch is the first design for the ceiling of the saleta in the Palacio Real, Madrid.
Oil on canvas, oval painted surface,
32 1/8 × 26 1/8 in. (81.6 × 66.4 cm)
Rogers Fund, 1937
37.165.3

The Apotheosis of the Spanish Monarchy
This sketch is later than 37.165.3 above and is closer to the finished ceiling of the saleta.
Oil on canvas, oval painted surface,
33 1/8 × 27 1/8 in. (84.1 × 68.9 cm)
Gift of Mr. and Mrs. Charles Wrightsman, 1980
1980.363

A Female Allegorical Figure (grisaille)
This painting is from a series of four (two are in the Rijksmuseum, Amsterdam, and one is in a private collection).
Oil on canvas, gold ground, oval,
32 × 24 7/8 in. (81.3 × 63.2 cm)
Gift of Mr. and Mrs. Charles Wrightsman, 1984
1984.49

Neptune and the Winds (sketch for a ceiling)
Oil on canvas, round painted surface,
24 1/2 × 24 1/2 in. (62.2 × 62.2 cm)
Rogers Fund, 1937
37.165.4

Giovanni Battista Tiepolo and Workshop
and
Girolamo Mengozzi (called Colonna)
Italian, Venetian, born 1688, died about 1766
Virtue and Abundance
This and the following four frescoes in monochrome (43.85.13–16) are from the ceiling and walls of the gallery of the Palazzo Valle-Marchesini-Sala, Vicenza. Frescoes representing Mars and Venus and Cupid (both, location unknown) were in the same room. The architectural elements—as well as the trompe-l'oeil architecture that surrounded them and is still intact—were painted by Mengozzi-Colonna.
Fresco, transferred to canvas, diameter 114 in. (289.6 cm)
Bequest of Grace Rainey Rogers, 1943
43.85.12

Giovanni Battista Tiepolo and Workshop
and
Girolamo Mengozzi (called Colonna)
Italian, Venetian, born 1688, died about 1766
Metaphysics (monochrome)
Fresco, transferred to canvas, 146 × 57⁷/₈ in.
(370.8 × 147 cm)
Inscribed (on base of statue): METAFISICA
Bequest of Grace Rainey Rogers, 1943
43.85.13

Arithmetic (monochrome)
Fresco, transferred to canvas, 146 × 57⁷/₈ in.
(370.8 × 147 cm)
Inscribed (on base of statue): ARITMETICA
Bequest of Grace Rainey Rogers, 1943
43.85.14

Geometry (monochrome)
Fresco, transferred to canvas, 146 × 57⁷/₈ in.
(370.8 × 147 cm)
Inscribed (on base of statue): GEOMETRIA
Bequest of Grace Rainey Rogers, 1943
43.85.15

Grammar (monochrome)
Fresco, transferred to canvas, 146 × 57⁷/₈ in.
(370.8 × 147 cm)
Inscribed (on base of statue): GRAMMATICA
Bequest of Grace Rainey Rogers, 1943
43.85.16

Workshop of Giovanni Battista Tiepolo
Prudence
This and the following three frescoes
(43.85.22–24) in grisaille on a black ground
are also from the Palazzo Valle-Marchesini-
Sala, Vicenza.
Fresco, transferred to canvas, oval,
49¹/₈ × 36¹/₄ in. (124.8 × 92.1 cm)
Inscribed (upper edge) with Greek and Latin
characters
Bequest of Grace Rainey Rogers, 1943
43.85.21

A Virtue, Possibly Patriotism (grisaille)
Fresco, transferred to canvas, oval,
49³/₈ × 36¹/₄ in. (125.4 × 92.1 cm)
Inscribed (upper edge) with Greek characters
Bequest of Grace Rainey Rogers, 1943
43.85.22

Temperance (grisaille)
Fresco, transferred to canvas, oval,
57⁷/₈ × 48 in. (141.9 × 121.9 cm)
Inscribed (upper edge) with Greek characters
Bequest of Grace Rainey Rogers, 1943
43.85.23

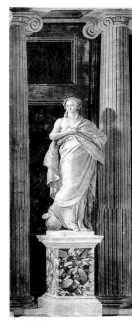

43.85.13 43.85.14 43.85.15 43.85.16

43.85.21 43.85.22

43.85.23 43.85.24

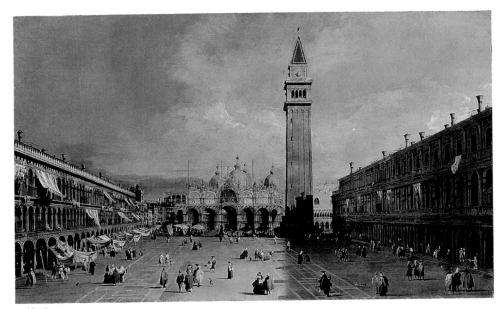

1988.162

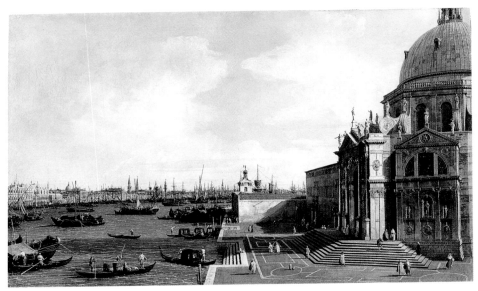

59.38

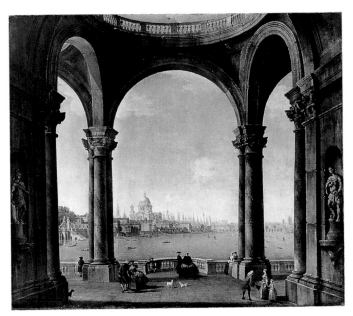

1970.212.2

Fortitude (grisaille)
Fresco, transferred to canvas, oval,
45⁵/₈ × 33¹/₂ in. (115.9 × 85.1 cm)
Inscribed (upper edge) with Greek and Latin characters
Bequest of Grace Rainey Rogers, 1943
43.85.24

Canaletto (Giovanni Antonio Canal)

Italian, Venetian, 1697–1768

Piazza San Marco
Oil on canvas, 27 × 44¹/₄ in.
(68.6 × 112.4 cm)
Purchase, Mrs. Charles Wrightsman Gift,
1988
1988.162

Venice: Santa Maria della Salute
Oil on canvas, 18³/₄ × 31¹/₄ in.
(47.6 × 79.4 cm)
Purchase, George T. Delacorte Jr. Gift, 1959
59.38

Antonio Joli

Italian, Venetian, born about 1700, died 1777

London: Saint Paul's and Old London Bridge
Oil on canvas, 42 × 47 in.
(106.7 × 119.4 cm)
Bequest of Alice Bradford Woolsey, 1970
1970.212.2

Pietro Longhi (Pietro Falca)

Italian, Venetian, 1702–1785

The Visit

This painting and the following three (14.32.1, 17.190.12, 36.16) are said to have belonged to a series of twenty painted for the Gambardi family of Florence.

Oil on canvas, 24 × 19½ in.
(61 × 49.5 cm)
Signed and dated (verso, now covered by relining canvas): Pietrus Longhi 1746.
Frederick C. Hewitt Fund, 1912
14.32.2

The Letter

Oil on canvas, 24 × 19½ in.
(61 × 49.5 cm)
Frederick C. Hewitt Fund, 1912
14.32.1

The Temptation

Oil on canvas, 24 × 19½ in.
(61 × 49.5 cm)
Gift of J. Pierpont Morgan, 1917
17.190.12

The Meeting

Oil on canvas, 24 × 19½ in.
(61 × 49.5 cm)
Gift of Samuel H. Kress, 1936
36.16

Francesco Zuccarelli

Italian, Venetian, 1702–1788

Landscape with Peasants at a Fountain

Oil on canvas, 31¼ × 47½ in.
(79.4 × 120.7 cm)
Gift of Bernard M. Baruch, in memory of his wife, Annie Griffen Baruch, 1959
59.189.1

Francesco Guardi

Italian, Venetian, 1712–1793

Capriccio

Oil on canvas, 12⅜ × 10⅝ in.
(31.4 × 27 cm)
The Lesley and Emma Sheafer Collection, Bequest of Emma A. Sheafer, 1973
1974.356.28

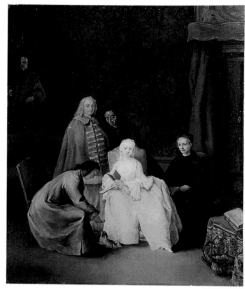

14.32.2

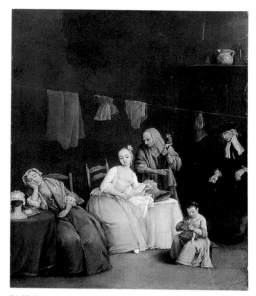

14.32.1

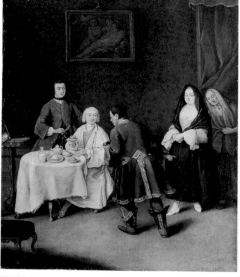

17.190.12

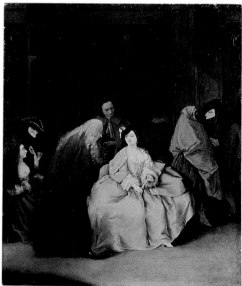

36.16

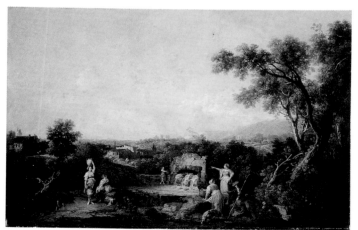

59.189.1

1974.356.28

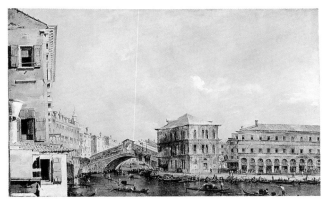

71.119

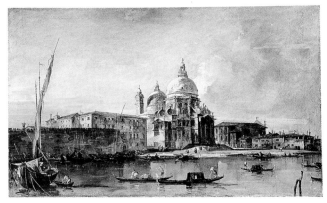

71.120

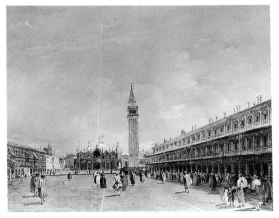

50.145.21

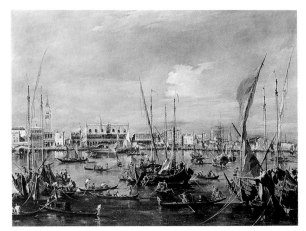

65.181.8

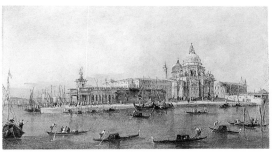

1982.60.14

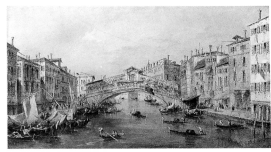

1982.60.15

Venice: The Grand Canal above the Rialto
Oil on canvas, 21 × 33³/₄ in. (53.3 × 85.7 cm)
Signed (lower left): Franᶜᵒ / De' Guardi
Inscribed (verso, upper left, in a later hand):
Vuduta del Sante di Rialto / in Venezia / del Guardi
(view of the Rialto [Bridge] in Venice by Guardi)
Purchase, 1871
71.119

Venice: Santa Maria della Salute
Pendant to 71.119
Oil on canvas, 21 × 33³/₄ in. (53.3 × 85.7 cm)
Inscribed (verso, upper left, in a later hand):
dalla / Veduta Salute in Venezia / del F.ᶜᵒ Guardi
(view of the Salute in Venice by Francesco Guardi)
Purchase, 1871
71.120

Venice: Piazza San Marco
Oil on canvas, 27¹/₈ × 33³/₄ in.
(68.9 × 85.7 cm)
Signed (lower right corner, on painting held
by man): Franᶜᵒ/Guardi
Bequest of Mary Stillman Harkness, 1950
50.145.21

Venice from the Bacino di San Marco
Oil on canvas, 48 × 60 in.
(121.9 × 152.4 cm)
Bequest of Adele L. Lehman, in memory of
Arthur Lehman, 1965
65.181.8

Workshop of Francesco Guardi

*Venice: The Dogana and Santa Maria
della Salute*
Oil on wood, 7¹/₈ × 12⁵/₈ in.
(18.1 × 32.1 cm)
The Jack and Belle Linsky Collection, 1982
1982.60.14

Venice: The Rialto
Pendant to 1982.60.14
Oil on wood, 7¹/₈ × 12⁵/₈ in.
(18.1 × 32.1 cm)
The Jack and Belle Linsky Collection, 1982
1982.60.15

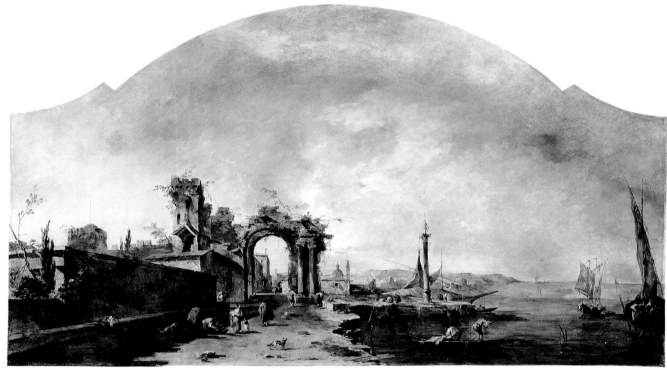

41.80

53.225.3

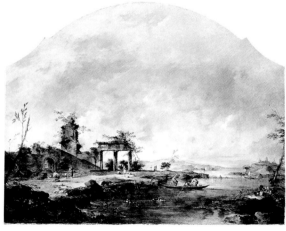

53.225.4

Francesco Guardi

Italian, Venetian, 1712–1793

Fantastic Landscape

This painting and the following two
(53.225.3, 4) are from the same series.
Oil on canvas, irregular, 61¹/₄ × 107¹/₂ in.
(155.6 × 273.1 cm)
Rogers Fund, 1941
41.80

Fantastic Landscape

Oil on canvas, irregular, 61¹/₄ × 74¹/₂ in.
(155.6 × 189.2 cm)
Gift of Julia A. Berwind, 1953
53.225.3

Fantastic Landscape

Oil on canvas, irregular, 61¹/₄ × 74¹/₂ in.
(155.6 × 189.2 cm)
Gift of Julia A. Berwind, 1953
53.225.4

Follower of Francesco Guardi

*Capriccio with a Circular Tower, Two
Houses, and a Bridge*

This painting and the following two
(1975.1.93, 94) were part of a series of four.
Oil on paper, laid down on Masonite,
2¹/₈ × 3¹/₂ in. (5.4 × 8.9 cm)
Robert Lehman Collection, 1975
1975.1.92
ROBERT LEHMAN COLLECTION

*Capriccio with a Square Tower and Two
Houses*

Oil on paper, laid down on Masonite,
2¹/₄ × 3³/₈ in. (5.7 × 8.6 cm)
Robert Lehman Collection, 1975
1975.1.93
ROBERT LEHMAN COLLECTION

*Capriccio with an Island, a Tower, and
Houses*

Oil on paper, laid down on Masonite,
2¹/₈ × 3¹/₂ in. (5.4 × 8.9 cm)
Robert Lehman Collection, 1975
1975.1.94
ROBERT LEHMAN COLLECTION

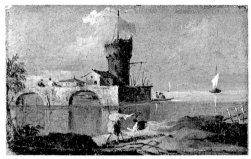

1975.1.92

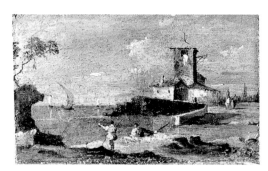

1975.1.93

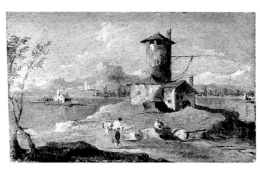

1975.1.94

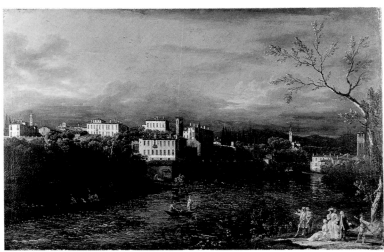

39.142

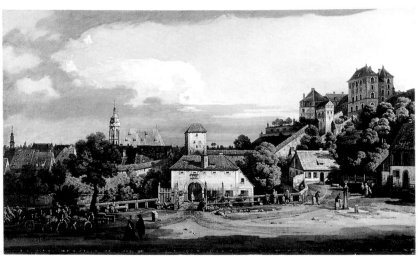

1991.306

Bernardo Bellotto
Italian, Venetian, 1721–1780

Vaprio d'Adda
The pendant (location unknown) shows the same subject from the north. Both were painted for Count Antonio Simonetta in 1744, according to Bellotto's inscriptions on the drawings (Hessisches Landesmuseum, Darmstadt) he made after the two paintings.
Oil on canvas, 25¼ × 39¼ in.
(64.1 × 99.7 cm)
Purchase, Joseph Pulitzer Bequest, 1939
39.142

Pirna: The Obertor from the South
Between 1753 and 1756 Bellotto painted Pirna from the south for Elector Frederick Augustus II of Saxony (Staatliche Kunstsammlungen, Dresden) and for his prime minister, Count Heinrich Brühl (Pushkin Museum, Moscow, on deposit in the museum at Alupka, Ukraine). This is a reduced replica with differing staffage.
Oil on canvas, 18¼ × 30¾ in.
(46.4 × 78.1 cm)
Wrightsman Fund, 1991
1991.306

Francesco Casanova
Italian, Venetian, 1727–1802

Cavalier and Shepherd
Oil on canvas, 25⅝ × 32 in.
(65.1 × 81.3 cm)
Gift of J. Pierpont Morgan, 1906
07.225.253

Giovanni Domenico Tiepolo
Italian, Venetian, 1727–1804

A Dance in the Country
Oil on canvas, 29¾ × 47¼ in.
(75.6 × 120 cm)
Gift of Mr. and Mrs. Charles Wrightsman, 1980
1980.67

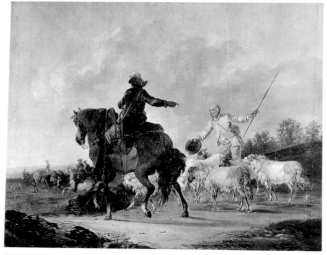

07.225.253

1980.67

43.85.19

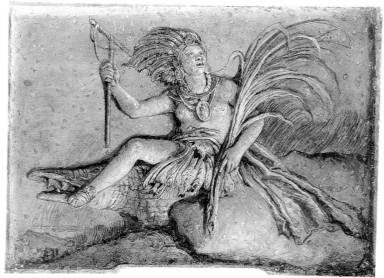

43.85.20

43.85.17

43.85.18

71.28

07.225.297

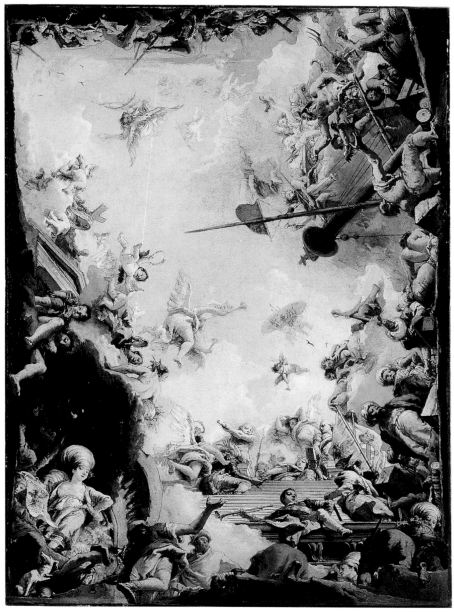

13.2

Giovanni Domenico Tiepolo
Italian, Venetian, 1727–1804

Europe
This and the following three overdoors in
monochrome (43.85.20, 17, 18) may also be
from the Palazzo Valle-Marchesini-Sala,
Vicenza (for which see Giovanni Battista
Tiepolo and Workshop, 43.85.12), although no
trace remains of their original location.
Fresco, transferred to canvas,
$32^{1}/_{4} \times 42^{3}/_{4}$ in. (81.9 × 108.6 cm)
Bequest of Grace Rainey Rogers, 1943
43.85.19

America (monochrome)
Fresco, transferred to canvas,
$32^{1}/_{4} \times 42^{3}/_{4}$ in. (81.9 × 108.6 cm)
Bequest of Grace Rainey Rogers, 1943
43.85.20

Asia (monochrome)
Fresco, transferred to canvas, $32^{1}/_{4} \times 41^{3}/_{4}$ in.
(81.9 × 106 cm)
Bequest of Grace Rainey Rogers, 1943
43.85.17

Africa (monochrome)
Fresco, transferred to canvas,
$32^{1}/_{4} \times 42^{3}/_{4}$ in. (81.9 × 108.6 cm)
Bequest of Grace Rainey Rogers, 1943
43.85.18

The Sacrifice of Isaac
Oil on canvas, $15^{3}/_{8} \times 21$ in.
(39.1 × 53.3 cm)
Purchase, 1871
71.28

Virtue and Nobility
Oil on canvas, $21 \times 15^{3}/_{4}$ in. (53.3 × 40 cm)
Gift of J. Pierpont Morgan, 1906
07.225.297

The Glorification of the Giustiniani Family
This sketch won Domenico Tiepolo the
commission for the ceiling of the Salone del
Maggior Consiglio in the ducal palace, Genoa
(destroyed in the 19th century). A contest was
proclaimed in 1782; the sketch was submitted
in 1783 and was chosen in 1784; the artist
painted the ceiling in 1785.
Oil on canvas, $46 \times 32^{1}/_{2}$ in.
(116.8 × 82.6 cm)
Inscribed: (on log) MZ; (on bale)
$\frac{T}{MA}$; (on box) $\frac{I}{B \cdot T}$; (on banner suspended from
trumpet) VIRTUS (virtue); (on scroll) CIVITAS
CHY (city of Chios) / V.I. (VINCENZO
GIUSTINIANI) / 1562
John Stewart Kennedy Fund, 1913
13.2

North Italian Painter

first quarter 14th century

Two Angels

The angels are from a fresco formerly in the
Capella Bonacolsi, Torre della Gabbia,
Mantua, the major part of which is a
Marriage of Saint Catherine (fragments
divided between two private collections).
Fresco; (a) 23³/₈ × 31¹/₂ in. (59.4 × 80 cm);
(b) 23¹/₂ × 31¹/₂ in. (59.7 × 80 cm)
Bequest of Edward Fowles, 1971
1971.115.1ab

**Michelino da Besozzo (Michelino de
Mulinari)**

Italian, Lombard, active 1388–1450

The Marriage of the Virgin

Tempera and gold on wood, 25⁵/₈ × 18³/₄ in.
(65.1 × 47.6 cm)
Maitland F. Griggs Collection, Bequest of
Maitland F. Griggs, 1943
43.98.7

1971.115.1a 1975.115b

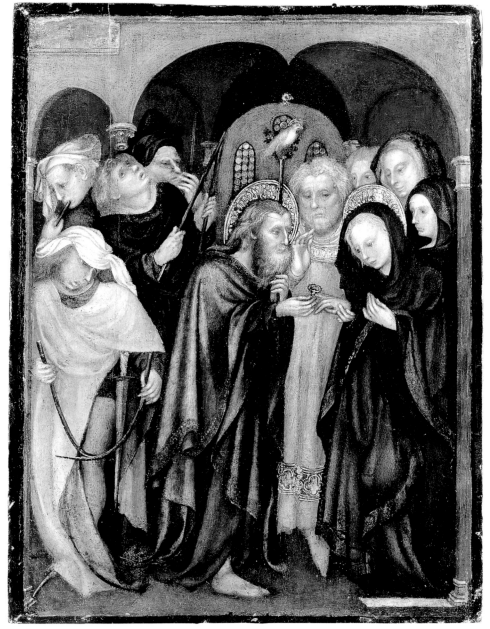

43.98.7

37.163.2 37.163.1 37.163.3

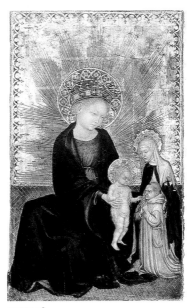

1975.1.98

30.95.293

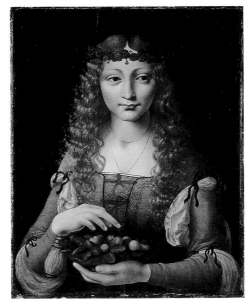

91.26.5

30.95.289

Donato de' Bardi
Italian, Lombard, active by 1426, died 1450/51

Madonna and Child with Saints Philip and Agnes (triptych)
The frames, though detached, are original.
Tempera on wood, gold ground; central panel, overall 23¹/₂ × 13¹/₈ in. (59.7 × 33.3 cm); central panel, painted surface 23¹/₈ × 12³/₄ in. (58.7 × 32.4 cm); each wing, overall 23⁵/₈ × 6 in. (60 × 15.2 cm); each wing, painted surface 23¹/₄ × 5¹/₂ in. (59.1 × 14 cm)
Signed (bottom, central panel): OP[V]S DONATI
Gift of Samuel H. Kress Foundation, 1937
37.163.1–3

Italian (Lombard) Painter
third quarter 15th century

Madonna and Child with Saint Catherine of Siena and a Carthusian Donor
Tempera on wood, gold ground; overall 22⁵/₈ × 13¹/₈ in. (57.5 × 33.3 cm); painted surface 21⁷/₈ × 12¹/₄ in. (55.6 × 31.1 cm)
Robert Lehman Collection, 1975
1975.1.98
ROBERT LEHMAN COLLECTION

Vincenzo Foppa
Italian, Lombard, active by 1456, died 1515/16

Madonna and Child
Tempera, oil, and gold on wood, 17¹/₄ × 12⁵/₈ in. (43.8 × 32.1 cm)
Theodore M. Davis Collection, Bequest of Theodore M. Davis, 1915
30.95.293

Attributed to Giovanni Ambrogio de Predis
Italian, Milanese, active by 1472, died after 1508

Girl with Cherries
Oil on wood, 19¹/₄ × 14³/₄ in. (48.9 × 37.5 cm)
Marquand Collection, Gift of Henry G. Marquand, 1890
91.26.5

Boccaccio Boccaccino
Italian, Cremonese, born before 1466, died 1524/25

Madonna and Child
Oil on wood; overall 20³/₈ × 14⁵/₈ in. (51.8 × 37.1 cm); painted surface 20 × 14 in. (50.8 × 35.6 cm)
Theodore M. Davis Collection, Bequest of Theodore M. Davis, 1915
30.95.289

23.188.1

23.188.2

23.188.3

23.188.4

23.188.5

23.188.6

23.188.7

23.188.8

23.188.9

23.188.10

23.188.11

23.188.12

23.188.13

23.188.14

North Italian Painter
late 15th century

Fourteen Heads (panels from a frieze)
Tempera on wood; height 13–17³/₄ in.
(33–45.1 cm); width 20¹/₂ in. (52.1 cm)
Gift of Dr. Ernest G. Stillman, 1923
23.188.1–14
ESDA

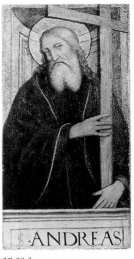
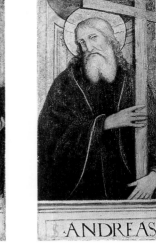
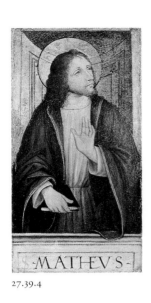

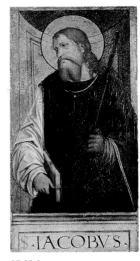

B TOLAMEVS

27.39.2

ANDREAS

27.39.3

MATHEVS

27.39.4

IACOBVS

27.39.5

Workshop of Bergognone
Italian, Milanese, active 1481–1522
*The Twelve Apostles: Saints
Bartholomew, Andrew, Matthew,
James the Greater, Thaddeus,
Philip, James the Lesser, Simon,
Peter, Paul, Thomas, and John*
Oil and gold on wood, each
12¼ × 6 in. (31.1 × 15.2 cm)
Inscribed (base of each panel) with
the apostle's name
Fletcher Fund, 1926
27.39.2–13

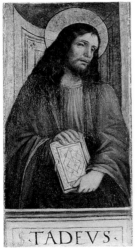
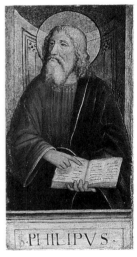
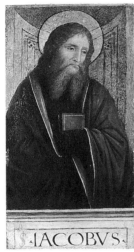
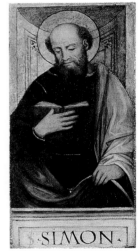

TADEVS

27.39.6

PHILIPVS

27.39.7

IACOBVS

27.39.8

SIMON

27.39.9

**Bergognone (Ambrogio di
Stefano da Fossano)**
Italian, Milanese, active 1481–1522
The Assumption of the Virgin
Oil and gold on wood,
95⅜ × 42½ in. (242.3 × 108 cm)
[the stars on the Virgin's robe are
not original]
Inscribed: (verso, in a later hand)
Ambrogio Borgognone fe.; (on
Christ's halo) IESVS CHRISTV[S]; (on
Virgin's halo) [BE?]NIGNA; (on hem
of Virgin's cloak) NOMEN DOM[I]NI
. . . MARIA . . . DOM . . . ; (on halo
of each apostle) with the apostle's
name
Fletcher Fund, 1926
27.39.1

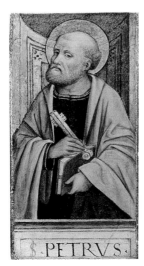
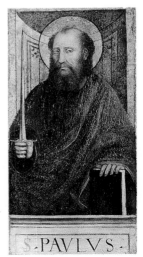
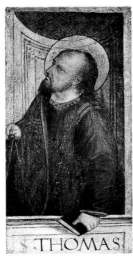
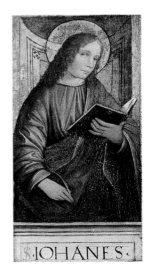

PETRVS

27.39.10

PAVLVS

27.39.11

THOMAS

27.39.12

IOHANES

27.39.13

Bramantino (Bartolomeo Suardi)

Italian, Milanese, active by 1490, died 1530

Madonna and Child

Tempera on wood; overall 13¹/₂ × 11¹/₄ in.
(34.3 × 28.6 cm); painted surface
13¹/₂ × 10⁷/₈ in. (34.3 × 27.6 cm)
Inscribed (neckline of Madonna's dress): AVE
REGINA CELLA
John Stewart Kennedy Fund, 1912
12.178.2

Andrea Solario

Italian, Milanese, active by 1495, died 1524

Salome with the Head of Saint John the Baptist

Oil on wood, 22¹/₂ × 18¹/₂ in. (57.2 × 47 cm)
Signed (lower right): ·ANDREAS·DE· /
·SOLARIO· / ·F·
The Friedsam Collection, Bequest of Michael
Friedsam, 1931
32.100.81

Christ Blessing

Oil on wood, 80¹/₄ × 51¹/₂ in. (203.8 × 130.8 cm)
From the Collection of James Stillman, Gift
of Dr. Ernest G. Stillman, 1922
22.16.12

Bernardino da Genoa

Italian, Genoese, active in 1515

Madonna and Child with Angels

Oil on wood, 29³/₈ × 22⁵/₈ in. (74.6 × 57.5 cm)
Signed and dated (on goldfinch's scroll):
BERNAR / DINVS / IANVE / 1515.
Gift of George Blumenthal, 1941
41.100.13

Giovanni Agostino da Lodi

Italian, Milanese, active first quarter 16th
century

Portrait of a Man

Oil on canvas, transferred from wood,
25¹/₂ × 22³/₈ in. (64.8 × 56.8 cm)
Gift of Harry Payne Bingham Jr., 1958
58.182

Italian (Lombard) Painter

first quarter 16th century

Twelve Heads

The panels, which formed part of a frieze, are
from the palace of San Martino Gusnago
(now Palazzo Pastore), near Ceresara, between
Brescia and Mantua. Twenty-seven others are
recorded, of which fifteen can be traced (six
in the Victoria and Albert Museum, London;
two in the Cornell Fine Arts Center Museum,
Rollins College, Winter Park, Florida; and
seven divided between two private collections).
Tempera on wood, square, sides 18–18¹/₄ in.
(45.7–46.4 cm)
Rogers Fund, 1905
05.2.1–12

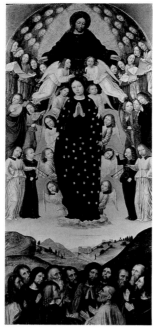

27.39.1

12.178.2

32.100.81

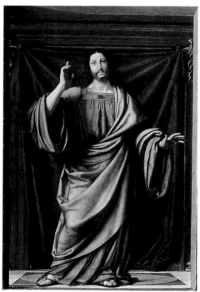

22.16.12

41.100.13

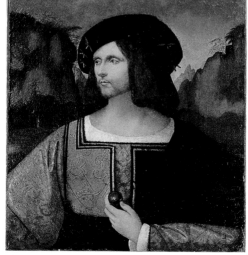

58.182

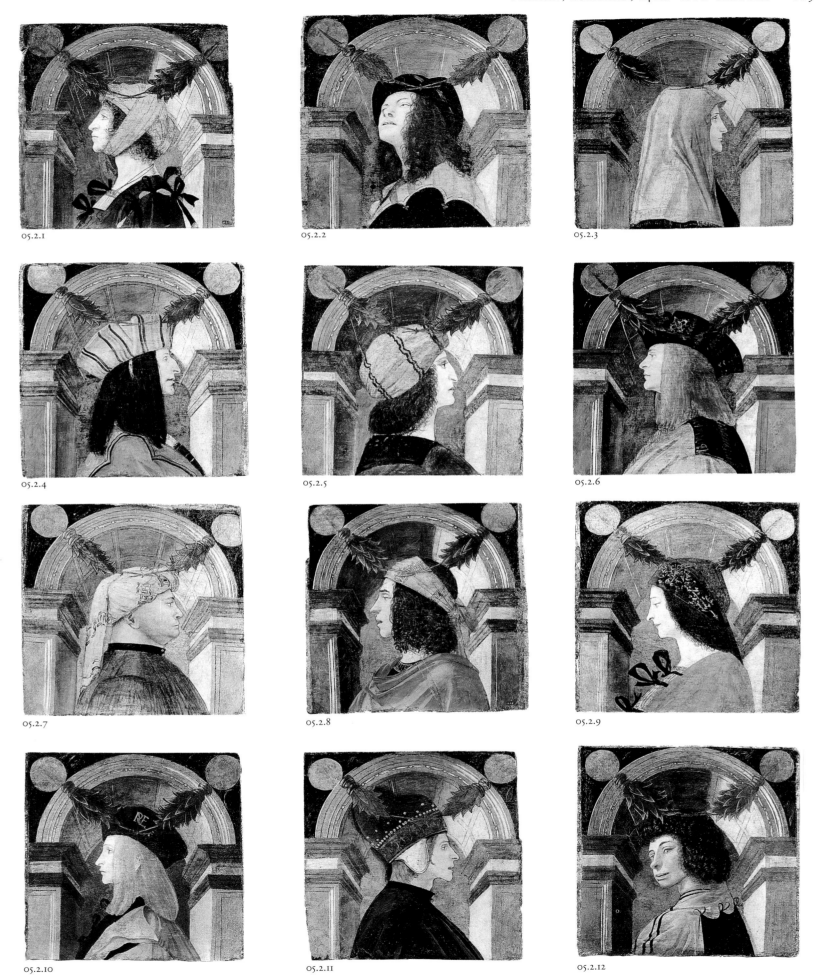

05.2.1

05.2.2

05.2.3

05.2.4

05.2.5

05.2.6

05.2.7

05.2.8

05.2.9

05.2.10

05.2.11

05.2.12

Bernardino dei Conti

Italian, Milanese, 1496–1522

Madonna and Child

Oil on wood; overall, with additions,
15⁷⁄₈ × 12 in. (40.3 × 30.5 cm); painted
surface 15⁵⁄₈ × 11⁵⁄₈ in. (39.7 × 29.5 cm)
The Jack and Belle Linsky Collection, 1982
1982.60.7

Defendente Ferrari

Italian, Piedmontese, active 1510–1531

Saints John the Evangelist and Lawrence

Oil on wood, 48¹⁄₂ × 19¹⁄₂ in.
(123.2 × 49.5 cm)
Inscribed (on book held by Saint John): INPR
/ I[N]CIPIO / ERAT / VER / BVM / ETVE / RBVM
/ ERAT (In the beginning was the Word, and
the Word was [with God] [John 1:1].)
Rogers Fund, 1915
15.56

**Giampietrino (Gian Pietro Rizzi, or
Giovanni Pedrini)**

Italian, Milanese, active first half 16th century

Diana the Huntress

Oil on wood, 44⁷⁄₈ × 23¹⁄₄ in.
(114 × 59.1 cm)
Purchase, Mr. and Mrs. Frank E. Richardson
Gift, 1989
1989.21

Giovanni Girolamo Savoldo

Italian, Brescian, active by 1508, died soon
after 1548

Saint Matthew and the Angel

Oil on canvas, 36³⁄₄ × 49 in.
(93.4 × 124.5 cm)
Marquand Fund, 1912
12.14

Girolamo Romanino

Italian, Brescian, 1484/87–1560

The Flagellation; The Madonna of Mercy

The paintings are the recto and verso of a
processional banner made for a Franciscan
penitential confraternity, possibly that of the
church of San Francesco, Brescia. The
Madonna is flanked by Saints Francis and
Anthony.
Distemper and oil(?) on canvas,
70⁷⁄₈ × 47¹⁄₂ in. (180 × 120.7 cm)
Purchase, Anonymous Bequest, by exchange,
1989
1989.86

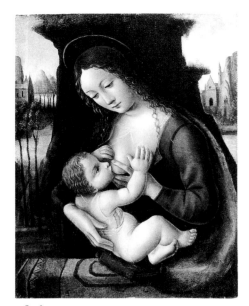

1982.60.7

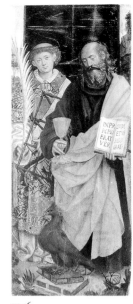

15.56

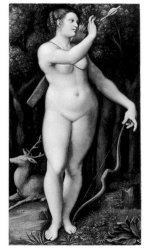

1989.21

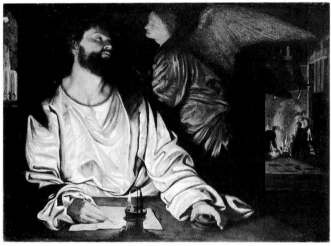

12.14

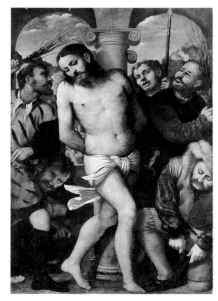

1989.86 (recto)

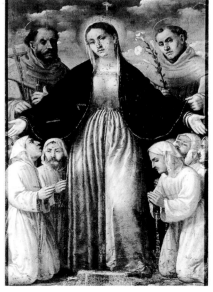

1989.86 (verso)

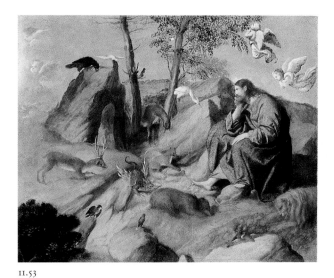

11.53

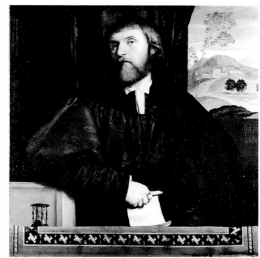

28.79

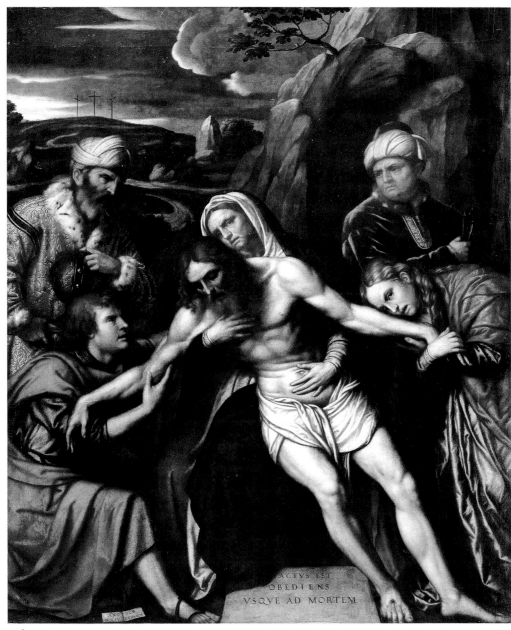

12.61

Moretto da Brescia (Alessandro Bonvicino)

Italian, Brescian, born about 1498, died 1554

Christ in the Wilderness
Oil on canvas, 18 × 21³/₄ in.
(45.7 × 55.2 cm)
Rogers Fund, 1911
11.53

Portrait of a Man
Oil on canvas, 34¹/₄ × 32 in. (87 × 81.3 cm)
Rogers Fund, 1928
28.79

The Entombment
Oil on canvas, 94¹/₂ × 74¹/₂ in.
(240 × 189.2 cm)
Dated and inscribed: (bottom left)
A̅N̅[N]O·DO̅M̅[INI] / MDLIV MENS[IS]
OCT[OBRIS] (In the year of our Lord 1554 in
the month of October); (bottom center)
FACTVS EST / OBEDIENS / VSQVE AD MORTEM
(He . . . became obedient unto death . . .
[Philippians 2:8].)
John Stewart Kennedy Fund, 1912
12.61

Italian (Lombard) Painter

about 1540

Portrait of a Man in a Fur-Trimmed Coat
Oil on canvas, 38³/₈ × 29¹/₂ in.
(97.5 × 74.9 cm)
Marquand Collection, Gift of Henry G.
Marquand, 1890
91.26.2

North Italian Painter

second quarter 16th century

Portrait of a Man
Oil on wood, 28¹/₄ × 20³/₈ in.
(71.8 × 51.8 cm)
Rogers Fund, 1906
06.1324

Bernardino Campi

Italian, Cremonese, 1522–1591

Portrait of a Woman

Oil on canvas, 55⅝ × 38¼ in.
(141.3 × 97.2 cm)
Anonymous Gift, 1963
63.43.1

Giovanni Battista Moroni

Italian, Lombard, born no later than 1524,
died 1578

Bartolommeo Bonghi (died 1584)

Oil on canvas, 40 × 32¼ in.
(101.6 × 81.9 cm)
Inscribed (on book): PLAV I. sup.I. / I.ff.si
q[ui]s Ius / dic[enti]. non obtempe[raverit].
[referring to Camillo Plauzio's commentary of
1553 on Justinian's Pandects, which Plauzio
dedicated to Bonghi, and from which the
quote is drawn]
Formerly dated and inscribed (left, under the
window, in a later hand): BARTHOLOMEVS
BONGVS. I[VRIS]. V[TRIVSQVE]. D[OCTOR]. /
CAN[ONIC]VS. ET PRIMICER[I]VS. CATH[EDRA]LIS.
BERG[AMEN]SIS / PROTHONOT[ARI]VS.
AP[OSTO]LĪCVS. COMES ET ÆQVES / ANNO.
D[OMI]NI. MDLXXXIV. (Bartolomeo Bonghi,
doctor of either law [canon and civil], canon
and dean of the cathedral of Bergamo,
apostolic protonotary, count and knight, in
the year of our Lord 1584) [this and the arms
of the Bonghi family, also a later addition,
have been removed]
Purchase, Joseph Pulitzer Bequest, 1913
13.177

Portrait of a Man

Oil on canvas, 48 × 40½ in.
(121.9 × 102.9 cm)
Inscribed: (right) TREV̄. VND / FRVMB. (faithful
and devout); (upper left) [illegible]
Theodore M. Davis Collection, Bequest of
Theodore M. Davis, 1915
30.95.238

Abbess Lucrezia Agliardi Vertova

(1490?–?1557)
Oil on canvas, 36 × 27 in. (91.4 × 68.6 cm)
Inscribed (on cartouche): LVCRETIA
NOBILISS[IMI]. ALEXIS ALARDI / BERGOMENSIS
FILIA HONORATISS[IMI]. / FRANCISCI CATANEI
VERTVATIS / VXOR DIVAE ANNAE ALBINENSE /
TEMPLVM IPSA STATVENDV CVRAVIT. /
M.D.LVII. (Lucretia, daughter of the most
noble Alessio Agliardi of Bergamo, wife of the
most honorable Francesco Cataneo Vertova,
herself founded the church of Saint Anne at
Albino. 1557)
Theodore M. Davis Collection, Bequest of
Theodore M. Davis, 1915
30.95.255

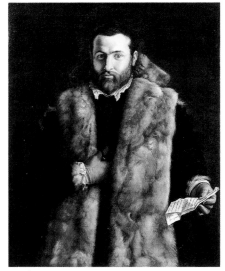

91.26.2

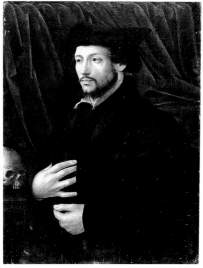

06.1324

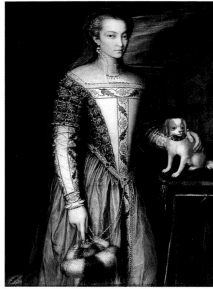

63.43.1

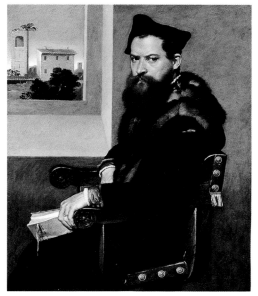

13.177

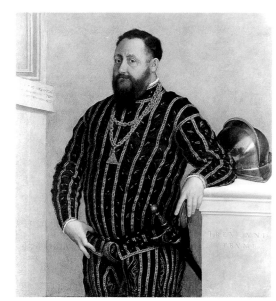

30.95.238

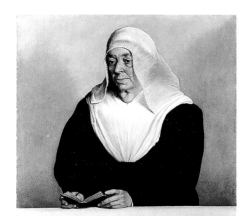

30.95.255

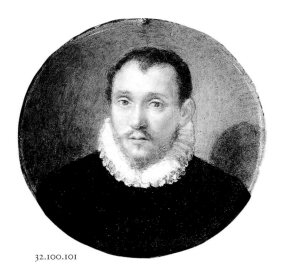

32.100.101

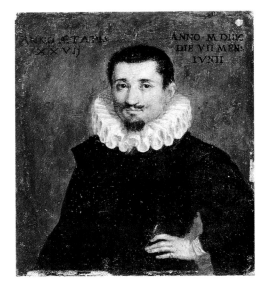

32.100.88

North Italian Painters

late 16th century

Portrait of a Man

Oil on copper, diameter 4⁷/₈ in. (12.4 cm)
The Friedsam Collection, Bequest of Michael
Friedsam, 1931
32.100.101

dated 1597

Portrait of a Man

Oil on wood, 7¹/₄ × 6¹/₄ in.
(18.4 × 15.9 cm)
Dated and inscribed: (upper left) ANNO
ÆTATIS / XXVII; (upper right) ANNO·MDIIIC /
DIE VII MEN·IVNII
The Friedsam Collection, Bequest of Michael
Friedsam, 1931
32.100.88

Italian (Cremonese) Painter

fourth quarter 16th century

The Adoration of the Shepherds

Gouache on parchment, 8⁵/₈ × 6⁷/₈ in.
(21.9 × 17.5 cm)
Inscribed (on angel's scroll): GLORIA IN
EXCELSĪS DEO ET IN TERRA PAX. H[. . .]
(Glory to God in the highest, and on earth
peace . . . [Luke 2:14].)
Gift of Coudert Brothers, 1888
88.3.68

88.3.68

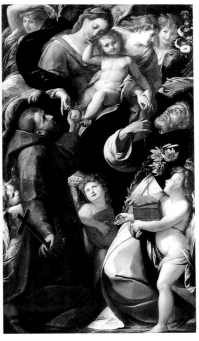

1979.209

Giulio Cesare Procaccini

Italian, Milanese, 1574–1625

***Madonna and Child with Saints Francis
and Dominic and Angels***

Oil on canvas, 101¹/₈ × 56³/₈ in.
(256.9 × 143.2 cm)
Purchase, Enid A. Haupt Gift, 1979
1979.209

Bernardo Strozzi

Italian, Genoese, 1581–1644

Tobias Curing His Father's Blindness

Oil on canvas, 57¹/₂ × 88 in.
(146.1 × 223.5 cm)
Purchase, Mary Wetmore Shively Bequest, in
memory of her husband, Henry L. Shively,
M.D., 1957
57.23

David with the Head of Goliath

Oil on canvas, 46 × 38³/₄ in.
(116.8 × 98.4 cm)
Fletcher Fund, 1927
27.93

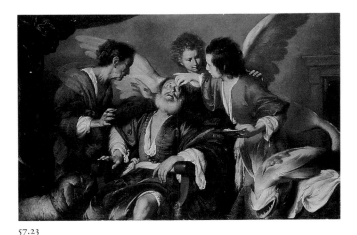

57.23

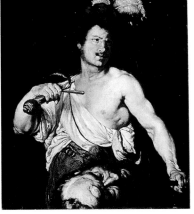

27.93

Francesco Cairo

Italian, Lombard, 1607–1665

Herodias

Evidently a fragment, the picture probably included a head of Saint John the Baptist.
Oil on canvas, 29⅝ × 24⅝ in.
(75.2 × 62.5 cm)
Gift of Paul Ganz, in memory of Rudolf Wittkower, 1973
1973.165

Domenico Guidobono

Italian, Genoese, 1668–1746

An Allegory

Oil on canvas, 56¾ × 92¼ in.
(144.1 × 234.3 cm)
Purchase, R. A. Farnsworth Gift, Gwynne Andrews, Charles B. Curtis, Rogers, Marquand, The Alfred N. Punnett Endowment, and Victor Wilbour Memorial Funds, 1970
1970.261

North Italian (?) Painter

17th century or later

King David; Musical Performers

These nine panels are the inside and outside of a clavicytherium case.
Oil on wood; open 51 × 52½ in.
(129.5 × 133.4 cm); closed 46¾ × 25¼ in.
(118.7 × 64.1 cm)
The Crosby Brown Collection of Musical Instruments, 1889
89.4.1224
MUSICAL INSTRUMENTS

Italian Painter

17th century or later

Tobit and the Angel

This panel is the inside of a harpsichord lid.
Oil on wood, 31 × 69 in. (78.7 × 175.3 cm)
The Crosby Brown Collection of Musical Instruments, 1889
89.4.1222
MUSICAL INSTRUMENTS

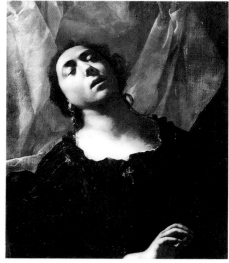

1973.165

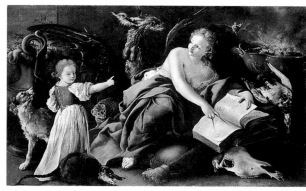

1970.261

89.4.1224 (open)

89.4.1224 (closed)

89.4.1222

89.4.1222

1984.191

1982.60.13

07.225.295

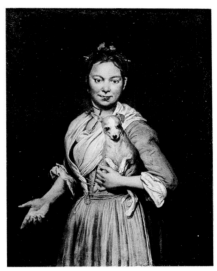

30.15

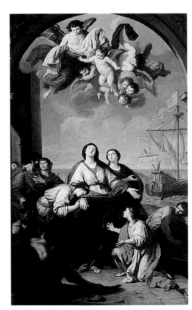

1991.445

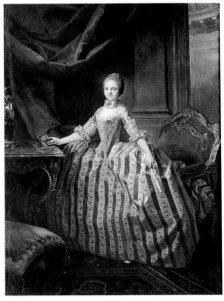

26.260.9

Alessandro Magnasco
Italian, Genoese, 1677–1749
The Tame Magpie
Oil on canvas, 25 × 29¹⁄₂ in.
(63.5 × 74.9 cm)
Purchase, Katherine D. W. Glover Gift, 1984
1984.191

Follower of Alessandro Magnasco
Italian, Milanese, first half 18th century
Nuns at Work
Oil on canvas, 20¹⁄₈ × 28³⁄₈ in.
(51.1 × 72.1 cm)
The Jack and Belle Linsky Collection, 1982
1982.60.13

Carlo Innocenzo Carloni
Italian, Lombard, 1686–1775
The Glorification of Saint Anthony Abbot
The painting is a sketch for the vault of the
chapel of Saint Anthony in the cathedral at
Monza.
Oil on canvas, 18¹⁄₄ × 17 in.
(46.4 × 43.2 cm)
Gift of J. Pierpont Morgan, 1906
07.225.295

Giacomo Ceruti
Italian, Lombard, 1698–1767
A Woman with a Dog
Oil on canvas, 38 × 28¹⁄₂ in.
(96.5 × 72.4 cm)
Maria DeWitt Jesup Fund, 1930
30.15

Giuseppe Bottani
Italian, Cremonese, 1717–1785
*The Departure of Saints Paula and
Eustochium for the Holy Land*
This is the modello for an altarpiece painted
in Rome in 1745 for the church of S.S. Cosma
e Damiano, Milan. The Metropolitan
Museum owns a drawing for the same
altarpiece.
Oil on canvas, 38³⁄₄ × 22¹⁄₂ in.
(98.4 × 57.2 cm)
Gift of Mr. and Mrs. Edward A. Friedman,
in loving memory of Milton Friedman, 1991
1991.445

Laurent Pécheux
French, 1729–1821
Maria Luisa of Parma (1751–1819), *Later
Queen of Spain*
Oil on canvas, 90⁷⁄₈ × 64³⁄₄ in.
(230.8 × 164.5 cm)
Bequest of Annie C. Kane, 1926
26.260.9

Master of the Life of Saint John the Baptist
Italian, Romagnole, active first third 14th century

The Execution of Saint John the Baptist and the Presentation of the Baptist's Head to Herod
This is one of a series of eight scenes that may have flanked a Madonna and Child (National Gallery of Art, Washington, D.C.). The others are the Annunciation to Zacharias (private collection), Birth of Saint John and Baptism of Christ (both National Gallery of Art, Washington, D.C.), Saint John in Prison (private collection), Saint John in the Wilderness (Pinacoteca Vaticana), Saint John and the Pharisees (Seattle Art Museum), and Saint John in Limbo (private collection).
Tempera on wood, gold ground,
17³/₈ × 19⁵/₈ in. (44.1 × 49.8 cm)
Robert Lehman Collection, 1975
1975.1.103
ROBERT LEHMAN COLLECTION

Master of Forlì
Italian, Romagnole, active first half 14th century

The Flagellation
This panel, the Stripping of Christ (location unknown), the Deposition (Thyssen-Bornemisza Foundation), and the following picture (1975.1.80) formed the shutters of a portable shrine.
Tempera on wood, gold ground; overall 7³/₄ × 5¹/₄ in. (19.7 × 13.3 cm); painted surface, excluding painted borders, 7³/₈ × 4⁵/₈ in. (18.7 × 11.7 cm)
Robert Lehman Collection, 1975
1975.1.79
ROBERT LEHMAN COLLECTION

The Entombment
Tempera on wood, gold ground; overall 8 × 5¹/₈ in. (20.3 × 13 cm); painted surface, excluding painted borders, 7³/₈ × 4⁷/₈ in. (18.7 × 12.4 cm)
Robert Lehman Collection, 1975
1975.1.80
ROBERT LEHMAN COLLECTION

Pietro da Rimini
Italian, Riminese, active 1324–1333

The Crucified Christ
This panel is a fragment of a crucifix. The top and arms may have been terminated by half-length figures of Christ Blessing, the Virgin, and Saint John the Evangelist (all Walters Art Gallery, Baltimore).
Tempera and gold on wood,
40⁷/₈ × 18 in. (103.8 × 45.7 cm)
Gift of Mrs. W. Murray Crane, 1939
39.42

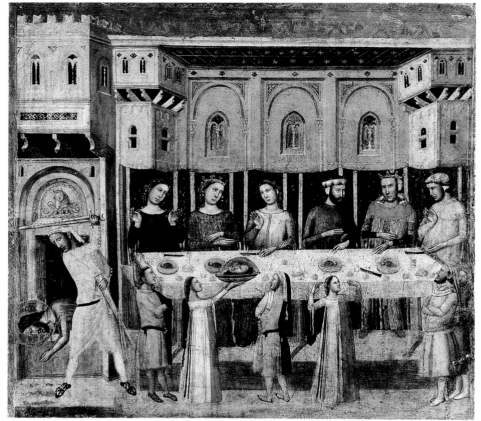

1975.1.103

1975.1.79

1975.1.80

Attributed to Giovanni Baronzio
Italian, Riminese, active by 1345, died about 1362

Scenes from the Life of Christ (possibly the right wing of a diptych)
The scenes are: the Coronation of the Virgin, Four Saints, the Deposition, the Pietà, Christ in Limbo, the Ascension, Pentecost, and the Last Judgment.
Tempera on canvas, transferred from wood, gold ground, 26¹/₄ × 15 in. (66.7 × 38.1 cm)
Rogers Fund, 1909
09.103

Italian (Romagnole) Painter
mid-15th century

Crucifix
The crucifix is double sided. On one side the crucified Christ is shown as a living figure, with eyes open and blood spurting from his wounds; on the other he is dead, with eyes closed.
Tempera on wood, gold ground; overall, excluding peg at base, 15⁵/₈ × 13⁷/₈ in. (39.7 × 35.2 cm)
Robert Lehman Collection, 1975
1975.1.25
ROBERT LEHMAN COLLECTION

39.42

09.103

1975.1.25 (recto)

1975.1.25 (verso)

65.181.5

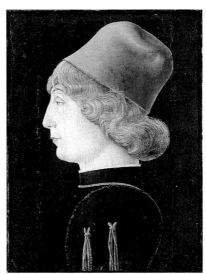

14.40.649

Master of the Madonna of Pietro de' Lardi

Italian, Ferrarese, about 1420–30

Madonna and Child with the Donor, Pietro de' Lardi, Presented by Saint Nicholas

Tempera and gold on wood; overall 45⁷/₈ × 43⁵/₈ in. (116.5 × 110.8 cm); painted surface 44¹/₈ × 41³/₄ in. (112.1 × 106 cm)
Inscribed (lower left): ALma dei genitrix mundus cui flectitur omnis / HAnc tibi deuoto construxit corde figuram / PEtrus de lardis presentat quem tibi sā[n]c̄tus / ATque suus pastor Nicolaus, tempore et illo / URbis ferrarie sum[m]o cum laudis honore / PResul erat dominus Petrus noster reuerē[n]dus / BOyarde stirpis natus de sanguine claro (Beloved Mother of God, to whom the whole world bows, with devout heart Pietro de' Lardi, whom his pastor Saint Nicholas presents to you, had this picture painted for you at the time when the protector of the city of Ferrara was our reverend master Pietro Boiardi, born of noble blood and honored with high praise)
Arms (lower left) unidentified; (lower right) of the Lardi family of Ferrara
Bequest of Adele L. Lehman, in memory of Arthur Lehman, 1965
65.181.5

Cosimo Tura (Cosimo di Domenico di Bonaventura)

Italian, Ferrarese, active by 1451, died 1495

A Young Man (fragment)

Tempera on wood, 11¹/₈ × 7³/₄ in. (28.3 × 19.7 cm)
Bequest of Benjamin Altman, 1913
14.40.649

The Flight into Egypt

This panel, the Adoration of the Magi (Fogg Art Museum, Cambridge, Massachusetts), and the Circumcision (Isabella Stewart Gardner Museum, Boston) formed a series.
Tempera on wood; overall, with corners made up, 15⁵/₈ × 15¹/₈ in. (39.7 × 38.4 cm); painted surface, diameter 15¹/₄ in. (38.7 cm)
The Jules Bache Collection, 1949
49.7.17

Saint Louis of Toulouse

A Saint Nicholas (Musée des Beaux-Arts, Nantes) is from the same altarpiece.
Tempera on canvas, stretched over wood, transferred from wood, gold ground; overall 28¹/₂ × 15⁵/₈ in. (72.4 × 39.7 cm); original size 28¹/₄ × 12⁵/₈ in. (71.8 × 32.1 cm)
Theodore M. Davis Collection, Bequest of Theodore M. Davis, 1915
30.95.259

Bartolomeo degli Erri
Italian, Modenese, active 1460–1479

Saint Dominic Resuscitating Napoleone Orsini
Saint Dominic resuscitates the youth, who was killed when he fell from his horse, and (background) the saint restores him to his uncle Cardinal Stefano of Fossanova. This is the only surviving element from the predella of an altarpiece painted between 1467 and 1475 for the high altar of San Domenico, Modena. A fragmentary Madonna and Child (Musée des Beaux-Arts, Strasbourg) may be the central panel.
Tempera on canvas, transferred from wood, 14 × 17¹/₂ in. (35.6 × 44.5 cm)
The Bequest of Michael Dreicer, 1921
22.60.59

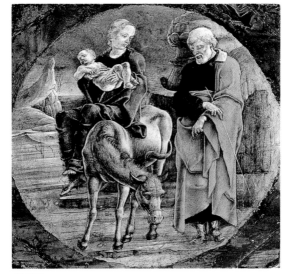

49.7.17

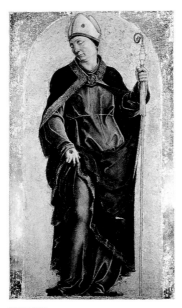

30.95.259

Saint Thomas Aquinas Aided by Saints Peter and Paul
Saint Thomas takes a book from a shelf and (right) is seated between Saints Paul and Peter, who appeared to him to explain a passage in Isaiah. This is one of a number of scenes that originally surrounded an image of Saint Thomas Aquinas (destroyed), from a chapel in the choir screen in San Domenico, Modena. Others from the series are the Birth of Saint Thomas (Yale University Art Gallery, New Haven), Saint Thomas Discusses Theology in Naples and the Vision of Fra Paolino (both Fine Arts Museums of San Francisco), Saint Thomas at Table with Saint Louis of France (private collection), Saint Thomas Preaching (National Gallery of Art, Washington, D.C.), a fragmentary Infant Saint Thomas and His Mother (art market, 1979), and the Death of Saint Thomas (Moravská Galérie, Brno).
Tempera on wood, 17 × 12 in.
(43.2 × 30.5 cm)
Fletcher Fund, 1923
23.140

22.60.59

23.140

Italian (Emilian) Painter
late 15th century

Portrait of a Member of the Gozzadini Family
This painting and the following (1975.1.96) represent a husband and wife and constitute a diptych.
Tempera on wood; overall 20³/₄ × 14⁵/₈ in. (52.7 × 37.1 cm); painted surface 19³/₈ × 14 in. (49.2 × 35.6 cm)
Inscribed (upper right, on building): VT SIT NOSTRA . . . (in order that our . . .)
Arms (upper right) of the Gozzadini family
Robert Lehman Collection, 1975
1975.1.95
ROBERT LEHMAN COLLECTION

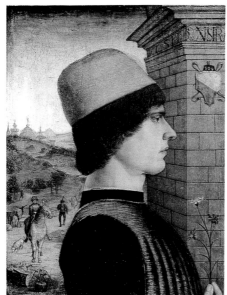

1975.1.95

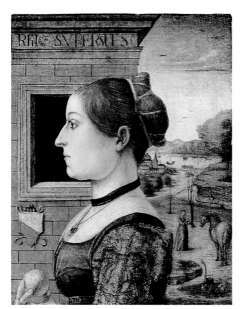

1975.1.96

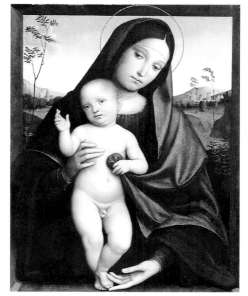

1982.448

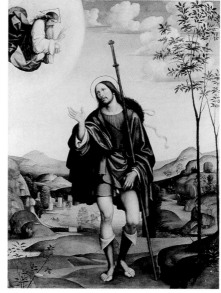

65.220.1

Portrait of a Woman of the Gozzadini Family
Tempera on wood; overall 19³/₄ × 14⁵/₈ in.
(50.2 × 37.1 cm); painted surface
19¹/₈ × 14¹/₈ in. (48.6 × 35.9 cm)
Inscribed (upper left, on building): . . .
FORMA·SVPERSTES (. . . features may survive)
Arms (lower left) of the Gozzadini family
Robert Lehman Collection, 1975
1975.1.96
ROBERT LEHMAN COLLECTION

Francesco Francia (Francesco di Marco di Giacomo Raibolini)

Italian, Bolognese, active by 1482, died 1517/18

Madonna and Child

Oil on wood, 24 × 18¹/₈ in. (61 × 46 cm)
Gift of Lewis C. Ledyard III, Mrs. Victor
Onet, and Mrs. T. F. Turner, in memory of
Lewis C. Ledyard, 1982
1982.448

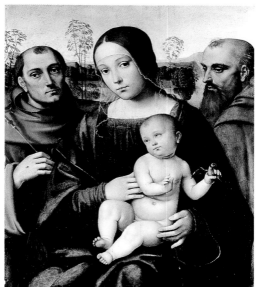

41.100.3

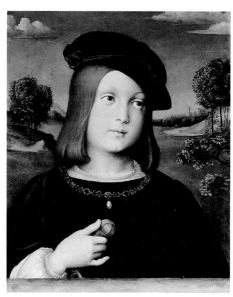

14.40.638

Saint Roch

This altarpiece is from the church of the
Arciconfraternità ed Ospedale di Santa Maria
della Morte, Bologna.
Tempera on wood, 85¹/₄ × 59³/₈ in.
(216.5 × 150.8 cm)
Signed and dated (lower left): FRA͠CIA
AVRIFABER / MCCCCCII
Gift of George R. Hann, 1965
65.220.1

Madonna and Child with Saints Francis and Jerome

Tempera on wood; overall 29¹/₂ × 22³/₈ in.
(74.9 × 56.8 cm); painted surface
27¹/₂ × 22¹/₄ in. (69.9 × 56.5 cm)
Gift of George Blumenthal, 1941
41.100.3

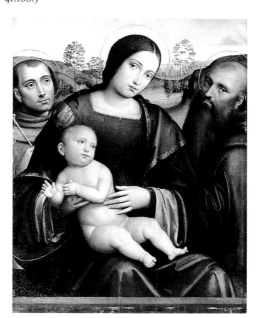

1975.1.97

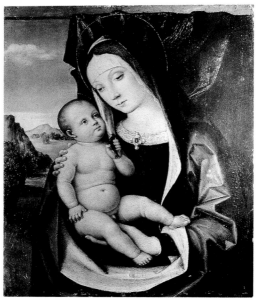

32.100.94

Federigo Gonzaga (1500–1540)

Tempera on wood, transferred from wood to
canvas and then again to wood; overall
18⁷/₈ × 14 in. (47.9 × 35.6 cm); painted
surface 17³/₄ × 13¹/₂ in. (45.1 × 34.3 cm)
Bequest of Benjamin Altman, 1913
14.40.638

Madonna and Child with Saints Francis and Jerome

Oil and gold on wood, 29¹/₂ × 22¹/₂ in.
(74.9 × 57.2 cm)
Signed (right, on parapet): FRANCIA
AURIFABER P.
Robert Lehman Collection, 1975
1975.1.97
ROBERT LEHMAN COLLECTION

Ercole Banci

Italian, Bolognese, active early 16th century

Madonna and Child

Tempera on wood, 15¼ × 12³/8 in.
(38.7 × 31.4 cm)
The Friedsam Collection, Bequest of Michael
Friedsam, 1931
32.100.94

Francesco Zaganelli (Francesco di Bosio)

Italian, Romagnole, active by 1499, died 1532

Saint Lucy

Tempera and gold on wood, 12³/8 × 7³/4 in.
(31.4 × 19.7 cm)
Theodore M. Davis Collection, Bequest of
Theodore M. Davis, 1915
30.95.292

L'Ortolano (Giovanni Battista Benvenuti)

Italian, Ferrarese, active by 1512, died after
1527

The Adoration of the Shepherds

Oil on canvas, transferred from wood,
19³/8 × 28³/4 in. (49.2 × 73 cm)
Theodore M. Davis Collection, Bequest of
Theodore M. Davis, 1915
30.95.296

Garofalo (Benvenuto Tisi)

Italian, Ferrarese, 1476?–1559

Saint Nicholas of Tolentino Reviving the Birds

It is likely that this painting, the following
(17.190.24), and the Mass of Saint Nicholas of
Tolentino (Pinacoteca Nazionale, Ferrara)
formed the predella of an altarpiece formerly
in the Muzzarelli chapel, Sant'Andrea, Ferrara.
At the center was a statue of the saint (Casa
Romei, Ferrara), flanked by paintings of Saint
John the Baptist and the Archangel Michael
(both presumed lost), also by Garofalo.
Oil on canvas, transferred from wood,
12⁷/8 × 26 in. (32.7 × 66 cm)
Gift of J. Pierpont Morgan, 1917
17.190.23

Saint Nicholas of Tolentino Reviving a Child (predella panel)

Oil on canvas, transferred from wood,
13 × 25³/4 in. (33 × 65.4 cm)
Gift of J. Pierpont Morgan, 1917
17.190.24

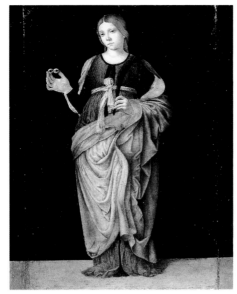

30.95.292

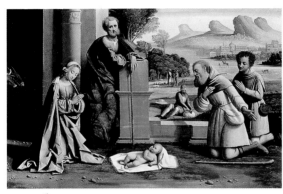

30.95.296

17.190.23

17.190.24

26.83

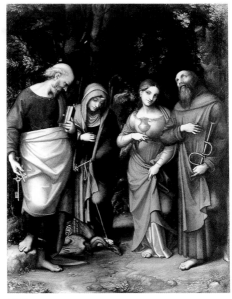

12.211

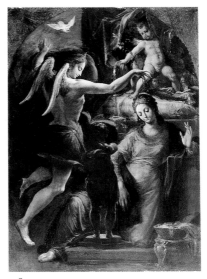

1982.319

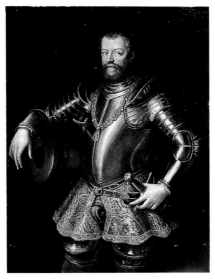

14.25.1874

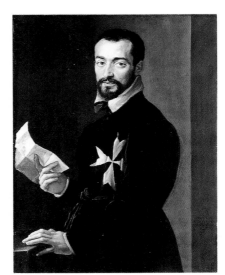

41.100.5

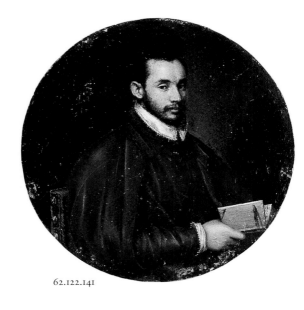

62.122.141

Dosso Dossi (Giovanni de Lutero)
Italian, Ferrarese, active by 1512, died 1542
The Three Ages of Man
Oil on canvas, 30¹/₂ × 44 in.
(77.5 × 111.8 cm)
Maria DeWitt Jesup Fund, 1926
26.83

Correggio (Antonio Allegri)
Italian, Parma, active by 1514, died 1534
Saints Peter, Martha, Mary Magdalen, and Leonard
Oil on canvas, 87¹/₄ × 63³/₄ in.
(221.6 × 161.9 cm)
John Stewart Kennedy Fund, 1912
12.211

Attributed to Parmigianino (Girolamo Francesco Maria Mazzola)
Italian, Parma, 1503–1540
The Annunciation
Oil on wood, 33³/₈ × 23¹/₈ in.
(84.8 × 58.7 cm)
Purchase, Gwynne Andrews Fund, James S. Deely Gift, special funds, and other gifts and bequests, by exchange, 1982
1982.319

Italian (Ferrarese) Painter
second quarter 16th century
Alfonso d'Este (1486–1534), *Duke of Ferrara*
Oil on canvas, 52⁷/₈ × 38¹/₄ in.
(134.3 × 97.2 cm)
Gift of William H. Riggs, 1913
14.25.1874
ARMS AND ARMOR

Bartolomeo Passerotti
Italian, Bolognese, 1529–1592
Portrait of a Knight of Malta
Oil on canvas, 35 × 26¹/₄ in.
(88.9 × 66.7 cm)
Dated and inscribed (lower right): ·MDLXVI/ ÆTATIS SVÆ /ANN[O] XXIX
Gift of George Blumenthal, 1941
41.100.5

Attributed to Lavinia Fontana
Italian, Bolognese, 1552–1614
Portrait of a Prelate
Oil on copper, diameter 5¹/₂ in. (14 cm)
Bequest of Millie Bruhl Fredrick, 1962
62.122.141

Agostino Carracci

Italian, Bolognese, 1557–1602

or

Annibale Carracci

Italian, Bolognese, 1560–1609

Two Children Teasing a Cat

Oil on canvas, 26 × 35 in. (66 × 88.9 cm)
Purchase, Gwynne Andrews Fund, and
Bequests of Collis P. Huntington and Ogden
Mills, by exchange, 1994
1994.142

Annibale Carracci

Italian, Bolognese, 1560–1609

The Coronation of the Virgin

This picture was painted for Cardinal Pietro
Aldobrandini (1572–1621), nephew of Pope
Clement VIII.
Oil on canvas, 46³/₈ × 55⁵/₈ in.
(117.8 × 141.3 cm)
Purchase, Bequest of Miss Adelaide Milton de
Groot (1876–1967), by exchange, and Dr. and
Mrs. Manuel Porter and sons Gift, in honor
of Mrs. Sarah Porter, 1971
1971.155

1994.142

1971.155

59.32

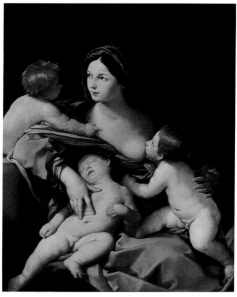

1974.348

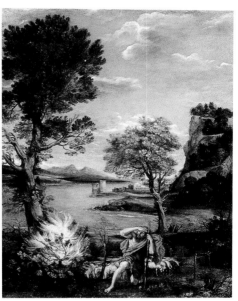

1976.155.2

1984.459.3

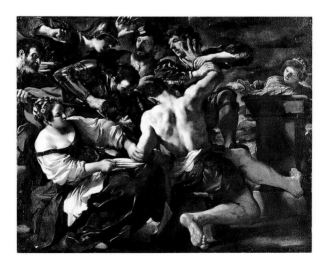

1984.459.2

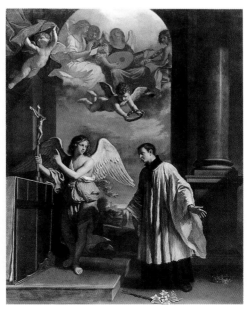

1973.311.3

Guido Reni
Italian, Bolognese, 1575–1642

The Immaculate Conception
The painting was commissioned in 1627 for Infanta María of Spain by the duke of Alcalá, the Spanish ambassador in Rome.
Oil on canvas, 105¹/₂ × 73 in.
(268 × 185.4 cm)
Victor Wilbour Memorial Fund, 1959
59.32

Charity
Oil on canvas, 54 × 41³/₄ in.
(137.2 × 106 cm)
Gift of Mr. and Mrs. Charles Wrightsman, 1974
1974.348

Domenichino (Domenico Zampieri)
Italian, Bolognese, 1581–1641

Landscape with Moses and the Burning Bush
This painting had a pendant, Landscape with Tobias Laying Hold of the Fish (National Gallery, London).
Oil on copper, 17³/₄ × 13³/₈ in.
(45.1 × 34 cm)
Gift of Mr. and Mrs. Charles Wrightsman, 1976
1976.155.2

The Assumption of the Virgin with Saints Nicholas of Myra and Anne
Oil on canvas, 100³/₄ × 66¹/₂ in.
(255.9 × 168.9 cm)
Signed and dated (lower right): DOM. ZAMPERIVS / F. A. MDCXXXVII
Gift of Mr. and Mrs. Charles Wrightsman, 1984
1984.459.3

Guercino (Giovanni Francesco Barbieri)
Italian, Ferrarese, 1591–1666

Samson Captured by the Philistines
Oil on canvas, 75¹/₄ × 93¹/₄ in.
(191.1 × 236.9 cm)
Gift of Mr. and Mrs. Charles Wrightsman, 1984
1984.459.2

The Vocation of San Luigi Gonzaga
Oil on canvas, 140 × 106 in.
(355.6 × 269.2 cm)
Gift of Mr. and Mrs. Charles Wrightsman, 1973
1973.311.3

Master of Saint Francis

Italian, Umbrian, active third quarter 13th century

Saints Bartholomew and Simon

This panel—with Saint Francis (Galleria Nazionale, Perugia), Saint James and Saint John the Evangelist (both National Gallery of Art, Washington, D.C.), Saint Matthew (Galleria Nazionale, Perugia), and Saint Peter (private collection)—formed the left side of one face of the main altarpiece at San Francesco al Prato, Perugia; the right side of the other face depicted Isaiah (Tesoro di San Francesco, Assisi), and the Deposition, the Lamentation, and Saint Anthony (all Galleria Nazionale, Perugia).
Tempera on wood, gold ground,
18³/₄ × 9 in. (47.6 × 22.9 cm)
Robert Lehman Collection, 1975
1975.1.104
ROBERT LEHMAN COLLECTION

1975.1.104

47.143

Italian (Umbrian) Painter

first quarter 14th century

Madonna and Child (fragment)

Tempera on wood, gold ground,
24¹/₄ × 16¹/₂ in. (61.5 × 41.9 cm)
Gift of Robert Lehman, 1947
47.143

Guido Palmeruccio (also called Guiduccio Palmerucci)

Italian, Gubbio, active 1315–1349

Saint Romuald

Tempera on wood, gold ground; overall, with engaged frame, 18¹/₈ × 10³/₄ in. (46 × 27.3 cm)
The Jack and Belle Linsky Collection, 1982
1982.60.1

1982.60.1

69.280.2

Francescuccio Ghissi (Francesco di Cecco Ghissi)

Italian, Marchigian, active 1359–1374

Saint John the Evangelist with Acteus and Eugenius

This panel and the following two (69.280.3, 1) are from a series dedicated to Saint John the Evangelist, which was arranged in rows on either side of a Crucifixion (Art Institute of Chicago). The others are Saint John Resuscitating Drusiana (Portland Art Museum, Oregon), Saint John and the Philosopher Crato, Acteus and Eugenius Requesting Saint John to Restore Their Gems, and Saint John and the Poisoned Cup (all North Carolina Museum of Art, Raleigh), and an eighth scene (location unknown).
Tempera on wood, gold ground,
14³/₈ × 16¹/₄ in. (36.5 × 41.3 cm)
Gift of Mrs. W. Murray Crane, 1969
69.280.2

69.280.3

69.280.1

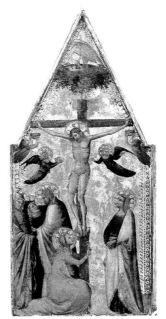

1975.1.106

30.95.262

32.100.96

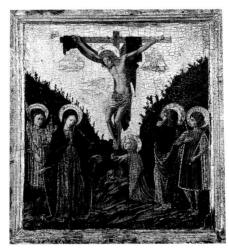

1975.1.108

thou was found worthy to bear, alleluia, has risen, as he said [Easter antiphon].)
Theodore M. Davis Collection, Bequest of Theodore M. Davis, 1915
30.95.262

Italian (possibly Marchigian) Painter

first half 15th century

The Annunciation

Tempera and gold on wood; overall 17⁷/₈ × 14⁷/₈ in. (45.4 × 37.8 cm); painted surface 15¹/₄ × 14 in. (38.7 × 35.6 cm)
Inscribed (on the wall, beside the Virgin): fiat m̄[ihi] se[cun]d̄[u]m v[e]rbū[m] tu[u]m (Be it unto me according to thy word [Luke 1:38].)
The Friedsam Collection, Bequest of Michael Friedsam, 1931
32.100.96

Italian Painter

of uncertain date

Christ on the Cross with the Virgin, Saint John the Evangelist, Saint Mary Magdalen, and Two Male Saints

While the panel is old, the paint surface is almost entirely modern. The Christ seems to derive from a figure in a predella panel by Giovanni Boccati (Umbrian, active by 1445, died 1480).
Tempera on wood, gold ground; overall 19³/₈ × 17 in. (49.1 × 43.2 cm); painted surface 17 × 14¹/₂ in. (43.2 × 36.8 cm)
Robert Lehman Collection, 1975
1975.1.108
ROBERT LEHMAN COLLECTION

Pietro di Domenico da Montepulciano

Italian, Marchigian, active first quarter 15th century

Madonna and Child with Angels

Tempera on wood, gold ground; overall, with engaged frame, 34⁵/₈ × 26¹/₄ in. (87.9 × 66.7 cm); painted surface 30⁵/₈ × 22¹/₄ in. (77.8 × 56.5 cm)
Signed, dated, and inscribed: (base of frame) petrus·dominici·demonte·pulitiano· pinsit· M·CCCC·XX·; (on Madonna's halo) AVE GRATIA PLENA D[OMIN]US TECU[M] (Luke 1:28); (on her crown) ACCIPE CORONAM (Receive [thy] crown); (border of her mantle) MARIA VIRGO SPONSA CHR[ISTI] (Virgin Mary, Bride of Christ); (neck of her dress) REGINA C[O]ELI (Queen of Heaven); (edges of her sleeves) AVE MARIA
Rogers Fund, 1907
07.201

Saint John the Evangelist Causes a Pagan Temple to Collapse

Tempera on wood, gold ground, 14¹/₈ × 15¹/₄ in. (35.9 × 38.7 cm)
Gift of Mrs. W. Murray Crane, 1969
69.280.3

Saint John the Evangelist Raises Satheus to Life

Tempera on wood, gold ground; overall 14¹/₈ × 16¹/₈ in. (35.9 × 41 cm); painted surface 13³/₄ × 15¹/₂ in. (34.9 × 39.4 cm)
Gift of Mrs. W. Murray Crane, 1969
69.280.1

Allegretto Nuzi

Italian, Marchigian, active by 1345, died 1373

The Crucifixion (part of a triptych or diptych)

Tempera on wood, gold ground, 17¹/₈ × 7⁷/₈ in. (43.5 × 20 cm)
Robert Lehman Collection, 1975
1975.1.106
ROBERT LEHMAN COLLECTION

Gentile da Fabriano (Gentile di Niccolò di Giovanni di Massio)

Italian, Umbrian, active by 1408, died 1427

Madonna and Child with Angels

Tempera on wood, traces of gold ground, 33³/₄ × 20 in. (85.7 × 50.8 cm)
Inscribed (on scroll): [R]egina c[o]eli l[a]eta re alle luia [quia] quem meruist[i] por tar[e a]ll[e]luya [r]esur[rexit] / sicut (Queen of Heaven, rejoice, alleluia, because he whom

Bartolomeo di Tommaso
Italian, Umbrian, active by 1425, died 1453/54

The Betrayal of Christ
This panel and the following (58.87.2) are
from the predella of the same altarpiece.
Tempera on wood; overall 8³⁄4 × 17 in.
(22.2 × 43.2 cm); irregular painted surface
7³⁄4 × 16¹⁄8 in. (19.7 × 41 cm)
Gwynne Andrews Fund, 1958
58.87.1

The Lamentation and the Entombment
(predella panel)
Tempera on wood, gold ground; overall
8³⁄4 × 17¹⁄8 in. (22.2 × 43.5 cm); irregular
painted surface 8 × 16¹⁄8 in. (20.3 × 41 cm)
Gwynne Andrews Fund, 1958
58.87.2

Fra Carnevale (Bartolomeo di Giovanni Corradini)
Italian, Marchigian, active by 1445, died 1484

The Birth of the Virgin
This painting has a companion piece
(Museum of Fine Arts, Boston) apparently
depicting the Presentation of the Virgin in the
Temple.
Tempera and oil on wood, 57 × 37⁷⁄8 in.
(144.8 × 96.2 cm)
Rogers and Gwynne Andrews Funds, 1935
35.121

Italian (Roman) Painter
about 1445

Santa Francesca Romana (1384–1440) Clothed by the Virgin
This panel, the following (1975.1.101), and a
Communion and Consecration of Blessed
Francesca Romana (Walters Art Gallery,
Baltimore) formed part of a more extensive
series of scenes from her life, presumed to
have been painted for the church of Santa
Maria Nuova, Rome. A Mystical Crucifixion
(National Gallery, Prague) may be from the
same complex.
Tempera on wood, gold ground,
21³⁄4 × 14⁷⁄8 in. (55.2 × 37.8 cm)
Inscribed (with excerpts from accounts of the
saint's visions, XCV and XLVII, from a
manuscript of 1469 in the Vatican Library):
(on Christ Child's scroll) Anima che si
ordinate pigliate l'arme mee da mi si
reformata che facci/lo mio volere puorti le
insegne mee fa che vivi in amore la luce con
ar/dore in ti farragio remanere, amame mi
anima amame che t'agio ri/amata damme ad
mi conforso cha io t'agio conforsata (Soul,
you are thus prepared to take up my arms, so
transformed by me that you will do my
bidding. Wear my emblems, live in [holy]
love. I will keep the light burning brightly
within you. Love me, my Soul; love me as I
have loved you. Comfort me as I have
comforted you.); (on Virgin's scroll) . . . ette
da l'alto creatore. che lo signore ve a accepte

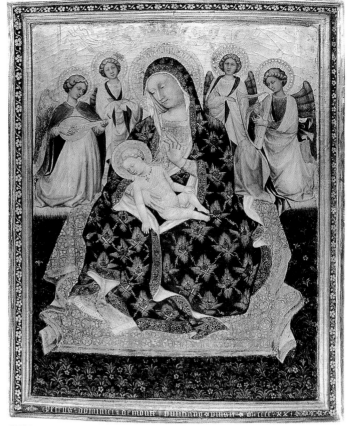

07.201

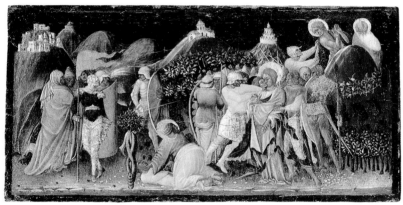

58.87.1

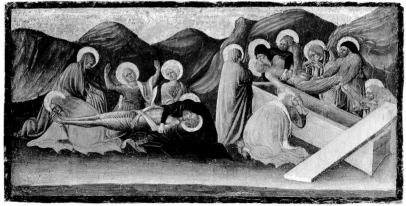

58.87.2

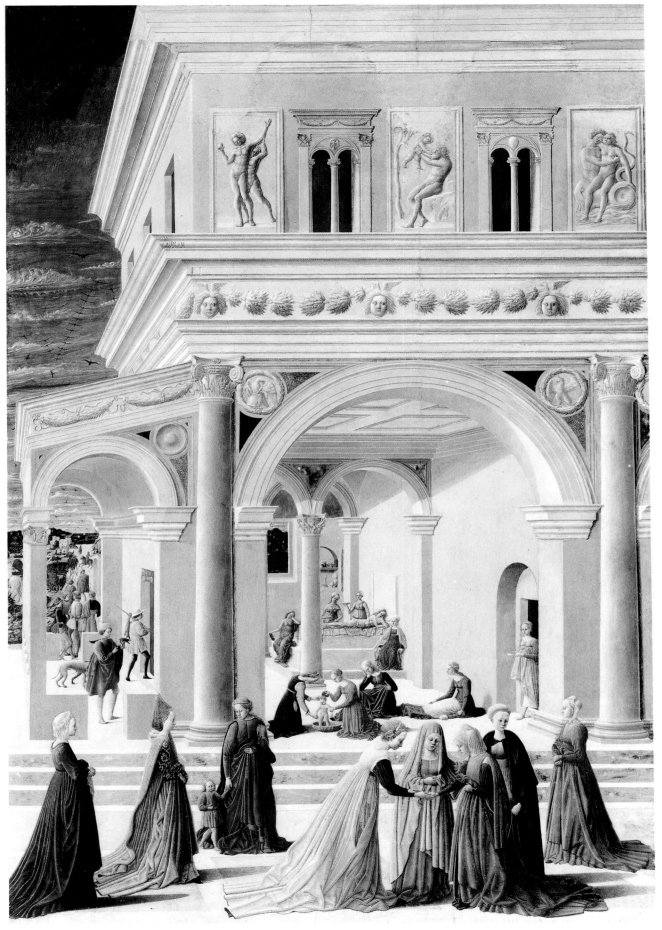

35.121

nella mea unione/. . . scelte nella mea
chiamata la donna anuntiata tutte voi ve
aspecta/. . . l'animo si reale. siate bene fuorti
ad cio che ve intervenerane ([proceeded?]
from the high creator . . . that the Lord has
accepted you all in his union with me . . .
you are in my appeal the woman united with
all the others [and he] awaits you . . . the soul
so regal. May you be strong in the face of
whatever may happen to you.); (on Saint
Paul's scroll) Preparate tu anima preparate ad
questi bieni ad[?] questi . . . li quali . . .
fa/chencie[?] si virile animosa et fervente . . .
confiamata et . . . te ardere de amore . . .
(Prepare yourself, soul; prepare yourself for
these blessings, [for?] these . . . which . . .
will make [you?] so strong, bold, and fervent
. . . enflamed and . . . burning with [holy]
love. . . .)
Robert Lehman Collection, 1975
1975.1.100
ROBERT LEHMAN COLLECTION

Santa Francesca Romana (1384–1440) Holding the Christ Child

Tempera on wood, gold ground, inscriptions
on parchment laid down on wood,
21³/₄ × 14⁷/₈ in. (55.2 × 37.8 cm)
Inscribed with lines from Dante's *Paradiso:*
(on Mary Magdalen's scroll) Vergine Madre,
figlia del tuo figlio: humile et alta più che
creatura,/[Termine] fisso d'etterno consiglo,
Tu sei colei che l'humana natur./Nobilitasti si
che'l suo Fattore Non si sdegno di farsi tua
factura Nel ventre tuo/si raccese l'amore: Per
lo cui caldo nell'heterna pace: Cosi è
germinato questo fiore. (Virgin mother,
daughter of thy Son, humble and exalted
more than any creature, fixed goal of the
eternal counsel, thou art she who didst so
ennoble human nature that its Maker did not
disdain to become its creature. In thy womb
was rekindled the Love under whose warmth
this flower in the eternal peace has thus
unfolded [33:1–9].); (on Virgin's scroll)
Donna, sei tanto grande et tanto vali, Che
qual vuol grazia, ed ad te non riccore./Sya
distanza vuol volar senza ale. La tua benignità
non pur socorre./A chi demanda: ma molto
fiate Leberamente al dimandar preccorre.
(Lady, thou art so great and so availest, that
whoso would have grace and has not recourse
to thee, his desire seeks to fly without wings.
Thy loving-kindness not only succors him
who asks, but oftentimes freely foreruns
the asking [33:13–18].); (on angel's scroll)
In te misericordia, in te pietate,/In te
magnificenzia, in te saduna:/Quantunque in
creatura e di bontate. (In thee is mercy, in
thee pity, in thee munificence, in thee is
found whatever of goodness is in any creature
[33:19–21].). (Trans. Charles S. Singleton,
Princeton University Press, 1975)
Robert Lehman Collection, 1975
1975.1.101
ROBERT LEHMAN COLLECTION

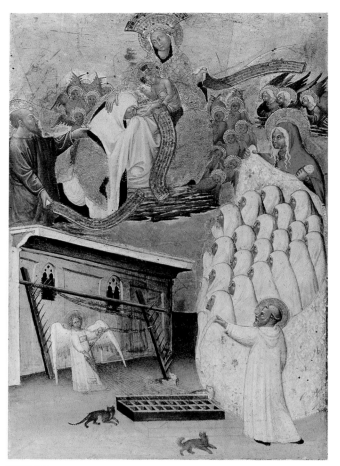

1975.1.100

1975.1.101

06.1214

41.190.9

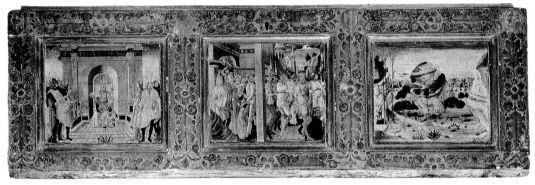

08.133

1975.1.107

32.100.74

Madonna and Child
Tempera on wood, gold ground; overall
14⅞ × 10¾ in. (37.8 × 27.3 cm); painted
surface 14⅛ × 10⅛ in. (35.9 × 25.7 cm)
Bequest of George Blumenthal, 1941
41.190.9

Central Italian Painter
fourth quarter 15th century
Scenes from the Life of King
Nebuchadnezzar (cassone panel)
Tempera on wood, embossed and gilt
ornament; overall, with engaged (modern)
frame, 24⅜ × 69⅛ in. (61.9 × 175.6 cm);
left, painted surface 12⅞ × 14⅝ in.
(32.7 × 37.1 cm); center, painted surface
12¾ × 14¾ in. (32.4 × 37.5 cm); right,
painted surface 12¾ × 14½ in.
(32.4 × 36.8 cm)
Inscribed: (left, on architrave) REX·REGVM
·DOMINVM [DOMINANTIVM] (King of Kings
and Lord [of Lords] [Revelation 19:16].);
(center, on entablature) . . . SOR REX
([Nebuchadnez]zar King)
Gift of James L. Loeb, 1908
08.133

Niccolò Alunno (Niccolò di Liberatore)
Italian, Umbrian, active by about 1456, died
1502
Saint Anne and the Virgin and Child
Enthroned with Angels
This panel and a Saint Michael Adored by
Members of a Confraternity (Art Museum,
Princeton University) formed the two faces of
a double-sided altarpiece or processional
standard.
Tempera on wood, gold ground,
47⅜ × 27⅛ in. (120.3 × 68.9 cm)
Inscribed: (base) NT. ESSE[T]; (bottom of
Virgin's cloak) AVE MARIA GRATIA PLENA
DOM[INVS] TECVM BENEDICTA
Robert Lehman Collection, 1975
1975.1.107
ROBERT LEHMAN COLLECTION

Italian (Umbrian) Painter
about 1500
Madonna and Child with Saints Jerome
and Francis
Tempera on wood; overall 24⅝ × 16¾ in.
(62.5 × 42.5 cm); painted surface
23⅝ × 15⅞ in. (60 × 40.3 cm)
The Friedsam Collection, Bequest of Michael
Friedsam, 1931
32.100.74

Antoniazzo Romano (Antonio di Benedetto Aquilio)
Italian, Roman, active by 1452, died by 1512
The Nativity
This is the central panel of a predella that
included the Feast of Herod (Gemäldegalerie,
SMPK, Berlin) and Saint Jerome Healing the
Lion's Paw (Ca' d'Oro, Venice). A Saint John

the Baptist (Städelsches Kunstinstitut,
Frankfurt) and a Saint Jerome (art market,
1920) have been identified as lateral panels of
the triptych.
Tempera on wood, 11½ × 26½ in.
(29.2 × 67.3 cm)
Rogers Fund, 1906
06.1214

Perugino (Pietro di Cristoforo Vannucci)

Italian, Umbrian, active by 1469, died 1523

The Resurrection

This panel and a Nativity, Baptism of Christ, Christ and the Woman of Samaria, and Noli Me Tangere (all Art Institute of Chicago) formed the predella of an altarpiece.
Tempera on wood, 10⅝ × 18 in.
(27 × 45.7 cm)
Frederick C. Hewitt Fund, 1911
11.65

Saint John the Baptist; Saint Lucy

The components of the high altarpiece of the Santissima Annunziata, Florence—from which these two panels come—also include the Deposition, which is in part by Filippino Lippi (Galleria dell'Accademia, Florence), the Assumption (Santissima Annunziata), Saint Helen (Staatliches Lindenau-Museum, Altenburg), two male Servite saints (Staatliches Lindenau-Museum and Galleria Nazionale, Palazzo Barberini, Rome), and Saint Catherine of Alexandria (art market, 1981).
Oil(?) on wood, each 63 × 26⅜ in.
(160 × 67 cm)
Gift of The Jack and Belle Linsky Foundation, 1981
1981.293.1–2

Luca Signorelli (Luca d'Egidio di Luca di Ventura)

Italian, Tuscan, active by 1470, died 1523

Madonna and Child

Oil and gold on wood, 20¼ × 18¾ in.
(51.4 × 47.6 cm)
Inscribed: (upper left corner, around edge of coin, partly in reverse) S·P·Q·R DOMICIANVS·II IM· / S / C (The Senate and the People of Rome. Domitian, emperor in the second year of his reign, by decree of the Senate); (upper right corner, around edge of coin) S·P·Q·R·CHA·CHALI·IM AN·III·M·IIII·/I C (The Senate and the People of Rome. Caracalla, emperor in the third year and fourth month of his reign . . .)
The Jules Bache Collection, 1949
49.7.13

Luca Signorelli and Workshop

The Assumption of the Virgin with Saints Michael and Benedict

This altarpiece was painted for the convent of Santissima Trinità, Cortona.
Oil and gold on wood, 67¼ × 51¾ in.
(170.8 × 131.4 cm)
Purchase, Joseph Pulitzer Bequest, 1929
29.164

11.65

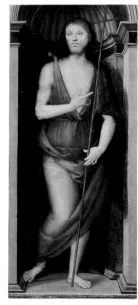

1981.293.1

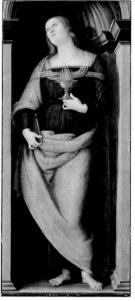

1981.293.2

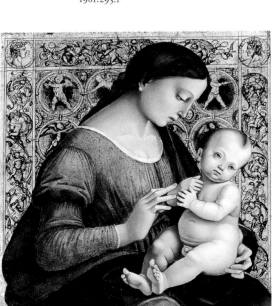

49.7.13

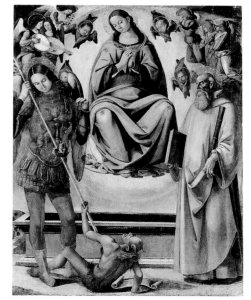

29.164

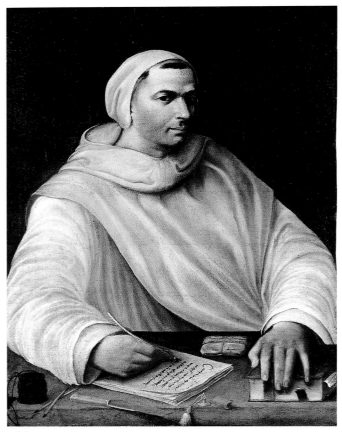

1986.339.1

14.114.1–22

Attributed to Baldassare Tommaso Peruzzi

Italian, Sienese, 1481–1536

Portrait of an Olivetan Monk, Possibly Barnaba Cevennini (died 1525)

Oil on canvas, 38¹/₄ × 28⁵/₈ in.
(97.2 × 72.7 cm)
Inscribed: (on packet) B[ologna(?)]; (on letter) C . . . [illegible]
Gift of Mrs. Charles Wrightsman, 1986
1986.339.1

Pinturicchio (Bernardino di Betto di Biagio) and Workshop

Italian, Umbrian, active by 1481, died 1513

Ceiling from the Palace of Pandolfo Petrucci (1451–1512), *Called Il Magnifico, Siena*

The original stucco work and a fragment of one fresco are in situ. The subjects are: (1–4) Putti with Garlands; (5) Rape of Proserpine; (6) Chariot of Apollo; (7) Triumph of Mars; (8) Chariot of Ceres; (9) Triumph of Cybele; (10) Triumph of Alexander; (11) Triumph of Amphitrite; (12) Triumph of a Warrior; (13) Galatea(?); (14) Hunt of the Calydonian Boar; (15) Judgment of Paris; (16) Helle on a Ram; (17) Hercules and Omphale; (18) Rape of Europa; (19) Bacchus, Pan, and Silenus; (20) Jupiter and Antiope; (21) Three Graces; (22) Venus and Cupid.

Fresco, transferred to canvas and laid down on wood; overall 190¹/₄ × 195¹/₄ in.
(483.2 × 495.9 cm)
Rogers Fund, 1914
14.114.1–22

14.114.1-4

14.114.5

14.114.6

14.114.7

14.114.8

14.114.9

14.114.10

14.114.11

14.114.12

14.114.13

14.114.14

14.114.15

14.114.16

14.114.17

14.114.18

14.114.19

14.114.20

14.114.21

14.114.22

48.17.8

48.17.2

48.17.4

48.17.6

48.17.3

48.17.7

48.17.10

48.17.5

48.17.9

48.17.11

48.17.1

48.17.12

Baldassare Tommaso Peruzzi

Italian, Sienese, 1481–1536

Frescoes from the Villa Stati-Mattei

These frescoes are from the vaulted ceiling of a loggia on the Palatine Hill, Rome. The subjects are: (1–12) the Signs of the Zodiac—Aquarius, Pisces, Aries, Taurus, Gemini, Cancer, Leo, Virgo, Libra, Scorpio, Sagittarius, and Capricorn; (13) Venus and Cupid with Poetry, Drama, Dance, and Music; (14) unidentified mythological subject; (15–22) Thalia, Terpsichore, Erato, Urania, Euterpe, Minerva, Melpomene, and Apollo. They are on long-term loan to the Villa Stati-Mattei. Eight mythological scenes from the walls are in the Hermitage, Saint Petersburg. Fresco, transferred to canvas; (1–12) each 12⁷/₈ × 12⁷/₈ in. (32.7 × 32.7 cm); (13–14) each 13⁷/₈ × 26⁷/₈ in. (35.2 × 68.3 cm); (15–22) each 35¹/₈ × 20¹/₂ in. (89.2 × 52.1 cm)

Gwynne Andrews Fund, 1947
48.17.1–22

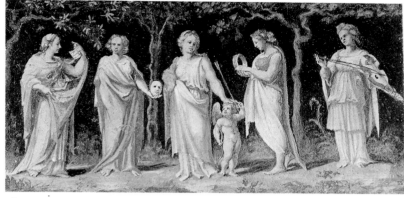

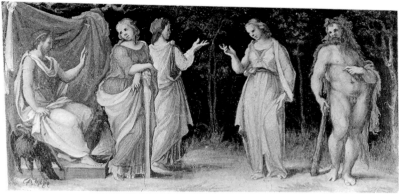

48.17.13

48.17.14

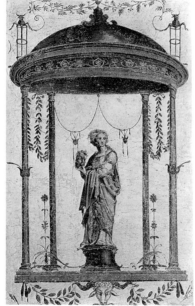

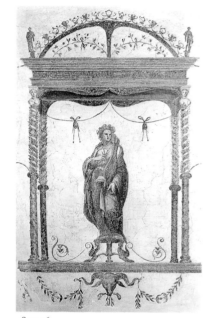

48.17.15

48.17.16

48.17.17

48.17.18

48.17.19

48.17.20

48.17.21

48.17.22

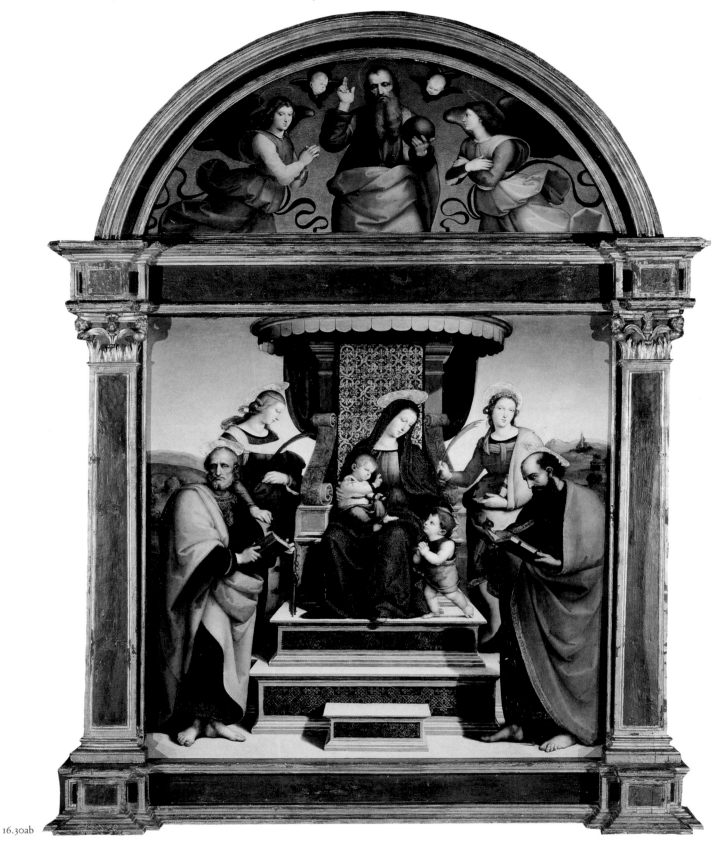

16.30ab

Raphael (Raffaello Sanzio or Santi)
Italian, Marchigian, 1483–1520

Madonna and Child Enthroned with Saints
This altarpiece is from the choir of the convent of Sant'Antonio da Padova, Perugia. Main panel: Madonna and Child with Saints

Peter, Catherine, Cecilia(?), Paul, and the infant John the Baptist; lunette: God the Father with two angels and two seraphim Tempera and gold on wood; main panel, overall 67⅞ × 67⅞ in. (172.4 × 172.4 cm); main panel, painted surface 66¾ × 66½ in. (169.5 × 168.9 cm); lunette, overall

29½ × 70⅞ in. (74.9 × 180 cm); lunette, painted surface 25½ × 67½ in. (64.8 × 171.5 cm)
Gift of J. Pierpont Morgan, 1916
16.30ab

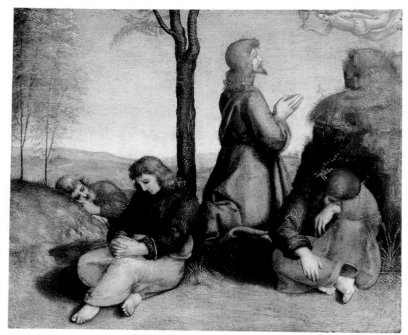

32.130.1

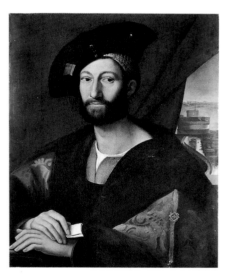

49.7.12

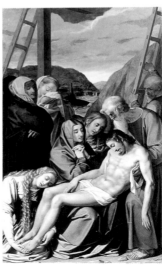

1984.74

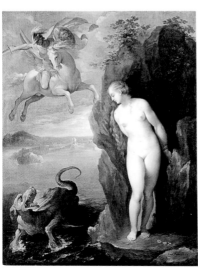

28.181

The Agony in the Garden
This is a predella panel from the preceding altarpiece (16.30ab); the others are the Way to Calvary (National Gallery, London), the Pietà (Isabella Stewart Gardner Museum, Boston), and, flanking these panels, Saints Francis and Anthony of Padua (both Dulwich Picture Gallery, London).
Tempera on wood, 9¹/₂ × 11³/₈ in.
(24.1 × 28.9 cm)
Funds from various donors, 1932
32.130.1

Copy after Raphael
16th century

Giuliano de' Medici (1479–1516), ***Duke of Nemours***
Tempera and oil on canvas, 32³/₄ × 26 in.
(83.2 × 66 cm)
Inscribed (lower left): R.S.M[DXI or DX]V
The Jules Bache Collection, 1949
49.7.12

Scipione Pulzone (Il Gaetano)
Italian, Roman, active by 1569, died 1598

The Lamentation
Oil on canvas, 114 × 68 in.
(289.6 × 172.7 cm)
Signed and dated (right, on cloth held by Joseph of Arimathea): SCIPIO CAIET[A] / NVS FACI[E] / BAT AN[NO] DNI / MD.XCI
Purchase, Anonymous Gift, in memory of Terence Cardinal Cooke, 1984
1984.74

Attributed to Bernardino Cesari
Italian, Roman, died 1614

Perseus and Andromeda
Oil on wood, 21 × 15¹/₂ in. (53.3 × 39.4 cm)
Inscribed(?) (lower right): Iosepe Arpino 16[]4
Gift of Eustace Conway, 1928
28.181

Federico Barocci

Italian, Umbrian, 1535?–1612

Head of a Bearded Man Looking to Lower Left

This is a full-scale study for the head of one of the bearers of the body of the dead Christ in the Entombment (Santa Croce, Senigallia), a painting begun in 1579 and finished in 1582.
Oil on paper, laid down on canvas,
15¼ × 10¾ in. (38.7 × 27.3 cm)
Harry G. Sperling Fund, 1976
1976.87.1
DRAWINGS AND PRINTS

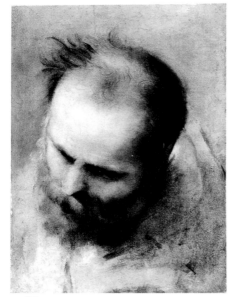

1976.87.1

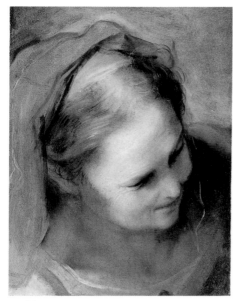

1976.87.2

Head of an Old Woman Looking to Lower Right

This is a full-scale study for the head of Saint Elizabeth in the Visitation (Chiesa Nuova, Rome), a painting begun in 1583 and finished in 1586.
Oil on paper, laid down on canvas,
15⅜ × 10¾ in. (39.1 × 27.3 cm)
Harry G. Sperling Fund, 1976
1976.87.2
DRAWINGS AND PRINTS

Caravaggio (Michelangelo Merisi)

Italian, Lombard, 1571–1610

The Musicians

This painting was commissioned by Cardinal Francesco Maria del Monte (1549–1626).
Oil on canvas, 36¼ × 46⅝ in.
(92.1 × 118.4 cm)
Inscribed (lower left): [MI]CHELANG[ELO].DA CARAVA/[G]GIO
Rogers Fund, 1952
52.81

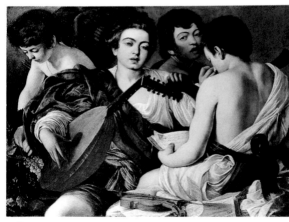

52.81

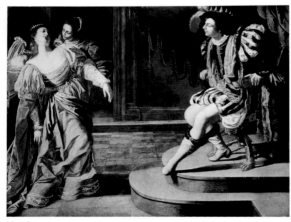

69.281

Artemisia Gentileschi

Italian, Roman, 1593–1651/53

Esther before Ahasuerus

Oil on canvas, 82 × 107¾ in. (208.3 × 273.7 cm)
Gift of Elinor Dorrance Ingersoll, 1969
69.281

Domenico Fetti

Italian, Roman, 1588/89–1623

The Parable of the Mote and the Beam

From a series of thirteen parables of Christ, which were painted about 1618–20 for Federigo Gonzaga at Mantua
Oil on wood, 24⅛ × 17⅜ in. (61.3 × 44.1 cm)
Rogers Fund, 1991
1991.153

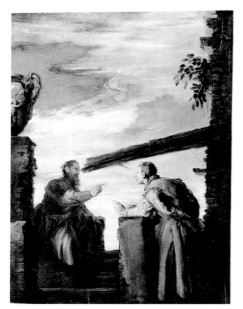

1991.153

30.31

Attributed to Domenico Fetti

The Good Samaritan

Oil on wood, 23⅝ × 17 in. (60 × 43.2 cm)
Rogers Fund, 1930
30.31

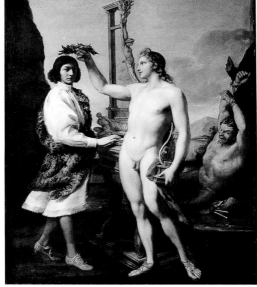

1981.317

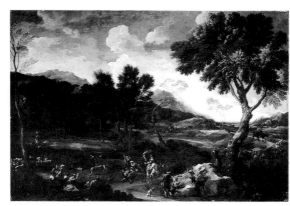

93.29

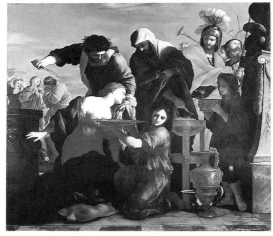

54.166

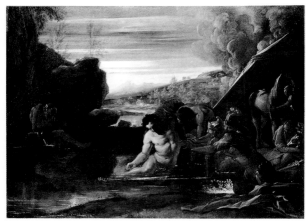

1987.75

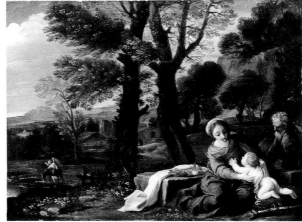

1993.20

71.118

Andrea Sacchi

Italian, Roman, 1599–1661

Marcantonio Pasqualini (1614–1691)
Crowned by Apollo
Oil on canvas, 96 × 76¹/₂ in.
(243.8 × 194.3 cm)
Purchase, Enid A. Haupt Gift and Gwynne
Andrews Fund, 1981
1981.317

Jan Miel

Flemish, 1599–1664

***Landscape with a Battle between Two
Rams***
While the figures are by Miel, the landscape
may be by another (Roman?) artist.
Oil on canvas, 68¹/₄ × 97⁵/₈ in.
(173.4 × 248 cm)
Gift of Princess Brancaccio, 1893
93.29

Giovanni Francesco Romanelli

Italian, Roman, 1610–1662

The Sacrifice of Polyxena
This picture and Achilles Surprised among the
Daughters of Lycomedes (Chrysler Museum,
Norfolk, Virginia) are from a set of four that
also included Cleopatra (private collection)
and Venus (Cassa di Risparmio, Viterbo). The
set was painted for Lorenzo di Lorenzo Chigi.
Oil on canvas, 77³/₄ × 88 in.
(197.5 × 223.5 cm)
Rogers Fund, 1954
54.166

Pietro Testa

Italian, Roman, 1612–1650

***Alexander the Great Rescued from the
River Cydnus***
Oil on canvas, 38 × 54 in.
(96.5 × 137.2 cm)
Gift of Eula M. Ganz, in memory of Paul H.
Ganz, 1987
1987.75

Pier Francesco Mola

North Italian, 1612–1666

The Rest on the Flight into Egypt
Oil on copper, 9 × 11 in. (22.9 × 27.9 cm)
Wrightsman Fund, 1993
1993.20

Italian (Roman) Painter

third quarter 17th century

***Still Life: Pomegranates and Other Fruit
in a Landscape***
Oil on canvas, 24³/₈ × 29¹/₈ in.
(61.9 × 74 cm)
Purchase, 1871
71.118

Italian (Roman?) Painters
late 17th/early 18th century

*Landscape with a Hunter; Tobit and the
Angel*
This panel is the inside of a harpsichord lid.
The crowned mermaid and the columnar
supports indicate that the instrument was
made for a member of the Colonna family.
Oil on wood, 35 × 95¼ in.
(88.9 × 241.9 cm)
Gift of Susan Dwight Bliss, 1945
45.41
MUSICAL INSTRUMENTS

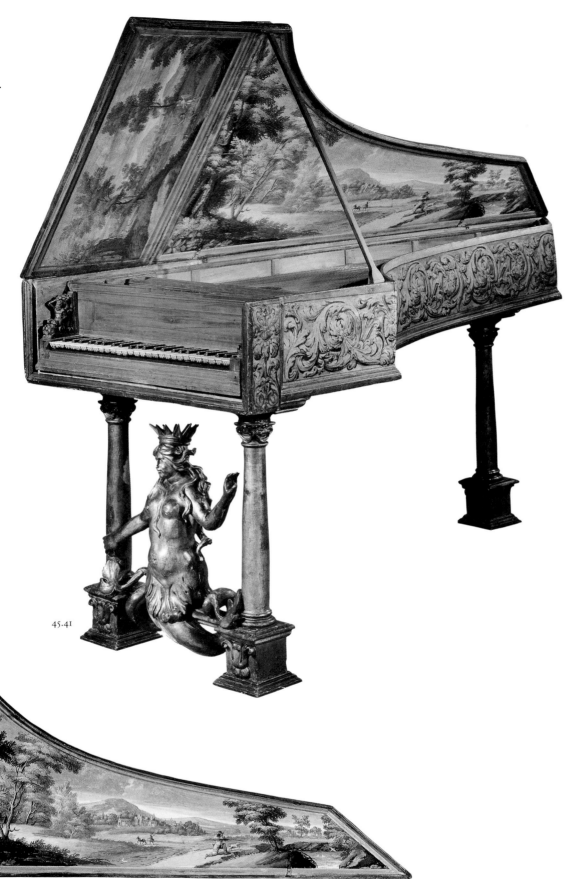

45.41

45.41

86.20

86.20

third quarter 17th century

Pastoral Scenes

This panel, painted on both sides, is the lid of a harpsichord. The instrument, dated Rome 1658, was formerly ascribed to Girolamo Zenti.

Oil on wood, 33¼ × 73½ in.
(84.5 × 186.7 cm)
Purchase by subscription, 1886
86.20
MUSICAL INSTRUMENTS

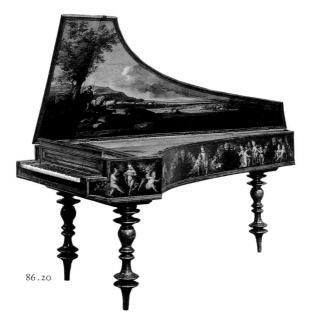

86.20

89.4.1231

17th century or later

Sleeping Venus; Angel Musicians

This panel is the inside lid of a harpsichord.
Oil on wood, 35 × 75½ in.
(88.9 × 191.8 cm)
The Crosby Brown Collection of Musical Instruments, 1889
89.4.1231
MUSICAL INSTRUMENTS

late 17th century

Landscapes

These panels are the interiors of the instrument cover and keyboard cover of a late 17th-century Roman harpsichord.
Oil on wood; instrument cover
27 × 36¾ in. (68.6 × 93.4 cm); keyboard cover 9¼ × 32⅛ in. (23.5 × 81.6 cm)
Gift of Lilliana Teruzzi, 1971
1971.4.1
ESDA

1971.4.1

1971.4.1

Giuseppe Bartolomeo Chiari

Italian, Roman, 1654–1727

Bathsheba at Her Bath

Oil on canvas, 53¹/₂ × 38¹/₂ in.
(135.9 × 97.8 cm)
Gift of Mario Modestini, 1993
1993.401

Jan Frans van Bloemen

Flemish, 1662–1749

Landscape with the Communion of Saint Mary of Egypt

Oil on canvas, 38¹/₂ × 52⁵/₈ in.
(97.8 × 133.7 cm)
Gift of Mr. and Mrs. Harold H. Burns, 1966
66.186

Giovanni Paolo Pannini (or Panini)

Italian, Roman, 1691–1765

Ancient Rome

Oil on canvas, 67³/₄ × 90¹/₂ in.
(172.1 × 229.9 cm)
Signed, dated, and inscribed (lower left, on
pedestal): I · P · PANINI ROMÆ / 1757
Gwynne Andrews Fund, 1952
52.63.1

Modern Rome

Pendant to 52.63.1
Oil on canvas, 67³/₄ × 91³/₄ in.
(172.1 × 233 cm)
Signed and dated (lower center, on base of
statue of Moses): I.P. PANINI.1757
Gwynne Andrews Fund, 1952
52.63.2

Interior of Saint Peter's, Rome

Oil on canvas, 29¹/₈ × 39¹/₄ in.
(74 × 99.7 cm)
Inscribed (around base of dome): TV ES
PETRVS ETS[VPER] . . . CELORVM (You are Peter
and upon . . . of heaven [Matthew 16:18–19].)
Purchase, 1871
71.31

Giovanni Maldura

Italian, Roman, active by 1810, died 1849

David at the Cave of Adullam

This is a copy of a painting by Claude
Lorrain of 1658 (National Gallery, London).
Oil on canvas, 45³/₄ × 76 in.
(116.2 × 193 cm)
Kretschmar Fund, 1921
21.184

1933.401

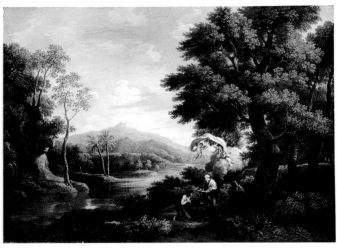

66.186

52.63.1

52.63.2

71.31

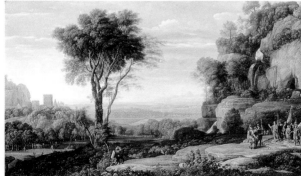

21.184

03.37.1

Pompeo Girolamo Batoni
Italian, Roman, 1708–1787

Portrait of a Young Man
Oil on canvas, 97¹⁄₈ × 69¹⁄₄ in.
(246.7 × 175.9 cm)
Inscribed (on books): ROMA / AN:E MO:; VITE
DE / PITTORI; ODISSEA / DI / OMERO / T:II:
(Rome . . . ; Lives of the Painters; Odyssey of
Homer, Volume 2)
Rogers Fund, 1903
03.37.1

Diana and Cupid
Sir Humphrey Morice (1723–1785), to whom
this picture was delivered in 1762,
commissioned a portrait of himself from
Batoni as a pendant (a version signed and
dated 1762, and another, an autograph replica,
are in private collections).
Oil on canvas, 49 × 68 in.
(124.5 × 172.7 cm)
Signed, dated, and inscribed (bottom):
Pompeo·Batoni·di Lucca·dipingeua·in Roma
1761·
Purchase, The Charles Engelhard Foundation,
Robert Lehman Foundation Inc., Mrs.
Haebler Frantz, April R. Axton, L. H. P.
Klotz, and David Mortimer Gifts; and Gifts
of Mr. and Mrs. Charles Wrightsman, George
Blumenthal, and J. Pierpont Morgan, Bequests
of Millie Bruhl Fredrick and Mary Clark
Thompson, and Rogers Fund, by exchange,
1982
1982.438

1982.438

Italian (Neapolitan or Avignon) Painter

mid-14th century

The Adoration of the Magi

This panel formed part of the same complex
as an Annunciation and a Nativity (both
Musée Granet, Aix-en-Provence).
Tempera on wood, gold ground; overall,
with engaged frame, 26¹/₈ × 18³/₈ in.
(66.4 × 46.7 cm); painted surface, including
tooled border, 21³/₈ × 15 in. (54.3 × 38.1 cm)
Robert Lehman Collection, 1975
1975.1.9
ROBERT LEHMAN COLLECTION

Roberto d'Odorisio

Italian, Neapolitan, active about 1340–1382 or
later

Saints John the Evangelist and Mary Magdalen

This panel is the right wing of a diptych; on
the left wing is the Virgin with the Dead
Christ (National Gallery, London).
Tempera on wood, gold ground,
23 × 15⁵/₈ in. (58.4 × 39.7 cm)
Robert Lehman Collection, 1975
1975.1.102
ROBERT LEHMAN COLLECTION

Andrea Delitio (Andrea da Lecce)

Italian, Abruzzese, active second and third
quarters 15th century

The Virgin Annunciate

This is the pinnacle of the right wing of a
triptych. On the back is a black-on-red
design representing brocade.
Tempera on wood, gold ground; overall,
with engaged frame, 19¹/₂ × 12 in.
(49.5 × 30.5 cm); painted surface
16¹/₈ × 9¹/₂ in. (41 × 24.1 cm)
Robert Lehman Collection, 1975
1975.1.29
ROBERT LEHMAN COLLECTION

Saturnino Gatti

Italian, Abruzzese, 1463–1518

The Translation of the Holy House of Loreto

Tempera and gold on wood, 33¹/₄ × 21⁵/₈ in.
(84.5 × 54.9 cm)
Gwynne Andrews Fund, 1973
1973.319

Massimo Stanzione

Italian, Neapolitan, 1585–1656

Judith with the Head of Holofernes

Oil on canvas, 78¹/₂ × 57¹/₂ in.
(199.4 × 146.1 cm)
Gift of Edward W. Carter, 1959
59.40

1975.1.9

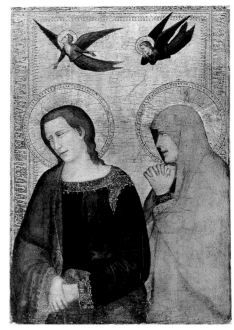

1975.1.102

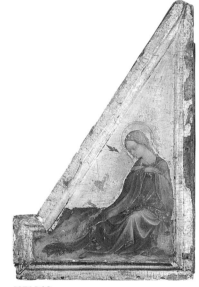

1975.1.29

1973.319

59.40

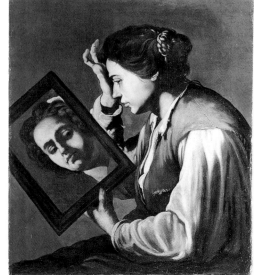

1982.60.12

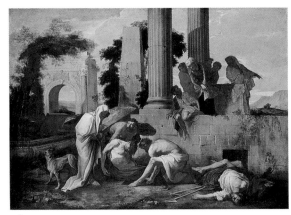

1989.225

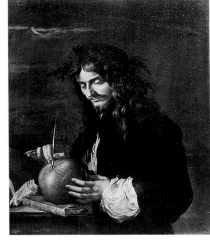

21.105

34.137

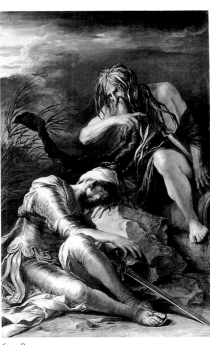

65.118

1978.402

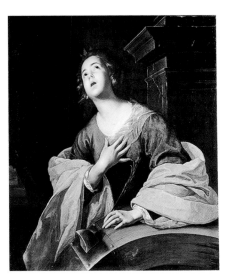

43.23

Master of the Annunciations to the Shepherds

Italian, Neapolitan, active second quarter 17th century

The Sense of Sight

Oil on canvas; overall, with added strips, 29⁷/₈ × 24⁷/₈ in. (75.9 × 63.2 cm); without additions 27³/₄ × 21³/₄ in. (70.5 × 55.2 cm)

The Jack and Belle Linsky Collection, 1982

1982.60.12

Andrea di Lione

Italian, Neapolitan, 1610–1685

Tobit Burying the Dead

A variant, on copper, is in a private collection.

Oil on canvas, 50¹/₄ × 68¹/₂ in. (127.6 × 174 cm)

Gwynne Andrews Fund, 1989

1989.225

Salvator Rosa

Italian, Neapolitan, 1615–1673

Self-portrait

Oil on canvas, 39 × 31¹/₄ in. (99.1 × 79.4 cm)

Inscribed: (on paper) Saluatore Rosa dipinse nell'Eremo / e dono a Gio. Batt. Ricciardi / suo Amico (Salvator Rosa painted this in a solitary place and gave it to his friend Giovanni Battista Ricciardi); (on skull, in Greek) Behold, whither, when; (on book) SENECA [pentiment]

Bequest of Mary L. Harrison, 1921

21.105

Bandits on a Rocky Coast

Oil on canvas, 29¹/₂ × 39³/₈ in. (74.9 × 100 cm)

Signed (lower left): SR [monogram?]

Charles B. Curtis Fund, 1934

34.137

The Dream of Aeneas

Oil on canvas, 77¹/₂ × 47¹/₂ in. (196.9 × 120.7 cm)

Signed (lower right): SR [monogram]

Rogers Fund, 1965

65.118

Mattia Preti

Italian, Neapolitan, 1613–1699

Pilate Washing His Hands

Oil on canvas, 81¹/₈ × 72³/₄ in. (206.1 × 184.8 cm)

Purchase, Gift of J. Pierpont Morgan and Bequest of Helena W. Charlton, by exchange, Gwynne Andrews, Marquand, Rogers, Victor Wilbour Memorial, and The Alfred N. Punnett Endowment Funds, and funds given or bequeathed by friends of the Museum, 1978

1978.402

Workshop of Bernardo Cavallino

Italian, Neapolitan, 1616–1654

Saint Catherine of Alexandria

Oil on canvas, 50¼ × 40¼ in.
(127.6 × 102.2 cm)
Rogers Fund, 1943
43.23

Giuseppe Recco

Italian, Neapolitan, 1634–1695

A Cat Stealing Fish

Oil on canvas, 38 × 50½ in.
(96.5 × 128.3 cm)
Signed (lower left): G R
Purchase, 1871
71.17

Luca Giordano

Italian, Neapolitan, 1632–1705

The Annunciation

Oil on canvas, 93⅛ × 66⅞ in.
(236.5 × 169.9 cm)
Signed and dated (on base of prie-dieu):
L. Jordanus F. 1672
Gift of Mr. and Mrs. Charles Wrightsman,
1973
1973.311.2

The Flight into Egypt

Oil on canvas, 24¼ × 19¼ in.
(61.5 × 48.9 cm)
Gift of Mr. and Mrs. Harold Morton Landon,
1961
61.50

61.50

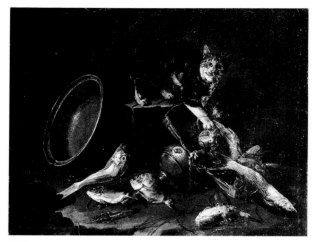

71.17

1973.311.2

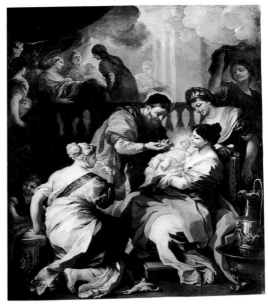

07.66

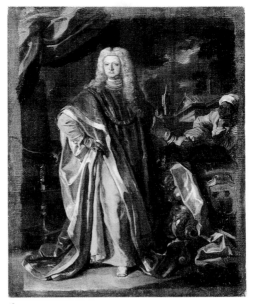

67.102

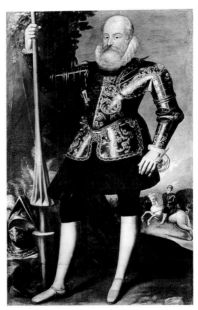

29.158.750

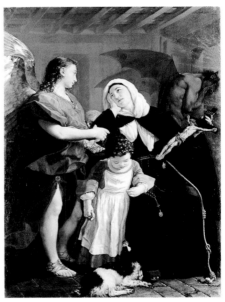

68.182

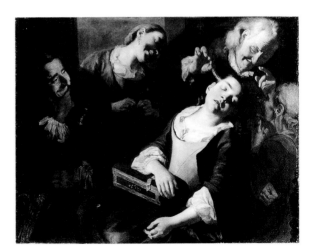

1976.100.19

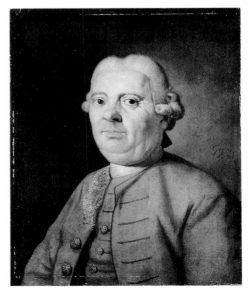

29.100.179

Francesco Solimena

Italian, Neapolitan, 1657–1747

The Birth of the Virgin

Oil on canvas, 80¹/₂ × 67¹/₄ in.
(204.5 × 170.8 cm)
Rogers Fund, 1906
07.66

Diego Pignatelli d'Aragona

This is a sketch for a larger portrait (private collection).
Oil on canvas, 23¹/₄ × 18¹/₄ in.
(59.1 × 46.4 cm)
Rogers Fund, 1967
67.102

Italian (Neapolitan) Painter

second quarter 17th century

Luigi III, Prince of Venosa

Oil on canvas, 80¹/₂ × 48 in.
(204.5 × 121.9 cm)
Inscribed (lower right): ALOYSIVS III.COMPSIÆ
/ COMES Vꞌ VENVSII / PRINCEPS PRIMVS. (Luigi
III, fifth count of Conza, first prince of
Venosa)
Bashford Dean Memorial Collection, Funds
from various donors, 1929
29.158.750
ARMS AND ARMOR

Gaspare Traversi

Italian, Neapolitan, born about 1722, died
1770

Saint Margaret of Cortona

Oil on canvas, 67³/₄ × 48¹/₄ in.
(172.1 × 122.6 cm)
Inscribed (on cross): INRI
Gwynne Andrews Fund, 1968
68.182

Teasing a Sleeping Girl

Oil on canvas, 34¹/₈ × 42³/₈ in.
(86.7 × 107.6 cm)
Bequest of Harry G. Sperling, 1971
1976.100.19

Attributed to Gaspare Traversi

Portrait of a Man

Oil on canvas, 22 × 17¹/₂ in.
(55.9 × 44.5 cm)
Inscribed (falsely, right center): Goya / 1780
H. O. Havemeyer Collection, Bequest of Mrs.
H. O. Havemeyer, 1929
29.100.179

Alberto Pasini

Italian, 1826–1899

The Mosque of Sultan Achmet,
Constantinople

Oil on canvas, 35 × 26¼ in. (88.9 × 66.7 cm)
Signed and dated (lower left): A. Pasini. 1872.
Bequest of Collis P. Huntington, 1900
25.110.94

A Mosque

Oil on canvas, 14⅝ × 21¾ in. (37.1 × 55.2 cm)
Signed and dated (lower right): A. Pasini. 1886.
Bequest of Martha T. Fiske Collord, in
memory of her first husband, Josiah M. Fiske,
1908
08.136.13

Antonio Mancini

Italian, Roman, 1852–1930

A Circus Boy

Oil on canvas, 59⅝ × 28½ in.
(151.4 × 72.4 cm)
Signed and dated (lower right): A. Mancini
1872
Bequest of Elizabeth U. Coles, in memory of
her son, William F. Coles, 1892
92.1.62

Giovanni Boldini

Italian, Ferrarese, 1845–1931

Gossip

Oil on wood, 7 × 9½ in. (17.8 × 24.1 cm)
Signed and dated (lower left): Boldini / 73
Catharine Lorillard Wolfe Collection, Bequest
of Catharine Lorillard Wolfe, 1887
87.15.81

The Dispatch-Bearer

Oil on wood, 16¾ × 13½ in.
(42.5 × 34.3 cm)
Signed (lower left): Boldini–
Inscribed: (beside building entrance) 12; (on
shop signs) OPTICIEN F, GLACE A R, HOTE[L] /
VAR; (on messenger's bag) Garde Republicai[ne]
Bequest of Martha T. Fiske Collord, in
memory of her first husband, Josiah M. Fiske,
1908
08.136.12

Mrs. Charles Warren-Cram (Ella Brooks
Carter, 1846–1896)
Oil on canvas, 19⅜ × 14 in. (49.2 × 35.6 cm)
Signed and dated (lower left): Boldini 1885
Arms (upper left) of Sir Fulke Greville, Lord
Brooke, reportedly an ancestor of the sitter,
and of the Freiherren von Cramm family
Gift of Mrs. Edward C. Moën, 1959
59.78

25.110.94

08.136.13

92.1.62

87.15.81

08.136.12

59.78

47.71

Consuelo Vanderbilt (1876–1964)*, Duchess
of Marlborough, and Her Son, Lord Ivor
Spencer-Churchill* (1898–1956)
Oil on canvas, 87¼ × 67 in.
(221.6 × 170.2 cm)
Signed and dated (lower right): Boldini/1906
Gift of Consuelo Vanderbilt Balsan, 1946
47.71

Master of Pedret

Spanish, Catalan, 12th century

Virgin and Child Enthroned between the Archangels Michael and Gabriel

These frescoes are from the central apse of the church of San Juan de Tredós, Valle d'Arán. The three large paintings are: (a) Virgin and Child, (b) Archangel Michael with Melchior, and (c) Archangel Gabriel with Balthasar and Caspar; they have been reassembled and are here shown as one work. There are, in addition, nine decorative fragments, irregular in size and shape [d–l not illustrated].
Fresco, mounted on canvas;
(a) 125½ × 70½ in. (318.8 × 179.1 cm);
(b) 124⅜ × 101⅝ in. (315.9 × 258.1 cm);
(c) 123⅝ × 101½ in. (314 × 257.8 cm)
Inscribed: (left to right) MIHAEL / MELHIOR / BALDASAR / GAS / PA[R] / GABRIEL; (on Gabriel's scroll) POSTVL ACIVS (declaration)
The Cloisters Collection, 1950
50.180a–l
THE CLOISTERS

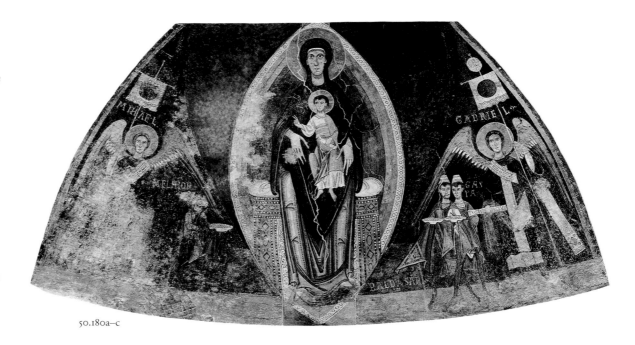

50.180a–c

Spanish Painters

12th century

Hunting Scene

This fresco and the following eight (57.97.2–6, 59.196, 61.219, 61.248) were executed for the hermitage of San Baudelio de Berlanga, Soria. Six (57.97.1–6) are on long-term loan to the Prado, Madrid.
Fresco, transferred to canvas, 71¾ × 141 in. (182.2 × 358.1 cm)
The Cloisters Collection, 1957
57.97.1
THE CLOISTERS

57.97.1

Hunting Scene

Fresco, transferred to canvas, 71⅞ × 96¼ in. (182.6 × 244.5 cm)
The Cloisters Collection, 1957
57.97.2
THE CLOISTERS

Decorative Panel

Fresco, transferred to canvas, 60⅞ × 44¼ in. (154.6 × 112.4 cm)
The Cloisters Collection, 1957
57.97.6
THE CLOISTERS

57.97.2

57.97.6

61.219

57.97.3

57.97.5

57.97.4

Camel
Fresco, 96 × 53¹/₂ in. (243.8 × 135.9 cm)
The Cloisters Collection, 1961
61.219
THE CLOISTERS

Warrior with a Shield
Fresco, transferred to canvas,
112³/₄ × 51⁷/₈ in. (286.4 × 131.8 cm)
The Cloisters Collection, 1957
57.97.3
THE CLOISTERS

Elephant
Fresco, transferred to canvas, 80³/₄ × 53¹/₄ in.
(205.1 × 135.3 cm)
The Cloisters Collection, 1957
57.97.5
THE CLOISTERS

Bear
Fresco, transferred to canvas,
78¹/₂ × 44¹/₄ in. (199.4 × 112.4 cm)
The Cloisters Collection, 1957
57.97.4
THE CLOISTERS

*The Healing of the Blind Man and the
Raising of Lazarus*
Fresco, transferred to canvas, 65 × 134 in.
(165.1 × 340.4 cm)
Gift of The Clowes Fund Incorporated and
E. B. Martindale, 1959
59.196
THE CLOISTERS

The Temptation of Christ
Fresco, 69¹/₄ × 119¹/₄ in. (175.9 × 302.9 cm)
The Cloisters Collection and Gift of E. B.
Martindale, 1961
61.248
THE CLOISTERS

59.196

61.248

Spanish (Castilian) Painter
early 13th century

Lion with a Frieze; Wyvern with a Frieze

These frescoes are from the clerestory of the chapter house of the monastery of San Pedro de Arlanza, near Hortigüela, Burgos.
Fresco, mounted on canvas; lion (1a) and wyvern (2a), each 89 × 132 in.
(226.1 × 335.3 cm); each frieze (1b, 2b)
48 × 132 in. (121.9 × 335.3 cm)
The Cloisters Collection, 1931
31.38.1ab–2ab
THE CLOISTERS

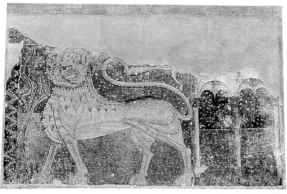

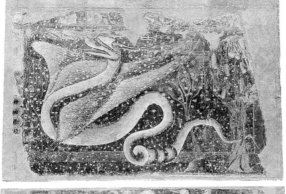
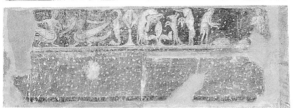

31.38.1ab

31.38.2ab

Spanish Painters
13th-century style (20th century)

Scenes from the Life of Christ

These two panels and the following (1977.94) are from the housing of the same shrine. The scenes (top to bottom) are: (a) the Betrayal of Christ and the Payment of Judas and Christ's Descent into Limbo and (b) the Deposition and the Entombment.
Tempera on wood; (a) 41¹⁄₂ × 15¹⁄₂ in.
(105.4 × 39.4 cm); (b) 41¹⁄₂ × 16³⁄₈ in.
(105.4 × 41.6 cm)
Inscribed: [mostly illegible]
The Cloisters Collection, 1955
55.62ab
THE CLOISTERS

Scenes from the Life of Christ

The scenes (top to bottom) are: Christ Entering Jerusalem (right half), the Flagellation, and Three Marys at the Tomb (right half).
Tempera on wood, 59 × 10¹⁄₂ in.
(149.9 × 26.7 cm)
Inscribed: [mostly illegible]
Bequest of Carl Otto von Kienbusch, 1977
1977.94
THE CLOISTERS

13th-century style (of uncertain date)

Processional Crucifix

Tempera on canvas, laid down on wood,
54¹⁄₂ × 32⁷⁄₈ in. (138.4 × 83.5 cm)
Inscribed (recto and verso) with the names of Christ and the four Evangelists
The Cloisters Collection, 1955
55.120.3
THE CLOISTERS

Christ in a Mandorla with the Twelve Apostles (altar frontal)

Tempera on wood; overall 40¹⁄₂ × 54 in.
(102.9 × 137.2 cm); main panel
32¹⁄₂ × 44³⁄₈ in. (82.6 × 112.7 cm)
The Cloisters Collection, 1957
57.49
THE CLOISTERS

55.62a 55.62b 1977.94

Spanish (Catalan) Painter
late 13th/early 14th century

The Miracle of the Jewels

This fresco is one of a series depicting scenes from the life of Saint John the Evangelist from the church of San Fructuoso, Bierge, Huesca.
Fresco, transferred to canvas, 47 × 61³⁄₈ in.
(119.4 × 155.9 cm)
Inscribed (top): FILOS[O]F[U]Ƨ: CRATON: (the philosopher Craton)/·IOh[ANNE]S· AP.[OSTO]L[U]S· (John the Apostle)
The Cloisters Collection, 1950
50.162
THE CLOISTERS

Spanish (Castilian) Painter
late 14th century

Saint Andrew and Scenes from the Creation; Scenes from the Life of Saint Andrew

These are the recto and verso, still joined, of a panel of an altarpiece, one other fragment of which is recorded (location unknown). Recto: (top) Creation of Animals and Creation of Adam; (center) Creation of Eve and Presentation of Eve to Adam; (bottom) Saint Andrew with Kneeling Donors. Verso: (top) Saint Andrew in a Fishing Boat and Christ Calling Saint Andrew; (center) Saint Andrew Preaching; (bottom) Saint Andrew Baptizing a Child, King Adoring a Demon, and Saint Andrew
Tempera on wood, gold ground,
78¹⁄₄ × 39³⁄₄ in. (198.8 × 101 cm)
Inscribed (in Spanish): (recto, center left) DIO LA SACA OS LA COSTI EL ADAM DORMI (God takes the bone from the sleeping Adam's rib); (recto, center right) CRIO DIO AEBA DE LA

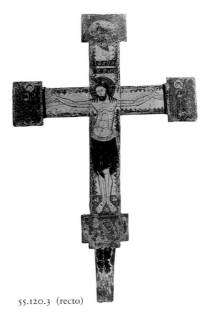

55.120.3 (recto)

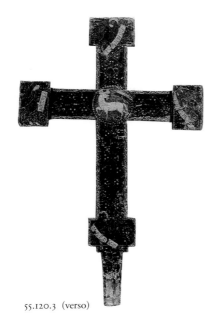

55.120.3 (verso)

COSTI EL [ADAM] (God creates Eve from [Adam's] rib); (recto, bottom) INSENSA EL ANGEL / SANT ANDRES APOSTOL / INSENSA EL ANGEL (censing angel / Saint Andrew the Apostle / censing angel); (left to right, on donors' scrolls, with their names) . . . AIS DAMIGO; ANOTRO [TR elided] FERANDES DE ANASTRO; MARTIN PERIS DE ANASTROELRA; (on donors' books) OSE POR SANT ANDRES ROG (Saint Andrew prays for . . .); (verso, top) SANT ANDRES ANDA PESCANDO LLAMA . . . CRISTO (Saint Andrew goes fishing, Christ calls . . .); (verso, center) SANT ANDRES PEDRICA A LAS GENTES PAGANAS (Saint Andrew preaches to the pagan people); (verso, bottom left) BATISA SANT ANDRES (Saint Andrew baptizes); (verso, bottom right) ADORA EL RE EL IDOLO SANT ANDRES (the king adores the idol, Saint Andrew)
The Cloisters Collection, 1925
25.120.257
THE CLOISTERS

57.49

50.162

Spanish Painter
late 14th/early 15th century

Virgin and Child with Scenes from the Lives of the Virgin and of Christ
These panels from an altarpiece are:
(a) Coronation of the Virgin (with the Virgin and Child below); (b) Crucifixion (with the Dormition below); (c) Pentecost (with the Resurrection below); (d) Nativity (with the Adoration of the Magi below); (e) Ascension; (f) Annunciation; (g) predella.
Tempera on wood, gold ground;
(a) 70¹/₂ × 38 in. (179.1 × 96.5 cm);
(b) 66⁷/₈ × 37³/₄ in. (169.9 × 95.9 cm);
(c) 70³/₄ × 28 in. (179.7 × 71.1 cm);
(d) 71 × 27¹/₄ in. (180.3 × 69.2 cm);
(e) 51¹/₂ × 27¹/₂ in. (130.8 × 69.9 cm);
(f) 51 × 27¹/₂ in. (129.5 × 69.9 cm);
(g) 15¹/₄ × 94¹/₂ in. (38.7 × 240 cm)
Inscribed: (Dormition [b], on books) In exitu / isr[ae]l de e / gipto do / m[us Ia] / cob / p[o]p[u]lō / barba / ro: Fac / taest· / iudea / s[anc]tifica / cio eiu[s] / isr[ae]l po / testas / e[i]us ma / re vi / dit et / fugit / jorda / [n]us qu[i]l / cō[n]ver / sus est / retror / sum (When Israel went out of Egypt, the house of Jacob from a people of strange language; Judah was his sanctuary, and Israel his dominion. The sea saw it, and fled: Jordan was driven back [Psalms 114:1–3].); (on scrolls held by prophets [b] Elijah and Enoch) with their names; (Annunciation [f]) Ecce ⋮ / ancilla / d[omi]ñi: Fi / at mi / chi se / cundū[m] / verbû[m] / tuum / Am̄ē[n] (Behold the handmaid of the Lord; be it unto me according to thy word [Luke 1:38].); (on predella [g], on scroll held by angel at right) Raphael
The Cloisters Collection, 1957
57.50a–g
THE CLOISTERS

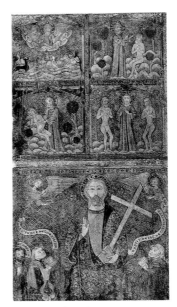

25.120.257 (recto)

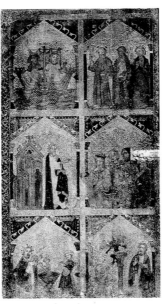

25.120.257 (verso)

Spanish (Valencian) Painter

early 15th century

The Trinity Adored by All Saints (retable)

Central panel: the Crucifixion with
Implements of the Passion, the Throne of
Grace, and Saint Michael Triumphant; lateral
panels: the Annunciation, prophets and
patriarchs, apostles and evangelists, martyrs,
monastic and ascetic saints, and women saints
[some of the saints, notably Honoratus and
Narcissus of Gerona, are peculiar to Valencia]
Tempera and gold on wood; central panel,
overall 67¹/₂ × 22 in. (171.5 × 55.9 cm);
left panel, overall 67³/₄ × 20¹/₈ in.
(172.1 × 51.1 cm); right panel, overall
67⁷/₈ × 20¹/₈ in. (172.4 × 51.1 cm)
Inscribed with the names of patriarchs,
prophets, and saints [some repainted and
some interchanged]
Arms (middle center) of the Cervellon family
of Catalonia
Fletcher Fund, 1939
39.54

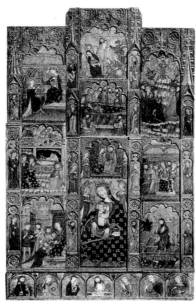

57.50a–g

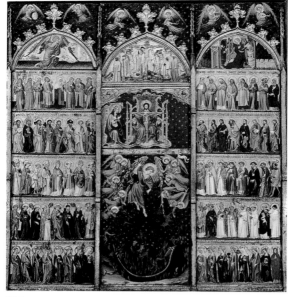

39.54

Spanish (Catalan) Painter

early 15th century

Saint Andrew with Scenes from His Life

(retable)

Central panel: (above) Virgin and Child with
Saints Catherine of Alexandria, Mary
Magdalen, and angels and (below) Saint
Andrew; left panel: (above) Calling of Saint
Andrew and (below) Punishment of a Wicked
Mother; right panel: (above) Crucifixion of
Saint Andrew and (below) Saint Andrew
Saving a Bishop from the Devil Disguised as
a Fair Woman; predella (left to right): Saint
Andrew and the Woman Who Prayed to
Diana on Behalf of Her Sister, Woman
Bringing the Saint to Her Sister, Saint
Andrew Driving Away Devils in the Form of
Dogs, the Man of Sorrows, Saint Andrew
Raising a Dead Youth, and Saint Andrew
Bringing Drowned Men to Life
Tempera on wood, gold ground, overall
123¹/₄ × 123⁵/₈ in. (313.1 × 314 cm)
Rogers Fund, 1906
06.1211.1–9
THE CLOISTERS

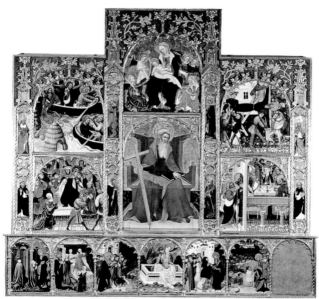

06.1211.1–9

76.10

Miguel Alcañiz (or Alcanyis)

Spanish, Valencian, active by 1408, died after
1447

Saint Giles with Christ Triumphant over Satan and the Mission of the Apostles

This lateral panel, the Ascension (central
panel), Saint Vincent, and banco panels
representing the Flagellation (last recorded
1921), the Entombment, and the Noli Me
Tangere (all others Hispanic Society, New
York) are from a retable that was probably
commissioned by Vicente Gil, whose will
dates from 1428, for the church of San Juan
del Hospital in Valencia. The central panel
has been attributed to the Master of the

Bambino Vispo, who is now identified with
Gherardo Starnina (born about 1354, died
before 1413).
Tempera on wood, gold ground; overall
59⁵/₈ × 39¹/₂ in. (151.4 × 100.3 cm);
upper left panel, painted surface
24¹/₈ × 16⁷/₈ in. (61.3 × 42.9 cm);
lower left panel, painted surface
24⁵/₈ × 16⁷/₈ in. (62.5 × 42.9 cm); right
panel, painted surface 46¹/₈ × 16⁷/₈ in.
(117.2 × 42.9 cm)
Inscribed: (upper left, on scrolls) ·iste·ē[st]·
d[omi]n̄[v]s·rex·glori[a]e· / ·et dominvs
·fortis·inp̂[rae]lio (This is the Lord, King of
glory, and the Lord mighty in battle [Psalms
24:8].); (lower left) ·hite·per·vniversvm

·mvndvm· / p̂[rae]dicate·evangelivm·ō[mn]ī
·creatvr[a]e· (Go ye into all the world, and
preach the gospel to every creature [Mark
16:15].)
Gift of J. Bruyn Andrews, 1876
76.10

Spanish (Valencian) Painter

first quarter 15th century

Saint Michael and the Dragon

Tempera on wood, gold ground,
41³/₈ × 40³/₄ in. (105.1 × 103.5 cm)
Rogers Fund, 1912
12.192

12.192

32.100.123

52.35

32.100.105

32.100.126

32.100.127

32.100.128

Spanish (Catalan) Painter

early 15th century

Christ among the Doctors
Tempera and gold on wood, 44 × 30 in.
(111.8 × 76.2 cm)
The Friedsam Collection, Bequest of Michael
Friedsam, 1931
32.100.123

Master of Riglos

Spanish, Aragonese, about 1450

The Virgin
This banco panel and four others—the Man
of Sorrows, Saint John the Evangelist, and
Saint Barbara (all location unknown), and
Saint Catherine of Alexandria (private
collection)—may have belonged to a retable
from the convent of San Martín, Huesca,
Aragon.
Tempera and oil on wood, gold ground,
overall 18³/₄ × 15⁷/₈ in. (47.6 × 40.3 cm)
Gift of Walter C. Baker, 1952
52.35

Spanish Painter

mid-15th century

*Virgin and Child Enthroned with Saints
Catherine and Jerome*
Tempera, oil, and gold on wood,
20³/₈ × 13³/₄ in. (51.8 × 34.9 cm)
The Friedsam Collection, Bequest of Michael
Friedsam, 1931
32.100.105

Spanish (Catalan) Painter

mid-15th century

Salome Dancing before Herod
This painting and the following two
(32.100.127, 128) are from the same altarpiece.
Tempera and gold on wood, 34¹/₄ × 33³/₄ in.
(87 × 85.7 cm)
The Friedsam Collection, Bequest of Michael
Friedsam, 1931
32.100.126

The Beheading of Saint John the Baptist
Tempera and gold on wood, 33³/₄ × 34 in.
(85.7 × 86.4 cm)
The Friedsam Collection, Bequest of Michael
Friedsam, 1931
32.100.127

*Salome with the Head of Saint John the
Baptist*
Tempera and gold on canvas, transferred from
wood, 34¹/₂ × 34¹/₂ in. (87.6 × 87.6 cm)
The Friedsam Collection, Bequest of Michael
Friedsam, 1931
32.100.128

Pedro Sánchez I

Spanish, Seville, active 1454–1480

Christ before Pilate; Saints Paul and Peter; Saints John the Baptist and John the Evangelist (triptych)

Oil and gold on wood; central panel, overall 25^1/$_4$ × 18^3/$_4$ in. (64.1 × 47.6 cm); each wing, overall 25^1/$_4$ × 8^7/$_8$ in. (64.1 × 22.5 cm)

Gift of Dr. Foo Chu and Dr. Marguerite Hainje-Chu, 1982

1982.447

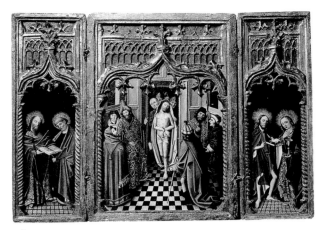

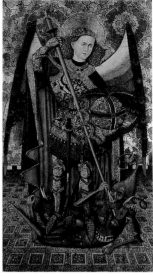

1982.447

55.120.2

Master of Belmonte

Spanish, Aragonese, active about 1460–1490

Saint Michael

This is the central panel from the retable of the high altar of the parish church of San Miguel, Belmonte de Calatayud. Additional panels, by at least two other artists, are in the Museu d'Arte de Catalunya, Barcelona, and in a private collection.

Tempera, oil, and gold on wood, 83^1/$_2$ × 47 in. (212.1 × 119.4 cm)

The Cloisters Collection, 1955

55.120.2

THE CLOISTERS

Domingo Ram

Spanish, Aragonese, active 1464–1507

Saint John the Baptist with Scenes from His Life (retable)

Central panel: Crucifixion, Visitation, and Saint John the Baptist Enthroned; left panel: Annunciation to Zacharias, Saint John Preaching, and Saint John Reproving Herod; right panel: Birth of Saint John, Baptism of Christ, and Banquet of Herod with the Beheading of Saint John; predella: Saints Martial, Sebastian, Mary Magdalen, Bridget, Christopher, and William

Tempera on wood, gold ground, overall 139 × 100 in. (353.1 × 254 cm) [upright panels truncated, modern frame]

Inscribed: (on cross) inri; (upper left, on angel's scroll) ioh̄[anne]s est no[m]īne eius (John is his name); (left to right, on banco) sant marcal sant sabastia santa mag santa brigida sant quilen

The Cloisters Collection, 1925

25.120.668–671, 673, 674, 927–929

THE CLOISTERS

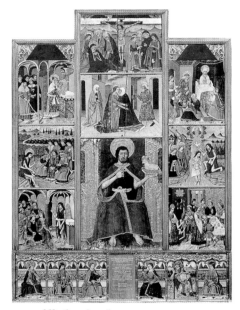

25.120.668–671, 673, 674, 927–929

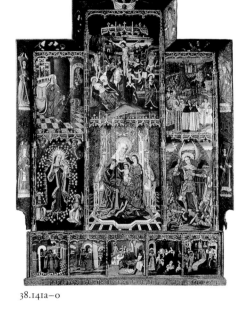

38.141a–o

Spanish (Aragonese) Painter

1473 or 1483

Saint Anne with the Virgin and Child; Virgin of the Rosary; Saint Michael (retable)

Central panel: Crucifixion and Saint Anne Enthroned with the Virgin and Child; left panel: Miracle of the Gentleman of Cologne and Virgin of the Rosary; right panel: Miracle of Monte Gargano and Saint Michael; predella (left to right): Expulsion of Joachim

44.63.1ab (detail)

44.63.1ab

44.63.1ab (detail)

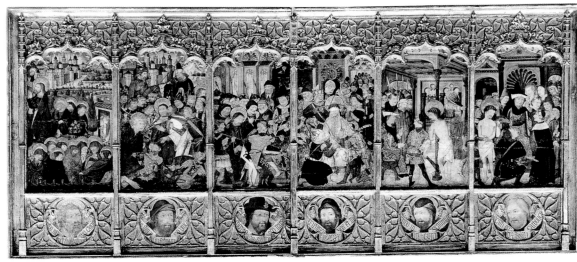

10.12

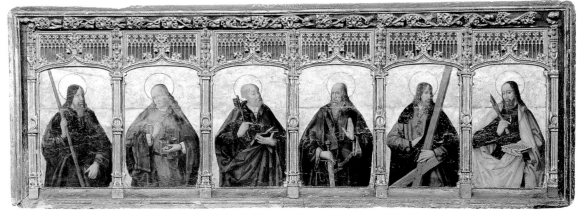

61.249

from the Temple, Meeting at the Golden Gate, Mass of Saint Gregory, Birth of the Virgin, and Presentation of the Virgin. The dust guards are decorated with angels holding instruments of the Passion.

Tempera and gold on wood, including dust guards, overall 184 × 133 in. (467.4 × 337.8 cm)
Dated and inscribed: (on cross) INRI; (below predella, in raised gold letters) SA[B?]EMO A[N] FECHO FAZER LOS MUY ONRADOS MOSE[N] MIGUEL ARMISE[N] IATON INCET ENEL ANYO DEMIL CCCC[L]XX[X?]III (The most honorable Mosén Miguel Armisén and Atón Incet have caused this to be made in the year 1473 [1483?])
Gift of Mrs. Herbert Shipman, in memory of her father and mother, Edson and Julia Wentworth Bradley, 1938
38.141a–o
THE CLOISTERS

Spanish Painter
second half 15th century

Paschal Candlestick
The shaft is hexagonal, tapering at the top, with three tiers containing six panels separated by vertical crockets. The panels represent (top to bottom, clockwise): the Angel Expelling Adam and Eve from Eden; the prophets Zacharias, Ezekiel, and Jeremiah; Saints Clare, Louis of Toulouse, Francis, Bernardino of Siena, Anthony of Padua, and Benedict; and the apostles Philip, Bartholomew, Thomas, Barnabas, John the Evangelist, and Matthew.
Tempera on wood, gold ground, overall 77 × 17¼ in. (195.6 × 43.8 cm)
Inscribed (on scrolls) with the names of the prophets, saints, and apostles
Fletcher Fund, 1944
44.63.1ab
THE CLOISTERS

Bonnat Master
Spanish, Aragonese, late 15th century

Scenes from the Passion
The scenes comprising the banco are: the Agony in the Garden, the Betrayal, Christ before Caiaphas, Christ Crowned with Thorns, the Flagellation, and Christ before Pilate; below each scene, in a medallion, is the head of one of the apostles (third from left, Saint James the Greater). There was probably a tabernacle at the center.
Tempera and gold on wood; left panel, overall 55⅞ × 61⅛ in. (141.9 × 155.3 cm); right panel, overall 56½ × 62⅜ in. (143.5 × 158.4 cm)
Inscribed: (in third scene) SPQ[R]; (below, in medallions, on scrolls, with quotations from the Apostles' Creed) CREDO IND[E]U[M] P[AT]REM OMN[I]POTE[N]TEM CR[E]ATOREM C[A]ELI ET TERR[A]E / ET IN IH[U]M XT[U]M FILIUM EJUS UNICU[M] D[OMI]N[UM] N[OST]R[U]M / Q[U]I CO[N]CEPTUS E[ST] D[E] SP[IRIT]U S[AN]C[T]O NATUS EX MARIA VERGI[N]E / [OMNIPOTENTI]S INDE V[E]NTURUS E[ST] JUDICA[RE] VIVOS ET MO[RTU]OS / S[?] CREDO IN IN SP[IRITU]M SCANTTUM / S[?] S[AN]C[T]AM ECCL[ES]I[A]M CATHOLICA[M] S[AN]C[TORUM COMMUNIONEM] (I believe in God, Father almighty, creator of heaven and earth / And in Jesus Christ, his only Son, Our Lord / Who was conceived of the Holy Spirit, born of the Virgin Mary / [of the (Father)] almighty, from there he will come to judge the living and the dead / [?] I believe in the Holy Spirit / [?] the holy Catholic Church [the communion of] Saints)
Gift of William M. Laffan, 1910
10.12
THE CLOISTERS

Spanish (Oña) Painter
Spanish, Castilian, late 15th century

Six Apostles
Tempera on wood, gold ground, overall 35⅛ × 93 in. (89.2 × 236.2 cm)
Inscribed (on halos): SANTIAGO, SAN JUAN, SAN PEDRO, SAN PAULO, SAN ANDRES, BARTOLOME
Gift of Irma N. Straus, 1961
61.249

Spanish (Castilian) Painter

late 15th century

***Virgin and Child with the Pietà and
Saints*** (retable)

Central section: painted sculpture of the
Virgin and Child with the Pietà (a) above;
left and right panels: Archangel Michael (e)
upper left and Saints Andrew (b) upper right,
Peter (c) lower left, and John the Baptist (d)
lower right
Tempera and gold on wood; (a) 49^1/$_4$ × 24^1/$_4$ in.
(125.1 × 61.5 cm); (b) 49 × 24^3/$_4$ in.
(124.5 × 62.9 cm); (c) 57 × 29 in.
(144.8 × 73.7 cm); (d) 49 × 24^3/$_4$ in.
(124.5 × 62.9 cm); (e) 49 × 24^1/$_2$ in.
(124.5 × 62.2 cm)
Bequest of George Blumenthal, 1941
41.190.27a–e

Morata Master

Spanish, Aragonese, late 15th century

***Virgin and Child Enthroned with Scenes
from the Life of the Virgin*** (retable)
Central panel: Virgin and Child Enthroned
and Coronation of Virgin Flanked by Music-
making Angels; left panel: Annunciation and
Nativity; right panel: Adoration of the Magi
and Resurrection. The dust guards are
decorated with unidentified escutcheons.
Tempera and gold on wood; central panel,
below, 52 × 34^5/$_8$ in. (132.1 × 87.9 cm);
central panel, above, 43^3/$_4$ × 34^1/$_2$ in.
(111.1 × 87.6 cm); each side panel
84^1/$_2$ × 22^3/$_4$ in. (214.6 × 57.8 cm)
Inscribed (below each scene) with the
identification of the subject
Bequest of George Blumenthal, 1941
41.190.28a–d

Spanish Painter

about 1490

The Mass of Saint Gregory
Oil and gold on wood, 28^3/$_8$ × 21^7/$_8$ in.
(72.1 × 55.6 cm)
Bequest of Harry G. Sperling, 1971
1976.100.24

Budapest Master

Spanish, Castilian, about 1500

The Annunciation
Oil and gold on canvas, transferred from
wood, 32 × 20^1/$_4$ in. (81.3 × 51.4 cm)
Inscribed: (on banner) Ave gracia plena /
dominus / tecum; (on halo) santa: mari[a]
Bequest of Muriel Stokes, 1958
58.145.1

41.190.27a–e

41.190.28a–d

1976.100.24

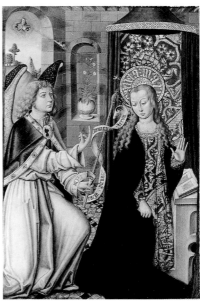

58.145.1

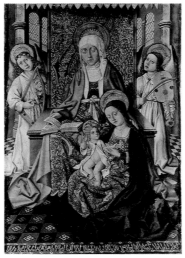

88.3.82

58.145.2

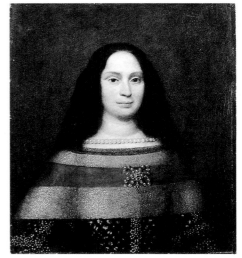

55.174

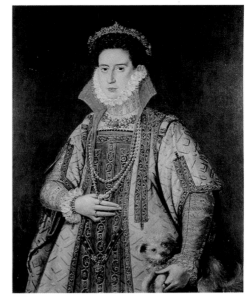

1976.100.18

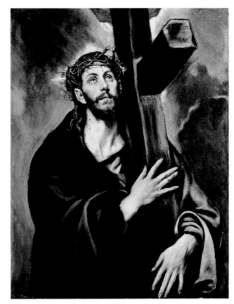

1975.1.145

Osma Master
Spanish, Castilian, about 1500
Saint Anne Enthroned with the Virgin and Child
Tempera and gold on wood, 59 × 32 in.
(149.9 × 81.3 cm)
Gift of Coudert Brothers, 1888
88.3.82

Frei Carlos
Portuguese, active second quarter 16th century
Saint Vincent, Patron Saint of Lisbon
Oil on wood, 64 × 20⁷/8 in. (162.6 × 53 cm)
Bequest of Muriel Stokes, 1958
58.145.2

Attributed to Juan Pantoja de la Cruz
Spanish, 1551–1608/9
Portrait of a Young Woman
Oil on canvas, 25 × 22 in. (63.5 × 55.9 cm)
Gift of Jean Ferry, in memory of her husband,
Mansfield Ferry, 1955
55.174

Alonzo Sánchez Coello
Spanish, 1531/32–1588
Portrait of a Woman
Oil on canvas, 38³/4 × 28³/8 in. (98.4 × 72.1 cm)
Bequest of Harry G. Sperling, 1971
1976.100.18

El Greco (Domenikos Theotokopoulos)
Greek, 1541–1614
Christ Carrying the Cross
Oil on canvas, 41³/8 × 31 in.
(105.1 × 78.7 cm)
Signed (on cross, above Christ's left hand, in
Greek): Domenikos Theotokopoulos made this
Robert Lehman Collection, 1975
1975.1.145
ROBERT LEHMAN COLLECTION

The Miracle of Christ Healing the Blind
Oil on canvas, 47 × 57¹/2 in.
(119.4 × 146.1 cm)
Gift of Mr. and Mrs. Charles Wrightsman,
1978
1978.416

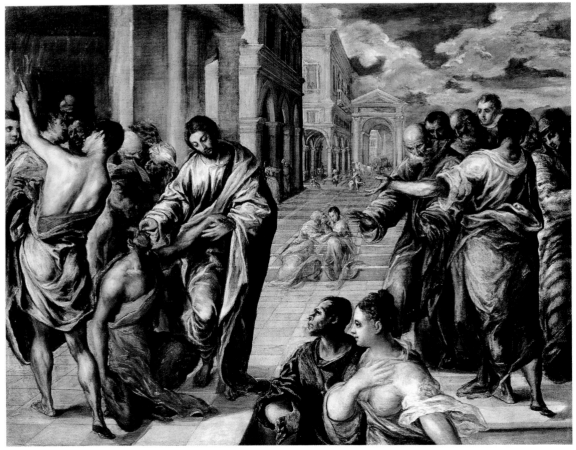

1978.416

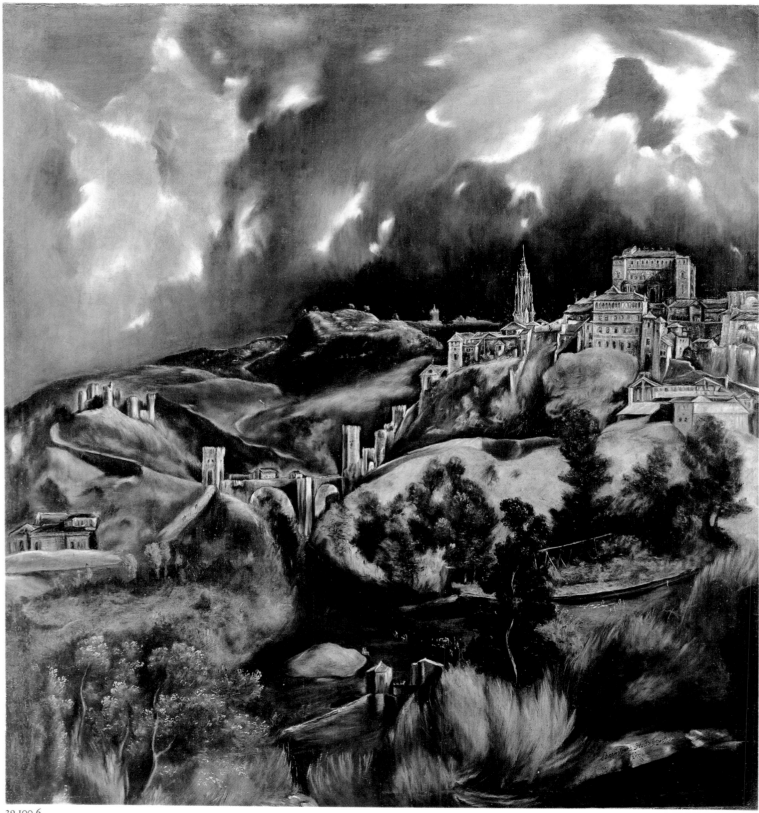

29.100.6

El Greco (Domenikos Theotokopoulos)
Greek, 1541–1614
View of Toledo
Oil on canvas, 47³/₄ × 42³/₄ in. (121.3 × 108.6 cm)
Signed (lower right, in Greek): Domenikos
Theotokopoulos / made this
H. O. Havemeyer Collection, Bequest of Mrs.
H. O. Havemeyer, 1929
29.100.6

Portrait of a Man
Oil on canvas, 20³/₄ × 18³/₈ in.
(52.7 × 46.7 cm)
Purchase, Joseph Pulitzer Bequest, 1924
24.197.1

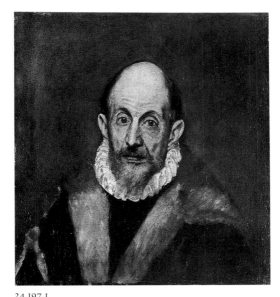

24.197.1

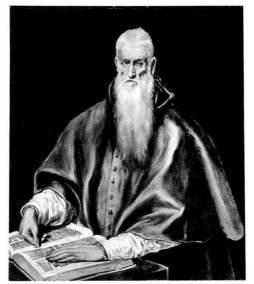

1975.1.146

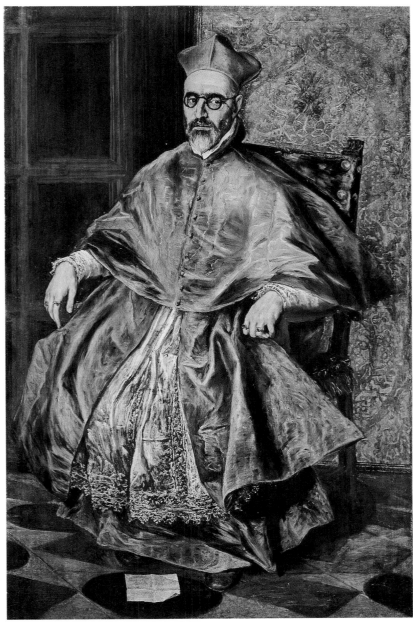

29.100.5

Saint Jerome as a Cardinal
Oil on canvas, 42¹/₂ × 34¹/₄ in.
(108 × 87 cm)
Robert Lehman Collection, 1975
1975.1.146
ROBERT LEHMAN COLLECTION

*Portrait of a Cardinal, Probably Cardinal
Don Fernando Niño de Guevara*
(1541–1609)
Oil on canvas, 67¹/₄ × 42¹/₂ in.
(170.8 × 108 cm)
Signed (lower center, on paper, in Greek):
Domenikos Theotokopoulos / made this
H. O. Havemeyer Collection, Bequest of Mrs.
H. O. Havemeyer, 1929
29.100.5

The Adoration of the Shepherds
Oil on canvas, 56⁷/₈ × 39⁷/₈ in.
(144.5 × 101.3 cm); with added strips
64¹/₂ × 42 in. (163.8 × 106.7 cm)
Inscribed (on scrolls): GLOR[IA] INEXC[ELSIS
D]EO / HOMI[NIBVS] / LAVDAMVSTE
BENEDICIMV[STE] (Glory to God in the
highest. . . . We praise thee, we bless thee
[from the Greater Doxology].)
Rogers Fund, 1905
05.42

The Adoration of the Shepherds
Oil on canvas, 43¹/₂ × 25⁵/₈ in.
(110.5 × 65.1 cm)
Signed (lower left, in Greek): Domenikos
Theotokopoulos / made this [largely illegible
because of an old tear]
Bequest of George Blumenthal, 1941
41.190.17

The Vision of Saint John
Unfinished altarpiece, probably intended for
the church of the hospital of Saint John the
Baptist, Toledo
Oil on canvas (top truncated),
87¹/₂ × 76 in. (222.3 × 193 cm); with added
strips 88¹/₂ × 78¹/₂ in. (224.8 × 199.4 cm)
Rogers Fund, 1956
56.48

Workshop of El Greco
Spanish, about 1610

Saint Andrew
Oil on canvas, 43¹/₄ × 25¹/₄ in.
(109.9 × 64.1 cm)
Bequest of Stephen C. Clark, 1960
61.101.8

Spanish Painters
early 17th century

Portrait of a Man in Armor
Oil on canvas, 81 × 43 in.
(205.7 × 109.2 cm)
Bashford Dean Memorial Collection, Funds
from various donors, 1929
29.158.755
ARMS AND ARMOR

Doña Marianna Stampa Parravicina (born
1612), *Condesa di Segrate*
Oil on canvas, 80¹/₂ × 46 in.
(204.5 × 116.8 cm)
Inscribed (upper left): D.MARIANA STAM / PA
PARAVICINA CONTE / SA DI SĀNGRATE
Bequest of Helen Hay Whitney, 1944
45.128.15

Jusepe de Ribera
Spanish, 1591–1652

*The Holy Family with Saints Anne and
Catherine of Alexandria*
Oil on canvas, 82¹/₂ × 60³/₄ in.
(209.6 × 154.3 cm)
Signed, dated, and inscribed (right): Jusepe de
Ribera español / accademíco RO^{no} (member
of the Roman Academy [Accademia di San
Luca]) / .F.1648
Samuel D. Lee Fund, 1934
34.73

Francisco de Zurbarán
Spanish, 1598–1664

The Young Virgin
Oil on canvas, 46 × 37 in. (116.8 × 94 cm)
Fletcher Fund, 1927
27.137

*The Battle between Christians and Moors
at El Sotillo*
This painting was the central element of an
altarpiece for the apse of the monastery
church of Nuestra Señora de la Defensión at
Jerez de la Frontera. Other components
include: the Annunciation, Adoration of the
Shepherds, Adoration of the Magi, and
Circumcision (all Musée de Peinture et de
Sculpture, Grenoble); the four Evangelists,
Saint Lawrence, Saint John the Baptist, and
two angels with censers (all Museo Provincial
de Cádiz); and, by José de Arce, statues of the
apostles (at Jerez) and of Christ on the Cross
(location unknown).
Oil on canvas, arched top, 131⁷/₈ × 75¹/₄ in.
(335 × 191.1 cm)
Kretschmar Fund, 1920
20.104

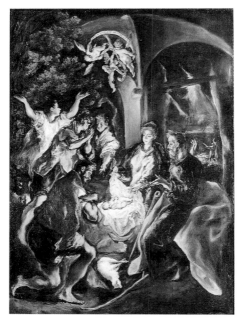

05.42

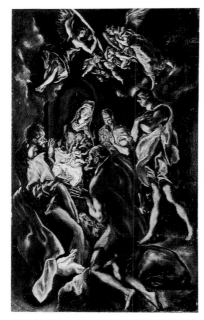

41.190.17

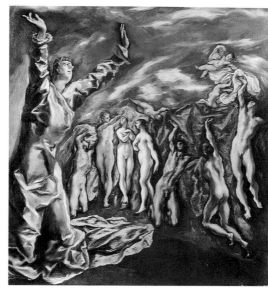

56.48

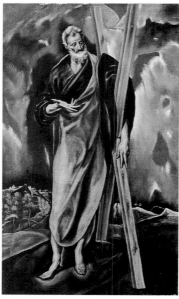

61.101.8

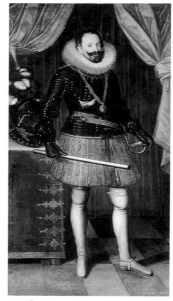

29.158.755

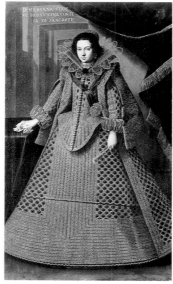

45.128.15

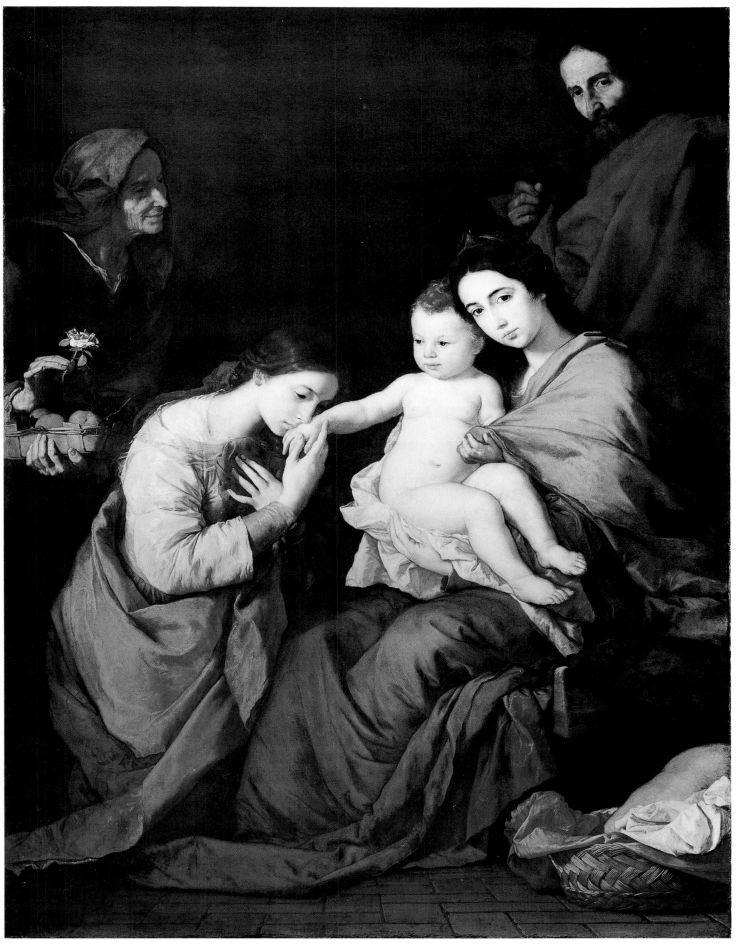

34.73

Francisco de Zurbarán

Spanish, 1598–1664

Saint Benedict

A Saint Jerome (San Diego Museum of Art)
is the only other known canvas from a series
of ten founders of religious orders, workshop
copies of which are in the Capuchin convent
at Castellón de la Plana.
Oil on canvas, 74 × 40³/₄ in.
(188 × 103.5 cm)
Bequest of Harry G. Sperling, 1971
1976.100.21

Workshop of Francisco de Zurbarán

The Crucifixion

Oil on canvas, arched top, 112 × 75⁷/₈ in.
(284.5 × 192.7 cm)
Inscribed (in Hebrew, Greek, and Latin):
IESVS NAZARENVS RE XIVDE / ORVM.
Gift of George R. Hann, 1965
65.220.2

Diego Rodríguez de Silva y Velázquez

Spanish, 1599–1660

The Supper at Emmaus

Oil on canvas, 48¹/₂ × 52¹/₄ in.
(123.2 × 132.7 cm)
Bequest of Benjamin Altman, 1913
14.40.631

Don Gaspar de Guzmán (1587–1645), Count-Duke of Olivares

Oil on canvas, 50¹/₄ × 41 in.
(127.6 × 104.1 cm)
Fletcher Fund, 1952
52.125

Juan de Pareja (born about 1610, died 1670)

This portrait was exhibited in Rome on
March 19, 1650.
Oil on canvas, 32 × 27¹/₂ in.
(81.3 × 69.9 cm)
Purchase, Fletcher and Rogers Funds, and
Bequest of Miss Adelaide Milton de Groot
(1876–1967), by exchange, supplemented by
gifts from friends of the Museum, 1971
1971.86

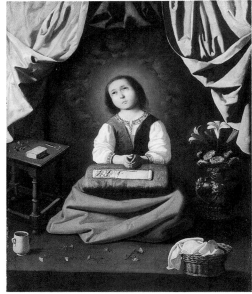

27.137

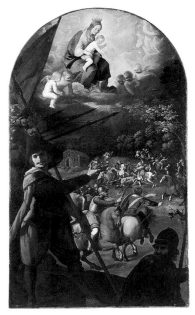

20.104

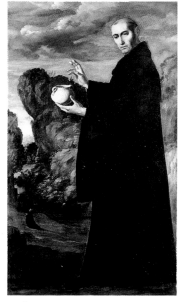

1976.100.21

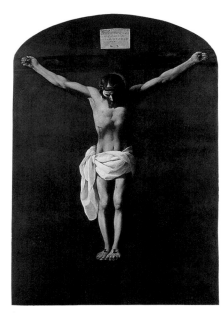

65.220.2

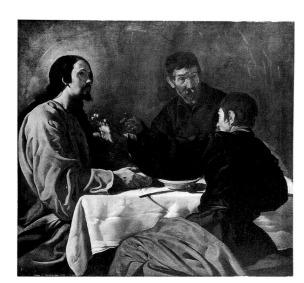

14.40.631

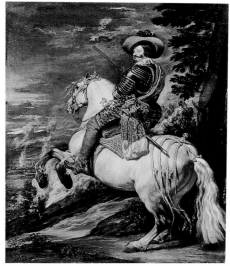

52.125

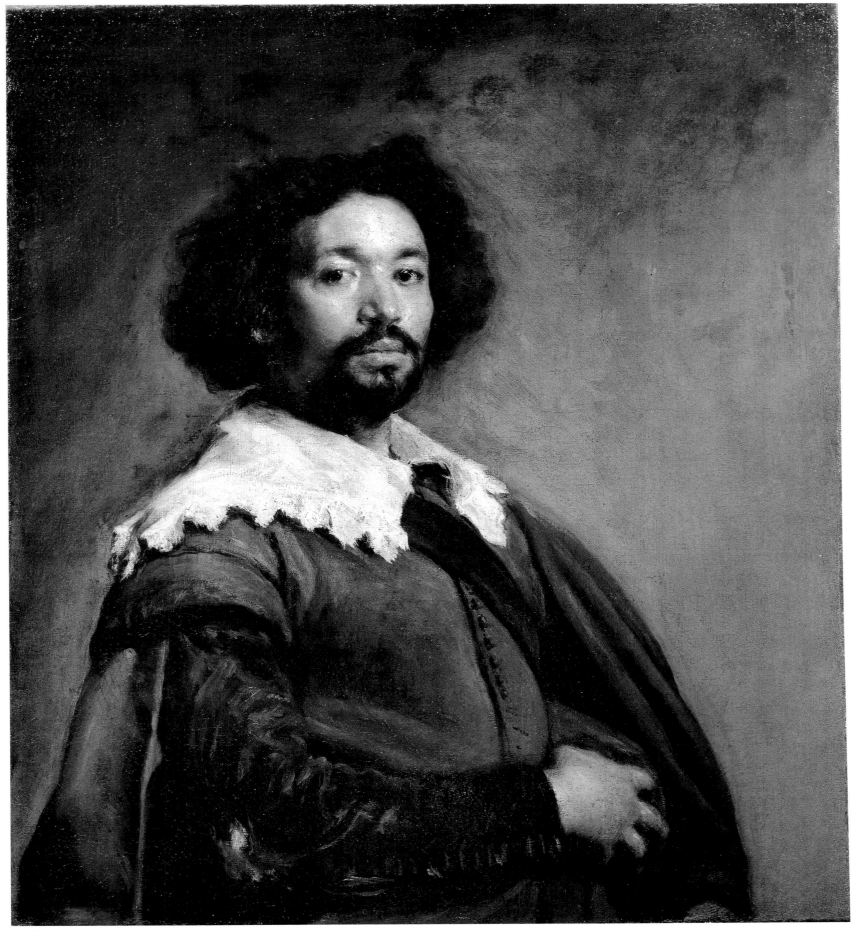

1971.86

Diego Rodríguez de Silva y Velázquez
Spanish, 1599–1660

María Teresa (1638–1683), *Infanta of Spain*
Oil on canvas; overall 13¹/₂ × 15³/₄ in.
(34.3 × 40 cm); original painted surface
12⁷/₈ × 15¹/₈ in. (32.7 × 38.4 cm) [possibly
cut down from a half-length portrait]
The Jules Bache Collection, 1949
49.7.43

María Teresa (1638–1683), *Infanta of Spain*
Oil on canvas, 19 × 14¹/₂ in.
(48.3 × 36.8 cm)
Robert Lehman Collection, 1975
1975.1.147
Robert Lehman Collection

Workshop of Diego Rodríguez de Silva y Velázquez

Philip IV (1605–1665), *King of Spain*
Oil on canvas, 78³/₄ × 40¹/₂ in.
(200 × 102.9 cm)
Bequest of Benjamin Altman, 1913
14.40.639

Mariana of Austria (1634–1696), *Queen of Spain*
Oil on canvas, 32¹/₄ × 39¹/₂ in.
(81.9 × 100.3 cm)
Marquand Collection, Gift of Henry G. Marquand, 1889
89.15.18

Portrait of a Man
Oil on canvas, 27¹/₄ × 22¹/₄ in.
(69.2 × 56.5 cm)
Marquand Collection, Gift of Henry G. Marquand, 1889
89.15.29

Portrait of a Man
Oil on canvas, 27 × 21³/₄ in.
(68.6 × 55.2 cm)
The Jules Bache Collection, 1949
49.7.42

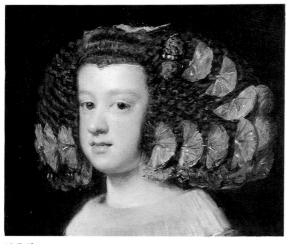

49.7.43

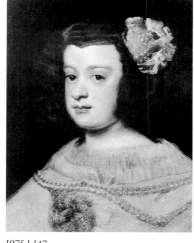

1975.1.147

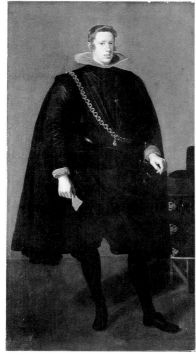

14.40.639

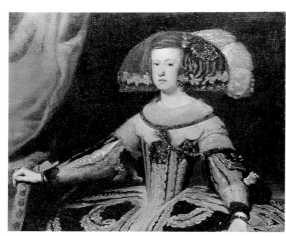

89.15.18

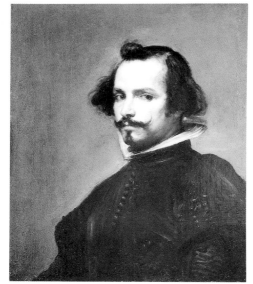

89.15.29

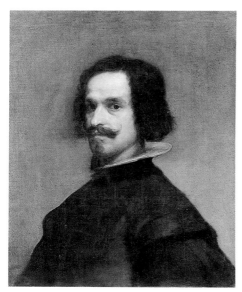

49.7.42

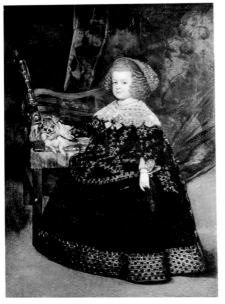

43.101

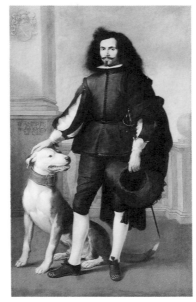

27.219

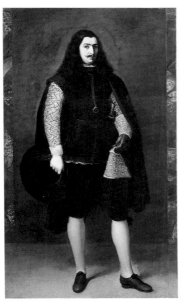

54.190

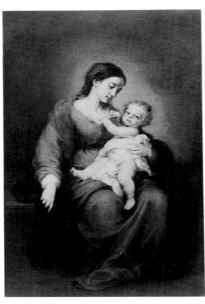

43.13

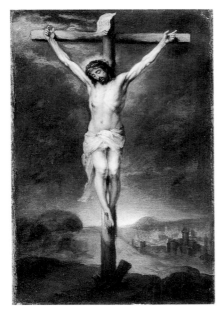

1976.100.17

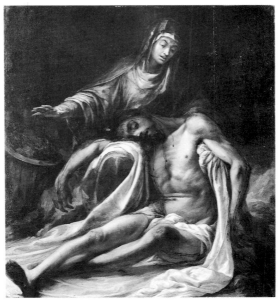

54.168

Juan Bautista Martínez del Mazo

Spanish, born about 1612, died 1667

María Teresa (1638–1683), *Infanta of Spain*

Oil on canvas, 58¼ × 40½ in.
(148 × 102.9 cm)
Rogers Fund, 1943
43.101

Bartolomé Esteban Murillo

Spanish, 1617–1682

Don Andrés de Andrade y la Cal

Oil on canvas, 79 × 47 in.
(200.7 × 119.4 cm)
Inscribed: (left, on column) D ANDRE[S] / de
Andrade y / la Cal.; (upper left, on coat of
arms) AVE MARIA GRACIA PLENA
Bequest of Collis P. Huntington, by exchange,
1927
27.219

A Knight of Alcántara or Calatrava

Oil on canvas; overall, with added strips,
77 × 43¾ in. (195.6 × 111.1 cm); original
canvas 77 × 38½ in. (195.6 × 97.8 cm)
Gift of Rudolf J. Heinemann, 1954
54.190

Virgin and Child

Oil on canvas, 65¼ × 43 in.
(165.7 × 109.2 cm)
Rogers Fund, 1943
43.13

The Crucifixion

Oil on canvas, 20 × 13 in. (50.8 × 33 cm)
Inscribed (on cross): INRI
Bequest of Harry G. Sperling, 1971
1976.100.17

Juan de Valdés Leal

Spanish, 1622–1690

Pietà

Oil on canvas, 63¼ × 56½ in.
(160.7 × 143.5 cm)
Victor Wilbour Memorial Fund, 1954
54.168

Spanish(?) Painter

mid-17th century or later

The Education of the Virgin

Oil on canvas, 18½ × 15 in. (47 × 38.1 cm)
Gift of Mr. and Mrs. Joshua Logan, 1963
63.194.2

Spanish (Castilian) Painter

mid-17th century or later

Head of a Man

Oil on canvas, 14 × 10¾ in.
(35.6 × 27.3 cm)
Inscribed (lower right): 758
H. O. Havemeyer Collection, Bequest of Mrs.
H. O. Havemeyer, 1929
29.100.607

Spanish (Andalusian) Painters

late 17th century

Saint Michael the Archangel

Oil on canvas, 64¾ × 43¼ in.
(164.5 × 109.9 cm)
Marquand Collection, Gift of Henry G.
Marquand, 1889
89.15.17

Portrait of a Man

This fragment from an altarpiece represents a
donor.
Oil on canvas, 25 × 20⅝ in.
(63.5 × 52.4 cm)
Inscribed (right): NVESTRA S[EÑORA] (Our
Lady)
The Friedsam Collection, Bequest of Michael
Friedsam, 1931
32.100.7

Luis Egidio Meléndez (or Menéndez)

Spanish, 1716–1780

Still Life: The Afternoon Meal

Oil on canvas, 41½ × 60½ in.
(105.4 × 153.7 cm)
Inscribed (lower right): 255.M.de.R. [inventory
number]
The Jack and Belle Linsky Collection, 1982
1982.60.39

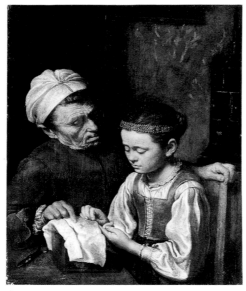

63.194.2

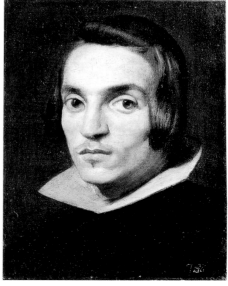

29.100.607

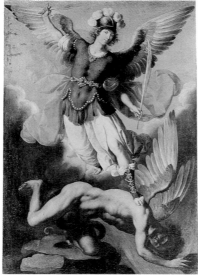

89.15.17

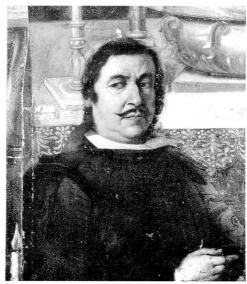

32.100.7

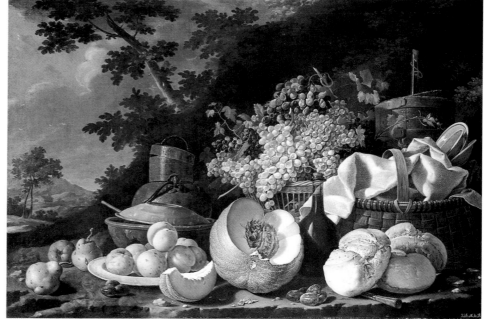

1982.60.39

1975.1.148

The Countess of Altamira (María Ygnacia Álvarez, died 1795) *and Her Daughter* (María Agustina Osoria Álvarez, born 1787)
Oil on canvas, 76¹/₂ × 45¹/₄ in.
(194.3 × 114.9 cm)
Inscribed (bottom): LA EX.ᵐᵃ S.ᵃ D.ᵃ MARIA YGNACIA ALVAREZ DE TOLEDO MARQVESA DE ASTORGA CONDESA DE ALTAMIRA / Y. LA S. D. MARIA AGVSTINA OSORIO ALVAREZ DE TOLEDO SV HIJA . NACIO . EN 21 DE FEBRERO DE 1787. (Her Excellency the Lady María Ygnacia Álvarez of Toledo, marchioness of Astorga and countess of Altamira, and the Lady María Agustina Osoria Álvarez of Toledo, her daughter, born on February 21, 1787.)
Robert Lehman Collection, 1975
1975.1.148
ROBERT LEHMAN COLLECTION

Francisco de Goya y Lucientes
Spanish, 1746–1828
Don Manuel Osorio Manrique de Zuñiga
(1784–1792)
Oil on canvas, 50 × 40 in.
(127 × 101.6 cm)
Signed and inscribed: (on card in bird's beak)
Dⁿ Francᵒ Goya; (bottom) EL Sʳ Dⁿ MANVEL
OSORIO MANRRIQVE DE ZVÑIGA Sʳ DE GINES
NACIO EN ABR A II DE 1784 (Señor Don
Manuel Osorio Manrique de Zuñiga, señor of
Ginés [Canary Islands], born on April 2,
1784)
The Jules Bache Collection, 1949
49.7.41

Don Sebastián Martínez y Pérez (1747–
1800)
Oil on canvas, 36⁵/₈ × 26⁵/₈ in.
(93 × 67.6 cm)
Signed, dated, and inscribed (on letter): Dⁿ
Sebastian / Martinez / Por su Amigo / Goya /
1792 (Don Sebastián Martínez by his friend
Goya 1792)
Rogers Fund, 1906
06.289

49.7.41

06.289

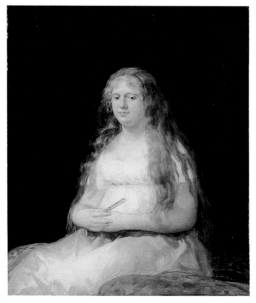

55.145.2

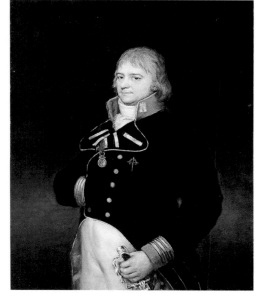

55.145.1

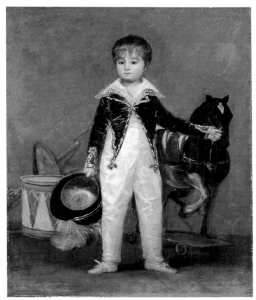

61.259

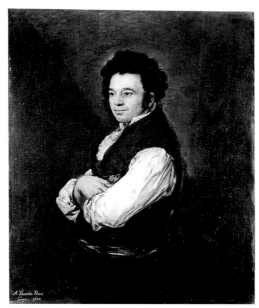

30.95.242

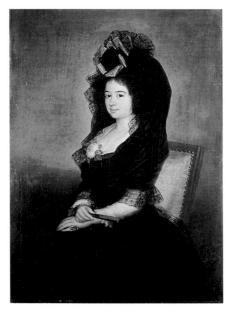

29.100.180

29.100.10

Doña Josefa Castilla Portugal de Garcini y Wanasbrok

Oil on canvas, 41 × 32³/₈ in.
(104.1 × 82.2 cm)
Signed, dated, and inscribed (lower right): Dª
Josefa Castilla. de / Garcini. pᵗ Goya. 1804
Bequest of Harry Payne Bingham, 1955
55.145.2

Don Ignacio Garcini y Queralt (1770–1825), *Brigadier of Engineers*

Pendant to 55.145.2
Oil on canvas, 41 × 32³/₄ in.
(104.1 × 83.2 cm)
Signed, dated, and inscribed (lower left): Dⁿ
Ignacio Garcini / por Goya. 1804.
Bequest of Harry Payne Bingham, 1955
55.145.1

José Costa y Bonells (died 1870), *Called Pepito*

Oil on canvas, 41³/₈ × 33¹/₄ in.
(105.1 × 84.5 cm)
Signed, dated, and inscribed (lower left):
Pepito Costa y Bonells / Por Goya. 18[]
Gift of Countess Bismarck, 1961
61.259

Don Tiburcio Pérez y Cuervo, the Architect

Oil on canvas, 40¹/₄ × 32 in.
(102.2 × 81.3 cm)
Signed, dated, and inscribed (lower left): A
Tiburcio Perez / Goya. 1.820.
Theodore M. Davis Collection, Bequest of
Theodore M. Davis, 1915
30.95.242

Attributed to Francisco de Goya

Doña Narcisa Barañana de Goicoechea

Oil on canvas, 44¹/₄ × 30³/₄ in.
(112.4 × 78.1 cm)
Signed (?) (on ring): Goya
H. O. Havemeyer Collection, Bequest of Mrs.
H. O. Havemeyer, 1929
29.100.180

Majas on a Balcony

Oil on canvas, 76³/₄ × 49¹/₂ in.
(194.9 × 125.7 cm)
H. O. Havemeyer Collection, Bequest of Mrs.
H. O. Havemeyer, 1929
29.100.10

Copies after Francisco de Goya

Spanish, 1797 or later

Don Bernardo de Iriarte (1734–1814)
This painting is a copy of the version in the Musée des Beaux-Arts, Strasbourg; a portrait of Iriarte was presented to the Royal Academy of San Fernando on November 1, 1797.
Oil on canvas, 42¹/₂ × 33¹/₂ in.
(108 × 85.1 cm)
Inscribed (bottom): Dⁿ Bernardo Yriarte, Vice-prot.ʳ de la R! Academia de las / tres nobles Artes, retratado por Goya entestimonio de mu- / tua estimacⁿ y afecto año de 1797 (Don Bernardo Yriarte, vice protector of the Royal Academy of Fine Arts, portrayed by Goya in testimony of mutual esteem and affection, [in] the year 1797)
Bequest of Mary Stillman Harkness, 1950
50.145.19

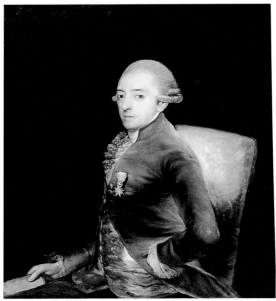

50.145.19

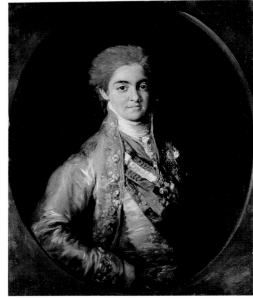

51.70

Spanish, 1800 or shortly after

Ferdinand VII (1784–1833), **When Prince of Asturias**
Oil on canvas, 32³/₄ × 26¹/₄ in. (83.2 × 66.7 cm)
Gift of René Fribourg, 1951
51.70

Infanta María Luisa (1782–1824) **and Her Son Don Carlos Luis** (1799–1883)
Oil on canvas, 39¹/₈ × 27 in.
(99.4 × 68.6 cm)
Theodore M. Davis Collection, Bequest of Theodore M. Davis, 1915
30.95.243

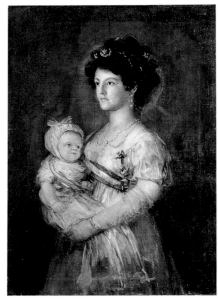

30.95.243

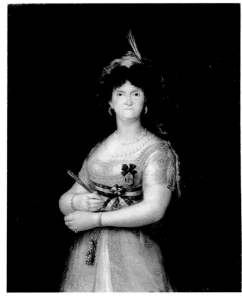

29.100.11

Spanish, after 1800

María Luisa of Parma (1751–1819), **Queen of Spain**
Oil on canvas, 43¹/₂ × 33¹/₂ in.
(110.5 × 85.1 cm)
H. O. Havemeyer Collection, Bequest of Mrs. H. O. Havemeyer, 1929
29.100.11

Style of Francisco de Goya

Spanish, early 19th century

Bullfight in a Divided Ring
Oil on canvas, 38³/₄ × 49³/₄ in.
(98.4 × 126.4 cm)
Catharine Lorillard Wolfe Collection, Wolfe Fund, 1922
22.181

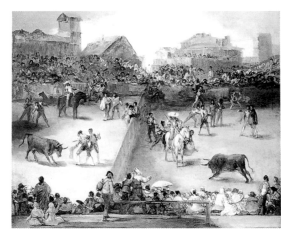

22.181

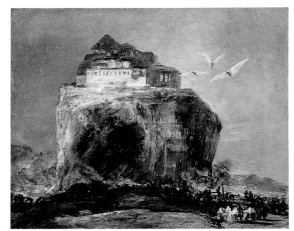

29.100.12

Spanish, 19th century

A City on a Rock
Oil on canvas, 33 × 41 in. (83.8 × 104.1 cm)
H. O. Havemeyer Collection, Bequest of Mrs. H. O. Havemeyer, 1929
29.100.12

64.164.385

87.15.39

15.30.71

81.1.666

87.15.57

83.11

Peruvian (Cuzco) Painter
about 1680
Virgin of the Rosary
Oil on canvas, 67¼ × 43½ in.
(170.8 × 110.5 cm)
Gift of Loretta Hines Howard, 1964
64.164.385

José Villegas
Spanish, 1848–1921
Examining Arms
Oil on wood, 15⅝ × 12½ in.
(39.7 × 31.8 cm)
Signed and dated (lower left): Villegas.1870–
Catharine Lorillard Wolfe Collection, Bequest
of Catharine Lorillard Wolfe, 1887
87.15.39

Martín Rico y Ortega
Spanish, 1833–1908
On the Seine
Oil on canvas, 15¼ × 25½ in.
(38.7 × 64.8 cm)
Signed (lower right): RICO
Bequest of Maria DeWitt Jesup, from the
collection of her husband, Morris K. Jesup,
1914
15.30.71

A Spanish Garden
Oil on canvas, 24 × 15¼ in. (61 × 38.7 cm)
Signed (lower right): RICO
Bequest of Stephen Whitney Phoenix, 1881
81.1.666

A Canal in Venice
Oil on canvas, 19¾ × 26¾ in.
(50.2 × 67.9 cm)
Signed (lower left): RICO
Catharine Lorillard Wolfe Collection, Bequest
of Catharine Lorillard Wolfe, 1887
87.15.57

Ignacio de Leon y Escosura
Spanish, 1834–1901
*Auction Sale in Clinton Hall, New York,
1876*
Oil on canvas, 22⅜ × 31⅝ in.
(56.8 × 80.3 cm)
Signed and dated (lower left): Leon / y /
Escosura 1876
Gift of the artist, 1883
83.11

Mariano Fortuny Marsal

Spanish, 1838–1874

Madame Gaye

Oil on canvas, 54 × 39¹/₂ in.
(137.2 × 100.3 cm)
Signed, dated, and inscribed (lower right): M.
Fortuny / Roma 186[5?].
Gift of Alfred Corning Clark, 1889
89.22

Francisco Domingo y Marqués

Spanish, 1842–1920

Portrait of an Old Man

Oil on wood, 10³/₄ × 8³/₄ in.
(27.3 × 22.2 cm)
Signed, dated, and inscribed (lower right):
Paris / Domingo / 1882
Bequest of Martha T. Fiske Collord, in
memory of her first husband, Josiah M. Fiske,
1908
08.136.14

89.22

08.136.14

Raimundo de Madrazo y Garreta

Spanish, 1841–1920

Samuel P. Avery (1822–1904)
Mr. Avery was a trustee of the Metropolitan
Museum, 1872–1904.
Oil on wood, 24 × 19¹/₄ in. (61 × 48.9 cm)
Signed, dated, and inscribed (upper right): à
Mʳ Avery / R. Madrazo / 1876.
Gift of the family of Samuel P. Avery, 1904
04.29.1

Girls at a Window

Oil on canvas, 28⁵/₈ × 23¹/₂ in.
(72.7 × 59.7 cm)
Signed (lower right): R. Madrazo
Catharine Lorillard Wolfe Collection, Bequest
of Catharine Lorillard Wolfe, 1887
87.15.131

04.29.1

87.15.131

Masquerade Ball at the Ritz Hotel, Paris

Oil on canvas, 35 × 47 in.
(88.9 × 119.4 cm)
Signed and dated (lower right): R. Madrazo /
1909
Bequest of Emma T. Gary, 1934
37.20.3

Masqueraders

Oil on canvas, 40 × 25¹/₂ in.
(101.6 × 64.8 cm)
Signed (lower right): R. Madrazo
Robert Lehman Collection, 1975
1975.1.233
ROBERT LEHMAN COLLECTION

37.20.3

1975.1.233

87.4.7

1983.498

09.71.2

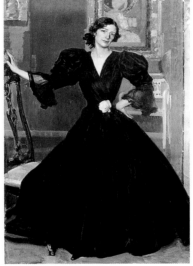

09.71.3

22.119.1

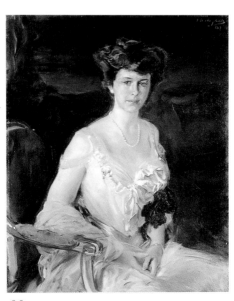

58.81

Federico de Madrazo y de Ochoa
Spanish, 1875–1934
Laure de Sade, Comtesse Adhéaume de Chevigné
Oil on canvas, 45¹/₂ × 29 in. (115.6 × 73.7 cm)
Signed (lower right): DE [monogram] MADRAZO
Anonymous Gift, 1983
1983.498

Dionisio Baixeras y Verdaguer
Spanish, 1862–1943
Boatmen of Barcelona
Oil on canvas, 59 × 83 in.
(149.9 × 210.8 cm)
Signed and dated (lower right): D.BAIXERAS. / 1886.
Gift of George I. Seney, 1886
87.4.7

Joaquín Sorolla y Bastida
Spanish, 1863–1923
The Bath, Jávea
Oil on canvas, 35¹/₂ × 50¹/₂ in.
(90.2 × 128.3 cm)
Signed and dated (lower right): J Sorolla Bastida / 1905.
Catharine Lorillard Wolfe Collection, Wolfe Fund, 1909
09.71.2

Señora de Sorolla (Clotilde García del Castillo, 1865–1929) ***in Black***
Oil on canvas, 73¹/₂ × 46³/₄ in.
(186.7 × 118.7 cm)
Signed, dated, and inscribed: (lower left) J. Sorolla Bastida 1906; (right edge) Clotilde de Sorolla.
Catharine Lorillard Wolfe Collection, Wolfe Fund, 1909
09.71.3

Castle of San Servando, Toledo
Oil on canvas, 26¹/₄ × 36¹/₂ in.
(66.7 × 92.7 cm)
Signed and dated (lower right): J Sorolla y Bastida / 1906
Gift of Archer M. Huntington, 1922
22.119.1

Mrs. Winthrop W. Aldrich (Harriet Alexander, 1888–1972)
Oil on canvas, 40 × 30³/₈ in.
(101.6 × 77.2 cm)
Signed and dated (upper right): J Sorolla y Bastida / 1909
Gift of Harriet Alexander Aldrich, 1958
58.81

Byzantine Painter

15th century

The Presentation in the Temple

Tempera on wood, gold ground,
17¹/₂ × 16⁵/₈ in. (44.5 × 42.2 cm)
Inscribed (in Greek): (on scroll held by
Anna) This Child created Heaven and Earth;
(above Virgin) Mary, Mother of God; (upper
left) Purification; (upper right, part of an
older inscription) Purification [partially
legible]
Bequest of Lillie P. Bliss, 1931
31.67.8

Nicolaos Tzafouris

Greek, active by 1489, died 1500

Christ Bearing the Cross

Oil and tempera on wood, gold ground,
27¹/₄ × 21¹/₂ in. (69.2 × 54.6 cm)
Signed and inscribed: (lower center)
NICOLAVS·ZAFVRI·PINXIT·; (top, in Greek)
[Christ] being dragged to the cross; (beside
Christ's head, in Greek) Jesus Christ; (right,
on banner) SPQR
Bashford Dean Memorial Collection, Funds
from various donors, 1929
29.158.746
ARMS AND ARMOR

Ioannes Mokos

Greek, active 1680–1724

The Dormition of the Virgin

Tempera and oil on wood, gold ground,
13¹/₂ × 11¹/₄ in. (34.3 × 28.6 cm)
Signed and inscribed (in Greek): (top) The
dormition of the Mother of God; (lower left)
[By the] hand of Ioannes Mokos
Gift of Mrs. Henry Morgenthau, 1933
33.79.17

31.67.8

29.158.746

33.79.17

33.79.15

33.79.14

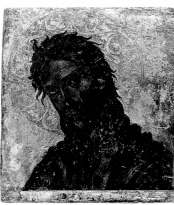

33.79.18

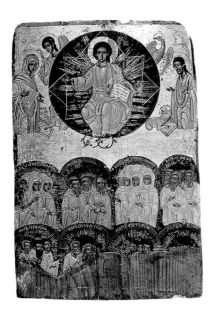

31.67.9

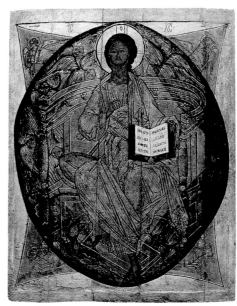

44.101

Emmanuel Tzanès
Greek, active by 1636, died 1690

Head of the Virgin
This panel is from a deesis, to which the following two panels (33.79.14, 33.79.18) also belonged.
Tempera on wood, gold ground,
8³/₈ × 7¹/₈ in. (21.3 × 18.1 cm)
Inscribed (background, in Greek): Mary, Mother of God
Gift of Mrs. Henry Morgenthau, 1933
33.79.15

Head of Christ
Tempera on wood, gold ground,
8³/₈ × 7¹/₈ in. (21.3 × 18.1 cm)
Signed and inscribed (in Greek): (lower left) [By the] hand of [the] priest [Em]manuel of [Tz]ane; (background) Jesus Christ
Gift of Mrs. Henry Morgenthau, 1933
33.79.14

Head of Saint John the Baptist
Tempera on wood, gold ground,
8³/₈ × 7¹/₈ in. (21.3 × 18.1 cm)
Inscribed (background, in Greek): John the Forerunner
Gift of Mrs. Henry Morgenthau, 1933
33.79.18

Greek Painter
possibly 18th century

All Saints
Tempera on wood, gold ground,
12¹/₂ × 8¹/₄ in. (31.8 × 21 cm)
Inscribed (in Greek): (upper left) Mary, Mother of God; (upper right) John the Forerunner; (either side of Christ's head) Jesus Christ; (on Christ's book) Come, ye blessed of my Father, inherit [the kingdom] prepared [for you . . .] [Matthew 25:34].; (below, identifying choirs of blessed) the holy women, the confessors [partially legible], the female martyrs, the just, the hierarchs, the prophets, the apostles, the male martyrs
Bequest of Lillie P. Bliss, 1931
31.67.9

Russian (possibly Novgorod) Painter
late 15th century

Christ Enthroned
This may be the central panel of a deesis.
Tempera on wood, 42¹/₈ × 30⁷/₈ in.
(107 × 78.4 cm)
Inscribed: (top, in Greek) Jesus Christ; (three corners, in Greek) with the names of the Evangelists; (on book, in Old Church Slavonic) Come to me and be judged justly
Gift of George R. Hann, 1944
44.101

Russian Painters

15th/16th century

The Dormition of the Virgin

Tempera on wood, 13¼ × 11½ in.
(33.7 × 29.2 cm)
Inscribed (top, in Russian): Dormition of the
Most Holy Mother of God
Gift of Humanities Fund Inc., 1972
1972.145.27

Saint Parasceva

Tempera on wood, 9¼ × 7⅜ in.
(23.5 × 18.7 cm)
Inscribed (on scroll, in Russian): I believe in
one God
Gift of Humanities Fund Inc., 1972
1972.145.28

16th century

The Protection of the Mother of God

Tempera on wood, 12⅜ × 10½ in.
(31.4 × 26.7 cm)
Inscribed (in Russian): (top) The Protection
of the Most Holy Mother of God; (on scroll)
[illegible]
Gift of Humanities Fund Inc., 1972
1972.145.24

second half 16th century

The Annunciation

Tempera on wood, 13 × 10⅜ in.
(33 × 26.4 cm)
Gift of Humanities Fund Inc., 1972
1972.145.14

possibly 16th century

Saint George

Tempera on wood, 27¼ × 19¾ in.
(69.2 × 50.2 cm)
Gift of Humanities Fund Inc., 1972
1972.145.13

Panel from a Saints' Calendar (painted on
both sides)

Tempera on wood, 7⅛ × 6⅛ in.
(18.1 × 15.6 cm)
Inscribed (recto and verso, in Russian) with
the names of the saints
Gift of Humanities Fund Inc., 1972
1972.145.23

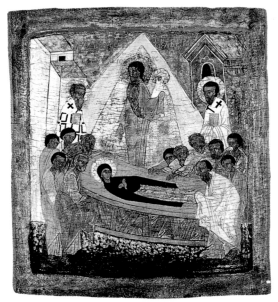

1972.145.27

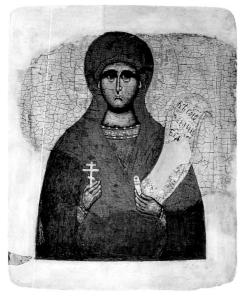

1972.145.28

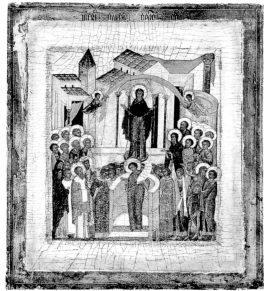

1972.145.24

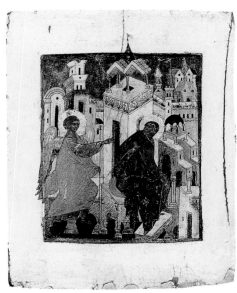

1972.145.14

1972.145.13

1972.145.23

1972.145.23

1972.145.19

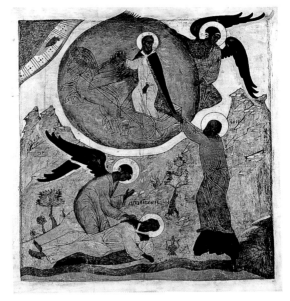

1972.145.20

1975.87

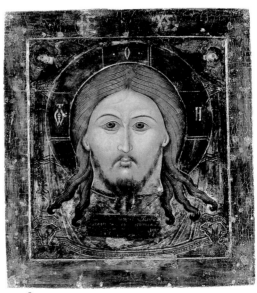

1975.87

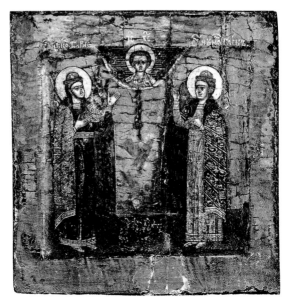

33.84a

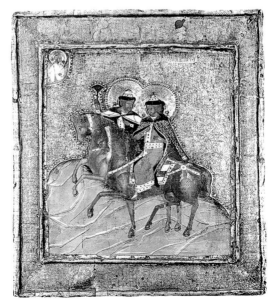

1972.145.29

late 16th / early 17th century

The Congregation of the Mother of God
Tempera on wood, 14⅛ × 12¼ in.
(35.9 × 31.1 cm)
Inscribed (on scrolls, in Russian): [illegible]
Gift of Humanities Fund Inc., 1972
1972.145.19

Saint Elias's Fiery Ascension
Tempera on wood, 27 × 23⅞ in.
(68.6 × 60.6 cm)
Inscribed (in Russian): (top) Elias; (right)
Elijah; (center) Angel of God Awakening Elias
Gift of Humanities Fund Inc., 1972
1972.145.20

early 17th century

The Face of Christ Not Made by Human Hands
Shown with and without the silver and
jeweled cover, which is dated 1637
Tempera on wood, 18 × 15⅜ in.
(45.7 × 39.1 cm)
Inscribed (in Russian): (top) Jesus Christ;
(bottom, on plaque) The image of the Lord
that was sent by the Lord himself to King
Abgar of Edessa for healing and this image
was placed in the monastery of Saint Silvester
with great honor to the glory of God's great
miracle.
Rogers Fund, 1975
1975.87
ESDA

16th–18th century

The Christ Child with Saints Boris and Gleb
Tempera and gold on wood; overall
4⅜ × 4 in. (11.1 × 10.2 cm); painted
surface 3½ × 3¼ in. (8.9 × 8.3 cm)
Inscribed (in Russian): (above Christ's head)
Jesus Christ; (upper left) Son Prince Boris;
(upper right) Son Prince Gleb
Gift of George D. Pratt, 1933
33.84a

17th century

Saints Boris and Gleb
Tempera on wood, silver and silver-gilt cover,
12½ × 10⅝ in. (31.8 × 27 cm)
Inscribed (top, in Russian): Orthodox good
Christians, Princes Boris and Gleb
Gift of Humanities Fund Inc., 1972
1972.145.29

Russian Painter
17th/18th century

Calendar of Saints and Festivals (series of twelve icons)
Tempera on wood, gold ground; each
$12^3/_8 \times 10^1/_4$ in. (31.4×26 cm)
Inscribed (in Old Church Slavonic) with the names of the saints and the identification of events
Gift of Mrs. Henry Morgenthau, 1933
33.79.1—12

33.79.12

33.79.6

33.79.10

33.79.11

33.79.7

33.79.8

33.79.3

33.79.1

33.79.5

33.79.9

33.79.4

33.79.2

Russian Painters
possibly 17th century

The Trinity
Tempera on wood, 12⁷/₈ × 10⁵/₈ in.
(32.7 × 27 cm)
Gift of Humanities Fund Inc., 1972
1972.145.16

***The Resurrection of Christ and the
Harrowing of Hell***
Tempera on wood, 12¹/₄ × 9⁷/₈ in.
(31.1 × 25.1 cm)
Gift of Zoltan Ovary, in memory of Baby and
Umberto Natali, 1982
1982.378

probably 17th century

Christ's Entry into Jerusalem
Tempera on wood, 12¹/₄ × 10¹/₄ in.
(31.1 × 26 cm)
Inscribed (top, in Russian): The Entry into
Jerusalem of Our Lord Jesus Christ
Gift of Humanities Fund Inc., 1972
1972.145.21

late 17th/18th century

Saint John the Evangelist
Tempera on wood, 12¹/₂ × 10⁵/₈ in.
(31.8 × 27 cm)
Inscribed (on book, in Russian): [In the
beginning was] the word [John 1:1].
Gift of Humanities Fund Inc., 1972
1972.145.17

18th century

Three Female Saints
Tempera on wood, silver-gilt and enamel
cover, 12¹/₄ × 10¹/₈ in. (31.1 × 25.7 cm)
Inscribed (on scroll, in Russian): Lord Jesus
Christ, Son of God, hear me, your servant
Gift of Humanities Fund Inc., 1972
1972.145.31

18th/19th century

***The Resurrection of Christ and the
Harrowing of Hell***
Tempera on wood, 12¹/₈ × 10¹/₂ in.
(30.8 × 26.7 cm)
Inscribed (in Russian) with the names of the
prophets; (top) The Resurrection of Our Lord
Jesus Christ
Gift of Humanities Fund Inc., 1972
1972.145.32

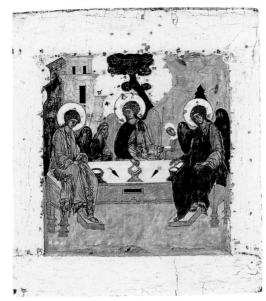

1972.145.16

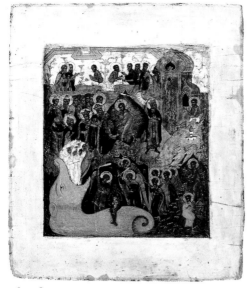

1982.378

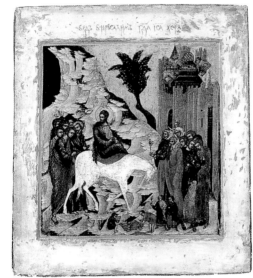

1972.145.21

1972.145.17

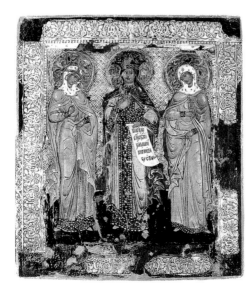

1972.145.31

1972.145.32

68.160a

32.72

1972.145.18

1972.145.25

before 1815

Bogoliubskaya Mother of God with the Chosen Saints
Tempera on wood, 14 × 11⁵/₈ in.
(35.6 × 29.5 cm)
Inscribed (in Russian) with the names of the saints; (on scroll held by Christ) Why, O my mother, are you standing tenderly before me in prayer?; (on scroll held by Virgin) My lord and master, Jesus Christ, and my God, listen to the prayer of your mother, who is begging you for the Christian people and for all the suffering faithful
Gift of Natalie Derujinsky, 1968
68.160a
ESDA

about 1890

Christ Preaching
Oil on wood, silver and enamel cover encrusted with pearls and stones,
4³/₄ × 4¹/₄ in. (12.1 × 10.8 cm)
Inscribed (on book, in Russian): This is my commandment. That ye love one another; as I have loved you [John 13:34].
Gift of Estate of Mary Harrison McKee, 1932
32.72
ESDA

of uncertain date

A Sainted Monk
Tempera on wood, 12¹/₈ × 10¹/₄ in.
(30.8 × 26 cm)
Inscribed (top of headdress, in Russian): Jesus Christ, King of Glory / Victory
Gift of Humanities Fund Inc., 1972
1972.145.18

Our Lady of Vladimir
Tempera on wood, 8⁵/₈ × 6⁷/₈ in.
(21.9 × 17.5 cm)
Inscribed (background, in Greek): Mother of God
Gift of Humanities Fund Inc., 1972
1972.145.25

Ivan Konstantinovich Aivazovsky

Russian, 1817–1900

Ship by Moonlight

Oil on canvas, 6¼ × 9¼ in.
(15.9 × 23.5 cm)
Signed or inscribed (lower right): A
Bequest of Mary Jane Dastich, in memory of
her husband, General Frank Dastich, 1975
1975.280.2

Alexei Kondratievich Savrasov

Russian, 1830–1897

Night Scene on the Volga

Oil on wood, 12⅞ × 21½ in.
(32.7 × 54.6 cm)
Signed and dated (lower right, in Russian): A.
Savrasov 1871
Gift of Humanities Fund Inc., 1972
1972.145.4

1975.280.2

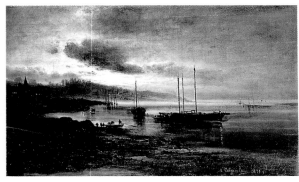

1972.145.4

Vasilii Grigorievich Perov

Russian, 1834–1882

Head of a Man

Oil on canvas board, 20⅞ × 13⅞ in.
(53 × 35.2 cm)
Signed (upper right, in Russian): V G Perov.
Bequest of Mary Jane Dastich, in memory of
her husband, General Frank Dastich, 1975
1975.280.6

Konstantin Igorovich Makovsky

Russian, 1839–1915

Portrait of a Young Woman

Oil on copper, 21¼ × 15⅜ in.
(54 × 39.1 cm)
Signed (upper left): C. Makowsky
Bequest of Mary Jane Dastich, in memory of
her husband, General Frank Dastich, 1975
1975.280.5

1975.280.6

1975.280.5

Arkhip Ivanovich Kuindzhi

Russian, 1842–1910

Red Sunset on the Dnieper

Oil on canvas, 53 × 74 in. (134.6 × 188 cm)
Rogers Fund, 1974
1974.100

Vasilii Dmitrivich Polenov

Russian, 1844–1927

Christ and the Woman Taken in Adultery

Oil on canvas, 9½ × 17 in.
(24.1 × 43.2 cm)
Dated (lower left): 1884
Gift of Humanities Fund Inc., 1972
1972.145.5

1974.100

1972.145.5

1975.280.4

1972.145.2

1972.145.1

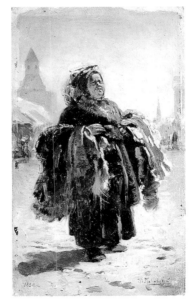

1972.145.3

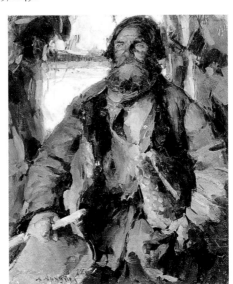

29.63

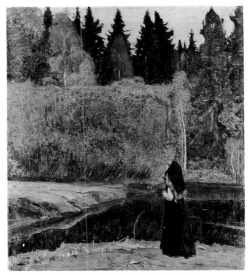

1972.145.6

Ilia Efimovich Repin

Russian, 1844–1930

Shepherd with a Flock of Sheep

Oil on canvas board, 4⅞ × 8⅞ in.
(12.4 × 22.5 cm)
Signed and dated (lower left, in Russian): I
Repin 70
Bequest of Mary Jane Dastich, in memory of
her husband, General Frank Dastich, 1975
1975.280.4

Vsevolod Mikhailovich Garshin (1855–1888)

Oil on canvas, 35 × 27¼ in.
(88.9 × 69.2 cm)
Signed and dated (lower left, in Russian):
1884/I. Repin
Gift of Humanities Fund Inc., 1972
1972.145.2

Portrait of a Boy

Oil on canvas, 22½ × 17⅜ in.
(57.2 × 44.1 cm)
Signed and dated (right, in Russian): I.
Repin/1884/x/15
Gift of Humanities Fund Inc., 1972
1972.145.1

Vladimir Igorovich Makovsky

Russian, 1848–1920

The Peddler

Oil on wood, 10 × 5¾ in. (25.4 × 14.6 cm)
Signed and dated: (lower right, in Russian) V.
Makovsky; (lower left) 1880.
Gift of Humanities Fund Inc., 1972
1972.145.3

Abram Efimovich Arkhipov

Russian, 1862–1930

Ivan Rodin

Oil on canvas, 44 × 34¼ in.
(111.8 × 87 cm)
Signed and dated (lower left, in Russian): A.
Arkhipov/28
Gift of George D. Pratt, 1929
29.63

Mikhail Vasilievich Nesterov

Russian, 1862–1942

The Nightingale Sings

Oil on canvas, 31⅞ × 27⅜ in.
(81 × 69.5 cm)
Signed and dated (lower right, in Russian): M.
NESTEROV. 1923.
Gift of Humanities Fund Inc., 1972
1972.145.6

British Painters

dated 1572

Walter Devereux (1541–1576), ***First Earl of Essex***

Another portrait (National Portrait Gallery, London), apparently by the same artist and differing only in the position of the sitter's right hand, is also signed and dated 1572.

Oil on wood, 41⅛ × 31½ in.
(104.5 × 80 cm)

Dated and inscribed: (upper left, on Garter ribbon) HONI·SOIT·QVI·MAL·Y·PENSE· [motto of the Order of the Garter]; (upper right) Aᵒ·DÑI·1572· / Æᵀ·SVÆ·32· / VIRTVTIS, COMES, INVIDIA [a personal motto]

Arms (upper left) of the Devereux family

Rogers Fund, 1920

20.151.6

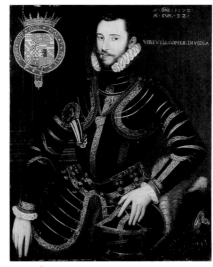

20.151.6

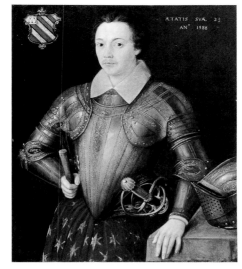

51.194.2

dated 1588

Sir John Shurley (1565–1632)

Oil on wood, 35¾ × 29⅜ in.
(90.8 × 74.6 cm)

Dated and inscribed: (upper right) ÆTATIS SVÆ 23 / ANᵒ 1588; (lower right) H

Arms (upper left) of the Shurley family of Isfield Place, Sussex

Gift of Kate T. Davison, in memory of her husband, Henry Pomeroy Davison, 1951

51.194.2

late 16th century

Portrait of a Noblewoman

Oil on wood, 44½ × 34¾ in.
(113 × 88.3 cm)

Gift of J. Pierpont Morgan, 1911

11.149.1

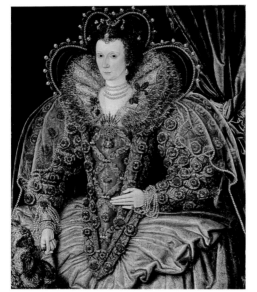

11.149.1

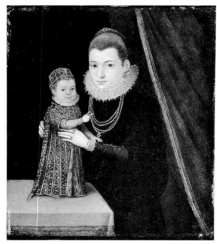

17.190.2

16th-century style (probably 20th century)

Portrait of a Mother and Her Son (The Duff-Ogilvie Portrait)

Oil on slate, 8⅞ × 7¾ in.
(22.5 × 19.7 cm)

Gift of J. Pierpont Morgan, 1917

17.190.2

Robert Peake the Elder

British, active by 1576, died 1619

Henry Frederick (1594–1612), ***Prince of Wales, and Sir John Harington*** (1592–1614)

Oil on canvas, 79½ × 58 in.
(201.9 × 147.3 cm)

Dated and inscribed: (center left) 1603 / fe / Æ·11·; (lower left) Sir John Harrington.; (upper right) 1603 / fe / Æ·9·; (lower right) Henry Frederick Prince of Wale[s] Son / of King James the Iˢᵗ

Purchase, Joseph Pulitzer Bequest, 1944

44.27

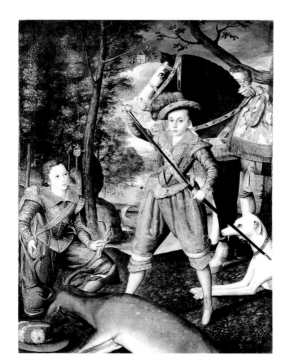

44.27

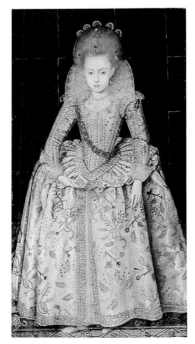

51.194.1

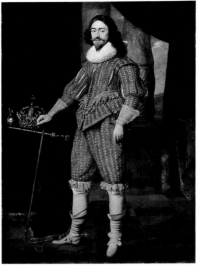

06.1289

08.237.1

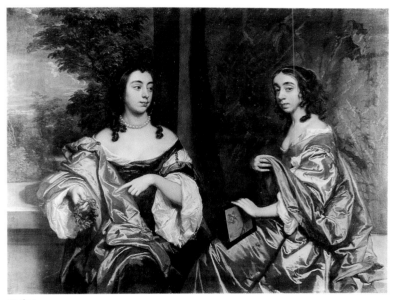

39.65.3

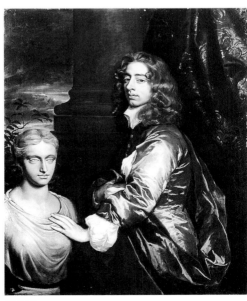

39.65.6

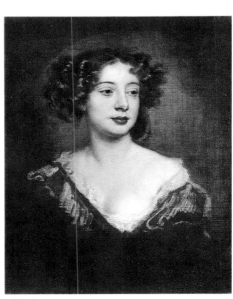

06.1198

Princess Elizabeth (1596–1662), ***Later Queen of Bohemia***

Oil on canvas, 60³/₄ × 31¹/₄ in. (154.3 × 79.4 cm)

Inscribed: (on book) No Tablet [flat inscribed jewel] / For thy brest / Thy Chr[ist]ian mo / ther gives hir / Dattere What / Jewell Fits hir / best A boke not / big but yet ther / in Some hidden / Vertu is So christ / So christ Procur. you / grace with / God And / Give you / endles / [bliss(?)]; (falsely, lower left) ELIZABETH QUEEN OF ENGLAND

Gift of Kate T. Davison, in memory of her husband, Henry Pomeroy Davison, 1951

51.194.1

Daniel Mijtens the Elder

Dutch, 1590–1647/48

Charles I (1600–1649), ***King of England***

Oil on canvas, 78⁷/₈ × 55³/₈ in. (200.3 × 140.7 cm)

Signed, dated, and inscribed: (lower right) Pinxit Daniel Mytens; (right, on column base) CAROLVS D[EI]G[RATIA] MAG[NI] / BRITANNIÆ FRANCIÆ / ET HIBERNIÆ REX / FIDEI DEFENSOR. / ÆTAT. 29. / ANNO 1629 (Charles, by the grace of almighty God, king of Britain, France, and Ireland. Defender of the Faith. Aged 29. In the year 1629)

Gift of George A. Hearn, 1906

06.1289

Attributed to Robert Streater

British, 1624–1679

John Milton (1608–1674)

Oil on canvas, 27¹/₄ × 21¹/₂ in. (69.2 × 54.6 cm)

Gift of Mrs. Wheeler Smith, 1908

08.237.1

Sir Peter Lely (Pieter van der Faes)

Dutch, 1618–1680

Mary Capel (1630–1715), ***Duchess of Beaufort, and Her Sister Elizabeth*** (1633–1678), ***Countess of Carnarvon***

This picture and the following (39.65.6) were apparently painted en suite.

Oil on canvas, 51¹/₄ × 67 in. (130.2 × 170.2 cm)

Signed and inscribed: (lower left, on parapet) PL. [monogram]; (on flower painting) E Carnarvon / fecit

Bequest of Jacob Ruppert, 1939

39.65.3

Sir Henry Capel (1638–1696)

Oil on canvas, 49³/₄ × 40¹/₂ in. (126.4 × 102.9 cm)

Signed (on column base): PL [monogram]

Bequest of Jacob Ruppert, 1939

39.65.6

Sir Peter Lely

Portrait of a Woman
Oil on canvas, 26¹/₂ × 21¹/₈ in. (67.3 × 53.7 cm)
Rogers Fund, 1906
06.1198

Workshop of Sir Peter Lely
British, after 1670

Barbara Villiers (1640–1709), **Duchess of Cleveland**
Oil on canvas, 89 × 54 in. (226.1 × 137.2 cm)
Inscribed (bottom): FRANCOISE VILERS DE CREVELANDE
Bequest of Jacob Ruppert, 1939
39.65.9

Willem Wissing
Dutch, 1656–1687

Portrait of a Woman
Oil on canvas, 49³/₄ × 40¹/₄ in.
(126.4 × 102.2 cm)
Signed (right): W. Wissing. Fecit
Bequest of Jacob Ruppert, 1939
39.65.7

Sir Godfrey Kneller
German, 1646–1723

Charles Beauclerk (1670–1726), **Duke of St. Albans**
Oil on canvas, 49⁷/₈ × 40¹/₂ in.
(126.7 × 102.9 cm)
Signed and inscribed: (lower left) GK
[monogram] F; (upper center) The [Ri]ght
Ho[n] / CHARLES BEAUCLAIRE / Baron
Heddington / Earle of BURFORD
Bequest of Jacob Ruppert, 1939
39.65.8

Lady Mary Berkeley, Wife of Thomas Chambers
Oil on canvas, 29 × 25 in. (73.7 × 63.5 cm)
Inscribed (left center): My Lady Mary
Berkeley / Wife to Tho Chamb[ers] Esq /
G. K. . . .
Gift of George A. Hearn, 1896
96.30.6

Michael Dahl the Elder
Swedish, 1656–1743

Portrait of a Woman
Oil on canvas, 77¹/₄ × 51³/₄ in.
(196.2 × 131.4 cm)
Gift of Margaret Bruguière, in memory of
Louis Bruguière, 1956
56.224.1

John Wootton
British, 1682–1765

Hunting Scene
This painting is the overmantel in the dining

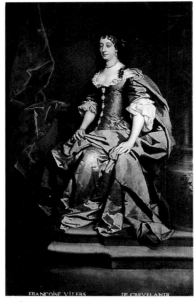

39.65.9

39.65.7

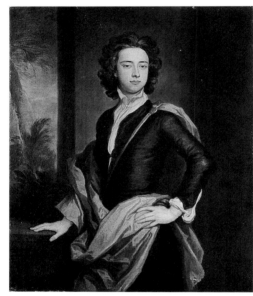

39.65.8

96.30.6

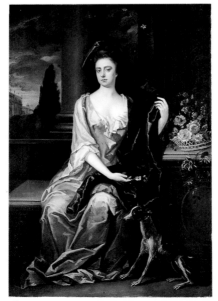

56.224.1

32.53.2

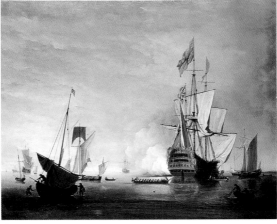

60.94.2

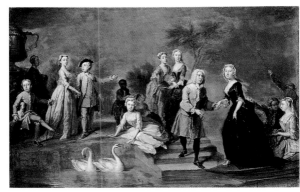

20.40

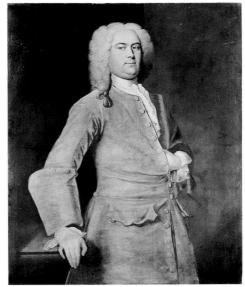

46.60

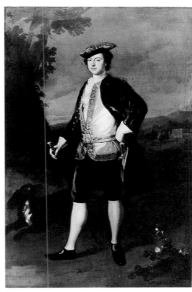

56.190

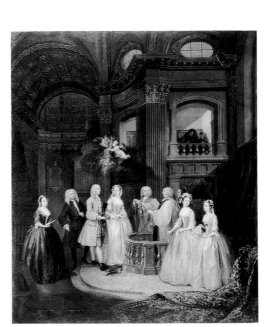

36.111

91.26.1

room from Kirtlington Park, Oxfordshire
(MMA).
Oil on canvas, 55¼ × 51⅜ in.
(140.3 × 130.5 cm)
Signed and dated (lower center): J. Wootton /
Fecit 1748
Fletcher Fund, 1931
32.53.2
ESDA

Peter Monamy
British, born about 1684, died 1749

*Harbor Scene: English Three-Decker Firing
a Salute*
Oil on canvas, 48 × 59 in. (121.9 × 149.9 cm)
Gift of William P. Clyde, 1960
60.94.2

Bartholomew Dandridge
British, born 1691, died about 1754

The Price Family
The sitters are Uvedale Tomkyns Price (1685–
1764), his son Robert (1717–1761), his cousins
Miss Rodd and Miss Greville, and other
members of the Rodd and Greville families.
Oil on canvas, 40¼ × 62½ in.
(102.2 × 158.8 cm)
Rogers Fund, 1920
20.40

British Painter
about 1720

*Portrait of a Man, Possibly George
Frederick Handel* (1685–1759)
Oil on canvas, 47⅜ × 37 in. (120.3 × 94 cm)
Gift of Francis Neilson, 1946
46.60

Enoch Seeman the Younger
British, 1694–1744

Sir James Dashwood (1715–1779), *Second
Baronet*
Oil on canvas, 96 × 60¼ in. (243.8 × 153 cm)
Signed, dated, and inscribed: (lower right)
Enoch Seeman / pinx.1737; (lower left) Sir
James Dashwood Barⁱ / (Painted in the 23ʳᵈ
Year of his age) / Died 1779 Aged 64
Victor Wilbour Memorial Fund, 1956
56.190

William Hogarth
British, 1697–1764

*The Wedding of Stephen Beckingham and
Mary Cox*
Oil on canvas, 50½ × 40½ in.
(128.3 × 102.9 cm)
Signed, dated, and inscribed (lower left):
Nuptiae: Stp Beckingham: Ar[mige]ʳ / June:
9th: 1729: Wᵐ Hogarth: Pinx[i]ᵗ:
Marquand Fund, 1936
36.111

Attributed to George Knapton

British, 1698–1778

Girl Building a House of Cards

Oil on canvas, 30¹/8 × 25¹/4 in.
(76.5 × 64.1 cm)
Marquand Collection, Gift of Henry G.
Marquand, 1890
91.26.1

James Seymour

British, 1702–1752

Portrait of a Horseman

Oil on canvas, 37 × 51⁵/8 in. (94 × 131.1 cm)
Signed and dated (lower right): J:s / 1748.
Gift of the children of the late Otto H. and
Addie W. Kahn (Lady Maud E. Marriott,
Mrs. Margaret D. Ryan, Roger W. Kahn, and
Gilbert W. Kahn), 1956
56.54.1

Samuel Scott

British, 1702–1772

The Building of Westminster Bridge

The pendant is a view of Old London Bridge
(private collection), signed and dated 1747.
Oil on canvas, 24 × 44³/8 in. (61 × 112.7 cm)
Signed (lower right): S. Scott
Purchase, Charles B. Curtis Fund and Joseph
Pulitzer Bequest, 1944
44.56

Charles Philips

British, 1708–1747

The Strong Family

The inscriptions on the period frame, which
identify (or perhaps misidentify in some cases)
various sitters, indicate that the family is that
of Edward Strong of Greenwich, master
mason of Saint Paul's cathedral.
Oil on canvas, 29⁵/8 × 37 in. (75.2 × 94 cm)
Signed and dated (lower right): CPhilips
[initials in monogram] pinxit 1732
Gift of Robert Lehman, 1944
44.159

Richard Wilson

British, 1713–1782

Lake Nemi from a Monastery Garden

Oil on canvas, 16⁷/8 × 21¹/8 in.
(42.9 × 53.7 cm)
Gift of George A. Hearn, 1905
05.32.3

Sir Joshua Reynolds

British, 1723–1792

Thomas (1741–1825) *and Martha Neate,
Later Mrs. Williams, and Their Tutor, Mr.
Needham*

Oil on canvas, 66¹/8 × 71 in. (168 × 180.3 cm)
Signed and dated (lower right, on edge

56.54.1

44.56

44.159

05.32.3

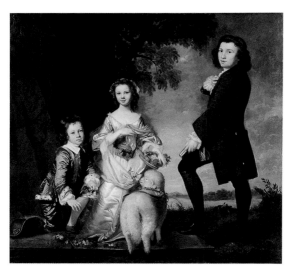

1986.264.5

of plinth): J Reynolds pinxit 1748
Gift of Heathcote Art Foundation, 1986
1986.264.5

Portrait of a Woman

Oil on canvas, 29⁵/8 × 24¹/2 in.
(75.2 × 62.2 cm)
Bequest of George D. Pratt, 1935
42.152.1

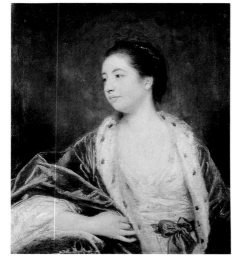

42.152.1

Anne Dashwood (1743–1830), *Later
Countess of Galloway*

Oil on canvas, 52¹/2 × 46³/4 in.
(133.4 × 118.7 cm), with strip of 7¹/8 in.
(18.1 cm) folded over the top of the stretcher
Signed and dated (right, above bas-relief):
Reynolds 1764 pinxit
Gift of Lillian S. Timken, 1950
50.238.2

50.238.2

48.181

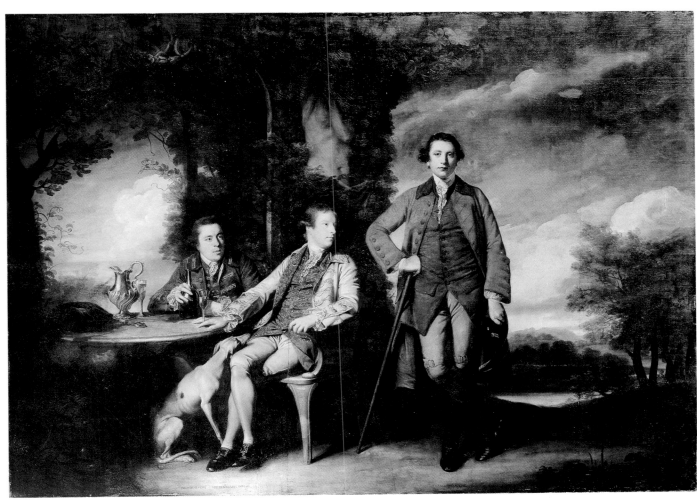

87.16

Sir Joshua Reynolds
British, 1723–1792

George, Viscount Malden (1757–1839), ***and His Sister, Lady Elizabeth Capel*** (1755–1834)
Oil on canvas, 71¹/₂ × 57¹/₄ in.
(181.6 × 145.4 cm)
Signed, dated, and inscribed (lower right):
George Visc! Malden & Lady Eliz. Capel
only / Son and Dau! of the Earl of Essex by
his first / wife Frances Dau! of S! Ch.
Hanbury / Williams & Lady Frances
Coningesby / L.ᵈ Malden Ætat 10 / L.ʸ Eli[z.]
Capel Ætat 13 / J. Reynolds Pinx! / 1768.
Gift of Henry S. Morgan, 1948
48.181

The Honorable Henry Fane (1739–1802)
with His Guardians, Inigo Jones and Charles Blair
Oil on canvas, 100¹/₄ × 142 in.
(254.6 × 360.7 cm)
Inscribed (bottom edge, beneath figures):
INIGO·IONES·ESQ.ʳ THE·HON.ᵇˡᵉ·
HENRY·FANE·ESQ! CHARLES·BLAIR·ESQ.ʳ
Gift of Junius S. Morgan, 1887
87.16

Annabella, Viscountess Maynard (Nancy
Parsons, born about 1734, died 1814/15)
Oil on canvas, 36¹/₄ × 28 in.
(92.1 × 71.1 cm)
Fletcher Fund, 1945
45.59.3

Colonel George K. H. Coussmaker (1759–1801), ***Grenadier Guards***
Oil on canvas, 93³/₄ × 57¹/₄ in.
(238.1 × 145.4 cm)
Bequest of William K. Vanderbilt, 1920
20.155.3

Georgiana Augusta Frederica Seymour
(1782–1813), ***Later Lady Charles Bentick***
Exhibited at the Royal Academy in 1785
Oil on canvas, 35 × 30 in. (88.9 × 76.2 cm)
Bequest of Maria DeWitt Jesup, from the
collection of her husband, Morris K. Jesup,
1914
15.30.38

John Barker (1707–1787)
Exhibited at the Royal Academy in 1786
Oil on canvas, 68¹/₄ × 47¹/₂ in.
(173.4 × 120.7 cm)
Gift of Ruth Armour, 1954
54.192

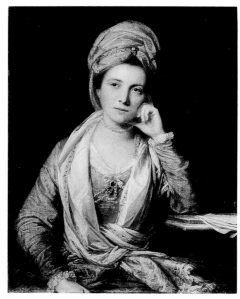

45.59.3

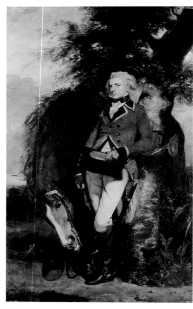

20.155.3

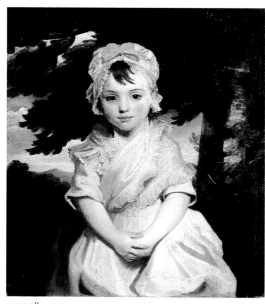

15.30.38

54.192

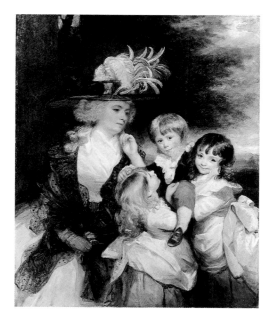

25.110.10

1987.47.2

06.1241

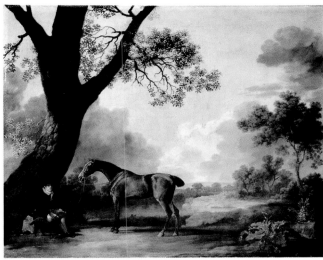

1980.468

Lady Smith (Charlotte Delaval) ***and Her
Children*** (George Henry, Louisa, and
Charlotte)
Exhibited at the Royal Academy in 1787
Oil on canvas, 55³/₈ × 44¹/₈ in.
(140.7 × 112.1 cm)
Bequest of Collis P. Huntington, 1900
25.110.10

The Honorable Mrs. Lewis Thomas Watson
(Mary Elizabeth Milles, 1767–1818)
This is an autograph replica of a portrait in a
private collection; both date from 1789.
Oil on canvas, 50 × 40 in.
(127 × 101.6 cm)
Bequest of Mrs. Harry Payne Bingham, 1986
1987.47.2

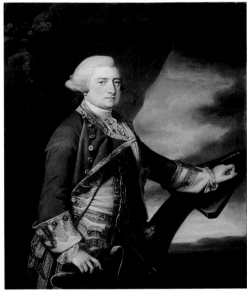

39.65.5

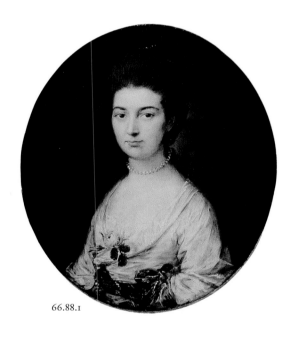

66.88.1

Attributed to Sir Joshua Reynolds

Mrs. Baldwin
After a full-length portrait (private collection)
exhibited at the Royal Academy in 1782
Oil on canvas, 36¹/₈ × 29¹/₈ in.
(91.8 × 74 cm)
Gift of William T. Blodgett and his sister
Eleanor Blodgett, in memory of their father,
William T. Blodgett, one of the founders of
the Museum, 1906
06.1241

George Stubbs
British, 1724–1806

***A Favorite Hunter of John Frederick
Sackville, Later Third Duke of Dorset***
Oil on canvas, 40 × 49³/₄ in.
(101.6 × 126.4 cm)
Signed and dated (lower right): Geo. Stubbs /
pinxit. 1768
Bequest of Mrs. Paul Moore, 1980
1980.468

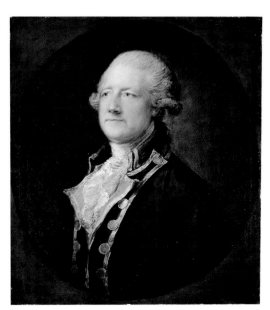

60.71.7

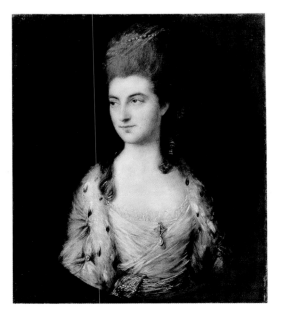

17.120.224

Francis Cotes
British, 1726–1770

Harry Paulet (1719–1794), ***Sixth Duke of
Bolton***
Oil on canvas, 50 × 40 in.
(127 × 101.6 cm)
Inscribed (verso): Harry 6th and last Duke of
Bolton. / Grandfather of Viscountess
Templetown.
Bequest of Jacob Ruppert, 1939
39.65.5

Thomas Gainsborough
British, 1727–1788

Mrs. Ralph Izard (Alice DeLancey, 1746/47–
1832)
Oil on canvas, oval, 30^1/$_4$ × 25^1/$_8$ in.
(76.8 × 63.8 cm)
Inscribed (verso): Mrs. Alice Izard / formerly
Alice Delancey / painted in London / by /
Gainsborough / 1772
Bequest of Jeanne King deRham, in memory
of her father, David H. King Jr., 1966
66.88.1

***Portrait of a Man, Called General Thomas
Bligh*** (1693–1775)
Oil on canvas, 29^1/$_2$ × 24^3/$_4$ in.
(74.9 × 62.9 cm)
Bequest of Lillian S. Timken, 1959
60.71.7

Portrait of a Woman, Called Miss Sparrow
Oil on canvas, 30^1/$_8$ × 24^7/$_8$ in.
(76.5 × 63.2 cm)
Mr. and Mrs. Isaac D. Fletcher Collection,
Bequest of Isaac D. Fletcher, 1917
17.120.224

Charles Rousseau Burney (1747–1819)
Oil on canvas, 30^1/$_4$ × 25^1/$_8$ in.
(76.8 × 63.8 cm)
Bequest of Mary Stillman Harkness, 1950
50.145.16

Lieutenant-Colonel Paul Pechell (1724–
1800)
Oil on canvas, 30^1/$_8$ × 25^1/$_8$ in.
(76.5 × 63.8 cm)
Inscribed (upper left): Sir Paul Pechell B! / an
Original by Gainsborough
Gift of Mr. and Mrs. Harry Payne Bingham
Jr., 1990
1990.200

Mrs. Grace Dalrymple Elliott (1754?–1823)
Oil on canvas, 92^1/$_4$ × 60^1/$_2$ in.
(234.3 × 153.7 cm)
Bequest of William K. Vanderbilt, 1920
20.155.1

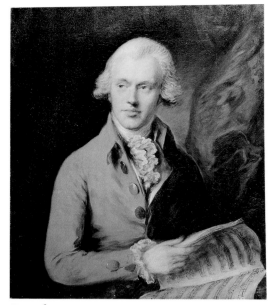

50.145.16

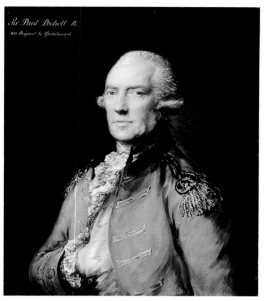

1990.200

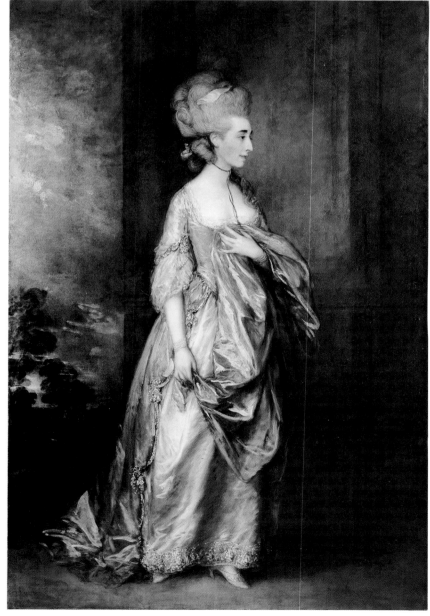

20.155.1

06.1279

49.7.55

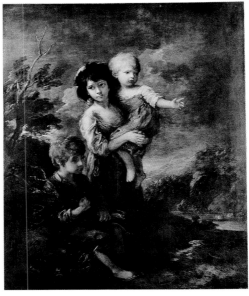

89.15.8

50.145.17

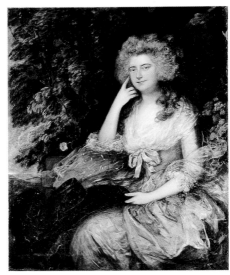

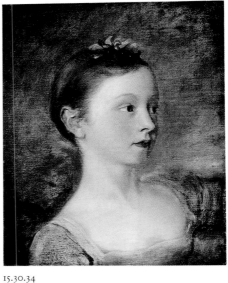

45.59.1

15.30.34

Wooded Upland Landscape
Oil on canvas, 47³/₈ × 58¹/₈ in.
(120.3 × 147.6 cm)
Gift of George A. Hearn, 1906
06.1279

Charlotte (1744–1818), Queen of England
The portrait is an autograph replica of the one belonging to Gainsborough's series of George III, his wife, and their thirteen children (British Royal Collection), which were painted at Windsor in 1782.
Oil on canvas, 23³/₄ × 17¹/₂ in.
(60.3 × 44.5 cm)
The Jules Bache Collection, 1949
49.7.55

A Child with a Cat
Oil on canvas, 59¹/₄ × 47¹/₂ in.
(150.5 × 120.7 cm)
Marquand Collection, Gift of Henry G. Marquand, 1889
89.15.8

The Wood Gatherers
Oil on canvas, 58¹/₈ × 47³/₈ in.
(147.6 × 120.3 cm)
Bequest of Mary Stillman Harkness, 1950
50.145.17

Mrs. William Tennant (Mary Wylde, died 1798)
Oil on canvas, 49¹/₂ × 40 in.
(125.7 × 101.6 cm)
Fletcher Fund, 1945
45.59.1

Copy after Thomas Gainsborough
British, probably third quarter 19th century

The Painter's Daughter Mary (1748–1826)
The painting is most likely a copy of the head at the left in Gainsborough's double portrait of his daughters (Victoria and Albert Museum, London).
Oil on canvas, 17¹/₄ × 13⁷/₈ in.
(43.8 × 35.2 cm)
Bequest of Maria DeWitt Jesup, from the collection of her husband, Morris K. Jesup, 1914
15.30.34

George Romney
British, 1734–1802

Mrs. Charles Frederick (Martha Rigden, died 1794)
Oil on canvas, 29³/₄ × 24³/₄ in.
(75.6 × 62.9 cm)
Fletcher Fund, 1945
45.59.5

Lady Elizabeth Hamilton (died 1797), ***Countess of Derby***
Sittings are recorded between 1776 and 1778.
Oil on canvas, 50 × 40 in.
(127 × 101.6 cm)
The Jules Bache Collection, 1949
49.7.57

Emilie Bertie Pott
Oil on canvas, 29³/₄ × 24⁷/₈ in.
(75.6 × 63.2 cm)
Gift of Jessie Woolworth Donahue, 1958
58.102.2

Sir Chaloner Ogle (born about 1727, died 1816)
Sittings are recorded in 1781–82.
Oil on canvas, 30 × 24⁵/₈ in.
(76.2 × 62.5 cm)
Inscribed (verso): Sir Chaloner Ogle. Bᵗ /
Senior Admiral of the Red. / Hˢ Royal Hˢ the
Duke of Clarence being made / Admiral of
the fleet over his head / died 1816
Gift of Lennen and Newell Inc., 1953
53.220

Mrs. George Horsley (Charlotte Talbot, died 1828)
Sittings are recorded in 1787.
Oil on canvas, 30 × 24⁷/₈ in.
(76.2 × 63.2 cm)
Bequest of Jacob Ruppert, 1939
39.65.1

The Honorable Charles Francis Greville
(1749–1809)
Oil on canvas, 30 × 24³/₄ in.
(76.2 × 62.9 cm)
Gift of Mr. and Mrs. Edwin C. Vogel, 1950
50.169

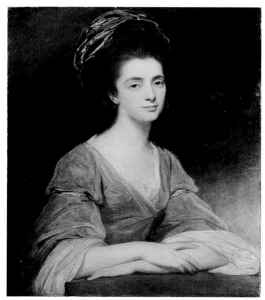

45.59.5

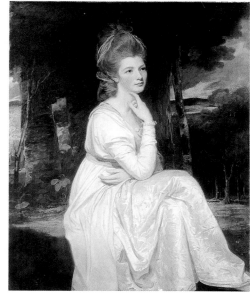

49.7.57

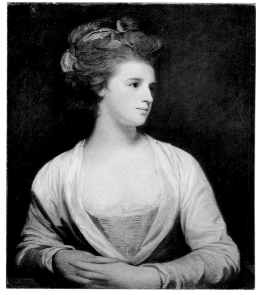

58.102.2

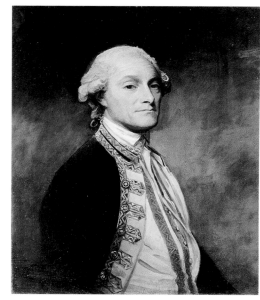

53.220

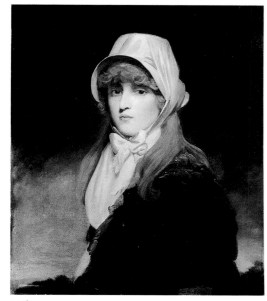

39.65.1

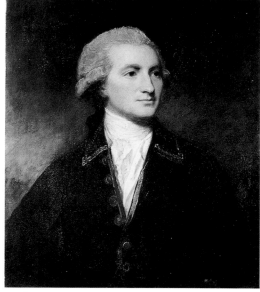

50.169

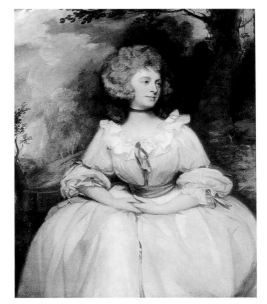

1975.I.235

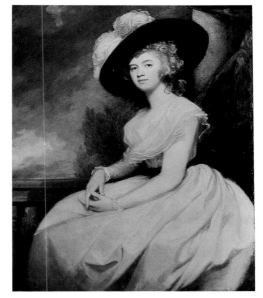

45.59.4

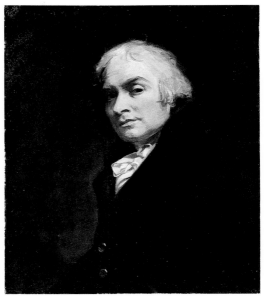

15.30.37

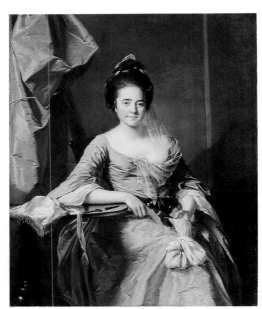

1986.264.6

60.50a

1976.201.20

Lady Lemon (1747–1823)
Oil on canvas, 50 × 40 in.
(127 × 101.6 cm)
Robert Lehman Collection, 1975
1975.I.235
ROBERT LEHMAN COLLECTION

Mrs. Bryan Cooke (Frances Puleston, 1765–1818)
Sittings are recorded in 1787 and 1789.
Oil on canvas, 50 × 39¹⁄₂ in.
(127 × 100.3 cm)
Fletcher Fund, 1945
45.59.4

Self-portrait
Oil on canvas, 30 × 25 in. (76.2 × 63.5 cm)
Bequest of Maria DeWitt Jesup, from the collection of her husband, Morris K. Jesup, 1914
15.30.37

Joseph Wright (Wright of Derby)
British, 1734–1791
Portrait of a Woman
Oil on canvas, 49⁷⁄₈ × 40 in.
(126.7 × 101.6 cm)
Gift of Heathcote Art Foundation, 1986
1986.264.6

British Painters
1765/66
Ceremonial Scene
Robert Adam's bill for this overmantel in grisaille—from his design, for the gallery at Croome Court (MMA)—is dated January 1766.
Oil on canvas, 60¹⁄₄ × 68 in.
(153 × 172.7 cm)
Fletcher Fund, 1960
60.50a
ESDA

second half 18th century
Man on Horseback with a Greyhound
Oil on canvas, 21¹⁄₈ × 25 in.
(53.7 × 63.5 cm)
Bequest of Joan Whitney Payson, 1975
1976.201.20

Richard Cosway

British, 1740–1821

Marianne Dorothy Harland (1759–1785), ***Later Mrs. William Dalrymple***
Exhibited at the Royal Academy in 1779
Oil on canvas, 28 × 36⅛ in.
(71.1 × 91.8 cm)
Gift of Mrs. William M. Haupt, from the
collection of Mrs. James B. Haggin, 1969
69.104

Angelica Kauffmann

Swiss, 1741–1807

Edward Stanley (1752–1834), ***Twelfth Earl
of Derby, with His First Wife*** (Elizabeth
Hamilton, died 1797) ***and Their Son***
(Edward Smith Stanley, 1775–1851)
This painting is a replica of one in a private
collection.
Oil on canvas, 50 × 40 in.
(127 × 101.6 cm)
Gift of Bernard M. Baruch, in memory of his
wife, Annie Griffen Baruch, 1959
59.189.2

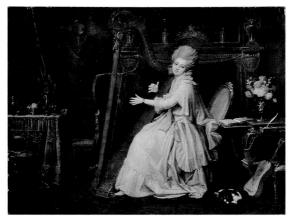

69.104

59.189.2

Telemachus and the Nymphs of Calypso
Oil on canvas, 32½ × 44¼ in.
(82.6 × 112.4 cm)
Bequest of Collis P. Huntington, 1900
25.110.188

The Sorrow of Telemachus
Pendant to 25.110.188
Oil on canvas, 32¾ × 45 in.
(83.2 × 114.3 cm)
Bequest of Collis P. Huntington, 1900
25.110.187

25.110.188

25.110.187

Style of Angelica Kauffmann

British, third quarter 18th century

The Temptation of Eros
Oil on canvas, 13 × 17¾ in. (33 × 45.1 cm)
Gift of James DeLancey Verplanck and John
Bayard Rodgers Verplanck, 1939
39.184.18
AMERICAN DECORATIVE ARTS

The Victory of Eros
Pendant to 39.184.18
Oil on canvas, 13 × 17¾ in. (33 × 45.1 cm)
Gift of James DeLancey Verplanck and John
Bayard Rodgers Verplanck, 1939
39.184.19
AMERICAN DECORATIVE ARTS

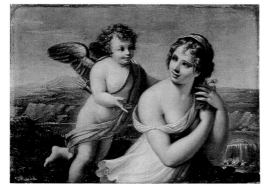

39.184.18

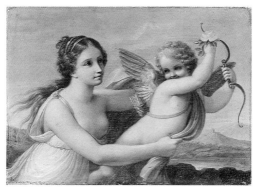

39.184.19

61.182.1

61.182.2

67.131

67.132

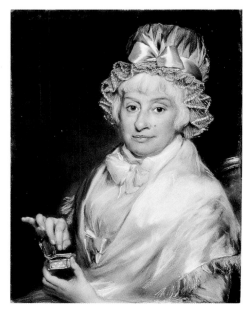

1975.217.2

1975.217.1

John Russell

British, 1745–1806

William Mann Godschall (born 1720)
Pastel on paper, laid down on canvas,
23³/₄ × 17³/₄ in. (60.3 × 45.1 cm)
Signed and dated (right center): J Russell RA.
pinxᵗ / 1791
Gift of Mr. and Mrs. Arthur Wiesenberger,
1961
61.182.1

Mrs. William Mann Godschall (Sarah
Godschall, born 1730)
Pendant to 61.182.1
Pastel on paper, laid down on canvas,
23³/₄ × 17³/₄ in. (60.3 × 45.1 cm)
Gift of Mr. and Mrs. Arthur Wiesenberger,
1961
61.182.2

Robert Shurlock (1779–1847)
Pastel on paper, laid down on canvas,
23³/₄ × 17³/₈ in. (60.3 × 44.1 cm)
Signed and dated (upper right): J Russell R.A
pᵗ 1801
Gift of Alan R. Shurlock, 1967
67.131

Mrs. Robert Shurlock (Henrietta Ann Jane
Russell, 1775–1849) ***and Her Daughter Ann***
The pastel is a pendant to the preceding one
(67.131). The sitter was the artist's daughter.
Pastel on paper, laid down on canvas,
23⁷/₈ × 17³/₄ in. (60.6 × 45.1 cm)
Signed and dated (upper right): J. Russell
R A. pinxt. / 1801
Gift of Geoffrey Shurlock, 1967
67.132

Mrs. Shurlock
Pastel on paper, 24 × 17⁷/₈ in.
(61 × 45.4 cm)
Signed and dated (upper left): J. Russell R.A.
pᵗ· 1801
Gift of Olive Shurlock Sjölander, 1975
1975.217.2

Attributed to John Russell

Robert Shurlock (1779–1847)
Pastel on paper, 23⁷/₈ × 17⁷/₈ in.
(60.6 × 45.4 cm)
Gift of Olive Shurlock Sjölander, 1975
1975.217.1

Gainsborough Dupont

British, born about 1754, died 1797

Mrs. John Puget (Catherine Hawkins)
There is a soft-ground etching of a cottage
among trees on the verso of the plate.
Oil on copper, 6 × 4³/₄ in. (15.2 × 12.1 cm)
Bequest of Mary Stillman Harkness, 1950
50.145.18

Lady Mulgrave (Anne Elizabeth Cholmley,
1769–1788)
Oil on wood; overall 7¹/₈ × 5³/₄ in.
(18.1 × 14.6 cm); painted surface
6 × 4³/₄ in. (15.2 × 12.1 cm)
The Jules Bache Collection, 1949
49.7.56

Sir William Beechey

British, 1753–1839

Edward Miles (1752–1828)
Oil on canvas, 11⁷/₈ × 9⁷/₈ in.
(30.2 × 25.1 cm)
Signed, dated, and inscribed: (lower right, on
portfolio) 1785 / W Beechey / pinx; (lower
left, on sketchbook) Edw.ᵈ Miles / Æt 32.
Gift of Heathcote Art Foundation, 1986
1986.264.2

George IV (1762–1830), ***When Prince of
Wales***
This portrait of the prince wearing the
uniform of the 10th Light Dragoons and the
star of the Order of the Garter is a version of
Beechey's diploma work, which was presented
to the Royal Academy, London, in 1798;
another version, commissioned by the sitter
and probably painted in 1803, is in the British
Royal Collection.
Oil on canvas, 56¹/₄ × 44¹/₂ in.
(142.9 × 113 cm)
Gift of Heathcote Art Foundation, 1986
1986.264.3

Portrait of a Woman
Oil on canvas, 50 × 40¹/₄ in.
(127 × 102.2 cm)
Gift of George A. Hearn, 1905
05.32.1

Sir Henry Raeburn

Scottish, 1756–1823

Mrs. Richard Alexander Oswald (Lucy
Johnstone, born about 1768, died 1798)
Oil on canvas, 48¹/₂ × 40⁷/₈ in.
(123.2 × 103.8 cm)
Gift of Mrs. Paul Moore, 1980
1980.305

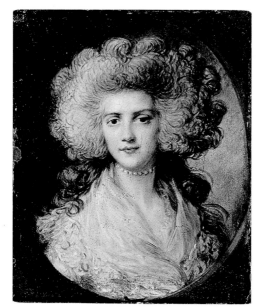

50.145.18 (recto)

50.145.18 (verso)

49.7.56

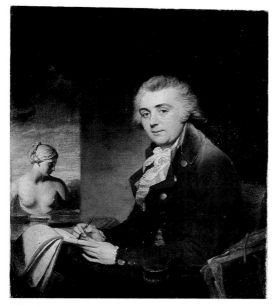

1986.264.2

1986.264.3

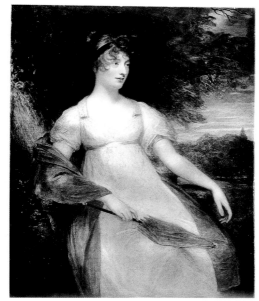

05.32.1

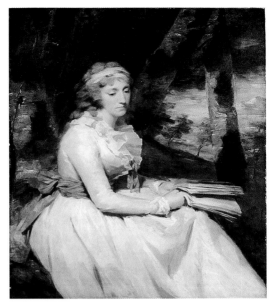

1980.305

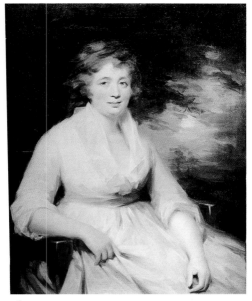

46.13.5

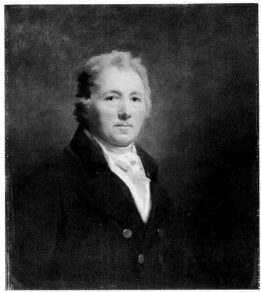

96.30.5

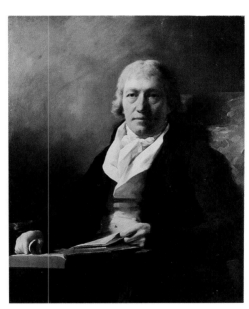

65.181.13

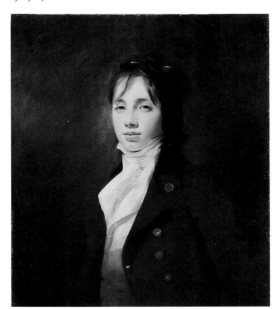

1975.1.234

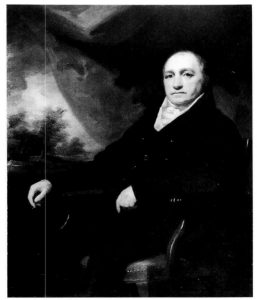

12.43.1

Janet Law
Oil on canvas, 35¼ × 27¼ in.
(89.5 × 69.2 cm)
Bequest of Helen Swift Neilson, 1945
46.13.5

William Forsyth (1749–1814)
There is a pendant portrait of the sitter's wife,
née Mary Rannie (1756–1826) (art market,
1992).
Oil on canvas, 30 × 24⅞ in.
(76.2 × 63.2 cm)
Gift of Arthur H. Hearn, 1896
96.30.5

James Johnston (died 1841)
There is a pendant portrait of the sitter's wife
(Memorial Art Gallery of the University of
Rochester, New York).
Oil on canvas, 35¼ × 27¼ in.
(89.5 × 69.2 cm)
Bequest of Adele L. Lehman, in memory of
Arthur Lehman, 1965
65.181.13

Edward Satchwell Fraser (1751–1835)
Oil on canvas, 29½ × 24½ in.
(74.9 × 62.2 cm)
Robert Lehman Collection, 1975
1975.1.234
ROBERT LEHMAN COLLECTION

Portrait of a Man, Called Dr. Blake
Oil on canvas, 51 × 40⅛ in.
(129.5 × 101.9 cm)
Gift of Victor G. Fischer, 1912
12.43.1

John Gray (1731–1811)
Oil on canvas, 49⅜ × 40 in.
(125.4 × 101.6 cm)
Bequest of Lillian S. Timken, 1959
60.71.13

William, Lord Robertson (1754–1835)
Oil on canvas, 49½ × 39¼ in.
(125.7 × 99.7 cm)
Inscribed (verso, now covered by relining
canvas): Taken Hf Length July [?]05
Bequest of Mary Stillman Harkness, 1950
50.145.32

George Harley Drummond (1783–1855)
Oil on canvas, 94¼ × 58 in.
(239.4 × 147.3 cm)
Gift of Mrs. Guy Fairfax Cary, in memory of
her mother, Mrs. Burke Roche, 1949
49.142

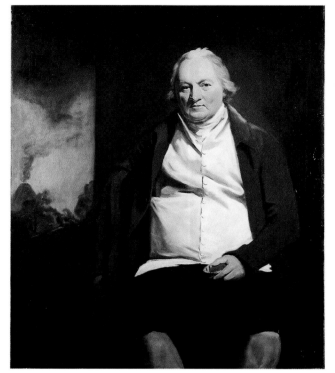

60.71.13

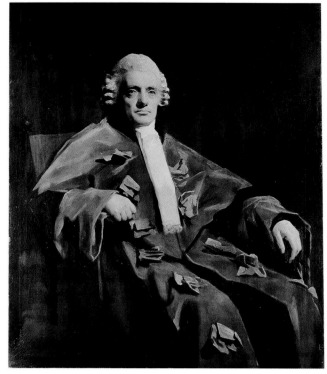

50.145.32

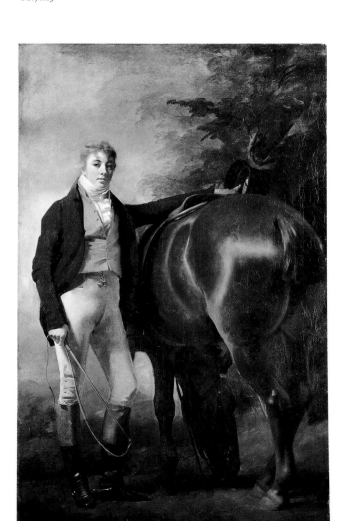

49.142

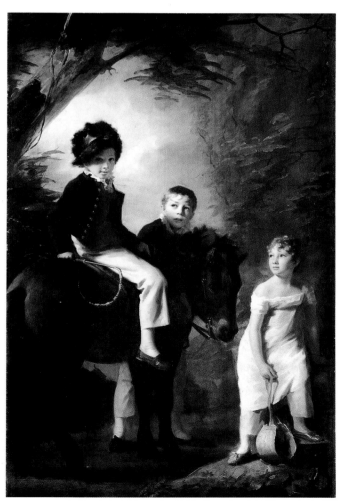

50.145.31

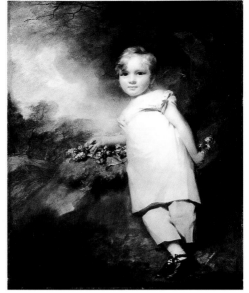

45.59.2

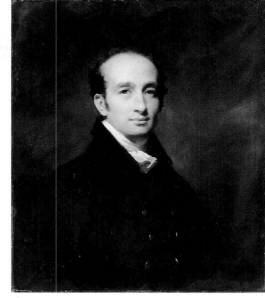

60.94.1

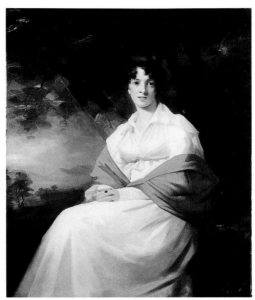

53.180

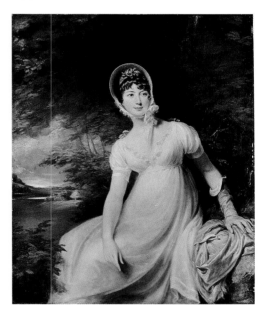

53.61.3

51.30.1

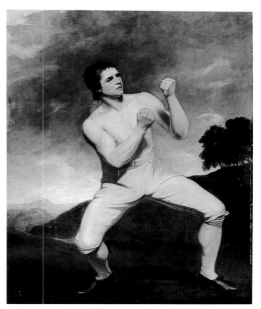

53.113

Sir Henry Raeburn
Scottish, 1756–1823

The Drummond Children
The sitters have been tentatively identified as
George Drummond (1802–1851), his sister
Margaret, and their foster brother.
Oil on canvas, 94¼ × 60¼ in.
(239.4 × 153 cm)
Bequest of Mary Stillman Harkness, 1950
50.145.31

William Scott-Elliot (1811–1901)
Oil on canvas, 47³/₈ × 36⁵/₈ in.
(120.3 × 93 cm)
Fletcher Fund, 1945
45.59.2

***The Honorable Alexander Maconochie-
Welwood*** (1777–1861), ***Lord Meadowbank***
Oil on canvas, 30¼ × 25 in.
(76.8 × 63.5 cm)
Inscribed (verso): Alexʳ Maconochie Welwood
/ of Meadowbank / & Garvock / (2ᵈ Lord
Meadowbank) / Raeburn pinx ᵀ
Gift of William P. Clyde, 1960
60.94.1

Lady Maitland (Catherine Connor, died
1865)
Oil on canvas, 49³/₄ × 39³/₄ in.
(126.4 × 101 cm)
Gift of Jessie Woolworth Donahue, 1953
53.180

British Painter
late 18th century

Portrait of a Young Woman
Oil on canvas, 50¹/₂ × 39⁷/₈ in.
(128.3 × 101.3 cm)
Gift of Julia A. Berwind, 1953
53.61.3

William Blake
British, 1757–1827

Zacharias and the Angel
Tempera and glue size on canvas,
10¹/₂ × 15 in. (26.7 × 38.1 cm)
Signed (lower left): WB
Bequest of William Church Osborn, 1951
51.30.1

John Hoppner
British, 1758–1810

Richard Humphreys, the Boxer
Oil on canvas, 55³/₄ × 44¹/₄ in.
(141.6 × 112.4 cm)
The Alfred N. Punnett Endowment Fund,
1953
53.113

John Hoppner
British, 1758–1810

Anthony James Radcliffe (1757–1814), *Fifth Earl of Newburgh*
Oil on canvas, 30 × 25 in. (76.2 × 63.5 cm)
Bequest of Lillian S. Timken, 1959
60.71.8

Anne Webb (1762–1861), *Countess of Newburgh*
Pendant to 60.71.8
Oil on canvas, 30 × 24⁷/₈ in.
(76.2 × 63.2 cm)
Bequest of Lillian S. Timken, 1959
60.71.9

Portrait of a Woman, Called Mrs. FitzHerbert (Mary Anne Smythe, 1756–1837); (verso, now covered by relining canvas) *Study of a Child's Head*
Oil on canvas, 30 × 24⁷/₈ in.
(76.2 × 63.2 cm)
Gift of William T. and Eleanor Blodgett, 1906
06.1242

Mrs. Richard Bache (Sarah Franklin, 1743–1808)
The painting had as a pendant a portrait of Richard Bache (1737–1811) (private collection).
Oil on canvas, 30¹/₈ × 24⁷/₈ in.
(76.5 × 63.2 cm)
Catharine Lorillard Wolfe Collection, Wolfe Fund, 1901
01.20

Mrs. Whaley (died before 1800)
Oil on canvas, 93¹/₂ × 58 in.
(237.5 × 147.3 cm)
Gift of Henry S. Morgan, 1947
47.138

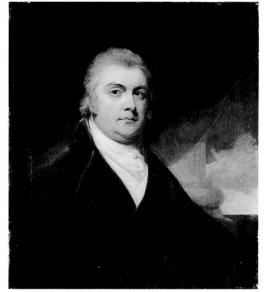

60.71.8

60.71.9

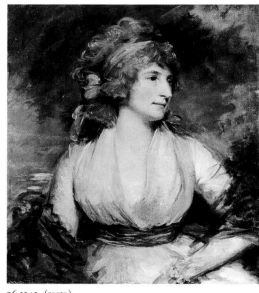

06.1242 (recto)

06.1242 (verso)

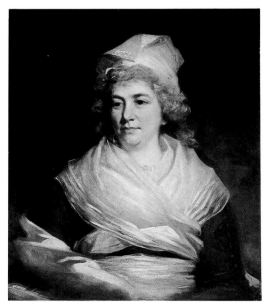

01.20

47.138

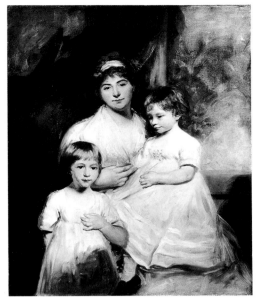

15.30.41

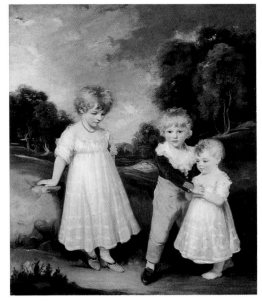

53.59.3

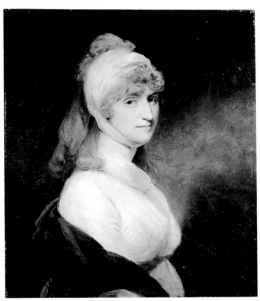

46.13.4

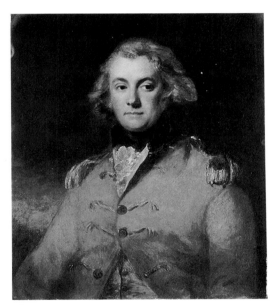

46.13.3

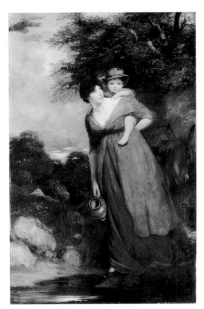

65.203

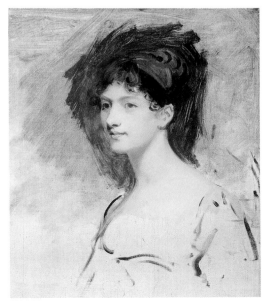

59.189.3

Mrs. Garden and Her Children
Oil on canvas, 50⅛ × 39⅞ in.
(127.3 × 101.3 cm)
Bequest of Maria DeWitt Jesup, from the
collection of her husband, Morris K. Jesup,
1914
15.30.41

The Sackville Children
The children are George John Frederick
Sackville (1793–1815), later fourth duke of
Dorset, and his sisters, Mary (1792–1864) and
Elizabeth (1795–1870).
Oil on canvas, 60 × 49 in.
(152.4 × 124.5 cm)
Bequest of Thomas W. Lamont, 1948
53.59.3

Mrs. Thomas Pechell (Charlotte Clavering,
died 1841)
Oil on canvas, 30 × 25 in. (76.2 × 63.5 cm)
Inscribed (verso): Painted by / Hoppner of
London / 1799 / Charlotte Lady Brooke
Pechell / Daughter of Gen! Sir John Clavering
K.B. / by the Lady Diana West / and Wife of
/ Major Gen! Sir Tho.⁵ Brooke / Pechell Bar!
Bequest of Helen Swift Neilson, 1945
46.13.4

Major-General Thomas Pechell (1753–1826)
Pendant to 46.13.4
Oil on canvas, 30 × 24⅞ in.
(76.2 × 63.2 cm)
Inscribed (verso): Painted by Hoppner of
London / 1799 / Major Genera! / Sir Thomas
Brooke Pechell Bar! / Genl Usher Privy
Chamber. / 34 Years to her Majesty Queen
Charlotte / He Died June 1826
Bequest of Helen Swift Neilson, 1945
46.13.3

Mrs. Richard Brinsley Sheridan (Hester
Jane Ogle, born about 1775, died 1817) **and
Her Son** (Charles Brinsley Sheridan, 1796–
1843)
Oil on canvas, 93¾ × 59 in.
(238.1 × 149.9 cm)
Gift of Mrs. Carll Tucker, 1965
65.203

Lady Hester King (died 1873)
Oil on canvas, 30 × 25 in. (76.2 × 63.5 cm)
Gift of Bernard M. Baruch, in memory of his
wife, Annie Griffen Baruch, 1959
59.189.3

John Opie

British, 1761–1807

Miss Walker

Oil on canvas, 29⁷/₈ × 24⁷/₈ in.
(75.9 × 63.2 cm)
Bequest of Mary Clark Thompson, 1923
24.80.488

John Crome

British, 1768–1821

Hautbois Common

Oil on canvas, 22 × 35 in.
(55.9 × 88.9 cm)
Marquand Collection, Gift of Henry G.
Marquand, 1889
89.15.14

George Morland

British, 1763–1804

The Bell Inn

Oil on canvas, 20¹/₂ × 26¹/₄ in.
(52.1 × 66.7 cm)
Signed (lower right): G. Morland. pinx
Bequest of Collis P. Huntington, 1900
25.110.20

The Dancing Dogs

Oil on canvas, 30 × 25¹/₈ in.
(76.2 × 63.8 cm)
Gift of Evander B. Schley, 1951
52.116

British Painter

first quarter 19th century

Haymaking

Oil on canvas, 14⁷/₈ × 19³/₈ in.
(37.8 × 49.2 cm)
Gift of Rodman A. Heeren, 1973
1973.331.1

Hay Wagon

Pendant to 1973.331.1
Oil on canvas, 14⁷/₈ × 19³/₈ in.
(37.8 × 49.2 cm)
Gift of Rodman A. Heeren, 1973
1973.331.2

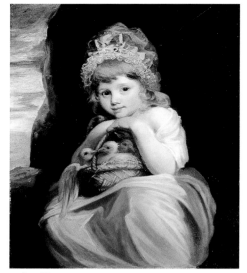

24.80.488

89.15.14

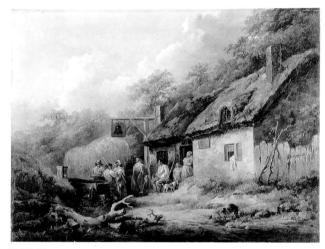

25.110.20

52.116

1973.331.1

1973.331.2

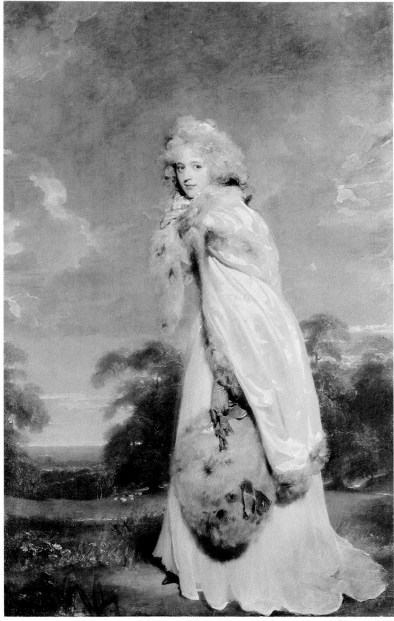

50.135.5

Sir Thomas Lawrence
British, 1769–1830

Elizabeth Farren (born about 1759, died 1829), ***Later Countess of Derby***
Oil on canvas, 94 × 57¹/₂ in.
(238.8 × 146.1 cm)
Bequest of Edward S. Harkness, 1940
50.135.5

The Calmady Children (Emily, 1818–1906, and Laura Anne, 1820–1894)
Oil on canvas, 30⁷/₈ × 30¹/₈ in.
(78.4 × 76.5 cm)
Bequest of Collis P. Huntington, 1900
25.110.1

Lady Harriet Maria Conyngham (died 1843), ***Later Lady Somerville***
Oil on canvas, 36¹/₄ × 28¹/₄ in.
(92.1 × 71.8 cm)
Gift of Jessie Woolworth Donahue, 1955
55.89

Portrait of a Man
Oil on canvas, 50³/₈ × 40⁵/₈ in.
(128 × 103.2 cm)
Gift of Victor G. Fischer, 1912
12.43.2

25.110.1

55.89

Sir Thomas Lawrence

British, 1769–1830

John Julius Angerstein (1735–1823)
The primary version is the property of Lloyd's of London; a posthumous replica is in the National Gallery, London. The present work may date to the mid- to late 1820s.
Oil on canvas, 36 × 28 in. (91.4 × 71.1 cm)
Bequest of Adele L. Lehman, in memory of Arthur Lehman, 1965
65.181.9

George Chinnery

British, 1774–1852

Self-portrait
Oil on canvas, 8⁵/₈ × 7¹/₄ in.
(21.9 × 18.4 cm)
Rogers Fund, 1943
43.132.4

William Owen

British, 1769–1825

The Grandchildren of Sir William Heathcote
Oil on canvas, 55¹/₄ × 67¹/₂ in.
(140.3 × 171.5 cm)
Gift of Heathcote Art Foundation, 1986
1986.264.4

Sir Martin Archer Shee

British, 1769–1850

Daniel O'Connell (1775–1847)
Oil on canvas, 35⁷/₈ × 28¹/₈ in.
(91.1 × 71.4 cm)
Gift of John D. Crimmins, 1899
99.30

William Archer Shee (1810–1899), ***the Artist's Son***
Oil on canvas, 30 × 24³/₄ in.
(76.2 × 62.9 cm)
Bequest of Maria DeWitt Jesup, from the collection of her husband, Morris K. Jesup, 1914
15.30.48

Joseph Mallord William Turner

British, 1775–1851

The Ferry Beach and Inn at Saltash, Cornwall
Oil on canvas, 35³/₈ × 47¹/₂ in.
(89.9 × 120.7 cm)
Inscribed: (right foreground, on building) SALTAS[H] / ENGLAND / EXPECT[S] EV[ERY] / [MAN TO DO HIS DUTY] (after Nelson's signal to the fleet before the Battle of Trafalgar); (middle ground, on building) BEER
Marquand Collection, Gift of Henry G. Marquand, 1889
89.15.9

12.43.2

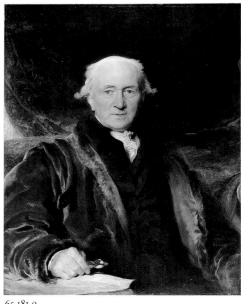
65.181.9

43.132.4

1986.264.4

99.30

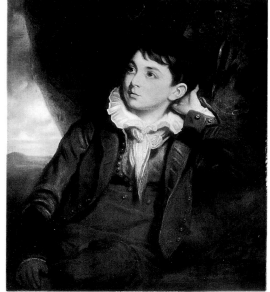
15.30.48

89.15.9

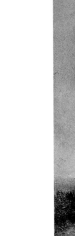

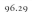

96.29

99.31

Joseph Mallord William Turner
British, 1775–1851

The Whale Ship
Exhibited at the Royal Academy in 1845
Oil on canvas, 36^1/8 × 48^1/4 in.
(91.8 × 122.6 cm)
Catharine Lorillard Wolfe Collection, Wolfe
Fund, 1896
96.29

The Grand Canal, Venice
Exhibited at the Royal Academy in 1835
Oil on canvas, 36 × 48^1/8 in.
(91.4 × 122.2 cm)
Bequest of Cornelius Vanderbilt, 1899
99.31

John Constable
British, 1776–1837

View at Stoke-by-Nayland
Oil on canvas, 11^1/8 × 14^1/4 in. (28.3 × 36.2 cm)
Charles B. Curtis Fund, 1926
26.128

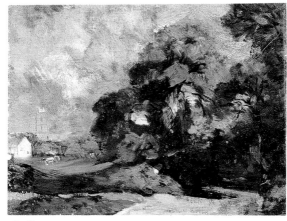

26.128

06.1272

Mrs. James Pulham Sr. (Frances Amys,
born about 1766, died 1856)
This painting dates from 1818 and is the
subject of a letter from James Pulham to
Constable.
Oil on canvas, 29^3/4 × 24^3/4 in.
(75.6 × 62.9 cm)
Gift of George A. Hearn, 1906
06.1272

Salisbury Cathedral from the Bishop's
Grounds
There are three sketches, of which this is the
third, and three finished paintings: a sketch,
probably from the summer of 1820 (National
Gallery of Canada, Ottawa), for the painting
signed and dated 1823 and exhibited at the
Royal Academy, London, in the same year
(Victoria and Albert Museum, London); a
sketch (private collection, on loan to the
Birmingham Museums and Art Gallery) and
a signed and dated painting (Huntington Art
Collections, San Marino) made later in 1823;
and this unfinished picture, probably of about
1825, and connected with a signed and dated
painting of 1826 (Frick Collection, New York).
All relate to the initial commission of 1822
from John Fisher, Bishop of Salisbury, who is
shown at the left.
Oil on canvas, 34^5/8 × 44 in.
(87.9 × 111.8 cm)
Bequest of Mary Stillman Harkness, 1950
50.145.8

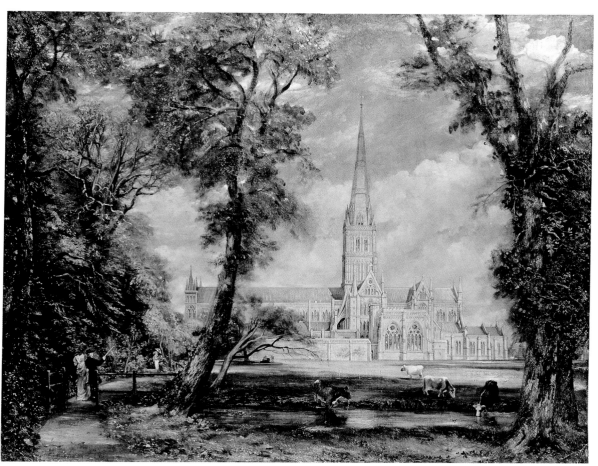

50.145.8

15.30.50

95.27.2

65.258.2

15.30.52

10.58.2

15.30.56

British Painter

about 1830

Tottenham Church

Oil on canvas, 20¹/₂ × 18¹/₈ in.
(52.1 × 46 cm)
Bequest of Maria DeWitt Jesup, from the
collection of her husband, Morris K. Jesup,
1914
15.30.50

George H. Harlow

British, 1787–1819

Self-portrait

Oil on canvas, 30 × 25 in. (76.2 × 63.5 cm)
Gift of George A. Hearn, 1895
95.27.2

David Cox

British, 1783–1859

Landscape with a Gypsy Tent

Oil on wood, 9 × 14 in. (22.9 × 35.6 cm)
Signed and dated (lower left): David Cox /
1848.
Gift of Mary Phelps Smith, in memory of her
husband, Howard Caswell Smith, 1965
65.258.2

Sir David Wilkie

Scottish, 1785–1841

The Highland Family

Exhibited at the Royal Academy in 1825
Oil on wood, 24 × 36 in. (61 × 91.4 cm)
Signed and dated (lower left): DAVID WILKIE f.
1[8]24
Bequest of Maria DeWitt Jesup, from the
collection of her husband, Morris K. Jesup,
1914
15.30.52

British Painter

early 19th century

Landscape

Oil on canvas, 48⁵/₈ × 67¹/₄ in.
(123.5 × 170.8 cm)
Gift of George A. Hearn, 1909
10.58.2

Patrick Nasmyth

British, 1787–1831

Landscape

Oil on wood, 27¹/₂ × 36¹/₄ in.
(69.9 × 92.1 cm)
Signed and dated (lower left): Pat..ᵏ Nasmyth.
1828
Bequest of Maria DeWitt Jesup, from the
collection of her husband, Morris K. Jesup,
1914
15.30.56

William Etty
British, 1787–1849

Allegory
Oil on canvas, laid down on wood, oval,
28 × 34¹/₂ in. (71.1 × 87.6 cm)
Gift of Martin Birnbaum, 1959
59.131

The Three Graces
The painting is a sketch for a figure group in
a larger composition, Venus and Her Satellites
(Museo de Arte, Ponce).
Oil on paper, laid down on canvas,
22¹/₂ × 18³/₄ in. (57.2 × 47.6 cm)
Rogers Fund, 1905
05.31

Charles Robert Leslie
British, 1794–1859

Dr. John Wakefield Francis (1789–1861)
Oil on wood, 15¹/₂ × 11¹/₂ in.
(39.4 × 29.2 cm)
Signed (upper left): C.R. Leslie.
Gift of John L. Cadwalader, 1896
96.25
AMERICAN PAINTINGS AND SCULPTURE

James Stark
British, 1794–1859

Willows by the Watercourse
Oil on wood, 17⁷/₈ × 24 in. (45.4 × 61 cm)
Gift of George A. Hearn, 1896
97.41.1

George Vincent
British, 1796–1831

Whitlingham near Norwich
Oil on canvas, 25¹/₄ × 36 in.
(64.1 × 91.4 cm)
Signed (lower right): G. Vincent
Gift of George A. Hearn, 1906
06.1300

Frederick Richard Lee
British, 1798–1879

Garibaldi's House at Caprera
Oil on canvas, 34¹/₄ × 54³/₈ in.
(87 × 138.1 cm)
Signed and dated (lower right): F.R. Lee RA
1865
Gift of Dr. Melvin Goldberg, 1974
1974.159

59.131

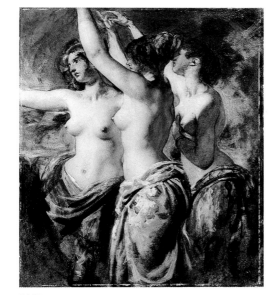

05.31

96.25

97.41.1

06.1300

1974.159

97.41.3

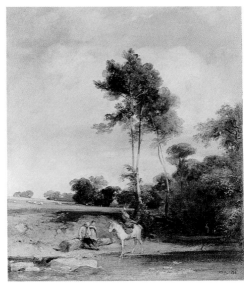

45.146.1

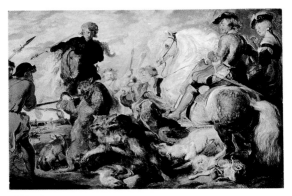

1990.75

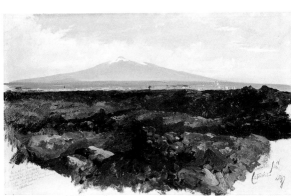

61.233

05.39.1

04.29.4

Frederick Waters Watts
British, 1800–1862
The Old Bridge
Oil on canvas, 21³/₄ × 32³/₄ in.
(55.2 × 83.2 cm)
Gift of George A. Hearn, 1897
97.41.3

Richard Parkes Bonington
British, 1802–1828
Roadside Halt
Oil on canvas, 18¹/₄ × 14⁷/₈ in.
(46.4 × 37.8 cm)
Signed and dated (lower right): R P B. 18[2]6
Gift of Francis Neilson, 1945
45.146.1

Sir Edwin Landseer
British, 1802–1873
Copy after Rubens's "Wolf and Fox Hunt"
This copy of Rubens's painting (10.73) dates
to 1824–26 and was painted in preparation for
The Hunting of Chevy Chase (Birmingham
Museums and Art Gallery), which was
exhibited at the Royal Academy in 1826.
Oil on wood, 16 × 23⁷/₈ in.
(40.6 × 60.6 cm)
Catharine Lorillard Wolfe Collection, Wolfe
Fund, 1990
1990.75

Edward Lear
British, 1812–1888
Catania and Mount Etna
Oil on board, 12¹/₄ × 19 in.
(31.1 × 48.3 cm)
Dated and inscribed: (lower right, in sepia)
Catania / 16 June. / 1847; (lower left, in
pencil) This was done on a thorough /
Sciroccato day & may therefore / make all
the colors infinitely / brighter Etna bluer –
sky warmer, / lava distant pinker – near
browner / & Asphaltumer.–
Rogers Fund, 1961
61.233

George Frederick Watts
British, 1817–1904
Ariadne in Naxos
Oil on canvas, 24 × 20 in. (61 × 50.8 cm)
Signed and dated (lower right): G. F. Watts. /
1894
Rogers Fund, 1905
05.39.1

John Thomas Peele

British, 1822–1897

Spring Flowers

Oil on canvas, oval, 30 × 25 in.
(76.2 × 63.5 cm)
Signed and dated (lower left): J. T. Peele 1860.
Gift of Samuel P. Avery Jr., 1904
04.29.4

Robert Charles Dudley

British, 1826–1900

Landing the Shore End of the Atlantic Cable

Cyrus Field, the donor of this work and of the five related paintings (92.10.47, 45, 43, 46, and 42) that follow, was among the founders of the American Telegraph Company. After unsuccessful attempts in 1857, 1858, and 1865, the Atlantic cable was laid and brought into use in July 1866.
Oil on canvas, 22½ × 33 in.
(57.2 × 83.8 cm)
Signed and dated (lower left): R. Dudley 1866.
Gift of Cyrus W. Field, 1892
92.10.44

Making the Splice between the Shore End and the Ocean Cable

Oil on canvas, 22³/₄ × 33¹/₄ in.
(57.8 × 84.5 cm)
Inscribed (verso): Atlantic Telegraph Cable Expedition of 1866— / Making the splice between the shore end and the Ocean Cable on board / the "Great Eastern," off Valencia. Latde 51ⁿ–50' Longde 11°–6' / July 13th 1866 / Painted by Robert Dudley— / London
Gift of Cyrus W. Field, 1892
92.10.47

Grappling for the Lost Cable

Oil on canvas, 22³/₄ × 33¹/₈ in.
(57.8 × 84.1 cm)
Gift of Cyrus W. Field, 1892
92.10.45

Awaiting the Reply

Oil on canvas, 23¹/₄ × 33¹/₂ in.
(59.1 × 85.1 cm)
Stamped? (lower left): R·DUDLEY
Gift of Cyrus W. Field, 1892
92.10.43

Landing at Newfoundland

Oil on canvas, 22³/₄ × 33¹/₄ in.
(57.8 × 84.5 cm)
Gift of Cyrus W. Field, 1892
92.10.46

92.10.44

92.10.47

92.10.45

92.10.43

92.10.46

92.10.42

1974.289.2

87.15.79

96.28

06.1328

Homeward Bound: "The Great Eastern"
Oil on canvas, 44³/₄ × 67¹/₄ in.
(113.7 × 170.8 cm)
Gift of Cyrus W. Field, 1892
92.10.42

John Brett
British, 1830–1902
Kynance
Oil on canvas, 7 × 14¹/₈ in.
(17.8 × 35.9 cm)
Dated and inscribed (lower right): Kynance
27 Sep 88
Bequest of Theodore Rousseau Jr., 1973
1974.289.2

Lord Frederic Leighton
British, 1830–1896
Head of a Woman, Called Lucia
Oil on canvas, 14⁷/₈ × 10 in.
(37.8 × 25.4 cm)
Catharine Lorillard Wolfe Collection, Bequest
of Catharine Lorillard Wolfe, 1887
87.15.79

Lachrymae
Oil on canvas, 62 × 24³/₄ in.
(157.5 × 62.9 cm)
Catharine Lorillard Wolfe Collection, Wolfe
Fund, 1896
96.28

Sir John Everett Millais
British, 1829–1896
Portia
Oil on canvas, 49¹/₄ × 33 in.
(125.1 × 83.8 cm)
Signed and dated (lower right): JEM
[monogram] / 1886
Catharine Lorillard Wolfe Collection, Wolfe
Fund, 1906
06.1328

Dante Gabriel Rossetti
British, 1828–1882
Mrs. William Morris (Jane Burden,
1840–1914)
Red, black, and white chalk on paper, four
pieces joined, 35³/₄ × 30³/₄ in.
(90.8 × 78.1 cm)
Signed and dated (lower right): DGR
[monogram] / 1868
Gift of Jessie Lemont Trausil, 1947
47.66
DRAWINGS AND PRINTS

Sir Edward Coley Burne-Jones
British, 1833–1898
The Love Song
Oil on canvas, 45 × 61³/₈ in.
(114.3 × 155.9 cm)
Signed (lower left): EBJ
The Alfred N. Punnett Endowment Fund,
1947
47.26

47.66

47.26

26.54

26.54 (detail)

22.177.1–4

1980.510.3

1979.135.17

09.1.1

The Backgammon Players
These two paintings are the doors of a cabinet designed by Philip Webb in 1861 for the firm of Morris, Marshall, Falkner & Co. Burne-Jones's preparatory pencil drawing (Fitzwilliam Museum, Cambridge) is signed and dated at lower right: EBJ 1861.
Oil on leather, each 23³/₄ × 20³/₈ in.
(60.3 × 51.8 cm)
Rogers Fund, 1926
26.54
ESDA

Style of Sir Edward Coley Burne-Jones
British, about 1871

Cabinet Doors with Painted Panels
The subjects (left to right) are: Ariadne and Thisbe (4); Medea and Cleopatra (3); Phyllis, Fama, and four floral designs (1); Amor, Alcestis, and four floral designs (2).
Oil and gold on wood, each 6¹/₄ × 3³/₈ in.
(15.9 × 8.6 cm)
Inscribed (each panel) with identifying names
Gift of Mrs. Frederick H. Allen, 1922
22.177.1–4
ESDA

Briton Riviere
British, 1840–1920

Pallas Athena and the Herdsman's Dogs
Oil on canvas, 44¹/₈ × 70¹/₈ in.
(112.1 × 178.1 cm)
Signed and dated (lower left): B. Riviere 1876–93–4
Gift of Richard Manney, 1980
1980.510.3

Philip Wilson Steer
British, 1860–1942

Richmond Castle, Yorkshire
Oil on canvas, 29¹/₈ × 34¹/₂ in.
(74 × 87.6 cm)
Signed and dated (lower right): P.W. Steer 1903
Catharine Lorillard Wolfe Collection, Wolfe Fund, 1908
09.1.1

Walter Richard Sickert
British, 1860–1942

The Cigarette (Jeanne Daurmont)
The sitter, a Belgian milliner, was painted in the spring of 1906.
Oil on canvas, 20 × 16 in.
(50.8 × 40.6 cm)
Signed (lower right): Sickert–
Bequest of Mary Cushing Fosburgh, 1978
1979.135.17

German (Nuremberg) Painter

1360–70

The Bishop of Assisi Handing a Palm to Saint Clare

This panel relates to six other scenes from the saint's life: Christ Appears to Saint Clare, Innocent IV Confirms the Rule of the Poor Clares, and Death and Coronation of Saint Clare (all Germanisches Nationalmuseum, Nuremberg), Hortolana Prays to Christ and Saint Clare Awakes the Dead (both Historisches Museum, Bamberg), and a Kneeling Figure (location unknown). All seven may be from two altarpieces painted for the Clara Kloster, Nuremberg.
Tempera and oil on wood, gold ground, 13¼ × 8⅝ in. (33.7 × 21.9 cm)
Inscribed (on book): eto / mes / fid / eles (Behold my faithful)
The Cloisters Collection, 1984
1984.343
THE CLOISTERS

Master of the Berswordt Altar

German, Westphalian, about 1400

The Crucifixion

This is one of eighteen scenes from the interior wings of an altarpiece of the Glorification of the Virgin, from the Neustädter Marienkirche, Bielefeld, Westphalia. The altarpiece was intact until the church was restored about 1840. The main panel with twelve flanking panels is in situ; eleven others from the wings have been identified, seven in private, three in public, collections (Gemäldegalerie, SMPK, Berlin; Oetker-Museum, Bielefeld; and Ashmolean Museum, Oxford), and one belonging to the church at Milton Ernest, Bedford, England.
Tempera and gold, transferred from wood, laid down on wood, 23½ × 17 in.
(59.7 × 43.2 cm)
Rogers Fund, 1943
43.161

German (Bavarian) Painter

about 1450

Virgin and Child with a Donor Presented by Saint Jerome

Oil on wood, gold ground,
25 × 19 in. (63.5 × 48.3 cm)
Inscribed (on Virgin's halo): VFWT [] RAOWB
Robert Lehman Collection, 1975
1975.1.133
ROBERT LEHMAN COLLECTION

1984.343

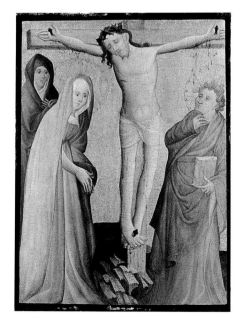

43.161

1975.1.133

32.100.38

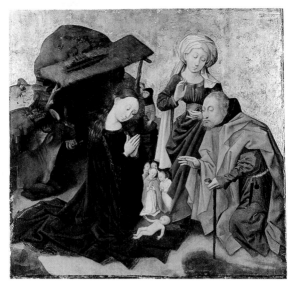

32.100.39

1981.365.1 (recto)

1981.365.1 (verso)

53.21 (interior)

53.21 (exterior)

South German Painter

mid-15th century

The Annunciation

This panel and the following (32.100.39) made up the interior left wing of an altarpiece depicting the Life of the Virgin, probably from a church in Dietenheim. Other panels from the altarpiece are: Joachim Cast Out of the Temple and the Meeting at the Golden Gate, exterior left wing (both Diözesanmuseum, Rottenburg); the Adoration of the Magi, joined to the Presentation of the Virgin in the Temple, top right wing, interior and exterior (Klosterkirche, Fischingen, Thurgau); and the Presentation of Christ in the Temple and the Birth of the Virgin, bottom right wing, interior and exterior (both John G. Johnson Collection, Philadelphia Museum).
Oil on wood, gold ground,
39 × 37 in. (99.1 × 94 cm)
Inscribed (on scroll): Ave GR[atia p]lena·dom[inus tecum]
The Friedsam Collection, Bequest of Michael Friedsam, 1931
32.100.38

The Nativity

Oil on wood, gold ground, 37 × 36¹/₄ in. (94 × 92.1 cm)
The Friedsam Collection, Bequest of Michael Friedsam, 1931
32.100.39

Master of the Acts of Mercy

Austrian, Salzburg, about 1465

The Martyrdom of Saint Lawrence; (verso) Giving Drink to the Thirsty

This panel, probably one of six, is from the wing of an altarpiece: two others (Städtisches Museum Simeonstift, Trier) represent the Beheading of John the Baptist (verso, Harboring the Pilgrim) and the Feast of Herod (verso, Feeding the Hungry).
Oil on wood, (recto) gold ground, painted surface 29 × 18³/₈ in. (73.7 × 46.7 cm)
Inscribed (recto, on hats of executioners) in pseudo-Greek and pseudo-Hebrew
Gift of The Jack and Belle Linsky Foundation, 1981
1981.365.1

Master of the Burg Weiler Altar

German, Middle Rhenish, about 1470

The Burg Weiler Altar (triptych)

From the chapel of the castle of Burg Weiler, Württemberg, near Heilbronn. Interior: the Virgin and Child with (left to right) Saints Jodokus, Wendelius, Apollonia, Barbara, Catherine of Alexandria, Lawrence, Sebastian,

and Maurice; exterior: Three Martyrs of the
Theban Legion and Saint Theodulus
Oil on wood, gold ground; overall, with
engaged frame: central panel 68¹/₂ × 60 in.
(174 × 152.4 cm); each wing 68¹/₂ × 26 in.
(174 × 66 cm)
Inscribed (interior, at bottom of each panel)
with the name of the saint depicted
The Cloisters Collection, 1953
53.21
The Cloisters

Friedrich Walther

German, born about 1440, died 1494

Sermon of Saint Albertus Magnus

Oil on wood, 49³/₄ × 27⁵/₈ in.
(126.4 × 70.2 cm)
Inscribed: (on scroll) Furcht·got·wan·die
·stund·seyns·urteils·ist·zukunfftig·apock /
XIIII. (Fear God . . . for the hour of his
judgment is come [Apocalypse 14:7].); (on
right folio of book) [same inscription]; (on
left folio of book and on plaque) [illegible]
The Cloisters Collection, 1964
64.215
The Cloisters

German (Rhenish) Painter

about 1480

Saint George and Saint Sebastian

Oil on wood, two panels, each
29¹/₄ × 13¹/₂ in. (74.3 × 34.3 cm)
Bashford Dean Memorial Collection, Funds
from various donors, 1929
29.158.743
Arms and Armor

Attributed to Ludwig Schongauer

German, active by 1479, died 1493/94

Christ before Pilate; The Resurrection

These pictures are the recto and verso of a
single panel, now separated. They are from
the same altarpiece as the Flagellation of
Christ and Christ Carrying the Cross (castle
of Salem, Germany).
Oil on wood; (a) overall 15¹/₈ × 8¹/₄ in.
(38.4 × 21 cm), painted surface
14³/₈ × 7³/₄ in. (36.5 × 19.7 cm); (b) overall
15¹/₈ × 8¹/₄ in. (38.4 × 21 cm), painted
surface 14¹/₂ × 7³/₄ in. (36.8 × 19.7 cm)
The Jack and Belle Linsky Collection, 1982
1982.60.34ab

Master of Eggenburg

Austrian, Tirol, active 1490–1500

A Bishop Saint and Saint Procopius

This painting and the following (44.147.2) are
likely to have been the recto and verso of a
single panel. Three other scenes from the
same altarpiece dedicated to Saint Wenceslas
are recorded: Saint Wenceslas Liberating

64.215

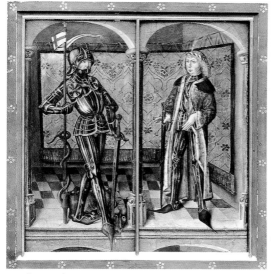

29.158.743

1982.60.34a (recto)

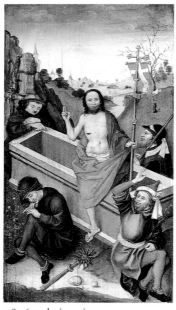

1982.60.34b (verso)

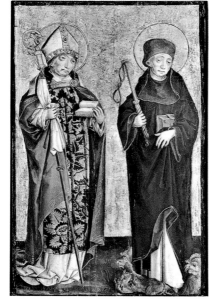

44.147.1

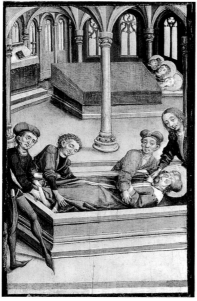

44.147.2

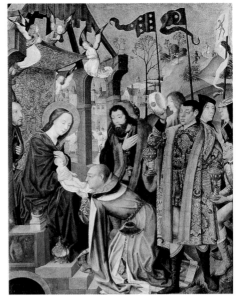

26.52a (recto) 26.52b (verso)

Prisoners (National Gallery, Prague), Saint Wenceslas Led by Angels before the Emperor and Securing the Body of Saint Wenceslas (both art market, 1921).
Oil on wood, gold ground; painted surface, including black border, 27¹⁄₈ × 17 in. (68.9 × 43.2 cm)
Gift of William Rosenwald, 1944
44.147.1

The Burial of Saint Wenceslas
Oil on wood; painted surface, including black border, 27¹⁄₈ × 17 in. (68.9 × 43.2 cm)
Gift of William Rosenwald, 1944
44.147.2

Master of the Holy Kinship

German, Cologne, active about 1480–1515 or after

The Adoration of the Magi; (verso) ***The Throne of Grace***
Oil on wood, 45³⁄₄ × 33⁵⁄₈ in. (116.2 × 85.4 cm)
Fletcher Fund, 1926
26.52ab

1991.10 (interior) 1991.10 (exterior)

German (Swabian) Painter

about 1490

Private Devotional Shrine
The shutters—representing (interior) Saints Catherine and Barbara and (exterior) Saints Ursula and Dorothea—flank a sculpture of the Holy Kinship with donors. The predella shows the sudarium.
Oil on wood, (interior) gold ground, overall height 13¹⁄₄ in. (33.7 cm)
The Cloisters Collection, 1991
1991.10
THE CLOISTERS

German (Strasbourg) Painter

fourth quarter 15th century

Four Saints
The shutters—representing (interior) Saints Barbara and Margaret and (exterior) Saints Sebastian and John the Baptist—flank a sculpture of the Virgin and Child with a kneeling bishop donor.
Oil on wood; overall, with engaged frame, each wing, 25⁵⁄₈ × 7⁵⁄₈ in. (65.1 × 19.4 cm); painted surface, each wing, 22⁷⁄₈ × 5¹⁄₄ in. (58.1 × 13.3 cm)
Rogers Fund, 1912
12.103
MEDIEVAL ART

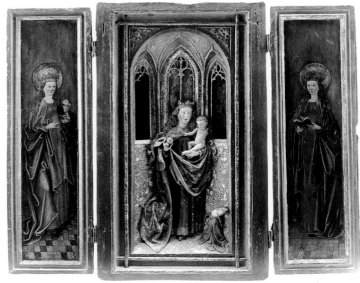

12.103 (interior) 12.103 (exterior)

Swiss Painter

fourth quarter 15th century

Saint Remigius Replenishing the Barrel of Wine; Saint Remigius and the Burning Wheat

This panel and the following (71.40ab)—each painted on both sides—are from the same ensemble.

Oil on wood, 54¼ × 30½ in.
(137.8 × 77.5 cm)
Purchase, 1871
71.33ab

A Martyr Saint in the Arena; The Beheading of a Martyr Saint

Oil on wood, 54¼ × 30½ in.
(137.8 × 77.5 cm)
Inscribed (verso, bottom, in a later hand): 87
Purchase, 1871
71.40ab

European Painter

before 1500

Head of Christ

Tempera on wood, gold ground; overall, with engaged frame, 19⅜ × 14⅛ in.
(49.2 × 35.9 cm); painted surface
16¾ × 12½ in. (42.5 × 31.8 cm)
Bequest of Harry G. Sperling, 1971
1976.100.4

German (Westphalian) Painter

15th century

The Adoration of the Magi

Oil and gold on wood, 7½ × 7 in.
(19.1 × 17.8 cm)
Robert Lehman Collection, 1975
1975.1.134
ROBERT LEHMAN COLLECTION

German (Upper Rhenish) Painter

dated 1491

Portrait of a Man

Oil on wood, 18¾ × 13 in. (47.6 × 33 cm)
Dated and inscribed (at top): ·1·4·9·1·/H.H.
[initials possibly added later]
Fletcher Fund, 1923
23.255

71.33a

71.33b

71.40a

71.40b

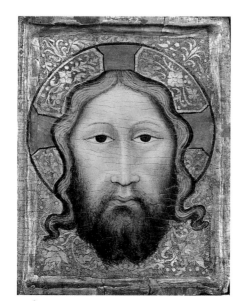

1976.100.4

1975.1.134

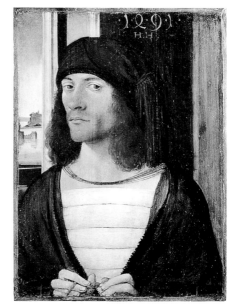

23.255

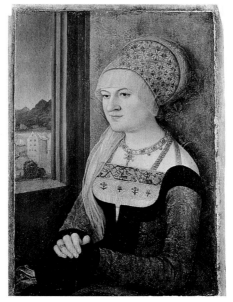

71.34

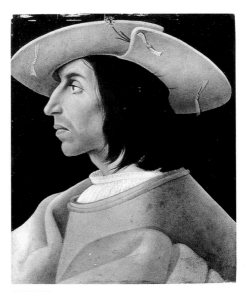

32.100.99

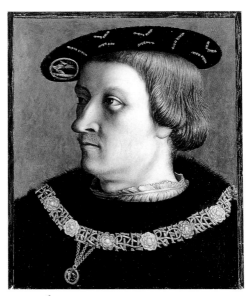

32.100.116

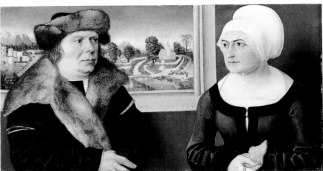

12.115

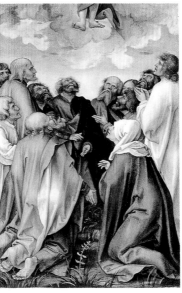

21.84

Bernhard Strigel

German, 1460/61–1528

Portrait of a Woman

Oil on wood, 15¹/₈ × 10¹/₂ in.
(38.4 × 26.7 cm)
Purchase, 1871
71.34

German (Augsburg) Painter

about 1525

Portrait of a Man in Profile

Oil on wood, 13¹/₄ × 10¹/₂ in.
(33.7 × 26.7 cm)
The Friedsam Collection, Bequest of Michael
Friedsam, 1931
32.100.99

Swiss Painter

first quarter 16th century

*Portrait of a Man Wearing the Order of
the Annunziata of Savoy*

Oil on wood, 14¹/₄ × 11 in.
(36.2 × 27.9 cm)
The Friedsam Collection, Bequest of Michael
Friedsam, 1931
32.100.116

Ulrich Apt the Elder

German, active by 1481, died 1532

Portrait of a Man and His Wife

There are two other versions of the
composition (British Royal Collection and
location unknown).
Oil on wood, 13 × 24⁷/₈ in. (33 × 63.2 cm)
Dated and inscribed: (center) ·15 12·; (on
window frame, with ages of sitters) ·52· ·35·
Rogers Fund, 1912
12.115

Hans Suess von Kulmbach

German, born about 1480, died 1521/22

The Ascension of Christ

The panel belongs to a series comprising the
Annunciation (Germanisches National-
museum, Nuremberg), the Nativity
(Staatsgalerie, Bamberg), and the Adoration of
the Magi (Allentown Art Museum,
Pennsylvania). This series has been further
associated with the Meeting at the Golden
Gate and the Presentation of the Virgin (both
Thyssen-Bornemisza Foundation), a predella
representing the Death of the Virgin
(Staatsgalerie, Bamberg), and a central relief of
the Coronation of the Virgin by Veit Stoss
(Germanisches Nationalmuseum, Nuremberg).
Oil on wood; overall 24¹/₄ × 15 in.
(61.5 × 38.1 cm); painted surface
24¹/₄ × 14¹/₈ in. (61.5 × 35.9 cm)
Rogers Fund, 1921
21.84

Hans Suess von Kulmbach
German, born about 1480, died 1521/22

Girl Making a Garland; (verso) *Portrait of a Young Man*
Oil on wood, 7 × 5 ¹/₂ in. (17.8 × 14 cm)
Inscribed: (on scroll) .ICH PINT MIT, VERGIS MEIN NIT. (I bind with forget-me-nots); (right center, falsely, with initials of Albrecht Dürer) AD [monogram] / 1508
Gift of J. Pierpont Morgan, 1917
17.190.21

Albrecht Dürer
German, 1471–1528

Virgin and Child with Saint Anne
Oil on wood, 23⁵/₈ × 19⁵/₈ in.
(60 × 49.8 cm)
Inscribed (right center): 1519/AD [monogram and date are later additions]
Bequest of Benjamin Altman, 1913
14.40.633

17.190.21 (recto)

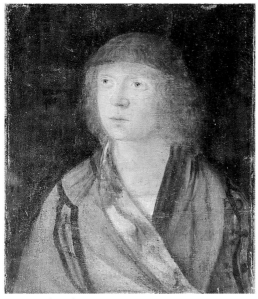

17.190.21 (verso)

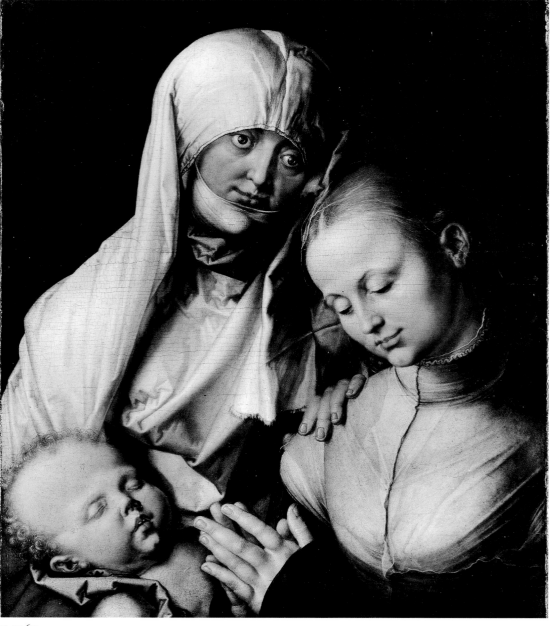

14.40.633

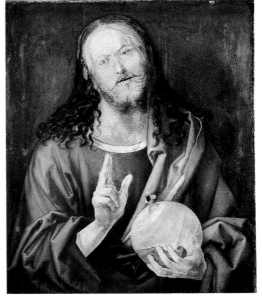

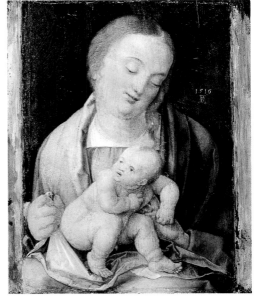

32.100.64

17.190.5

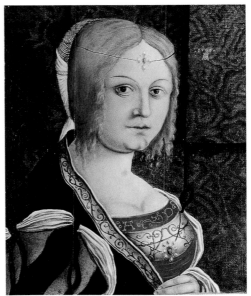

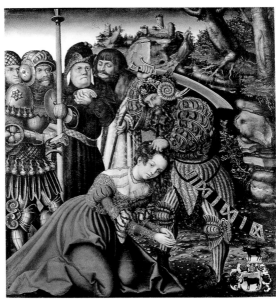

49.7.27

57.22

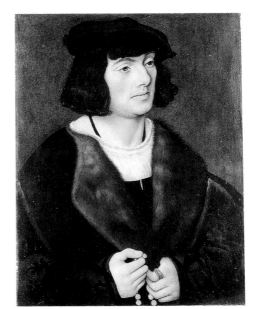

29.100.24 (recto)

29.100.24 (verso)

Salvator Mundi
Oil on wood, 22⁷/₈ × 18¹/₂ in.
(58.1 × 47 cm)
The Friedsam Collection, Bequest of Michael
Friedsam, 1931
32.100.64

Attributed to Albrecht Dürer

Virgin and Child
Oil on wood, 11 × 7³/₈ in.
(27.9 × 18.7 cm); set in panel 11 × 8³/₄ in.
(27.9 × 22.2 cm)
Signed (?) and dated (right center): 1516 / AD
[monogram]
Gift of J. Pierpont Morgan, 1917
17.190.5

Style of Albrecht Dürer
Italian, probably 16th century

Portrait of an Italian Woman
This painting is a copy of a rare sixteenth-
century North Italian engraving (British
Museum, London).
Oil on wood, 17³/₄ × 13³/₄ in.
(45.1 × 34.9 cm)
Inscribed (falsely, twice, with initials of
Albrecht Dürer): (upper right, the first two
digits of the date are original) -1506- / AD
[monogram]; (on bodice) A D
The Jules Bache Collection, 1949
49.7.27

Lucas Cranach the Elder
German, 1472–1553

The Martyrdom of Saint Barbara
Oil on wood; overall 60³/₈ × 54¹/₄ in.
(153.4 × 137.8 cm); painted surface
59³/₈ × 53¹/₈ in. (150.8 × 134.9 cm)
Arms (lower right) of the Rehm family of
Augsburg
Rogers Fund, 1957
57.22

Portrait of a Man with a Rosary
This painting was probably the wing of a
triptych; the verso (severely damaged)
represents a male saint in a niche in grisaille.
It seems to have had as a pendant a portrait
of a young woman (Kunsthaus, Zurich), with
a comparable female saint, identified as Saint
Catherine of Alexandria, on the verso.
Oil on wood, 18³/₄ × 13⁷/₈ in.
(47.6 × 35.2 cm)
H. O. Havemeyer Collection, Bequest of Mrs.
H. O. Havemeyer, 1929
29.100.24

Lucas Cranach the Elder
German, 1472–1553

Venus and Cupid the Honey Thief
Oil on wood, 14¹/₂ × 10 in.
(36.8 × 25.4 cm)
Signed (on tree trunk) with winged serpent
and dated 1530
Inscribed (upper left): DVM PVER ALVEOLO
FVRATVR MELLA CVPIDO. / FVRANTI DIGITVM
SEDVLA PVNXIT APIS. / SIC ETIAM NOBIS
BREVIS ET MORITVRA VOLVPTas / QVAM
PETIMVS TRISTI MIXTA DOLORE NOCET (As
Cupid was stealing honey from the hive / A
bee stung the thief on the finger / And so do
we seek transitory and dangerous pleasures /
That are mixed with sadness and bring us
pain)
Robert Lehman Collection, 1975
1975.1.135
ROBERT LEHMAN COLLECTION

Venus and Cupid
Oil on wood, diameter 4³/₄ in. (12.1 cm)
Signed (lower left, on stone) with winged
serpent
The Jack and Belle Linsky Collection, 1982
1982.60.48

The Judgment of Paris
Oil on wood, 40¹/₈ × 28 in.
(101.9 × 71.1 cm)
Signed (right foreground, on rock) with
winged serpent
Rogers Fund, 1928
28.221

Judith with the Head of Holofernes
Oil on wood, 35¹/₄ × 24³/₈ in.
(89.5 × 61.9 cm)
Signed (lower right) with winged serpent
Rogers Fund, 1911
11.15

Portrait of a Man with a Gold-Embroidered Cap
Oil on wood, 20 × 14³/₈ in.
(50.8 × 36.5 cm)
Signed (center left) with winged serpent and
dated 1532
Bequest of Gula V. Hirschland, 1980
1981.57.1

John, Duke of Saxony
Oil on wood, 25⁵/₈ × 17³/₈ in.
(65.1 × 44.1 cm)
Rogers Fund, 1908
08.19

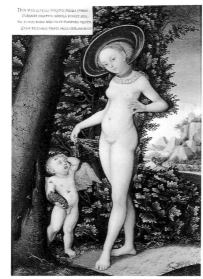

1975.1.135

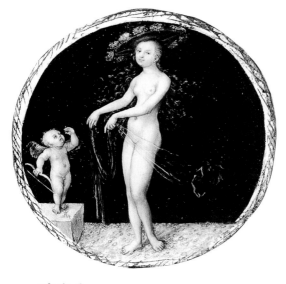

1982.60.48

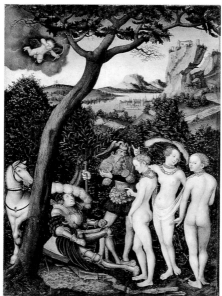

28.221

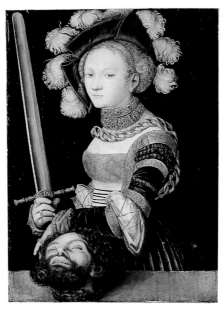

11.15

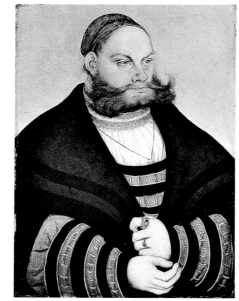

1981.57.1

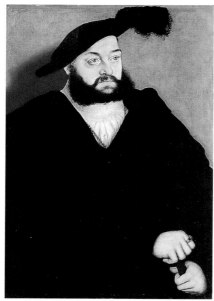

08.19

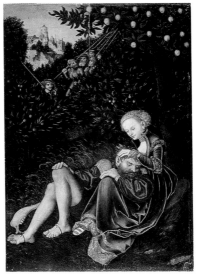

1976.201.11

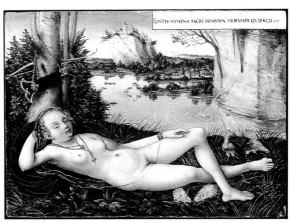

1975.1.136

KOMEN.VND WERET INEN NICHT.DENN
SOLCHER IST DAS REICH GOTTES.
- MARCVS.X. - (Suffer the little children to
come unto me, and forbid them not: for of
such is the kingdom of God [Mark 10:14].)
The Jack and Belle Linsky Collection, 1982
1982.60.36

Attributed to Lucas Cranach the Elder

Frederick III (1463–1525), *the Wise, Elector of Saxony*

This portrait and the following two (46.179.2
and 71.128) may have been among sixty such
images, dating from 1532 to 1533, that are
recorded as having been ordered from the
artist.
Oil on paper, laid down on wood,
8 × 5⅝ in. (20.3 × 14.3 cm)
Signed (upper left) with winged serpent and
dated 15 33
Labeled (printed paper on panel):
(upper right) Friderich der Drit/Chur-/fur[s]t
vnd Herzog zu/Sachssen.; (bottom)

> Fridrich bin ich billich genand
> Schönen frid ich erhielt im land.
> Durch gros vernunfft gedult und glück
> Widder manchen erzbösen tück.
> Das land ich zieret mit gebew
> Und Stifft ein hohe Schul auffs new,
> Zu Wittenberg im Sachssen land
> Inn der welt die ward bekand
> Denn aus der selb kam Gottes wort
> Und thet gros ding an manchem ort.
> Das [tzt?]epstlich Reich störgt es nidder
> Und bracht rechten glauben widder.
> Zum Keisar ward erkorn ich
> Des mein alter beschweret sich.
> Dafur ich [Keisar Car]l erwelt
> Von dem mich nicht wand gonst noch gelt.

(I am rightly called Friedrich, / for I
maintained a blessed peace in my domain /
with great wisdom, patience, and luck, /
despite the machinations of a number of
rogues. / I graced my lands with new
buildings / and endowed a new university /
at Wittenberg in Saxony / that became
famous throughout the world, / for from it
the Word of God came forth / and
wrought great change in many places. / It
destroyed the papal empire / and brought
back the true faith. / They elected me
emperor, / but my old age protested, / so I
chose Emperor Charles [Charles V, 1500–
1558] / and neither favors nor money could
dissuade me.)

Gift of Robert Lehman, 1946
46.179.1

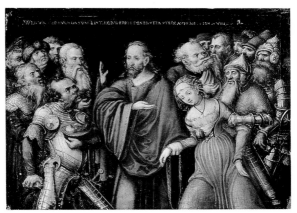

1982.60.35

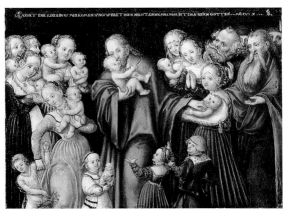

1982.60.36

Samson and Delilah

Oil on wood, 22½ × 14⅞ in.
(57.2 × 37.8 cm)
Signed (center right, on rock) with winged
serpent
Bequest of Joan Whitney Payson, 1975
1976.201.11

Nymph of the Spring

Oil on wood, 6 × 8 in. (15.2 × 20.3 cm)
Signed (on tree trunk) with winged serpent
(wings folded)
Inscribed (upper right): FONTIS NYMPHA
SACRI SOMNVM NERVMPE QVIESCO (I am the
nymph of the sacred spring; do not disturb
my sleep; I am resting)
Robert Lehman Collection, 1975
1975.1.136
ROBERT LEHMAN COLLECTION

Christ and the Adulteress

Oil on wood, 6¼ × 8½ in.
(15.9 × 21.6 cm)
Signed (upper right) with winged serpent
(wings folded?)
Inscribed (top): WER VNTER EVCH ON SVNDE
IST. DER WERFFE DEN ERSTEN STEIN AVFF SIE.
-IOH-VIII- (He that is without sin among you,
let him first cast a stone at her [John 8:7].)
The Jack and Belle Linsky Collection, 1982
1982.60.35

Christ Blessing the Children

Pendant to 1982.60.35
Oil on wood, 6½ × 8¾ in.
(16.5 × 22.2 cm)
Signed (upper right) with winged serpent
(wings folded)
Inscribed (top): LASSET DIE KINDLIN ZV MIR

Workshop of Lucas Cranach the Elder

John I (1468–1532), *the Steadfast, Elector of Saxony*

Pendant to 46.179.1
Oil on paper, laid down on wood,
8 × 5⅝ in. (20.3 × 14.3 cm)
Labeled (printed paper on panel):
(upper left) Johans der Erst / Churfurst / und
Herzog zu Sachssen.; (bottom)

Nach meines [lieben bruders e]nd
Bleib auff m[i]r d[as ganz Regim]end.
Mit grosser sorg [und mancher fa]hr
Da der Bawr toll und [töricht w]ar.
Die auffrhur fast inn allem [land]
Wie gros fewer im wald [entbrand].
Welches ich halff dempffen mit Gott
Der Deudsches land erret aus not.
Der Rotten geister feind ich war
Hielt im land das wort rein und klar
Gros drawen bittern hass und neid
Umb Gottes worts willen ich leid.
Frey bekand ichs aus herzem grund
Und personlich selbst ich da stund.
Vor dem Keisar vnd ganzen Reich
Von Fursten gschach vor nie des gleich
Solchs gab mir mein Gott besnnder
Und vor der wellt was ein wunder.
Umb land und leût [zu bringen] mich
Hofft beid freund vnd [feind ge]wislich.
Ferdnand zu Rômisc[hm Kônig] gmacht
Und sein wahl ich allein anfacht.
Auff das da[s] alte Recht bestünd
Inn der gulden Bullen gegründ.
Wiewol das grossen zorn erregt
Mich doch mehr recht denn gunst
beweg[t.]
Das hertz gab Gott dem Keisar zart
Mein guter freund zu lezt er ward.
Das ich mein end ym frid beschlos
Wast sehr den Teuffel das verdros.
Erfarn hab ichs und zeugen thar
Wie uns die Schrifft sagt und ist war.
Wer Gott mit ernst vertrawen kan
Der bleibt ein unnerdorben man.
Es zürne Teuffel odder welt
Den sieg er doch zu lezt behelt.

(On the death of my beloved brother / the
whole job of ruling fell to me, / bringing
much worry and considerable danger, / for
the peasants were wild and foolish. /
Violence flared throughout my country /
like a great forest fire, / which I helped to
quench with God, / who rescued German
territory from its misery. / I was an enemy
of the leaders of the rabble / and kept the
Word pure and undefiled in my land. / I
had to suffer dire threats, bitter hatred, and
envy / for the sake of God's Word. / I
professed it freely from the bottom of my
heart, / and I myself took a stand / before
the emperor and the entire realm. / No
prince had ever done such a thing before. /
My God gave me alone that role, / and it
was a marvel to the world. / Friend and foe
alike sought to rob me / of my land and
people, to be sure, / and made Ferdinand
[Ferdinand I, 1503–1564] king of the

Romans. / I alone opposed his election, /
hoping to ensure that authority might
continue / to be based on the Golden Bull
as of old. / Though this occasioned great
wrath, / I acted according to what was
right rather than out of partiality. / God
gave the emperor a kind heart, / and in the
end he became my friend / so that I ended
my days in peace— / much to the Devil's
dismay. / I have seen it myself, and I assure
you / that as the scriptures tell us—and it
is true— / the man who can truly trust in
God / will never be defeated. / The Devil
and the world may rage all they will, / yet
his is the victory in the end.)

Gift of Robert Lehman, 1946
46.179.2

John I (1468–1532), *the Steadfast, Elector of Saxony*

This portrait is likely to have been one of a pair.
Oil on canvas, transferred from wood,
8¼ × 5⅞ in. (21 × 14.9 cm)
Labeled (printed paper):
(upper left) Johans der Erst / Churfurst / und
Herzog zu Sachssen; (bottom)

Nach meines lieben bruders end
Bleib auff mir das ganz Regimend.
Mit grosser sorg und mancher fahr
Da der Bawr toll und töricht war.
Die auffrhur fast inn allem land
Wie gros fewer im wald entbrand.
Welches ich halff dempffen mit Gott
Der Deudsches land erret aus not.
Der Rotten geister feind ich war
Hielt im land das wort rein und klar
Gros drawen bittern hass und neid
Umb Gottes worts willen ich leid.
Frey bekand ichs aus herzem grund
Und personlich selbst ich da stund.
Vor dem Keisar vnd ganzen Reich
Von Fursten gschach vor nie des gleich
Solchs gab mir mein Gott besnnder
Und vor der wellt was ein wunder.
Umb land und leût zu bringen mich
Hofft beid freund vnd feind gewislich.
Ferdnand zu Rômischm Kônig gmacht
Und sein wahl ich allein anfacht.
Auff das das alte Recht bestünd
Inn der gulden Bullen gegründ.
Wiewol das grossen zorn erregt
Mich doch mehr recht denn gunst bewegt.
Das hertz gab Gott dem Keisar zart
Mein guter freund zu lezt er ward.
Das ich mein end ym frid beschlos
Wast sehr den Teuffel das verdros.
Erfarn hab ichs und zeugen thar
Wie uns die Schrifft sagt und ist war.
Wer Gott mit ernst vertrawen kan
Der bleibt ein unnerdorben man.
Es zürne Teuffel odder welt
Den sieg er doch zu lezt behelt.

(For translation, see 46.179.2 above.)

Purchase, 1871
71.128

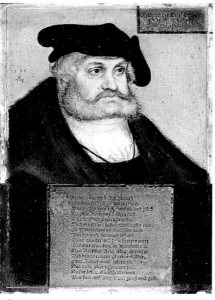

46.179.1

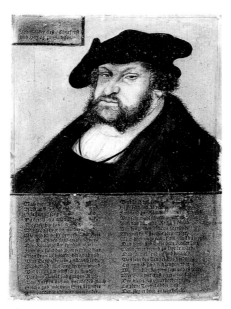

46.179.2

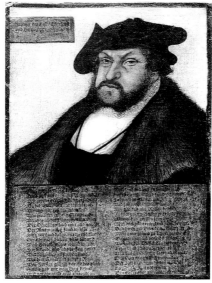

71.128

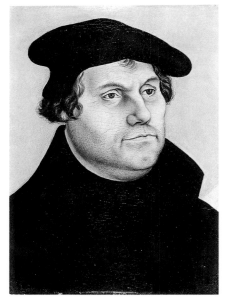

55.220.2

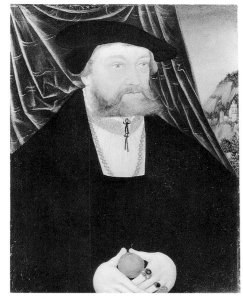

32.100.61

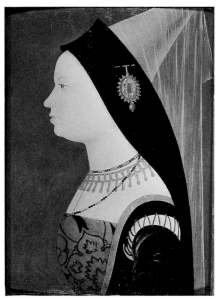

1975.1.137

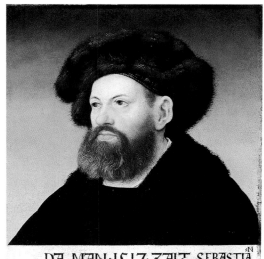

32.100.33

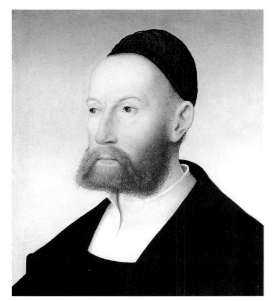

14.40.630

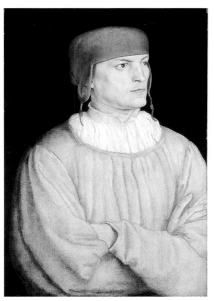

12.194

Martin Luther (1483–1546)
This is one of many large-format replicas after a portrait (Gemäldegalerie, Dresden) signed with Cranach's winged serpent and dated 1532.
Oil on wood, 13⅛ × 9⅛ in.
(33.3 × 23.2 cm)
Gift of Robert Lehman, 1955
55.220.2

Portrait of a Man
Oil on wood, 22 × 16¾ in.
(55.9 × 42.5 cm)
Dated (top): MDXXXVII
The Friedsam Collection, Bequest of Michael Friedsam, 1931
32.100.61

Hans Maler zu Schwaz
German, active about 1500, died 1529

Mary of Burgundy (1458–1482)
Oil on wood, 17¼ × 12¼ in.
(43.8 × 31.1 cm)
Robert Lehman Collection, 1975
1975.1.137
ROBERT LEHMAN COLLECTION

Sebastian Andorfer (1469–1537)
Oil on wood, 17 × 14⅛ in.
(43.2 × 35.9 cm)
Dated and inscribed (base): (left) DA MAN·1517·ZALT· / WAS ICH·48·IAR ALT (When 1517 was counted I was 48 years old); (right) SEBASTIA / -N / ANNDORFE- / ER
The Friedsam Collection, Bequest of Michael Friedsam, 1931
32.100.33

Ulrich Fugger (1490–1525)
Oil on wood, 15⅞ × 12¾ in.
(40.3 × 32.4 cm)
Dated and inscribed (verso, covered by cradling): DOMINI / MDXXV / ANNO CVRENTE / XXXV / ETATIS
Bequest of Benjamin Altman, 1913
14.40.630

Barthel Beham
German, 1502–1540

Chancellor Leonhard von Eck (1480–1550)
Oil on wood, 22⅛ × 14⅞ in.
(56.2 × 37.8 cm)
John Stewart Kennedy Fund, 1912
12.194

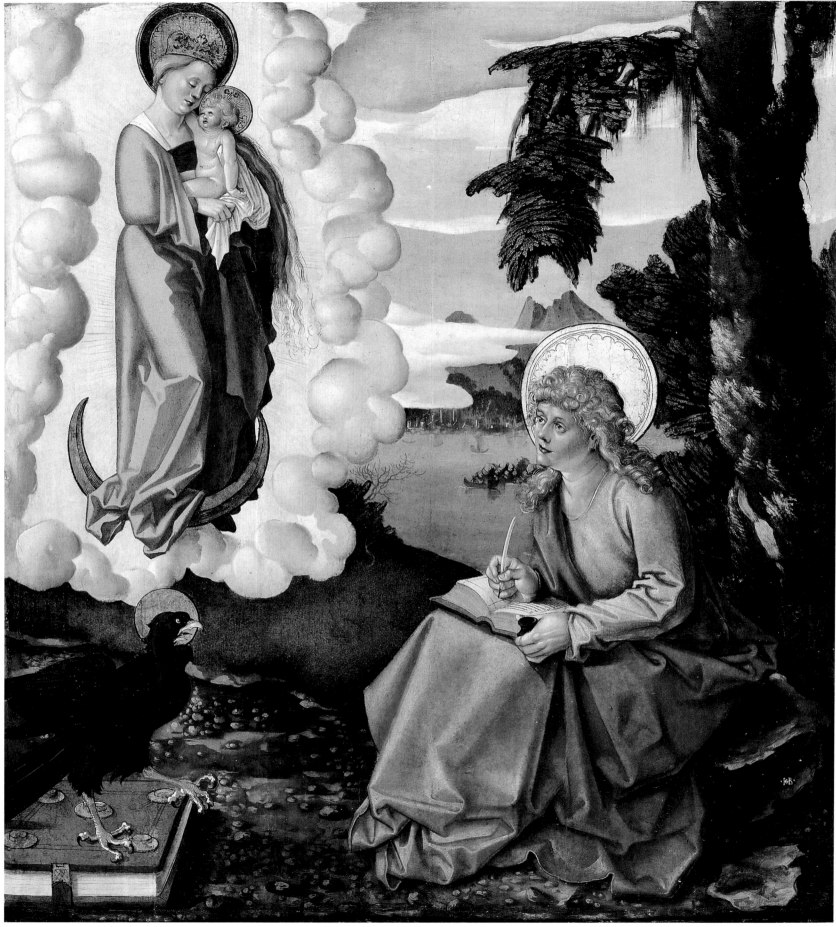

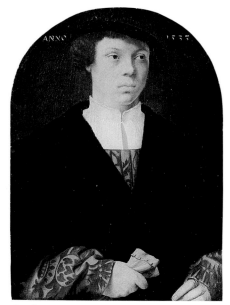

62.267.1

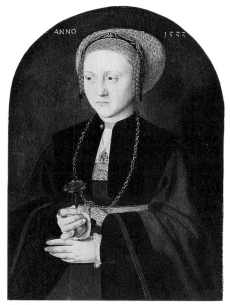

62.267.2

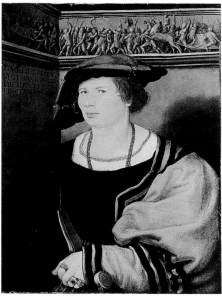

06.1038

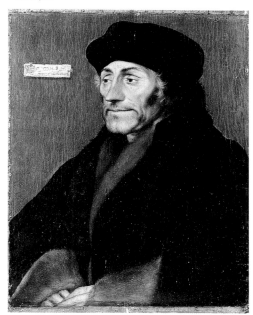

1975.1.138

Hans Baldung (called Grien)

German, 1484/85–1545

Saint John on Patmos

This panel and Saint Anne with the Christ Child, the Virgin, and Saint John the Baptist (National Gallery of Art, Washington, D.C.) are the lateral panels of a triptych, with the Mass of Saint Gregory (Cleveland Museum of Art) at the center. It was painted in 1511 for the commandery of the Hospitalers of Saint John of Jerusalem at Grünen Wörth in Strasbourg and shows, at the right of the central panel, the Johannite Erhart Künig (died 1511), commander from 1504.
Oil on wood; overall 35 1/4 × 30 1/4 in.

(89.5 × 76.8 cm); painted surface 34 3/8 × 29 3/4 in. (87.3 × 75.6 cm)
Signed (lower right, on rock): HBG [monogram]
Purchase, Rogers and Fletcher Funds; The Vincent Astor Foundation, The Dillon Fund, The Charles Engelhard Foundation, Lawrence A. Fleischman, Mrs. Henry J. Heinz II, The Willard T. C. Johnson Foundation Inc., Reliance Group Holdings Inc., Baron H. H. Thyssen-Bornemisza, and Mr. and Mrs. Charles Wrightsman Gifts; Joseph Pulitzer Bequest; special funds; and other gifts and bequests, by exchange, 1983
1983.451

Barthel Bruyn the Elder

German, 1493–1555

Portrait of a Man

Oil on wood, arched top; overall 12 × 8 7/8 in. (30.5 × 22.5 cm); painted surface 11 3/4 × 8 1/8 in. (29.8 × 20.6 cm)
Dated (top): ANNO 1533
Gift of James A. Moffett 2nd, 1962
62.267.1

Portrait of a Woman

Pendant to 62.267.1
Oil on wood, arched top; overall 12 × 8 7/8 in. (30.5 × 22.5 cm); painted surface 11 3/4 × 8 1/8 in. (29.8 × 20.6 cm)
Dated (top): ANNO 1533
Gift of James A. Moffett 2nd, 1962
62.267.2

Hans Holbein the Younger

German, 1497/98–1543

Benedikt von Hertenstein (born about 1495, died 1522)

Oil on paper, laid down on wood; overall 20 5/8 × 15 in. (52.4 × 38.1 cm); painted surface 20 1/4 × 14 5/8 in. (51.4 × 37.1 cm)
Signed, dated, and inscribed (upper left): DA·ICH·HET·DIE·GE / STALT·WAS·ICH·22· / ·IAR·ALT·1517·H·H· / ·PINGEBAT (When I looked like this I was twenty-two years old, 1517. H.H. painted it)
Rogers Fund, aided by subscribers, 1906
06.1038

Desiderius Erasmus (1469?–1536)

Oil on wood, 7 3/8 × 5 3/4 in. (18.7 × 14.6 cm)
Inscribed: (upper left, in a 17th-century hand, on cartellino) [illegible, possibly the mark of the earl of Arundel collection]; (verso) HAUNCE HOLBEIN ME FECIT, JOHANNE[S] NORYCE ME DEDIT, EDWARDUS BANYSTER ME POSSEDIT (Hans Holbein made me, John Norris [or Norreys] gave me, Edward Bannister possesses me)
Robert Lehman Collection, 1975
1975.1.138
ROBERT LEHMAN COLLECTION

Hans Holbein the Younger

German, 1497/98–1543

Portrait of a Member of the Wedigh Family, Probably Hermann Wedigh

(died 1560)
Oil on wood, 16⅝ × 12¾ in.
(42.2 × 32.4 cm), with added strip
of ½ in. (1.3 cm) at bottom
Signed, dated, and inscribed: (across center)
ANNO.1532. ÆTATIS.SVÆ.29.; (on cover of
book) ·H·H·; (on edge of book) HER[W
within a shield]WID.; (on sheet of paper in
book) Veritas odiū[m] parit: ˜ (Truth breeds
hatred [Terence, *Andria*, l. 69].)
Bequest of Edward S. Harkness, 1940
50.135.4

Portrait of a Man in a Red Cap

Oil on wood; overall, with engaged frame,
diameter 5 in. (12.7 cm); painted surface
diameter 3¾ in. (9.5 cm)
Inscribed (on tunic): H[R?]
Bequest of Mary Stillman Harkness, 1950
50.145.24

Derek Berck

Oil on canvas, transferred from wood,
21 × 16¾ in. (53.3 × 42.5 cm)
Dated and inscribed: (lower right) AN 1536 ÆTA:
30·; (left, on cartellino) Olim meminisse iuvabit
([Perchance even this distress it] will some
day be a joy to recall [Virgil, *Aeneid,* l.
203].); (on letter in sitter's hand) Dem Ersam
. . . / . . . Derick Berck / lvnden vpt Staelhoff
. . . (To the honorable . . . Derick Berck,
London, at the Steelyard . . .)
The Jules Bache Collection, 1949
49.7.29

Workshop of Hans Holbein the Younger

Portrait of a Man

Oil on wood, diameter 12 in. (30.5 cm)
Dated and inscribed (across center): ANNO
DOMI[NI] 1535 ETATIS SVÆ 28
The Jules Bache Collection, 1949
49.7.28

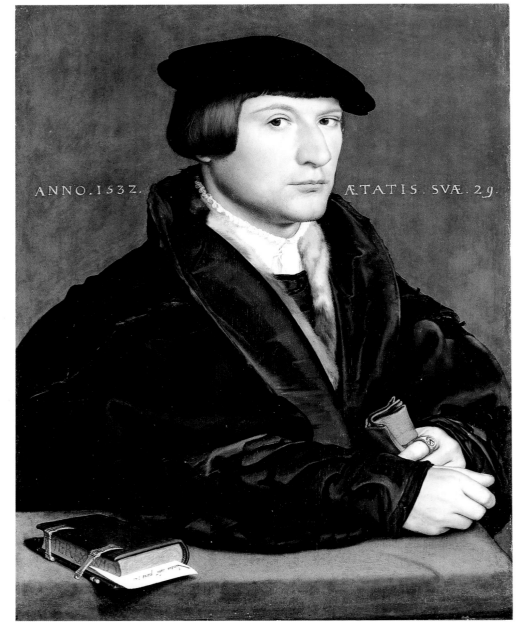

50.135.4

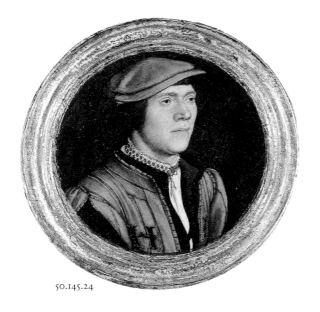

50.145.24

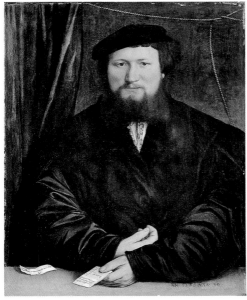

49.7.29

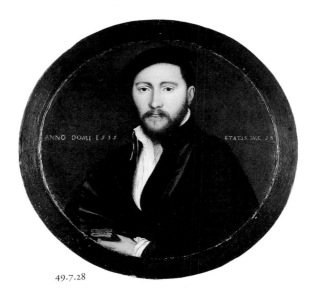

49.7.28

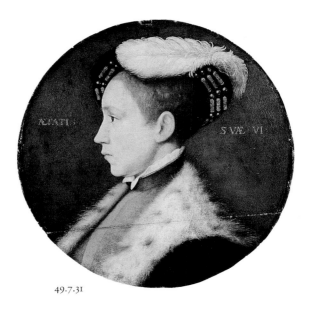

49.7.31

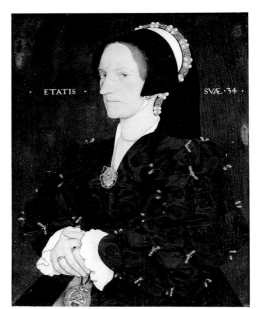

14.40.637

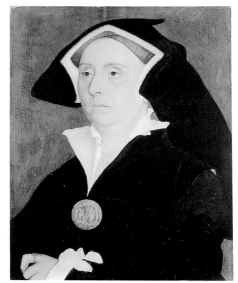

14.40.646

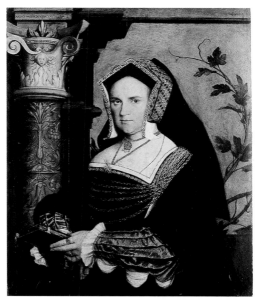

20.155.4

49.7.30

Lady Rich (Elizabeth Jenks, died 1558)
Oil on wood, 17¹⁄₂ × 13³⁄₈ in.
(44.5 × 34 cm)
Bequest of Benjamin Altman, 1913
14.40.646

after 1543
Edward VI (1537–1553), ***When Duke of Cornwall***
Oil on wood, diameter 12³⁄₄ in. (32.4 cm)
Inscribed (across center): ÆTATIS·SVÆ·VI·
The Jules Bache Collection, 1949
49.7.31

Copies after Hans Holbein the Younger

British, 16th century

Lady Guildford (Mary Wotton, born 1500)
This is a copy of a painting in the Saint
Louis Art Museum.
Oil on wood, 32¹⁄₈ × 26¹⁄₈ in.
(81.6 × 66.4 cm)
Dated and inscribed: (top left) ANNO·MDXXVII
ÆTATIS·SVÆ 27; (on book) VITA.CHRISTI (Life
of Christ)
Bequest of William K. Vanderbilt, 1920
20.155.4

Lady Lee (Margaret Wyatt, born about 1509)
Oil on wood, 16³⁄₄ × 12⁷⁄₈ in.
(42.5 × 32.7 cm)
Inscribed (across center): ·ETATIS· ·SVÆ·34·
Bequest of Benjamin Altman, 1913
14.40.637

Style of Hans Holbein the Younger

British, second half 16th century

Portrait of a Young Woman
Oil on wood, 11¹⁄₈ × 9¹⁄₈ in.
(28.3 × 23.2 cm)
Inscribed (across center): ANNO ETATIS·SVÆ
XVII
The Jules Bache Collection, 1949
49.7.30

Conrad Faber von Creuznach
German, active by 1524, died 1552/53

Portrait of a Member of the vom Rhein Family
Oil and gold on wood; overall
21³/₄ × 15⁵/₈ in. (55.2 × 39.7 cm); painted
surface 21¹/₂ × 15 in. (54.6 × 38.1 cm)
The Jack and Belle Linsky Collection, 1982
1982.60.37

Portrait of a Man with a Moor's Head on His Signet Ring
Oil and gold on wood, 20⁷/₈ × 14¹/₈ in.
(53 × 35.9 cm)
John Stewart Kennedy Fund, 1912
12.75

Attributed to Hans Brosamer
German, active by 1536, probably died 1552

Katharina Merian
Oil and gold on wood; overall
18¹/₄ × 13¹/₈ in. (46.4 × 33.3 cm); painted
surface 17⁵/₈ × 13¹/₈ in. (44.8 × 33.3 cm)
The Jack and Belle Linsky Collection, 1982
1982.60.38

Attributed to Jörg Breu the Younger
German, active after 1530, died 1547

Unidentified Scene
Distemper on canvas, 67⁵/₈ × 57¹/₄ in.
(171.8 × 145.4 cm)
Inscribed: (right foreground, on sword sheath)
MAR SVE·; (on breastplate) []S· IN·SO; (on
floor) [illegible]
Marquand Collection, Gift of Henry G.
Marquand, 1889
89.15.20

Attributed to Ludger tom Ring the Younger
German, 1522–1584

Christ Blessing, Surrounded by a Donor and His Family (triptych)
Oil on wood; central panel 31³/₈ × 37⁵/₈ in.
(79.7 × 95.6 cm); each wing 32 × 14⁵/₈ in.
(81.3 × 37.1 cm)
Inscribed on central panel: (top, on plaque)
ICK LEVE. VND CY SCHO- / LEN OCK LEVEN,
IOH 14· ([Because] I live, ye shall live also
[John 14:19].); (over sitters' heads, left to
right) ÆTA. / TIS / 21 / ÆTATIS 54 / ÆTATIS·6·
/ ÆTATIS 52. / ÆTAT: / 16.; (left, on plaque)
HERE LATH MÏI DÏ NE/GNADE WEDERVAREN, /
DÏNE HVLPE NA DÏ: / NEM WORDE. / PSAL. 118
(Let thy mercies come also unto me, . . . even
thy salvation, according to thy word [Psalms
118 (actually Psalms 119:41)].); (right, on
plaque) HERE. / WENN ICK / MEN DŸ HEBBE /

1982.60.37

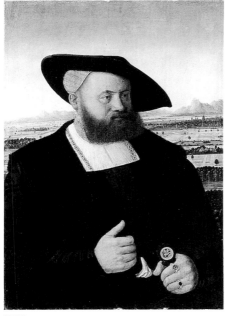
12.75

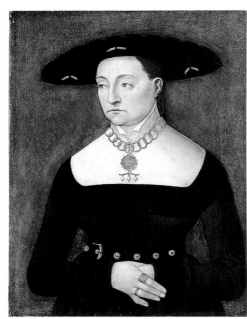
1982.60.38

89.15.20

SO FRAGE ICK NICHT / NA HEMEL VNDE /
ERDE. PSALM. 73· (Whom have I in heaven
but thee? And there is none upon earth that I
desire beside thee [Psalms 73:25].)
Inscribed on left wing: (over sitter's head)
ÆTATIS 33; (on plaque) EINS BÏDDE ICK VĀ DĒ
/ HEREN DAT HEDDE ICK / GERNE. DAT ICK IM
HV: / SE DES HEREN BLĪVEN̄ / MOGE MŸN
LEVE/LANCK. PSAL: 27· (One thing have I
desired of the Lord, that will I seek after; that
I may dwell in the house of the Lord all the

days of my life [Psalms 27:4].)
Inscribed on right wing: (over sitter's head)
ÆTATIS. 18.; (on plaque) HERE WENDE MŸNE /
OGENN AFF DAT SE / NICHT SEHEN NA VN: /
NVTTER LERE. SŌDER / VERQVICKE MY VP
DINEM / WEGE. PSAL 119 (Turn away mine
eyes from beholding vanity; and quicken thou
me in thy way [Psalms 119:37].)
Gift of J. Pierpont Morgan, 1917
17.190.13–15

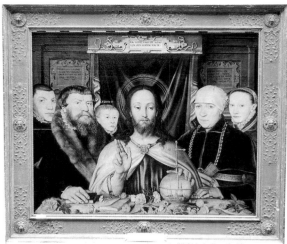
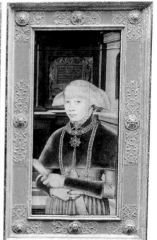

17.190.13–15

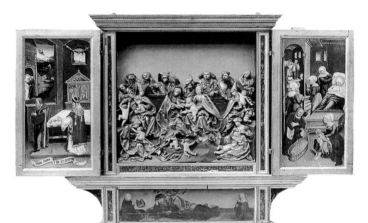
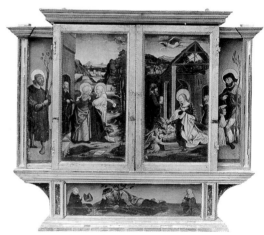

90.3.5 (interior)

90.3.5 (exterior)

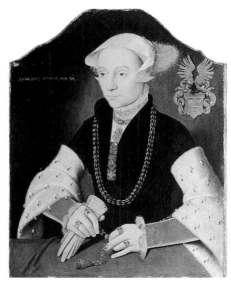
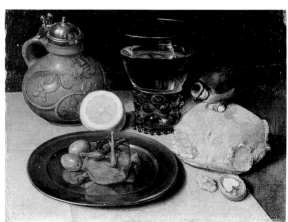

32.100.50

21.152.1

German (Franconian) Painter
dated 1548

Scenes from the Life of the Virgin
(altarpiece)

Exterior (left to right): Saint Otho(?), Visitation, Nativity, Saint Roch; interior: (left wing) Joachim Expelled from the Temple, Annunciation to Joachim, and Meeting at the Golden Gate; (right wing) Birth of the Virgin and Presentation of the Virgin in the Temple; predella: Tree of Jesse with a Kneeling Bishop and a Prioress. Within the shrine is a carved, painted, and gilt relief of the Virgin and Child with Saint Anne and the holy kindred. Oil on wood; overall, with engaged frame, 32³/₈ × 33⁷/₈ in. (82.2 × 86 cm); painted surface, each wing, 18³/₄ × 9¹/₄ in. (47.6 × 23.5 cm); painted surface, each fixed side panel, 18³/₄ × 3⁵/₈ in. (47.6 × 9.2 cm); painted surface, predella, 4³/₄ × 19¹/₂ in. (12.1 × 49.5 cm)
Dated and inscribed: (left wing, exterior) 1548; (left wing, interior) Anno domini M·D·xxxxviii v; (predella, on bishop's shield) F[]w
Bequest of Mrs. A. M. Minturn, 1890
90.3.5
MEDIEVAL ART

Barthel Bruyn the Younger
German, born about 1530, died before 1610

Portrait of a Woman of the Slosgin Family of Cologne
Oil on wood, shaped top, 17³/₄ × 14¹/₈ in. (45.1 × 35.9 cm)
Dated and inscribed (upper left): ANNO.1557.ÆTATIS.SVÆ 34
Arms (upper right) of the Slosgin (Schlössgen) family, who were merchants in Cologne
The Friedsam Collection, Bequest of Michael Friedsam, 1931
32.100.50

Georg Flegel
German, 1563–1638

Still Life
Oil on wood, 10⁵/₈ × 13³/₈ in. (27 × 34 cm)
Signed (lower right): GF [monogram]
Gift of Dr. W. Bopp, 1921
21.152.1

Jürgen Ovens

German, 1623–1678

Portrait of a Woman

Oil on canvas, 49³/₈ × 37³/₄ in.
(125.4 × 95.9 cm)
Signed and dated (lower left): J. oūens, f.A.
1650, / ,10 Maij
Marquand Collection, Gift of Henry G.
Marquand, 1889
89.15.28

Bernhard Keil

Danish, 1624–1687

The Lacemaker

Oil on canvas, 28¹/₄ × 38¹/₄ in.
(71.8 × 97.2 cm)
Bequest of Edward Fowles, 1971
1971.115.2

Abraham Mignon

German, 1640–1679

Portrait of a Man, Possibly a Self-portrait

Oil on canvas, 22¹/₄ × 18³/₄ in.
(56.5 × 47.6 cm)
Signed (lower left): AM [monogram]
Mignon, f
Gift of Marcel Aubry, 1968
68.190

Marten van Mytens the Younger

Swedish, 1695–1770

A Huntsman and His Wife

Oil on canvas, 90¹/₈ × 75 in.
(228.9 × 190.5 cm)
Gift of Mr. and Mrs. Nate B. Spingold, 1950
50.50

German Painter

early 18th century

Landscape with Schulenburg Castle

This panel is the inside lid of a harpsichord
said to have been made for George I of
England; the instrument, inscribed with the
name Hermans Willen Brock, is dated 1712.
Oil on wood, 32 × 89¹/₂ in. (81.3 × 227.3 cm)
The Crosby Brown Collection of Musical
Instruments, 1889
89.4.2741
MUSICAL INSTRUMENTS

Johann Georg Lederer

German, active 1734–1757

A Masked Ball in Bohemia

This painting is a sketch for the decoration,
signed and dated 1748, of the Maškarny Sal at
Český Krumlov in southern Bohemia.
Oil on canvas, 19 × 38 in. (48.3 × 96.5 cm)
Bequest of Mariana Griswold Van Rensselaer,
1934
34.83.2

1971.115.2

89.15.28

68.190

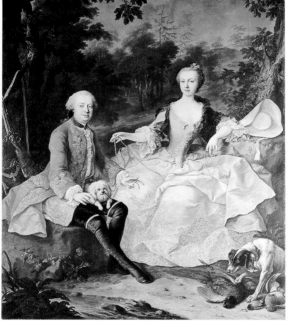

50.50

34.83.2

89.4.2741

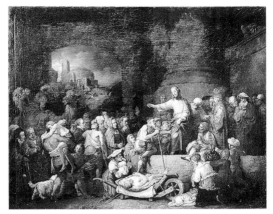

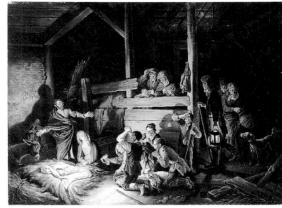

85.9

71.162

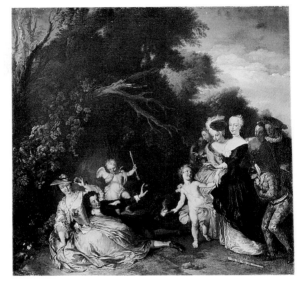

71.142

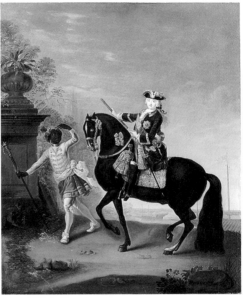

1978.554.2

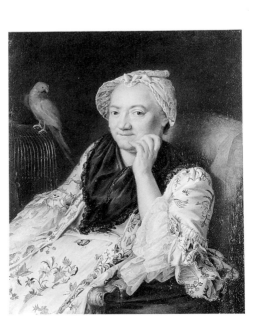

22.174

48.141

Christian Wilhelm Ernst Dietrich
German, 1712–1774

Christ Healing the Sick
Oil on canvas, 35¹/₈ × 41³/₈ in.
(89.2 × 105.1 cm)
Signed and dated (lower right):
Dietricÿ·pinxt·1742
Gift of William H. Webb, 1885
85.9

The Adoration of the Shepherds
Oil on canvas, 21⁵/₈ × 28³/₄ in.
(54.9 × 73 cm)
Signed and dated (lower right): C.W.E.
Dietricy 176[]
Purchase, 1871
71.162

Surprised, or Infidelity Found Out
Oil on canvas, 28³/₄ × 28⁵/₈ in.
(73 × 72.7 cm)
Signed (lower right): Peint Par C.W.E.
Dietrich
Purchase, 1871
71.142

Georg Christoph Grooth
German, 1716–1749

The Empress Elizabeth of Russia (1709–
1762) ***on Horseback, Attended by a Page***
Oil on canvas, 31³/₈ × 24¹/₂ in.
(79.7 × 62.2 cm)
Gift of Mr. and Mrs. Nathaniel Spear Jr.,
1978
1978.554.2

Johann Nikolaus Grooth
German, 1723?–1797

Portrait of a Woman
Oil on canvas, 32 × 25⁵/₈ in.
(81.3 × 65.1 cm)
Gift of Édouard Jonas, 1922
22.174

Anton Raphael Mengs
German, 1728–1779

Johann Joachim Winckelmann (1717–1768)
Oil on canvas, 25 × 19³/₈ in.
(63.5 × 49.2 cm)
Inscribed (on spine of book, in Greek): ILIAD
Harris Brisbane Dick Fund, 1948
48.141

Johann Eleazer Zeissig Schenau

German, 1737–1806

Domestic Scene

Oil on canvas, 18 × 14⁷/₈ in.
(45.7 × 37.8 cm)
Bequest of Edward Fowles, 1971
1971.115.6

Franz Casppar Hofer

German, active 1758

Saint Cecilia

The painting conceals the bellows of a
chamber organ dated 1700 from Castle Stein,
Taunus.
Oil on wood, 24 × 31 in. (61 × 78.7 cm)
Signed, dated, and inscribed (on musical
score): Aria ORGANA / FRANZ. / CASPPAR /
HOFER / InV: et pinx / A: 1758
The Crosby Brown Collection of Musical
Instruments, 1889
89.4.3516
MUSICAL INSTRUMENTS

Henry Fuseli (Johann Heinrich Füssli)

Swiss, 1741–1825

The Night-Hag Visiting Lapland Witches

Oil on canvas, 40 × 49³/₄ in.
(101.6 × 126.4 cm)
Purchase, Bequest of Lillian S. Timken, by
exchange, and Victor Wilbour Memorial, The
Alfred N. Punnett Endowment, Marquand
and Charles B. Curtis Funds, 1980
1980.411

Attributed to Franz Wolfgang Rohrich

German, 1787–1834

*Frederick the Elder, Margrave of
Brandenburg*

This painting and its companion (07.245.2)
are copies, reduced from full to three-quarter
length, of portraits after designs by Hans von
Kulmbach (born about 1480, died 1522) from
the Margrafenfenster of 1515 (church of Saint
Sebald, Nuremberg).
Oil on canvas, 30¹/₄ × 22³/₈ in.
(76.8 × 56.8 cm)
Gift of Laura Wolcott Lowndes, in memory of
her father, Lucius Tuckerman, 1907
07.245.1

Sophia of Poland

Oil on canvas, 30¹/₄ × 22¹/₄ in.
(76.8 × 56.5 cm)
Gift of Laura Wolcott Lowndes, in memory of
her father, Lucius Tuckerman, 1907
07.245.2

1971.115.6

89.4.3516

1980.411

07.245.1

07.245.2

01.21

1978.403

67.187.119

87.15.110

1990.233

87.15.65

Franz Xaver Winterhalter

German, 1805–1873

Florinda
This painting is a replica of one given by
Queen Victoria to Prince Albert in 1852
(British Royal Collection).
Oil on canvas, 70¹/₄ × 96³/₄ in.
(178.4 × 245.7 cm)
Signed (lower right): Fx. Winterhalter
Bequest of William H. Webb, 1899
01.21

The Empress Eugénie (Eugénie de Montijo,
1826–1920, Condesa de Teba)
Oil on canvas, 36¹/₂ × 29 in. (92.7 × 73.7 cm)
Signed, dated, and inscribed (lower right): Fr[?]
Winterhalter Paris 1854
Purchase, Mr. and Mrs. Claus von Bülow
Gift, 1978
1978.403

Countess Maria Ivanovna Lamsdorf
Oil on canvas, 57¹/₄ × 45¹/₄ in.
(145.4 × 114.9 cm)
Signed, dated, and inscribed (lower left):
FrWinterhalter / Paris 1859.
Bequest of Miss Adelaide Milton de Groot
(1876–1967), 1967
67.187.119

Wilhelm von Kaulbach

German, 1805–1874

Crusaders before Jerusalem
Oil on canvas, 61⁵/₈ × 74¹/₂ in.
(156.5 × 189.2 cm)
Signed (lower left): W. Kaulbach
Catharine Lorillard Wolfe Collection, Bequest
of Catharine Lorillard Wolfe, 1887
87.15.110

Christen Købke

Danish, 1810–1848

Valdemar Hjartvar Købke (1813–1893), *the
Artist's Brother*
There is a pendant of the sitter's wife,
Jacobine Feilberg (art market, 1992).
Oil on canvas, 21¹/₈ × 18¹/₄ in. (53.7 × 46.4 cm)
Catharine Lorillard Wolfe Collection, Wolfe
Fund, 1990
1990.233

Johann Georg Meyer

German, 1813–1886

The Letter
Oil on canvas, 25⁵/₈ × 19³/₈ in. (65.1 × 49.2 cm)
Signed, dated, and inscribed (lower right):
Meyer von Bremen / Berlin 1873
Catharine Lorillard Wolfe Collection, Bequest
of Catharine Lorillard Wolfe, 1887
87.15.65

August Friedrich Pecht

German, 1814–1903

Richard Wagner (1813–1883)
Oil on canvas, 51³/₄ × 46¹/₄ in.
(131.4 × 117.5 cm)
Signed and dated (right): Fr. Pecht.p/1865
Gift of Frederick Loeser, 1889
89.8

Julius Schrader

German, 1815–1900

Baron Alexander von Humboldt
(1769–1859)
Oil on canvas, 62¹/₂ × 54³/₈ in.
(158.8 × 138.1 cm)
Signed and dated (lower right): Julius
Schrader. 1859.
Gift of H. O. Havemeyer, 1889
89.20

89.8 89.20

Andreas Achenbach

German, 1815–1910

Sunset after a Storm on the Coast of Sicily
Oil on canvas, 32³/₄ × 42¹/₄ in.
(83.2 × 107.3 cm)
Signed and dated (lower right): A. Achenbach
/ 1853
Catharine Lorillard Wolfe Collection, Bequest
of Catharine Lorillard Wolfe, 1887
87.15.23

Carl Georg Anton Graeb

German, 1816–1884

Interior of the Cathedral of Freiburg
Oil on canvas, 31³/₄ × 41 in.
(80.6 × 104.1 cm)
Signed, dated, and inscribed: (lower right)
Carl Graeb. / Berlin. 1874; (on plaques set
into church walls) memorial inscriptions
Catharine Lorillard Wolfe Collection, Bequest
of Catharine Lorillard Wolfe, 1887
87.15.33

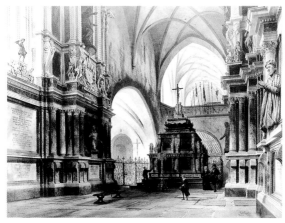

87.15.23 87.15.33

Arthur Georg von Ramberg

Austrian, 1819–1875

The Meeting on the Lake
Oil on canvas, 45¹/₂ × 36¹/₂ in.
(115.6 × 92.7 cm)
Signed and dated (lower left): Ramberg / 1869
Catharine Lorillard Wolfe Collection, Bequest
of Catharine Lorillard Wolfe, 1887
87.15.132

23.103.3

August Xaver Karl von Pettenkofen

Austrian, 1821–1889

Market Scene
Oil on wood, 4 × 8¹/₂ in. (10.2 × 21.6 cm)
Signed (lower left): a.p.
The John Hobart Warren Bequest, 1923
23.103.3

87.15.132

26.90

26.100

87.2

87.15.105

87.15.61

Arnold Böcklin

Swiss, 1827–1901

Island of the Dead

This painting, the first of five versions, was commissioned in the spring of 1880. The four others were painted later in 1880 (Kunstmuseum, Basel), and in 1883 (Nationalgalerie, SMPK, Berlin), 1884 (location unknown), and 1886 (Museum der bildenden Künste, Leipzig).
Oil on wood, 29 × 48 in. (73.7 × 121.9 cm)
Signed (lower right, on rock): A B
Reisinger Fund, 1926
26.90

Attributed to Arnold Böcklin

Roman Landscape

Oil on canvas, several pieces joined, 12¹/₂ × 18¹/₈ in. (31.8 × 46 cm)
Gift of Fearon Galleries Inc., 1926
26.100

Karl Theodor von Piloty

German, 1826–1886

Thusnelda at the Triumphal Entry of Germanicus into Rome

Oil on canvas, 53 × 77¹/₄ in. (134.6 × 196.2 cm)
Signed and inscribed (lower right): Carl Piloty / München
Gift of Horace Russell, 1887
87.2

Oswald Achenbach

German, 1827–1905

Near Naples, Moonrise

Oil on canvas, 39⁷/₈ × 56³/₄ in. (101.3 × 144.1 cm)
Signed (lower right): Osw. Achenbach
Catharine Lorillard Wolfe Collection, Bequest of Catharine Lorillard Wolfe, 1887
87.15.105

August Friedrich Albrecht Schenck

Danish, 1828–1901

Lost: Souvenir of Auvergne

Oil on canvas, 58 × 97³/₄ in. (147.3 × 248.3 cm)
Signed (lower left): Schenck.
Catharine Lorillard Wolfe Collection, Bequest of Catharine Lorillard Wolfe, 1887
87.15.61

Adolf Schreyer

German, 1828–1899

Arabs on the March

Oil on canvas, 22⁵/₈ × 37³/₄ in.
(57.5 × 95.9 cm)
Signed (bottom left): Ad. Schreyer
Catharine Lorillard Wolfe Collection, Bequest
of Catharine Lorillard Wolfe, 1887
87.15.127

Battle Scene: Arabs Making a Detour

Oil on canvas, 59³/₈ × 99¹/₂ in.
(150.8 × 252.7 cm)
Signed (lower right): ad. Schreyer
Gift of John Wolfe, 1893
94.24.2

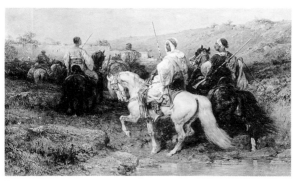

87.15.127

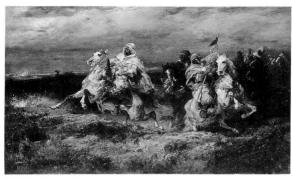

94.24.2

H. Hamm

German, active 1848

Jacob Wiedenman (1829–1893)
Oil on canvas, 18⁷/₈ × 14⁷/₈ in.
(47.9 × 37.8 cm)
Signed, dated, and inscribed (lower right):
H. Hamm / München / 1848 / Juli
Gift of Marguerite Wiedenman, 1946
46.104.1

Ferdinand Schauss

German, 1832–1916

Resignation

Oil on canvas, 29¹/₄ × 24 in.
(74.3 × 61 cm)
Signed (lower left): F. Schauss
Gift of William Schaus Jr., in memory of
Catharine Dennice Schaus, 1887
87.22.1

46.104.1

87.22.1

Ludwig Knaus

German, 1829–1910

Charity

Oil on wood, 33¹/₄ × 47¹/₂ in.
(84.5 × 120.7 cm)
Signed and dated (lower left): L. Knaus. 1887.
Bequest of Collis P. Huntington, 1900
25.110.68

Anton Dieffenbach

German, 1831–1904

The Two Savoyards

Oil on canvas, 17¹/₂ × 14³/₈ in.
(44.5 × 36.5 cm)
Signed (lower right): Anton Dieffenbach
Gift of Elsa A. Stiefel, 1964
64.151

25.110.68

64.151

25.110.46

39.65.4

87.15.99

09.48

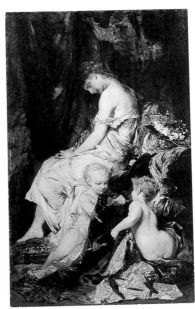

87.15.133

87.15.58

Franz von Lenbach

German, 1836–1904

Marion Lenbach, the Artist's Daughter
Oil on canvas, 58⁷/₈ × 41¹/₂ in.
(149.5 × 105.4 cm)
Signed and dated (lower right): Lenbach 1900.
Bequest of Collis P. Huntington, 1900
25.110.46

Prince Regent Luitpold of Bavaria
(1821–1912)
This painting is a late replica of the portrait
in the Lenbachhaus, Munich.
Oil on board, 30 × 24¹/₄ in. (76.2 × 61.5 cm)
Signed and dated (lower left): fLenbach
[initials in monogram] / 1902
Bequest of Jacob Ruppert, 1939
39.65.4

Alfred Wahlberg

Swedish, 1834–1906

A Day in October, near Waxholm, Sweden
Oil on canvas, 41 × 64¹/₂ in. (104.1 × 163.8 cm)
Signed and dated (lower left): Alfr. Wahlberg 73
Catharine Lorillard Wolfe Collection, Bequest
of Catharine Lorillard Wolfe, 1887
87.15.99

Hans Thoma

German, 1839–1924

At Lake Garda
Oil on millboard, 33 × 26³/₄ in.
(83.8 × 67.9 cm)
Signed and dated (lower right): HTh
[monogram] / 1907
Gift of Hugo Reisinger, 1909
09.48

Hans Makart

Austrian, 1840–1884

The Dream after the Ball
Oil on canvas, 62³/₈ × 37¹/₄ in.
(158.4 × 94.6 cm)
Signed (lower right): Hans Makart
Catharine Lorillard Wolfe Collection, Bequest
of Catharine Lorillard Wolfe, 1887
87.15.133

Gabriel Max

Austrian, 1840–1915

The Last Token: A Christian Martyr
Oil on canvas, 67¹/₂ × 47 in.
(171.5 × 119.4 cm)
Signed and inscribed: (lower right) Gab.
MAX; (lower center) Ein Grüs[s] (a salute)
Catharine Lorillard Wolfe Collection, Bequest
of Catharine Lorillard Wolfe, 1887
87.15.58

Mihály de Munkácsy

Hungarian, 1844–1900

The Music Room

Oil on wood, 35 × 46 in. (88.9 × 116.8 cm)
Signed (lower right): Munkacsy
Bequest of Martha T. Fiske Collord, in
memory of her first husband, Josiah M. Fiske,
1908
08.136.11

08.136.11

16.148.1

Wilhelm Leibl

German, 1844–1900

Peasant Girl with a White Headcloth

Oil on canvas, 9⁷/₈ × 9¹/₈ in.
(25.1 × 23.2 cm)
Signed and dated (right center): W. Leibl /
1885
Reisinger Fund, 1916
16.148.1

Gyula Benczúr

Hungarian, 1844–1920

Project for a Room for King Ludwig II
(1854–1886) of Bavaria

Oil on canvas, 30³/₄ × 39¹/₂ in.
(78.1 × 100.3 cm)
Signed (bottom left): Benczúr.
Gift of Frederick Loeser, 1890
90.30

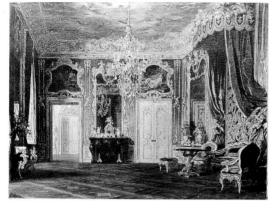

90.30

25.110.40

Hermann Kaulbach

German, 1846–1909

Baby Holding Yarn

Oil on wood, 12 × 17³/₄ in.
(30.5 × 45.1 cm)
Signed (upper right): H. Kaulbach.
Bequest of Collis P. Huntington, 1900
25.110.40

Friedrich Karl Hermann von Uhde

German, 1848–1911

Going Home

Oil on wood, 30⁷/₈ × 39¹/₄ in.
(78.4 × 99.7 cm)
Signed (lower left): F Uhde
Mr. and Mrs. Isaac D. Fletcher Collection,
Bequest of Isaac D. Fletcher, 1917
17.120.203

17.120.203

16.16

Hugo von Habermann

German, 1849–1929

In the Studio

Oil on canvas, 39⁵/₈ × 37³/₄ in.
(100.6 × 95.9 cm)
Signed, dated, and inscribed: (lower right)
Habermann / 1885; (verso) H Habermann
fecit
Reisinger Fund, 1916
16.16

16.148.2

16.148.3

1975.280.9

16.15

20.33

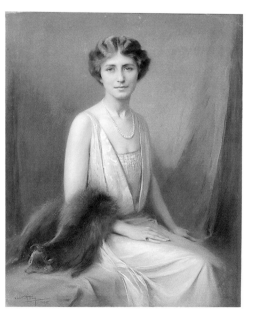

1974.356.37

Max Liebermann
German, 1849–1935
The Ropewalk in Edam
Oil on canvas, 39³/₄ × 28 in. (101 × 71.1 cm)
Signed and dated (lower left): M Liebermann 1904.
Reisinger Fund, 1916
16.148.2

Friedrich August von Kaulbach
German, 1850–1920
Italian Garden
Oil on canvas, 19³/₈ × 25³/₈ in. (49.2 × 64.5 cm)
Signed and dated (lower right): FAK
[monogram] / April 1894
Reisinger Fund, 1916
16.148.3

Fritz Steinmetz-Noris
German, born 1860
Nude on a Sofa
Oil on wood, 3¹/₄ × 7¹/₈ in. (8.3 × 18.1 cm)
Bequest of Mary Jane Dastich, in memory of
her husband, General Frank Dastich, 1975
1975.280.9

Wilhelm Trübner
German, 1851–1917
Landscape
Oil on canvas, 29⁷/₈ × 24¹/₄ in. (75.9 × 61.5 cm)
Signed and dated (lower right): W.Trübner:
1910.
Reisinger Fund, 1916
16.15

Alphonse Marie Mucha
Czechoslovakian, 1860–1939
Maude Adams (1872–1953) *as Joan of Arc*
This painting—a poster design—announced
Adams's performance in Schiller's *Maid of
Orleans* at Harvard University on June 21, 1909.
Oil on canvas, 82¹/₄ × 30 in.
(208.9 × 76.2 cm)
Signed, dated, and inscribed: (lower left)
Mucha / 1909; (bottom) MAUDE ADAMS AS
JOAN OF ARC
Gift of A. J. Kobler, 1920
20.33

Hoëy (?)
active 1925
Emma Alexander Sheafer (1891–1973)
Pastel on canvas, 44³/₈ × 34³/₈ in.
(112.7 × 87.3 cm)
Signed and dated (lower left): Hoëy[?] / 1925
The Lesley and Emma Sheafer Collection,
Bequest of Emma A. Sheafer, 1973
1974.356.37

Anders Leonard Zorn
Swedish, 1860–1920

Mrs. Walter Rathbone Bacon
(Virginia Purdy, died 1919)
Oil on canvas, 67¼ × 42½ in.
(170.8 × 108 cm)
Signed and dated (lower right): Zorn / 1897
Gift of Mrs. Walter Rathbone Bacon, in
memory of her husband, 1917
17.204

Edward R. Bacon (1846–1915)
Oil on canvas, 48¼ × 35¼ in.
(122.6 × 89.5 cm)
Signed and dated (lower right): Zorn 1897
Bequest of Virginia Purdy Bacon, 1919
19.112

Frieda Schiff (1876–1958), ***Later Mrs. Felix
M. Warburg***
Oil on canvas, 39¾ × 30 in.
(101 × 76.2 cm)
Signed and dated (lower left): Zorn / 94
Bequest of Carola Warburg Rothschild, 1987
1988.72

Mrs. John Crosby Brown (Mary Elizabeth
Adams, 1842–1918)
Mrs. Brown's musical instruments, given in
her husband's name in 1889, comprise the
nucleus of the Metropolitan Museum's
collection.
Oil on canvas, 29 × 23¾ in.
(73.7 × 60.3 cm)
Signed (lower right): Zorn
Bequest of Eliza Coe Moore, 1959
60.85

Gustav Klimt
Austrian, 1862–1918

Serena Lederer (died 1943)
Oil on canvas, 75⅛ × 33⅝ in.
(190.8 × 85.4 cm)
Signed (lower right): GVS.TAV / KLIMT·
Purchase, Wolfe Fund, and Rogers and
Munsey Funds, Gift of Henry Walters, and
Bequests of Catharine Lorillard Wolfe and
Collis P. Huntington, by exchange, 1980
1980.412

Mäda Primavesi (born 1903)
Oil on canvas, 59 × 43½ in.
(149.9 × 110.5 cm)
Signed (lower right): GVSTAV / KLIMT
Gift of André and Clara Mertens, in memory
of her mother, Jenny Pulitzer Steiner, 1964
64.148

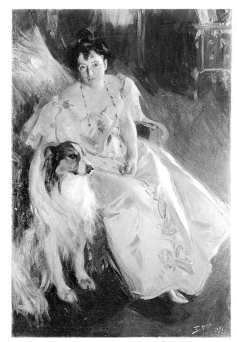

17.204

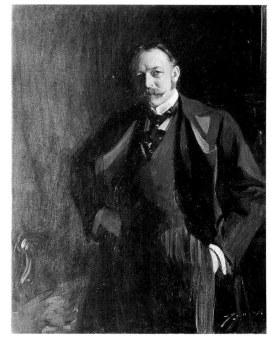

19.112

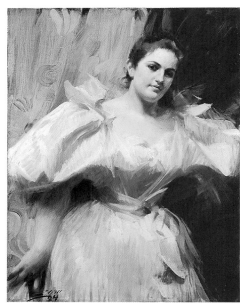

1988.72

60.85

1980.412

64.148

Robert Campin

Netherlandish, active by 1406, died 1444

The Annunciation (triptych)
Central panel: Annunciation; left wing:
kneeling donors; right wing: Joseph in his
workshop
Oil on wood; central panel 25¼ × 24⅞ in.
(64.1 × 63.2 cm); each wing
25⅜ × 10¾ in. (64.5 × 27.3 cm)
Arms (central panel, left window) probably of
the Ingelbrechts family of Mechelen (Malines)
and of Spain; (central panel, right window)
possibly of the Calcum (Lohausen) family of
Germany; (left wing, on messenger's badge)
possibly of the lords of Berthout (members of
the Merode family) or of the city of Mechelen
The Cloisters Collection, 1956
56.70
THE CLOISTERS

56.70

Jan van Eyck

Netherlandish, active by 1422, died 1441

The Crucifixion; The Last Judgment
Oil on canvas, transferred from wood; each
22¼ × 7¾ in. (56.5 × 19.7 cm)
Inscribed: (on cross, in Hebrew, Greek, and
Latin) IHC·NAZAR[ENVS]·REX·IVDE[ORVM];
(twice, below Christ's hands) Venite
benedi[c]ti p[at]ris mei (Come, ye blessed of
my Father [Matthew 25:34].); (on Saint
Michael's shield and armor) [illegible]; (twice,
below Saint Michael's wings) . . . vos
maledi[ct]ī i[n] ignem [aeternum?] (. . . ye
cursed, into everlasting fire [Matthew 25:41].);
(on Death's wings) CHAOS MAGNV[M] / VMBRA
MORTIS (great chaos / shadow of death)
Inscribed (on the original gilt frames) with
verses from Isaiah (53:6–9, 12), Revelation
(20:13 and 21:3–4), and Deuteronomy (32:23–
24)
Fletcher Fund, 1933
33.92ab

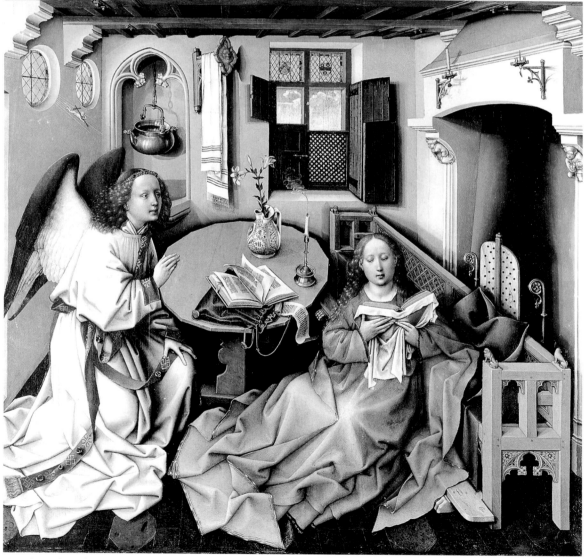

56.70 (central panel)

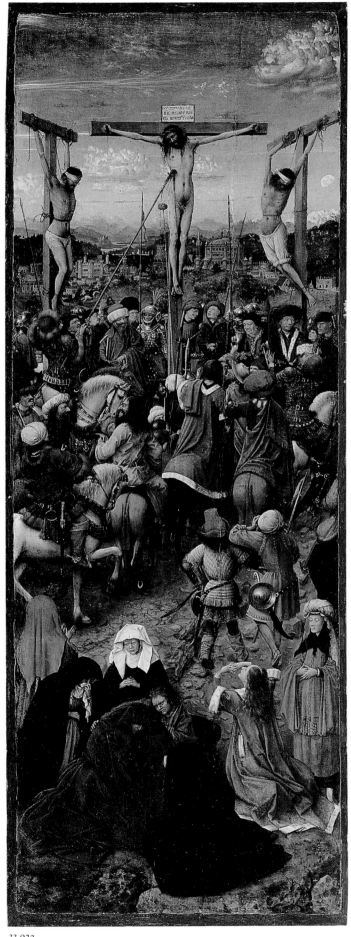

33.92a

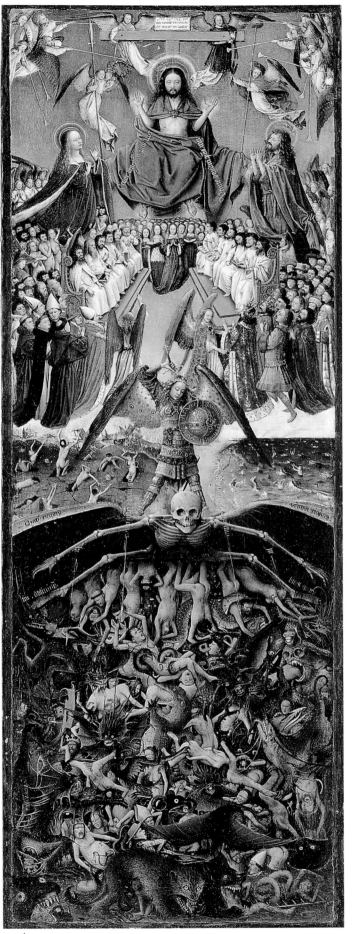

33.92b

Attributed to Robert Campin
Netherlandish, active by 1406, died 1444

Man in Prayer
Oil on wood; overall 12¹/₂ × 9¹/₈ in.
(31.8 × 23.2 cm); painted surface
12³/₈ × 9 in. (31.4 × 22.9 cm)
Bequest of Mary Stillman Harkness, 1950
50.145.35

Workshop of Robert Campin

Virgin and Child in an Apse
Oil on wood, transferred from wood,
17³/₄ × 13¹/₂ in. (45.1 × 34.3 cm)
Rogers Fund, 1905
05.39.2

Style of Jan van Eyck
Netherlandish, second quarter 15th century

A Donor Presented by a Saint (fragment)
Oil on wood, 8³/₄ × 7 in. (22.2 × 17.8 cm)
The Friedsam Collection, Bequest of Michael
Friedsam, 1931
32.100.41

Netherlandish, about 1500

Virgin and Child
Oil on wood, 23 × 12¹/₈ in.
(58.4 × 30.8 cm)
Inscribed: (on canopy) DOMVS.DEI.EST.ET.
PORTA.C[O]ELI ([This is none other but] the
house of God and [this is] the gate of heaven
[Genesis 28:17].); (on step) IPSA EST [MVLIER]
QVAM PR[A]EPARAVIT DOM[INV]S̄ FILIO
D[OMI]NI MEI (Let the same be [the woman]
whom the Lord hath appointed out for my
master's son [Genesis 24:44].)
Marquand Collection, Gift of Henry G.
Marquand, 1889
89.15.24

Attributed to Rogier van der Weyden
Netherlandish, 1399/1400–1464

Portrait of a Man in a Turban
Oil on wood; overall 11 × 7³/₄ in.
(27.9 × 19.7 cm); painted surface
10⁵/₈ × 7¹/₄ in. (27 × 18.4 cm)
The Jules Bache Collection, 1949
49.7.24

Rogier van der Weyden
Netherlandish, 1399/1400–1464

Francesco d'Este (born about 1430, died after
1475)
Oil on wood; overall 12¹/₂ × 8³/₄ in.
(31.8 × 22.2 cm); painted surface, each side
11³/₄ × 8 in. (29.8 × 20.3 cm)
Inscribed (verso): v[oi]r̄e tout (see all) /
m[archio] e[stensis] (marquis of Este) [twice]
/ francisque (Francesco)
Incised (verso, upper left, at slightly later

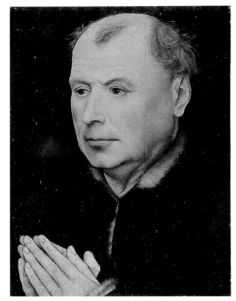

50.145.35

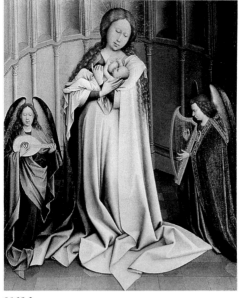

05.39.2

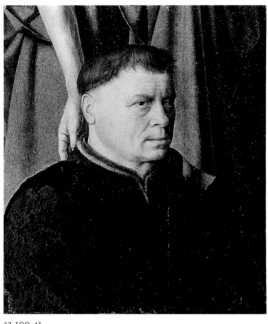

32.100.41

89.15.24

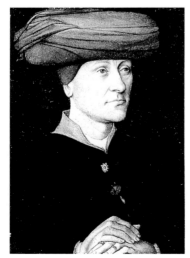

49.7.24

32.100.43 (verso)

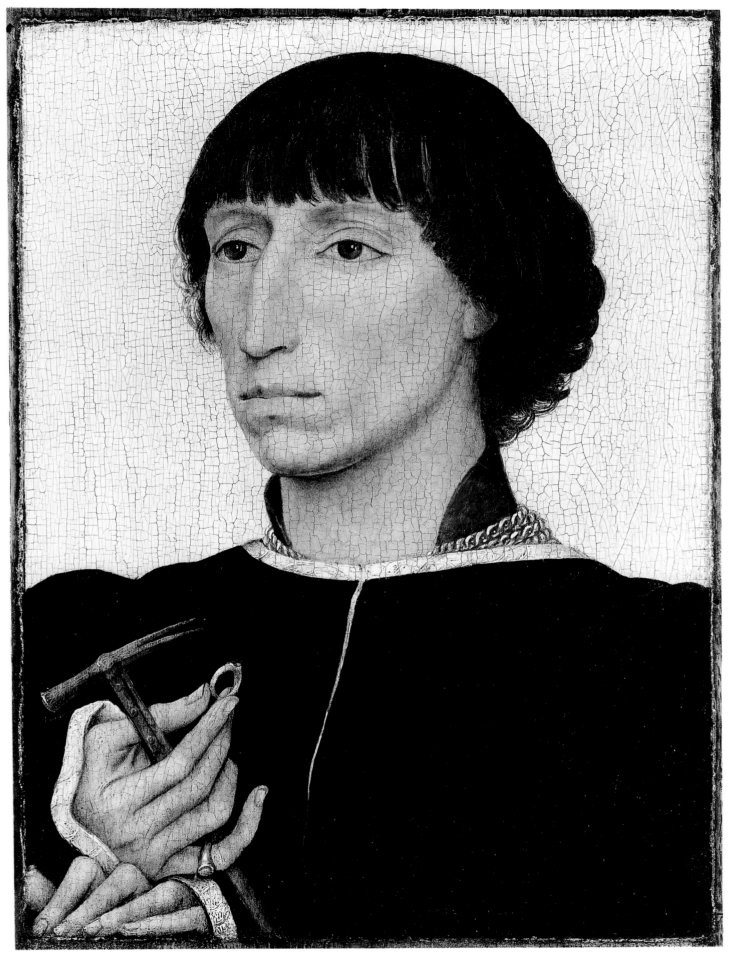

32.100.43 (recto)

date): non plus / courcelles [referring possibly
to the village of Corcelles, near the Grandson
battlefield, where the sitter may conceivably
have died in 1476]
Arms and crest (verso) of the Este family,
quartered with the augmentation of honor
bestowed on the house of Este in 1432 by
Charles VII of France
The Friedsam Collection, Bequest of Michael
Friedsam, 1931
32.100.43

Workshop of Rogier van der Weyden

The Nativity (incomplete altarpiece)
Central panel: Annunciation to Augustus,
Nativity, and Annunciation to the Magi and
(above) God the Father with Angels; lower left
wing: Visitation (interior) and Saint John the
Baptist (exterior); lower right wing: Adoration
of the Magi (interior) and Saint Catherine of
Alexandria (exterior); upper wings: angels
(interior) and Expulsion of Adam and Eve
(exterior)
Oil on wood; central panel 55¹⁄₈ × 76¹⁄₈ in.
(140 × 193.4 cm); each upper wing
17⁷⁄₈ × 7⁷⁄₈ in. (45.4 × 20 cm); each lower
wing 33⁵⁄₈ × 16⁵⁄₈ in. (85.4 × 42.2 cm)
Inscribed: (on banderole of Tiburtine sibyl)
Con Contritum . . . (with contrition . . .);
(on banderole of Virgin and Child) . . .
dixerit vobis . . . (. . . will have said to you
. . .)
The Cloisters Collection, 1949
49.109
THE CLOISTERS

Follower of Rogier van der Weyden

Netherlandish, second half 15th century

The Mystic Mass of Saint Gregory
The panels form a triptych, with Saint
Michael Weighing Souls at left and Saint
Jerome at right.
Oil on wood; central panel 6¹⁄₈ × 3³⁄₄ in.
(15.6 × 9.5 cm); left panel 6¹⁄₄ × 3⁷⁄₈ in.
(15.9 × 9.8 cm); right panel 6¹⁄₄ × 3³⁄₄ in.
(15.9 × 9.5 cm)
Bequest of William H. Herriman, 1920
21.134.3a–c

Style of Rogier van der Weyden

Netherlandish, mid-15th century

***The Holy Family with Saint Paul and a
Donor***
Oil on wood; overall, with added strip,
22⁵⁄₈ × 19 in. (57.5 × 48.3 cm); painted
surface 22 × 18¹⁄₈ in. (55.9 × 46 cm)
The Friedsam Collection, Bequest of Michael
Friedsam, 1931
32.100.44

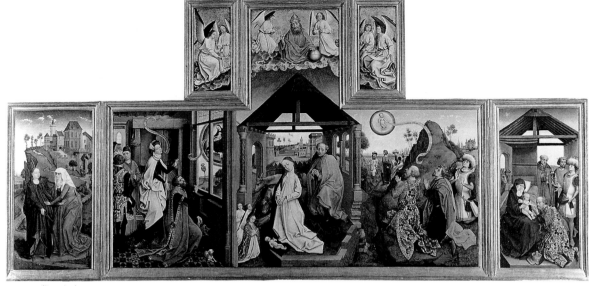

49.109 (interior)

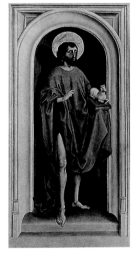

49.109 (exterior)

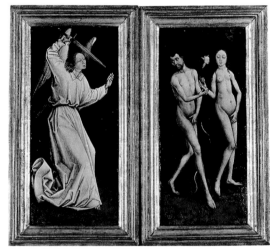

49.109 (exterior) 49.109 (exterior)

49.109 (exterior)

21.134.3a–c

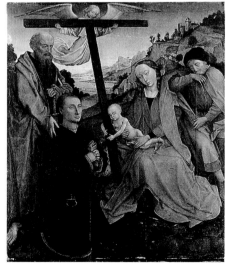

32.100.44

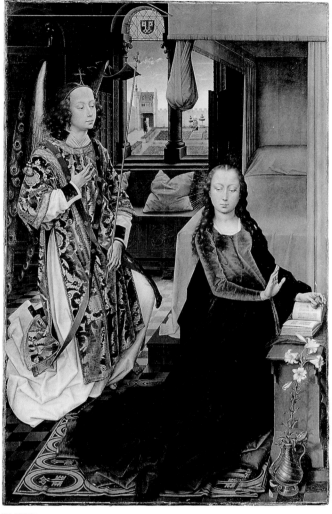

17.190.7

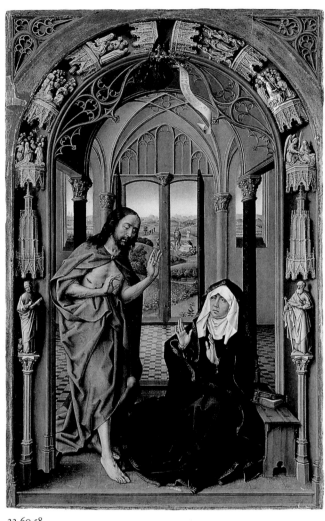

22.60.58

Follower of Rogier van der Weyden
Netherlandish, second half 15th century

The Annunciation
Oil on wood, 73¹/₄ × 45¹/₄ in.
(186.1 × 114.9 cm)
Arms (on window and in pattern of rug) of
the Clugny family
Gift of J. Pierpont Morgan, 1917
17.190.7

Copy after Rogier van der Weyden
Netherlandish, late 15th century

Christ Appearing to His Mother
With the Holy Family and the Lamentation
(both Capilla Real, Granada), this panel
formed a triptych that belonged to Isabella I
of Castile (Spain) at her death in 1504. The
works are copies of the panels of Rogier's
triptych (Gemäldegalerie, SMPK, Berlin) from
the charterhouse of Miraflores near Burgos.
Oil on wood; overall 25 × 15 in.
(63.5 × 38.1 cm); painted surface
24¹/₂ × 14⁵/₈ in. (62.2 × 37.1 cm)
Inscribed: (on scroll held by angel) mulier
h[a]ec pleuerauit vi[n]cens o[mn]ia ideo /
data ē[st] ei corona: ex apoc.vi°.i°. (This
woman fulfilled all things triumphantly;

therefore a crown was given unto her
[Apocalypse 6:1].); (on border of Virgin's
cloak) MANGNIF[I]CAT A[NIMA MEA]
DOMIN[UM] ET ET EXA[LT]AVIT [SPIRITUS]
ME[US IN DEO SALUTARI MEO QUI]A RESPEXIT
HUMILITATEMANCIL[A]E [SUAE] ECCE ENIM [EX
HOC] BEATEM ME [DICENT] . . . AB[?] . . .
POTENSESTE[T SANCTUM NOMINE EIUS] ([My
soul] doth magnify the Lord, and my [spirit]
hath rejoiced [in God my Savior. For he hath]
regarded the low estate of [his] handmaiden:
for, behold, [from henceforth] . . . [shall call]
me blessed . . . that is mighty . . . and [holy
is his name] [Luke 1:46–49].)
The Bequest of Michael Dreicer, 1921
22.60.58

Petrus Christus

Netherlandish, active by 1444, died 1475/76

Head of Christ

Oil on parchment, laid down on wood; overall 5⁷/₈ × 4¹/₄ in. (14.9 × 10.8 cm); parchment 5³/₄ × 4¹/₈ in. (14.6 × 10.5 cm) Inscribed (bottom, on simulated frame); this inscription has been read as "Petrus Christus," but it does not resemble the artist's usual signature.
Bequest of Lillian S. Timken, 1959
60.71.1

Portrait of a Carthusian

Oil on wood; overall 11¹/₂ × 8¹/₂ in. (29.2 × 21.6 cm); painted surface 11¹/₂ × 7³/₈ in. (29.2 × 18.7 cm) Signed and dated (bottom, on simulated frame): ·PETRVS·XPĪ·ME·FECIT·Aᵒ·1446· (Petrus Christus made me in the year 1446)
The Jules Bache Collection, 1949
49.7.19

Saint Eligius

Oil on wood, 39 × 33¹/₂ in. (99.1 × 85.1 cm) Signed and dated (bottom): m petr[vs] xpī me· ·fecit·aᵒ 1449. (Master Petrus Christus made me in the year 1449) [with the artist's emblem, which resembles a clock escapement combined with a heart]
Robert Lehman Collection, 1975
1975.1.110
ROBERT LEHMAN COLLECTION

The Lamentation

Oil on wood; overall 10¹/₈ × 14 in. (25.7 × 35.6 cm); painted surface 10 × 13³/₄ in. (25.4 × 34.9 cm)
Marquand Collection, Gift of Henry G. Marquand, 1890
91.26.12

Attributed to Petrus Christus

The Annunciation

Oil on wood; overall 31 × 25⁷/₈ in. (78.7 × 65.7 cm); painted surface 30¹/₂ × 25¹/₄ in. (77.5 × 64.1 cm) Inscribed (on step): REGINA C[O]ELI L[A]ET[ARE] (Queen of Heaven, rejoice [Easter antiphon of the Virgin].)
The Friedsam Collection, Bequest of Michael Friedsam, 1931
32.100.35

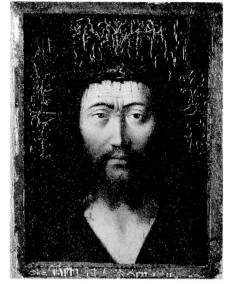

60.71.1

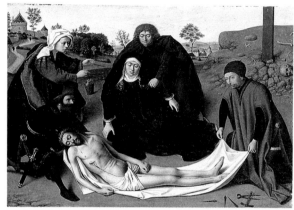

49.7.19

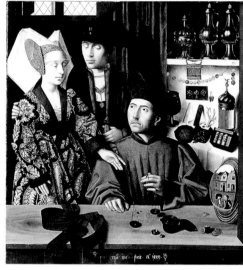

1975.1.110

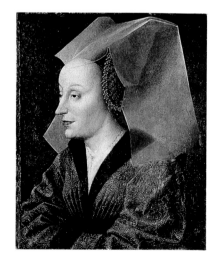

91.26.12

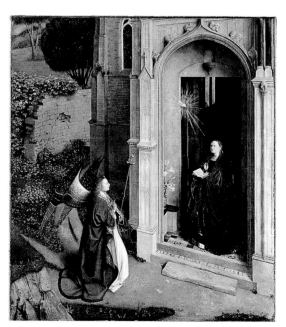

32.100.35

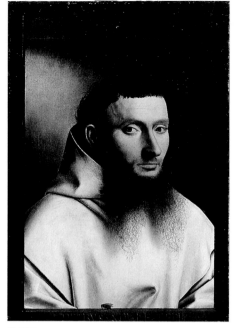

50.145.15

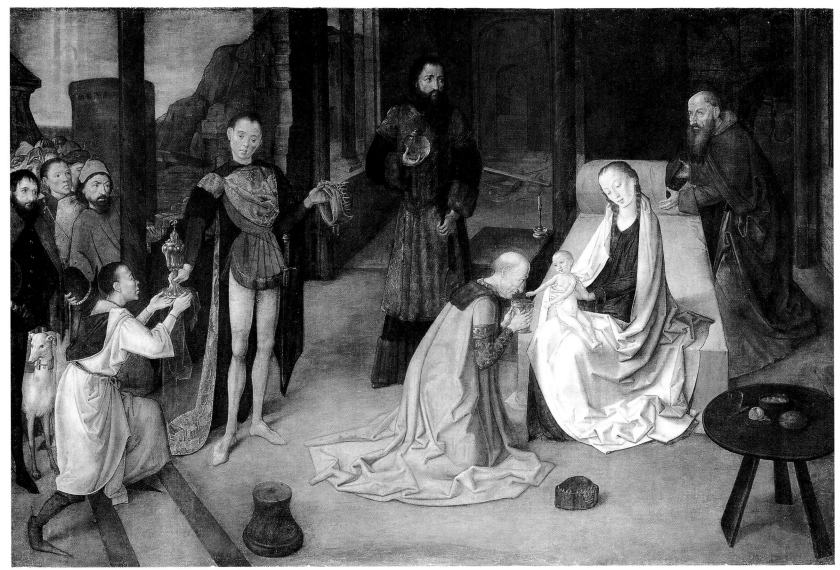

41.190.21

Netherlandish Painter
mid-15th century
Portrait of a Noblewoman, Probably
Isabella of Portugal (1397–1472)
Oil on wood; overall 13⁵/8 × 10⁵/8 in.
(34.6 × 27 cm), with added strips of ¹/8 in.
(0.3 cm) at each side
Bequest of Mary Stillman Harkness, 1950
50.145.15

Justus of Ghent (Joos van
Wassenhove)
Netherlandish, active by 1460, died about
1480
The Adoration of the Magi
Distemper on canvas, 43 × 63 in.
(109.2 × 160 cm)
Bequest of George Blumenthal, 1941
41.190.21

Attributed to Aelbert van Ouwater

Netherlandish, active mid-15th century

Head of a Donor (fragment)

Oil on wood, 3⁷/₈ × 3¹/₂ in. (9.8 × 8.9 cm)

Gift of J. Pierpont Morgan, 1917

17.190.22

Dieric Bouts

Netherlandish, active by 1457, died 1475

Virgin and Child

Oil on wood, 8¹/₂ × 6¹/₂ in.

(21.6 × 16.5 cm)

Theodore M. Davis Collection, Bequest of

Theodore M. Davis, 1915

30.95.280

Portrait of a Man

This painting is a fragment, and the hands

are a later addition.

Oil on wood; overall 12 × 8¹/₂ in.

(30.5 × 21.6 cm); painted surface

11⁵/₈ × 8¹/₈ in. (29.5 × 20.6 cm)

Bequest of Benjamin Altman, 1913

14.40.644

Workshop of Dieric Bouts

Virgin and Child

Oil on wood, 11¹/₂ × 8¹/₄ in. (29.2 × 21 cm)

The Jules Bache Collection, 1949

49.7.18

Virgin and Child

Oil on wood; overall 11¹/₂ × 8¹/₄ in.

(29.2 × 21 cm); painted surface

11¹/₄ × 7³/₄ in. (28.6 × 19.7 cm)

The Jack and Belle Linsky Collection, 1982

1982.60.16

Follower of Dieric Bouts

Netherlandish or German, second half 15th

century

Virgin and Child

Oil on wood, 15⁵/₈ × 12¹/₈ in.

(39.7 × 30.8 cm)

Purchase, Joseph Pulitzer Bequest, 1922

22.96

17.190.22

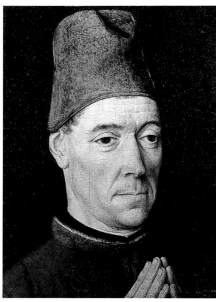

14.40.644

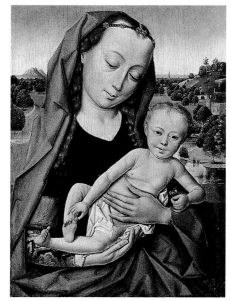

1982.60.16

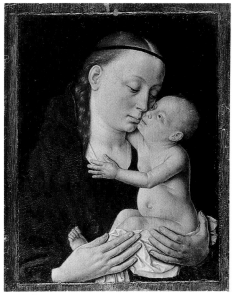

30.95.280

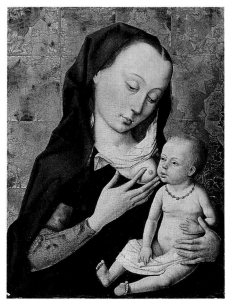

49.7.18

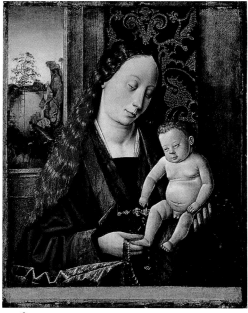

22.96

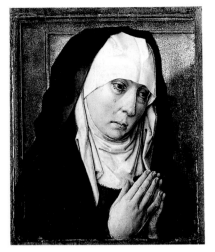

71.157

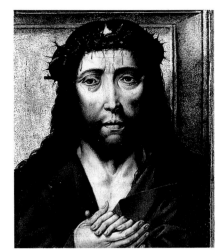

71.156

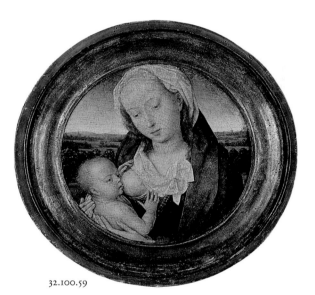

32.100.59

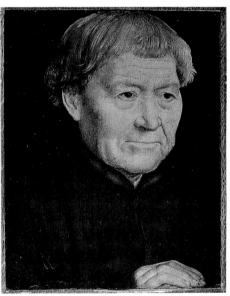

14.40.648

Copy after Dieric Bouts
Netherlandish, 16th century
The Mourning Virgin; The Man of Sorrows
Oil on wood, each 16 × 12¹/₂ in.
(40.6 × 31.8 cm)
Purchase, 1871
71.156–157

Hans Memling
Netherlandish, active about 1465, died 1494
Virgin and Child
Oil on wood; overall, with engaged frame,
diameter 9³/₄ in. (24.8 cm); painted surface
diameter 6⁷/₈ in. (17.5 cm)
The Friedsam Collection, Bequest of Michael
Friedsam, 1931
32.100.59

Portrait of an Old Man
Oil on wood; overall 10³/₈ × 7⁵/₈ in.
(26.4 × 19.4 cm); painted surface
10 × 7¹/₄ in. (25.4 × 18.4 cm)
Bequest of Benjamin Altman, 1913
14.40.648

Portrait of a Young Man
Oil on wood, 15¹/₄ × 11¹/₈ in.
(38.7 × 28.3 cm)
Robert Lehman Collection, 1975
1975.1.112
ROBERT LEHMAN COLLECTION

Mystic Marriage of Saint Catherine
Oil on wood; overall 26⁷/₈ × 28⁷/₈ in.
(68.3 × 73.3 cm); painted surface
26³/₈ × 28³/₈ in. (67 × 72.1 cm)
Bequest of Benjamin Altman, 1913
14.40.634

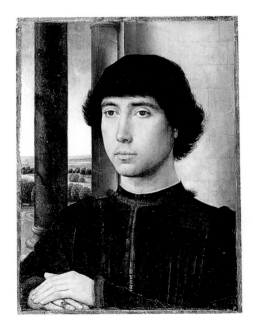

1975.1.112

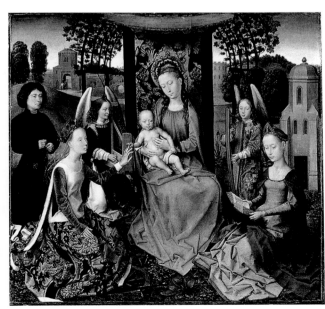

14.40.634

Hans Memling

Netherlandish, active about 1465, died 1494

Tommaso Portinari (born about 1432, died 1501)
Oil on wood; overall 17³/₈ × 13¹/₄ in. (44.1 × 33.7 cm); painted surface 16⁵/₈ × 12¹/₂ in. (42.2 × 31.8 cm)
Bequest of Benjamin Altman, 1913
14.40.626

The Annunciation
Oil on canvas, transferred from wood, 31 × 21⁵/₈ in. (78.7 × 54.9 cm)
Robert Lehman Collection, 1975
1975.1.113
ROBERT LEHMAN COLLECTION

Virgin and Child
Oil on wood, 12¹/₂ × 8 in. (31.8 × 20.3 cm)
Robert Lehman Collection, 1975
1975.1.111
ROBERT LEHMAN COLLECTION

Attributed to Hans Memling

Portrait of a Young Woman
Oil on wood; overall 10¹/₄ × 8¹/₄ in. (26 × 21 cm); painted surface 9¹/₈ × 7¹/₄ in. (23.2 × 18.4 cm)
Bequest of Mary Stillman Harkness, 1950
50.145.28

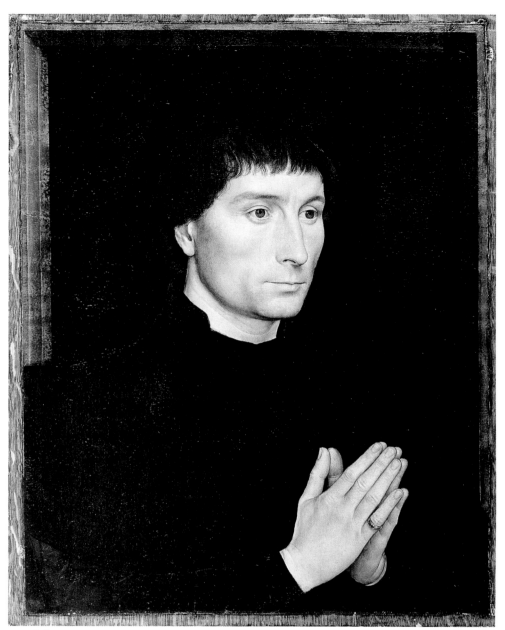

14.40.626

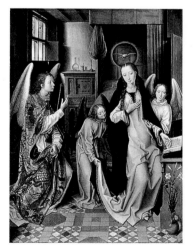

1975.1.113

1975.1.111

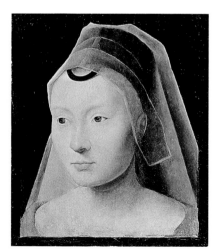

50.145.28

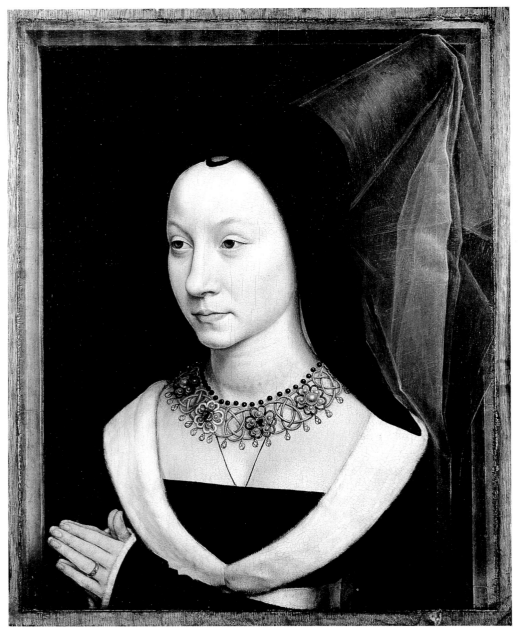

14.40.627

Hans Memling
Netherlandish, active about 1465, died 1494
Maria Maddalena Baroncelli (born 1456),
Wife of Tommaso Portinari
Pendant to 14.40.626
Oil on wood; overall 17³/₈ × 13³/₈ in.
(44.1 × 34 cm); painted surface
16⁵/₈ × 12⁵/₈ in. (42.2 × 32.1 cm)
Bequest of Benjamin Altman, 1913
14.40.627

Attributed to Hans Memling
about 1480
Young Woman with a Pink
This painting and Two Horses in a Landscape
(Museum Boymans-van Beuningen,
Rotterdam) formed a diptych or were both
parts of the same, larger complex.
Oil on wood; overall 17 × 7³/₈ in.
(43.2 × 18.7 cm); painted surface
17 × 6⁷/₈ in. (43.2 × 17.5 cm)
The Jules Bache Collection, 1949
49.7.23

Workshop of Hans Memling
Salvator Mundi
Oil on wood; overall, with engaged frame,
diameter 10³/₄ in. (27.3 cm); painted surface
diameter 8 in. (20.3 cm)
The Friedsam Collection, Bequest of Michael
Friedsam, 1931
32.100.54

Virgin and Child
Oil on wood; overall 10³/₄ × 8¹/₄ in.
(27.3 × 21 cm); painted surface 9 × 6⁵/₈ in.
(22.9 × 16.8 cm)
The Jules Bache Collection, 1949
49.7.22

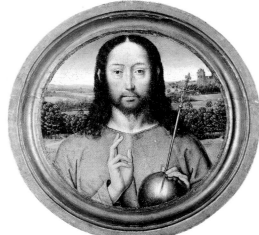

49.7.23

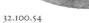

32.100.54

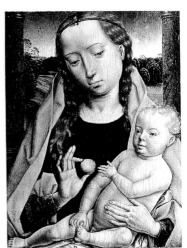

49.7.22

Style of Hans Memling

Netherlandish, late 15th century

Virgin and Child

Oil on wood; overall 14¹/₈ × 10¹/₄ in.
(35.9 × 26 cm); painted surface
13³/₈ × 9¹/₂ in. (34 × 24.1 cm)
The Friedsam Collection, Bequest of Michael
Friedsam, 1931
32.100.58

Hugo van der Goes

Netherlandish, active by 1467, died 1482

Portrait of a Man

Oil on wood, oval; overall 12¹/₂ × 10¹/₂ in.
(31.8 × 26.7 cm); painted surface
12¹/₂ × 10¹/₄ in. (31.8 × 26 cm)
H. O. Havemeyer Collection, Bequest of Mrs.
H. O. Havemeyer, 1929
29.100.15

Attributed to Hugo van der Goes

A Benedictine Monk

Oil on wood; overall 9⁷/₈ × 7³/₈ in.
(25.1 × 18.7 cm), with added strip of
³/₄ in. (1.9 cm) at right
The Bequest of Michael Dreicer, 1921
22.60.53

Copy after Hugo van der Goes

Netherlandish, late 15th century

The Adoration of the Magi

Oil on wood, 29¹/₈ × 25⁵/₈ in.
(74 × 65.1 cm)
Purchase, 1871
71.100

Simon Marmion

Netherlandish, active by 1449, died 1489

The Lamentation

Oil on wood, 20³/₈ × 12⁷/₈ in.
(51.8 × 32.7 cm)
Arms (verso) of Charles the Bold and
Margaret of York, surrounded by four pairs of
entwined initials (C M)
Robert Lehman Collection, 1975
1975.1.128
ROBERT LEHMAN COLLECTION

Master of the Saint Barbara Legend

Netherlandish, active late 15th century

*Abner's Messenger before David(?); The
Queen of Sheba Bringing Gifts to Solomon;
(verso) The Annunciation*

The recto and verso of these panels, the wings
of an altarpiece, have been separated.
Oil on wood, each panel 36³/₄ × 17⁵/₈ in.
(93.3 × 44.8 cm)
The Friedsam Collection, Bequest of Michael
Friedsam, 1931
32.100.56a–d

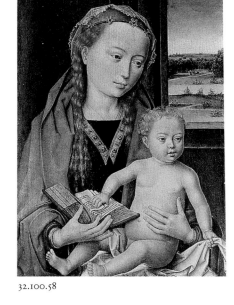

32.100.58

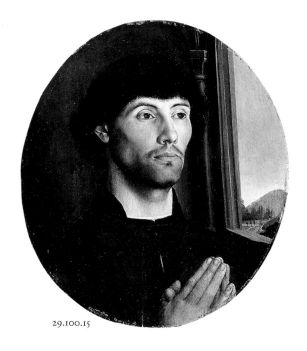

29.100.15

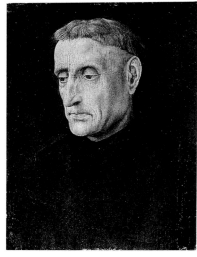

22.60.53

71.100

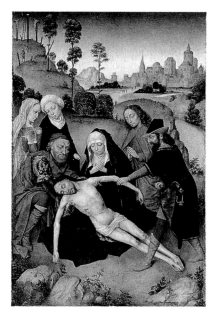

1975.1.128 (recto)

1975.1.128 (verso)

32.100.56a

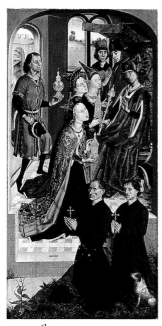

32.100.56b

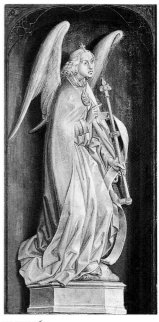

32.100.56c

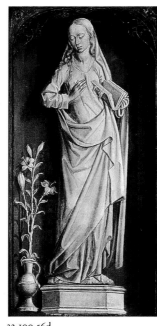

32.100.56d

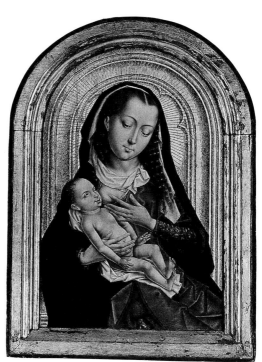

17.190.16

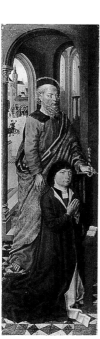

32.100.63a

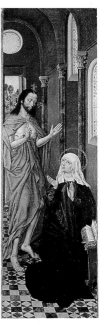

32.100.63b

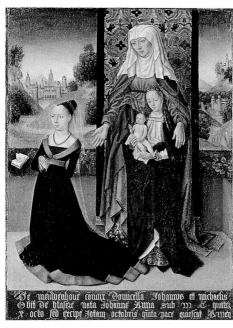

1975.1.114

Master of the Saint Ursula Legend
Netherlandish, active late 15th century
Virgin and Child
Oil on wood, arched top, 22¹/8 × 13¹/2 in.
(56.2 × 34.3 cm)
Gift of J. Pierpont Morgan, 1917
17.190.16

*Saint Paul with a Donor; Christ Appearing
to His Mother* (wings of an altarpiece)
Oil on wood; (a) overall 37³/8 × 11³/8 in.
(94.9 × 28.9 cm); (a) painted surface
36³/4 × 10⁷/8 in. (93.4 × 27.6 cm);
(b) overall 37¹/4 × 11¹/4 in.
(94.6 × 28.6 cm); (b) painted surface
36³/4 × 10³/4 in. (93.4 × 27.3 cm)
The Friedsam Collection, Bequest of Michael
Friedsam, 1931
32.100.63ab

*Virgin and Child with Saint Anne
Presenting Anna van Nieuwenhove*
Oil on wood, 19⁵/8 × 13⁵/8 in.
(49.8 × 34.6 cm)
Inscribed (bottom): De nieuwenhoue
cō[n]iunx domicella Johannis et michaelis /
Obit de blasere nata Johanne Anna sub
·M·C·quater / ·X·octo·sed excipe iotam
octobris·qūi[n]ta·pace quiescat Amen (The
companion and wife of Jan and [sic] Michiel
van Nieuwenhove, born Anna, daughter of

Johannes de Blasere, died in 1480, minus iota [1479], the 5th of October; may she rest in peace. Amen)
Arms on frame (left) of the van Nieuwenhove family and (right) of van Nieuwenhove and de Blasere
Robert Lehman Collection, 1975
1975.1.114
ROBERT LEHMAN COLLECTION

Master of the Brunswick Diptych
Netherlandish, active late 15th century

Virgin and Child with Saints
Oil on wood, 19¹/₄ × 15¹/₄ in.
(48.9 × 38.7 cm)
Gift of Dr. and Mrs. Max A. Goldzieher, 1960
60.18

Follower of the Master of the Virgin among Virgins
Netherlandish, active late 15th century

The Lamentation
This panel appears to have belonged to the same altarpiece as a Resurrection with a grisaille saint on the verso (Rijksmuseum, Amsterdam).
Oil on wood, 34⁷/₈ × 20¹/₄ in.
(88.6 × 51.4 cm)
Rogers Fund, 1926
26.26

Master of the Saint Godelieve Legend
Netherlandish, active fourth quarter 15th century

The Life and Miracles of Saint Godelieve
The story of this eleventh-century Netherlandish saint is recounted in seven scenes over five panels (left to right): Godelieve with her family; Godelieve feeding the poor; the feast for the count of Boulogne; Godelieve's marriage to Bertolf, who plots with his mother against her; and Godelieve's strangulation and miracles. On the exterior are Saints Josse, Nicholas of Bari, Quirinus, and John the Baptist.
Oil on wood, overall 49³/₄ × 126 in.
(126.4 × 320 cm)
Unidentified arms (exterior)
John Stewart Kennedy Fund, 1912
12.79

Master of Saint Gudule
Netherlandish, about 1485

Young Man Holding a Book
Oil on wood, arched top; overall
8¹/₄ × 5¹/₈ in. (21 × 13 cm); painted surface
8¹/₈ × 5 in. (20.6 × 12.7 cm)
Bequest of Mary Stillman Harkness, 1950
50.145.27

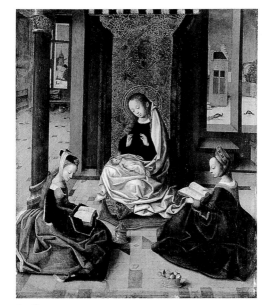

60.18

26.26

12.79 (interior)

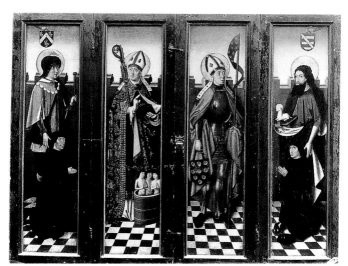

12.79 (exterior)

50.145.27

61.199

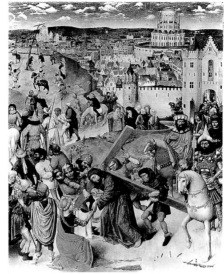

43.95

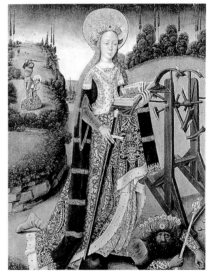

44.105.2

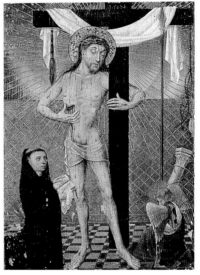

1974.392

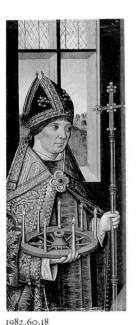

1982.60.18

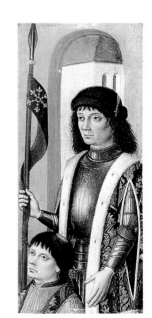

1982.60.19

Master of Saint Augustine
Netherlandish, about 1490

Scenes from the Life of Saint Augustine
Saint Augustine is consecrated bishop of
Hippo; he is ordained (upper left), preaches
from the pulpit (lower left), converses with a
boy attempting to fill a hole in the sand with
water from the sea (upper right), and teaches
(lower right). This is the central panel of an
altarpiece, the right wing of which represents
the vision and death of Saint Augustine
(National Gallery of Ireland, Dublin).
Oil and silver on wood; overall, with added
strips, 54¹/₄ × 59 in. (137.8 × 149.9 cm);
painted surface 53 × 57³/₄ in.
(134.6 × 146.7 cm)
Inscribed: (on orphreys) ihs; (on Saint
Augustine's sleeve) . . . HES· . . .
The Cloisters Collection, 1961
61.199
THE CLOISTERS

Netherlandish Painters
late 15th century

Christ Bearing the Cross
Oil on wood, 42³/₈ × 32³/₈ in.
(107.6 × 82.2 cm)
Inscribed (on various garments): [illegible]
Bequest of George D. Pratt, 1935
43.95

fourth quarter 15th century

Saint Catherine of Alexandria
Oil on wood, 16¹/₈ × 11³/₄ in.
(41 × 29.8 cm)
Bequest of George D. Pratt, 1935
44.105.2

Man of Sorrows with Kneeling Donor
The figure of Christ, the cross, and the donor
date from the fourth quarter of the fifteenth
century. The balance is a free invention dating
from the late nineteenth century. Some part of
the background was originally gilded.
Oil on wood, 18 × 12¹/₂ in.
(45.7 × 31.8 cm)
The Cloisters Collection, 1974
1974.392
THE CLOISTERS

about 1490

***Saint Donatian; A Warrior Saint,
Probably Victor, Presenting a Donor***
These panels may have been cut from the
wings of a devotional triptych, or they may be
fragments of a single work. They would have
flanked a Virgin and Child, to whom the
donor is presented by his patron saint.
Oil on wood; (18) 9¹/₂ × 3⁷/₈ in.
(24.1 × 9.8 cm); (19) 9¹/₂ × 4 in.
(24.1 × 10.2 cm)
The Jack and Belle Linsky Collection, 1982
1982.60.18–19

Aelbert Bouts
Netherlandish, born about 1451/54, died 1549

The Man of Sorrows
Oil on wood, arched top, 17½ × 11¼ in.
(44.5 × 28.6 cm)
The Friedsam Collection, Bequest of Michael
Friedsam, 1931
32.100.55

Head of Saint John the Baptist on a Charger
Oil on wood, diameter 11⅛ in. (28.3 cm)
Bequest of Rupert L. Joseph, 1959
60.55.2

Saint Christopher and the Infant Christ
Oil on wood, 14½ × 9½ in.
(36.8 × 24.1 cm)
Robert Lehman Collection, 1975
1975.1.115
ROBERT LEHMAN COLLECTION

Gerard David
Netherlandish, active by 1484, died 1523

Virgin and Child
Oil on wood, 6¼ × 4½ in.
(15.9 × 11.4 cm)
Robert Lehman Collection, 1975
1975.1.118
ROBERT LEHMAN COLLECTION

Christ Taking Leave of His Mother
This panel may have been the right wing
of a diptych, with a Virgin and Child
(Bearstead collection at Upton House,
National Trust) as the left wing. The verso
is painted to imitate porphyry.
Oil on wood, arched top; overall 6⅛ × 5 in.
(15.6 × 12.7 cm); painted surface
6⅛ × 4¾ in. (15.6 × 12.1 cm)
Bequest of Benjamin Altman, 1913
14.40.636

The Rest on the Flight into Egypt
Oil on wood, 20 × 17 in. (50.8 × 43.2 cm)
The Jules Bache Collection, 1949
49.7.21

The Nativity; Saint John the Baptist; Saint Francis Receiving the Stigmata
The central panel and the wings were
united as a triptych in 1923.
Oil on wood; central panel, overall
18¾ × 13½ in. (47.6 × 34.3 cm); central
panel, painted surface 18½ × 13⅜ in.
(47 × 34 cm); left wing, overall
18 × 6½ in. (45.7 × 16.5 cm); left wing,
original painted surface 17⅜ × 6 in.
(44.1 × 15.2 cm); right wing, overall

32.100.55

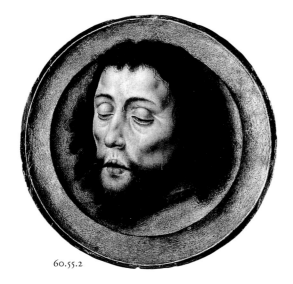

60.55.2

1975.1.115

1975.1.118

14.40.636

49.7.21

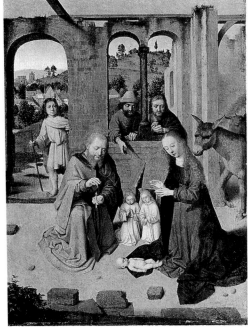

32.100.40b

32.100.40a

32.100.40c

1975.1.119

1975.1.120

18 × 6¹/₂ in. (45.7 × 16.5 cm); right wing,
original painted surface 17³/₈ × 5⁷/₈ in.
(44.1 × 14.9 cm)
The Friedsam Collection, Bequest of Michael
Friedsam, 1931
32.100.40a–c

Christ Bearing the Cross and the Crucifixion; The Resurrection and the Pilgrims of Emmaus
These panels are the interior wings of an
altarpiece.
Oil on wood, each panel 34 × 11 in.
(86.4 × 27.9 cm)
Robert Lehman Collection, 1975
1975.1.119
ROBERT LEHMAN COLLECTION

The Annunciation
These panels are the exterior wings of the
altarpiece mentioned in the preceding entry
(1975.1.119).
Oil on wood, each panel 34 × 11 in.
(86.4 × 27.9 cm)
Robert Lehman Collection, 1975
1975.1.120
ROBERT LEHMAN COLLECTION

Gerard David

Netherlandish, active by 1484, died 1523

The Annunciation: The Archangel Gabriel and the Virgin

These two panels formed the second tier of a polyptych, with a Virgin and Child Enthroned (central panel), flanked by Saints Benedict and Jerome (all Palazzo Bianco, Genoa), and a lunette representing God the Father (Louvre, Paris). The polyptych is recorded shortly after 1790 in the apse of the abbey church of San Girolamo della Cervara, near Genoa, and the frame is said to have been dated 1506.

Oil on wood; angel, overall 31¹/₈ × 25 in. (79.1 × 63.5 cm); angel, painted surface 30¹/₄ × 24³/₈ in. (76.8 × 61.9 cm); Virgin, overall 31¹/₈ × 25¹/₄ in. (79.1 × 64.1 cm); Virgin, painted surface 30¹/₂ × 24³/₈ in. (77.5 × 61.9 cm)

Inscribed: (on angel's cope) [VIRTVS AL]TISSIMI OBOMBRABIT T[IBI] ([the power of the] Highest shall overshadow thee [Luke 1:35].) and ALPHA ET OM[EGA]; (on Virgin's robe) MOEDER·ONS:HER[N] / AVE·MARIA· GRACI[A]E·M[ATER] / MISERICORDI[A]E·TV· NOS: ABHOS[TE]·[PROTEGE] (the first words on the Virgin's robe meaning Mother of Our Lord, and the remainder from Salutis auctor, a hymn sung at Compline, and included, as is the verse from Luke on the angel's cope, in the office of the Feast of the Annunciation)

Bequest of Mary Stillman Harkness, 1950 50.145.9ab

50.145.9a

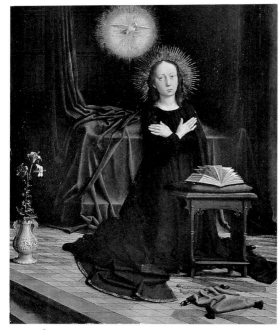

50.145.9b

The Nativity with Donors and Saints Jerome and Vincent

Two forest scenes (Rijksmuseum, Amsterdam, on loan to the Mauritshuis, The Hague) from the verso of the wings were separated from the triptych about 1928.

Oil on canvas, transferred from wood; central panel 35¹/₂ × 28 in. (90.2 × 71.1 cm); each wing 35¹/₂ × 12³/₈ in. (90.2 × 31.4 cm)

The Jules Bache Collection, 1949 49.7.20a–c

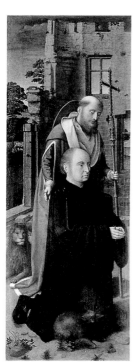

49.7.20b

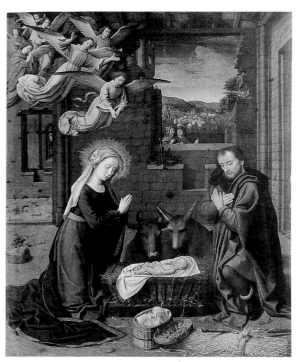

49.7.20a

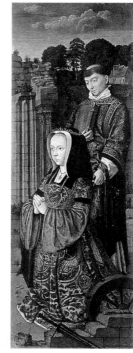

49.7.20c

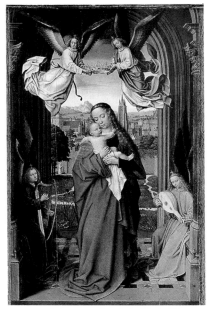

1977.1.1

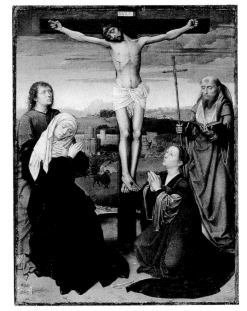

09.157

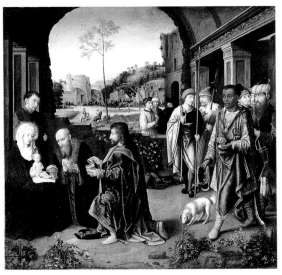

1982.60.17

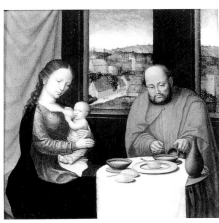

1975.1.121

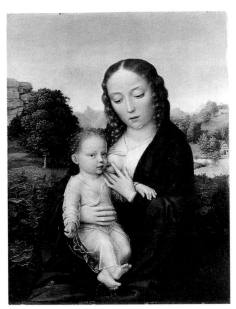

32.100.53

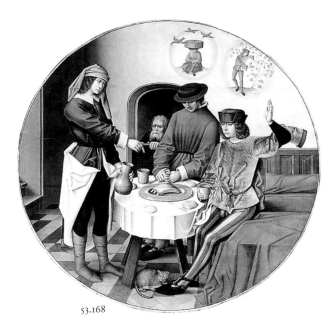

53.168

Virgin and Child with Four Angels
Oil on wood, 24⁷/₈ × 15³/₈ in.
(63.2 × 39.1 cm)
Inscribed (on cloth): IHESVS [RE]DEMPT[OR]
(Jesus Redeemer)
Gift of Mr. and Mrs. Charles Wrightsman,
1977
1977.1.1

The Crucifixion
Oil on wood, 21 × 15 in. (53.3 × 38.1 cm)
Inscribed (on cross): ·Î Ñ R̂ Î
Rogers Fund, 1909
09.157

Follower of Gerard David
Netherlandish, about 1525

The Adoration of the Magi
Oil on wood; overall 27³/₄ × 28⁷/₈ in.
(70.5 × 73.3 cm); painted surface
27¹/₂ × 28³/₈ in. (69.9 × 72.1 cm)
The Jack and Belle Linsky Collection, 1982
1982.60.17

Workshop of Gerard David
Virgin and Child with Saint Joseph
Oil on wood, 9 × 9¹/₂ in. (22.9 × 24.1 cm)
Robert Lehman Collection, 1975
1975.1.121
ROBERT LEHMAN COLLECTION

Follower of Gerard David
Netherlandish, about 1520–30

Virgin and Child
Oil on wood; overall 10 × 8¹/₄ in.
(25.4 × 21 cm), with added strip of
³/₈ in. (1 cm) at top; painted surface
9⁵/₈ × 8¹/₄ in. (24.4 × 21 cm)
The Friedsam Collection, Bequest of
Michael Friedsam, 1931
32.100.53

Master of the Story of Joseph
Netherlandish, about 1500

*Joseph Interpreting the Dreams of His
Fellow Prisoners*
Oil on wood, diameter 61¹/₂ in. (156.2 cm)
Harris Brisbane Dick Fund, 1953
53.168

Juan de Flandes

Netherlandish, active (in Spain) by 1496, died 1519

The Marriage Feast at Cana

This panel is one of a series commissioned by Isabella I of Castile (Spain). Forty-seven had been completed at her death in 1504 and are recorded in the inventory of her estate. Twenty-eight panels by no less than three hands, including Michiel Sittow (born about 1469, died 1525/26) as well as Juan de Flandes, are known (in two private and numerous public collections, primarily the Museo del Palacio Real, Madrid).

Oil on wood, 8¼ × 6¼ in. (21 × 15.9 cm)
The Jack and Belle Linsky Collection, 1982
1982.60.20

Saints Michael and Francis

This painting may have belonged to a retable commissioned in 1505 for the chapel of the University of Salamanca, where a panel from the banco representing Saints Apollonia and Mary Magdalen remains.

Oil on wood, gold ground; overall, with added strips at right and bottom, 36⁷⁄₈ × 34¼ in. (93.7 × 87 cm); painted surface 35³⁄₈ × 32³⁄₄ in. (89.9 × 83.2 cm)
Inscribed (below figures): SANT:MIGVEL; Sant:francisco:
Purchase, Mary Wetmore Shively Bequest, in memory of her husband, Henry L. Shively, M.D., 1958
58.132

Jan Provost

Netherlandish, active by 1491, died 1529

Virgin and Child

Oil on wood; overall 12¼ × 6³⁄₄ in. (31.1 × 17.1 cm); painted surface 11³⁄₄ × 6¹⁄₈ in. (29.8 × 15.6 cm)
Bequest of Joan Whitney Payson, 1975
1976.201.17

Attributed to Jan Provost

The Crucifixion

Oil on wood; overall 13¹⁄₈ × 10³⁄₄ in. (33.3 × 27.3 cm); painted surface 12⁵⁄₈ × 10¹⁄₄ in. (32.1 × 26 cm)
Inscribed (top center, on cross): INRI
The Jack and Belle Linsky Collection, 1982
1982.60.21

Master of Frankfort

Netherlandish, born about 1460, died about 1515

The Adoration of the Shepherds

Oil on wood, 22¹⁄₂ × 15¹⁄₂ in. (57.2 × 39.4 cm)
Robert Lehman Collection, 1975
1975.1.116
ROBERT LEHMAN COLLECTION

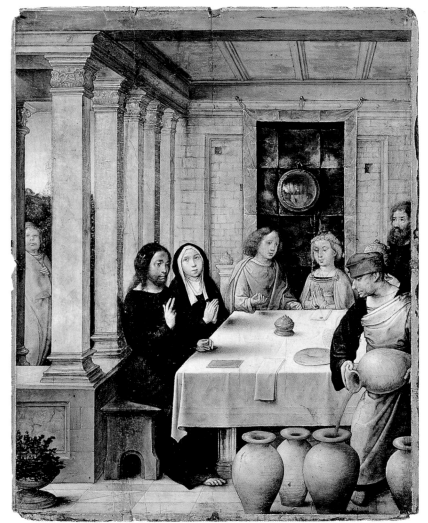

1982.60.20

58.132

1976.201.17

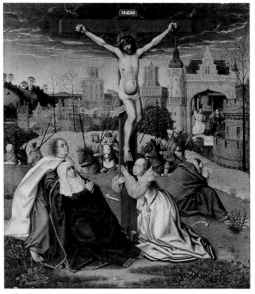

1982.60.21

1975.1.116

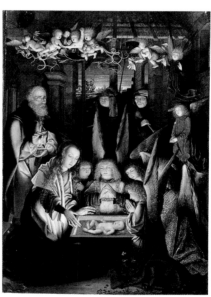

1982.60.22

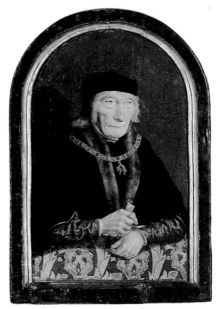

32.100.122

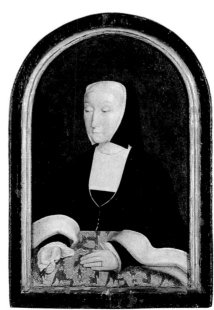

32.100.118

Follower of Jan Joest
Netherlandish, active about 1515

Nativity with the Annunciation to the Shepherds
Oil on wood; overall 41 × 28¹/₄ in.
(104.1 × 71.8 cm); painted surface
41 × 27⁵/₈ in. (104.1 × 70.2 cm)
The Jack and Belle Linsky Collection, 1982
1982.60.22

Master of Alkmaar
Netherlandish, about 1504

Jan* (1438–1516), *First Count of Egmond
Oil on canvas, transferred from wood,
arched top; overall 16³/₄ × 10¹/₄ in.
(42.5 × 26 cm); original painted surface
16¹/₄ × 9⁵/₈ in. (41.3 × 24.4 cm)
The Friedsam Collection, Bequest of Michael
Friedsam, 1931
32.100.122

Magdalena van Werdenburg* (1464–1538), *Countess of Egmond
Pendant to 32.100.122
Oil on wood, arched top; overall, with
engaged frame, 19¹/₄ × 12¹/₂ in.
(48.9 × 31.8 cm); painted surface
16¹/₂ × 9³/₄ in. (41.9 × 24.8 cm)
The Friedsam Collection, Bequest of Michael
Friedsam, 1931
32.100.118

Netherlandish Painter (possibly Goswijn van der Weyden, active by 1491, died after 1538)
about 1515–20

The Fifteen Mysteries and the Virgin of the Rosary
The arrangement of the panels as reassembled
is as follows: five Joyful Mysteries
(Annunciation, Visitation, Nativity,
Presentation, and Christ in the Temple [b–
f]), five Sorrowful Mysteries (Agony in the
Garden, Scourging, Crowning with Thorns,
Christ Carrying the Cross, and Crucifixion
[g–k]), five Glorious Mysteries (Resurrection,
Ascension, Descent of the Holy Spirit,
Dormition of the Virgin, and Coronation of
the Virgin [l–p]), and the Virgin of the
Rosary (a).
Oil on wood; (a) 9⁷/₈ × 21 in.
(25.1 × 53.3 cm); (b–p) each 5 × 4¹/₈ in.
(12.7 × 10.5 cm)
Anonymous Bequest, 1984
1987.290.3a–p

Netherlandish Painters

about 1520

Charles V (1500–1558), *Holy Roman Emperor*

Oil on wood, 11⁵/₈ × 8⁷/₈ in. (29.5 × 22.5 cm)

The Friedsam Collection, Bequest of Michael Friedsam, 1931

32.100.46

first quarter 16th century

Portrait of a Young Man of the van Steynoert Family

Oil on wood, arched top; overall, with engaged frame, 16¹/₈ × 12³/₄ in. (41 × 32.4 cm); painted surface 13⁵/₈ × 10¹/₈ in. (34.6 × 25.7 cm)

Arms (upper left) of the van Steynoert family

The Friedsam Collection, Bequest of Michael Friedsam, 1931

32.100.45

Style of Hieronymus Bosch

Netherlandish, first quarter 16th century

Christ's Descent into Hell

Oil on wood, 21 × 46 in. (53.3 × 116.8 cm)

Harris Brisbane Dick Fund, 1926

26.244

16th century

The Adoration of the Magi

Oil and gold on wood, 28 × 22¹/₄ in. (71.1 × 56.5 cm)

John Stewart Kennedy Fund, 1913

13.26

Netherlandish Painter

first quarter 16th century

The Adoration of the Magi (central panel of a triptych)

Oil on wood, arched top, 8³/₄ × 5¹/₄ in. (22.2 × 13.3 cm)

Inscribed (on wings): MARIA · MATER · GRACIÆ MATER MISERICORDIE · TV · NOS AB HOSTE PROTEGE IN HORA MORTIS SVSCIPE · (Mary, Mother of Grace, protect us from the evil one and deliver us in the hour of our death. [Possibly from a hymn to the Virgin])

Robert Lehman Collection, 1975

1975.1.122

ROBERT LEHMAN COLLECTION

1987.290.3a–p

32.100.46

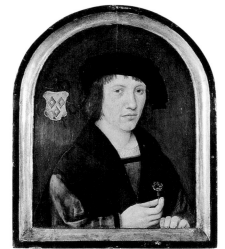

32.100.45

26.244

13.26

1975.1.122

21.132.2

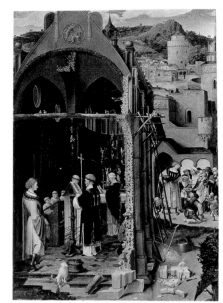

08.183.2

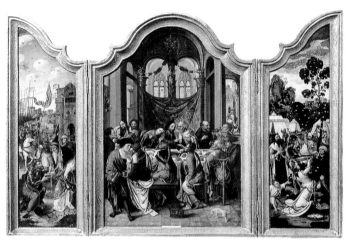

17.190.18a–c

17.190.18b 17.190.18c

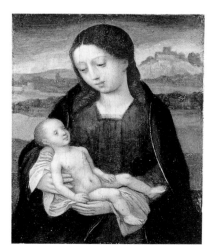

1975.1.123

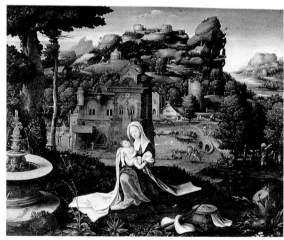

29.100.599

Netherlandish (Antwerp Mannerist) Painters

about 1520

The Adoration of the Magi

Oil on wood, 27¹/₈ × 21¹/₂ in.
(68.9 × 54.6 cm)
Bequest of Helen L. Bullard, in memory of
Harold C. Bullard, 1921
21.132.2

first quarter 16th century

A Sermon on Charity (possibly the Conversion of Saint Anthony)

Oil on wood, 33¹/₂ × 23 in.
(85.1 × 58.4 cm)
Rogers Fund, 1908
08.183.2

The Last Supper (triptych)

Central panel: Last Supper; left wing:
Abraham Receiving Bread and Wine from
Melchizedek; right wing: Fall of Manna;
exterior: Adam and Eve
Oil on wood, shaped top; central panel,
overall, with engaged frame, 47 × 33³/₄ in.
(119.4 × 85.7 cm); left wing, overall,
with engaged frame, 47 × 16⁷/₈ in.
(119.4 × 42.9 cm); right wing, overall,
with engaged frame, 47¹/₈ × 17 in.
(119.7 × 43.2 cm)
Inscribed (on frame): (under left wing)
CENANTIBVSILLIS, ACZEPIT; (under central
panel) IESVS PANEM BENEDIXIT, ᴬᶜFREJIT,
DEDITQV[E]; (under right wing) DISCIPVLIS,
SVIS, DICENS (And as they were eating, Jesus
took bread, and blessed it, and brake it, and
gave it to the disciples, and said . . .
[Matthew 26:26].); (right wing, on tent in
background) AVE MARIA . . .
Gift of J. Pierpont Morgan, 1917
17.190.18a–c

Master of the Demi-Figures

Netherlandish, active early 16th century

Virgin and Child

Oil on wood, 3¹/₂ × 2³/₄ in. (8.9 × 7 cm)
Robert Lehman Collection, 1975
1975.1.123
ROBERT LEHMAN COLLECTION

Netherlandish Painter

early 16th century

The Rest on the Flight into Egypt

Oil on wood, 23³/₈ × 28 in.
(59.4 × 71.1 cm)
H. O. Havemeyer Collection, Bequest of Mrs.
H. O. Havemeyer, 1929
29.100.599

Quentin Massys (also Matsys or Metsys)
Netherlandish, 1465/66–1530

Portrait of a Man
Oil on wood, arched top; overall, with engaged frame, 18¹/₈ × 13¹/₂ in. (46 × 34.3 cm); painted surface 15⁵/₈ × 11¹/₄ in. (39.7 × 28.6 cm)
Inscribed (on collar): LEVER
The Friedsam Collection, Bequest of Michael Friedsam, 1931
32.100.49

Portrait of a Woman
Oil on wood, 19 × 17 in. (48.3 × 43.2 cm)
The Friedsam Collection, Bequest of Michael Friedsam, 1931
32.100.47

The Adoration of the Magi
Oil on wood, 40¹/₂ × 31¹/₂ in. (102.9 × 80 cm)
Dated (on pilaster): [15]26.
John Stewart Kennedy Fund, 1911
11.143

Followers of Quentin Massys
Netherlandish, mid-16th century

The Rest on the Flight into Egypt
This painting may be the work of two artists.
Oil on wood, 37¹/₂ × 30¹/₄ in. (95.3 × 76.8 cm)
The Friedsam Collection, Bequest of Michael Friedsam, 1931
32.100.52

Master of the Mansi Magdalen
Netherlandish, active first quarter 16th century

Virgin and Child
Oil on wood, 19¹/₈ × 15¹/₄ in. (48.6 × 38.7 cm)
Bequest of William H. Herriman, 1920
21.134.2

Master of the Holy Blood
Netherlandish, about 1520

The Descent from the Cross (triptych)
The central panel is based on a lost prototype by Rogier van der Weyden (1399/1400–1464). Left panel: Saint Joseph of Arimathea; right panel: Saint Mary Magdalen
Oil on wood; central panel, overall 36 × 28¹/₂ in. (91.4 × 72.4 cm); central panel, painted surface 35⁵/₈ × 28¹/₂ in. (90.5 × 72.4 cm); left panel, overall 36 × 12³/₈ in. (91.4 × 31.4 cm); left panel, painted surface 35¹/₂ × 12³/₈ in. (90.2 × 31.4 cm); right panel, overall 35⁷/₈ × 12⁵/₈ in. (91.1 × 32.1 cm); right panel, painted surface 35³/₈ × 12¹/₂ in. (89.9 × 31.8 cm)
Gift of Clyde Fitch and Ferdinand Gottschalk, 1917
17.187a–c

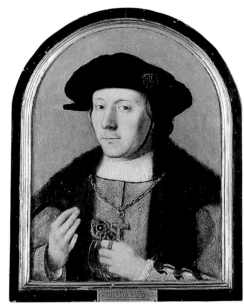

32.100.49

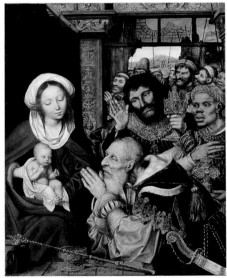

11.143

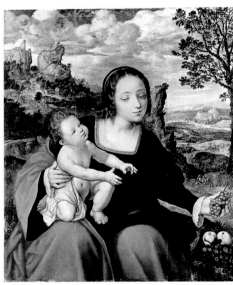

32.100.47

32.100.52

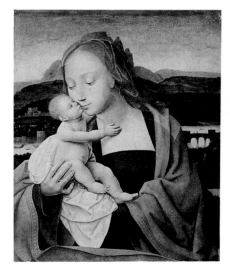

21.134.2

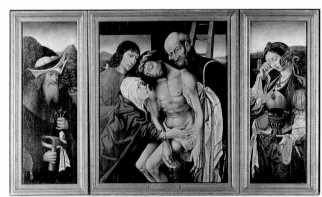

17.187a–c

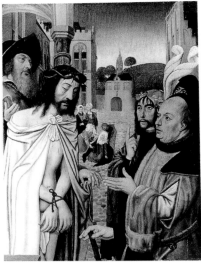

1982.60.25

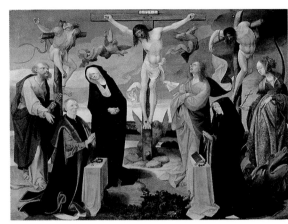

88.3.88

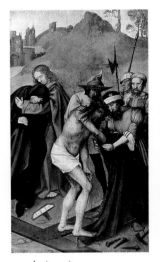

11.193a (recto)

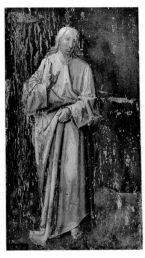

11.193b (recto)

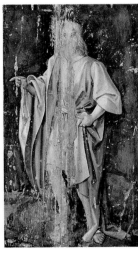

11.193a (verso)

11.193b (verso)

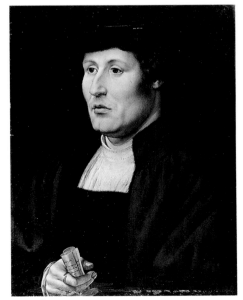

32.100.62

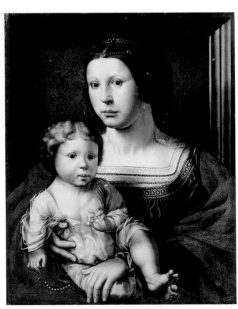

17.190.17

Jan Mostaert
Netherlandish, active by 1498, died 1555/56

Christ Shown to the People
Oil on wood; overall 12 × 8⁷/8 in.
(30.5 × 22.5 cm); painted surface
11¹/2 × 8¹/4 in. (29.2 × 21 cm)
The Jack and Belle Linsky Collection, 1982
1982.60.25

Cornelis Engebrechtsz
Netherlandish, 1468–1527

The Crucifixion with Donors and Saints Peter and Margaret
Oil on wood, 24¹/4 × 35¹/4 in.
(61.5 × 89.5 cm)
Inscribed (on cross): ⌒I⌒N⌒R⌒I⌒
Gift of Coudert Brothers, 1888
88.3.88

Workshop of Cornelis Engebrechtsz

Ecce Homo, (verso) **Christ Blessing; The Disrobing of Christ,** (verso) **Saint John the Baptist**
The panels, whose versos are in grisaille, are the wings of an altarpiece.
Oil on wood, each 16¹/2 × 8³/4 in.
(41.9 × 22.2 cm)
Inscribed (Disrobing of Christ, on plaque):
·i̅·n̅·r̅·i̅·
Gift of Ferdinand Hermann, 1911
11.193ab

Jan Gossart (called Mabuse)
Netherlandish, active by 1503, died 1532

Portrait of a Man
Oil on wood, 18¹/2 × 13³/4 in.
(47 × 34.9 cm)
Signed: (on scroll) . . . om̅rpses / J[o]annes
. . . / malbodius . . . / pingeba[t]; (on hat
ornament) IM [monogram]
The Friedsam Collection, Bequest of Michael
Friedsam, 1931
32.100.62

Virgin and Child
Oil on wood; overall 17⁷/8 × 13⁵/8 in.
(45.4 × 34.6 cm); painted surface
17¹/4 × 13 in. (43.8 × 33 cm)
Gift of J. Pierpont Morgan, 1917
17.190.17

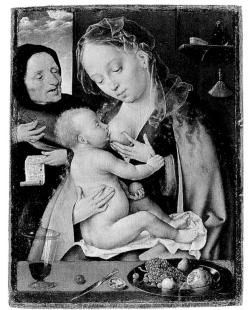

32.100.57

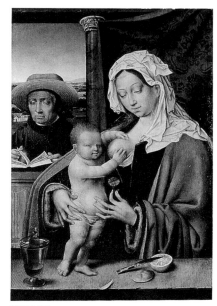

1975.1.117

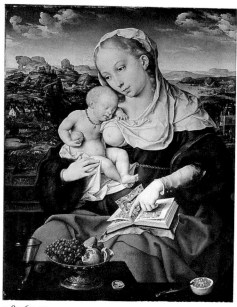

1982.60.47

41.190.20b

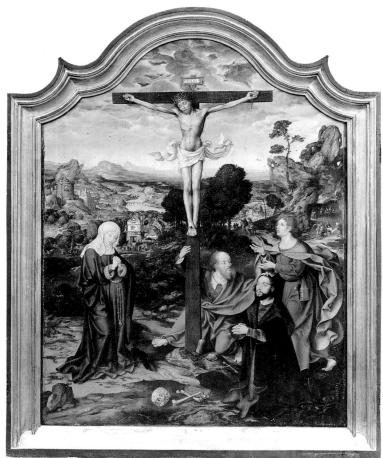

41.190.20a

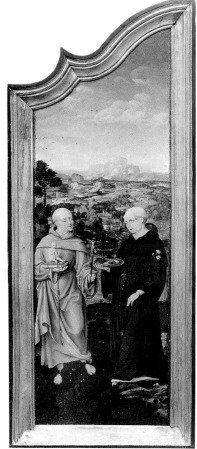

41.190.20c

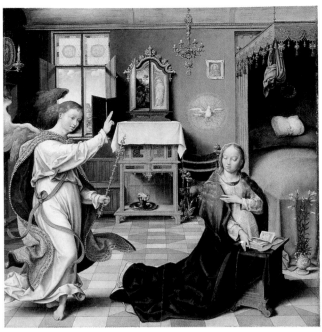

32.100.60

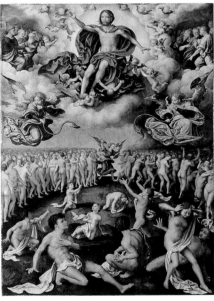

40.174.1

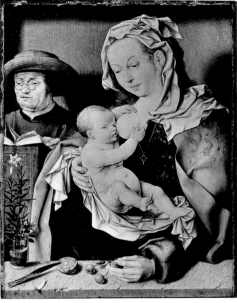

41.190.19

Joos van Cleve
Netherlandish, active by 1507, died 1540/41

The Holy Family
Oil on wood, 16³/₄ × 12¹/₂ in.
(42.5 × 31.8 cm)
Inscribed (on scroll): . . . et benedictus /
fructus ventris tui / . . . / . . . / Magnificat
[a]N̄[im]A / mea dominum / Et exultavit
Sp[iritu]s me / us in deo salutari meo / Quia
respexit humi / litatem ancillae suae / [ecce
enim ex hoc] b[ea]tam / [me dicent omnes]
generat / [iones. Quia] fecit mihi [magna] /
qui potens est et / [sanctum nomen] ejus Et /
[misericordia] ejus a / [progenie in progenies
timentibus eum.] (. . . and blessed is the
fruit of thy womb. . . . My soul doth magnify
the Lord, and my spirit hath rejoiced in God
my Savior. For he hath regarded the low

estate of his handmaiden: [for, behold, from
henceforth all] generations [shall call me]
blessed. For he that is mighty hath done to
me [great things]; and [holy is his name].
And his [mercy is on them that fear him
from generation to generation] [Luke 1:42,
46–50, including the first five lines of the
Magnificat].)
The Friedsam Collection, Bequest of Michael
Friedsam, 1931
32.100.57

The Holy Family
Oil on wood, 21⁵/₈ × 14¹/₄ in. (54.9 × 36.2 cm)
Robert Lehman Collection, 1975
1975.1.117
ROBERT LEHMAN COLLECTION

Virgin and Child
Oil on wood; overall 28³/₈ × 21¹/₄ in.
(72.1 × 54 cm); painted surface
27³/₄ × 20³/₄ in. (70.5 × 52.7 cm)
Inscribed (on prayer book pages): . . . /
recordatus misericordiae suae / Sicut loctus·est
ad / patres nostras Abra / ham et=semini
eius i[n] / saecula Gloria patri et / filio et
spir[ito] / sancto S[icut erat in] / principi[o et
nunc et semper] / et in saecu[la saeculorum] /
De profundis clamavi / [ad te] domine :
domine ex / [audi v]ocem : meam / [Fiant
aures tua]e intenden / [tes in vocem
depreca]tiones / [meae.] / . . . misericoria et
co / [piosa] (. . . in remembrance of his
mercy; As he spake to our fathers, to
Abraham, and to his seed for ever. Glory to
the father and to the son and to the holy
spirit, [as it was in the] beginning, [is now,
and shall be for ever.] Out of the depths have
I cried [unto thee,] O Lord. Lord, [hear] my
voice: [let thine ears] be attentive [to the voice
of my] supplications [Luke 1:54–55, the Gloria
patri, and Psalms 130:1–2 and possibly 7].)
The Jack and Belle Linsky Collection, 1982
1982.60.47

The Crucifixion with Saints and a Donor
(triptych)
Central panel: Crucifixion with the Virgin,
Saints John the Evangelist and Joseph of
Arimathea, and a kneeling donor; left wing:
Saints John the Baptist and Catherine of
Alexandria; right wing: Saints Anthony of
Padua and Nicholas of Tolentino
Oil on wood, shaped top; central panel,
painted surface 38³/₄ × 29¹/₄ in.
(98.4 × 74.3 cm); each wing, painted surface
39³/₄ × 12⁷/₈ in. (101 × 32.7 cm)
Inscribed (on cross): ·INRI·
Bequest of George Blumenthal, 1941
41.190.20a–c

The Annunciation
Oil on wood, 34 × 31¹/₂ in. (86.4 × 80 cm)
Inscribed (background, on predella of
altarpiece): ABRAHAM; MELCHICED
[Melchizedek]
The Friedsam Collection, Bequest of Michael
Friedsam, 1931
32.100.60

The Last Judgment
Oil on wood, 48³/₄ × 34 in. (123.8 × 86.4 cm)
Bequest of Mr. and Mrs. Graham F. Blandy,
1940
40.174.1

Workshop of Joos van Cleve
The Holy Family
Oil on wood, 20³/₈ × 14⁵/₈ in. (51.8 × 37.1 cm)
Bequest of George Blumenthal, 1941
41.190.19

Workshop of Joos van Cleve

Francis I (1494–1547), ***King of France***
Oil on canvas, transferred from wood,
16 × 12⁷/₈ in. (40.6 × 32.7 cm)
The Friedsam Collection, Bequest of Michael
Friedsam, 1931
32.100.120

Master of the Louvre Madonna

Netherlandish, active first half 16th century

Virgin Suckling the Child
Distemper on canvas, 15⁵/₈ × 11⁷/₈ in.
(39.7 × 30.2 cm)
Inscribed (on simulated frame): (sides and
top) Ave·regina·celorum·ave·domina
·angelorum·salve·radix·sancta·ex·qua·mundo
·lux·[est]·orta· (Hail to thee, O Queen of
Heaven; hail, Mistress of Angels; hail, root
and gateway through whom the light has
risen upon the world. [From a Compline
antiphon]); (base) Beata·es[t]·maria·qu[a]e
·omniu[m]·p[o]rtasti / creatorem·genuisti·
eum·qui·te fecit / et·inaeternum·permane[s]
Virgo (Blessed art thou, O Mary the Virgin,
who didst bear the creator of all things. Thou
broughtest forth him who made thee and
remainest a virgin forever. [From the offertory
of the old office of the Immaculate
Conception])
Gift of Robert Lehman, 1945
45.170.1

Adriaen Isenbrant

Netherlandish, active by 1510, died 1551

The Nativity (triptych)
Left wing: Adoration of the Magi and
(exterior) Annunciation; right wing:
Flight into Egypt and (exterior) Visitation.
The exterior is in grisaille.
Oil on wood; central panel, overall, with
engaged frame, 12³/₈ × 10¹/₈ in.
(31.4 × 25.7 cm); central panel, painted
surface 9¹/₈ × 6⁷/₈ in. (23.2 × 17.5 cm);
each wing, overall, with engaged frame,
12³/₈ × 5 in. (31.4 × 12.7 cm); each wing,
painted surface 10³/₄ × 3¹/₂ in. (27.3 × 8.9 cm)
Frederick C. Hewitt Fund, 1913
13.32a–c

Man Weighing Gold
Oil on wood, 20 × 12 in. (50.8 × 30.5 cm),
with added strips of 1³/₄ in. (4.5 cm) at left
and right
The Friedsam Collection, Bequest of Michael
Friedsam, 1931
32.100.36

***Christ Crowned with Thorns and the
Mourning Virgin***
Oil on canvas, transferred from wood,
41¹/₂ × 36¹/₂ in. (105.4 × 92.7 cm)
Rogers Fund, 1904
04.32

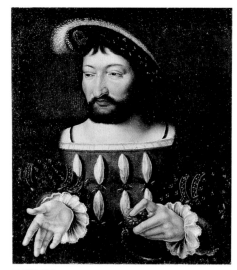

32.100.120

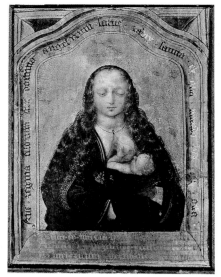

45.170.1

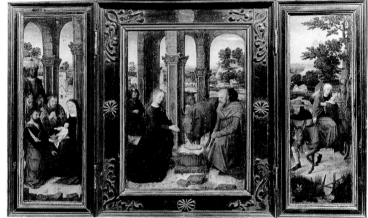

13.32a–c

13.32bc

32.100.36

04.32

36.14a–c

36.14bc

14.40.632

41.190.14

1982.60.23

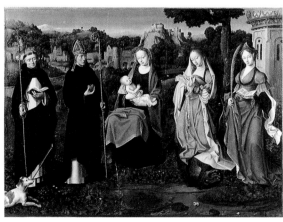

41.190.18

Joachim Patinir

Netherlandish, active by 1515, died 1524

The Penitence of Saint Jerome (triptych)
Interior wings: Baptism of Christ and
Temptation of Saint Anthony; exterior, in
grisaille: Saint Anne with the Virgin and
Child and Saint Sebald
Oil on wood, shaped top; central panel,
overall, with engaged frame, 46¼ × 32 in.
(117.5 × 81.3 cm); each wing, overall, with
engaged frame, 47½ × 14 in.
(120.7 × 35.6 cm)
Fletcher Fund, 1936
36.14a–c

Bernaert van Orley

Netherlandish, active by 1515, died 1541/42

Virgin and Child with Angels
Oil on wood, 33⅝ × 27½ in.
(85.4 × 69.9 cm)
Inscribed: (on Virgin's robe) MARIA MATER
GRASIA MA . . . (Mary, Mother of Grace,
mo[ther] . . .); (falsely, lower left, with date
and initials of Albrecht Dürer) 1505/AD
[monogram]
Bequest of Benjamin Altman, 1913
14.40.632

Style of Bernaert van Orley

Netherlandish, about 1520

Four Scenes from the Passion
The scenes are the Agony in the Garden,
Bearing of the Cross, Crucifixion, and
Lamentation.
Oil on wood, 11¾ × 11⅜ in.
(29.8 × 28.9 cm)
Inscribed (on cross): I,N,R,I,
Bequest of George Blumenthal, 1941
41.190.14

Ambrosius Benson

Netherlandish, active by 1519, died 1550

The Lamentation
Oil on canvas, transferred from wood, shaped
top, 36 × 22⅛ in. (91.4 × 56.2 cm)
Inscribed (top center, on cross): INRI
The Jack and Belle Linsky Collection, 1982
1982.60.23

Attributed to Ambrosius Benson

*Virgin and Child with Saints Dominic,
Augustine, Margaret, and Barbara*
Oil on canvas, transferred from wood,
38¾ × 51 in. (98.4 × 129.5 cm)
Bequest of George Blumenthal, 1941
41.190.18

Netherlandish Painters
first half 16th century
Portrait of a Man
Oil on wood, arched top; overall
8¼ × 6½ in. (21 × 16.5 cm); painted
surface 8⅛ × 6⅛ in. (20.6 × 15.6 cm)
The Jack and Belle Linsky Collection, 1982
1982.60.28

mid-16th century
Virgin and Child
Oil on wood, 5⅛ × 4 in. (13 × 10.2 cm)
Robert Lehman Collection, 1975
1975.1.124
ROBERT LEHMAN COLLECTION

Workshop of Herri met de Bles
Netherlandish, probably born 1480, died after
1550
The Temptation of Saint Anthony
Oil on wood; overall 8⅞ × 13¾ in.
(22.5 × 34.9 cm); painted surface
8½ × 13⅜ in. (21.6 × 34 cm)
Bequest of Harry G. Sperling, 1971
1976.100.1

Master LC
Netherlandish, active second quarter 16th
century
The Arrival in Bethlehem
Oil on wood, 26½ × 36⅞ in. (67.3 × 93.7 cm)
Rogers Fund, 1916
16.69

Copy after Lucas van Leyden
Netherlandish or German, possibly late 16th
century
Christ Presented to the People
The painting is close in size to the engraving
of 1510 by Lucas van Leyden (Netherlandish,
active by 1508, died 1533) from which it derives.
Oil on wood, 10⅞ × 18 in. (27.6 × 45.7 cm)
Marquand Collection, Gift of Henry G.
Marquand, 1889
89.15.13

Marten van Heemskerck
Netherlandish, 1498–1574
Jacob Willemsz. van Veen (born about 1457,
died after 1532), *the Artist's Father*
Oil on wood, 20½ × 13¾ in.
(52.1 × 34.9 cm)
Signed, dated, and inscribed (bottom):
mij[n]·sōē[n]·heft·mij·hier·
gheconterfeit·doe·ic·gheleeft·had·
lxxv·iārē[n]·somē[n]·seijt· (My
son portrayed me here when I had lived
seventy-five years so they say) / ·1532·MVH
[monogram]
Purchase, 1871
71.36

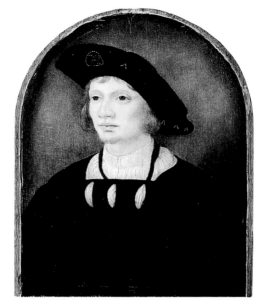

1982.60.28

1975.1.124

1976.100.1

16.69

89.15.13

71.36

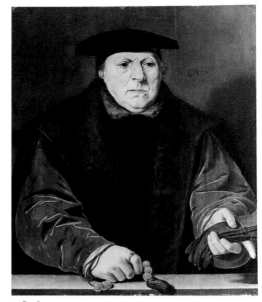

1982.60.26

1982.60.27

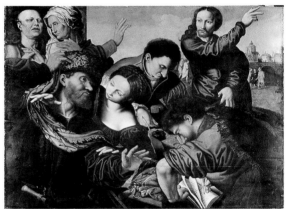

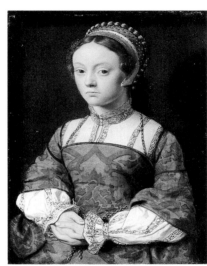

71.155

49.7.32

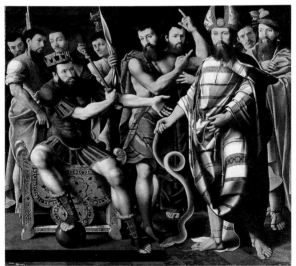

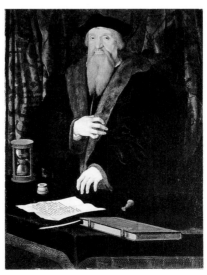

50.70

91.26.3

Attributed to Jan Cornelisz. Vermeyen
Netherlandish, 1500–1559

Queen Mary of Hungary (1505–1558)
Oil on wood, 21¹/₂ × 18 in. (54.6 × 45.7 cm)
The Jack and Belle Linsky Collection, 1982
1982.60.26

Portrait of a Man with a Rosary
Oil on wood, 20 × 16¹/₄ in. (50.8 × 41.3 cm)
Dated and inscribed: (left of sitter's head)
·1545·; (right of sitter's head) ·63·
The Jack and Belle Linsky Collection, 1982
1982.60.27

Jan Sanders van Hemessen
Netherlandish, active by about 1524, died
about 1564

The Calling of Matthew
Oil on wood, 43⁷/₈ × 59¹/₂ in. (111.4 × 151.1 cm)
Purchase, 1871
71.155

Netherlandish Painter
about 1535

Portrait of a Young Woman
Oil on wood, 10¹/₂ × 8¹/₄ in.
(26.7 × 21 cm)
The Jules Bache Collection, 1949
49.7.32

Netherlandish or French Painter
dated 1537

***Moses and Aaron before Pharaoh: An
Allegory of the Dinteville Family***
The brothers are Jean (as Moses); Gaucher;
François II, Bishop of Auxerre (as Aaron); and
Guillaume. Pharaoh is presumably a
generalized portrait of the king, Francis I.
Oil on wood, 69¹/₂ × 75⁷/₈ in.
(176.5 × 192.7 cm)
Dated and inscribed: (on hem of Moses'
garment) ·IEHAN Sʳ DE·POLISY· / ·EN·AGE 33·
/ ·BAILLY·DE·TROYES / [EN?] ·1537·; (on hem
of Gaucher's robe) 1537 / GAVCHER·Sʳ·DE·
VANLAY· / EN AGE / 28; (on hem of
Guillaume's robe) GVILLAVME· / DE SCHESNET
/ DE·DINTEVILLE·CHEV . . . / ·DESCVL IE·DE
·MO [last letter cut by panel edge] / EN / AGE
32; (on Aaron's miter) CREDIDIT. /
ABRAM·DÑO. / ETREPVTATV̂. / EST·ILLI·AD.IVS
/ TITIAM· (And [Abraham] believed in the
Lord; and he counted it to him for
righteousness [Genesis 15:6].); (on border of
Aaron's gown) EN / 8; (upper left, on
entablature) VIRTVTI FORTVNA COMES·
(Fortune, the companion of merit [motto of
the Dinteville family]); (lower left, falsely, on
base of pharaoh's throne) IOANNES·HOLBEIN·1537
Arms (beneath his right foot) of François
II de Dinteville, Bishop of Auxerre
Wentworth Fund, 1950
50.70

Netherlandish Painters

dated 1539

Portrait of a Man, Possibly Jean de Langeac (died 1541), Bishop of Limoges

Oil on wood, 47¼ × 34½ in. (120 × 87.6 cm)
Dated and inscribed: (lower left) A? D. 1539;
(on paper)
SCIĀMVS ENIM QVONIĀ[M] / TERRESTRIS
DOMVS N[OST]RA / HVIVS HABITATIO[N]ĪS DIS
SOVLET[VR] ET Q[VOD] [A]EDIFICATIO[N]Ē[M] /
EX DEO HABEM´[VS] DOMV̄[M] NO[N] /
MANVFACTA[M] [A]ETERNA[M] IN / C[O]ELIS
NĀ[M] ET INHOC Ī[N]GEMISCIM´[VS] /
HABITATIO[N]Ē[M] N[OST]RA[M] Q[VAE] DE /
C[O]ELO Ē[ST] SVP[ER]Ī[N]DVI CVPIĒ[N]TES / SI
T[AME]N̄ VESTITI ET NŌ[N] / [N]VDI
INVENIAMVR / AD. COR.2 / CAP.5. (For we
know that, if our earthly house of this
tabernacle were dissolved, we have a building
of God, a house not made with hands,
eternal in the heavens. For in this we groan,
earnestly desiring to be clothed upon with our
house which is from heaven: If so be that
being clothed we shall not be found naked
[2 Corinthians 5: 1–3].)
Marquand Collection, Gift of Henry G.
Marquand, 1890
91.26.3

about 1540–50

Portrait of a Woman

Oil on wood, 29¼ × 22⅝ in. (74.3 × 57.5 cm)
Gift of Winston F. C. Guest, 1969
69.282

dated 1569

Portrait of a Surgeon

Oil on wood, 8¼ × 6⅛ in. (21 × 15.6 cm)
Dated and inscribed: (left) siet om of swijcht
(Be cautious or keep silent); (right, on column)
A? I[5]69. / siet om of swijcht / ÆT? 47.
Theodore M. Davis Collection, Bequest of
Theodore M. Davis, 1915
30.95.287

Anthonis Mor van Dashorst

Netherlandish, 1519–1575

Portrait of a Man, Possibly Ottavio Farnese (1524–1586), Duke of Parma and Piacenza

Oil on canvas, 82¼ × 46¾ in.
(208.9 × 118.7 cm)
Dated (left center): 1563
Gift of Mr. and Mrs. Nate B. Spingold, 1951
51.5

Pieter Jansz. Pourbus

Netherlandish, 1524–1584

Portrait of a Young Woman

Oil on wood, 15½ × 12½ in. (39.4 × 31.8 cm)
Charles B. Curtis Fund, 1939
39.143

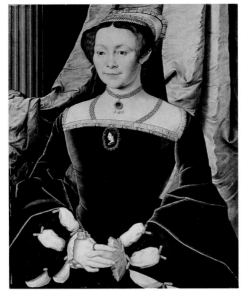

69.282

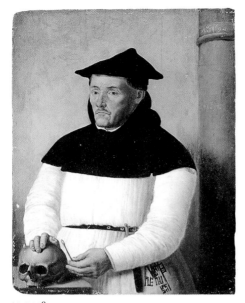

30.95.287

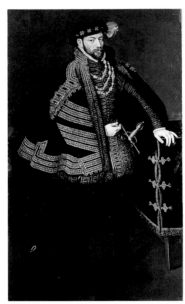

51.5

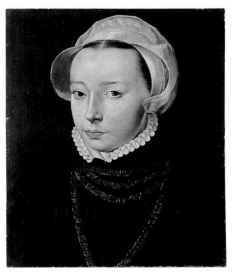

39.143

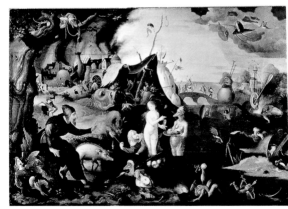

15.133

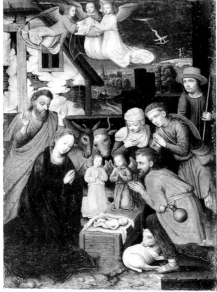

17.190.3

19.164

Pieter Huys
Netherlandish, active by 1545, died 1584

The Temptation of Saint Anthony
Oil on wood, 43 × 59 in. (109.2 × 149.9 cm)
Inscribed (lower left, falsely): V. Breughel
Anonymous Gift, 1915
15.133

Marcellus Coffermans
Netherlandish, active 1549–1570

The Adoration of the Shepherds
Oil on wood, 8¹/₈ × 5¹/₂ in. (20.6 × 14 cm)
Signed (lower right): MARCEL.ꜰELMON.FE[CIT]
Gift of J. Pierpont Morgan, 1917
17.190.3

Pieter Bruegel the Elder
Netherlandish, active by 1551, died 1569

The Harvesters
This painting is from a series of six
constituting a cycle of the seasons, four others
of which are known: Hunters in the Snow
and Gloomy Day (both Kunsthistorisches
Museum, Vienna), Haymaking (National
Gallery, Prague), and Return of the Herd
(Kunsthistorisches Museum, Vienna).
Oil on wood, 46¹/₂ × 63¹/₄ in.
(118.1 × 160.7 cm)
Signed and dated (lower right): BRVEGEL /
[MD]LXV [now largely illegible]
Rogers Fund, 1919
19.164

Netherlandish (Antwerp?) Painter
about 1581

Musical Party
This panel is the lid of a double virginal;
the instrument was built in 1581 by Hans
Ruckers the Elder of Antwerp.
Oil on wood, 19¹/₂ × 71³/₄ in.
(49.5 × 182.2 cm)
Gift of B. H. Homan, 1929
29.90
MUSICAL INSTRUMENTS

29.90

Kerstiaen de Keuninck
Flemish, born about 1560, died 1632/33

A Mountainous Landscape with a Waterfall
Oil on wood, 27¹/₄ × 48 in. (69.2 × 121.9 cm)
Signed (bottom center): K D Keuninck
Purchase, Anonymous Gift, L. H. P. Klotz
and George T. Delacorte Jr. Gifts; Rogers,
Marquand, Charles B. Curtis, and The Alfred
N. Punnett Endowment Funds; and Gift of
Eugen Boross and Bequest of Collis P.
Huntington, by exchange, 1983
1983.452

1983.452

1974.293

Jan Brueghel the Elder
Flemish, 1568–1625

A Woodland Road with Travelers
Oil on wood, 18¹/₈ × 32³/₄ in. (46 × 83.2 cm)
Signed and dated (lower left): BRVEGHEL 1607·
Purchase, Fletcher, Rogers, Pfeiffer, Dodge,
Harris Brisbane Dick, and Louis V. Bell
Funds, and Joseph Pulitzer Bequest, 1974
1974.293

Pieter Brueghel the Younger
Flemish, 1564/65–1637/38

The Whitsun Bride
Oil on wood, 20 × 30⁵/₈ in.
(50.8 × 77.8 cm)
Signed (right, on window):
·P·BREVGHE[L]
Gift of Estate of George Quackenbush, in his
memory, 1939
39.16

39.16

22.45.5

Workshop of Pieter Brueghel the Younger

A Winter Landscape with Skaters and a Bird Trap
Oil on wood, 15¹/₄ × 22⁷/₈ in.
(38.7 × 58.1 cm)
Bequest of Grace Wilkes, 1921
22.45.5

50.209

45.94.2

25.110.21

1971.101

1982.60.24

Attributed to Jacob van der Heyden
Flemish, 1573–1645
Interior of Strasbourg Cathedral
Tempera on vellum, 5¹/₄ × 4¹/₈ in.
(13.3 × 10.5 cm)
Rogers Fund, 1950
50.209

Hendrick van Steenwyck II
Flemish, born about 1580, died 1649
A Renaissance Portico with Elegant Figures
Oil on copper, diameter 4³/₈ in. (11.1 cm)
Signed and dated (bottom center, on step):
HEN[DRICK] V. STE[EN]WYCK 16[]
Gift of Mrs. James Eads Switzer, in memory
of her aunt, Yrene Ceballos de Sanz, 1945
45.94.2

Frans Pourbus the Younger
Flemish, 1569–1622
*Margherita Gonzaga (1591–1632), Princess
of Mantua*
Oil on canvas, 36¹/₂ × 27¹/₄ in.
(92.7 × 69.2 cm)
Bequest of Collis P. Huntington, 1900
25.110.21

Abraham Janssen van Nuyssen
Flemish, born about 1575, died 1632
*The Dead Christ in the Tomb with Two
Angels*
Oil on canvas, 45³/₈ × 58 in.
(115.3 × 147.3 cm)
Gift of James Belden, in memory of Evelyn
Berry Belden, 1971
1971.101

Peter Paul Rubens
Flemish, 1577–1640
*Portrait of a Man, Possibly an Architect or
Geographer*
Oil on copper, 8¹/₂ × 5³/₄ in.
(21.6 × 14.6 cm)
Inscribed: (upper left) [MDLXXX]XVII; (upper
right) ÆTAT. XXVI·; (engraved, verso of copper
plate) PETRVS PAVLVS RVBENS / PI.
The Jack and Belle Linsky Collection, 1982
1982.60.24

Peter Paul Rubens

Flemish, 1577–1640

Study of Two Heads
Oil on wood, 27¹/₂ × 20¹/₂ in.
(69.9 × 52.1 cm)
Bequest of Miss Adelaide Milton de Groot
(1876–1967), 1967
67.187.99

The Holy Family with Saint Elizabeth,
Saint John, and a Dove
Oil on wood, 26 × 20¹/₄ in. (66 × 51.4 cm)
Bequest of Ada Small Moore, 1955
55.135.1

Peter Paul Rubens
and
Jan Brueghel the Elder

Flemish, 1568–1625

The Feast of Acheloüs
Oil on wood, 42¹/₂ × 64¹/₂ in.
(108 × 163.8 cm)
Gift of Alvin and Irwin Untermeyer, in
memory of their parents, 1945
45.141

Peter Paul Rubens

Flemish, 1577–1640

Atalanta and Meleager
Oil on wood, 52¹/₂ × 42 in.
(133.4 × 106.7 cm)
Fletcher Fund, 1944
44.22

Portrait of a Woman, Probably Susanna
Lunden (née Fourment, 1599–1628)
Oil on wood, 30¹/₄ × 23⁵/₈ in.
(76.8 × 60 cm), including added strip of
3³/₄ in. (9.5 cm) at bottom
Gift of Mr. and Mrs. Charles Wrightsman,
1976
1976.218

The Triumph of Henry IV
This is the final oil sketch of four (art
market, 1984; Wallace Collection, London;
and Musée Bonnat, Bayonne) for the painting
(Uffizi, Florence), which was a projected
decoration for the Palais du Luxembourg,
Paris.
Oil on wood, 19¹/₂ × 32⁷/₈ in.
(49.5 × 83.5 cm)
Rogers Fund, 1942
42.187

67.187.99

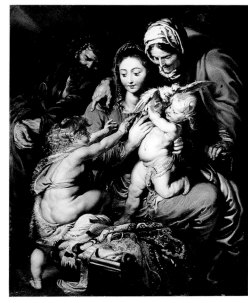

55.135.1

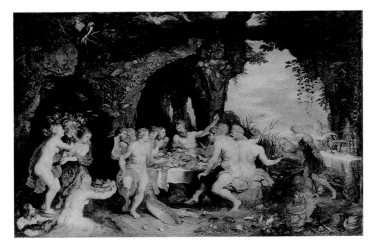

45.141

44.22

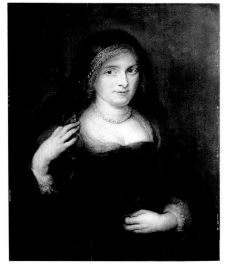

1976.218

42.187

37.160.12

1984.433.336

02.24

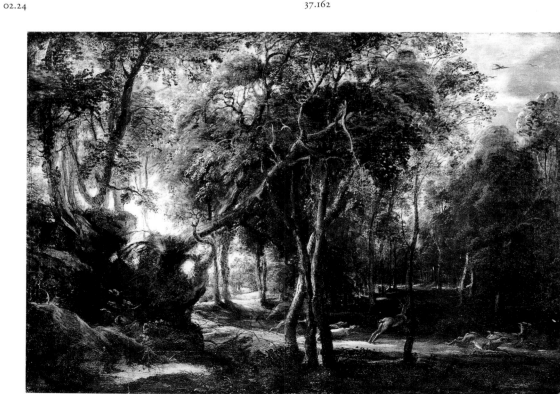

1990.196

The Glorification of the Eucharist
This painting is a design for the altarpiece ensemble formerly on the high altar of the Carmelite church in Antwerp.
Oil on wood, 28 × 19 in. (71.1 × 48.3 cm)
Bequest of Ogden Mills, 1929
37.160.12

The Coronation of the Virgin
This is a sketch for a canvas by Rubens with workshop assistance (formerly Kaiser-Friedrich-Museum, Berlin, destroyed in 1945).
Oil on wood, 19⁵/₈ × 16 in.
(49.8 × 40.6 cm)
Bequest of Scofield Thayer, 1982
1984.433.336

The Holy Family with Saints Francis and Anne and the Infant Saint John the Baptist
Oil on canvas, 69¹/₂ × 82¹/₈ in.
(176.5 × 208.6 cm)
Gift of James Henry Smith, 1902
02.24

Venus and Adonis
Oil on canvas, with added strips,
77³/₄ × 95⁵/₈ in. (197.5 × 242.9 cm)
Gift of Harry Payne Bingham, 1937
37.162

A Forest at Dawn with a Deer Hunt
Oil on wood, 24¹/₄ × 35¹/₂ in.
(61.5 × 90.2 cm)
Purchase, The Annenberg Foundation, Mrs. Charles Wrightsman, Michel David-Weill, The Dillon Fund, Henry J. and Drue Heinz Foundation, Lola Kramarsky, Annette de la Renta, Mr. and Mrs. Arthur Ochs Sulzberger, The Vincent Astor Foundation, and Peter J. Sharp Gifts; special funds, gifts, and other gifts and bequests, by exchange, 1990
1990.196

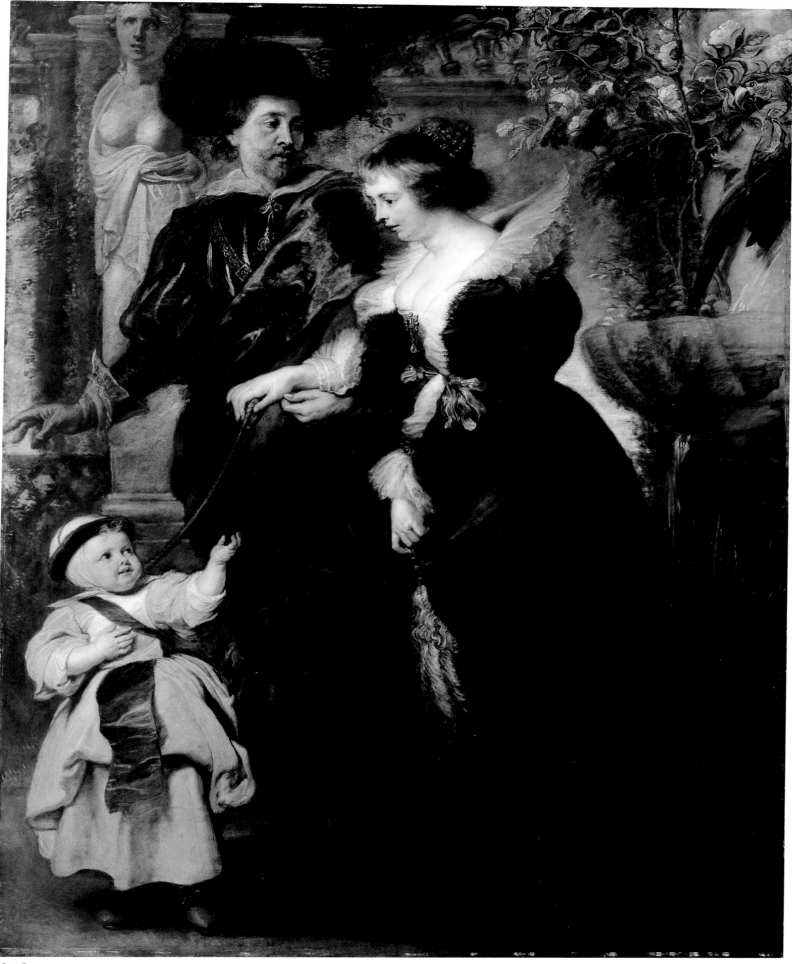

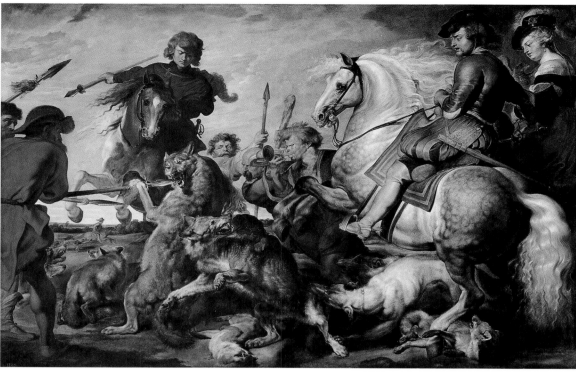

10.73

32.100.42

32.100.37

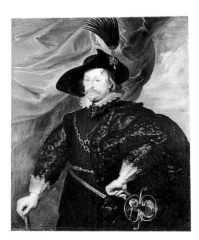

29.100.13

91.26.4

Peter Paul Rubens

Flemish, 1577–1640

Rubens, His Wife Helena Fourment
(1614–1673), and Their Son Peter Paul
(born 1637)
Oil on wood, 80¼ × 62¼ in.
(203.8 × 158.1 cm)
Gift of Mr. and Mrs. Charles Wrightsman, in
honor of Sir John Pope-Hennessy, 1981
1981.238

Peter Paul Rubens and Workshop

Wolf and Fox Hunt
Oil on canvas, 96⅝ × 148⅛ in.
(245.4 × 376.2 cm)
Inscribed (lower left): 1125
John Stewart Kennedy Fund, 1910
10.73

Workshop of Peter Paul Rubens

Virgin and Child
Oil on wood, 39¾ × 30⅜ in.
(101 × 77.2 cm)
The Friedsam Collection, Bequest of Michael
Friedsam, 1931
32.100.42

Frans Francken I (1542–1616)
Oil on wood, 25¼ × 19⅛ in.
(64.1 × 48.6 cm)
The Friedsam Collection, Bequest of Michael
Friedsam, 1931
32.100.37

Ladislas Sigismund IV (1595–1648), *King of*
Poland
Oil on canvas, 49¼ × 39¾ in.
(125.1 × 101 cm)
H. O. Havemeyer Collection, Bequest of
Mrs. H. O. Havemeyer, 1929
29.100.13

Susanna and the Elders
Oil on wood, 18¼ × 25⅜ in.
(46.4 × 64.5 cm)
Marquand Collection, Gift of Henry G.
Marquand, 1890
91.26.4

Workshop of Peter Paul Rubens

Saint Teresa of Ávila Interceding for Souls in Purgatory
Oil on wood, 25¹/₄ × 19¹/₄ in.
(64.1 × 48.9 cm)
Gift of J. Pierpont Morgan, 1917
17.190.19

Copies after Peter Paul Rubens

Flemish, 17th century

Ferdinand (1609–1641), *Cardinal-Infante of Spain*
Oil on wood, 23¹/₄ × 19⁵/₈ in.
(59.1 × 49.8 cm)
Gift of Mrs. Ralph J. Hines, 1956
56.172

probably 17th century

Portrait of a Young Girl, Possibly Clara Serena Rubens (1611–1623), *the Artist's Daughter*
Oil on wood, 14 × 10¹/₄ in. (35.6 × 26 cm)
Gift of Josephine Bay Paul, 1960
60.169

probably 18th century

Cambyses Appointing Otanes Judge
Oil on wood, 18 × 17¹/₂ in.
(45.7 × 44.5 cm)
Gift of William E. Dodge, 1900
00.16

Jacob van Hulsdonck

Flemish, 1582–1647

Still Life: A Basket of Grapes and Other Fruit
Oil on wood, 19⁵/₈ × 25¹/₂ in.
(49.8 × 64.8 cm)
Signed (lower left): IVHVLSDON[C]K·[initials in monogram] FE·
The Alfred N. Punnett Endowment Fund,
1964
64.294

Abraham van Diepenbeeck

Flemish, 1596–1675

Saint Cecilia
Oil on canvas, 47⁷/₈ × 40³/₄ in.
(121.6 × 103.5 cm)
H. O. Havemeyer Collection, Bequest of
Mrs. H. O. Havemeyer, 1929
29.100.14

17.190.19

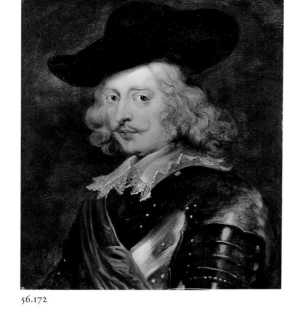

56.172

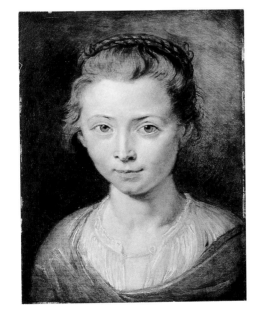

60.169

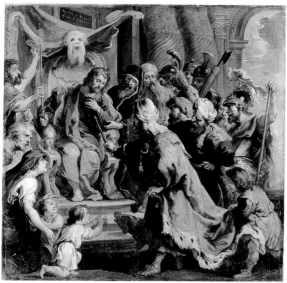

00.16

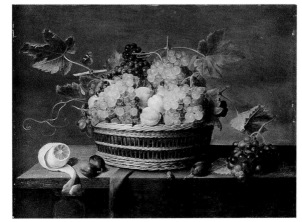

64.294

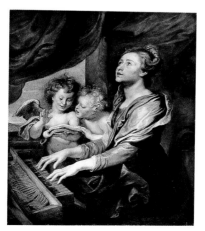

29.100.14

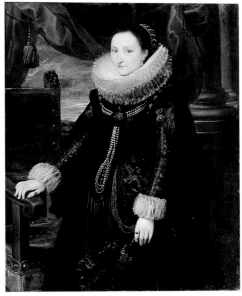

89.15.37

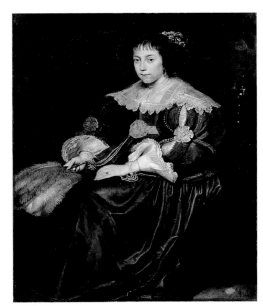

71.46

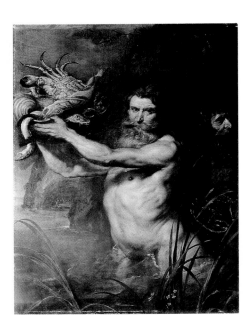

06.1039

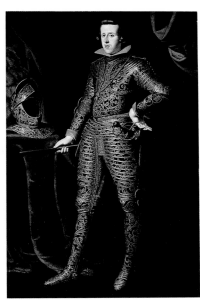

45.128.14

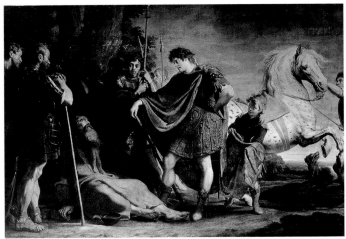

71.1

Cornelis de Vos
Flemish, 1583/84–1651
Portrait of a Woman
Oil on wood, 49³/₈ × 38 in.
(125.4 × 96.5 cm)
Marquand Collection, Gift of Henry G.
Marquand, 1889
89.15.37

Portrait of a Young Woman
Oil on canvas, 46¹/₂ × 37¹/₄ in.
(118.1 × 94.6 cm), including added strip of
2³/₄ in. (7 cm) at top
Purchase, 1871
71.46

Attributed to Cornelis de Vos
and
Frans Snyders
Flemish, 1579–1657
Two Tritons at the Feast of Acheloüs
Oil on canvas, 62³/₄ × 45⁷/₈ in.
(159.4 × 116.5 cm)
Marquand Fund, 1906
06.1039

Gaspar de Crayer
Flemish, 1585–1669
Philip IV (1605–1665) *in Parade Armor*
Oil on canvas, 78 × 46¹/₂ in.
(198.1 × 118.1 cm)
Bequest of Helen Hay Whitney, 1944
45.128.14

*The Meeting of Alexander the Great and
Diogenes*
Oil on canvas, 88³/₄ × 127⁵/₈ in.
(225.4 × 324.2 cm), including added strips of
13¹/₂ in. (34.3 cm) at left and 15¹/₂ in.
(39.4 cm) at right
Purchase, 1871
71.1

Pieter Neeffs the Elder

Flemish, active 1605–1656/61

and

Frans Francken III

Flemish, 1607–1667

Interior of a Gothic Church by Day

Oil on copper, 5⅛ × 6½ in. (13 × 16.5 cm)
Signed: (left, under window) P.N.; (lower
right, inside painted frame) [Pi]eter Neeffs f.;
(left, on column base) ffr[anc]k[en]
Bequest of Edward C. Post, 1915
30.58.20

Interior of a Gothic Church at Night

Pendant to 30.58.20
Oil on copper, 5⅛ × 6½ in. (13 × 16.5 cm)
Signed: (right, under window) P.N.; (bottom
center, on tomb) ffranck[en]
Bequest of Edward C. Post, 1915
30.58.21

Pieter Neeffs the Elder

Flemish, active 1605–1656/61

Interior of a Gothic Church

Oil on wood, 16⅝ × 22⅞ in. (42.2 × 58.1 cm)
Signed and dated: (right, on pier) NEFS.;
(above signature, on monument) . . . /
ANNO. / 1636
Purchase, 1871
71.109

Pieter Snayers

Flemish, 1592–?1667

Soldiers Bivouacking

Oil on wood, 28⅝ × 41⅛ in. (72.7 × 104.5 cm)
Signed (lower left, below footpath): Peet[er]
Snaeÿers
The Collection of Giovanni P. Morosini,
presented by his daughter Giulia, 1932
32.75.3

Jacob Jordaens

Flemish, 1593–1678

***The Holy Family with Saint Anne and the
Young Baptist and His Parents***

Oil on wood, 66⅞ × 59 in. (169.9 × 149.9 cm)
Inscribed (lower center): RADIX SANTA ET
RAMI / Rōm · 11 · 16 (If the root be holy, so are
the branches [Romans 11:16].)
Purchase, 1871
71.11

30.58.20

30.58.21

71.109

32.75.3

71.11

67.187.76

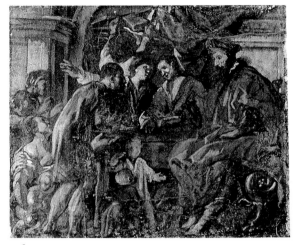

71.83

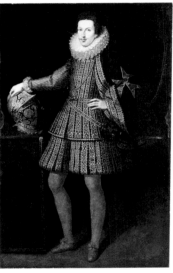

22.150

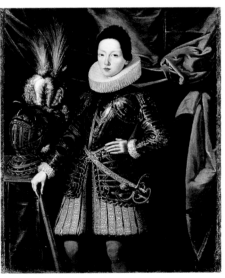

45.128.13

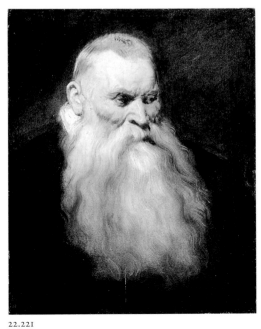

22.221

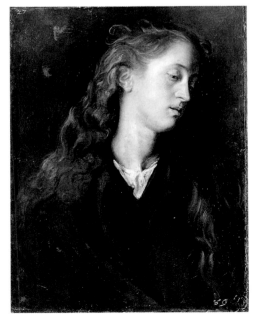

57.37

The Holy Family with Shepherds
Oil on canvas, transferred from wood,
42 × 30 in. (106.7 × 76.2 cm)
Signed and dated (top left): J.JOR[DAENS] FE /
1616
Bequest of Miss Adelaide Milton de Groot
(1876–1967), 1967
67.187.76

Saint Ives Receiving Supplicants
Oil on paper, laid down on canvas,
10 × 11⁷/8 in. (25.4 × 30.2 cm)
Purchase, 1871
71.83

Workshop of Justus Sustermans
Flemish, 1597–1681
Cosimo II de' Medici (1590–1621),
Grand Duke of Tuscany
Oil on canvas, transferred from wood,
78 × 48 in. (198.1 × 121.9 cm)
Gift of Bashford Dean, 1922
22.150
ARMS AND ARMOR

Copy after Justus Sustermans
Flemish, 17th century
Ferdinando II de' Medici (1610–1670) *as a*
Boy
Oil on canvas, 51⁷/8 × 40¹/2 in.
(131.8 × 102.9 cm)
Bequest of Helen Hay Whitney, 1944
45.128.13

Anthony van Dyck
Flemish, 1599–1641
Study Head of an Old Man with a White
Beard
Oil on wood, 26 × 20¹/4 in. (66 × 51.4 cm)
Egleston Fund, 1922
22.221

Study Head of a Young Woman
Oil on paper, laid down on wood,
22¹/4 × 16³/8 in. (56.5 × 41.6 cm)
Inscribed: (upper left) 27; (lower right) 89;
[on the lined paper support, a few Italian and
Flemish words can be read]
Gift of Mrs. Ralph J. Hines, 1957
57.37

Anthony van Dyck
Flemish, 1599–1641

Portrait of a Man
Oil on wood, 41³/₄ × 28⁵/₈ in.
(106 × 72.7 cm)
Marquand Collection, Gift of Henry G.
Marquand, 1889
89.15.11

Self-portrait
Oil on canvas, 47¹/₈ × 34⁵/₈ in.
(119.7 × 87.9 cm)
The Jules Bache Collection, 1949
49.7.25

Virgin and Child
Oil on wood, 25¹/₄ × 19¹/₂ in.
(64.1 × 49.5 cm)
Fletcher Fund, 1951
51.33.1

Portrait of a Woman, Called the Marchesa Durazzo
Oil on canvas, 44⁵/₈ × 37³/₄ in.
(113.3 × 95.9 cm)
Bequest of Benjamin Altman, 1913
14.40.615

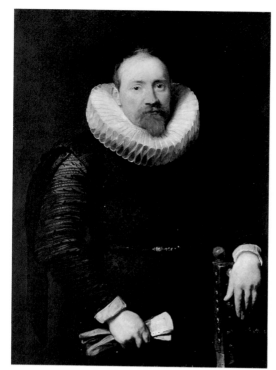

89.15.11

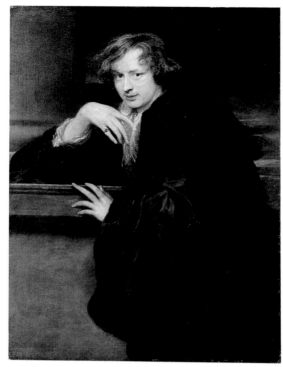

49.7.25

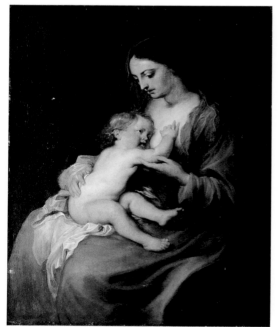

51.33.1

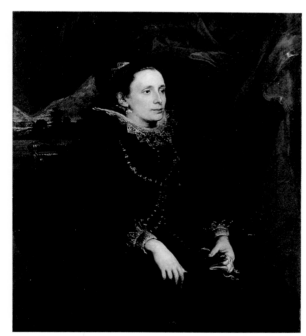

14.40.615

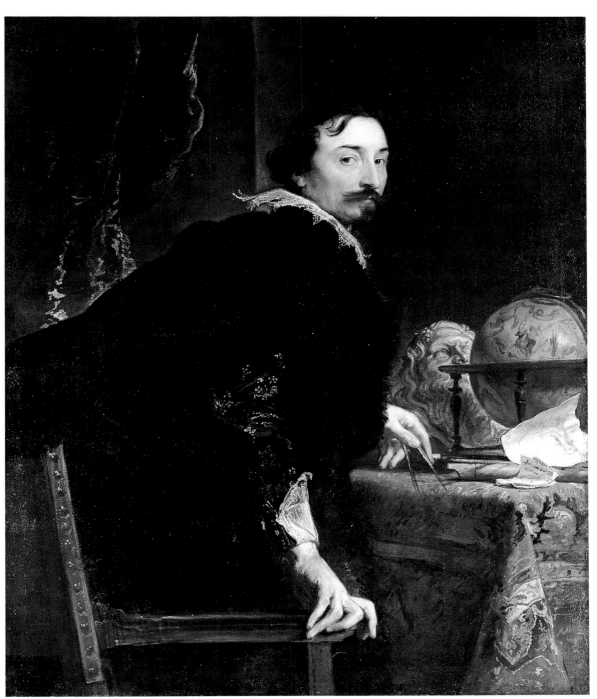

14.40.619

Lucas van Uffel (died 1637)
Oil on canvas, 49 × 39⁵/₈ in.
(124.5 × 100.6 cm)
Bequest of Benjamin Altman, 1913
14.40.619

Saint Rosalie Interceding for the Plague-Stricken of Palermo
Oil on canvas, 39¹/₄ × 29 in.
(99.7 × 73.7 cm)
Purchase, 1871
71.41

Virgin and Child with Saint Catherine of Alexandria
Oil on canvas, 43 × 35³/₄ in.
(109.2 × 90.8 cm); with added strips
44¹/₈ × 37 in. (112.1 × 94 cm)
Bequest of Lillian S. Timken, 1959
60.71.5

Robert Rich (1587–1658), *Second Earl of Warwick*
Oil on canvas, 81⁷/₈ × 50³/₈ in.
(208 × 128 cm), with added strip of 2¹/₈ in.
(5.4 cm) at top
Inscribed (lower left): Robert Rich 2nd
Earle / Warwick Uncle [to] Lady Mary /
Countess Breadalbane.
The Jules Bache Collection, 1949
49.7.26

James Stuart (1612–1655), *Duke of Richmond and Lennox*
Oil on canvas, 85 × 50¹/₄ in.
(215.9 × 127.6 cm)
Marquand Collection, Gift of Henry G.
Marquand, 1889
89.15.16

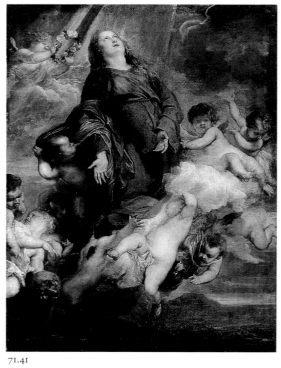

71.41

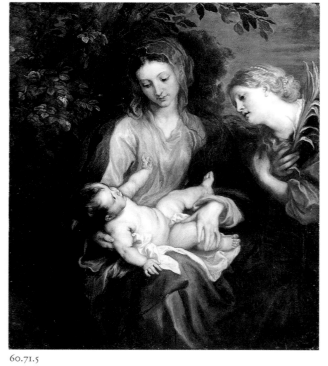

60.71.5

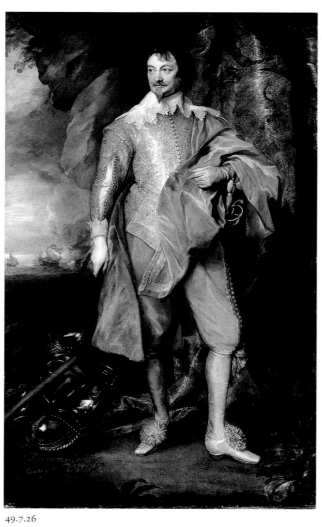

49.7.26

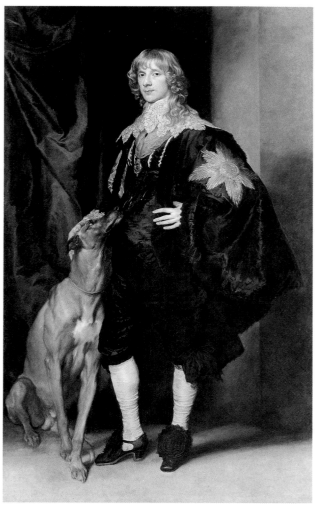

89.15.16

49.145.2

49.145.1

Attributed to Anthony van Dyck

A Man Mounting a Horse
Oil on wood, monochrome, 10 × 8³/₄ in.
(25.4 × 22.2 cm)
Gift of Mr. and Mrs. Siegfried Bieber, 1949
49.145.2

A Man Riding a Horse
Oil on wood, monochrome, 10¹/₈ × 8⁷/₈ in.
(25.7 × 22.5 cm)
Gift of Mr. and Mrs. Siegfried Bieber, 1949
49.145.1

Copy after Anthony van Dyck

Flemish, 17th century

Sir Peter Paul Rubens (1577–1640)
The painting is a copy of an oil sketch by
van Dyck (private collection).
Oil on wood, monochrome, 10 × 7⁵/₈ in.
(25.4 × 19.4 cm)
Bequest of Bertha H. Buswell, 1941
42.23.1

42.23.1

71.50

Pieter Neeffs the Younger

Flemish, born 1620, died after 1675
and
Frans Francken III

Flemish, 1607–1667

Interior of a Gothic Church at Night
Oil on wood, 10 × 7³/₄ in.
(25.4 × 19.7 cm)
Signed (bottom center, on tombstone): D. i
[De jonge] Franck·f·
Purchase, 1871
71.50

Jan Brueghel the Younger

Flemish, 1601–1678

Aeneas and the Sibyl in the Underworld
Oil on copper, 10¹/₂ × 14¹/₈ in.
(26.7 × 35.9 cm)
Gift of Mrs. Erna S. Blade, in memory of her
uncle, Sigmund Herrmann, 1991
1991.444

A Basket of Flowers
Oil on wood, 18¹/₂ × 26⁷/₈ in.
(47 × 68.3 cm)
Bequest of Miss Adelaide Milton de Groot
(1876–1967), 1967
67.187.58

1991.444

67.187.58

Adriaen Brouwer

Flemish, 1606?–1638

A Peasant Woman Picking Fleas off a Dog

Oil on wood; oval 7¹⁄₈ × 5³⁄₈ in.
(18.1 × 13.7 cm); set in a rectangular panel
8 × 6¹⁄₄ in. (20.3 × 15.9 cm)
The Friedsam Collection, Bequest of Michael
Friedsam, 1931
32.100.1

A Peasant with a Bird

Pendant to 32.100.1
Oil on wood; oval 7¹⁄₈ × 5¹⁄₂ in.
(18.1 × 14 cm); set in a rectangular panel
8 × 6¹⁄₄ in. (20.3 × 15.9 cm)
The Friedsam Collection, Bequest of Michael
Friedsam, 1931
32.100.3

The Smokers

Oil on wood, 18¹⁄₄ × 14¹⁄₂ in.
(46.4 × 36.8 cm)
Signed (lower left): Brauwer
The Friedsam Collection, Bequest of Michael
Friedsam, 1931
32.100.21

Copy after Adriaen Brouwer

Flemish, 17th century

The Brawl

Oil on wood, 9⁵⁄₈ × 7¹⁄₂ in.
(24.4 × 19.1 cm)
The Friedsam Collection, Bequest of Michael
Friedsam, 1931
32.100.2

David Teniers the Younger

Flemish, 1610–1690

Guardroom with the Deliverance of Saint Peter

Oil on wood, 21³⁄₄ × 29⁷⁄₈ in.
(55.2 × 75.9 cm)
Signed (lower right): D·TENIERS·f
Anonymous Gift, 1964
64.65.5

Judith with the Head of Holofernes

Oil on copper, 14¹⁄₂ × 10³⁄₈ in.
(36.8 × 26.4 cm)
Signed (upper right): D·TENIERS·F
Gift of Gouverneur Kemble, 1872
72.2

32.100.1

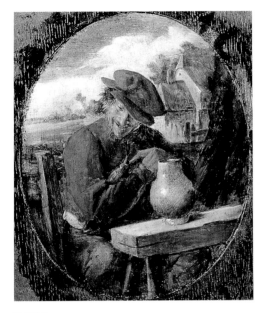

32.100.3

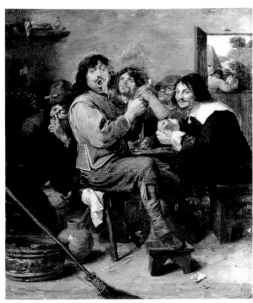

32.100.21

32.100.2

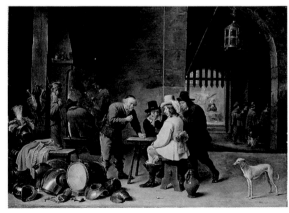

64.65.5

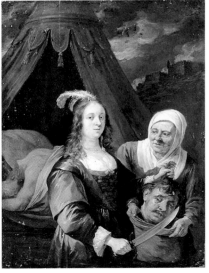

72.2

89.15.25

89.15.22

1975.1.126

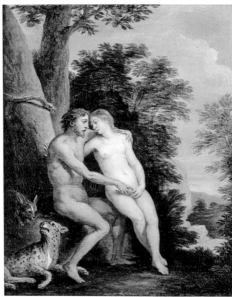

1975.1.127

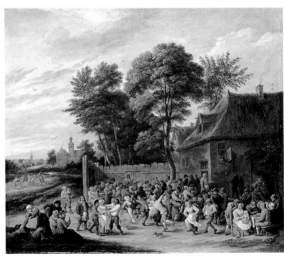

71.99

22.47.3

The Good Samaritan

This painting and the following (89.15.22) are two of an extensive series of copies, completed in 1656, after paintings then in the collection of Archduke Leopold Wilhelm of Austria, Governor of the Netherlands. The source of Teniers's copy is a painting by Francesco(?) Bassano (Kunsthistorisches Museum, Vienna).
Oil on wood, 6³/₄ × 9 in. (17.1 × 22.9 cm)
Marquand Collection, Gift of Henry G. Marquand, 1889
89.15.25

Shepherds and Sheep

The whereabouts of the painting by Francesco(?) Bassano of which this is a copy are unknown.
Oil on wood, 6⁵/₈ × 9 in. (16.8 × 22.9 cm)
Marquand Collection, Gift of Henry G. Marquand, 1889
89.15.22

An Incantation

Oil on wood, 8⁷/₈ × 6⁵/₈ in.
(22.5 × 16.8 cm)
Robert Lehman Collection, 1975
1975.1.126
ROBERT LEHMAN COLLECTION

Adam and Eve in Paradise

Oil on wood, 8³/₄ × 6¹/₂ in.
(22.2 × 16.5 cm)
Robert Lehman Collection, 1975
1975.1.127
ROBERT LEHMAN COLLECTION

Peasants Dancing and Feasting

Oil on canvas, 25¹/₈ × 29¹/₂ in.
(63.8 × 74.9 cm); with added strip
26⁷/₈ × 29¹/₂ in. (68.3 × 74.9 cm)
Signed (lower right): D·TENIERS·FEC
Purchase, 1871
71.99

Workshop of David Teniers the Younger

Landscape with Thatched Cottages

Oil on wood, 5³/₄ × 7³/₄ in.
(14.6 × 19.7 cm)
Inscribed (lower right): DT [monogram]
Bequest of John Henry Abegg, 1921
22.47.3

Jan Fyt
Flemish, 1611–1661

A Hare, Partridges, and Fruit
Oil on canvas, 37¹/₂ × 43¹/₂ in.
(95.3 × 110.5 cm)
Signed and dated (left center): [Joa]nnes FyT
/ 16[]
The Friedsam Collection, Bequest of Michael
Friedsam, 1931
32.100.141

A Partridge and Small Game Birds
Oil on canvas, 18¹/₄ × 14¹/₄ in.
(46.4 × 36.2 cm)
Signed (lower left): ·Joannes·FYT·
Purchase, 1871
71.45

A Basket and Birds
This painting and the following (71.44) are
very probably pendants and may have been
intended as overdoors.
Oil on canvas, 23³/₄ × 30¹/₄ in.
(60.3 × 76.8 cm)
Purchase, 1871
71.43

A Hare and Birds
Oil on canvas, 23⁷/₈ × 31 in.
(60.6 × 78.7 cm)
Purchase, 1871
71.44

Jacques d'Arthois
Flemish, born 1613, died about 1686
and
Flemish Painter
about 1645

Family Group in a Landscape
Oil on canvas, 49¹/₈ × 60¹/₈ in.
(124.8 × 152.7 cm)
Theodore M. Davis Collection, Bequest of
Theodore M. Davis, 1915
30.95.241

Peeter Gysels
Flemish, 1621–1690/91

A Winter Carnival in a Small Flemish Town
Oil on copper, 10¹/₄ × 13³/₄ in.
(26 × 34.9 cm)
Signed (lower right): PEETER·GEYSELS
Gift of Francis Neilson, 1945
45.146.4

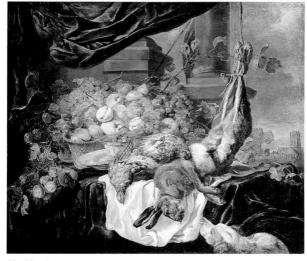

32.100.141

71.45

71.43

71.44

30.95.241

45.146.4

71.12

71.13

David Ryckaert III

Flemish, 1612–1661

The Yard of the Inn at Emmaus

Oil on canvas, 35⅝ × 45⅜ in.
(90.5 × 115.3 cm)
Purchase, 1871
71.12

Rustic Interior

Oil on canvas, 36⅜ × 45⅝ in.
(92.4 × 115.9 cm)
Signed (lower left): D. Rÿckart
Purchase, 1871
71.13

Michiel Sweerts

Flemish, 1618–1664

Clothing the Naked

Oil on canvas, 32¼ × 45 in.
(81.9 × 114.3 cm)
Gift of Mr. and Mrs. Charles Wrightsman,
1984
1984.459.1

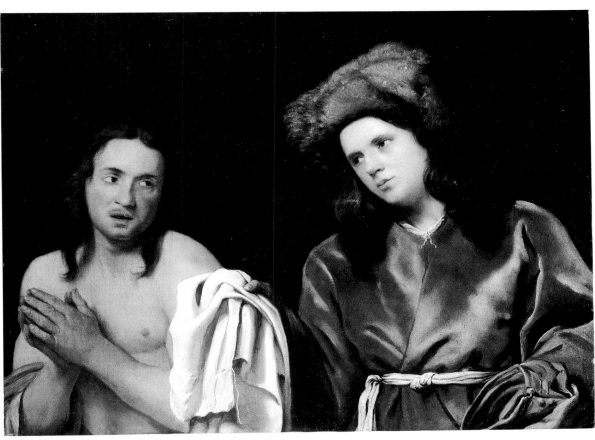

1984.459.1

Wallerant Vaillant

Flemish, 1623–1677

Portrait of a Boy with a Falcon

Oil on canvas, 29³/₄ × 25 in.
(75.6 × 63.5 cm)
Purchase, George T. Delacorte Jr. Gift, 1957
57.104

Gillis van Tilborgh

Flemish, born about 1625, died about 1678

Group Portrait: A Wedding Celebration

Oil on canvas, 45¹/₂ × 63¹/₄ in.
(115.6 × 160.7 cm)
Purchase, 1871
71.32

Adam Frans van der Meulen

Flemish, 1632–1690

A Cavalry Engagement

Oil on wood, 8⁵/₈ × 12¹/₂ in.
(21.9 × 31.8 cm)
Signed (lower center): .A.F.V̄ MEVLEN.FEC.
Purchase, 1871
71.96

Nicolaes van Veerendael

Flemish, 1640–1691

A Bouquet of Flowers in a Crystal Vase

Oil on canvas, 19¹/₂ × 15⁷/₈ in.
(49.5 × 40.3 cm)
Signed and dated (lower left): N. V.
Veerendael, 1662.
Bequest of Stephen Whitney Phoenix, 1881
81.1.652

Peter Jacob Horemans

Flemish, 1700–1776

*A Musical Gathering at the Court of the
Elector Karl Albrecht of Bavaria*

Oil on canvas, 34¹/₂ × 42 in.
(87.6 × 106.7 cm)
Signed and dated (right, on pedestal):
P. Horemans. 1730
The Collection of Giovanni P. Morosini,
presented by his daughter Giulia, 1932
32.75.4

Léonard Defrance

Flemish, 1735–1805

The Forge

Oil on wood, 12⁵/₈ × 16¹/₂ in.
(32.1 × 41.9 cm)
Signed (lower left): L·Defrance· / Liege
Purchase, 1871
71.93

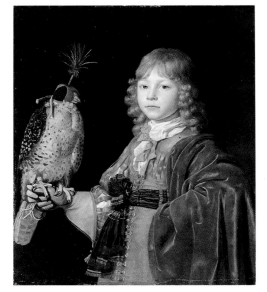

57.104

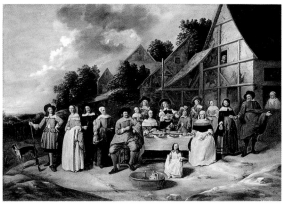

71.32

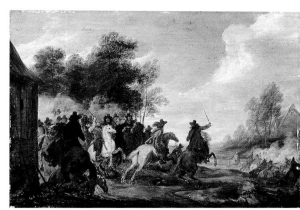

71.96

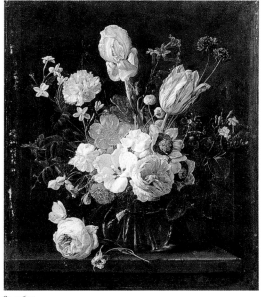

81.1.652

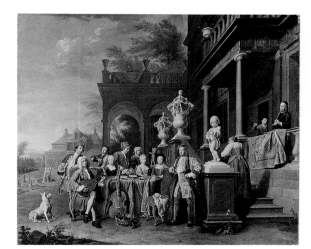

32.75.4

71.93

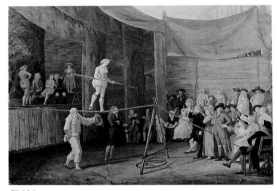

71.105

71.154

The Rope Dance
Oil on wood, 19⁷/₈ × 28⁵/₈ in.
(50.5 × 72.7 cm)
Signed (lower right): L. Defrance / de Liege
Purchase, 1871
71.105

Brigands Dividing Booty
Oil on wood, 18⁷/₈ × 29¹/₈ in.
(47.9 × 74 cm)
Signed (lower center, on trunk): L Defrance·
/ de Liege·
Purchase, 1871
71.154

Peter Faes
Flemish, 1750–1814

Flowers by a Stone Vase
Oil on wood, 20 × 14⁷/₈ in.
(50.8 × 37.8 cm)
Signed and dated (lower right): P: Faes 1786
Bequest of Catherine D. Wentworth, 1948
48.187.737

Flowers in a Stone Vase
Pendant to 48.187.737
Oil on wood, 19¹/₂ × 15¹/₈ in.
(49.5 × 38.4 cm)
Signed and dated (lower right): P: Faes 1786
Bequest of Catherine D. Wentworth, 1948
48.187.738

48.187.737

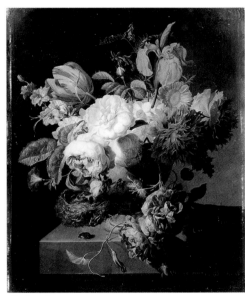

48.187.738

Joachim Wtewael

Dutch, 1566–1638

The Golden Age

Oil on copper, 8⁷/₈ × 12 in. (22.5 × 30.5 cm)
Signed and dated (bottom center, on rock):
JOACHIM, WTE / WAEL FECIT / AN 1605
Purchase, The Edward Joseph Gallagher III
Memorial Collection, Edward J. Gallagher Jr.
Bequest; Lila Acheson Wallace Gift; special
funds; and Gift of George Blumenthal,
Bequest of Lillian S. Timken, The Collection
of Giovanni P. Morosini, presented by his
daughter Giulia, Gift of Mr. and Mrs.
Nathaniel Spear Jr., Gift of Mrs. William M.
Haupt, from the collection of Mrs. James B.
Haggin, special funds, gifts, and bequests, by
exchange, 1993
1993.333

Abraham Bloemaert

Dutch, 1564–1651

Moses Striking the Rock

Oil on canvas, 31³/₈ × 42¹/₂ in.
(79.7 × 108 cm)
Signed and dated (lower right):
A·Blomaert·fe / aº·1596
Purchase, Gift of Mary V. T. Eberstadt, by
exchange, 1972
1972.171

Jacques de Gheyn the Elder

Dutch, 1565–1629

Vanitas Still Life

Oil on wood, 32¹/₂ × 21¹/₄ in.
(82.6 × 54 cm)
Signed, dated, and inscribed: (on sill)
JDGHEYN FE ANº 1603 [now largely illegible];
(on keystone of arch) HVMANA / VANA
(human vanity); (lower left, on obverse of
coin) IOANA·ET·KAROLVS·REGES·[ARA]GONVM
·TRVNFATORES·[ET]·KATHOLICIS / C A (Joanna
and Charles triumphant and Catholic kings of
Aragon); (lower right, on reverse of coin)
IOANA·ET·KAROLVS·[EIVS·FI]LIVS·PRIMO·
GENITVS·DEI·GRA[CI]A·R[E]X / ARAGON[VM] /
L S (Joanna and Charles her firstborn son by
the grace of God king of Aragon) [from a
coin struck in 1528]
Charles B. Curtis, Marquand, Victor Wilbour
Memorial, and The Alfred N. Punnett
Endowment Funds, 1974
1974.1

1993.333

1972.171

1974.1

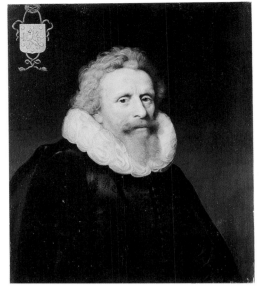

25.110.13

25.110.12

30.95.257

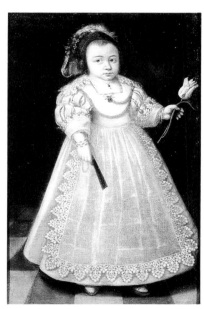

61.154

12.202

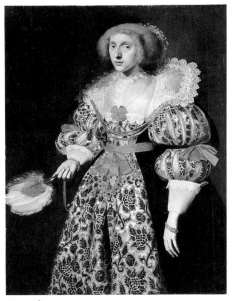

30.95.267

Michiel Jansz. van Miereveld

Dutch, 1567–1641

Jacob van Dalen (1571–1644)

Oil on wood, 27½ × 23 in. (69.9 × 58.4 cm)
Signed, dated, and inscribed (left): Ætatis.69.
/ Aº 1640. / M. Miereveld.
Arms (upper left) of the van Dalen family
Bequest of Collis P. Huntington, 1900
25.110.13

Margaretha van Clootwijk (born 1583), *Wife of Jacob van Dalen*

Pendant to 25.110.13
Oil on wood, 27¾ × 22⅞ in.
(70.5 × 58.1 cm)
Signed, dated, and inscribed (right): Ætatis.
56. / Aº 1639 / M. Miereveld
Arms (upper right) of the van Dalen and van
Clootwijk families
Bequest of Collis P. Huntington, 1900
25.110.12

Portrait of a Woman with a Lace Collar

Oil on wood, 29⅜ × 23¾ in.
(74.6 × 60.3 cm)
Theodore M. Davis Collection, Bequest of
Theodore M. Davis, 1915
30.95.257

Dutch Painter

dated 1631

Sarra Depeyster

Oil on canvas, 38¼ × 24⅛ in.
(97.2 × 61.3 cm)
Dated and inscribed (upper left): Sarra·
Depeyster Ætatis / 30. Maenden·23 Mey·
1631
Gift of Livingston L. Short and Anna
Livingston Jones, 1961
61.154
AMERICAN PAINTINGS AND SCULPTURE

Jan Anthonisz. van Ravesteyn

Dutch, born about 1570, died 1657

Portrait of a Woman

Oil on wood, 26⅞ × 22⅞ in.
(68.3 × 58.1 cm)
Signed and dated (upper right): Anno 1635 /
JVR. [monogram] F.
Gift of Henry Goldman, 1912
12.202

Workshop of Jan Anthonisz. van Ravesteyn

Portrait of a Woman with Red Hair

Oil on wood, 45 × 33⅝ in.
(114.3 × 85.4 cm)
Dated (upper left): A̅Nº 1631.
Theodore M. Davis Collection, Bequest of
Theodore M. Davis, 1915
30.95.267

Paulus Moreelse

Dutch, 1571–1638

Portrait of a Child

Oil on wood, oval, 23 × 19⁵/₈ in.
(58.4 × 49.8 cm)
Bequest of Alexandrine Sinsheimer, 1958
59.23.17

Woman Wearing a Cap and Ruffle

Oil on wood, 21¹/₄ × 24⁵/₈ in.
(54 × 62.5 cm)
Bequest of Helen R. Bleibtreu, 1985
1986.81.3

Dutch Painter

dated 1636

A Young Woman in a Landscape

Oil on wood, 26 × 19⁷/₈ in. (66 × 50.5 cm)
Dated and inscribed (lower right): Ao 1636 /
AETA. 32
The Friedsam Collection, Bequest of Michael
Friedsam, 1931
32.100.10

David Vinckboons

Dutch, 1576–1632

Forest Landscape with Two of Christ's Miracles

Jairus (far left) beseeches Christ to raise up
his daughter, whose death is announced by a
messenger (right). The woman (kneeling left)
who had an issue of blood touches the hem of
Christ's garment and is healed. These miracles
are recounted in the Synoptic Gospels (see
Matthew 9:18–22).
Oil on wood, 22³/₄ × 37¹/₄ in.
(57.8 × 94.6 cm)
Signed (left foreground, on tree): DvB
[monogram]
Bequest of Harry G. Sperling, 1971
1976.100.20

Adam Willaerts

Dutch, 1577–1664

River Scene with Boats

Oil on wood, 18¹/₄ × 33⁵/₈ in.
(46.4 × 85.4 cm)
Signed and dated (left): A.W. / 1643
Gift of George A. Hearn, 1906
06.1303

Dutch Painter

second quarter 17th century

A Young Woman in an Interior

Oil on wood, 17 × 13⁷/₈ in.
(43.2 × 35.2 cm)
Bequest of Annette B. McFadden, 1971
1971.186

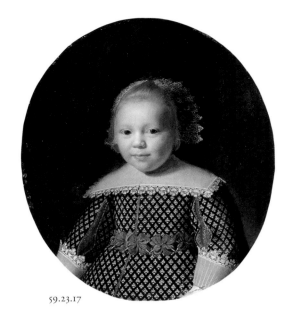

59.23.17

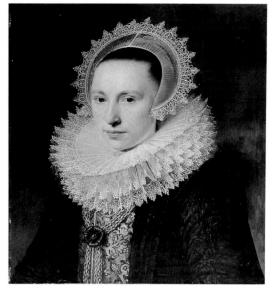

1986.81.3

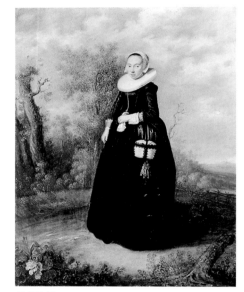

32.100.10

1976.100.20

06.1303

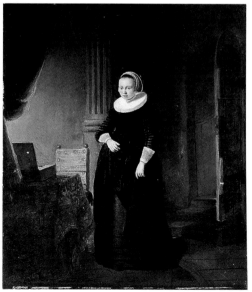

1971.186

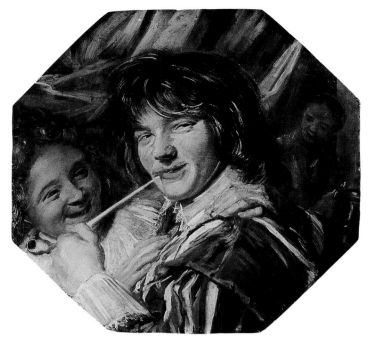

89.15.34

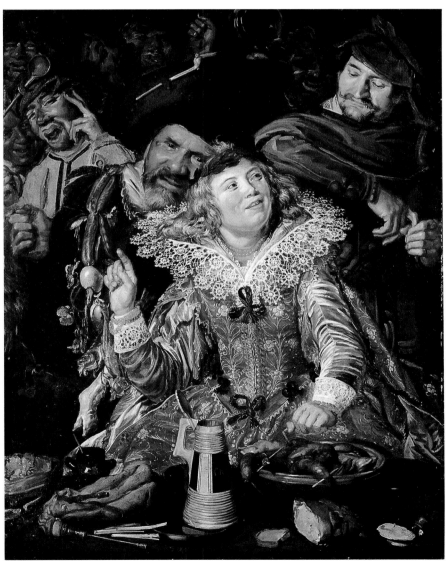

14.40.605

Frans Hals
Dutch, born after 1580, died 1666
The Smoker
Oil on wood, octagonal, 18³/₈ × 19¹/₂ in.
(46.7 × 49.5 cm)
Marquand Collection, Gift of Henry G.
Marquand, 1889
89.15.34

Merrymakers at Shrovetide
Oil on canvas, 51³/₄ × 39¹/₄ in.
(131.4 × 99.7 cm)
Signed (on flagon): fh
Bequest of Benjamin Altman, 1913
14.40.605

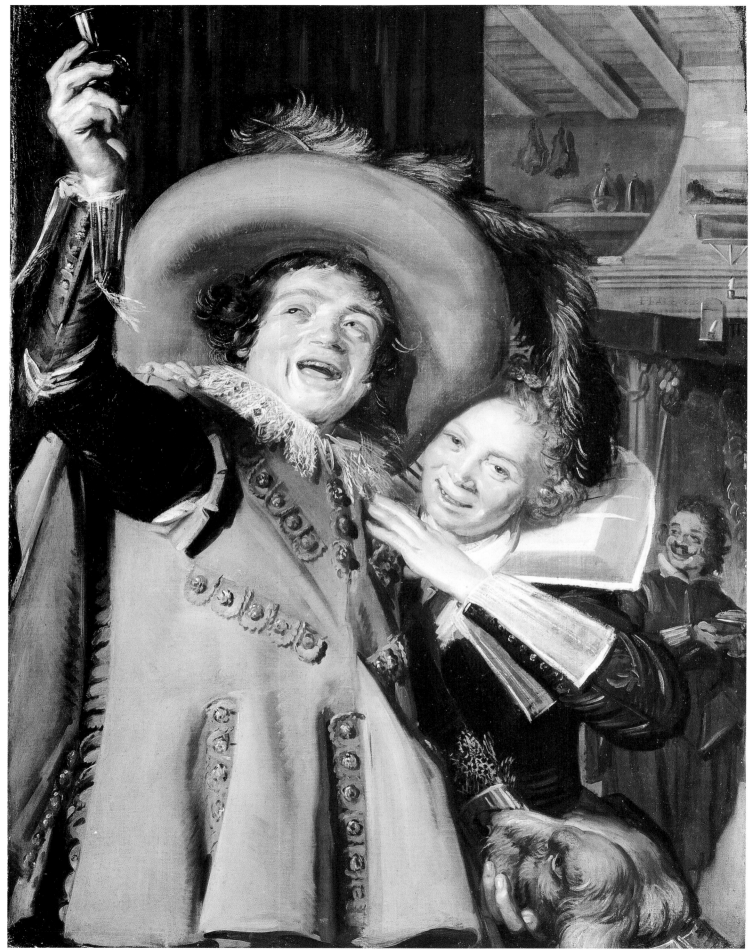

14.40.602

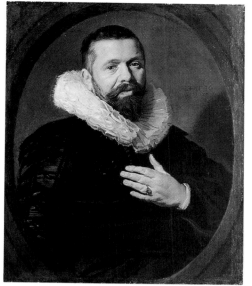

49.7.34

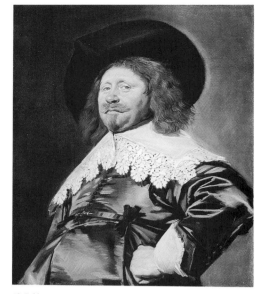

49.7.33

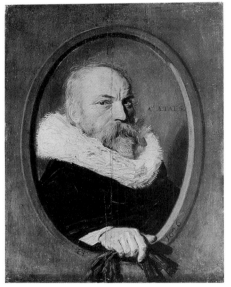

29.100.8

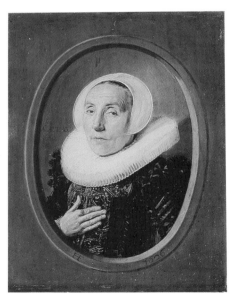

29.100.9

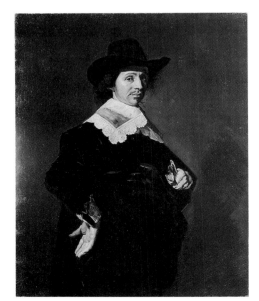

26.101.11

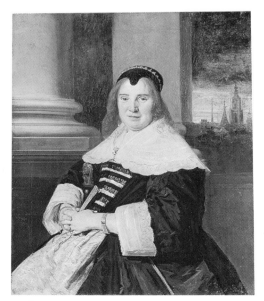

91.26.10

Frans Hals

Dutch, born after 1580, died 1666

Young Man and Woman in an Inn ("Yonker Ramp and His Sweetheart")

Oil on canvas, 41¹/₂ × 31¹/₄ in.
(105.4 × 79.4 cm)
Signed and dated (right, above fireplace):
FHALS [initials in monogram] 1623
Bequest of Benjamin Altman, 1913
14.40.602

Portrait of a Bearded Man with a Ruff

Oil on canvas, 30 × 25 in. (76.2 × 63.5 cm)
Dated and inscribed (right): ÆTAT 36 / ANᵒ
1625
The Jules Bache Collection, 1949
49.7.34

Claes Duyst van Voorhout (born about 1600)

Oil on canvas, 31³/₄ × 26 in. (80.6 × 66 cm)
The Jules Bache Collection, 1949
49.7.33

Petrus Scriverius (1576–1660)

Oil on wood, 8³/₄ × 6¹/₂ in.
(22.2 × 16.5 cm)
Signed, dated, and inscribed: (lower border of
painted frame) FHF [initials in monogram]
1626; (right center) Aᵒ ÆTAT.50
H. O. Havemeyer Collection, Bequest of Mrs.
H. O. Havemeyer, 1929
29.100.8

Anna van der Aar (born 1576/77, died after 1626)

Pendant to 29.100.8
Oil on wood, 8³/₄ × 6¹/₂ in.
(22.2 × 16.5 cm)
Signed, dated, and inscribed: (lower border of
painted frame) FHF [initials in monogram]
1626; (left center) Aᵒ ÆTAT / 50
H. O. Havemeyer Collection, Bequest of Mrs.
H. O. Havemeyer, 1929
29.100.9

Paulus Verschuur (1606–1667)

Oil on canvas, 46³/₄ × 37 in.
(118.7 × 94 cm)
Signed, dated, and inscribed (right center):
ÆTAT SVÆ 37 / ANᵒ 1643 / FH·[monogram]
Gift of Archer M. Huntington, in memory of
his father, Collis Potter Huntington, 1926
26.101.11

Portrait of a Woman

Oil on canvas, 39³/₈ × 32¹/₄ in.
(100 × 81.9 cm)
Marquand Collection, Gift of Henry G.
Marquand, 1890
91.26.10

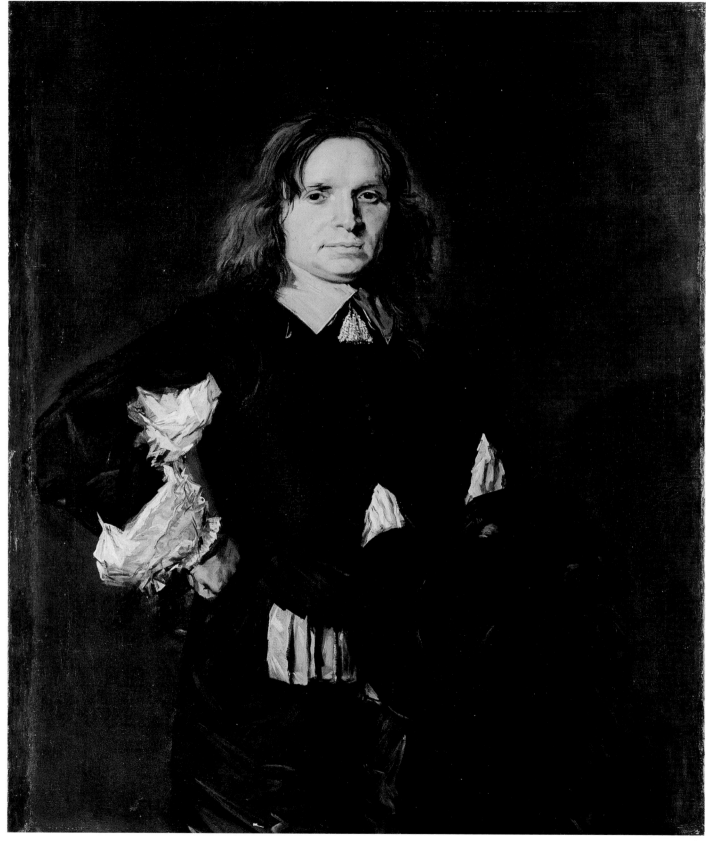

91.26.9

Frans Hals
Dutch, born after 1580, died 1666

Portrait of a Man
Oil on canvas, 43¹/₂ × 34 in. (110.5 × 86.4 cm)
Marquand Collection, Gift of Henry G.
Marquand, 1890
91.26.9

14.40.604

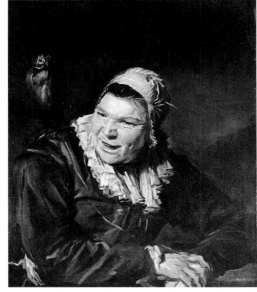

71.76

32.100.8

71.5

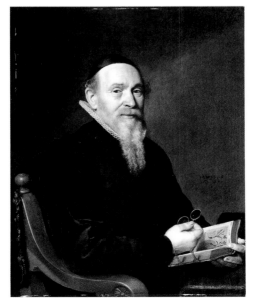

1982.60.29

1971.255

Attributed to Frans Hals

Boy with a Lute
Oil on canvas, 28³/₈ × 23¹/₄ in.
(72.1 × 59.1 cm)
Bequest of Benjamin Altman, 1913
14.40.604

Style of Frans Hals
Dutch, second quarter 17th century

Malle Babbe
Oil on canvas, 29¹/₂ × 24 in.
(74.9 × 61 cm)
Inscribed (falsely, right center, with initials of
Frans Hals): FH [monogram]
Purchase, 1871
71.76

Copy after Frans Hals
Dutch, 17th century

Frans Hals (born after 1580, died 1666)
Oil on wood, 12⁷/₈ × 11 in.
(32.7 × 27.9 cm)
The Friedsam Collection, Bequest of Michael
Friedsam, 1931
32.100.8

Jacob Vosmaer
Dutch, 1584–1641

A Vase with Flowers
Oil on wood, 33¹/₂ × 24⁵/₈ in.
(85.1 × 62.5 cm)
Signed and dated (lower left): Vosmaer 16[18?]
Purchase, 1871
71.5

David Bailly
Dutch, 1584?–1657

Portrait of a Man, Possibly a Botanist
Oil on wood, 33 × 24¹/₂ in.
(83.8 × 62.2 cm)
Dated and inscribed (center right): Ætatis 66
/ ANᵒ 1641
The Jack and Belle Linsky Collection, 1982
1982.60.29

Jacob Pynas
Dutch, born about 1585, died after 1650

Paul and Barnabas at Lystra
Oil on wood, 19 × 28⁷/₈ in.
(48.3 × 73.3 cm)
Inscribed (bottom center, on step): PL
[monogram]
Gift of Emile E. Wolf, 1971
1971.255

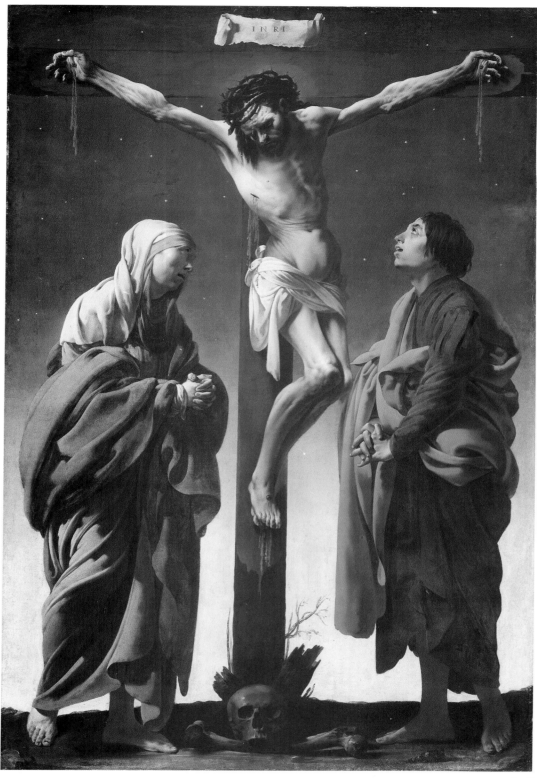

56.228

Hendrick ter Brugghen
Dutch, 1588–1629

The Crucifixion with the Virgin and Saint John
Oil on canvas, 61 × 40¼ in. (154.9 × 102.2 cm)
Signed, dated, and inscribed: (lower center)
HTB [monogram] fecit / 162[]; (on cross) IN RI
Funds from various donors, 1956
56.228

1976.100.22

71.63

57.30.1

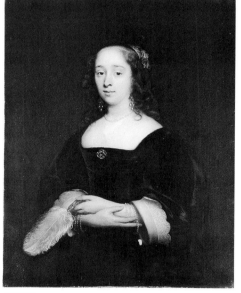

57.30.2

1975.1.125

71.108

Nicolaes Eliasz. Pickenoy
Dutch, 1588–1650/56

Man with a Celestial Globe
Oil on wood, 41¼ × 30 in.
(104.8 × 76.2 cm)
Dated and inscribed (upper right): ·Ætatis·
Sua·/·47·/Anº·1624·
Bequest of Harry G. Sperling, 1971
1976.100.22

Abraham de Vries
Dutch, born about 1590, died 1650/52

Portrait of a Man
Oil on wood, 25¼ × 21 in.
(64.1 × 53.3 cm)
Signed, dated, and inscribed (right): Fecit
Hage Comitis / A. de Vries / anno 1643.
Purchase, 1871
71.63

Cornelis Jonson van Ceulen the Elder
Dutch, 1593–1664/65

Portrait of a Man
Oil on canvas; overall 40¾ × 31½ in.
(103.5 × 80 cm); painted surface
40¾ × 31⅛ in. (103.5 × 79.1 cm)
Signed and dated (lower left): Cor. Jonson /
fecit 1648
Gift of Mrs. J. E. Spingarn, 1957
57.30.1

Portrait of a Woman
Pendant to 57.30.1
Oil on canvas; overall 40¾ × 31½ in.
(103.5 × 80 cm); painted surface
40¾ × 30⅞ in. (103.5 × 78.4 cm)
Signed and dated (lower right): Cor. Jonson /
Fecit 1648—
Gift of Mrs. J. E. Spingarn, 1957
57.30.2

Dirck van Baburen
Dutch, 1590/95–1624

Two Musicians
Oil on canvas, 38½ × 48 in.
(97.8 × 121.9 cm)
Robert Lehman Collection, 1975
1975.1.125
ROBERT LEHMAN COLLECTION

Dirck Hals
Dutch, 1591–1656

A Banquet
Oil on wood, 16 × 26 in. (40.6 × 66 cm)
Signed and dated (lower center): Dirck hals /
163[]
Purchase, 1871
71.108

Jan Josephsz. van Goyen
Dutch, 1595–1656

Sandy Road with a Farmhouse
Oil on wood, 12¹/₈ × 16¹/₄ in.
(30.8 × 41.3 cm)
Signed and dated (lower left): I V GOIEN 1627
Bequest of Myra Mortimer Pinter, 1972
1972.25

View of Haarlem and the Haarlemmer Meer
Oil on wood, 13⁵/₈ × 19⁷/₈ in.
(34.6 × 50.5 cm)
Signed and dated (lower left): VG 1646
Purchase, 1871
71.62

Country House near the Water
Oil on wood, 14³/₈ × 13 in. (36.5 × 33 cm)
Signed and dated (on boat): VG 1646
The Friedsam Collection, Bequest of Michael Friedsam, 1931
32.100.6

The Pelkus Gate near Utrecht
Oil on wood, 14¹/₂ × 22¹/₂ in.
(36.8 × 57.2 cm)
Signed and dated (on boat): VG 1646
Gift of Francis Neilson, 1945
45.146.3

Castle by a River
Oil on wood, 26 × 38¹/₄ in.
(66 × 97.2 cm)
Signed and dated (lower left, on boat):
V Goyen 1647
Anonymous Gift, 1964
64.65.1

Style of Jan Josephsz. van Goyen
Dutch, mid-17th century

River View with a Village Church
Oil on canvas, 25¹/₂ × 38¹/₂ in.
(64.8 × 97.8 cm)
Bequest of Adele L. Lehman, in memory of Arthur Lehman, 1965
65.181.11

1972.25

71.62

32.100.6

45.146.3

64.65.1

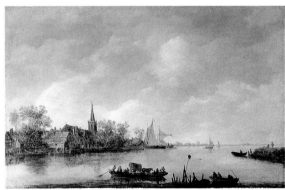

65.181.11

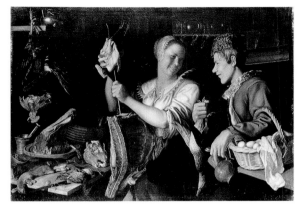

06.288

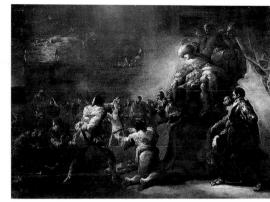

11.73

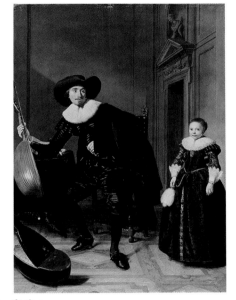

64.65.4

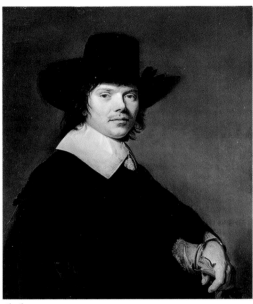

36.162.1

1991.305

Peter Wtewael
Dutch, 1596–1660
Kitchen Scene
Oil on canvas, 44³/₄ × 63 in.
(113.7 × 160 cm)
Rogers Fund, 1906
06.288

Leonard Bramer
Dutch, 1596–1674
The Judgment of Solomon
Oil on wood, 31¹/₈ × 40¹/₂ in.
(79.1 × 102.9 cm)
Gift of National Surety Company, 1911
11.73

Thomas de Keyser
Dutch, 1596–1667
A Musician and His Daughter
Oil on wood, 29¹/₂ × 20³/₄ in.
(74.9 × 52.7 cm)
Signed and dated (upper right, on lintel): TDK
[monogram] 1629
Anonymous Gift, 1964
64.65.4

Johannes Cornelisz. Verspronck
Dutch, born 1606/9, died 1662
Portrait of a Man
Oil on canvas, 31¹/₄ × 25¹/₄ in.
(79.4 × 64.1 cm)
Signed and dated (lower right): J VSpronc[k]
[VS in monogram] a[n]nº 1645∴
Bequest of Susan P. Colgate, in memory of
her husband, Romulus R. Colgate, 1936
36.162.1

Bartholomeus Breenbergh
Dutch, 1598–1657
The Preaching of Saint John the Baptist
Oil on wood, 21¹/₂ × 29⁵/₈ in.
(54.6 × 75.2 cm)
Signed and dated (lower right): B.B.f. A 1634
Purchase, The Annenberg Foundation Gift,
1991
1991.305

Pieter de Molijn

Dutch, 1595–1661

Landscape with a Cottage

Oil on wood, 14³/₄ × 21³/₄ in.
(37.5 × 55.2 cm)
Signed and dated (lower left): PMoLyn
[initials in monogram] / 1629
Gift of Henry G. Marquand, 1895
95.7

Pieter Claesz.

Dutch, 1597/98–1660

Still Life with a Skull and a Writing Quill

Oil on wood, 9¹/₂ × 14¹/₈ in.
(24.1 × 35.9 cm)
Signed and dated (middle right): PC
[monogram] / A° 1628·
Rogers Fund, 1949
49.107

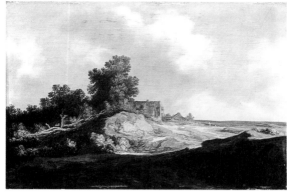

95.7

49.107

Matthias Stom

Dutch, born about 1600, probably died after
1649

Old Woman Praying

Oil on canvas, 30⁵/₈ × 25¹/₈ in.
(77.8 × 63.8 cm)
Gift of Ian Woodner, 1981
1981.25

Jacob Duck

Dutch, born about 1600, died 1667

The Procuress

Oil on wood, oval, 9⁷/₈ × 13 in.
(25.1 × 33 cm)
Signed (lower right, beside fireplace): DVCK
Gift of Dr. and Mrs. Richard W. Levy, 1971
1971.102

1981.25

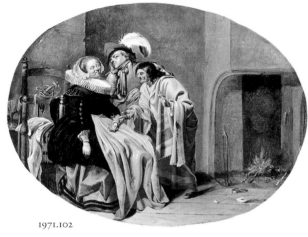

1971.102

Paulus Bor

Dutch, born about 1601, died 1669

The Enchantress

Oil on canvas, 61¹/₄ × 44¹/₄ in.
(155.6 × 112.4 cm)
Gift of Ben Heller, 1972
1972.261

Adriaen Hanneman

Dutch, born about 1601, died 1671

Portrait of a Woman

Oil on canvas, 31¹/₂ × 25 in. (80 × 63.5 cm)
Marquand Collection, Gift of Henry G.
Marquand, 1889
89.15.27

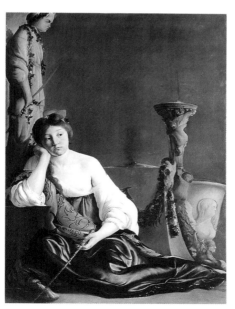

1972.261

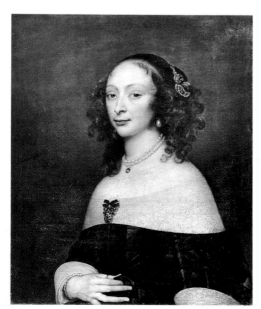

89.15.27

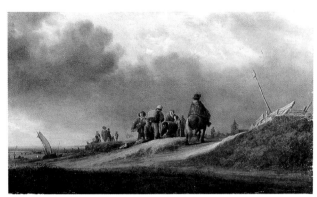

60.55.4

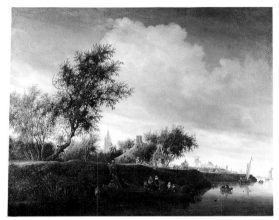

15.30.4

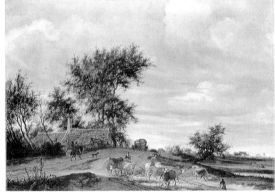

06.1201

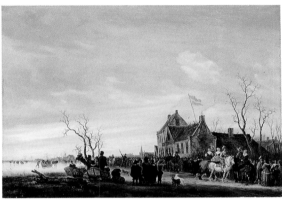

71.75

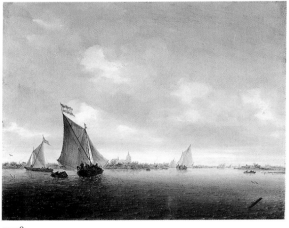

71.98

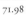

71.135

Salomon van Ruysdael
Dutch, 1600/1603–1670

Market by the Seashore
Oil on wood, 16 × 23³/₈ in.
(40.6 × 59.4 cm)
Signed and dated (center right, on fence): SvR
[vR in monogram] 1637
Bequest of Rupert L. Joseph, 1959
60.55.4

Ferry near Gorinchem
Oil on canvas, 41⁷/₈ × 52¹/₂ in.
(106.4 × 133.4 cm)
Signed and dated (lower center, on boat):
S.vRvysdael [vR in monogram] 164[6]
Bequest of Maria DeWitt Jesup, from the
collection of her husband, Morris K. Jesup,
1914
15.30.4

A Country Road
Oil on canvas, 38⁷/₈ × 52⁷/₈ in.
(98.7 × 134.3 cm)
Signed and dated (lower left): S.vRvysDAEL
[vR in monogram] / 1648
Rogers Fund, 1906
06.1201

Drawing the Eel
Oil on wood, 29¹/₂ × 41³/₄ in.
(74.9 × 106 cm)
Signed and dated (lower center): SvR [vR in
monogram] / 165[]
Purchase, 1871
71.75

Marine
Oil on wood, 13⁵/₈ × 17¹/₈ in.
(34.6 × 43.5 cm)
Signed and dated (lower right, on plank): SvR
[vR in monogram]·1650
Purchase, 1871
71.98

View of the Town of Alkmaar
Oil on wood, 20¹/₄ × 33 in.
(51.4 × 83.8 cm)
Purchase, 1871
71.135

Simon Jacobsz. de Vlieger
Dutch, 1600/1601–1653

Calm Sea
Oil on wood, 14³/₄ × 17¹/₂ in.
(37.5 × 44.5 cm)
Rogers Fund, 1906
06.1200

Aert van der Neer
Dutch, 1603/4–1677

Landscape at Sunset
Oil on canvas, 20 × 28¹/₈ in. (50.8 × 71.4 cm)
Signed (lower center): AV DN [monogram]
Gift of J. Pierpont Morgan, 1917
17.190.11

The Farrier
Oil on wood, 19 × 24¹/₈ in. (48.3 × 61.3 cm)
Signed (lower left): AV DN [monogram]
Purchase, 1871
71.60

Sports on a Frozen River
Oil on wood, 9¹/₈ × 13³/₄ in.
(23.2 × 34.9 cm)
Signed (lower left): AVN [AV in monogram]
The Friedsam Collection, Bequest of Michael
Friedsam, 1931
32.100.11

Pieter Jansz. Quast
Dutch, 1606–1647

A Party of Merrymakers
Oil on wood, 14³/₄ × 19¹/₂ in.
(37.5 × 49.5 cm)
Bequest of Josephine Bieber, in memory of her
husband, Siegfried Bieber, 1970
1973.155.1

Jan Davidsz. de Heem
Dutch, 1606–1683/84

Still Life with a Glass and Oysters
Oil on wood, 9⁷/₈ × 7¹/₂ in.
(25.1 × 19.1 cm)
Signed (upper right): J.De heem
Purchase, 1871
71.78

Rembrandt Harmensz. van Rijn
Dutch, 1606–1669

Portrait of a Man
Oil on wood, oval, 29³/₄ × 20¹/₂ in.
(75.6 × 52.1 cm)
Signed, dated, and inscribed: (center right)
RHL van Rijn [initials in monogram] / 1632.;
(center left) ÆT·40·
Gift of Mrs. Lincoln Ellsworth, in memory of
Lincoln Ellsworth, 1964
64.126

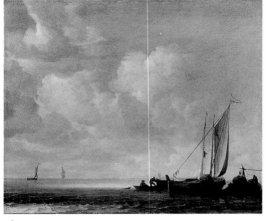
06.1200

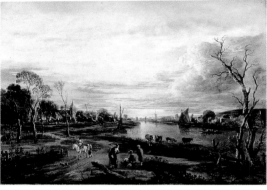
17.190.11

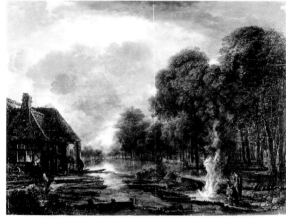
71.60

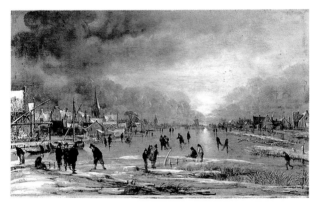
32.100.11

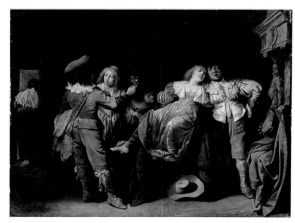
1973.155.1

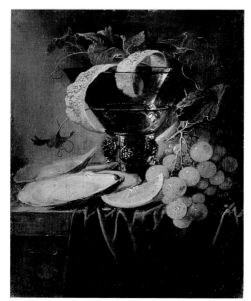
71.78

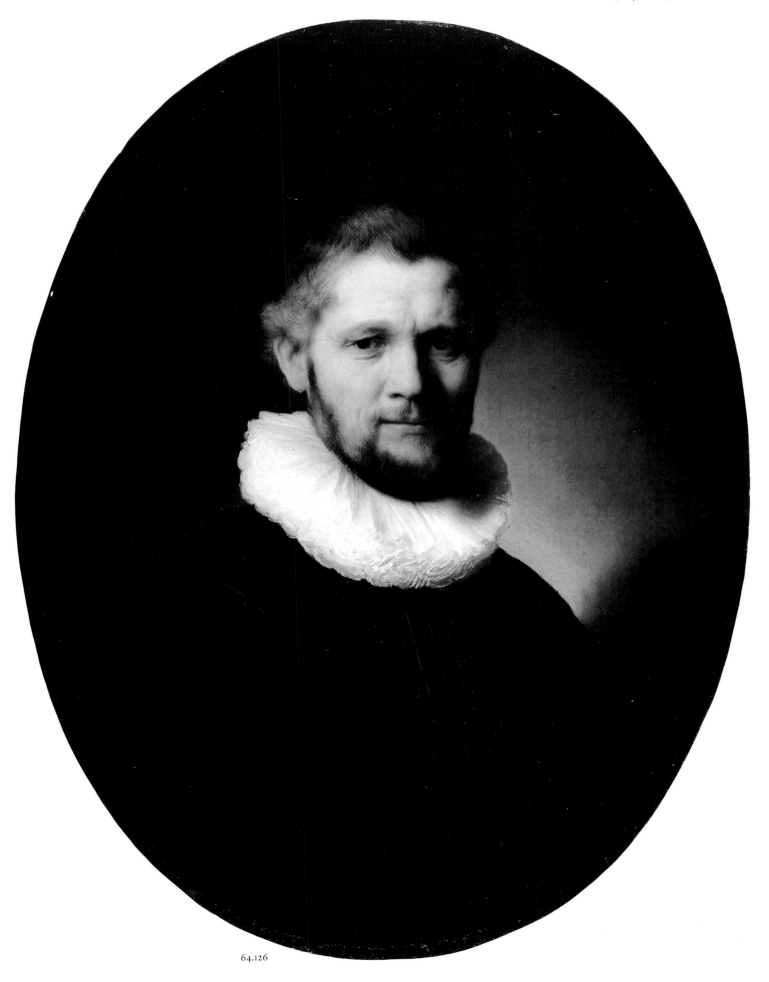

64.126

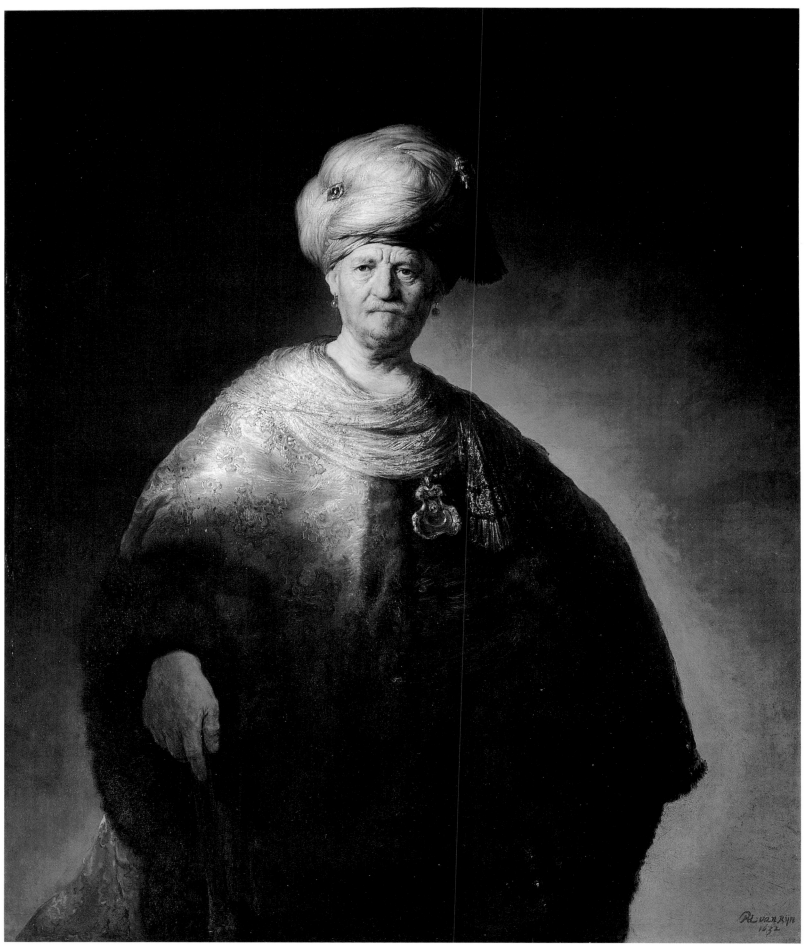

20.155.2

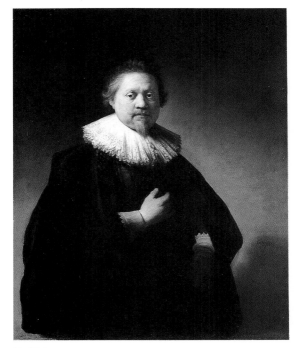

29.100.3

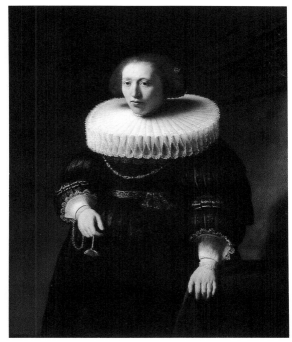

29.100.4

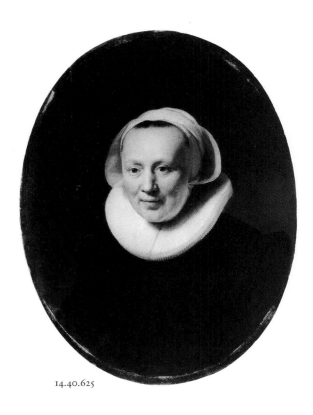

14.40.625

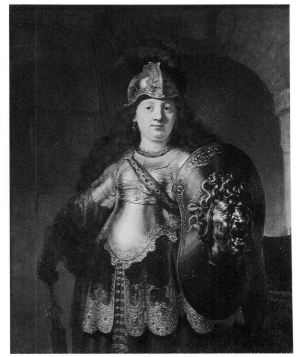

32.100.23

Rembrandt Harmensz. van Rijn
Dutch, 1606–1669

Man in Oriental Costume ("The Noble Slav")
Oil on canvas, 60¹/₈ × 43³/₄ in.
(152.7 × 111.1 cm)
Signed and dated (lower right): RHL·van
Rijn [initials in monogram] / 1632
Bequest of William K. Vanderbilt, 1920
20.155.2

Portrait of a Man
Oil on canvas, 44 × 35 in. (111.8 × 88.9 cm)
Signed and dated (lower right): RHL van
Rijn [initials in monogram] / 1632
H. O. Havemeyer Collection, Bequest of Mrs.
H. O. Havemeyer, 1929
29.100.3

Portrait of a Woman
Pendant to 29.100.3
Oil on canvas, 44 × 35 in. (111.8 × 88.9 cm)
Signed and dated (lower right): RHL·van
Rijn [initials in monogram] / 1632
H. O. Havemeyer Collection, Bequest of Mrs.
H. O. Havemeyer, 1929
29.100.4

Portrait of a Woman
Oil on wood, oval, 26³/₄ × 19³/₄ in.
(67.9 × 50.2 cm)
Signed and dated (lower left): Rembrandt f·
/ 1633·
Bequest of Benjamin Altman, 1913
14.40.625

Bellona
Oil on canvas, 50 × 38³/₈ in.
(127 × 97.5 cm)
Signed, dated, and inscribed: (lower left)
Rembrandt f. / 1633·; (on lower rim of shield)
BE[LL]OON[A]
The Friedsam Collection, Bequest of Michael
Friedsam, 1931
32.100.23

Rembrandt Harmensz. van Rijn
Dutch, 1606–1669

Portrait of a Young Woman with a Fan
The portrait is a pendant to Young Man
Rising from His Chair (The Taft Museum,
Cincinnati).
Oil on canvas, 49¹/₂ × 39³/₄ in.
(125.7 × 101 cm)
Signed and dated (lower left): Rembrandt·ft:
/ 1633
Gift of Helen Swift Neilson, 1943
43.125

Portrait of an Elderly Man
Oil on canvas, 42⁵/₈ × 32¹/₂ in.
(108.3 × 82.6 cm)
Signed and dated (upper right): Rembrandt f.
/ 1638
Robert Lehman Collection, 1975
1975.1.139
ROBERT LEHMAN COLLECTION

Herman Doomer (born about 1595, died
1650)
Oil on wood, 29⁵/₈ × 21³/₄ in.
(75.2 × 55.2 cm)
Signed and dated (lower right): .Rembrandt / f
1640
H. O. Havemeyer Collection, Bequest of Mrs.
H. O. Havemeyer, 1929
29.100.1

The Toilet of Bathsheba
Oil on wood, 22¹/₂ × 30 in.
(57.2 × 76.2 cm)
Signed and dated (lower left): Rembrandt f /
1643
Bequest of Benjamin Altman, 1913
14.40.651

Portrait of a Man Holding Gloves
Oil on wood, 31³/₄ × 26¹/₂ in.
(80.6 × 67.3 cm)
Signed and dated (lower right): Rembran[dt] /
f. 164[]
Bequest of Benjamin Altman, 1913
14.40.620

Flora
Oil on canvas, 39³/₈ × 36¹/₈ in.
(100 × 91.8 cm)
Gift of Archer M. Huntington, in memory of
his father, Collis Potter Huntington, 1926
26.101.10

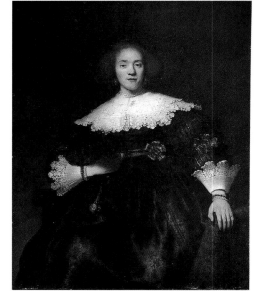
43.125

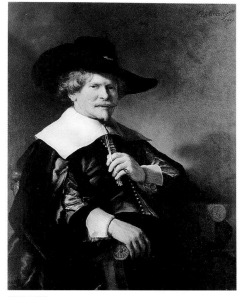
1975.1.139

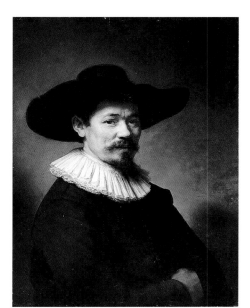
29.100.1

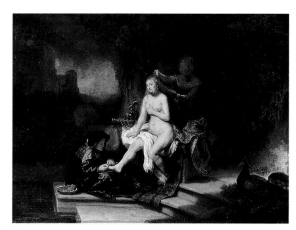
14.40.651

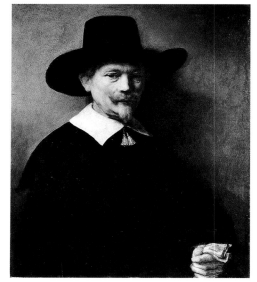
14.40.620

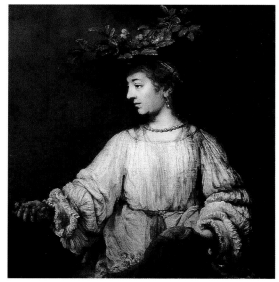
26.101.10

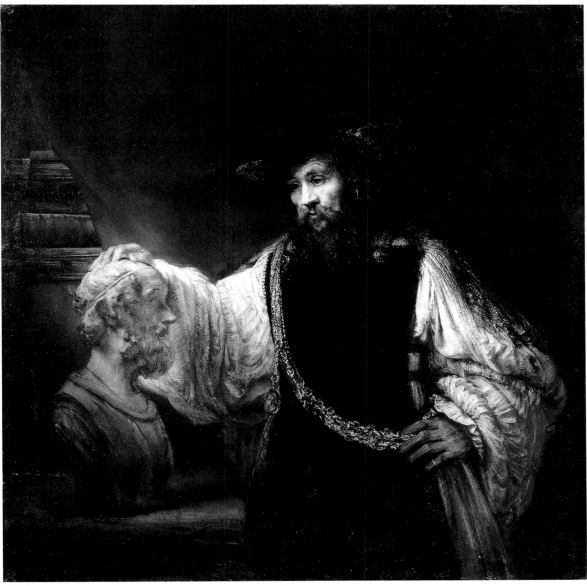

61.198

Aristotle with a Bust of Homer
Oil on canvas, 56½ × 53¾ in.
(143.5 × 136.5 cm)
Signed and dated (on pedestal of bust):
Rembrandt.f. / 1653.
Purchase, special contributions and funds
given or bequeathed by friends of the
Museum, 1961
61.198

The Standard Bearer (Floris Soop)
(1604–1657)
Oil on canvas, 55¼ × 45¼ in.
(140.3 × 114.9 cm)
Signed and dated (lower left): Rembrandt f
1654
The Jules Bache Collection, 1949
49.7.35

Hendrickje Stoffels (born about 1625/26,
died 1663)
Oil on canvas, 30⅞ × 27⅛ in.
(78.4 × 68.9 cm)
Signed and dated (right): Rembrandt / f 1660
Gift of Archer M. Huntington, in memory of
his father, Collis Potter Huntington, 1926
26.101.9

49.7.35 26.101.9

14.40.618

91.26.7

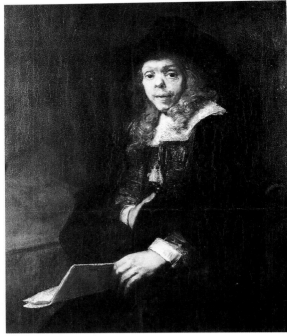

1975.1.140

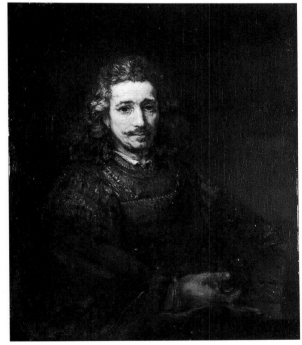

14.40.621

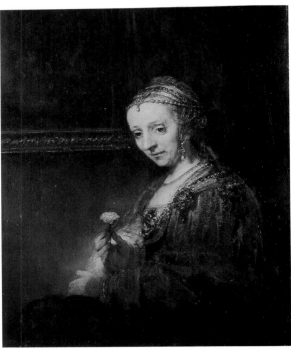

14.40.622

Rembrandt Harmensz. van Rijn

Dutch, 1606–1669

Self-portrait

Oil on canvas, 31⁵/₈ × 26¹/₂ in.
(80.3 × 67.3 cm)
Signed and dated (lower right): Rembrandt /
f.1660
Bequest of Benjamin Altman, 1913
14.40.618

Portrait of a Man

Oil on canvas, 32⁷/₈ × 25³/₈ in.
(83.5 × 64.5 cm)
Marquand Collection, Gift of Henry G.
Marquand, 1890
91.26.7

Gerard de Lairesse (1641–1711)

Oil on canvas, 44¹/₄ × 34¹/₂ in.
(112.4 × 87.6 cm)
Signed and dated (lower left): Rembrandt f.
1665.
Robert Lehman Collection, 1975
1975.1.140
ROBERT LEHMAN COLLECTION

Man with a Magnifying Glass

Oil on canvas, 36 × 29¹/₄ in.
(91.4 × 74.3 cm)
Bequest of Benjamin Altman, 1913
14.40.621

Woman with a Pink

Pendant to 14.40.621
Oil on canvas, 36¹/₄ × 29³/₈ in.
(92.1 × 74.6 cm)
Bequest of Benjamin Altman, 1913
14.40.622

Attributed to Rembrandt

Dutch, 1606–1669

Head of Christ

Oil on canvas, 16³/₄ × 13¹/₂ in.
(42.5 × 34.3 cm); with added strips,
18⁵/₈ × 14⁵/₈ in. (47.3 × 37.1 cm)
Mr. and Mrs. Isaac D. Fletcher Collection,
Bequest of Isaac D. Fletcher, 1917
17.120.222

Christ and the Woman of Samaria

Oil on wood, 25 × 19¹/₄ in.
(63.5 × 48.9 cm)
Signed (?) and dated (lower center, on step):
Rembrandt. / f 1655.
Bequest of Lillian S. Timken, 1959
60.71.14

Followers of Rembrandt

Dutch, second or third quarter 17th century

Saskia as Flora

Oil on canvas, transferred from wood, oval,
26¹/₄ × 19⁷/₈ in. (66.7 × 50.5 cm)
Inscribed and dated (lower right): Rembrandt
f. / 1632
Bequest of Lillian S. Timken, 1959
60.71.15

Portrait of a Young Man with a Beret

Oil on canvas, 29⁷/₈ × 24³/₄ in.
(75.9 × 62.9 cm)
Gift of Charles S. Payson, 1975
1975.373

Portrait of a Man ("The Auctioneer")

Oil on canvas, 42³/₄ × 34 in.
(108.6 × 86.4 cm)
Inscribed and dated (on book): Rembrandt /
f.1658.
Bequest of Benjamin Altman, 1913
14.40.624

Christ with a Pilgrim's Staff

Oil on canvas, 37¹/₂ × 32¹/₂ in.
(95.3 × 82.6 cm)
Inscribed and dated (right center): Rembrandt f.
/ 1661
The Jules Bache Collection, 1949
49.7.37

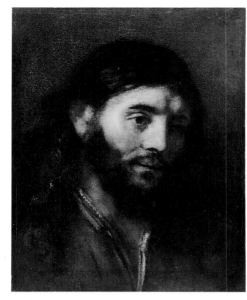

17.120.222

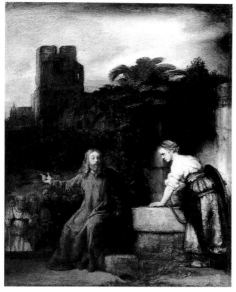

60.71.14

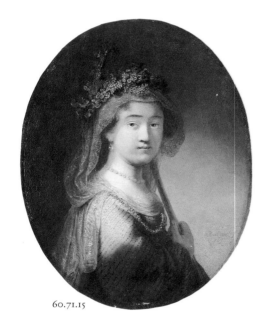

60.71.15

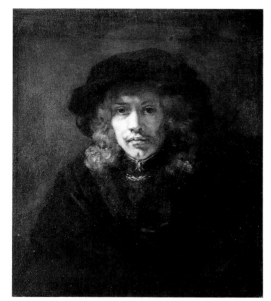

1975.373

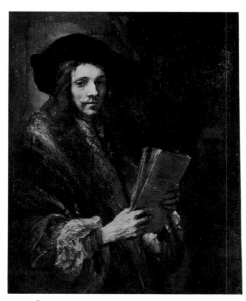

14.40.624

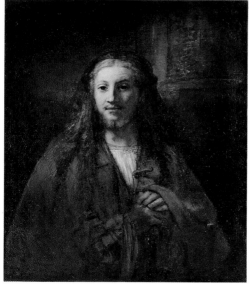

49.7.37

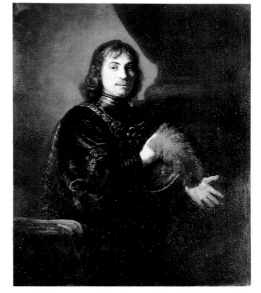

29.100.102

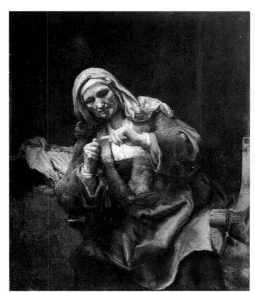

29.100.103

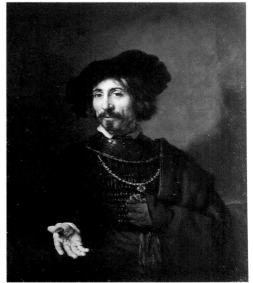

14.40.601

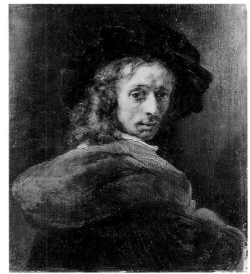

14.40.609

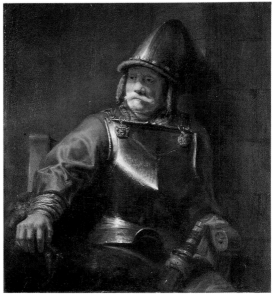

71.84

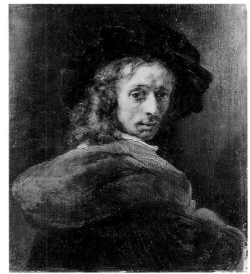

49.7.36

Style of Rembrandt
Dutch, second or third quarter 17th century

Portrait of a Man with a Breastplate and Plumed Hat
Oil on canvas, 47³/₄ × 38³/₄ in.
(121.3 × 98.4 cm)
H. O. Havemeyer Collection, Bequest of Mrs.
H. O. Havemeyer, 1929
29.100.102

Portrait of a Woman
Pendant to 29.100.102
Oil on canvas, 47⁵/₈ × 38⁵/₈ in.
(121 × 98.1 cm)
Inscribed and dated (left, on chair):
Rembrandt f / 1643
H. O. Havemeyer Collection, Bequest of Mrs.
H. O. Havemeyer, 1929
29.100.103

Man with a Steel Gorget
Oil on canvas, 37¹/₈ × 30⁵/₈ in.
(94.3 × 77.8 cm)
Inscribed and dated (lower left): Rembrandt /
f. 1644
Bequest of Benjamin Altman, 1913
14.40.601

Old Woman Cutting Her Nails
Oil on canvas, 49⁵/₈ × 40¹/₈ in.
(126.1 × 101.9 cm)
Inscribed and dated (lower left): Rembrandt /
1648
Bequest of Benjamin Altman, 1913
14.40.609

Man in Armor (Mars?)
Oil on canvas, 40¹/₈ × 35⁵/₈ in.
(101.9 × 90.5 cm)
Purchase, 1871
71.84

Man in a Red Cloak
Oil on wood, 15¹/₈ × 12¹/₄ in.
(38.4 × 31.1 cm)
Inscribed and dated (lower right):
Rembr[andt] / f. 1659[?]
The Jules Bache Collection, 1949
49.7.36

Style of Rembrandt

Dutch, 17th century

The Sibyl
Oil on canvas, 38¹/₂ × 30³/₄ in.
(97.8 × 78.1 cm)
Theodore M. Davis Collection, Bequest of
Theodore M. Davis, 1915
30.95.268

Pilate Washing His Hands
Oil on canvas, 51¹/₄ × 65³/₄ in.
(130.2 × 167 cm)
Bequest of Benjamin Altman, 1913
14.40.610

17th century or later

Rembrandt (1606–1669) ***as a Young Man***
Oil on wood, 8⁵/₈ × 6¹/₂ in.
(21.9 × 16.5 cm)
Inscribed (right, falsely): RL [monogram]
Bequest of Evander B. Schley, 1952
53.18

Rembrandt's Son Titus (1641–1668)
Oil on canvas, 31¹/₈ × 23¹/₄ in.
(79.1 × 59.1 cm)
Inscribed (upper left, falsely): Rembrandt. f.
1655.
Bequest of Benjamin Altman, 1913
14.40.608

Lieven W. van Coppenol (born 1598, died
after 1667)
Oil on wood, 14³/₈ × 11³/₈ in.
(36.5 × 28.9 cm)
Bequest of Mary Stillman Harkness, 1950
50.145.33

Study Head of an Old Man
Oil on wood, 8¹/₄ × 6⁷/₈ in. (21 × 17.5 cm)
Bequest of Lillian S. Timken, 1959
60.71.16

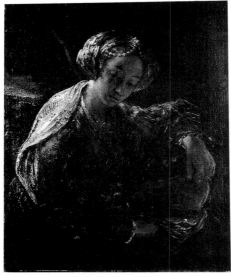

30.95.268

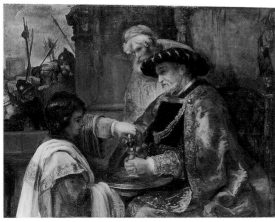

14.40.610

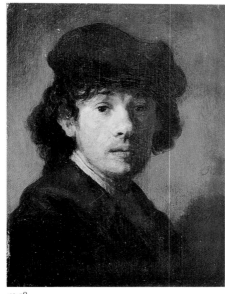

53.18

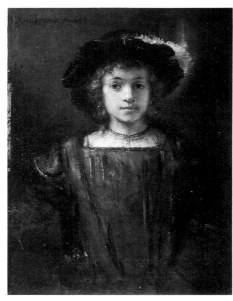

14.40.608

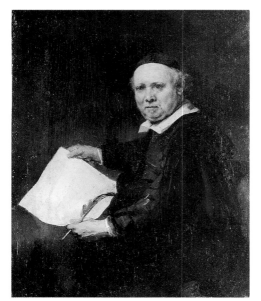

50.145.33

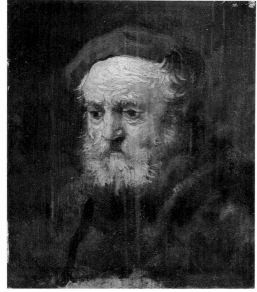

60.71.16

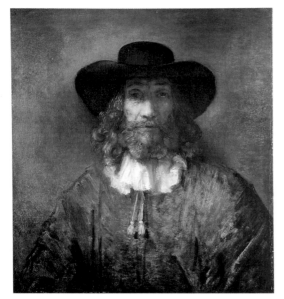

89.15.3

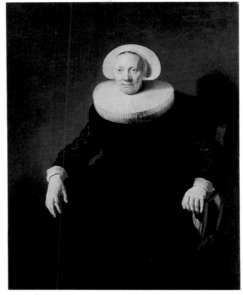

14.40.603

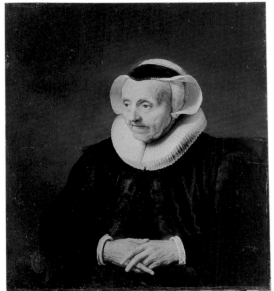

29.100.2

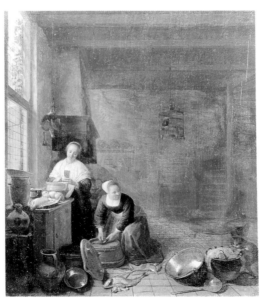

89.15.7

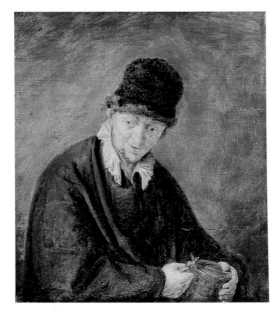

29.100.198

1976.23.2

Man with a Beard
Oil on canvas, 28⁷/₈ × 25¹/₄ in.
(73.3 × 64.1 cm)
Inscribed (lower left, falsely): Rembrandt / f.
1665
Marquand Collection, Gift of Henry G.
Marquand, 1889
89.15.3

Attributed to Jacob Adriaensz. Backer
Dutch, 1608–1651
Old Woman in an Armchair
Oil on canvas, 50³/₈ × 39¹/₈ in.
(128 × 99.4 cm)
Inscribed and dated: (upper right) Rembrandt
f. / 1635; (upper left) ÆT·SVÆ·70 / 24: / [3?]
Bequest of Benjamin Altman, 1913
14.40.603

Style of Jacob Adriaensz. Backer
Dutch, second quarter 17th century
Portrait of an Old Woman
Oil on wood, 28 × 24 in. (71.1 × 61 cm)
Inscribed and dated: (lower right) Rembrandt
/ f. 1640; (upper left) ÆT·SVÆ·87·
H. O. Havemeyer Collection, Bequest of Mrs.
H. O. Havemeyer, 1929
29.100.2

Hendrick Martensz. Sorgh
Dutch, 1609/11–1670
A Kitchen
Oil on wood, 20¹/₂ × 17³/₈ in.
(52.1 × 44.1 cm)
Marquand Collection, Gift of Henry G.
Marquand, 1889
89.15.7

Style of Adriaen van Ostade
Dutch, second half 17th century
Man with a Tankard
Oil on wood, 10¹/₈ × 8¹/₂ in.
(25.7 × 21.6 cm)
H. O. Havemeyer Collection, Bequest of Mrs.
H. O. Havemeyer, 1929
29.100.198

Hendrick Cornelisz. van Vliet
Dutch, 1611/12–1675
Interior of the Oude Kerk, Delft
Oil on canvas, 32¹/₂ × 26 in.
(82.6 × 66 cm)
Signed and dated (foreground, at base of
column): H. van vliet / 1660
Gift of Clarence Dillon, 1976
1976.23.2

Bartholomeus van der Helst
Dutch, 1613–1670

Portrait of a Man
Oil on wood, oval, 26¼ × 21⅝ in.
(66.7 × 54.9 cm)
Signed, dated, and inscribed (lower right):
Æta. 62 / B. vanderhelst / 1647
Purchase, 1871
71.73

The Musician
Oil on canvas, 54½ × 43¾ in.
(138.4 × 111.1 cm)
Signed, dated, and inscribed: (lower left) B.
vanderhelst / 1662; (on sheet of music) iris;
(on cover of book) Supe[r]ius
Purchase, 1873
73.2

Gerard Dou
Dutch, 1613–1675

Self-portrait
Oil on wood, 19¼ × 15⅜ in.
(48.9 × 39.1 cm)
Signed (left, on ledge): GDO[U] [initials in
monogram]
Bequest of Benjamin Altman, 1913
14.40.607

An Evening School
Oil on wood, arched top, 10 × 9 in.
(25.4 × 22.9 cm)
Bequest of Lillian M. Ellis, 1940
40.64

Frans Post
Dutch, born about 1612, died 1680

A Brazilian Landscape
Oil on wood, 24 × 36 in. (61 × 91.4 cm)
Signed and dated (right, on papaya tree): F
POST / 1650
Purchase, Rogers Fund, special funds, James
S. Deely Gift, and Gift of Edna H. Sachs
and other gifts and bequests, by exchange,
1981
1981.318

Govert Flinck
Dutch, 1615–1660

Bearded Man with a Velvet Cap
Oil on wood, 23¾ × 20⅝ in.
(60.3 × 52.4 cm)
Signed and dated (left center): G. flinck f.
164[5?]
Bequest of Collis P. Huntington, 1900
25.110.27

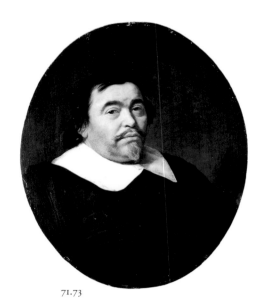

71.73

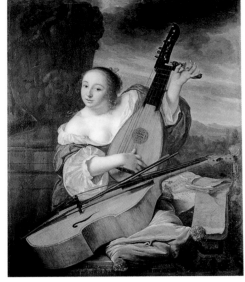

73.2

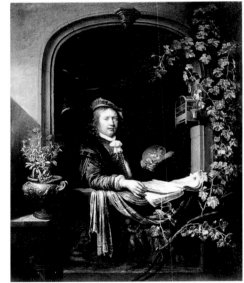

14.40.607

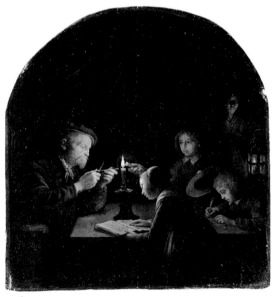

40.64

1981.318

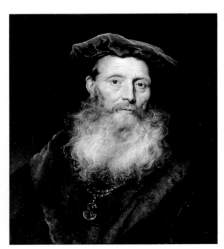

25.110.27

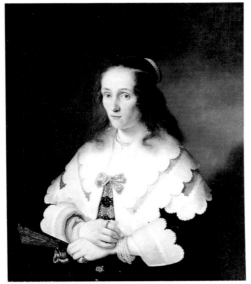

30.95.269

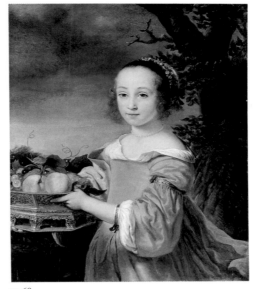

57.68

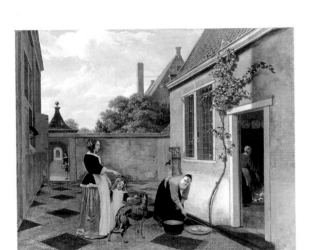

20.155.5

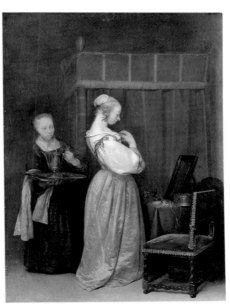

17.190.10

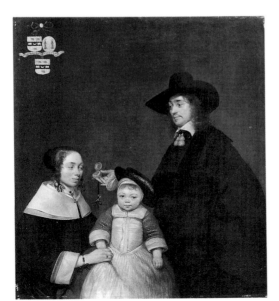

1982.60.30

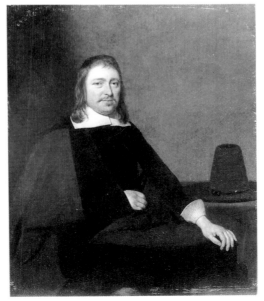

89.15.15

Ferdinand Bol
Dutch, 1616–1680

Portrait of a Woman
Oil on canvas, 34³/₈ × 28 in.
(87.3 × 71.1 cm)
Signed and dated (left center): f. Bol fecit /
1642
Theodore M. Davis Collection, Bequest of
Theodore M. Davis, 1915
30.95.269

Young Girl with a Basket of Fruit
Oil on canvas, 31⁵/₈ × 26 in.
(80.3 × 66 cm)
Signed and dated (lower right): FBol [initials
in monogram] / 1657
Purchase, George T. Delacorte Jr. Gift, 1957
57.68

Ludolf de Jongh
Dutch, 1616–1679

Scene in a Courtyard
Oil on canvas, 26¹/₂ × 32³/₈ in.
(67.3 × 82.2 cm)
Bequest of William K. Vanderbilt, 1920
20.155.5

Gerard ter Borch
Dutch, 1617–1681

A Young Woman at Her Toilet with a Maid
Oil on wood, 18³/₄ × 13⁵/₈ in.
(47.6 × 34.6 cm)
Gift of J. Pierpont Morgan, 1917
17.190.10

The van Moerkerken Family
The sitters are the artist's cousin Hartogh van
Moerkerken (1622–1694); his first wife, Sibilla
Nijkerken; and their son, Philippus (born
1652).
Oil on wood, 16¹/₄ × 14 in.
(41.3 × 35.6 cm)
Inscribed (upper left, on scrolls):
V:MOERKERKEN / NYKERKEN
Arms (upper left) of the sitters
The Jack and Belle Linsky Collection, 1982
1982.60.30

Portrait of a Seated Man
Oil on wood, 14¹/₈ × 12 in.
(35.9 × 30.5 cm)
Marquand Collection, Gift of Henry G.
Marquand, 1889
89.15.15

Gerard ter Borch
Dutch, 1617–1681

A Woman Playing the Theorbo for a Cavalier
Oil on wood, 14¹/₂ × 12³/₄ in.
(36.8 × 32.4 cm)
Bequest of Benjamin Altman, 1913
14.40.617

Curiosity
Oil on canvas, 30 × 24¹/₂ in.
(76.2 × 62.2 cm)
The Jules Bache Collection, 1949
49.7.38

Burgomaster Jan van Duren (1613–1687)
Oil on canvas, 32 × 26 in.
(81.3 × 66 cm)
Signed and inscribed: (center left) GTB
[monogram]; (verso) JAN VAN DUREN
BURGEMEESTER EN CAMERAAR VAN DEVENTER
(Jan van Duren, burgomaster and treasurer of
Deventer)
Robert Lehman Collection, 1975
1975.1.141
ROBERT LEHMAN COLLECTION

Margaretha van Haexbergen (1614–1676),
Wife of Jan van Duren
Pendant to 1975.1.141
Oil on canvas, 32 × 26 in.
(81.3 × 66 cm)
Robert Lehman Collection, 1975
1975.1.142
ROBERT LEHMAN COLLECTION

Abraham van Cuylenborch
Dutch, active by 1639, died 1658

Bacchus and Nymphs
Oil on wood, 22⁷/₈ × 28³/₈ in.
(58.1 × 72.1 cm)
Signed (lower left): AvC·[monogram]f
Bequest of Collis P. Huntington, 1900
25.110.37

Pieter van Overschee
Dutch, active about 1645–61

Still Life of Fruit and Game
Oil on wood, 32⁷/₈ × 46³/₄ in.
(83.5 × 118.7 cm)
Signed and dated (right, on table): Pieter van
Overschee f. 1645·
Bequest of Grace Wilkes, 1921
22.45.10

14.40.617

49.7.38

1975.1.141

1975.1.142

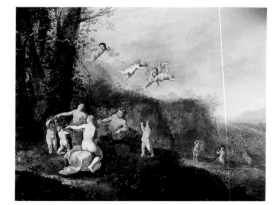

25.110.37

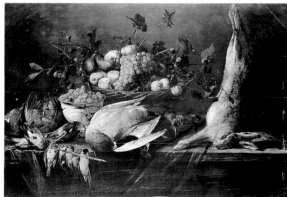

22.45.10

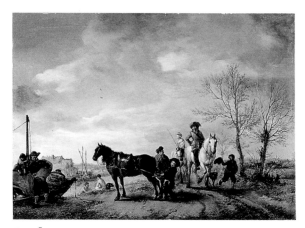

1971.48

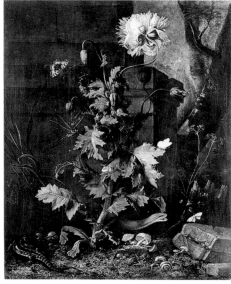

53.155

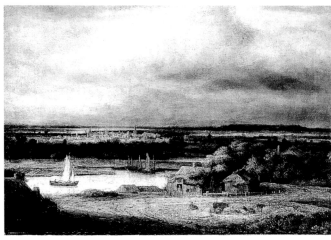

63.43.2

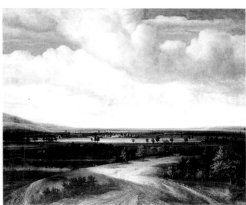

11.144

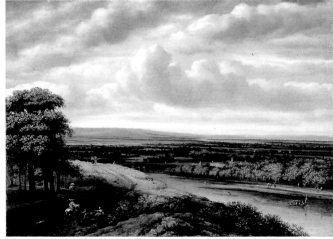

1980.4

39.184.20

Philips Wouwermans

Dutch, 1619–1668

A Man and Woman on Horseback

Oil on wood, 12¹/₈ × 16¹/₄ in.
(30.8 × 41.3 cm)
Signed (lower left): PHLSW [monogram]
Purchase, Pfeiffer Fund, Joseph Pulitzer
Bequest, and Gift of Dr. Ernest G. Stillman,
by exchange, 1971
1971.48

Otto Marseus van Schrieck

Dutch, 1619–1678

Still Life with Poppy, Insects, and Reptiles

Oil on canvas, 26⁷/₈ × 20³/₄ in.
(68.3 × 52.7 cm)
Signed (lower left): otho Marseus / van
Schrieck fecit
Rogers Fund, 1953
53.155

Philips Koninck

Dutch, 1619–1688

Wide River Landscape

Oil on canvas, 16¹/₄ × 22⁷/₈ in.
(41.3 × 58.1 cm)
Anonymous Gift, 1963
63.43.2

Landscape

Oil on canvas, 56³/₈ × 68¹/₄ in.
(143.2 × 173.4 cm)
Signed and dated (lower right): P. koninck /
164[9?]
John Stewart Kennedy Fund, 1911
11.144

An Extensive Wooded Landscape

Oil on canvas, 32³/₄ × 44⁵/₈ in.
(83.2 × 113.3 cm)
Signed (lower left): P. Koninck.
Purchase, Mr. and Mrs. David T. Schiff and
George T. Delacorte Jr. Gifts, special funds,
and Bequest of Mary Cushing Fosburgh and
other gifts and bequests, by exchange, 1980
1980.4

Dutch Painter

third quarter 17th century

The Ark

Oil on canvas, 46¹/₄ × 61¹/₄ in.
(117.5 × 155.6 cm)
Gift of James DeLancey Verplanck and John
Bayard Rodgers Verplanck, 1939
39.184.20
AMERICAN DECORATIVE ARTS

Willem Kalf

Dutch, 1619–1693

Interior of a Kitchen

Oil on wood, 10¹/₂ × 12¹/₂ in.
(26.7 × 31.8 cm)
Signed (on chest): KALF
Purchase, 1871
71.69

***Still Life with Fruit, Glassware, and a
Wan-li Bowl***

Oil on canvas, 23 × 20 in. (58.4 × 50.8 cm)
Signed and dated (lower right): W.KALF 1659.
Maria DeWitt Jesup Fund, 1953
53.111

Jan Victors

Dutch, 1620–1676

Abraham's Parting from the Family of Lot

Oil on canvas, 58 × 65¹/₈ in.
(147.3 × 165.4 cm)
Signed (right): Jan Victors
Purchase, 1871
71.170

Nicolaas Berchem

Dutch, 1620–1683

Rest

Oil on wood, 17 × 13¹/₂ in.
(43.2 × 34.3 cm)
Signed (lower left): Berchem
Purchase, 1871
71.125

Aelbert Cuyp

Dutch, 1620–1691

Piping Shepherds

Oil on canvas, 35³/₄ × 47 in.
(90.8 × 119.4 cm)
Signed (lower right): A cüyp. F.
Bequest of Collis P. Huntington, 1900
25.110.15

Starting for the Hunt: Michiel (1638–1653)
and Cornelis Pompe van Meerdervoort
(1639–1680) ***with Their Tutor and
Coachman***

This painting was installed until 1680 over a
fireplace in the Meerdervoort house, near
Zwijndrecht, for which it was painted.
Oil on canvas, 43¹/₄ × 61¹/₂ in.
(109.9 × 156.2 cm)
Signed (lower left): A. cüyp. fecit.
The Friedsam Collection, Bequest of Michael
Friedsam, 1931
32.100.20

71.69

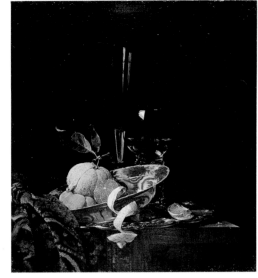

53.111

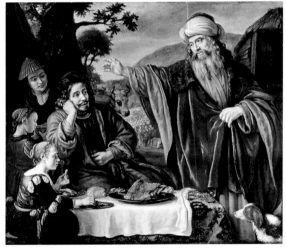

71.170

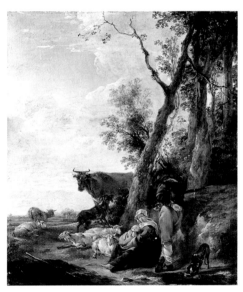

71.125

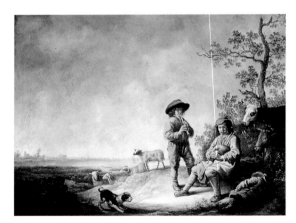

25.110.15

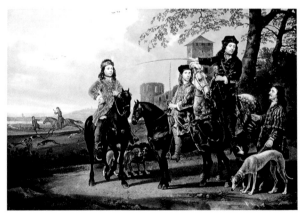

32.100.20

1973.155.2

14.40.616

34.83.1

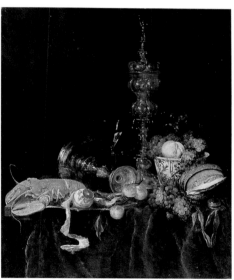

1971.254

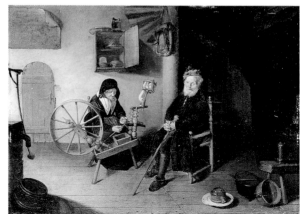

71.110

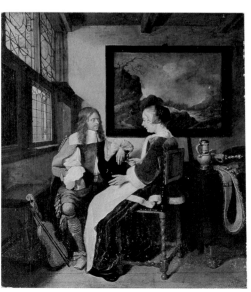

32.100.19

Landscape with the Flight into Egypt
Oil on wood, 18 × 22⁷/₈ in.
(45.7 × 58.1 cm)
Signed (lower left): A:C
Bequest of Josephine Bieber, in memory of her
husband, Siegfried Bieber, 1970
1973.155.2

Young Herdsmen with Cows
Oil on canvas, 44¹/₈ × 52¹/₈ in.
(112.1 × 132.4 cm)
Signed (bottom left): A : cuÿp.
Bequest of Benjamin Altman, 1913
14.40.616

Style of Aelbert Cuyp
Dutch, 17th century
Children and a Cow
Oil on wood, 17¹/₄ × 21¹/₂ in.
(43.8 × 54.6 cm)
Inscribed (lower right): A. cuyp.
Bequest of Mariana Griswold Van Rensselaer,
in memory of her father, George Griswold,
1934
34.83.1

Abraham van Beyeren
Dutch, 1620/21–1690
Still Life with Lobster and Fruit
Oil on wood, 38 × 31 in. (96.5 × 78.7 cm)
Signed (left, on table): ·AVB· [monogram] f
Anonymous Gift, 1971
1971.254

Quiringh Gerritsz. van Brekelenkam
Dutch, born about 1620, died 1668
The Spinner
Oil on wood, 19 × 25¹/₄ in.
(48.3 × 64.1 cm)
Signed and dated (on spinning wheel): Q V B
1653
Purchase, 1871
71.110

Sentimental Conversation
Oil on wood, 16¹/₄ × 13⁷/₈ in.
(41.3 × 35.2 cm)
The Friedsam Collection, Bequest of Michael
Friedsam, 1931
32.100.19

Gerbrand van den Eeckhout
Dutch, 1621–1674

Isaac Blessing Jacob
Oil on canvas, 39⅝ × 50½ in.
(100.6 × 128.3 cm)
Signed and dated (lower center): G V
-eeckhoŭt / A̶N° 1642
Bequest of Collis P. Huntington, 1900
25.110.16

A Musical Party
Oil on canvas, 20 × 24½ in.
(50.8 × 62.2 cm)
Bequest of Annie C. Kane, 1926
26.260.8

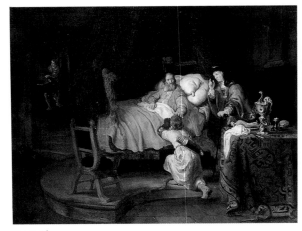

25.110.16

26.260.8

Jan Abrahamsz. Beerstraaten
Dutch, 1622–1666

Skating at Slooten, near Amsterdam
Oil on canvas, 36¼ × 51⅝ in.
(92.1 × 131.1 cm)
Signed and inscribed (lower right): Slooten /
J. Beerstraaten / Pingit
Rogers Fund, 1911
11.92

Emanuel Murant
Dutch, born 1622, died about 1700

The Old Castle
Oil on wood, 15⅝ × 21⅞ in.
(39.7 × 55.6 cm)
Theodore M. Davis Collection, Bequest of
Theodore M. Davis, 1915
30.95.260

11.92

30.95.260

Johannes Lingelbach
Dutch, 1622–1674

Peasants Dancing
Oil on canvas, 26½ × 29½ in.
(67.3 × 74.9 cm)
Signed and dated (lower center, on bench):
J:lingelbach 165[1?]
Purchase, 1871
71.123

Battle Scene
Oil on canvas, 44⅜ × 63¼ in.
(112.7 × 160.7 cm)
Signed and dated (bottom center, on tree
trunk): I / LIN[G]ELBACH / fe / 1671
Purchase, 1871
71.23

71.123

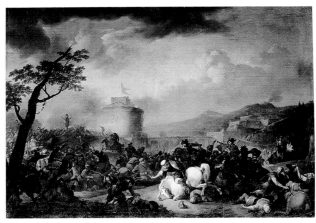

71.23

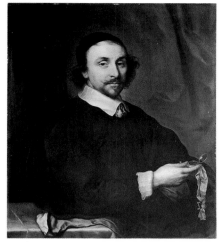

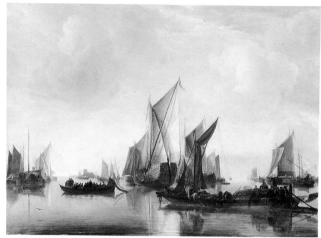

41.116.3

12.31

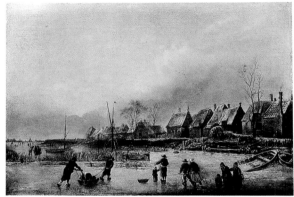

32.100.16

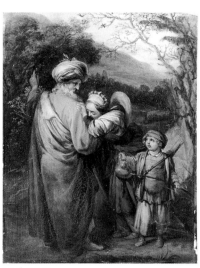

1976.100.23

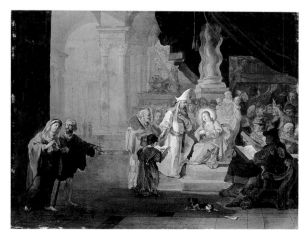

1974.368

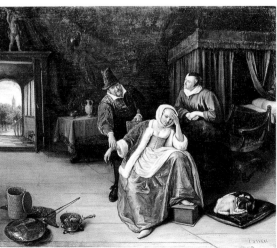

46.13.2

Cornelis Jonson van Ceulen the Younger
Dutch, born after 1622, died after 1698
Portrait of a Man with a Watch
Oil on canvas, 33 × 27³/₄ in.
(83.8 × 70.5 cm)
Signed and dated (lower left): Cornelius
Jonson / van Ceulen / Junior / 1657
Given in memory of Felix M. Warburg by his
wife and children, 1941
41.116.3

Jan van de Cappelle
Dutch, 1624/26–1679
The Mouth of the Scheldt
Oil on wood, 27¹/₂ × 36³/₈ in.
(69.9 × 92.4 cm)
Signed (lower right): J.V. Cappelle
Francis L. Leland Fund, 1912
12.31

Winter Scene
Oil on wood, 13³/₈ × 19¹/₂ in.
(34 × 49.5 cm)
Signed (lower right): J.V DE CAPPELLE
The Friedsam Collection, Bequest of Michael
Friedsam, 1931
32.100.16

Barent Fabritius
Dutch, 1624–1673
Hagar and Ishmael
Oil on wood, 19¹/₂ × 14 in.
(49.5 × 35.6 cm)
Bequest of Harry G. Sperling, 1971
1976.100.23

Abraham Hondius
Dutch, 1625–1695
Christ among the Doctors
Oil on wood, 15 × 19¹/₂ in.
(38.1 × 49.5 cm)
Signed and dated (lower left): Abraham
Hondius / 1668
Gift of Dr. and Mrs. Carl F. Culicchia, 1974
1974.368

Jan Havicksz. Steen
Dutch, 1626–1679
The Lovesick Maiden
Oil on canvas, 34 × 39 in. (86.4 × 99.1 cm)
Signed (lower right): i STEEN
Bequest of Helen Swift Neilson, 1945
46.13.2

Jan Havicksz. Steen
Dutch, 1626–1679

The Dissolute Household
Oil on canvas, 42¹/₂ × 35¹/₂ in.
(108 × 90.2 cm)
Signed (lower right): I. STEEN
The Jack and Belle Linsky Collection, 1982
1982.60.31

Merry Company on a Terrace
Oil on canvas, 55¹/₂ × 51³/₄ in.
(141 × 131.4 cm)
Signed (lower right): JSteen [initials in
monogram]
Fletcher Fund, 1958
58.89

Gabriel Metsu
Dutch, 1629–1667

Tavern Scene
Oil on wood, 14³/₈ × 12⁵/₈ in.
(36.5 × 32.1 cm)
Signed (on table leg): GMetsu. [initials in
monogram]
Bequest of William H. Herriman, 1920
21.134.5

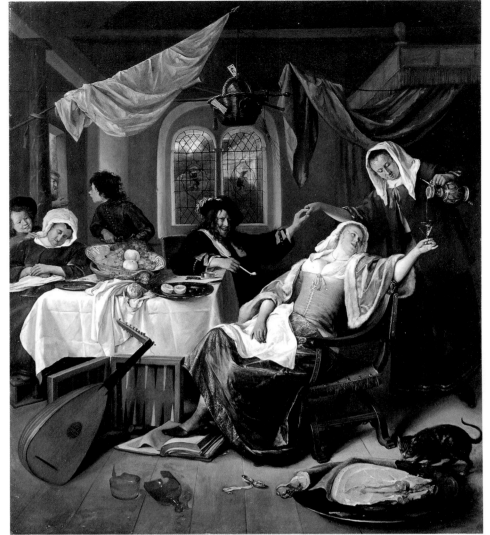

1982.60.31

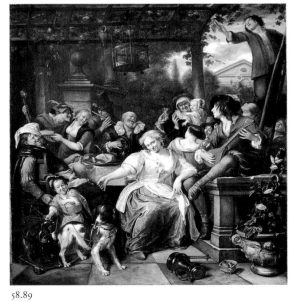

58.89

21.134.5

91.26.11

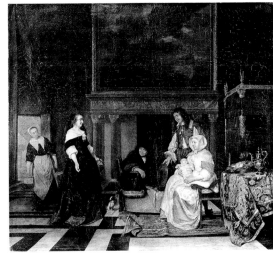

17.190.20

1982.60.32

1992.133

65.181.10

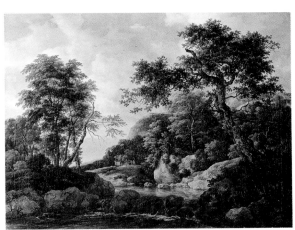

89.15.4

A Musical Party

Oil on canvas, 24½ × 21⅜ in.
(62.2 × 54.3 cm)
Signed, dated, and inscribed: (lower left, on paper) GMetsu [initials in monogram] / 1659; (on dowel at top of map) NOVISS[I]MA HOL[LANDIA . . .] (newest [map of the provinces of] Hol[land and West Friedland]) [The map, by Balthasar Florisz. van Berckenrode, was first published by Willem Jansz. Blaeu in 1620, and this is one of the two later editions, revised and reissued by Claes Jansz. Visscher in 1651 and 1656.]
Marquand Collection, Gift of Henry G. Marquand, 1890
91.26.11

The Visit to the Nursery

Oil on canvas, 30½ × 32 in. (77.5 × 81.3 cm)
Signed and dated (left, above door): G.Metsu 1661
Gift of J. Pierpont Morgan, 1917
17.190.20

Woman Seated at a Window

It is probable that this picture and the Huntsman (Mauritshuis, The Hague)—similarly signed and dated 1661—were pendants.
Oil on wood, 10⅞ × 8⅞ in. (27.6 × 22.5 cm)
Signed (bottom center): G. Metsu
The Jack and Belle Linsky Collection, 1982
1982.60.32

Samuel van Hoogstraten

Dutch, 1627–1678

The Annunciation of the Death of the Virgin

Oil on canvas, 26 × 20¾ in. (66 × 52.7 cm)
Signed (lower left): S.v.H.
Purchase, Rogers Fund and Joseph Pulitzer Bequest, 1992
1992.133

Jacob Isaacksz. van Ruisdael

Dutch, 1628/29–1682

Landscape with a Village in the Distance

Oil on wood, 30 × 43 in. (76.2 × 109.2 cm)
Signed and dated (lower right): Jv Ru[i]sdael [initials in monogram] 1646
Bequest of Adele L. Lehman, in memory of Arthur Lehman, 1965
65.181.10

The Forest Stream

Oil on canvas, 39¼ × 50⅞ in.
(99.7 × 129.2 cm)
Signed (lower right): JvRuisd[ae]l [initials in monogram]
Marquand Collection, Gift of Henry G. Marquand, 1889
89.15.4

Jacob Isaacksz. van Ruisdael
Dutch, 1628/29–1682

Wheat Fields
Oil on canvas, 39³/₈ × 51¹/₄ in.
(100 × 130.2 cm)
Signed (lower right): JvRŭisdael [initials in monogram]
Bequest of Benjamin Altman, 1913
14.40.623

Grainfields
Oil on canvas, 18¹/₂ × 22¹/₂ in.
(47 × 57.2 cm)
Signed (lower right): JvRŭisdael [initials in monogram]
The Friedsam Collection, Bequest of Michael Friedsam, 1931
32.100.14

Mountain Torrent
Oil on canvas, 21¹/₄ × 16¹/₂ in.
(54 × 41.9 cm)
Bequest of Collis P. Huntington, 1900
25.110.18

Pieter de Hooch
Dutch, 1629–1684

The Visit
Oil on wood, 26³/₄ × 23 in.
(67.9 × 58.4 cm)
H. O. Havemeyer Collection, Bequest of Mrs. H. O. Havemeyer, 1929
29.100.7

A Woman and Two Men in an Arbor
Oil on wood; overall 17³/₈ × 14³/₄ in.
(44.1 × 37.5 cm); painted surface
17 × 14³/₈ in. (43.2 × 36.5 cm)
Signed (lower left, largely illegible): P. [de hoogh?]
Bequest of Harry G. Sperling, 1971
1976.100.25

Interior with a Young Couple
Oil on canvas, 21⁵/₈ × 24³/₄ in.
(54.9 × 62.9 cm)
Bequest of Benjamin Altman, 1913
14.40.613

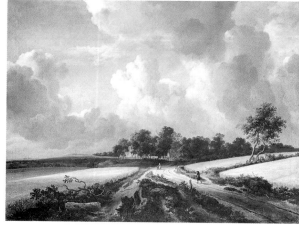

14.40.623

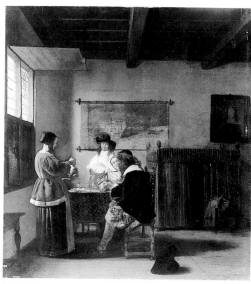

32.100.14

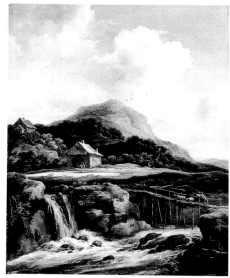

25.110.18

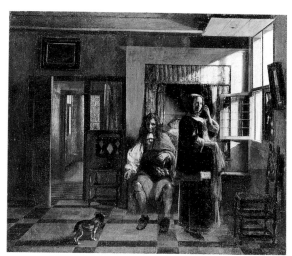

29.100.7

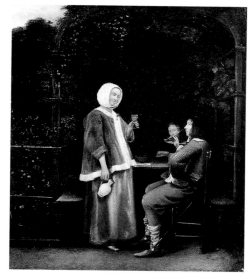

1976.100.25

14.40.613

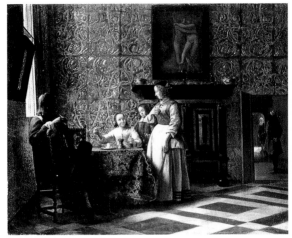

1975.1.144

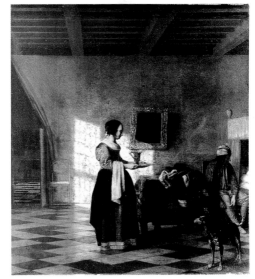

32.100.15

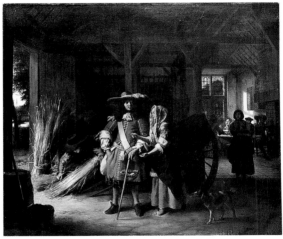

58.144

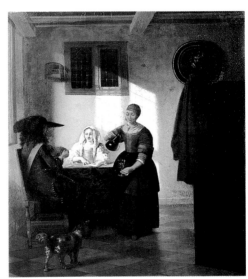

1975.1.143

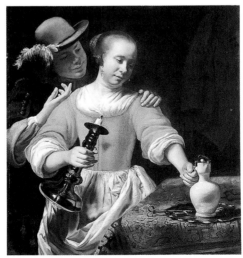

1982.60.33

32.100.12

Interior with Figures
Oil on canvas, 23 × 27 in. (58.4 × 68.6 cm)
Signed (on stretcher of chair): P. D. HOOCH
Robert Lehman Collection, 1975
1975.1.144
ROBERT LEHMAN COLLECTION

The Maidservant
Oil on canvas, 24¼ × 20½ in.
(61.5 × 52.1 cm)
The Friedsam Collection, Bequest of Michael
Friedsam, 1931
32.100.15

Paying the Hostess
Oil on canvas, 37¼ × 43¾ in.
(94.6 × 111.1 cm)
Signed (upper right, on beam): P d·Hoogh·
Gift of Stuart Borchard and Evelyn B.
Metzger, 1958
58.144

Card Players
Oil on canvas, 27 × 23 in. (68.6 × 58.4 cm)
Signed (on wall above baseboard): PDH
Robert Lehman Collection, 1975
1975.1.143
ROBERT LEHMAN COLLECTION

Cornelis Bisschop
Dutch, 1634–1674
A Young Woman and a Cavalier
Oil on canvas, 38½ × 34¾ in.
(97.8 × 88.3 cm)
The Jack and Belle Linsky Collection, 1982
1982.60.33

Anthonie van Borssum
Dutch, 1630/31–1677
Barnyard Scene
Oil on canvas, 20 × 27 in.
(50.8 × 68.6 cm)
The Friedsam Collection, Bequest of Michael
Friedsam, 1931
32.100.12

Johannes Vermeer
Dutch, 1632–1675

A Maid Asleep
Oil on canvas, 34¹/₂ × 30¹/₈ in.
(87.6 × 76.5 cm)
Signed (left, above girl's head): I·VMeer·
[VM in monogram]
Bequest of Benjamin Altman, 1913
14.40.611

Woman with a Lute
Oil on canvas, 20¹/₄ × 18 in.
(51.4 × 45.7 cm)
Inscribed (on map): EUROPA
Bequest of Collis P. Huntington, 1900
25.110.24

Young Woman with a Water Jug
Oil on canvas, 18 × 16 in. (45.7 × 40.6 cm)
Marquand Collection, Gift of Henry G.
Marquand, 1889
89.15.21

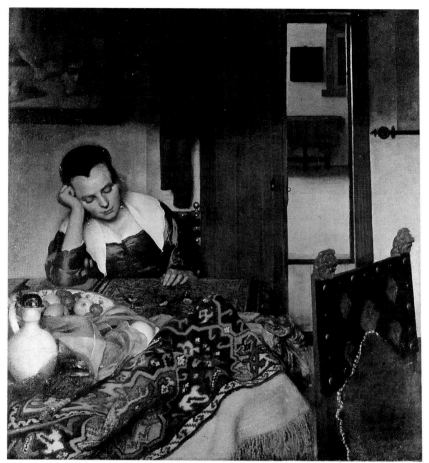

14.40.611

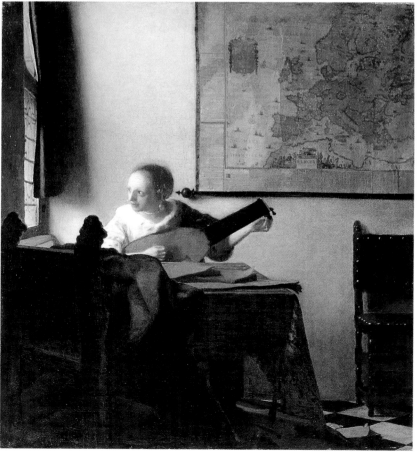

25.110.24

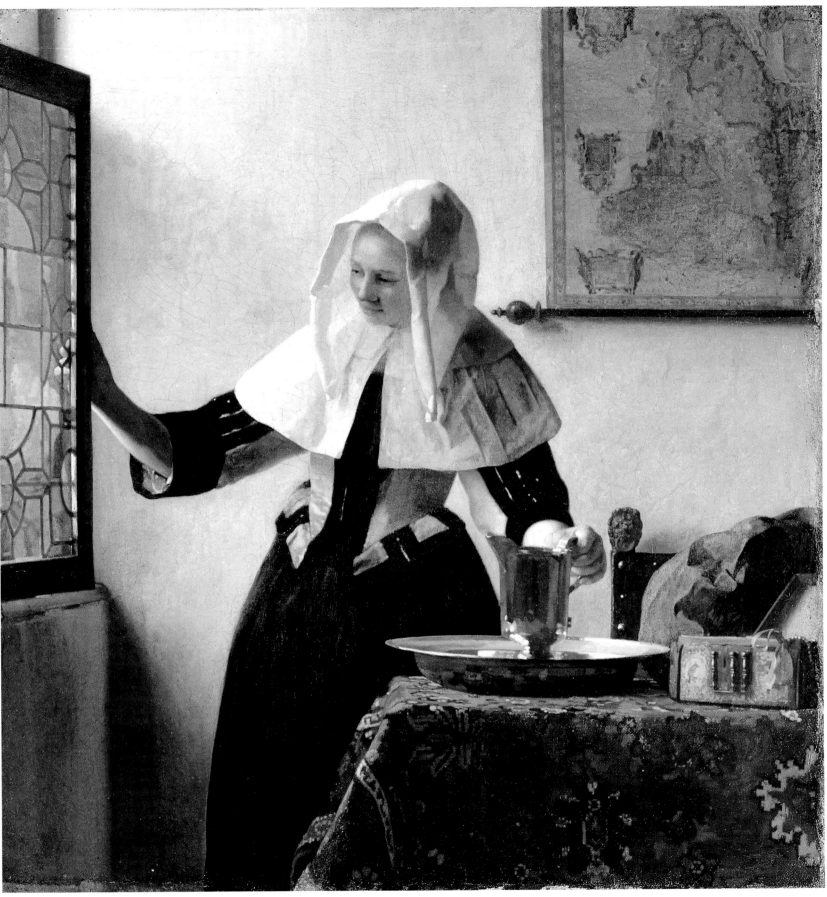

89.15.21

Johannes Vermeer
Dutch, 1632–1675

Portrait of a Young Woman
Oil on canvas, 17¹/₂ × 15³/₄ in.
(44.5 × 40 cm)
Signed (upper left): IVMeer. [initials in
monogram]
Gift of Mr. and Mrs. Charles Wrightsman, in
memory of Theodore Rousseau Jr., 1979
1979.396.1

Allegory of the Faith
Oil on canvas, 45 × 35 in. (114.3 × 88.9 cm)
The Friedsam Collection, Bequest of Michael
Friedsam, 1931
32.100.18

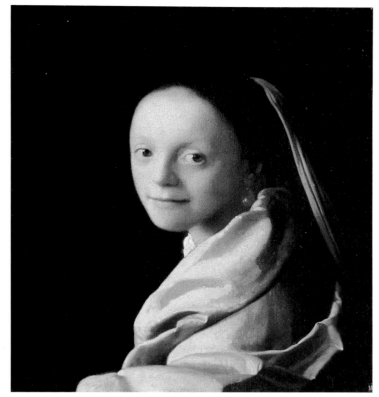

1979.396.1

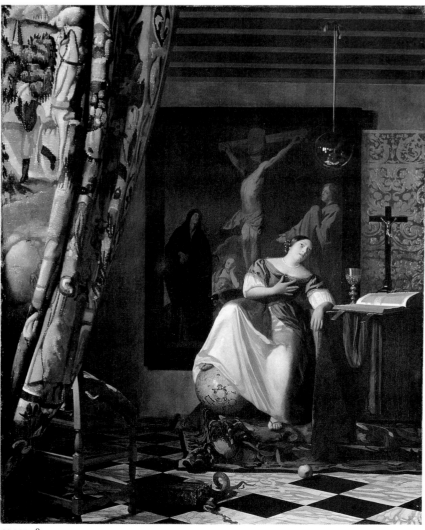

32.100.18

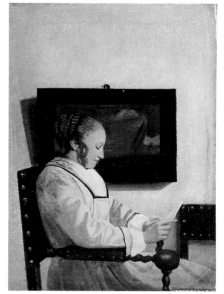

49.7.40

71.116

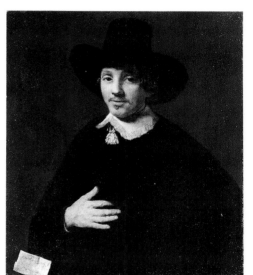

41.116.2

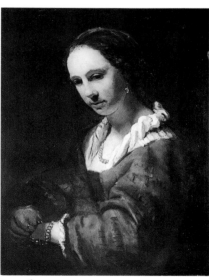

14.40.629

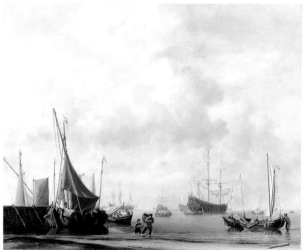

20.155.6

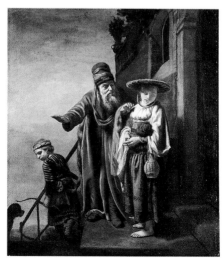

1971.73

Style of Johannes Vermeer
first quarter 20th century
Young Woman Reading
Oil on canvas, 7³/₄ × 5³/₄ in.
(19.7 × 14.6 cm)
The Jules Bache Collection, 1949
49.7.40

Roelof van Vries
Dutch, born 1630/31, probably died after 1681
The Pigeon House
Oil on canvas, 14¹/₂ × 12 in.
(36.8 × 30.5 cm)
Signed (lower right): v[r]ies
Purchase, 1871
71.116

Willem Drost
Dutch, active 1652–80
Portrait of a Man
Oil on canvas, 34¹/₈ × 28¹/₂ in.
(86.7 × 72.4 cm)
Signed and inscribed (lower left): Wilhelm
Drost f / Amsterdam
Given in memory of Felix M. Warburg by his
wife and children, 1941
41.116.2

Copy after Willem Drost
Dutch, second half 17th century
Portrait of a Woman
The painting is a copy with variations of
Drost's Young Woman Wearing Pearl Jewelry
(Gemäldegalerie, Dresden).
Oil on canvas, 33¹/₈ × 24¹/₂ in.
(84.1 × 62.2 cm)
Inscribed (lower right): [illegible]
Bequest of Benjamin Altman, 1913
14.40.629

Willem van de Velde the Younger
Dutch, 1633–1707
Entrance to a Dutch Port
Oil on canvas, 25⁷/₈ × 30⁵/₈ in.
(65.7 × 77.8 cm)
Signed (lower left): w.v.v.
Bequest of William K. Vanderbilt, 1920
20.155.6

Nicolaes Maes
Dutch, 1634–1693
Abraham Dismissing Hagar and Ishmael
Oil on canvas, 34¹/₂ × 27¹/₂ in.
(87.6 × 69.9 cm)
Signed and dated (lower center, on step):
NMAES. [first four letters in ligature] 1653
Gift of Mrs. Edward Brayton, 1971
1971.73

Nicolaes Maes
Dutch, 1634–1693

Young Girl Peeling Apples
Oil on wood, 21¹⁄₂ × 18 in.
(54.6 × 45.7 cm)
Bequest of Benjamin Altman, 1913
14.40.612

The Lacemaker
Oil on canvas, 17³⁄₄ × 20³⁄₄ in.
(45.1 × 52.7 cm)
Signed (on base of child's chair): N.MAES.
The Friedsam Collection, Bequest of Michael
Friedsam, 1931
32.100.5

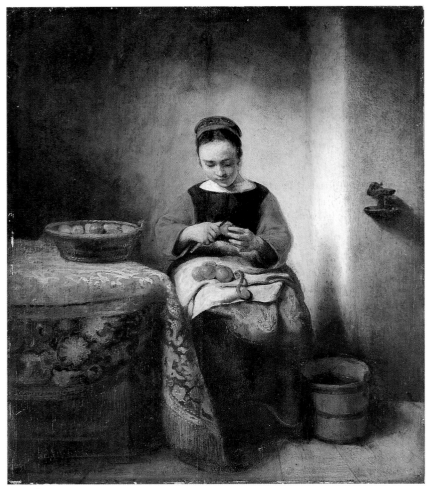

14.40.612

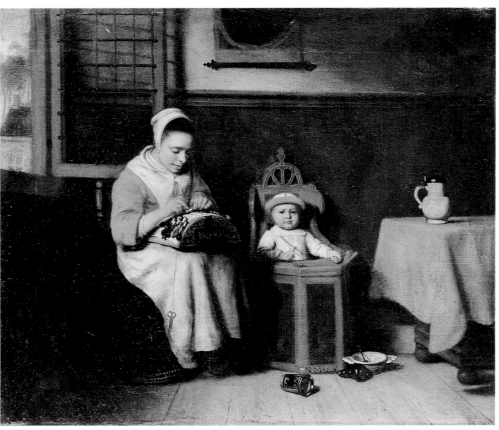

32.100.5

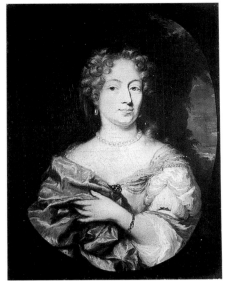

11.149.3

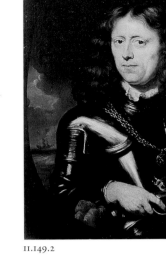

11.149.2

06.1325

1980.203.5

32.100.9

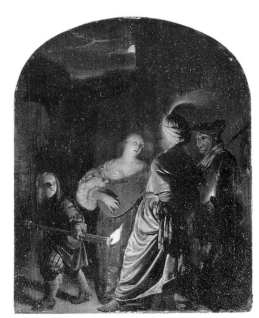

60.71.3

Ingena Rotterdam (died 1704), ***Betrothed of Admiral Jacob Binckes***
Oil on canvas, 17¼ × 13 in.
(43.8 × 33 cm)
Signed and dated (lower right): Maes / 1676
Gift of J. Pierpont Morgan, 1911
11.149.3

Admiral Jacob Binckes (died 1677)
Pendant to 11.149.3
Oil on canvas, 17¼ × 12⅞ in.
(43.8 × 32.7 cm)
Signed (lower right): MAAS
Gift of J. Pierpont Morgan, 1911
11.149.2

Portrait of a Woman
Oil on canvas, 44 × 35¼ in.
(111.8 × 89.5 cm)
Rogers Fund, 1906
06.1325

Jakob Ochtervelt
Dutch, 1634–1682

The Love Letter
Oil on canvas, 36 × 25 in.
(91.4 × 63.5 cm)
Partial and Promised Gift of Mr. and Mrs. Walter Mendelsohn, 1980
1980.203.5

Eglon Hendrik van der Neer
Dutch, 1634–1703

The Reader
Oil on canvas, 15 × 11 in. (38.1 × 27.9 cm)
Inscribed (falsely, lower right, with initials of Gerard ter Borch): GTB [monogram]
The Friedsam Collection, Bequest of Michael Friedsam, 1931
32.100.9

Frans van Mieris the Elder
Dutch, 1635–1681

The Serenade
Oil on wood, arched top, 5¾ × 4⅜ in.
(14.6 × 11.1 cm)
Bequest of Lillian S. Timken, 1959
60.71.3

Jan van der Heyden
Dutch, 1637–1712
The Huis ten Bosch Seen from the Back
Oil on wood, 15³/8 × 21³/4 in.
(39.1 × 55.2 cm)
Signed (lower left): IVD Heÿde[n]
Anonymous Gift, 1964
64.65.2

The Huis ten Bosch Seen from the Side
Pendant to 64.65.2
Oil on wood, 15³/8 × 21⁵/8 in.
(39.1 × 54.9 cm)
Signed (lower right): I·V·D·Heyden
Anonymous Gift, 1964
64.65.3

64.65.2 64.65.3

Meindert Hobbema
Dutch, 1638–1709
Entrance to a Village
Oil on wood, 29¹/2 × 43³/8 in.
(74.9 × 110.2 cm)
Signed (lower right): m [Ho]bb[ema]
Bequest of Benjamin Altman, 1913
14.40.614

Woodland Road
Oil on canvas, 37¹/4 × 51 in.
(94.6 × 129.5 cm)
Signed (lower right): m. Hobbema
Bequest of Mary Stillman Harkness, 1950
50.145.22

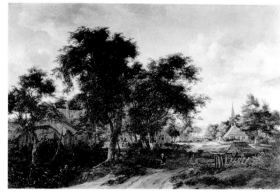 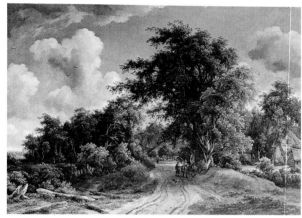

14.40.614 50.145.22

Melchior d'Hondecoeter
Dutch, 1636–1695
Peacocks
Oil on canvas, 74⁷/8 × 53 in.
(190.2 × 134.6 cm)
Signed and dated (center right):
MDHondecoeter. / Æ 1683
Gift of Samuel H. Kress, 1927
27.250.1

Caspar Netscher
Dutch, 1639–1684
The Card Party
Oil on canvas, 19³/4 × 17³/4 in.
(50.2 × 45.1 cm)
Signed and dated (on stretcher of stool):
CNetsch[er] / [1]66[]
Marquand Collection, Gift of Henry
G. Marquand, 1889
89.15.6

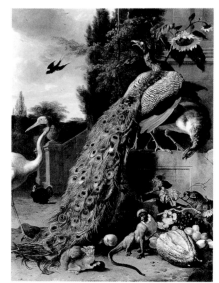 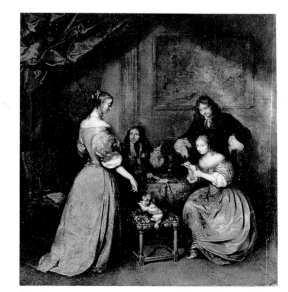

27.250.1 89.15.6

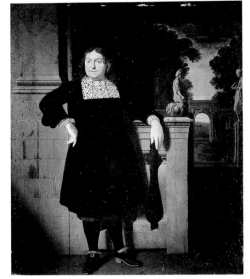

71.70

60.55.1

Pieter Cornelisz. van Slingeland
Dutch, 1640–1691

Portrait of a Man
Oil on wood, 14¹/₂ × 11³/₄ in. (36.8 × 29.8 cm)
Signed (lower left): P·V· Slingeland fecit
Purchase, 1871
71.70

Attributed to Pieter Cornelisz. van Slingeland

Portrait of a Man
Oil on copper, oval, 3³/₈ × 2¹/₂ in.
(8.6 × 6.4 cm)
Bequest of Rupert L. Joseph, 1959
60.55.1

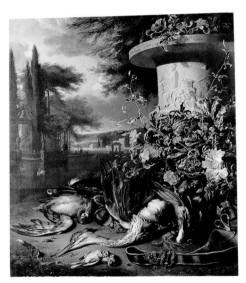

43.118

50.55

Gerard de Lairesse
Dutch, 1641–1711

Apollo and Aurora
Oil on canvas, 80¹/₂ × 76¹/₈ in.
(204.5 × 193.4 cm)
Signed and dated (lower left): G. Lairesse f
. . . 1671
Gift of Manuel E. and Ellen G. Rionda, 1943
43.118

Jan Weenix
Dutch, 1642–1719

Falconer's Bag
Oil on canvas, 52³/₄ × 43³/₄ in. (134 × 111.1 cm)
Signed and dated (upper right): Jan Weeninx
Fecit A°1695
Rogers Fund, 1950
50.55

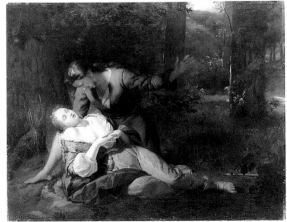

1974.109

71.19

Godfried Schalcken
Dutch, 1643–1706

Cephalus and Procris
Oil on canvas, 25¹/₂ × 31³/₈ in. (64.8 × 79.7 cm)
Signed (upper left): G. Schalcken
Rogers Fund, 1974
1974.109

Edwaert Collier
Dutch, active by 1662, died after 1706

Vanitas
Oil on wood, 37 × 44¹/₈ in. (94 × 112.1 cm)
Signed and dated (left, on book): ·EC·
[monogram] / 1662
Inscribed: (lower left, on ring) E.K; (lower left,
on book) Almanach . . . ; (center, on
bookmark) VANITAS; (lower center, on print)
IACOB. CATZ. RIDDER RAED / PENSION. VAÑ.
H. M. HEEREN. / STATEN. VAN. HOLLANT.
CVRAT. (Jacob Cats, grand pensionary of their
majesties the lords of the States General of
Holland); (right, on book) DE DERDE ENDE /
VIERDE DECAS DER SER. / MOONEN HENRCHI
BVLLINGE / . . . (The third and fourth *decas*
of the sermons of Hendrick Bullinge . . .)
Purchase, 1871
71.19

Matthys Naiveu

Dutch, 1647–?1721

The Newborn Baby

Oil on canvas, 25¼ × 31½ in.
(64.1 × 80 cm)
Signed and dated (lower left): M: Naiveú F. /
1675
Purchase, 1871
71.160

Jan Jansz. de Heem

Flemish, born 1650, died after 1695

Still Life: A Banqueting Scene

Oil on canvas, 53¼ × 73 in.
(135.3 × 185.4 cm)
Signed: (lower left) DeHeem fc; (on napkin)
JDH [monogram]
Charles B. Curtis Fund, 1912
12.195

71.160

12.195

Jacob de Wit

Dutch, 1695–1754

Children Playing with a Goat (grisaille)

Oil on canvas, 26¾ × 41 in.
(67.9 × 104.1 cm)
Signed (lower left): de Wit
Gift of J. Pierpont Morgan, 1906
07.225.257

Allegory of Government: Wisdom Defeating Discord (sketch for a ceiling decoration)

Oil on canvas, 20⅛ × 15⅜ in.
(51.1 × 39.1 cm)
Inscribed: (on shield) . . . BET . . . PROBAT;
(on book) IN LEGIBVS SALVS (prosperity under
law)
Gift of J. Pierpont Morgan, 1906
07.225.296

07.225.257

07.225.296

Allegory of the Arts (sketch for a ceiling decoration)

Oil on canvas, 18⅞ × 23¼ in.
(47.9 × 59.1 cm)
Signed and dated (lower left): J.d.Wit / .1742
Gift of J. Pierpont Morgan, 1906
07.225.298

Apotheosis of Flora

This sketch was for a ceiling decoration in a
house at Herengracht 609, Amsterdam.
Oil on canvas, 20⅞ × 24⅞ in.
(53 × 63.2 cm)
Signed and dated (lower left): J.d.Wit / .1743
Gift of J. Pierpont Morgan, 1906
07.225.301

07.225.298

07.225.301

71.6

07.225.470

91.26.8

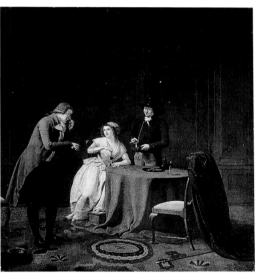

1981.239

Margareta Haverman
Dutch, active by 1716, died after 1750
A Vase of Flowers
Oil on wood, 31¼ × 23¾ in.
(79.4 × 60.3 cm)
Signed and dated (lower right): .Margareta.
Haverman fecit. / A 1716
Purchase, 1871
71.6

Willem van Leen
Dutch, 1753–1825
Flowers in a Blue Vase
Oil on canvas, arched top, 55 × 29⅛ in.
(139.7 × 74 cm)
Signed (bottom right): Van Leen–Fec
Gift of J. Pierpont Morgan, 1906
07.225.470
ESDA

Jacob van Strij
Dutch, 1756–1815
Landscape with Cattle
Oil on wood, 31½ × 42¼ in.
(80 × 107.3 cm)
Inscribed (lower right, falsely): A. cŭÿp.
Marquand Collection, Gift of Henry G.
Marquand, 1890
91.26.8

Jan Ekels the Younger
Dutch, 1759–1793
Conversation Piece
Oil on canvas, 25⅞ × 23½ in.
(65.7 × 59.7 cm)
Gift of Mr. and Mrs. Bertram L. Podell, 1981
1981.239

Barend Cornelis Koekkoek

Dutch, 1803–1862

Winter Landscape, Holland

Oil on wood, 14 × 17 in.
(35.6 × 43.2 cm)
Signed and dated (lower left): B C
Koek-Koek 1833
Catharine Lorillard Wolfe Collection, Bequest
of Catharine Lorillard Wolfe, 1887
87.15.30

Sunset on the Rhine

Oil on canvas, 32¼ × 42⅜ in.
(81.9 × 107.6 cm)
Signed and dated (lower right):
BC Koek Koek ft. / 1853
Catharine Lorillard Wolfe Collection, Bequest
of Catharine Lorillard Wolfe, 1887
87.15.45

87.15.30

87.15.45

Paul-Jean Clays

Belgian, 1819–1900

*Celebration of the Freedom of the Port of
Antwerp, 1863*

Oil on canvas, 48⅝ × 79 in.
(123.5 × 200.7 cm)
Signed (lower right): P.J. Clays.
Gift of the artist and an association of
gentlemen, 1881
81.5

Émile van Marcke

Belgian, 1827–1890

The Flood Gate

Oil on canvas, 24½ × 32½ in.
(62.2 × 82.6 cm)
Signed (lower left): Em van.Marcke.
Bequest of Susan P. Colgate, in memory of
her husband, Romulus R. Colgate, 1936
36.162.2

81.5

36.162.2

Jozef Israëls

Dutch, 1824–1911

Grandmother's Treasure

Oil on canvas, 27 × 35⅝ in.
(68.6 × 90.5 cm)
Signed (lower left): Jozef Israels.
Mr. and Mrs. Isaac D. Fletcher Collection,
Bequest of Isaac D. Fletcher, 1917
17.120.227

Expectation

Oil on canvas, 71½ × 54 in.
(181.6 × 137.2 cm)
Signed (lower left): Jozef Israels
Gift of George I. Seney, 1887
87.8.13

17.120.227

87.8.13

46.150.1

87.15.56

Alfred Stevens
Belgian, 1823–1906

After the Ball
Oil on canvas, 37³/₄ × 27¹/₈ in.
(95.9 × 68.9 cm)
Signed and dated (upper left): Alfred Stevens, 74
Gift of Estate of Marie L. Russell, 1946
46.150.1

The Japanese Robe
Oil on canvas, 36¹/₂ × 25¹/₈ in.
(92.7 × 63.8 cm)
Signed (lower right): AStevens [initials in monogram]
Catharine Lorillard Wolfe Collection, Bequest of Catharine Lorillard Wolfe, 1887
87.15.56

In the Studio
Oil on canvas, 42 × 53¹/₂ in.
(106.7 × 135.9 cm)
Signed and dated (lower left): AStevens [initials in monogram] .88.
Gift of Mrs. Charles Wrightsman, 1986
1986.339.2

1986.339.2

Anton Mauve

Dutch, 1838–1888

Gathering Wood

Oil on canvas, 16¹/₂ × 13 in.
(41.9 × 33 cm)
Signed (lower right): AMauve
Bequest of Richard De Wolfe Brixey, 1943
43.86.8

Twilight

Oil on canvas, 25⁷/₈ × 17⁷/₈ in.
(65.7 × 45.4 cm)
Signed (lower right): A Mauve f
Bequest of Benjamin Altman, 1913
14.40.812

Changing Pasture

Oil on canvas, 24 × 39⁵/₈ in.
(61 × 100.6 cm)
Signed (lower right): AMauve
Bequest of Benjamin Altman, 1913
14.40.810

The Return to the Fold

Oil on canvas, 19³/₄ × 33⁷/₈ in.
(50.2 × 86 cm)
Signed (lower right): AMauve f
Bequest of Benjamin Altman, 1913
14.40.816

A Shepherdess and Her Flock

Oil on canvas, 17⁷/₈ × 25¹/₄ in.
(45.4 × 64.1 cm)
Signed (lower right): A. Mauve f.
Gift of Cole J. Younger, 1985
1985.88

43.86.8

14.40.812

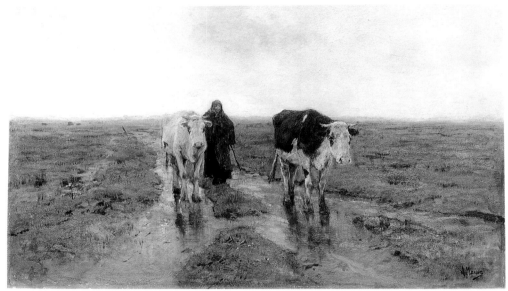

14.40.810

14.40.816

1985.88

81.1.662

87.15.80

92.1.49

33.136.3

1975.443

Guillaume Koller

Belgian, 1829–1884

Hugo van der Goes Painting the Portrait of Mary of Burgundy
Oil on wood, 23³/₈ × 34 in.
(59.4 × 86.4 cm)
Signed (lower right): G.Koller.
Bequest of Stephen Whitney Phoenix, 1881
81.1.662

Frederik Hendrik Kaemmerer

Dutch, 1839–1902

Young Woman
Oil on canvas, 9³/₄ × 6¹/₄ in.
(24.8 × 15.9 cm)
Signed (lower center): FHKAEMMERER·
Catharine Lorillard Wolfe Collection, Bequest
of Catharine Lorillard Wolfe, 1887
87.15.80

Matthys Maris

Dutch, 1839–1917

Reverie
Oil on canvas, 12 × 9¹/₄ in.
(30.5 × 23.5 cm)
Signed and dated (upper right): MM
[monogram] .75.
Bequest of Elizabeth U. Coles, in memory of
her son, William F. Coles, 1892
92.1.49

Jacob Maris

Dutch, 1837–1899

Canal Side
Oil on canvas, 5³/₈ × 7 in.
(13.7 × 17.8 cm)
Signed (lower left): J.Maris
Bequest of Margaret Crane Hurlbut, 1933
33.136.3

Herman Willem Koekkoek

Dutch, 1867–1929

Mill on the Laan
Oil on wood, 7¹/₂ × 12 in. (19.1 × 30.5 cm)
Signed (lower right): HWK.
Gift of Mr. and Mrs. Morton L. Ostow, 1975
1975.443

Northern French Painter

about 1450

The Crucifixion of Saint Peter with a Donor; The Legend of Saint Anthony Abbot with a Donor

Interiors of wings from an altarpiece; exteriors (32.100.108–109) are below.
Oil on wood, each 45 × 31 in.
(114.3 × 78.7 cm)
Unidentified arms (left and right)
The Friedsam Collection, Bequest of Michael Friedsam, 1931
32.100.110–111

The Annunciation

Exteriors of wings from the same altarpiece as 32.100.110–111
Oil on wood, each 45 × 31 in.
(114.3 × 78.7 cm)
Dated and inscribed: (left wing, on scroll) Ave ·gracia·plena·; (left wing, on sill, probably in a later hand) 1451; (right wing, on scroll) dominus·tecum·; (right wing, on ewer) AD[M?] (possibly for ancilla domini [the handmaid of the Lord] [Luke 1:38])
The Friedsam Collection, Bequest of Michael Friedsam, 1931
32.100.108–109

French Painters

third quarter 15th century

Portrait of a Woman, Possibly Margaret of York (1446–1503)

Oil on wood, 22⅞ × 16¼ in.
(58.1 × 41.3 cm)
Robert Lehman Collection, 1975
1975.1.129
ROBERT LEHMAN COLLECTION

painted in 1480

The Pérussis Altarpiece

The altarpiece, painted for the Chartreuse de Bonpas near Avignon, represents Saints John the Baptist and Francis with two donors venerating the cross in a landscape with a view of Avignon. The original frame is recorded as having been dated 1480.
Oil and gold on wood; three panels, each 54½ × 23 in. (138.4 × 58.4 cm)
Inscribed (on cross): inri
Arms (left and right) of the Pérussis (Peruzzi) family and their motto (on scrolls held by angels left and right) DATVM·EST·DE·SVPER·
Purchase, Mary Wetmore Shively Bequest, in memory of her husband, Henry L. Shively, M.D., 1954
54.195

32.100.110

32.100.111

32.100.108

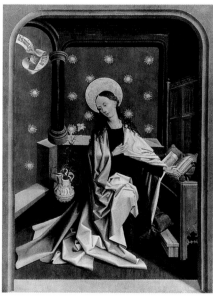

32.100.109

1975.1.129

54.195

32.100.106 (recto)

32.100.107 (recto)

32.100.106 (verso)

32.100.107 (verso)

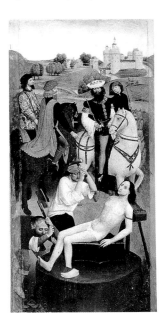

22.60.56

22.60.57

Northern French Painters

about 1460

The Crucifixion and (verso) *Saint Francis of Assisi; The Resurrection* and (verso) *An Abbot Saint, Possibly Saint Benedict*
(altarpiece wings)
Oil on wood, each 19¹/₂ × 8³/₄ in.
(49.5 × 22.2 cm)
Inscribed (on cross): i·n·r·i·
The Friedsam Collection, Bequest of Michael Friedsam, 1931
32.100.106–107

about 1480

The Martyrdom of Saint Adrian; The Martyrdom of Two Saints, Possibly Ache and Acheul
These panels are from an altarpiece originally in the abbey of Eaucourt, Arras.
Oil on canvas, transferred from wood; each, including added strips, 22⁷/₈ × 11 in.
(58.1 × 27.9 cm)
The Bequest of Michael Dreicer, 1921
22.60.56–57

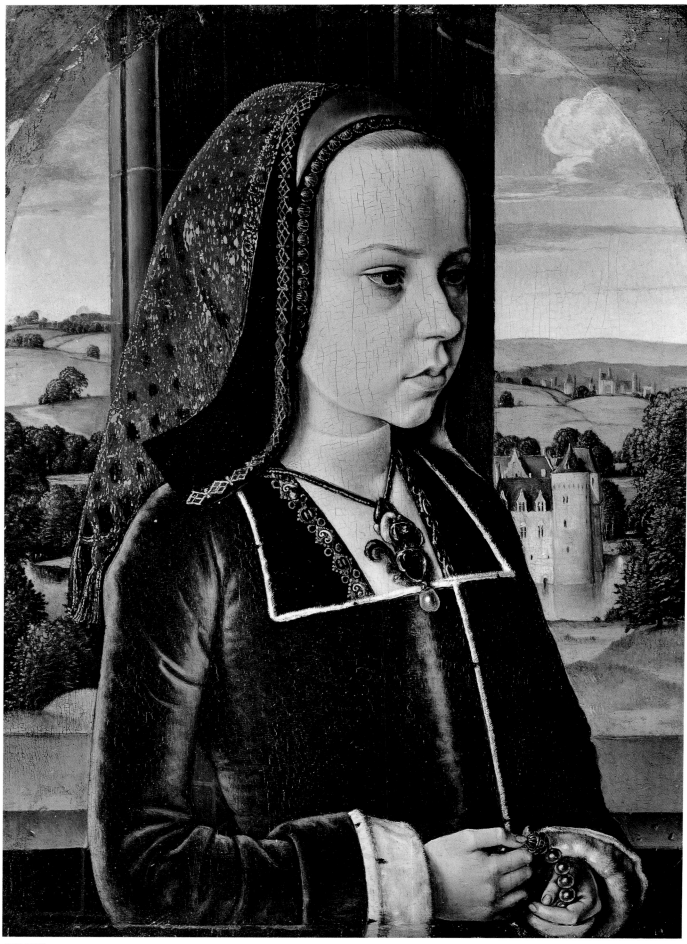

1975.I.130

32.100.112

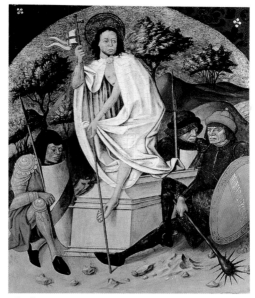

1982.60.40

32.100.115

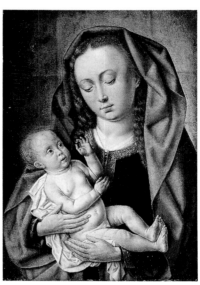

1975.1.131

37.155

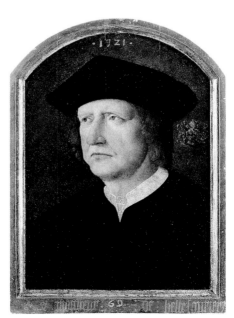

32.100.114

Jean Hey
Netherlandish, active fourth quarter 15th century

Portrait of a Young Princess, Probably Margaret of Austria (1480–1530)
Oil on wood, 13¹/₂ × 9¹/₂ in. (34.3 × 24.1 cm)
Robert Lehman Collection, 1975
1975.1.130
ROBERT LEHMAN COLLECTION

Northern French Painter
about 1480

Christ Bearing the Cross
Oil on wood, 14³/₄ × 10⁵/₈ in. (37.5 × 27 cm)
The Friedsam Collection, Bequest of Michael Friedsam, 1931
32.100.112

French or German Painter
late 15th century

The Resurrection
Oil and silver on wood, gold ground,
31 × 24⁷/₈ in. (78.7 × 63.2 cm)
The Jack and Belle Linsky Collection, 1982
1982.60.40

French (Burgundian?) Painter
about 1495

Portrait of a Young Man
Oil on wood, arched top; overall,
with engaged frame, 13 × 10¹/₈ in.
(33 × 25.7 cm); painted surface
10⁵/₈ × 8 in. (27 × 20.3 cm)
The Friedsam Collection, Bequest of Michael Friedsam, 1931
32.100.115

Master of the Saint Aegidius Legend
French, about 1500

Virgin and Child
Oil on paper, laid down on wood,
10¹/₂ × 7¹/₄ in. (26.7 × 18.4 cm)
Robert Lehman Collection, 1975
1975.1.131
ROBERT LEHMAN COLLECTION

French Painter
about 1500

Portrait of a Monk in Prayer
Oil on wood; overall 13¹/₄ × 9¹/₂ in.
(33.7 × 24.1 cm); painted surface
13¹/₈ × 9¹/₂ in. (33.3 × 24.1 cm)
Fletcher Fund, 1937
37.155

French Painter

dated 1521

Monsieur de Bellefourière

Oil on wood, arched top; overall, with
engaged frame, 18³/₈ × 13¹/₈ in.
(46.7 × 33.3 cm)
Dated and inscribed: (top) ·1521·; (bottom, on
frame) monsieur:69:de:bellefouriere
Unidentified arms (right)
The Friedsam Collection, Bequest of Michael
Friedsam, 1931
32.100.114

Jean Bellegambe

French, active 1504–1534

The Le Cellier Altarpiece

The Virgin and Child enthroned (central
panel), adored by donors and Cistercian
monks, presented by Saint Bernard (left wing)
and an unidentified Cistercian saint (right
wing); the Virgin appearing to Saint Bernard
of Clairvaux (exterior)
Oil on wood, shaped top; central panel
40 × 24 in. (101.6 × 61 cm); left wing
37³/₄ × 10 in. (95.9 × 25.4 cm); right wing
37¹/₂ × 9¹/₂ in. (95.3 × 24.1 cm)
Arms (interior of left wing, top) of the family
of Saint Bernard, used by the Cistercian
order, and (interior of right wing, top) of
Jeanne de Boubais, abbess of the Cistercian
convent of Flines
The Friedsam Collection, Bequest of Michael
Friedsam, 1931
32.100.102

Charles Coguin, Abbot of Anchin (wing of a
triptych)

Oil on wood, arched top, 26³/₄ × 11³/₈ in.
(67.9 × 28.9 cm)
Arms (on prie-dieu) of Abbot Coguin
The Friedsam Collection, Bequest of Michael
Friedsam, 1931
32.100.125

Jean Clouet

French, active by 1516, died 1541

Guillaume Budé (1467–1540)

Budé, a scholar and humanist at the court of
Francis I, established the library that became
the nucleus of the Bibliothèque Nationale,
Paris. In about 1536 he noted that Jean Clouet
had painted his portrait; a preparatory study
is in the Musée Condé, Chantilly.
Oil on wood, 15⁵/₈ × 13¹/₂ in.
(39.7 × 34.3 cm)
Inscribed: (upper left) ORONCIO [later
addition incorrectly identifying the sitter as
Oronce Fine (1494–1555), whom Clouet is
known to have painted in 1530]; (on book, in
Greek) While it seems to be good to get what
one desires, the greatest good is not to desire
what one does not need.
Maria DeWitt Jesup Fund, 1946
46.68

32.100.102 (exterior) 33.100.102 (interior)

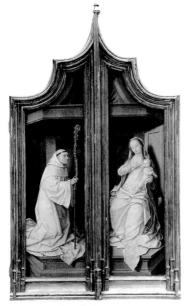

32.100.125

46.68

Corneille de Lyon

Netherlandish, active by 1533, died 1575

Portrait of a Man with Gloves

This painting is one of a number formerly
ascribed to the Master of the Benson Portraits
and now given to Corneille by comparison
with the portrait of Pierre Aymeric (Louvre,
Paris) of 1534.
Oil on wood, 8³/₈ × 6¹/₂ in.
(21.3 × 16.5 cm)
Theodore M. Davis Collection, Bequest of
Theodore M. Davis, 1915
30.95.279

30.95.279

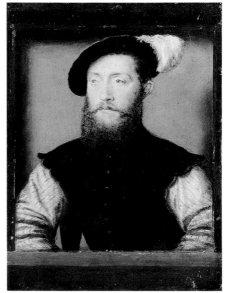

49.7.44

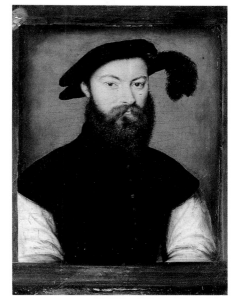

49.7.45

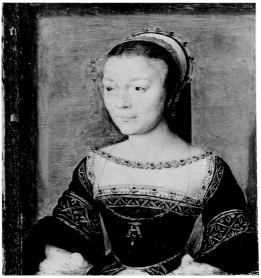

29.100.197

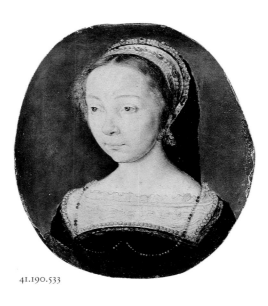

41.190.533

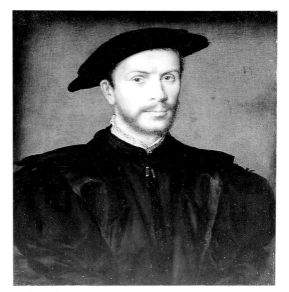

1978.301.6

32.100.103

Attributed to Corneille de Lyon

Charles de Cossé (1506–1563), **Comte de Brissac**
Oil on wood, 6¹/₂ × 5¹/₂ in. (16.5 × 14 cm); with added strips, 8¹/₂ × 6 in. (21.6 × 15.2 cm)
The Jules Bache Collection, 1949
49.7.44

Portrait of a Man with a Black-Plumed Hat
Oil on wood, 7 × 5¹/₂ in. (17.8 × 14 cm); with added strips, 8¹/₂ × 6 in. (21.6 × 15.2 cm)
The Jules Bache Collection, 1949
49.7.45

Anne de Pisseleu (1508–1576), **Duchesse d'Étampes**
Oil on wood, 7 × 5⁵/₈ in. (17.8 × 14.3 cm)
H. O. Havemeyer Collection, Bequest of Mrs. H. O. Havemeyer, 1929
29.100.197

Portrait of a Young Woman
Oil on wood, oval, 5³/₄ × 5¹/₈ in. (14.6 × 13 cm)
Bequest of George Blumenthal, 1941
41.190.533

Portrait of a Bearded Man in Black
Oil on wood, 6³/₄ × 6¹/₄ in. (17.1 × 15.9 cm)
Bequest of George D. Pratt, 1935
1978.301.6

Jean d'Albon de Saint-André (1472–1549)
Oil on wood, 6⁷/₈ × 5³/₄ in. (17.5 × 14.6 cm)
The Friedsam Collection, Bequest of Michael Friedsam, 1931
32.100.103

Attributed to Corneille de Lyon

Portrait of a Man with a Gold Chain
Oil on wood, 5¼ × 4⅜ in. (13.3 × 11.1 cm)
The Friedsam Collection, Bequest of Michael
Friedsam, 1931
32.100.129

Portrait of a Bearded Man in White
Oil on wood; overall 8½ × 6 in.
(21.6 × 15.2 cm), including added strip of
½ in. (1.3 cm) at bottom
Inscribed (bottom, on added strip):
ANTOINE·DE BOVRBON ROY·DE·NAVARRE·
Bequest of George D. Pratt, 1935
1978.301.7

Portrait of a Man with Gloves
Oil on wood, 6⅞ × 6½ in.
(17.5 × 16.5 cm)
Bequest of George Blumenthal, 1941
41.190.532

Portrait of a Man
Oil on wood, 6⅝ × 5½ in. (16.8 × 14 cm)
Robert Lehman Collection, 1975
1975.1.132
ROBERT LEHMAN COLLECTION

Portrait of a Man
Oil on wood, 6⅞ × 6⅛ in.
(17.5 × 15.6 cm)
H. O. Havemeyer Collection, Bequest of Mrs.
H. O. Havemeyer, 1929
29.100.22

Portrait of a Man
Oil on wood, diameter 3¾ in. (9.5 cm)
The Jack and Belle Linsky Collection, 1982
1982.60.41

32.100.129

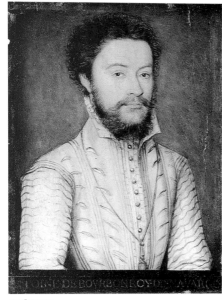

1978.301.7

41.190.532

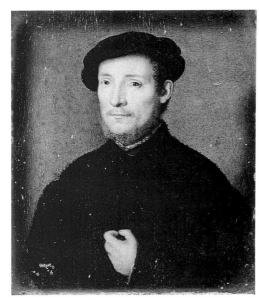

1975.1.132

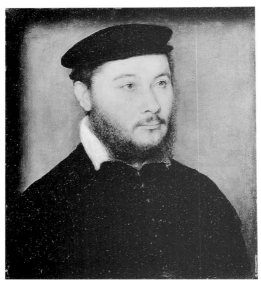

29.100.22

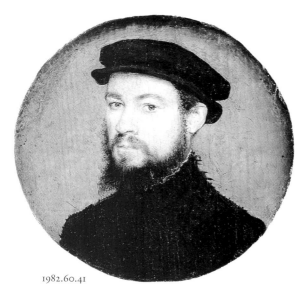

1982.60.41

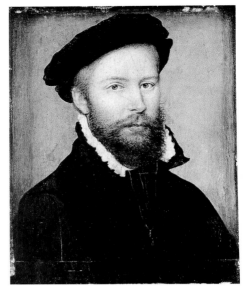

32.100.121

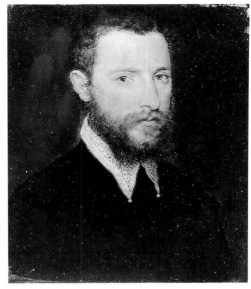

32.100.131

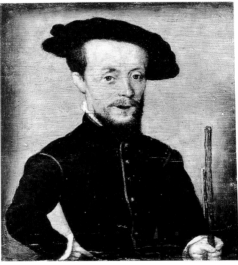

22.60.63

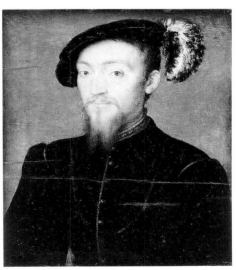

30.95.286

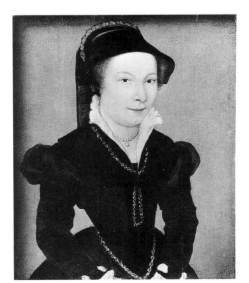

32.100.113

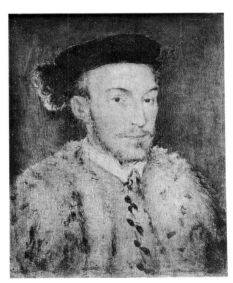

17.190.4

Portrait of a Man
Oil on wood, 7 × 5¹/₂ in. (17.8 × 14 cm)
Inscribed (top): M de la Nove
The Friedsam Collection, Bequest of Michael
Friedsam, 1931
32.100.121

Portrait of a Man with a Pointed Collar
Oil on wood, 5⁵/₈ × 4³/₄ in.
(14.3 × 12.1 cm)
The Friedsam Collection, Bequest of Michael
Friedsam, 1931
32.100.131

Style of Corneille de Lyon

French, second quarter 16th century

Portrait of a Dwarf
Oil on wood, 5³/₄ × 4³/₄ in.
(14.6 × 12.1 cm)
The Bequest of Michael Dreicer, 1921
22.60.63

Portrait of a Man
Oil on wood, 6⁷/₈ × 5⁷/₈ in.
(17.5 × 14.9 cm)
Theodore M. Davis Collection, Bequest of
Theodore M. Davis, 1915
30.95.286

Portrait of a Widow
Oil on wood, 8³/₄ × 7 in. (22.2 × 17.8 cm)
The Friedsam Collection, Bequest of Michael
Friedsam, 1931
32.100.113

French Painter

second or third quarter 16th century

Portrait of a Man in a White Fur Coat
Oil on wood, 7 × 5¹/₂ in. (17.8 × 14 cm)
Gift of J. Pierpont Morgan, 1917
17.190.4

Workshop of François Clouet

French, active by 1536, died 1572

Henry II (1519–1559), **King of France**
Oil on canvas, transferred from wood,
61¹/₂ × 53 in. (156.2 × 134.6 cm)
Bequest of Helen Hay Whitney, 1944
45.128.12

Style of François Clouet

French, painted shortly after 1561

Charles IX (1550–1574), **King of France**
Oil on wood, 12³/₈ × 9 in. (31.4 × 22.9 cm)
The Friedsam Collection, Bequest of Michael
Friedsam, 1931
32.100.124

French Painter

dated 1540

*Portrait of a Member of the de Thou
Family*
Oil on wood, 6¹/₈ × 5³/₈ in.
(15.6 × 13.7 cm)
Dated and inscribed (top): ·ROMÆ 1540. MEN.
MAR. (month of March) 'ETA.[2]8.
Arms (upper right) of the de Thou and de
Marle families
The Bequest of Michael Dreicer, 1921
22.60.46

Monogrammist LAM

French, active 1568–1574

Portrait of a Man in White
Oil on wood, 16¹/₈ × 9¹/₂ in.
(41 × 24.1 cm)
Signed, dated, and inscribed (right): ANNO
DOMINI· / 1574· / ÆTATIS·SVÆ· / 30·LAM
[monogram]
The Friedsam Collection, Bequest of Michael
Friedsam, 1931
32.100.119

French Painters

dated 1570

Portrait of a Man with a High Hat
Oil on wood, 9⁵/₈ × 7¹/₂ in.
(24.4 × 19.1 cm)
Dated and inscribed (top): Aᵒ ·1570· ·ÆTˢ·
SVÆ·32·
The Friedsam Collection, Bequest of Michael
Friedsam, 1931
32.100.104

late 16th century

Portrait of a Knight
Oil on canvas, 47 × 35³/₄ in.
(119.4 × 90.8 cm)
Gift of William H. Riggs, 1913
14.25.1870
ARMS AND ARMOR

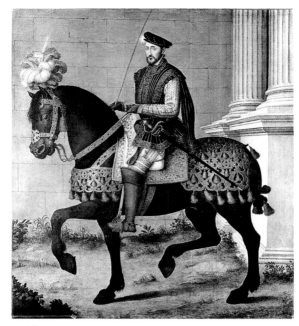

45.128.12

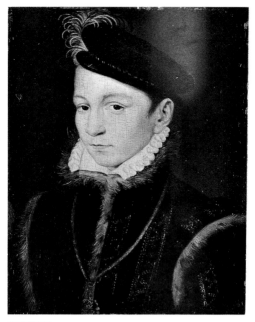

32.100.124

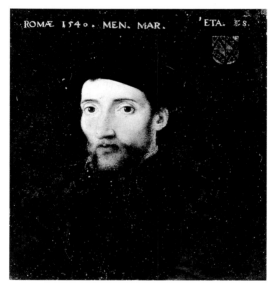

22.60.46

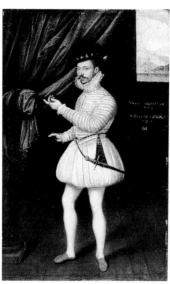

32.100.119

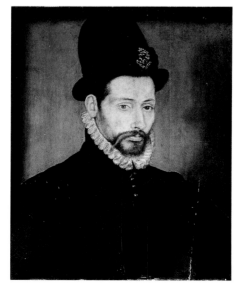

32.100.104

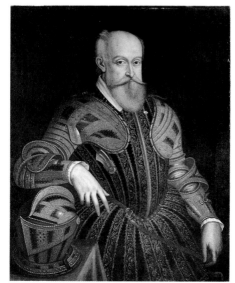

14.25.1870

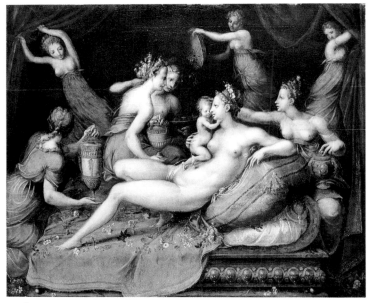

41.48

42.150.12

67.55.2

32.100.130

Master of Flora

Italian (Fontainebleau), second half 16th century

The Birth of Cupid

Oil on wood; overall 42$^{1}/_{2}$ × 51$^{3}/_{8}$ in. (108 × 130.5 cm), including added strip of 3$^{1}/_{2}$ in. (8.9 cm) at top
Rogers Fund, 1941
41.48

French (Fontainebleau) Painter

third quarter 16th century

The Nymph of Fontainebleau

Oil on wood, 26 × 47$^{3}/_{4}$ in. (66 × 121.3 cm)
Inscribed: (bottom) O PHIDIAS O APELLES QVIDQVAM NE ORNATIVS VESTRIS TEMPORIBVS EXCOGITARI POTVIT EA SCVLPTVRA CVIVS HIC PICTVRAM CERNITIS QVAM / FRANCISCVS PRIMVS FRANCORVM REX POTENTISS BONARVM ARTIVM AC LITERARVM PATER SVB DIANÆ A VENATV C̄OQVIESCĒTIS / ATQVE VRNAM FONTISBELLAQVÆ EFFVNDENTIS STATVA DOMI SVÆ INCHOATAM RELIQVIT– (O Phidias, O Apelles, could anything more excellent have been devised in your times than that sculpture, of which you see here a picture, that Francis I, king of the Franks, the most mighty father of fine arts and literature, left unfinished in his home, surrounding a figure of Diana resting from the chase and emptying the urn of the Fountain of Beautiful Water); (below central medallion) F with a crown encircling the stem, within a wreath (this and the flaming salamander above the central medallion are devices of Francis I)
Gift of Mrs. Heyward Cutting, 1942
42.150.12

French Painter

late 16th century

Henry III (1551–1589), King of France

Oil on wood, 12$^{3}/_{4}$ × 9$^{7}/_{8}$ in. (32.4 × 25.1 cm)
Bequest of Susan Dwight Bliss, 1966
67.55.2

Northern French Painter

dated 1605

Portrait of a Man of the Moncheaux Family

Oil on wood; overall, with engaged frame, 10$^{3}/_{4}$ × 8$^{3}/_{8}$ in. (27.3 × 21.3 cm); painted surface 9 × 6$^{3}/_{4}$ in. (22.9 × 17.1 cm)
Dated and inscribed: (left) En Esperãt Mõcheaulx; (right) ÆTA : SVÆ. 80 / 6 MOIS.Ao 1605
Arms (upper left) of the Moncheaux family
The Friedsam Collection, Bequest of Michael Friedsam, 1931
32.100.130

Claude Deruet

French, 1588–1660

Departure of the Amazons

Oil on canvas, 20 × 26 in. (50.8 × 66 cm)
Signed (bottom left): [D]ERV[ET]
Bequest of Harry G. Sperling, 1971
1976.100.6

Battle of Amazons and Greeks

Pendant to 1976.100.6
Oil on canvas, 20¼ × 26 in.
(51.4 × 66 cm)
Signed (bottom left): DERVET
Bequest of Harry G. Sperling, 1971
1976.100.7

Georges de La Tour

French, 1593–1652

The Fortune Teller

Oil on canvas, 40⅛ × 48⅝ in.
(101.9 × 123.5 cm)
Signed and inscribed: (upper right) G. de La
Tour Fecit Luneuilla Lothar: (Lunéville
Lorraine); (on young man's watch chain)
AMOR (love) FIDES (faith)
Rogers Fund, 1960
60.30

The Penitent Magdalen

Oil on canvas, 52½ × 40¼ in.
(133.4 × 102.2 cm)
Gift of Mr. and Mrs. Charles Wrightsman,
1978
1978.517

1976.100.6 1976.100.7

60.30

Nicolas Poussin

French, 1594–1665

Midas Washing at the Source of the Pactolus

The picture, based on Ovid (*Metamorphoses* II), is the pendant to the Arcadian Shepherds (Duke of Devonshire, Chatsworth). An unfinished variant is in a private collection.
Oil on canvas, 38³/₈ × 28⁵/₈ in.
(97.5 × 72.7 cm)
Purchase, 1871
71.56

The Companions of Rinaldo

The painting illustrates an episode from Torquato Tasso's *Jerusalem Delivered* (1580). Probably painted in the early 1630s for Cassiano dal Pozzo (1588–1657), Rome
Oil on canvas, 46¹/₂ × 40¹/₄ in.
(118.1 × 102.2 cm)
Gift of Mr. and Mrs. Charles Wrightsman, 1977
1977.1.2

The Rape of the Sabine Women

Oil on canvas, 60⁷/₈ × 82⁵/₈ in.
(154.6 × 209.9 cm)
Harris Brisbane Dick Fund, 1946
46.160

Blind Orion Searching for the Rising Sun

Painted for Michel Passart, Paris, in 1658
Oil on canvas, 46⁷/₈ × 72 in.
(119.1 × 182.9 cm)
Fletcher Fund, 1924
24.45.1

Saints Peter and John Healing the Lame Man

The picture illustrates the first apostolic miracle (Acts 3:1–10). Painted for M. Mercier, Lyons, in 1655
Oil on canvas, 49¹/₂ × 65 in.
(125.7 × 165.1 cm)
Marquand Fund, 1924
24.45.2

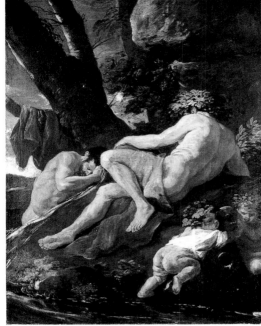

71.56

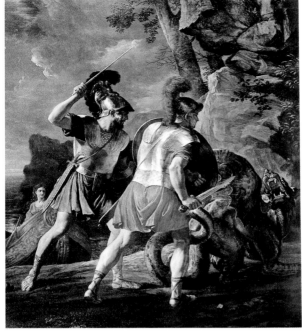

1977.1.2

46.160

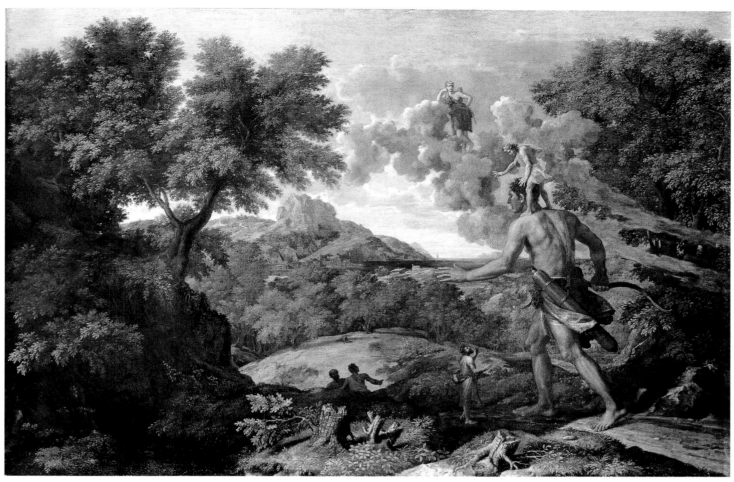

24.45.1

24.45.2

Style of Nicolas Poussin

French, third quarter 17th century

Orpheus and Eurydice
Oil on canvas, 47¹/₂ × 70³/₄ in.
(120.7 × 179.7 cm)
H. O. Havemeyer Collection, Bequest of Mrs.
H. O. Havemeyer, 1929
29.100.20

Jacques Blanchard

French, 1600–1638

Angelica and Medoro
Oil on canvas, with added strip at top,
47⁷/₈ × 69¹/₄ in. (121.6 × 175.9 cm)
Gift of George A. Hearn, 1906
06.1268

Philippe de Champaigne

French, 1602–1674

Jean Baptiste Colbert (1619–1683)
Oil on canvas, 36¹/₄ × 28¹/₂ in.
(92.1 × 72.4 cm)
Dated (on paper in sitter's hand): Aº 1655.
Gift of The Wildenstein Foundation Inc., 1951
51.34

Henri Mauperché

French, 1602?–1686

Classical Landscape with Figures
Oil on canvas, 27⁷/₈ × 44¹/₄ in.
(70.8 × 112.4 cm)
Bequest of Harry G. Sperling, 1971
1976.100.9

Laurent de La Hyre

French, 1606–1656

Allegory of Music
This may be one of seven half-length figures
representing the Liberal Arts, which were
painted for the house of Gédéon Tallement
(1613–1668) in the rue d'Angoulmois, the
Marais, Paris. It was apparently flanked by
Music-Making Putti (both Musée Magnin,
Dijon).
Oil on canvas, 41⁵/₈ × 56³/₄ in.
(105.7 × 144.1 cm)
Signed, dated, and inscribed: (lower left) DE
LA HIRE, / P. 1649 ·; (on music, apparently
with words from a song) C'est a ce coup . . .
(It is with this drink . . .)
Charles B. Curtis Fund, 1950
50.189

Gaspard Dughet

French, 1615–1675

Imaginary Landscape
Oil on canvas, 37⁷/₈ × 60¹/₂ in.
(96.2 × 153.7 cm)
Rogers Fund, 1908
08.227.1

29.100.20

06.1268

51.34

1976.100.9

50.189

08.227.1

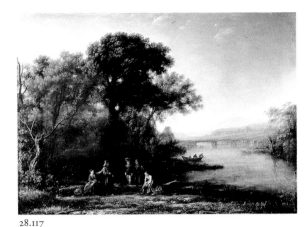

28.117

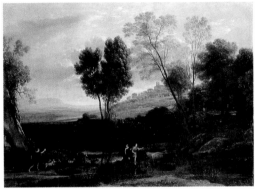

65.181.12

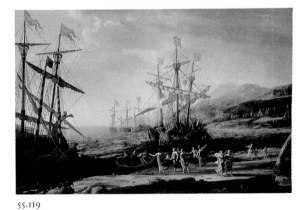

55.119

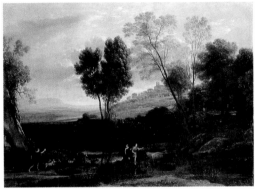

47.12

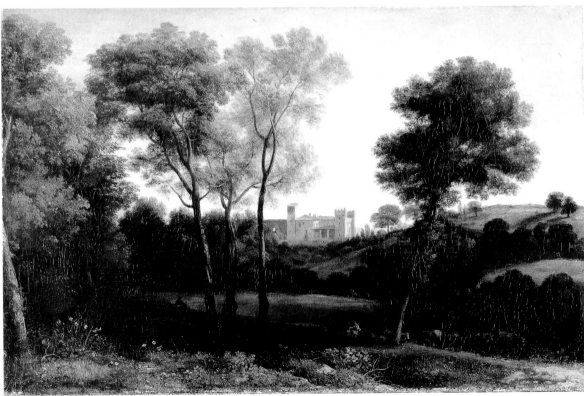

1978.205

Claude Lorrain (Claude Gellée)
French, 1604/5?–1682

The Ford
Number 8 of the *Liber veritatis*, painted for an unspecified Parisian client
Oil on canvas, 29¼ × 39¾ in. (74.3 × 101 cm)
Signed and dated (lower left): CLAVD[IO F?] / ROM[AE?] [with traces of a date, no longer legible]
Fletcher Fund, 1928
28.117

Pastoral Landscape: The Roman Campagna
Number 42 of the *Liber veritatis*, painted for an unspecified Parisian client
Oil on canvas, 40 × 53½ in. (101.6 × 135.9 cm)
Signed (lower center); CLAVDIO Gille f [ROM?] A [signature reinforced?]
Bequest of Adele L. Lehman, in memory of Arthur Lehman, 1965
65.181.12

The Trojan Women Setting Fire to Their Fleet
The picture illustrates a passage from Virgil's *Aeneid* (5: 604–695). Number 41 of the *Liber veritatis*, painted for Girolamo Farnese (1599–1668), Rome
Oil on canvas, 41³⁄₈ × 59⁷⁄₈ in. (105.1 × 152.1 cm)
Signed (lower right, on rock): Cl[avdio?] / ROMA [reportedly; no longer legible]
Fletcher Fund, 1955
55.119

Sunrise
Number 109 of the *Liber veritatis*, painted for an unspecified client in Lyons, and probably a pendant to Pastoral Landscape with the Flight into Egypt (Gemäldegalerie, Dresden), LV 110, painted in 1647 for a M. Parasson
Oil on canvas, 40½ × 52¾ in. (102.9 × 134 cm)
Fletcher Fund, 1947
47.12

View of La Crescenza
Number 118 of the *Liber veritatis*
Oil on canvas, 15¼ × 22⁷⁄₈ in. (38.7 × 58.1 cm)
Purchase, The Annenberg Fund Inc. Gift, 1978
1978.205

Copy after Claude Lorrain
Italian, Roman, 1630 or later

Landscape with an Artist Drawing
The painting is probably a contemporaneous copy of Idyll: Landscape with a Draftsman Sketching Ruins (Spencer Museum, University of Kansas).
Oil on canvas, 22³/₄ × 32 in.
(57.8 × 81.3 cm)
Inscribed (lower right); CLAVDIO I.V. / ROMA / 1630
Bequest of Harry G. Sperling and The Alfred N. Punnett Endowment Fund, 1975
1975.152

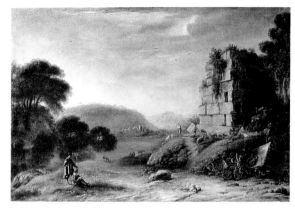

1975.152

Eustache Le Sueur
French, 1616–1655

The Rape of Tamar
Oil on canvas, 74¹/₂ × 63¹/₂ in.
(189.2 × 161.3 cm)
Purchase, Mr. and Mrs. Charles Wrightsman Gift, 1984
1984.342

1984.342

Sébastien Bourdon
French, 1616–1671

The Baptism of Christ
Oil on canvas; overall 59³/₄ × 46¹/₂ in.
(151.8 × 118.1 cm); painted surface (oval) 59¹/₈ × 45¹/₂ in. (150.2 × 115.6 cm)
Purchase, George T. Delacorte Jr. Gift, 1974
1974.2

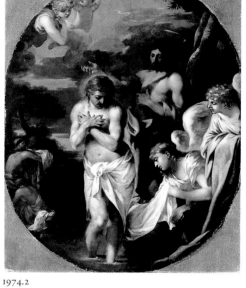

1974.2

A Classical Landscape
Oil on canvas, 27¹/₂ × 36¹/₄ in.
(69.9 × 92.1 cm)
Inscribed (left, on monument): U.NE
Gift of Atwood A. Allaire, Pamela Askew, and Phoebe A. DesMarais, in memory of their mother, Constance Askew, 1985
1985.90

1985.90

Attributed to Sébastien Bourdon

Portrait of a Young Boy
Oil on canvas, 23¹/₄ × 19³/₄ in.
(59.1 × 50.2 cm)
The Jules Bache Collection, 1949
49.7.39

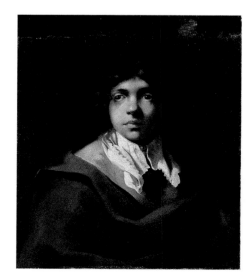

49.7.39

Francisque Millet
French, 1642–1679

Mercury and Battus
Oil on canvas, 47 × 70 in.
(119.4 × 177.8 cm)
H. O. Havemeyer Collection, Bequest of Mrs. H. O. Havemeyer, 1929
29.100.21

29.100.21

27.59

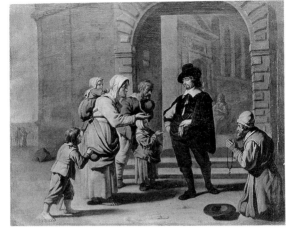

71.80

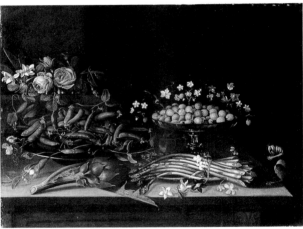

1976.100.10

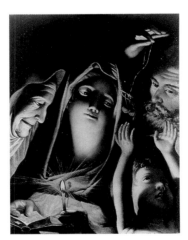

1976.100.12

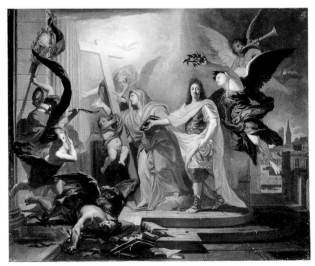

1976.100.11

1976.100.13

Jean Michelin

French, born about 1616, died 1670

The Baker's Cart

Oil on canvas, 38³/₄ × 49³/₈ in.
(98.4 × 125.4 cm)
Signed and dated (center left): J. Michelin/f
1656
Fletcher Fund, 1927
27.59

Master of the Béguins

French, active 1650–1660

Beggars at a Doorway

Oil on canvas, 20¹/₄ × 23³/₈ in.
(51.4 × 59.4 cm)
Purchase, 1871
71.80

French Painters

17th century

Still Life with Strawberries

Oil on canvas, 23⁵/₈ × 31⁵/₈ in.
(60 × 80.3 cm)
Bequest of Harry G. Sperling, 1971
1976.100.10

Holy Family with Saint Anne

Oil on canvas, 27 × 20 in.
(68.6 × 50.8 cm)
Bequest of Harry G. Sperling, 1971
1976.100.12

late 17th century

*An Allegory, Perhaps of the Revocation of
the Edict of Nantes in 1685*

Oil on canvas, 18⁵/₈ × 22 in.
(47.3 × 55.9 cm)
Bequest of Harry G. Sperling, 1971
1976.100.11

Trompe l'oeil with Palettes and Miniature

Oil on canvas, 46⁷/₈ × 36¹/₈ in.
(119.1 × 91.8 cm)
Inscribed (upper right, on etching): N.L. In.
et fecit. et ex. C.P.R.
Bequest of Harry G. Sperling, 1971
1976.100.13

Nicolas de Largillierre

French, 1656–1746

Portrait of a Woman, Perhaps Madame Claude Lambert de Thorigny (Marie Marguerite Bontemps, 1668–1701)
Oil on canvas, 55 × 42 in.
(139.7 × 106.7 cm)
Signed and dated (lower left, on fountain): peint / par N. de / Largillierre– / 1696
Rogers Fund, 1903
03.37.2

André François Alloys de Theys d'Herculais
(1692–1779)
Oil on canvas, 54¼ × 41½ in.
(137.8 × 105.4 cm)
Signed and dated (verso): peint par N. de Largillierre / 17[2?]7
Gift of Mr. and Mrs. Charles Wrightsman, 1973
1973.311.4

Hyacinthe Rigaud

French, 1659–1743

Louis XV (1710–1774) ***as a Child***
This is one of numerous repetitions of the portrait at Versailles.
Oil on canvas, 77 × 55½ in.
(195.6 × 141 cm)
Purchase, Mary Wetmore Shively Bequest, in memory of her husband, Henry L. Shively, M.D., 1960
60.6

Henri Louis de la Tour d'Auvergne (1679–1753), ***Comte d'Évreux, Maréchal de France***
Oil on canvas, 54 × 41³⁄₈ in.
(137.2 × 105.1 cm)
The Alfred N. Punnett Endowment Fund, 1959
59.119

Attributed to Hyacinthe Rigaud

Portrait of a Man, Possibly François de Chambrier (1663–1730)
Oil on canvas, oval, 32½ × 25¾ in.
(82.6 × 65.4 cm)
Bequest of Catherine D. Wentworth, 1948
48.187.733

Alexandre François Desportes

French, 1661–1743

Still Life with Silver
Oil on canvas, 103 × 73¾ in.
(261.6 × 187.3 cm)
Signed (lower right): Desportes
Purchase, Mary Wetmore Shively Bequest, in memory of her husband, Henry L. Shively, M.D., 1964
64.315

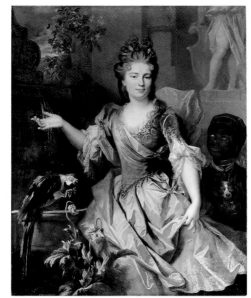

03.37.2

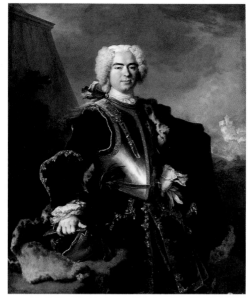

1973.311.4

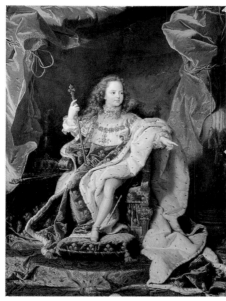

60.6

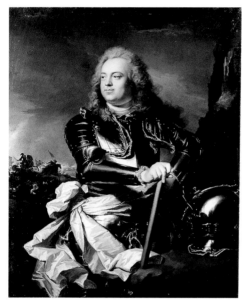

59.119

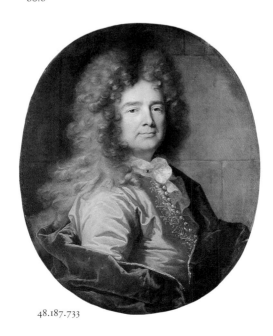

48.187.733

64.315

63.120

48.187.732

48.187.731

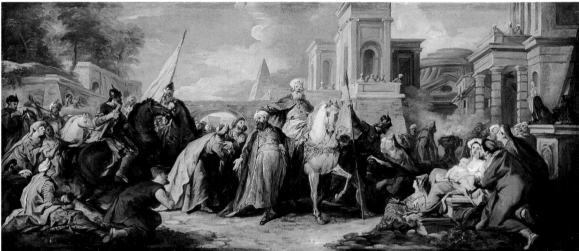

07.225.285

60.120

48.187.734

Pierre Gobert

French, 1662–1744

Marie Adélaïde de Savoie (1685–1712), *Duchesse de Bourgogne*

Oil on canvas, oval, 28³/₄ × 23¹/₄ in. (73 × 59.1 cm)

Dated and inscribed (top): ADELAIDE DE SAVOIE / DUCHESSE DE BOURGOGNE. 1710

Gift of the Marquis de La Bégassière, 1963

63.120

French Painter

first quarter 18th century

Portrait of a Man in a Brown Coat

Oil on canvas, oval, 28³/₄ × 23¹/₄ in. (73 × 59.1 cm)

Bequest of Catherine D. Wentworth, 1948

48.187.732

Portrait of a Woman in a Rose Dress

Pendant to 48.187.732

Oil on canvas, oval, 28¹/₂ × 23¹/₄ in. (72.4 × 59.1 cm)

Bequest of Catherine D. Wentworth, 1948

48.187.731

Jean François de Troy

French, 1679–1752

The Triumph of Mordecai

This is a study for a tapestry cartoon (Musée des Arts Décoratifs, Paris) that was painted in Rome in 1739.

Oil on canvas, 33⁷/₈ × 59¹/₈ in. (86 × 150.2 cm)

Gift of J. Pierpont Morgan, 1906

07.225.285

Robert Levrac Tournières

French, 1668–1752

Self-portrait with Pierre de la Roche

Oil on wood, 17 × 13¹/₈ in. (43.2 × 33.3 cm)

Gift of the Marquis de La Bégassière, 1960

60.120

French Painter

mid-18th century

Portrait of a Woman Holding a Book

Oil on canvas, 32¹/₄ × 25⁷/₈ in. (81.9 × 65.7 cm)

Unidentified arms (upper left)

Bequest of Catherine D. Wentworth, 1948

48.187.734

Jean Antoine Watteau

French, 1684–1721

The French Comedians

Oil on canvas, 22¹/₂ × 28³/₄ in.
(57.2 × 73 cm)
The Jules Bache Collection, 1949
49.7.54

Mezzetin

Oil on canvas, 21³/₄ × 17 in.
(55.2 × 43.2 cm)
Munsey Fund, 1934
34.138

Attributed to Jean Antoine Watteau

The Peasant Dance

Oil on wood, diameter 8¹/₂ in. (21.6 cm)
Bequest of Lillian S. Timken, 1959
60.71.20

The Cascade

Pendant to 60.71.20
Oil on wood, diameter 8¹/₂ in. (21.6 cm)
Bequest of Lillian S. Timken, 1959
60.71.21

Jean Baptiste Oudry

Flemish, 1686–1755

Ducks Resting in Sunshine

Oil on canvas, 25¹/₂ × 31³/₄ in.
(64.8 × 80.6 cm)
Signed and dated (lower left): JB. oudry / 1753
Purchase, 1871
71.57

Dog Guarding Dead Game

Pendant to 71.57
Oil on canvas, 25¹/₂ × 31³/₄ in.
(64.8 × 80.6 cm)
Signed and dated (lower left): JB. oudry. 1753
Purchase, 1871
71.89

Jean Marc Nattier

French, 1685–1766

Madame Marsollier and Her Daughter

Oil on canvas, 57¹/₂ × 45 in.
(146.1 × 114.3 cm)
Signed and dated (right, on pilaster): Nattier
pinxit. / 1749
Bequest of Florence S. Schuette, 1945
45.172

49.7.54

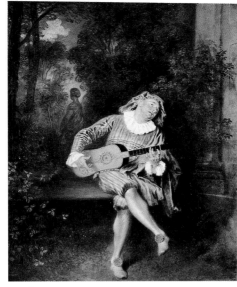

34.138

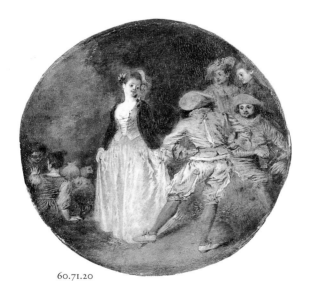

60.71.20

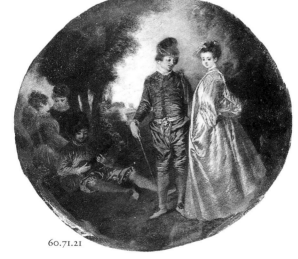

60.71.21

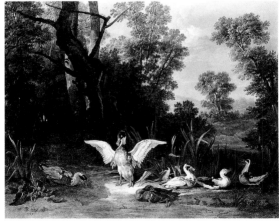

71.57

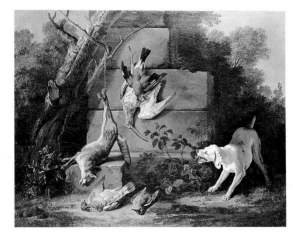

71.89

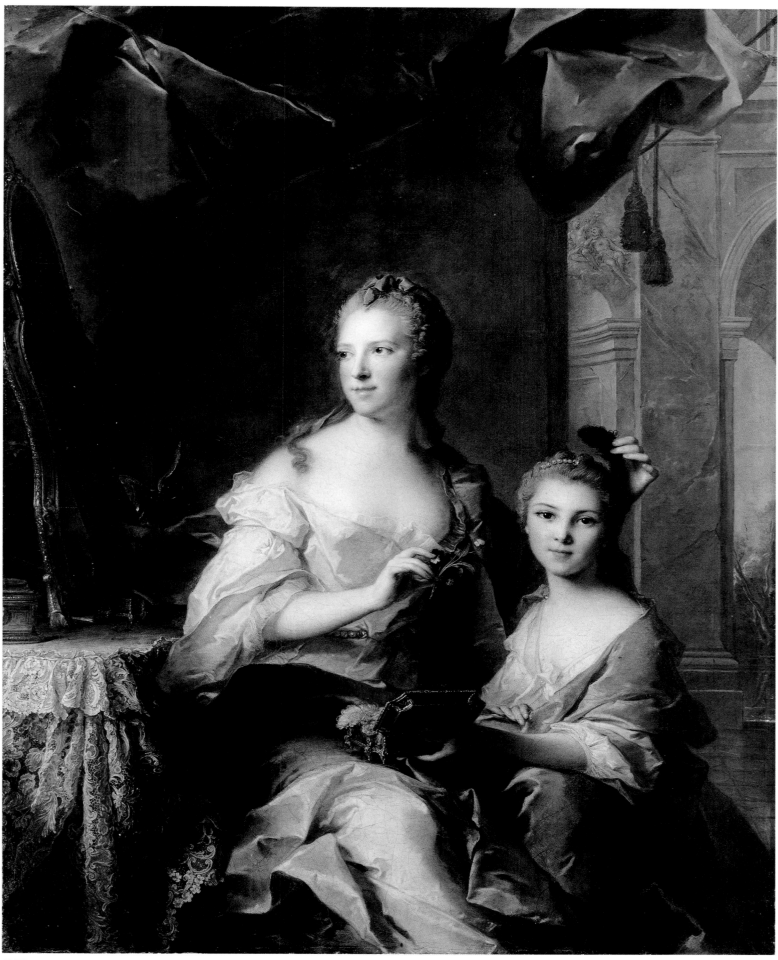

45.172

Jean Marc Nattier

French, 1685–1766

Louise Henriette de Bourbon-Conti (1726–1759), *Later Duchesse d'Orléans*
Oil on canvas, 31³/₄ × 25⁵/₈ in.
(80.6 × 65.1 cm)
Gift of Jessie Woolworth Donahue, 1956
56.100.2

Marie Françoise de La Cropte de St. Abre, Marquise d'Argence
Oil on canvas, 32¹/₂ × 25¹/₂ in.
(82.6 × 64.8 cm)
Gift of Jessie Woolworth Donahue, 1958
58.102.1

Portrait of a Woman, Called the Marquise Perrin de Cypierre
Oil on canvas, 31¹/₂ × 25¹/₄ in.
(80 × 64.1 cm), with later additions of
1¹/₄ in. (3.2 cm) at bottom, 1 in. (2.5 cm) at
left, and ¹/₂ in. (1.3 cm) at right
Signed and dated (center left, on tree trunk):
[N]attier. p. x. / 1753
The Jack and Belle Linsky Collection, 1982
1982.60.42

Portrait of a Young Woman as Diana
Oil on canvas, 53³/₄ × 41³/₈ in.
(136.5 × 105.1 cm)
Signed and dated (lower right): Nattier p.x. /
1756.
Rogers Fund, 1903
03.37.3

Jean Baptiste Joseph Pater

French, 1695–1736

Troops on the March
Oil on canvas, 21¹/₄ × 25³/₄ in.
(54 × 65.4 cm)
Bequest of Ethel Tod Humphrys, 1956
56.55.1

Troops at Rest
Pendant to 56.55.1
Oil on canvas, 21¹/₄ × 25³/₄ in.
(54 × 65.4 cm)
Bequest of Ethel Tod Humphrys, 1956
56.55.2

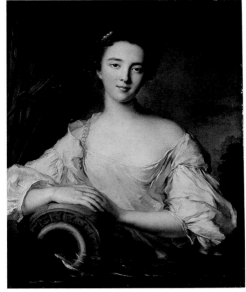

56.100.2

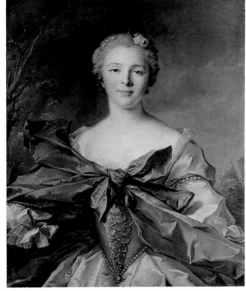

58.102.1

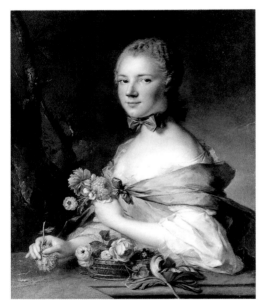

1982.60.42

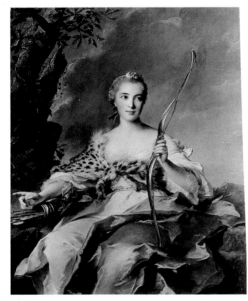

03.37.3

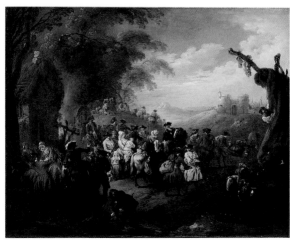

56.55.1

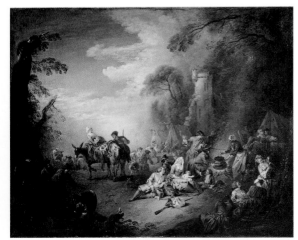

56.55.2

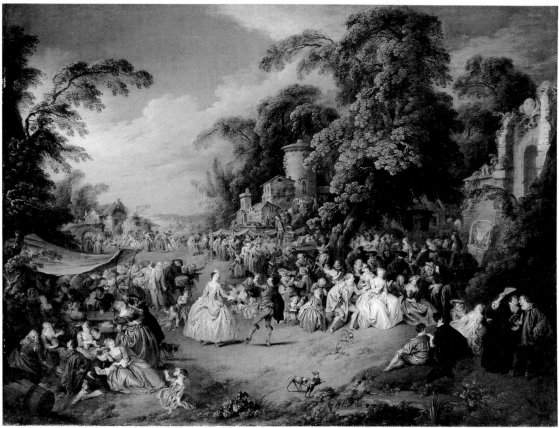

49.7.52

1982.60.43

37.27

55.205.1

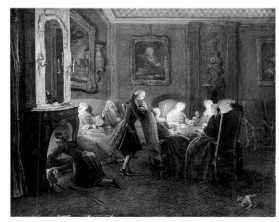

1976.100.8

The Fair at Bezons
Oil on canvas, 42 × 56 in.
(106.7 × 142.2 cm)
The Jules Bache Collection, 1949
49.7.52

The Golden Age
Oil on wood, 6³/₈ × 9 in. (16.2 × 22.9 cm)
The Jack and Belle Linsky Collection, 1982
1982.60.43

Concert Champêtre
Oil on canvas, 20¹/₂ × 26³/₄ in.
(52.1 × 67.9 cm)
Signed (lower left): PATER. F.
Purchase, Joseph Pulitzer Bequest, 1937
37.27

Louis Tocqué
French, 1696–1772

Jean Marc Nattier (1685–1766)
This painting is a sketch for the portrait in
the Statens Museum for Kunst, Copenhagen.
Oil on canvas, 30¹/₂ × 23¹/₄ in.
(77.5 × 59.1 cm)
Gift of Colonel and Mrs. Jacques Balsan, 1955
55.205.1

Pierre Louis Dumesnil the Younger
French, 1698–1781

Interior with Card Players
Oil on canvas, 31¹/₈ × 38³/₄ in.
(79.1 × 98.4 cm)
Bequest of Harry G. Sperling, 1971
1976.100.8

Jean Siméon Chardin
French, 1699–1779

Soap Bubbles
This is one of three autograph variants of a
lost original (the others are in the Los Angeles
County Museum and the National Gallery of
Art, Washington, D.C.).
Oil on canvas, 24 × 24⁷/₈ in.
(61 × 63.2 cm)
Signed (left, on stone): ·J·chardin
Wentworth Fund, 1949
49.24

The Silver Tureen
Oil on canvas, 30 × 42¹/₂ in.
(76.2 × 108 cm)
Signed (left of center): J·chardin
Fletcher Fund, 1959
59.9

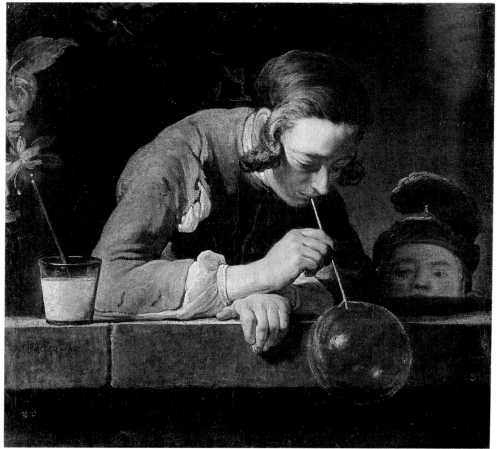

49.24

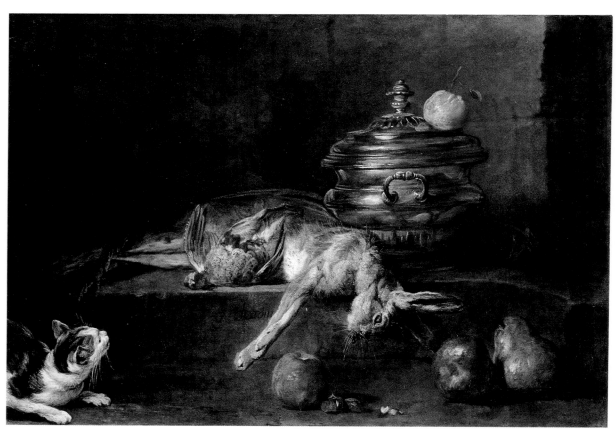

59.9

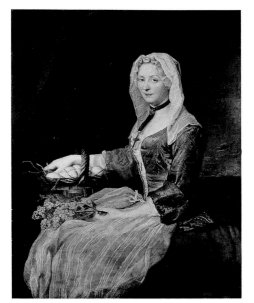

53.61.1

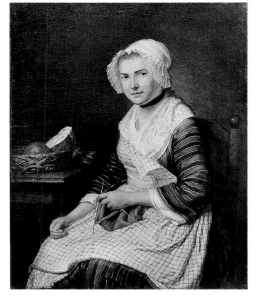

17.120.211

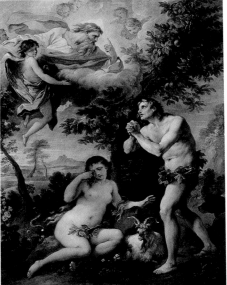

1987.279

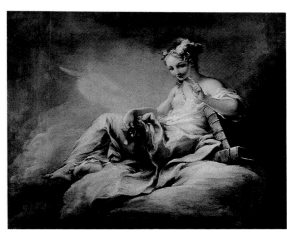

1974.356.27

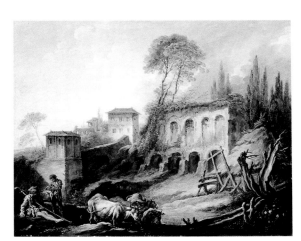

1982.60.44

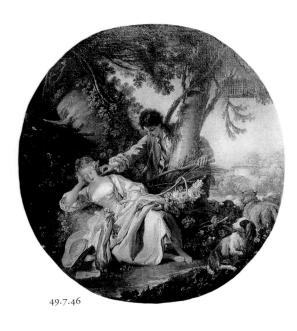

49.7.46

Style of Jean Siméon Chardin

French, second quarter 18th century

Portrait of a Woman with Lilacs and Eggs

Oil on canvas, 51¹/₈ × 38¹/₄ in. (129.9 × 97.2 cm)
Inscribed (lower left): S. Chardin
Gift of Julia A. Berwind, 1953
53.61.1

French, third quarter 18th century

Young Woman Knitting

Oil on canvas, 36¹/₄ × 28¹/₂ in. (92.1 × 72.4 cm)
Mr. and Mrs. Isaac D. Fletcher Collection,
Bequest of Isaac D. Fletcher, 1917
17.120.211

Charles Joseph Natoire

French, 1700–1777

The Expulsion from Paradise

Oil on copper, 26³/₄ × 19³/₄ in. (67.9 × 50.2 cm)
Signed and dated (lower left): C. Natoire / 1740
Purchase, Mr. and Mrs. Frank E. Richardson
III, George T. Delacorte Jr., and Mr. and
Mrs. Henry J. Heinz II Gifts; Victor Wilbour
Memorial, Marquand, and The Alfred N.
Punnett Endowment Funds; and The Edward
Joseph Gallagher III Memorial Collection,
Edward J. Gallagher Jr. Bequest, 1987
1987.279

Pierre Charles Trémolières

French, 1703–1739

Comedy

This is a study for, or reduction of, the canvas
exhibited at the 1738 Salon (Musée des Arts
de Cholet).
Oil on canvas, 18³/₄ × 23¹/₂ in. (47.6 × 59.7 cm)
The Lesley and Emma Sheafer Collection,
Bequest of Emma A. Sheafer, 1973
1974.356.27

François Boucher

French, 1703–1770

Capriccio View from the Campo Vaccino

Oil on canvas, 25 × 31⁷/₈ in. (63.5 × 81 cm)
Signed and dated (lower left center):
boucher·1734
The Jack and Belle Linsky Collection, 1982
1982.60.44

The Interrupted Sleep

This painting seems to have had as a pendant
the Love Letter (National Gallery of Art,
Washington, D.C.).
Oil on canvas; overall 32¹/₄ × 29⁵/₈ in.
(81.9 × 75.2 cm); painted surface (irregular
oval) 31 × 27³/₄ in. (78.7 × 70.5 cm)
Signed and dated (left center, on thatched
shelter): f. Boucher / 1750
The Jules Bache Collection, 1949
49.7.46

François Boucher
French, 1703–1770

The Toilet of Venus
Oil on canvas, 42⁵/₈ × 33¹/₂ in.
(108.3 × 85.1 cm)
Signed and dated (lower right): f-Boucher 1751
Bequest of William K. Vanderbilt, 1920
20.155.9

***Jupiter, in the Guise of Diana, and
Callisto***
Oil on canvas, oval, 25¹/₂ × 21⁵/₈ in.
(64.8 × 54.9 cm)
Signed (lower right): f. Bouch[er]
The Jack and Belle Linsky Collection, 1982
1982.60.45

Angelica and Medoro
Pendant to 1982.60.45
Oil on canvas, oval, 26¹/₄ × 22¹/₈ in.
(66.7 × 56.2 cm)
Signed and dated (lower left): f. Boucher /
1763
The Jack and Belle Linsky Collection, 1982
1982.60.46

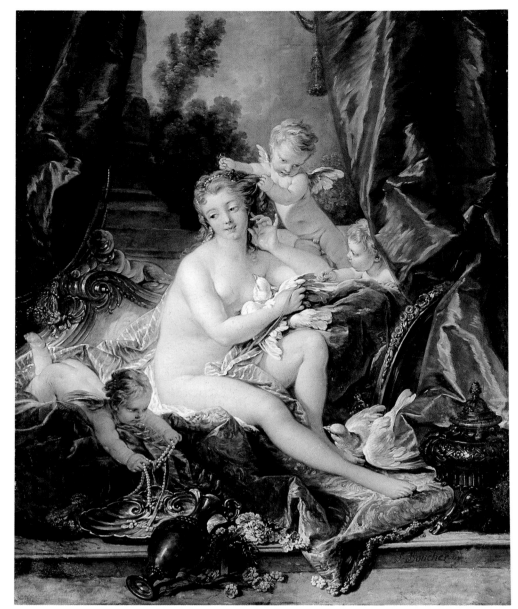

20.155.9

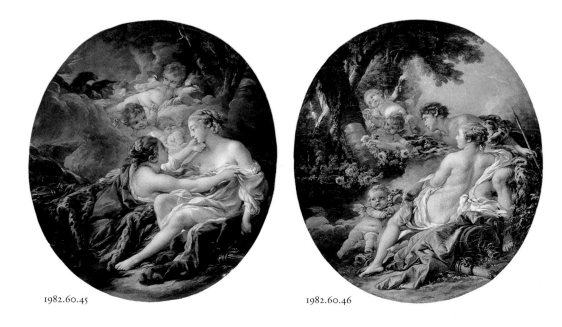

1982.60.45 1982.60.46

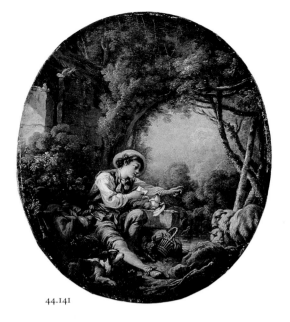

44.141

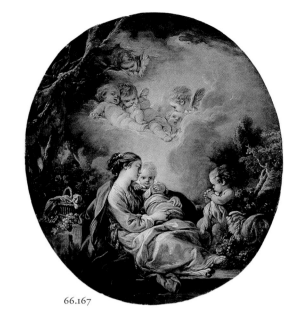

66.167

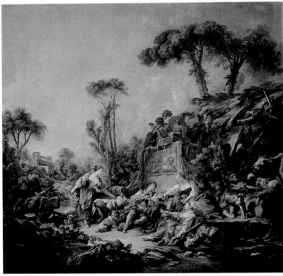

53.225.1

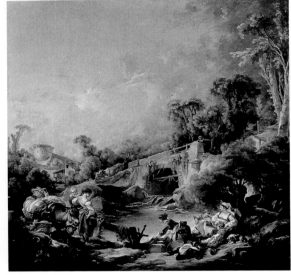

53.225.2

07.225.291

69.129

The Dispatch of the Messenger
Oil on canvas, oval, 12⅝ × 10½ in.
(32.1 × 26.7 cm)
Signed and dated (lower right): f. Boucher /
1765
Gift of Mrs. Joseph Heine, in memory of her
husband, I. D. Levy, 1944
44.141

*Virgin and Child with the Young Saint
John the Baptist and Angels*
Oil on canvas, oval, 16⅛ × 13⅝ in.
(41 × 34.6 cm)
Signed and dated (lower right): f Boucher /
1765
Gift of Adelaide Milton de Groot, in memory
of the de Groot and Hawley families, 1966
66.167

Shepherd's Idyll
Oil on canvas, 94½ × 93½ in.
(240 × 237.5 cm)
Signed and dated (lower right): f Boucher 1768
Gift of Julia A. Berwind, 1953
53.225.1

Washerwomen
Pendant to 53.225.1
Oil on canvas, 95 × 93 in.
(241.3 × 236.2 cm)
Signed and dated (lower right): f Boucher.1768
Gift of Julia A. Berwind, 1953
53.225.2

Attributed to François Boucher
Study for a Monument
Oil on paper, laid down on canvas,
15 × 12⅝ in. (38.1 × 32.1 cm)
Gift of J. Pierpont Morgan, 1906
07.225.291

Jean Baptiste Marie Pierre
French, 1713–1789
The Death of Harmonia
Oil on canvas, 77½ × 58¼ in.
(196.9 × 148 cm)
Gift of Mr. and Mrs. Harry N. Abrams, by
exchange, 1969
69.129

Claude Joseph Vernet
French, 1714–1789
*Harbor Scene with Fishermen and a
Grotto*
Oil on canvas, 22¾ × 42⅛ in.
(57.8 × 107 cm)
Bequest of Catherine D. Wentworth, 1948
48.187.739

Louis Nicolas van Blarenberghe

French, 1716–1794

The Outer Harbor of Brest
Oil on canvas, 29¼ × 42⅛ in.
(74.3 × 107 cm)
Signed and dated (lower left): van
Blarenberghe f. 1773
Gift of Mrs. Vincent Astor, 1978
1978.493

Joseph Siffred Duplessis

French, 1725–1802

Benjamin Franklin (1706–1790)
Oil on canvas, oval, 28½ × 23 in.
(72.4 × 58.4 cm)
Signed, dated, and inscribed (right center):
J.S. Duplessis / pinx.parisis / 1778
The Friedsam Collection, Bequest of Michael
Friedsam, 1931
32.100.132

Workshop of Joseph Siffred Duplessis

Benjamin Franklin (1706–1790)
Replica of 32.100.132
Oil on canvas, oval, 27⅝ × 22¼ in.
(70.2 × 56.5 cm)
Inscribed (verso, possibly by the artist, now
covered by relining canvas): Peint par
Duplessis pour / obliger monsieur le vicomte /
De Buissy (Painted by Duplessis to oblige M.
the vicomte de Buissy)
Gift of George A. Lucas, 1895
95.21

Joseph Siffred Duplessis

Madame de Saint-Maurice
Oil on canvas, 39½ × 31⅞ in.
(100.3 × 81 cm)
Signed and dated (right center): Duplessis /
pinx. 1776
Bequest of James A. Aborn, 1968
69.161

Jean Baptiste Pillement

French, 1727–1808

A Wreck during a Tempest
Pastel on paper, 24¾ × 36 in.
(62.9 × 91.4 cm)
Signed and dated (lower left): J. Pille[ment] /
17[9?]2
Gift of Martin Birnbaum, 1956
56.7

Jean Baptiste Greuze

French, 1725–1805

Broken Eggs
Oil on canvas, 28¾ × 37 in. (73 × 94 cm)
Signed, dated, and inscribed (lower right):
Greuze f. Roma / 1756
Bequest of William K. Vanderbilt, 1920
20.155.8

48.187.739

1978.493

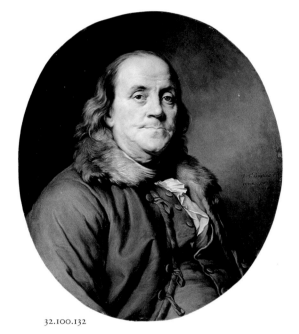

32.100.132

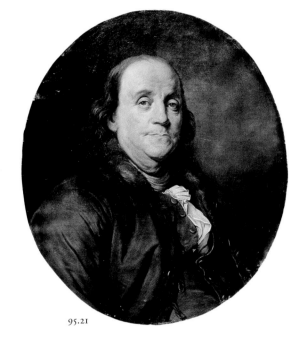

95.21

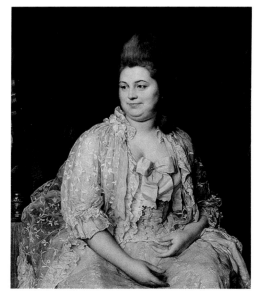

69.161

56.7

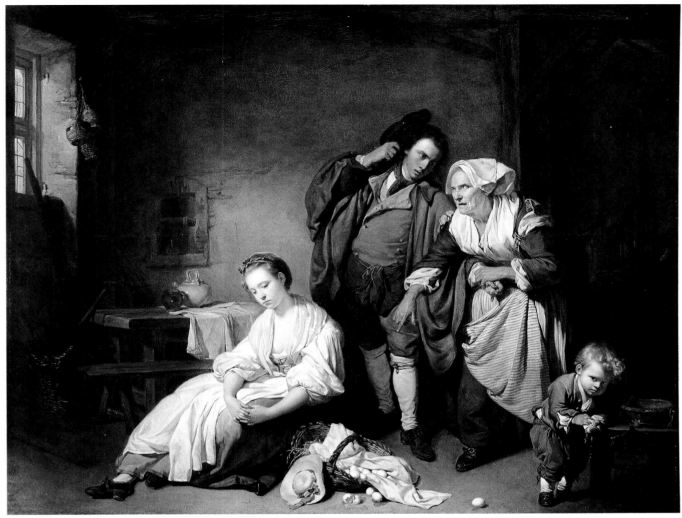

20.155.8

71.91

32.100.137

Jean Baptiste Greuze
French, 1725–1805

Head of a Woman
Oil on wood, 18¹/₂ × 16 in. (47 × 40.6 cm)
Purchase, 1871
71.91

A Young Peasant Boy
Oil on canvas, 18⁷/₈ × 15³/₈ in. (47.9 × 39.1 cm)
The Friedsam Collection, Bequest of Michael
Friedsam, 1931
32.100.137

*Charles Claude de Flahaut de La
Billarderie* (1730–1809), *Comte d'Angiviller*
Oil on canvas, 25¹/₄ × 21¹/₄ in. (64.1 × 54 cm)
Gift of Edith C. Blum (et al.) Executors, in
memory of Mr. and Mrs. Albert Blum, 1966
66.28.1

66.28.1

56.55.3

The Sculptor Jean Jacques Caffieri (1725–
1792)
Oil on canvas, oval, 25¹/₄ × 20³/₄ in.
(64.1 × 52.7 cm)
Bequest of Ethel Tod Humphrys, 1956
56.55.3

Aegina Visited by Jupiter
Oil on canvas, 57⁷/₈ × 77¹/₈ in. (147 × 195.9 cm)
Gift of Harry N. Abrams and Purchase,
Joseph Pulitzer Bequest, Pfeiffer, Fletcher, and
Rogers Funds, 1970
1970.295

Contemplation
Oil on canvas, 16¹/₈ × 12³/₄ in. (41 × 32.4 cm)
Bequest of Miss Adelaide Milton de Groot
(1876–1967), 1967
67.187.72

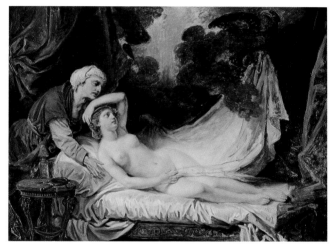

1970.295

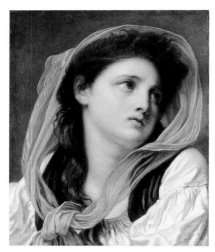

67.187.72

Madame Jean Baptiste Nicolet (Anne
Antoinette Desmoulins, 1743–1817)
Oil on wood, 25¹/₄ × 21 in. (64.1 × 53.3 cm)
Inscribed (on books): OEUVRE / DE / MOLIERE
/ TOME / III; OEUVRE / DE / ROUSSEAU (The
Work[s] of Molière, volume 3; The Work[s] of
Rousseau)
Gift of Colonel and Mrs. Jacques Balsan, 1955
55.205.2

*Portrait of a Young Woman, Called
Mademoiselle Montredon*
Oil on canvas, oval, 24¹/₄ × 20¹/₈ in.
(61.5 × 51.1 cm)
Gift of Mrs. William M. Haupt, from the
collection of Mrs. James B. Haggin, 1965
65.242.4

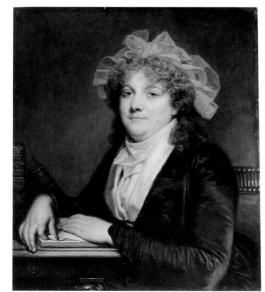

55.205.2

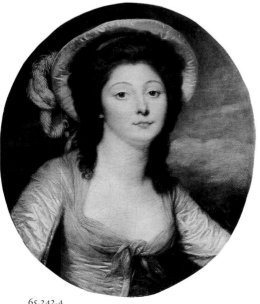

65.242.4

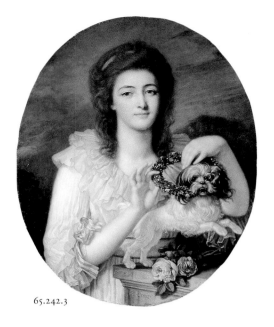

65.242.3

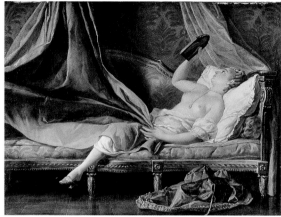

57.152

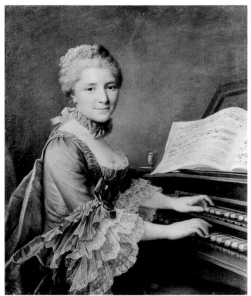

17.120.210

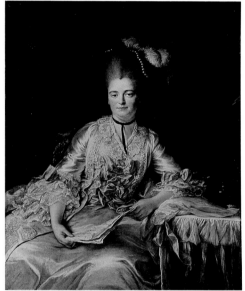

49.7.47

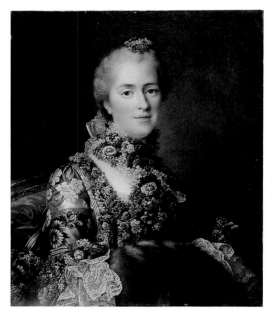

64.159.1

49.7.48

Princess Varvara Nikolaevna Gagarine
(1762–1802)
Oil on canvas, oval, 31¹/₂ × 25 in.
(80 × 63.5 cm)
Signed (lower center): J.B. Greuze
Gift of Mrs. William M. Haupt, from the
collection of Mrs. James B. Haggin, 1965
65.242.3

Attributed to Louis Jean François Lagrenée

French, 1725–1805

Woman on a Couch
The picture has a pendant, a draped nude
posed frontally (private collection, 1992).
Oil on canvas, 21 × 27 in. (53.3 × 68.6 cm)
Gift of Forsyth Wickes, 1957
57.152

François Hubert Drouais

French, 1727–1775

Madame Charles Simon Favart (Marie
Justine Benoîte Duronceray, 1727–1772)
Oil on canvas, 31¹/₂ × 25¹/₂ in.
(80 × 64.8 cm)
Signed and dated (on harpsichord): Drouais le
fils. 1757.
Mr. and Mrs. Isaac D. Fletcher Collection,
Bequest of Isaac D. Fletcher, 1917
17.120.210

Marie de Verrières (born about 1728, died
1775)
The painting had as a pendant a portrait of
the sitter's sister Geneviève de Verrières
(location unknown).
Oil on canvas, 45¹/₂ × 34⁵/₈ in.
(115.6 × 87.9 cm)
Signed and dated (left center): Drouais le fils
/ 1761
The Jules Bache Collection, 1949
49.7.47

Sophie (1734–1782), *Princess of France*
Oil on canvas, 25⁵/₈ × 20⁷/₈ in.
(65.1 × 53 cm)
Signed and dated (right): Drouais le fils /
1762
Gift of Barbara Lowe Fallass, 1964
64.159.1

Boy with a Black Spaniel
This is a replica of a portrait signed and
dated 1766 (private collection).
Oil on canvas, oval, 25³/₈ × 21 in.
(64.5 × 53.3 cm)
The Jules Bache Collection, 1949
49.7.48

François Hubert Drouais

French, 1727–1775

Portrait of a Young Woman as a Vestal Virgin

Oil on canvas, 31¹/₂ × 24⁷/₈ in.
(80 × 63.2 cm)
Signed and dated (lower left, on altar):
Drouais, 1767.
Gift of Mrs. William M. Haupt, from the
collection of Mrs. James B. Haggin, 1965
65.242.2

Boy with a House of Cards

Oil on canvas, oval, 28 × 23 in.
(71.1 × 58.4 cm)
Inscribed (right, on playing card): CHA . . .
Gift of Mrs. William M. Haupt, from the
collection of Mrs. James B. Haggin, 1965
65.242.1

Jean-Baptiste Deshays

French, 1729–1756

Shepherds Dreaming of the Flight into Egypt

Oil over black chalk on paper, laid down on
canvas, 13¹/₈ × 12¹/₈ in. (33.3 × 30.8 cm)
Harry G. Sperling Fund, 1983
1983.66
DRAWINGS AND PRINTS

Jean Claude Richard, Abbé de Saint-Non

French, 1727–1791

The Two Sisters

This pastel is a copy of Fragonard's painting
of the same name (53.61.5), made before the
painting was cut down.
Pastel on paper, laid down on canvas,
31⁵/₈ × 25 in. (80.3 × 63.5 cm)
Signed and dated (left): SaintNon / 1770
Gift of Daniel Wildenstein, 1977
1977.383

Jean Honoré Fragonard

French, 1732–1806

The Stolen Kiss

Oil on canvas, 19 × 25 in. (48.3 × 63.5 cm)
Gift of Jessie Woolworth Donahue, 1956
56.100.1

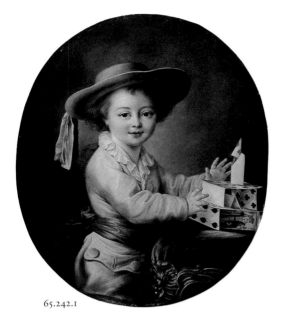

65.242.2

65.242.1

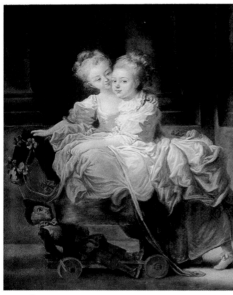

1983.66

1977.383

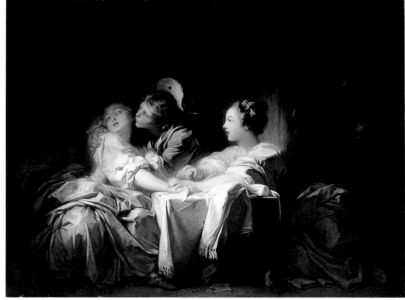

56.100.1

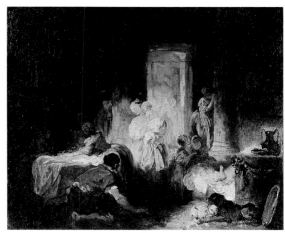

46.30

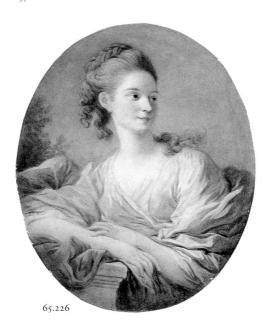

37.118

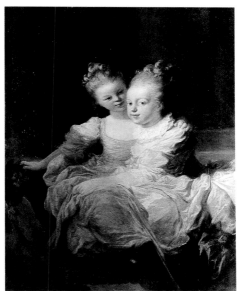

53.61.5

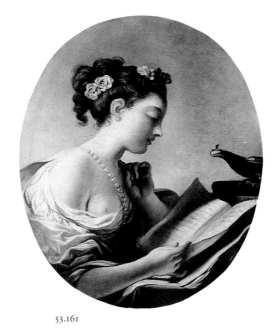

53.161

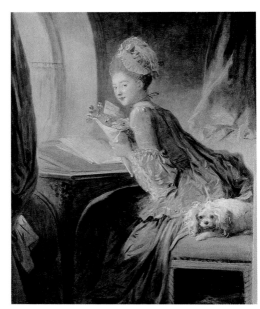

49.7.49

Italian Interior
Oil on canvas, 19¹/₄ × 23³/₈ in.
(48.9 × 59.4 cm)
Harris Brisbane Dick Fund, 1946
46.30

Portrait of a Woman with a Dog
Oil on canvas, 32 × 25³/₄ in.
(81.3 × 65.4 cm)
Fletcher Fund, 1937
37.118

The Two Sisters
The painting has been cut down; for its
original composition see the pastel by Saint-
Non (1977.383).
Oil on canvas, 28¹/₄ × 22 in.
(71.8 × 55.9 cm)
Gift of Julia A. Berwind, 1953
53.61.5

**Gabrielle de Caraman, Marquise de la
Fare**
Oil on canvas, oval, 31³/₄ × 25 in.
(80.6 × 63.5 cm)
Bequest of Margaret V. Haggin, 1965
65.226

Young Woman Reading
Oil on canvas, oval, 27¹/₈ × 21⁵/₈ in.
(68.9 × 54.9 cm)
Gift of René Fribourg, 1953
53.161

The Love Letter
Oil on canvas, 32³/₄ × 26³/₈ in.
(83.2 × 67 cm)
Inscribed (on letter): Monsieur / Mon[?]
Cuvillere
The Jules Bache Collection, 1949
49.7.49

Jean Honoré Fragonard

French, 1732–1806

The Cascade

Oil on wood, 11¹/₂ × 9¹/₂ in.
(29.2 × 24.1 cm)
The Jules Bache Collection, 1949
49.7.50

A Shaded Avenue

Pendant to 49.7.50
Oil on wood, 11¹/₂ × 9¹/₂ in.
(29.2 × 24.1 cm)
The Jules Bache Collection, 1949
49.7.51

Hubert Robert

French, 1733–1808

The Portico of a Country Mansion

Salon of 1775
Oil on canvas, 80³/₄ × 48¹/₄ in.
(205.1 × 122.6 cm)
Signed, dated, and inscribed (right corner, on
block of stone): H · · / ROBERT. / PINXIT. L. /
PARISIORUM.. / ANNO 1773.
Bequest of Lucy Work Hewitt, 1934
35.40.2

The Return of the Cattle

Salon of 1775
Pendant to 35.40.2
Oil on canvas, 80³/₄ × 48 in.
(205.1 × 121.9 cm)
Bequest of Lucy Work Hewitt, 1934
35.40.1

The Ruins

Oil on canvas, diameter 32³/₄ in. (83.2 cm)
Signed, dated, and inscribed (left, on stone
tablet): Q R / Robert / 1777
Gift of Mrs. William M. Haupt, from the
collection of Mrs. James B. Haggin, 1965
65.242.6

The Old Bridge

Pendant to 65.242.6
Oil on canvas, diameter 32³/₄ in. (83.2 cm)
Gift of Mrs. William M. Haupt, from the
collection of Mrs. James B. Haggin, 1965
65.242.7

49.7.50

49.7.51

35.40.2

35.40.1

65.242.6

65.242.7

17.190.30

17.190.29

17.190.27

17.190.28

17.190.26

17.190.25

Wandering Minstrels
Salon of 1779
This painting and the following five
(17.190.29, 27, 28, 26, 25) are a set
commissioned as the decoration of the *salle
des bains* at the comte d'Artois's Château de
Bagatelle, Paris. They are datable between
1777 and 1779, with further work in 1784.
Oil on canvas, 68³/₄ × 48¹/₄ in.
(174.6 × 122.6 cm)
Gift of J. Pierpont Morgan, 1917
17.190.30

The Bathing Pool
Oil on canvas, 68³/₄ × 48³/₄ in.
(174.6 × 123.8 cm)
Gift of J. Pierpont Morgan, 1917
17.190.29

The Swing
Oil on canvas, 68¹/₄ × 34⁵/₈ in. (173.4 × 87.9 cm)
Signed (on base of statue): H.ROBERT
Gift of J. Pierpont Morgan, 1917
17.190.27

The Dance
Oil on canvas, 68¹/₄ × 33⁵/₈ in. (173.4 × 85.4 cm)
Gift of J. Pierpont Morgan, 1917
17.190.28

The Fountain
Oil on canvas, 68¹/₄ × 31³/₈ in. (173.4 × 79.7 cm)
Inscribed (on pedestal of fountain): FONTEM /
PUBL[ICUM] (public fountain)
Gift of J. Pierpont Morgan, 1917
17.190.26

The Mouth of a Cave
Oil on canvas, 68³/₄ × 31¹/₄ in. (174.6 × 79.4 cm)
Signed and dated (lower right): H· ROBERT /
1784·
Gift of J. Pierpont Morgan, 1917
17.190.25

Bridge over a Cascade (overdoor)
Oil on canvas, 32 × 54¹/₈ in. (81.3 × 137.5 cm)
Gift of J. Pierpont Morgan, 1906
07.225.264a

Aqueduct in Ruins (overdoor)
Pendant to 07.225.264a
Oil on canvas, 32¹/₈ × 54¹/₈ in. (81.6 × 137.5 cm)
Gift of J. Pierpont Morgan, 1906
07.225.264b

Arches in Ruins (overdoor)
Oil on canvas, 23¹/₈ × 61¹/₄ in. (58.7 × 155.6 cm)
Gift of J. Pierpont Morgan, 1917
17.190.31

Hubert Robert

French, 1733–1808

A Colonnade in Ruins (overdoor)
Pendant to 17.190.31
Oil on canvas, 23 × 61¹/₈ in. (58.4 × 155.3 cm)
Gift of J. Pierpont Morgan, 1917
17.190.32

Antoine Vestier

French, 1740–1824

Eugène Joseph Stanislas Foulon d'Écotier
(1753–1821)
Salon of 1787
Oil on canvas, oval, 31⁵/₈ × 25¹/₈ in.
(80.3 × 63.8 cm)
Signed and dated (lower right, on map
cartouche): vestier / pinxit— / 1785; inscribed:
(on book) ORDON[NANCES] / DE LA / MARINE
(naval regulations); (on pamphlet) MEMOIR[E]
(report); (on map) CARTE REDUITE DES ISLE[S
DE]/LA GUADELOUPE / MARIE GALANTE ET LES
SAINT[ES] / Dressé au Depon des Pl . . . /
POUR LE SERVICE DE . . . / Par Ordre de M.
BE . . . (Reduced map of the islands of
Guadeloupe, Marie Galante, and Les Saintes,
drawn up for the depository of maps [of the
naval ministry], for the use of [the king's
vessels], by order of M. Be[rryer . . .] [This
inscription is a faithful copy of a cartouche
from a map of 1759, with the artist's name
and the date substituted for the date of
publication.])
Gift of Mr. and Mrs. Charles Wrightsman,
1983
1983.405

François Guillaume Ménageot

French, 1744–1816

***The Virgin Placing Saint Teresa of Ávila
under the Protection of Saint Joseph***
This is a study for a painting completed in
1787 for the chapel of the Carmelites at Saint-
Denis and now in the Hôtel-Dieu, Quebec.
Oil over pen and brown ink on paper, laid
down on canvas, 20¹/₂ × 12¹/₄ in.
(52.1 × 31.1 cm)
Purchase, David L. Klein Jr. Memorial
Foundation Inc. Gift, 1991
1991.48
DRAWINGS AND PRINTS

Piat Joseph Sauvage

French, 1744–1818

Venus and Cupid (grisaille)
Oil on canvas, 49⁷/₈ × 29¹/₄ in.
(126.7 × 74.3 cm)
Gift of J. Pierpont Morgan, 1906
07.225.265
ESDA

07.225.264a

07.225.264b

17.190.31

17.190.32

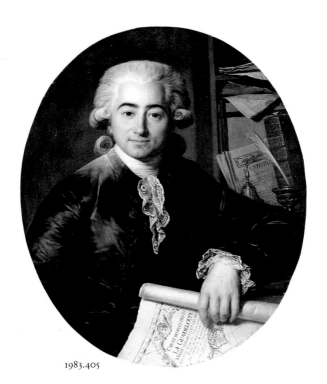

1983.405

1991.48

07.225.265

07.225.504

Anne Vallayer-Coster
French, 1744–1818
Vase of Flowers
Oil on canvas, oval, 19³/₄ × 15 in.
(50.2 × 38.1 cm)
Signed and dated (lower right): Mˡˡᵉ Vallayer /
1780
Gift of J. Pierpont Morgan, 1906
07.225.504

Jacques-Louis David
French, 1748–1825
The Death of Socrates
Oil on canvas, 51 × 77¹/₄ in.
(129.5 × 196.2 cm)
Signed, dated, and inscribed: (lower left) L.D /
MDCCLXXXVII; (right, on bench) L. David;
(right, on bench, in Greek) Athenaion (of
Athens)
Catharine Lorillard Wolfe Collection, Wolfe
Fund, 1931
31.45

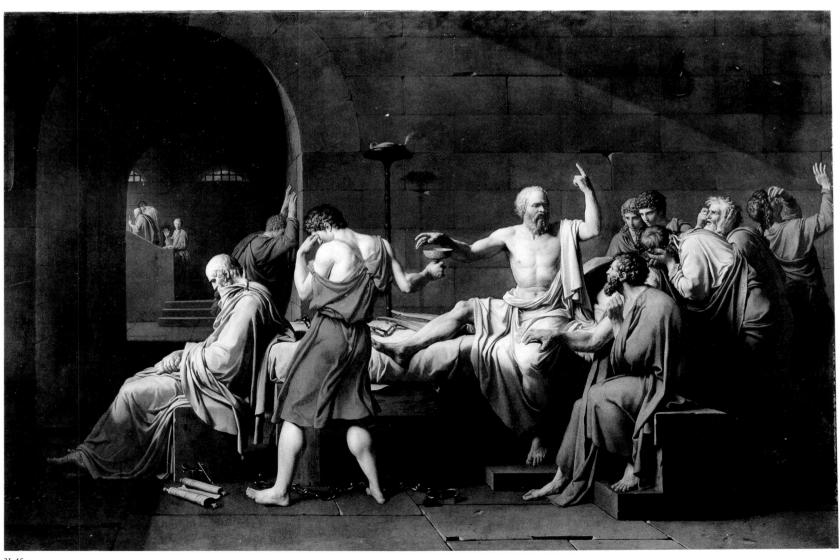

31.45

Jacques-Louis David

French, 1748–1825

Antoine-Laurent Lavoisier (1743–1794) ***and
His Wife*** (Marie-Anne-Pierrette Paulze, 1758–
1836)
Oil on canvas, 102¼ × 76⅝ in.
(259.7 × 194.6 cm)
Signed, dated, and inscribed (lower left): L.
David [faciebat] / parisiis anno / 1788
Purchase, Mr. and Mrs. Charles Wrightsman
Gift, in honor of Everett Fahy, 1977
1977.10

General Étienne-Maurice Gérard (1774–
1852), ***Marshal of France***
Oil on canvas, 77⅝ × 53⅝ in.
(197.2 × 136.2 cm)
Signed, dated, and inscribed: (on pedestal
base) L. DAVID. 1816 / BRUX[ELLES]; (on
envelope) A Son Excellence / L[e] Gé[néral]
Gérard / Com[mandant en] Chef. (To his
excellency General Gérard, commander in
chief)
Purchase, Rogers and Fletcher Funds, and
Mary Wetmore Shively Bequest, in memory of
her husband, Henry L. Shively, M.D., 1965
65.14.5

Attributed to Jacques-Louis David

Head of a Boy
Oil on canvas, 15¾ × 12⅝ in.
(40 × 32.1 cm)
Bequest of Harry G. Sperling, 1971
1976.100.5

Style of Jacques-Louis David

French, about 1803

Jeanne Eglé Desbassayns de Richemont
(1778–1855) ***and Her Daughter, Camille***
(1801–1804)
Oil on canvas, 46 × 35¼ in.
(116.8 × 89.5 cm)
Gift of Julia A. Berwind, 1953
53.61.4

French(?) Painter

fourth quarter 18th century

Portrait of a Woman and Child
Oil on canvas, 44½ × 35⅛ in.
(113 × 89.2 cm)
Purchase, Howard Isermann Gift, in honor of
his wife, Betty Isermann, 1983
1983.264

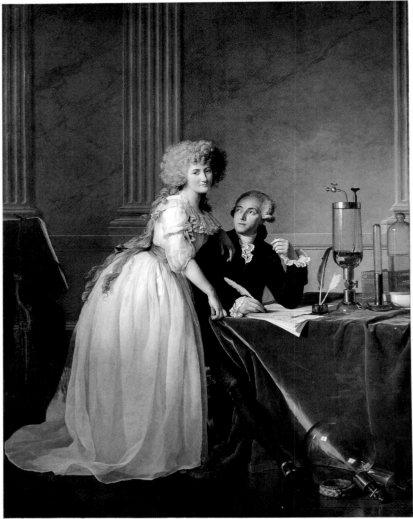

1977.10

65.14.5

1976.100.5

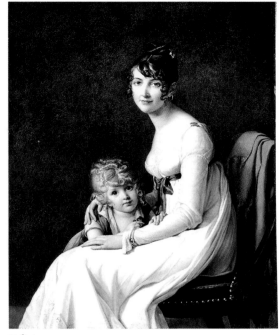

53.61.4

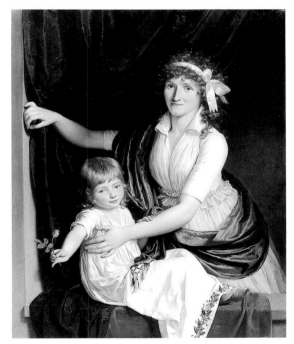

1983.264

1983.426

Pierre Charles Jombert

French, born 1748/49, probably died 1825

The Punishment of the Arrogant Niobe by Diana and Apollo

Oil on canvas, laid down on board,
14¹/₈ × 11¹/₈ in. (35.9 × 28.3 cm)
Inscribed (on label on verso of board):

Jombert (Charles Pierre) fils de Charles Antoine, libraire du Roi (célèbre éditeur, grand amateur des Beaux-Arts) a remporté le grand prix de peinture en 1772, sur le programme: La punition de l'orgueilleuse Niobé par Diane et Apollon.

Jombert, mon ami, mon camarade d'étude dans la même école, m'a légué l'esquisse faite en loge, de son tableau, qui en est aujourd'hui l'archétype.

L'approbation générale qui a relevé l'éclat de sa couronne de lauréat, du grand prix de peinture, m'entraîne d'offrir à l'académie des Beaux-Arts son esquisse pour remplir une lacune qui interrompt l'arrangement périodique des monumens solennels de l'émulation. (1)

Son tableau manque dans cet arrangement, ainsi que quelques autres. Des inscriptions ou des esquisses autographes

compléteroient une série monumentale que réclament l'histoire des beaux-arts en France, et les noms des familles honorablement proclamées par le tribunal académique.

Gault de Saint Germain

(1) Les productions de cet artiste sont peu nombreuses, car sa longévité ne fut pour ainsi dire qu'une longue agonie. Dans son éloge que j'ai prononcée à l'hôtel de Ville (11 décembre 1825) je ne cite du développement de ses bonnes études, dans l'école de Rome, que son tableau (ordonné par le Roi en 1774 [or 1779]) placé dans une des chapelles de l'église paroissiale de Saint-Sulpice, et le beau plafond qu'il a éxécuté à l'hôtel d'Orsay (rue de Varenne).

Jombert (Charles Pierre) son of Charles Antoine, librarian of the king (celebrated publisher, amateur of the fine arts) won the grand prize for painting in 1772 on the theme: The Punishment of the Arrogant Niobe by Diana and Apollo.

Jombert, my friend, my fellow student in the same school, has bequeathed to me the sketch, made *en loge*, for his painting, which has today become the archetype [for this subject].

The general approbation that greeted Jombert's success as winner of the grand prize in painting leads me to give his sketch to the Académie des Beaux-Arts, in order to fill a gap in the chronological display of solemn memorials to be emulated. (1)

Jombert's painting is missing from this display, as are several others. Inscriptions [?] or autograph sketches would complete a memorial series celebrating the history of the fine arts in France and the families whose names were honorably proclaimed by the jury of the Academy.

Gault de Saint Germain

(1) The works of this artist are few because his life was, so to speak, nothing but a long agony. When I delivered his eulogy at the *hôtel de ville* [city hall] (December 11, 1825), I did not mention the fine studies he made while a student in Rome, but only the painting (commissioned by the king in 1774 [or 1779]) that was installed in one of the chapels of the parish church of Saint-Sulpice, and the beautiful ceiling that he executed at the hôtel d'Orsay (rue de Varenne).

Van Day Truex Fund, 1983
1983.426
DRAWINGS AND PRINTS

Adélaïde Labille-Guiard

French, 1749–1803

Self-portrait with Two Pupils,
Mademoiselle Marie Gabrielle Capet (1761–
1818) *and Mademoiselle Carreaux de*
Rosemond (died 1788)
Oil on canvas, 83 × 59¹/₂ in.
(210.8 × 151.1 cm)
Signed and dated (left, on easel): Labille f.ᵐᵉ
Guiard / 1785.
Gift of Julia A. Berwind, 1953
53.225.5

Marie Victoire Lemoine

French, 1754–1820

Atelier of a Painter, Probably Madame
Vigée Le Brun (1755–1842), *and Her Pupil*
Oil on canvas, 45⁷/₈ × 35 in.
(116.5 × 88.9 cm)
Gift of Mrs. Thorneycroft Ryle, 1957
57.103

Pierre-Henri de Valenciennes

French, 1750–1819

Roman Ruins
Oil on paper, laid down on canvas,
9¼ × 15¼ in. (23.5 × 38.7 cm)
Harry G. Sperling Fund, 1978
1978.48.2

Frédéric Schall

French, 1752–1825

Mademoiselle Duthé (Rosalie Gérard, 1752–
1820) *Dancing*
Oil on wood, irregular, 12³/₄ × 9¹/₄ in.
(32.4 × 23.5 cm)
Gift of Mrs. William M. Haupt, from the
collection of Mrs. James B. Haggin, 1965
65.242.8

Nicolas Antoine Taunay

French, 1755–1830

The Billiard Room
Oil on wood, 6³/₈ × 8⁵/₈ in.
(16.2 × 21.9 cm)
The Jack and Belle Linsky Collection, 1982
1982.60.49

53.225.5

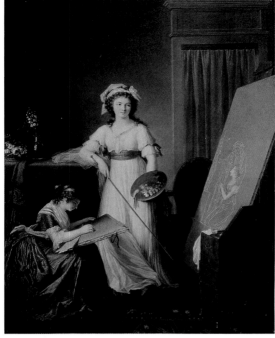

57.103

1978.48.2

65.242.8

1982.60.49

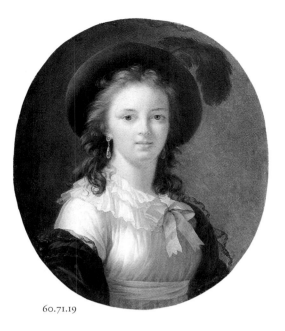

60.71.19

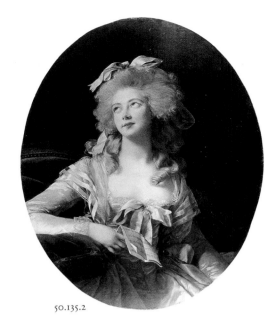

50.135.2

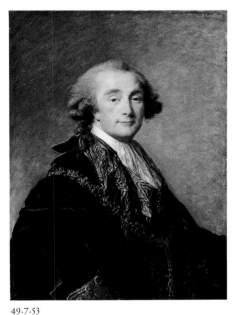

49.7.53

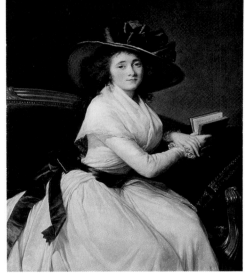

54.182

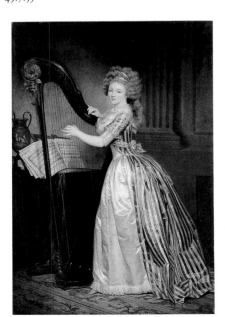

67.55.1

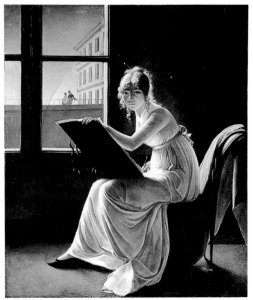

17.120.204

Élisabeth Louise Vigée Le Brun
French, 1755–1842

Self-portrait
This is a replica of the painting at the Kimbell Art Museum, Fort Worth.
Oil on canvas, oval, 25¼ × 21 in. (64.1 × 53.3 cm)
Bequest of Lillian S. Timken, 1959
60.71.19

Madame Grand (Catherine Noele Worlée, born about 1762, died 1835), *Later Princesse de Talleyrand-Périgord*
Oil on canvas, oval, 36¼ × 28½ in. (92.1 × 72.4 cm)
Signed and dated (left): L.E.Lebrun 1783
Bequest of Edward S. Harkness, 1940
50.135.2

Alexandre Charles Emmanuel de Crussol-Florensac (1747–1815)
Oil on wood, 35⅜ × 25½ in. (89.9 × 64.8 cm)
Signed and dated (upper right): L.ze E.bet vigée: LeBrun: P.xte 1787
The Jules Bache Collection, 1949
49.7.53

Comtesse de la Châtre (Marie Charlotte Louise Perrette Aglaé Bontemps, 1762–1848)
The artist listed this portrait in the appendix to her memoirs under the year 1789.
Oil on canvas, 45 × 34½ in. (114.3 × 87.6 cm)
Gift of Jessie Woolworth Donahue, 1954
54.182

Rose Adélaïde Ducreux
French, 1761–1802

Self-portrait with a Harp
Oil on canvas, 76 × 50¾ in. (193 × 128.9 cm)
Inscribed: (on book) Opera; (on music) Romance / par Benoit pollet / [?] tendre amour . . . marit je rend l[es]/ar—me je rend les ar—me / il est pour moi si plein de / charme que j'en atta . . . (verses from a song by Jean Joseph Benoît Pollet [1753–1818], which has not been identified)
Bequest of Susan Dwight Bliss, 1966
67.55.1

French Painter
about 1800

Portrait of a Young Woman, Called Mademoiselle Charlotte du Val d'Ognes
Oil on canvas, 63½ × 50⅝ in. (161.3 × 128.6 cm)
Mr. and Mrs. Isaac D. Fletcher Collection, Bequest of Isaac D. Fletcher, 1917
17.120.204

Jacques de La Joue the Younger

French, 1686–1761

Allegory of Winter (overdoor)
Oil on canvas, irregular, 39¼ × 41⅝ in.
(99.7 × 105.7 cm)
Signed (bottom right): Lajoüe
Gift of J. Pierpont Morgan, 1906
07.225.258

French Painter

about 1719/20

Panthers of Bacchus Eating Grapes
This sketch relates to a woven Savonnerie
panel whose design has been attributed to
François Desportes (French, 1661–1748).
Oil on cardboard, 13⅝ × 6¾ in.
(34.6 × 17.1 cm)
Gift of J. Pierpont Morgan, 1906
07.225.287

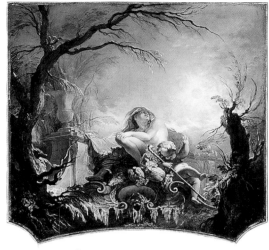

07.225.258

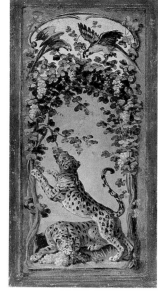

07.225.287

François Boucher and Workshop

French, 1703–1770

Allegory of Autumn
Oil on canvas, irregular, 44¾ × 63¾ in.
(113.7 × 161.9 cm)
Signed and dated (lower right): f.Boucher/1753
Purchase, Mr. and Mrs. Charles Wrightsman
Gift, 1969
69.155.1
ESDA

Allegory of Lyric Poetry
Pendant to 69.155.1
Oil on canvas, irregular, 45¼ × 62¾ in.
(114.9 × 159.4 cm)
Signed and dated (lower left): Boucher / 1753
Purchase, Mr. and Mrs. Charles Wrightsman
Gift, 1969
69.155.2
ESDA

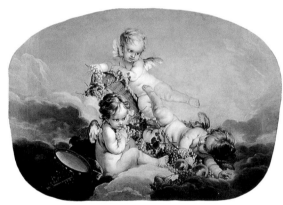

69.155.1

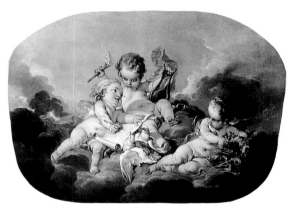

69.155.2

French Painter

about 1770–75

***Busts of Women in Oval Medallions
Draped with Garlands*** (overdoors)
Oil on canvas; (a) 32⅝ × 60⅜ in.
(82.9 × 153.4 cm); (b) 35 × 57¼ in.
(88.9 × 145.4 cm)
Gift of J. Pierpont Morgan, 1906
07.225.505ab
ESDA

07.225.505a

07.225.505b

07.225.438a

07.225.438b

Charles Dominique Joseph Eisen
French, 1720–1778
Putti with a Medallion
Oil on wood, oval, 36¼ × 27½ in.
(92.1 × 69.9 cm)
Gift of J. Pierpont Morgan, 1906
07.225.438a
ESDA

Putti with a Medallion
Pendant to 07.225.438a
Oil on wood, oval, 36¼ × 27½ in.
(92.1 × 69.9 cm)
Gift of J. Pierpont Morgan, 1906
07.225.438b
ESDA

07.225.461

07.225.281

Attributed to Michel Bruno Bellengé
French, 1726–1793
Vase of Flowers in a Niche (overdoor)
Oil on canvas, 48⅜ × 55 in.
(122.9 × 139.7 cm)
Gift of J. Pierpont Morgan, 1906
07.225.461
ESDA

Attributed to Jean Baptiste Pillement
French, 1727–1808
Flowers and Chinoiserie
Oil on canvas, 52⅜ × 31 in.
(133 × 78.7 cm)
Gift of J. Pierpont Morgan, 1906
07.225.281
ESDA

Flowers
Oil on brown paper, 9½ × 6½ in.
(24.1 × 16.5 cm)
The Lesley and Emma Sheafer Collection,
Bequest of Emma A. Sheafer, 1973
1974.356.29

1974.356.29

1975.39

French Painter
fourth quarter 18th century
Cartoon for the Back of a Tapestry Settee
Oil on canvas, 26¾ × 68½ in.
(67.9 × 174 cm)
Inscribed (bottom left): N° 175 Dossier de
Canapé 4 sur[?] Tableau. (N° 175 Back of a
settee 4 [. . . ?] Painting.)
Gift of Mrs. Francis Henry Lenygon, 1975
1975.39
ESDA

French Painters

first quarter 18th century

Allegorical Subject (overdoor)

Oil on canvas, irregular, 33³/₈ × 52¹/₄ in.
(84.8 × 132.7 cm)
Gift of J. Pierpont Morgan, 1906
07.225.157
ESDA

18th century

Cupid as a Messenger with a Caduceus

Oil on canvas, oval, 34¹/₄ × 38³/₄ in.
(87 × 98.4 cm)
Gift of J. Pierpont Morgan, 1906
07.225.255
ESDA

about 1775

Woman in a Straw Hat; Woman with a Dog

These overdoors, from 46, rue Saint-Antoine,
Paris, incorporate motifs from Boucher.
Oil on canvas, ovals; (a) 26 × 19¹/₂ in.
(66 × 49.5 cm); (b) 25⁵/₈ × 18⁷/₈ in.
(65.1 × 47.9 cm)
Gift of J. Pierpont Morgan, 1906
07.225.155ab
ESDA

Jean Baptiste Blin de Fontenay

French, 1653–1715

Vase of Flowers (overdoor)

Oil on canvas, 28³/₄ × 34¹/₈ in. (73 × 86.7 cm)
Gift of J. Pierpont Morgan, 1906
07.225.274
ESDA

French Painters

late 18th century

Putti Musicians in a Medallion,
Surrounded by Musical Attributes, Flowers,
and Fruit (overdoor)

Oil on canvas, 33¹/₈ × 54 in. (84.1 × 137.2 cm)
Inscribed (on score): 19 / Stabil / 21 / aria del
/ sign. / 22 / Air D'[Ab]anese / Charmentes
fleurs quites les . . . / plus heureux destin . . .
/ 24 / . . . (verses from a song by an
unidentified composer)
Gift of J. Pierpont Morgan, 1906
07.225.259
ESDA

18th century

Vase of Flowers Draped with Garlands

Oil on canvas, 28¹/₈ × 17¹/₂ in.
(71.4 × 44.5 cm)
Gift of J. Pierpont Morgan, 1906
07.225.267
ESDA

07.225.157

07.225.255

07.225.155a

07.225.155b

07.225.274

07.225.259

07.225.267

07.225.278

07.225.266

07.225.263a

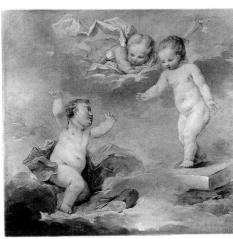

07.225.310

07.225.155c

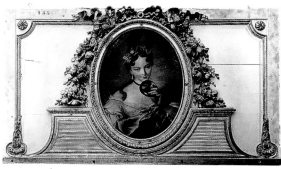

07.225.155d

07.225.456a

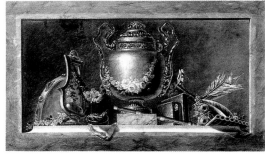

07.225.456b

22.225.6 22.225.4 22.225.2 22.225.1 22.225.3 22.225.5

Vase of Flowers Resting on Foliate Scrolls
Oil on canvas, 46¹/₈ × 30³/₄ in.
(117.2 × 78.1 cm)
Gift of J. Pierpont Morgan, 1906
07.225.278
ESDA

1770–90
Basket of Flowers with Garlands
Oil on canvas, 83³/₄ × 26 in. (212.7 × 66 cm)
Gift of J. Pierpont Morgan, 1906
07.225.266
ESDA

18th century
Cupids and Dolphins (overdoor, from an
engraving after Boucher)
Oil on canvas, 48 × 56³/₄ in. (121.9 × 144.1 cm)
Gift of J. Pierpont Morgan, 1906
07.225.263a
ESDA

Pygmalion and Galatea as Infants
Oil on canvas, 28³/₄ × 28³/₄ in. (73 × 73 cm)
Gift of J. Pierpont Morgan, 1906
07.225.310
ESDA

about 1775
Woman with a Rose; Woman with a Mask
These overdoors, from 46, rue Saint-Antoine,
Paris, incorporate motifs from Boucher.
Oil on canvas, ovals; (c) 25⁵/₈ × 19 in.
(65.1 × 48.3 cm); (d) 26 × 19¹/₂ in.
(66 × 49.5 cm.)
Gift of J. Pierpont Morgan, 1906
07.225.155cd
ESDA

18th century
Overdoors with Musical Instruments
Oil on canvas, each 22¹/₂ × 37 in. (57.2 × 94 cm)
Gift of J. Pierpont Morgan, 1906
07.225.456ab
ESDA

Style of Jean Antoine Watteau
French or German, second half 18th century
January and February
This painting and the following five (22.225.4,
2, 1, 3, 5) comprise a decorative scheme
illustrating the months of the year.
Oil on wood, 116 × 15¹/₂ in. (294.6 × 39.4 cm)
Purchase, Joseph Pulitzer Bequest, 1922
22.225.6
ESDA

Style of Jean Antoine Watteau

French or German, second half 18th century

March and April

Oil on wood, 116 × 15¹/₂ in. (294.6 × 39.4 cm)
Purchase, Joseph Pulitzer Bequest, 1922
22.225.4
ESDA

May and June

Oil on canvas, 119 × 55¹/₄ in. (302.3 × 140.3 cm)
Purchase, Joseph Pulitzer Bequest, 1922
22.225.2
ESDA

July and August

Oil on canvas, 119 × 73 in. (302.3 × 185.4 cm)
Purchase, Joseph Pulitzer Bequest, 1922
22.225.1
ESDA

September and October

Oil on canvas, 119 × 38¹/₂ in. (302.3 × 97.8 cm)
Purchase, Joseph Pulitzer Bequest, 1922
22.225.3
ESDA

November and December

Oil on wood, 116 × 15¹/₂ in. (294.6 × 39.4 cm)
Purchase, Joseph Pulitzer Bequest, 1922
22.225.5
ESDA

French Painters

18th century

Putti in a Medallion

Oil on canvas, 23³/₄ × 19³/₄ in.
(60.3 × 50.2 cm)
Gift of J. Pierpont Morgan, 1906
07.225.303
ESDA

Bust of Henry IV in an Oval Medallion Supported by Two Cupids (overdoor)

Oil on canvas, 29³/₄ × 46¹/₈ in.
(75.6 × 117.2 cm)
Gift of J. Pierpont Morgan, 1906
07.225.279
ESDA

Diana or a Nymph in an Oval Medallion Supported by Cupids (two overdoors in grisaille)

Oil on canvas; (a) 32 × 52 in.
(81.3 × 132.1 cm); (b) 32¹/₈ × 52 in.
(81.6 × 132.1 cm)
Gift of J. Pierpont Morgan, 1906
07.225.471ab
ESDA

07.225.303

07.225.279

07.225.471a

07.225.471b

07.225.251a

07.225.251b

07.225.457a

07.225.457b

07.225.305

07.225.288

07.225.472

07.225.261

07.225.269

07.225.455

07.225.136.1

07.225.136.2

French Painters

18th century

Dancing Children (grisaille)
Oil on canvas; (a) 17$^1/_2$ × 31$^1/_8$ in.
(44.5 × 79.1 cm); (b) 17$^3/_4$ × 31$^3/_8$ in.
(45.1 × 79.7 cm)
Gift of J. Pierpont Morgan, 1906
07.225.251ab
ESDA

***Perfume-Burner Supported by Baby
Tritons and Garlanded with Flowers;
Perfume-Burner Supported by Cupids and
Serpents and Garlanded with Flowers***
(overdoors)
Oil on canvas; (a) 21 × 26$^5/_8$ in.
(53.3 × 67.6 cm); (b) 21 × 26$^3/_4$ in.
(53.3 × 67.9 cm)
Gift of J. Pierpont Morgan, 1906
07.225.457ab
ESDA

Putti with a Basket of Flowers (green
monochrome)
Oil on canvas, 19$^1/_4$ × 28$^3/_8$ in. (48.9 × 72.1 cm)
Gift of J. Pierpont Morgan, 1906
07.225.305
ESDA

Putto on a Pedestal
Oil on canvas, oval, 9$^5/_8$ × 12$^3/_4$ in.
(24.4 × 32.4 cm)
Gift of J. Pierpont Morgan, 1906
07.225.288
ESDA

***Profile Portrait of a Woman in a
Medallion Supported by Cupids*** (overdoor)
Oil on canvas, 19$^5/_8$ × 43$^3/_4$ in.
(49.8 × 111.1 cm)
Gift of J. Pierpont Morgan, 1906
07.225.472
ESDA

***Nymph and Cupids in an Octagonal
Medallion*** (overdoor)
Oil on canvas, 28 × 56$^7/_8$ in. (71.1 × 144.5 cm)
Gift of J. Pierpont Morgan, 1906
07.225.261
ESDA

Cupid Seated on a Garland (possibly an
overdoor)
Oil on canvas, 19 × 34$^3/_4$ in.
(48.3 × 88.3 cm)
Gift of J. Pierpont Morgan, 1906
07.225.269
ESDA

French Painters

18th century

Putto in a Medallion Surrounded by a Garland

Oil on wood, 47¹/₂ × 17¹/₄ in.
(120.7 × 43.8 cm)
Gift of J. Pierpont Morgan, 1906
07.225.455
ESDA

1770–90

Astronomy; Mathematics (overdoors in grisaille)

Oil on canvas, diameter, each 38¹/₄ in.
(97.2 cm)
Gift of J. Pierpont Morgan, 1906
07.225.136.1–2
ESDA

07.225.462

07.225.252

late 18th century

Winter: Putti around a Fire, in a Medallion (overdoor)

Oil on canvas, 39³/₈ × 67³/₈ in.
(100 × 171.1 cm)
Gift of J. Pierpont Morgan, 1906
07.225.462
ESDA

Style of Piat Joseph Sauvage

French, late 18th century

Triumph of Bacchus (overdoor in grisaille)

Oil on canvas, 30⁵/₈ × 30³/₄ in.
(77.8 × 78.1 cm)
Gift of J. Pierpont Morgan, 1906
07.225.252
ESDA

07.225.254

07.225.312

Putti with Birds (overdoor in grisaille)

Oil on canvas, 27¹/₂ × 36³/₄ in.
(69.9 × 93.4 cm)
Gift of J. Pierpont Morgan, 1906
07.225.254
ESDA

Autumnal Sacrifice (grisaille)

Oil on canvas, 17 × 25 in. (43.2 × 63.5 cm)
Gift of J. Pierpont Morgan, 1906
07.225.312
ESDA

Mothers and Children (grisaille)

Oil on canvas, 19⁷/₈ × 23⁷/₈ in.
(50.5 × 60.6 cm)
Gift of J. Pierpont Morgan, 1906
07.225.302
ESDA

07.225.302

07.225.314b

07.225.268a

07.225.268b

Infant Bacchanal (grisaille)
Oil on canvas, 10¼ × 29⅝ in.
(26 × 75.2 cm)
Gift of J. Pierpont Morgan, 1906
07.225.314b
ESDA

Allegory of Agriculture; Allegory of the Chase (both grisaille)
Oil on canvas; (a) 14⅝ × 28¼ in.
(37.1 × 71.8 cm); (b) 16⅜ × 30⅜ in.
(41.6 × 77.2 cm)
Gift of J. Pierpont Morgan, 1906
07.225.268ab
ESDA

07.225.315a

07.225.315b

Putti at Play (both grisaille)
Oil on canvas, each 16⅜ × 29 in.
(41.6 × 73.7 cm)
Gift of J. Pierpont Morgan, 1906
07.225.315ab
ESDA

Nymph and Putti in a Vintage Scene; Nymph with Floral Crown and Putti (both grisaille)
Oil on marble; (a) 9½ × 23¼ in.
(24.1 × 59.1 cm); (b) 9⅝ × 23¾ in.
(24.4 × 60.3 cm)
Gift of J. Pierpont Morgan, 1906
07.225.306ab
ESDA

07.225.306a

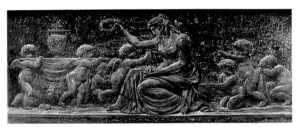

07.225.306b

Triumph of Bacchus (overdoor in grisaille)
Oil on canvas, 14 × 32⅞ in.
(35.6 × 83.5 cm)
Gift of J. Pierpont Morgan, 1906
07.225.314a
ESDA

Triumph of Bacchus (overdoor in grisaille)
Oil on canvas, 19⅛ × 45⅞ in.
(48.6 × 116.5 cm)
Gift of J. Pierpont Morgan, 1906
07.225.272
ESDA

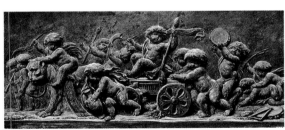

07.225.314a

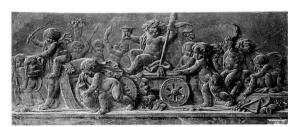

07.225.272

Carle (Antoine Charles Horace) Vernet
French, 1758–1836

The Triumph of Aemilius Paulus
This painting, Vernet's reception piece, was
presented to the Académie Royale in 1789 and
exhibited at the Salon in that same year and
in 1791.
Oil on canvas, 51¹/₈ × 172¹/₂ in.
(129.9 × 438.2 cm)
Signed and dated (lower left): Carle Vernet 1789
Gift of Darius O. Mills, 1906
06.144

06.144

Pierre-Paul Prud'hon
French, 1758–1823

Charles-Maurice de Talleyrand-Périgord
(1754–1838), *Prince de Bénévent*
This is one of three life-size full-length
portraits of Talleyrand by Prud'hon; the other
two were commissioned by Napoleon for the
Château de Compiègne in 1806 (Château de
Valençay, Indre) and 1807 (Musée Carnavalet,
Paris). In 1817 Prud'hon painted this third
portrait for Talleyrand.
Oil on canvas, 85 × 57⁷/₈ in.
(215.9 × 141.9 cm)
Signed (lower left, on plinth): P. P. Prud'hon
pinxit.
Purchase, Mrs. Charles Wrightsman Gift, in
memory of Jacqueline Bouvier Kennedy
Onassis, 1994
1994.190

Andromache and Astyanax
Completed by Charles Boulanger de
Boisfrémont (French, 1773–1838) and exhibited
at the Salon of 1824
Oil on canvas, 52 × 67¹/₈ in. (132.1 × 170.5 cm)
Signed (lower left, on base of plinth): P. P.
Prud'hon
Bequest of Collis P. Huntington, 1900
25.110.14

1994.190

25.110.14

Copy after Pierre-Paul Prud'hon
French, 19th century

The Abduction of Psyche
The composition reverses that of Prud'hon's
painting (Louvre, Paris) exhibited in the Salon
of 1808.
Oil on wood, 17¹/₂ × 14 in. (44.5 × 35.6 cm)
Bequest of Lillian S. Timken, 1959
60.71.24

French Painters
early 19th century

Portrait of a Man in a Blue Coat
Oil on canvas, 24¹/₄ × 19⁵/₈ in.
(61.5 × 49.8 cm)
Bequest of Catherine D. Wentworth, 1948
48.187.735

60.71.24

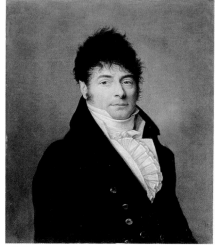

48.187.735

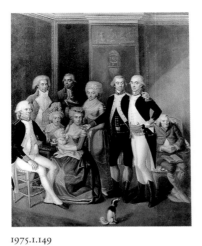

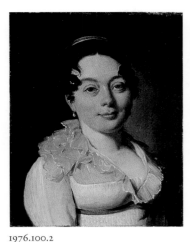

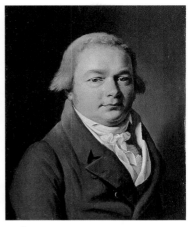

1975.1.149

1976.100.2

1976.100.3

25.110.8

80.2

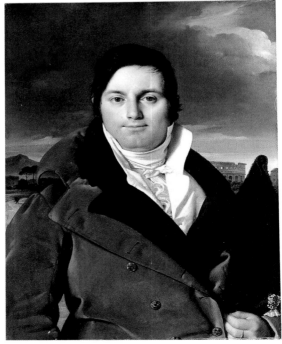

29.100.23

1985.118

Military Family Portrait
Oil on canvas, 24¹/₈ × 19³/₄ in.
(61.3 × 50.2 cm)
Robert Lehman Collection, 1975
1975.1.149
ROBERT LEHMAN COLLECTION

Louis-Léopold Boilly
French, 1761–1845
Portrait of a Woman
Oil on canvas, 8³/₄ × 6⁷/₈ in.
(22.2 × 17.5 cm)
Bequest of Harry G. Sperling, 1971
1976.100.2

Portrait of a Man
Pendant to 1976.100.2
Oil on canvas, 8³/₄ × 6⁷/₈ in.
(22.2 × 17.5 cm)
Bequest of Harry G. Sperling, 1971
1976.100.3

Georges Michel
French, 1763–1843
The Mill of Montmartre
Oil on canvas, 29 × 40 in.
(73.7 × 101.6 cm)
Bequest of Collis P. Huntington, 1900
25.110.8

Landscape with a Plowed Field and a Village
Oil on canvas, 20¹/₈ × 27⁵/₈ in.
(51.1 × 70.2 cm)
Gift of Paul Durand-Ruel, 1880
80.2

Jean-Auguste-Dominique Ingres
French, 1780–1867
Joseph-Antoine Moltedo (born 1775)
Oil on canvas, 29⁵/₈ × 22⁷/₈ in.
(75.2 × 58.1 cm)
H. O. Havemeyer Collection, Bequest of Mrs.
H. O. Havemeyer, 1929
29.100.23

Head of Saint John the Evangelist
This picture is one of several oil studies for
Ingres's altarpiece Christ Delivering the Keys
to Saint Peter (Musée Ingres, Montauban),
commissioned for Santa Trinità dei Monti,
Rome, in 1817 and completed in 1820.
Oil on canvas, laid down on wood,
15¹/₂ × 10⁵/₈ in. (39.4 × 27 cm)
Signed (lower right, partially legible): Ingres
Catharine Lorillard Wolfe Collection,
Purchase, Bequest of Catharine Lorillard
Wolfe, by exchange, and Wolfe Fund, 1985
1985.118

1975.1.186

Jean-Auguste-Dominique Ingres
French, 1780–1867
Joséphine-Éléonore-Marie-Pauline de
Galard de Brassac de Béarn (1825–1860),
Princesse de Broglie
Oil on canvas, 47³/₄ × 35³/₄ in.
(121.3 × 90.8 cm)
Signed and dated (left center): J. INGRES. p^{it}
1853
Arms (upper right) of the de Broglie family
Robert Lehman Collection, 1975
1975.1.186
ROBERT LEHMAN COLLECTION

19.77.2

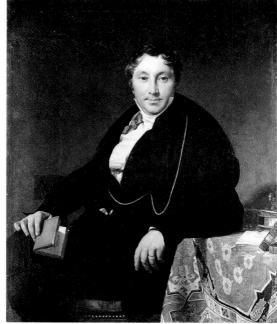

19.77.1

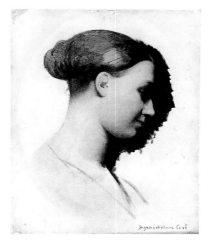

43.85.3

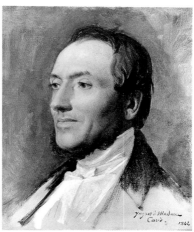

43.85.2

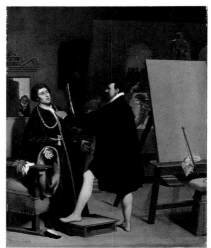

1975.1.185

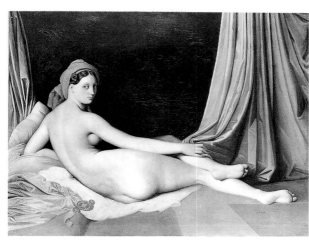

38.65

Madame Jacques-Louis Leblanc (Françoise
Poncelle, 1788–1839)
Salon of 1834
Oil on canvas, 47 × 36½ in.
(119.4 × 92.7 cm)
Signed, dated, and inscribed (lower left):
Ingres P. flor. 1823.
Catharine Lorillard Wolfe Collection, Wolfe
Fund, 1918
19.77.2

Jacques-Louis Leblanc (1774–1846)
Companion to 19.77.2
Oil on canvas, 47⅝ × 37⅝ in.
(121 × 95.6 cm)
Signed (right, on paper): Ingres / Pinx.
Catharine Lorillard Wolfe Collection, Wolfe
Fund, 1918
19.77.1

Madame Edmond Cavé (Marie-Elisabeth
Blavot, born 1810)
Oil on canvas, 16 × 12⅞ in.
(40.6 × 32.7 cm)
Signed and inscribed (lower right): Ingres à
Madame Cavé
Bequest of Grace Rainey Rogers, 1943
43.85.3

Edmond Cavé (1794–1852)
Painted later as a companion piece to 43.85.3
Oil on canvas, 16 × 12⅞ in.
(40.6 × 32.7 cm)
Signed, dated, and inscribed (lower right):
Ingres à Madame / Cavè. / 1844
Bequest of Grace Rainey Rogers, 1943
43.85.2

Aretino and Tintoretto
Oil on canvas, 17½ × 14 in.
(44.5 × 35.6 cm)
Signed and dated (lower left): Ingres. 1848.
Robert Lehman Collection, 1975
1975.1.185
ROBERT LEHMAN COLLECTION

Jean-Auguste-Dominique Ingres and Workshop

Odalisque in Grisaille
Unfinished repetition of the Grande
Odalisque of 1814 (Louvre, Paris)
Oil on canvas, 32¾ × 43 in.
(83.2 × 109.2 cm)
Catharine Lorillard Wolfe Collection, Wolfe
Fund, 1938
38.65

Copy after Jean-Auguste-Dominique Ingres

French, 19th century

Ingres (1780–1867) ***as a Young Man***
Oil on canvas, 34 × 27¹/₂ in.
(86.4 × 69.9 cm)
Inscribed (lower left, falsely): Ingres / 1804
Bequest of Grace Rainey Rogers, 1943
43.85.1

François-Marius Granet

French, 1775–1849

The Choir of the Capuchin Church in Rome
Oil on canvas, 77¹/₂ × 58¹/₄ in.
(196.9 × 148 cm)
Signed, dated, and inscribed: (lower right)
GRANET / 1815; (center right, on doorframe)
F.A.BARRI
Gift of L. P. Everard, 1880
80.5.2

Émile-Jean-Horace Vernet

French, 1789–1863

The Start of the Race of the Riderless Horses
This painting is a study for the main motif of a larger picture of the race (private collection).
Oil on canvas, 18¹/₈ × 21¹/₄ in.
(46 × 54 cm)
Signed (lower right): H. V.
Catharine Lorillard Wolfe Collection, Bequest of Catharine Lorillard Wolfe, 1887
87.15.47

Bertel Thorvaldsen (1768–1844) ***with the Bust of Horace Vernet***
This painting is a replica of the portrait signed and dated 1833 (Thorvaldsens Museum, Copenhagen).
Oil on canvas, 38 × 29¹/₂ in.
(96.5 × 74.9 cm)
Gift of Dr. Rudolf J. Heinemann, 1962
62.254

Jean-Louis-André-Théodore Gericault

French, 1791–1824

Evening: Landscape with an Aqueduct
This painting is from a series depicting the times of day that includes Morning: Landscape with Fishermen (Neue Pinakothek, Munich) and Noon: Landscape with a Roman Tomb (Musée du Petit Palais, Paris).
Oil on canvas, 98¹/₂ × 86¹/₂ in.
(250.2 × 219.7 cm)
Purchase, Gift of James A. Moffett 2nd, in memory of George M. Moffett, by exchange, 1989
1989.183

43.85.1

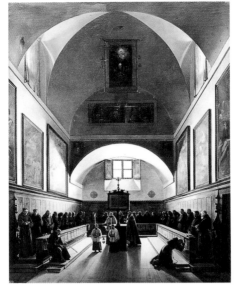

80.5.2

87.15.47

62.254

1989.183

41.17

52.71

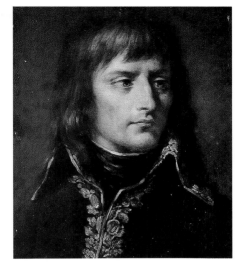

77.6

1994.376

50.71.2

22.27.2

1976.201.13

1974.3

Alfred Dedreux (1810–1860) ***as a Child***
Oil on canvas, 18 × 15 in. (45.7 × 38.1 cm)
The Alfred N. Punnett Endowment Fund,
1941
41.17

French Painters

about 1816

Study of a Nude Man

This is an anonymous study relating to the
work of Gericault.
Oil on canvas, 31³/₄ × 25¹/₄ in.
(80.6 × 64.1 cm)
Rogers Fund, 1952
52.71

mid-19th century

Napoleon Bonaparte (1769–1821)
Oil on wood, 18¹/₄ × 15 in.
(46.4 × 38.1 cm)
Gift of Estate of P. R. Strong, 1877
77.6

Achille-Etna Michallon

French, 1796–1822

Waterfall at Mont-Dore

Oil on canvas, 16¹/₄ × 22¹/₈ in.
(41.3 × 56.2 cm)
Signed and dated (lower left):
MICHALLON / 1818
Purchase, Wolfe Fund and Nancy
Richardson Gift, 1994
1994.376

Jean-Baptiste-Camille Corot

French, 1796–1875

Italian Landscape

Oil on paper, laid down on canvas,
5 × 10⁵/₈ in. (12.7 × 27 cm)
Signed (lower left): COROT.
Gift of Mr. and Mrs. William B. Jaffe, 1950
50.71.2

Lake Albano and Castel Gandolfo

Oil on paper, laid down on wood,
9 × 15¹/₂ in. (22.9 × 39.4 cm)
Stamped (lower left): VENTE / COROT
Purchase, Dikran G. Kelekian Gift, 1922
22.27.2

Monsieur Lemaistre (died 1888)

Oil on canvas, 15¹/₈ × 11⁵/₈ in.
(38.4 × 29.5 cm)
Signed and dated (upper right): C. Corot. /
1833.
Bequest of Joan Whitney Payson, 1975
1976.201.13

Jean-Baptiste-Camille Corot
French, 1796–1875

Honfleur: Calvary
Oil on wood, 11³/₄ × 16¹/₈ in.
(29.8 × 41 cm)
Signed and inscribed: (lower left) COROT; (on cross) INRI
Purchase, Mr. and Mrs. Richard J. Bernhard Gift, by exchange, 1974
1974.3

Fontainebleau: Oak Trees at Bas-Bréau
Oil on paper, laid down on wood,
15⁵/₈ × 19¹/₂ in. (39.7 × 49.5 cm)
Inscribed (verso): Cette étude de mon maître Corot peinte vers 1830 / qui lui a servi pour son tableau d'Hagar dans le désert / fut donné [par lui à?] Célestin Nanteuil en 183[5?] / Je l'ai retrouvé en fort mauvais état en 1884 / à Ma . . . lle [Marseille?] Je l'ai nettoyée et fait mettre / sur Panneau dans l'état où elle se trouve / Corot l'estimait comme une de ses meilleurs. / Français (This study by my master Corot painted about 1830 / which he used for his painting of Hagar in the desert / was given [by him to?] Célestin Nanteuil in 183[5?] / I rediscovered it in very bad condition in 1884 / at Ma . . . lle [Marseilles?] I cleaned it and had it put / on panel, its present state. / Corot considered it one of his best. / Français)
Catharine Lorillard Wolfe Collection, Wolfe Fund, 1979
1979.404

Diana and Actaeon
Oil on canvas, 61⁵/₈ × 44³/₈ in.
(156.5 × 112.7 cm)
Signed and dated (lower right): COROT. 1836
Robert Lehman Collection, 1975
1975.1.162
ROBERT LEHMAN COLLECTION

Hagar in the Wilderness
Salon of 1835
Oil on canvas, 71 × 106¹/₂ in.
(180.3 × 270.5 cm)
Signed and dated (lower left): COROT / 18[35]
Stamped? (lower right): VENTE / COROT
Rogers Fund, 1938
38.64

1979.404

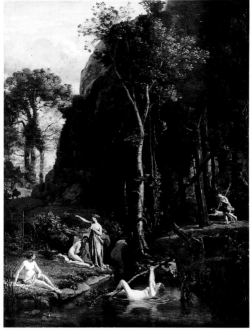

1975.1.162

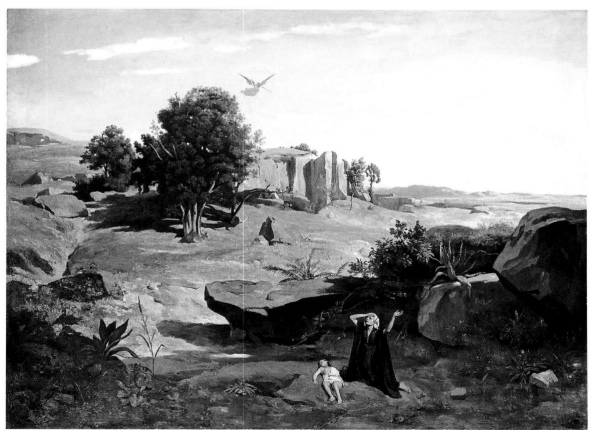

38.64

29.100.564

1980.203.4

1984.75

29.100.18

25.110.17

Portrait of a Child
Oil on wood, 12⅝ × 9¼ in.
(32.1 × 23.5 cm)
Signed (lower left): COROT
Inscribed (lower left): Corot
H. O. Havemeyer Collection, Bequest of Mrs.
H. O. Havemeyer, 1929
29.100.564

View of Lormes
Oil on canvas, 6½ × 21⅝ in.
(16.5 × 54.9 cm)
Partial and Promised Gift of Mr. and Mrs.
Walter Mendelsohn, 1980
1980.203.4

Study for "The Destruction of Sodom"
Study for the painting (29.100.18) shown at
the Salons of 1844 and 1857
Oil on canvas, 14⅛ × 19⅝ in.
(35.9 × 49.8 cm)
Catharine Lorillard Wolfe Collection, Wolfe
Fund, 1984
1984.75

The Destruction of Sodom
The painting, first shown at the Salon of
1844, was subsequently cut down and
substantially altered; it was exhibited again at
the Salon of 1857.
Oil on canvas, 36⅜ × 71⅜ in.
(92.4 × 181.3 cm)
Signed (lower right): COROT.
H. O. Havemeyer Collection, Bequest of Mrs.
H. O. Havemeyer, 1929
29.100.18

A Village Street: Dardagny
Oil on canvas, 13½ × 9½ in.
(34.3 × 24.1 cm)
Signed (lower left): COROT
Inscribed (center right, on wall): 48
Bequest of Collis P. Huntington, 1900
25.110.17

The Curious Little Girl
Oil on wood, 16¼ × 11¼ in.
(41.3 × 28.6 cm)
Signed (lower right): COROT
Anticipated Bequest of Walter H. Annenberg

Jean-Baptiste-Camille Corot

French, 1796–1875

The Environs of Paris

Oil on wood, 13¹/₂ × 20¹/₄ in.
(34.3 × 51.4 cm)
Theodore M. Davis Collection, Bequest of
Theodore M. Davis, 1915
30.95.272

Reverie

Oil on wood, 19⁵/₈ × 14³/₈ in.
(49.8 × 36.5 cm)
Signed (lower left): COROT
H. O. Havemeyer Collection, Bequest of Mrs.
H. O. Havemeyer, 1929
29.100.563

Mother and Child

Oil on wood, 12³/₄ × 8⁷/₈ in.
(32.4 × 22.5 cm)
Signed (lower right): COROT
H. O. Havemeyer Collection, Gift of Mrs.
P. H. B. Frelinghuysen, 1930
30.13

The Muse: History

Oil on canvas, 18¹/₈ × 13⁷/₈ in.
(46 × 35.2 cm)
Signed (lower left): COROT
H. O. Havemeyer Collection, Bequest of Mrs.
H. O. Havemeyer, 1929
29.100.193

Girl Weaving a Garland

Oil on canvas, 16¹/₂ × 11³/₄ in.
(41.9 × 29.8 cm)
Stamped (lower right): VENTE / COROT
H. O. Havemeyer Collection, Bequest of Mrs.
H. O. Havemeyer, 1929
29.100.562

The Ferryman

Oil on canvas, 26¹/₈ × 19³/₈ in.
(66.4 × 49.2 cm)
Signed (lower right): COROT
Bequest of Benjamin Altman, 1913
14.40.811

30.95.272

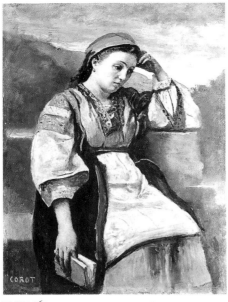

29.100.563

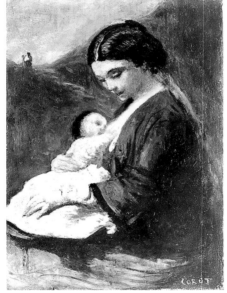

30.13

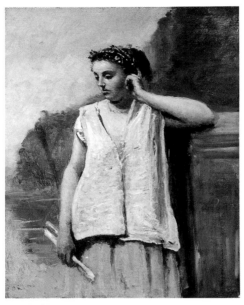

29.100.193

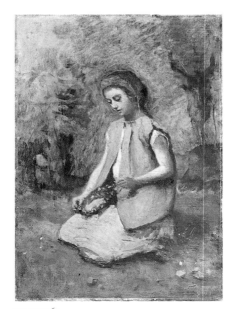

29.100.562

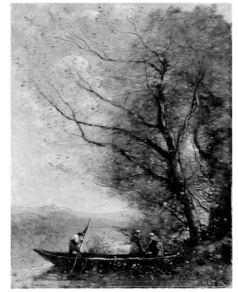

14.40.811

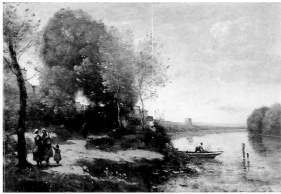

11.45.4

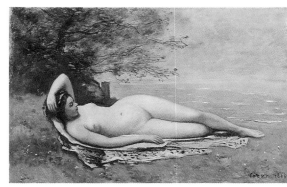

29.100.19

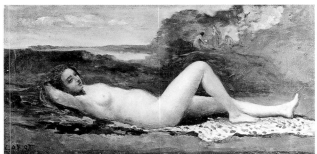

29.100.598

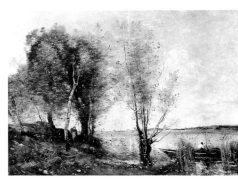

32.100.136

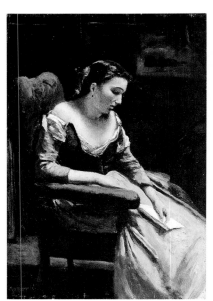

29.160.33

21.70.4

River with a Distant Tower
Oil on canvas, 21¹/₂ × 30⁷/₈ in.
(54.6 × 78.4 cm)
Signed (lower left): C. COROT
Bequest of Robert Graham Dun, 1900
11.45.4

Bacchante by the Sea
Oil on wood, 15¹/₄ × 23³/₈ in.
(38.7 × 59.4 cm)
Signed and dated (lower right): COROT 1865
H. O. Havemeyer Collection, Bequest of Mrs.
H. O. Havemeyer, 1929
29.100.19

Bacchante in a Landscape
Oil on canvas, 12¹/₈ × 24¹/₄ in.
(30.8 × 61.5 cm)
Signed (lower left): COROT
H. O. Havemeyer Collection, Bequest of Mrs.
H. O. Havemeyer, 1929
29.100.598

Boatman among the Reeds
Oil on canvas, 23¹/₂ × 32 in.
(59.7 × 81.3 cm)
Signed (lower left): COROT.
The Friedsam Collection, Bequest of Michael
Friedsam, 1931
32.100.136

The Letter
Oil on wood, 21¹/₂ × 14¹/₄ in.
(54.6 × 36.2 cm)
Signed (lower left): COROT
H. O. Havemeyer Collection, Gift of Horace
Havemeyer, 1929
29.160.33

A Wheelwright's Yard on the Seine
Oil on canvas, 18¹/₄ × 21⁷/₈ in.
(46.4 × 55.6 cm)
Signed: (lower left) COROT; (lower right)
COROT
Bequest of Eloise Lawrence Breese Norrie,
1921
21.70.4

Jean-Baptiste-Camille Corot
French, 1796–1875

A Pond in Picardy
Oil on canvas, 17 × 25 in. (43.2 × 63.5 cm)
Signed (lower left): COROT
Bequest of Benjamin Altman, 1913
14.40.813

Ville-d'Avray
Salon of 1870
Oil on canvas, 21⅝ × 31½ in.
(54.9 × 80 cm)
Signed (lower right): COROT
Catharine Lorillard Wolfe Collection, Bequest
of Catharine Lorillard Wolfe, 1887
87.15.141

A Woman Reading
Salon of 1869
Oil on canvas, 21³⁄₈ × 14³⁄₄ in.
(54.3 × 37.5 cm)
Signed (lower left): [COR]OT
Gift of Louise Senff Cameron, in memory of
her uncle, Charles H. Senff, 1928
28.90

14.40.813

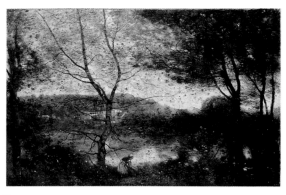

87.15.141

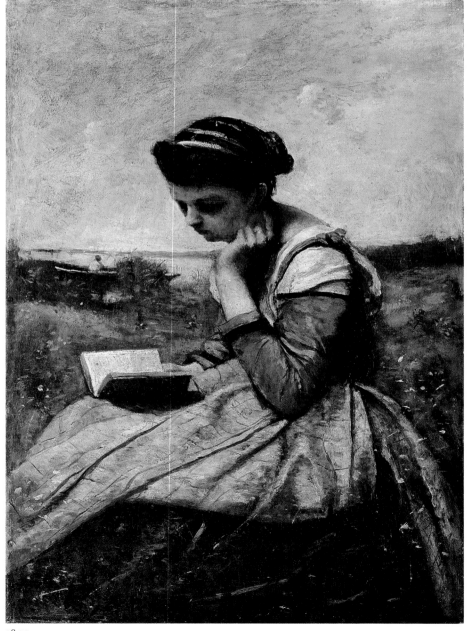

28.90

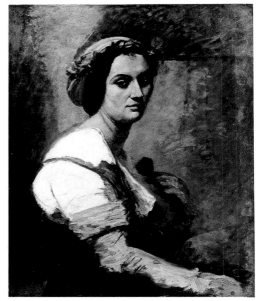

29.100.565

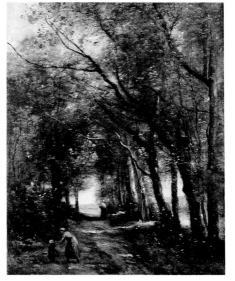

14.40.817

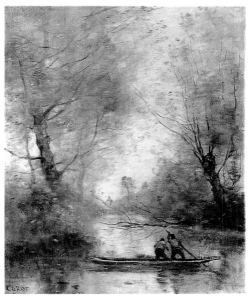

17.120.218

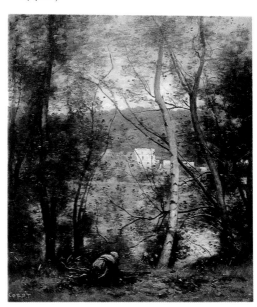

17.120.225

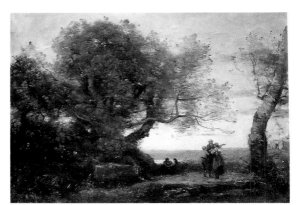

17.120.212

1986.296

Sibylle
Oil on canvas, 32¼ × 25½ in.
(81.9 × 64.8 cm)
H. O. Havemeyer Collection, Bequest of Mrs.
H. O. Havemeyer, 1929
29.100.565

A Lane through the Trees
Oil on canvas, 24 × 18 in. (61 × 45.7 cm)
Signed (lower right): COROT
Bequest of Benjamin Altman, 1913
14.40.817

River Landscape with Two Boatmen
Oil on canvas, 16 × 12⅞ in.
(40.6 × 32.7 cm)
Signed (lower left): COROT
Mr. and Mrs. Isaac D. Fletcher Collection,
Bequest of Isaac D. Fletcher, 1917
17.120.218

*A Woman Gathering Faggots at
Ville-d'Avray*
Oil on canvas, 28⅜ × 22½ in.
(72.1 × 57.2 cm)
Signed (lower left): COROT
Mr. and Mrs. Isaac D. Fletcher Collection,
Bequest of Isaac D. Fletcher, 1917
17.120.225

The Gypsies
Oil on canvas, 21¾ × 31½ in.
(55.2 × 80 cm)
Signed and dated (lower left): COROT. 1872
Mr. and Mrs. Isaac D. Fletcher Collection,
Bequest of Isaac D. Fletcher, 1917
17.120.212

Édouard Bertin
French, 1797–1871

Ravine at Sorrento
Oil on paper, laid down on board,
16⅛ × 11⅝ in. (41 × 29.5 cm)
Signed (lower right): E. Bertin.
Purchase, Karen B. Cohen Gift, 1986
1986.296

Eugène Delacroix
French, 1798–1863

The Natchez
Salon of 1835
Oil on canvas, 35¹/₂ × 46 in.
(90.2 × 116.8 cm)
Signed (lower right): EugDelacroix
Purchase, Gifts of George N. and Helen M.
Richard and Mr. and Mrs. Charles S.
McVeigh and Bequest of Emma A. Sheafer,
by exchange, 1989
1989.328

George Sand's Garden at Nohant
Oil on canvas, 17⁷/₈ × 21³/₄ in.
(45.4 × 55.2 cm)
Signed (lower left): E. Delacroix
Purchase, Dikran G. Kelekian Gift, 1922
22.27.4

Hamlet and His Mother
Oil on canvas, 10³/₄ × 7¹/₈ in.
(27.3 × 18.1 cm)
Signed (lower left): Eug. Delacroix.
Bequest of Miss Adelaide Milton de Groot
(1876–1967), 1967
67.187.61

The Abduction of Rebecca
Oil on canvas, 39¹/₂ × 32¹/₄ in.
(100.3 × 81.9 cm)
Signed and dated (lower right): Eug.
Delacroix / 1846
Catharine Lorillard Wolfe Collection, Wolfe
Fund, 1903
03.30

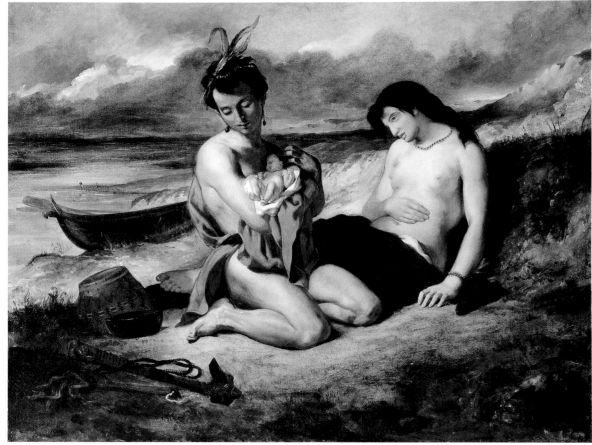

1989.328

22.27.4

67.187.61

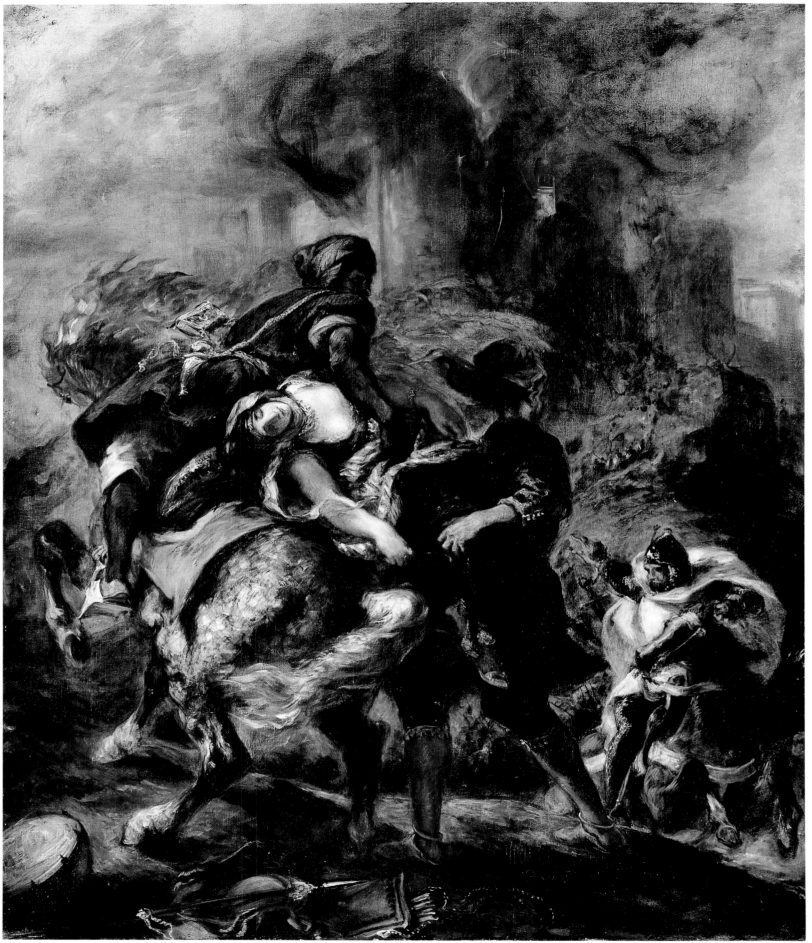

03.30

Eugène Delacroix
French, 1798–1863

Basket of Flowers
Salon of 1849
Oil on canvas, 42¼ × 56 in. (107.3 × 142.2 cm)
Bequest of Miss Adelaide Milton de Groot
(1876–1967), 1967
67.187.60

Christ Asleep during the Tempest
Oil on canvas, 20 × 24 in. (50.8 × 61 cm)
Signed (lower left): Eug. Delacroix
H. O. Havemeyer Collection, Bequest of Mrs.
H. O. Havemeyer, 1929
29.100.131

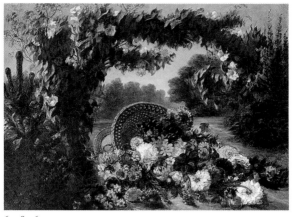

67.187.60

29.100.131

Théodore Caruelle d'Aligny
French, 1798–1871

Landscape with a Cave
Oil on canvas, 24½ × 18 in. (62.2 × 45.7 cm)
Signed and inscribed (verso): à l'ami
Duverger[?] (to my friend Duverger[?]) / CA
[monogram]
Catharine Lorillard Wolfe Collection, Wolfe
Fund, 1989
1989.138

Alexandre-Gabriel Decamps
French, 1803–1860

The Experts
Salon of 1839
Oil on canvas, 18¼ × 25¼ in.
(46.4 × 64.1 cm)
Signed, dated, and inscribed: (left) DE
CAMPS.1837; (on sticker applied to landscape)
107; (bottom center, on book) Expertise[s] /
10%[?] / Nous soussign[és] / Estimateurs /
Appréciateurs / Experts / . . . (Appraisal[s] /
10%[?] / We the undersigned / Assessors /
Appraisers / Connoisseurs / . . .)
H. O. Havemeyer Collection, Bequest of Mrs.
H. O. Havemeyer, 1929
29.100.196

1989.138

29.100.196

The Night Patrol at Smyrna
This is a later variant of The Turkish Patrol
(Wallace Collection, London) exhibited at the
Salon of 1831.
Oil on canvas, 29¼ × 36⅜ in.
(74.3 × 92.4 cm)
Signed (lower right): DECAMPS.
Catharine Lorillard Wolfe Collection, Bequest
of Catharine Lorillard Wolfe, 1887
87.15.93

The Good Samaritan
Oil on canvas, 36⅝ × 29⅛ in.
(93 × 74 cm)
H. O. Havemeyer Collection, Gift of Horace
Havemeyer, 1929
29.160.36

87.15.93

29.160.36

25.110.38

53.160

25.110.30

1975.1.242

17.120.214

14.40.819

Louis-Gabriel-Eugène Isabey

French, 1803–1886

A Church Interior

Oil on wood, 13³/₄ × 11¹/₈ in.
(34.9 × 28.3 cm)
Signed and dated (lower right): E. Isabey. 66
Bequest of Collis P. Huntington, 1900
25.110.38

Eugène Deveria

French, 1805–1865

Louis-Félix Amiel (1802–1864)

Oil on canvas, 24 × 19³/₄ in.
(61 × 50.2 cm)
Signed and dated (center right):
Eug—Deveria / 1837
Rogers Fund, 1953
53.160

Narcisse-Virgile Diaz de la Peña

French, 1808–1876

Diana

This is a larger replica of a painting shown at
the Salon of 1848.
Oil on canvas, 46¹/₂ × 27³/₄ in.
(118.1 × 70.5 cm)
Signed and dated (lower left): N. Diaz. 49.
Bequest of Collis P. Huntington, 1900
25.110.30

Figures and a Dog in a Landscape

Oil on wood, 17¹/₄ × 11³/₄ in.
(43.8 × 29.8 cm)
Signed and dated (lower left): N. Diaz. 52.
Robert Lehman Collection, 1975
1975.1.242
ROBERT LEHMAN COLLECTION

Autumn: The Woodland Pond

Oil on canvas, 19³/₄ × 26 in.
(50.2 × 66 cm)
Signed and dated (lower left): N. Diaz. 67.
Mr. and Mrs. Isaac D. Fletcher Collection,
Bequest of Isaac D. Fletcher, 1917
17.120.214

The Edge of the Woods

Oil on wood, 14⁷/₈ × 18¹/₂ in.
(37.8 × 47 cm)
Signed and dated (lower left): N. Diaz. 72.
Bequest of Benjamin Altman, 1913
14.40.819

Narcisse-Virgile Diaz de la Peña
French, 1808–1876

A Pool in a Meadow
Oil on wood, 12¹/₂ × 16¹/₈ in.
(31.8 × 41 cm)
Signed and dated (lower right): N. Diaz. 73.
Bequest of Maria DeWitt Jesup, from the
collection of her husband, Morris K. Jesup,
1914
15.30.13

A Vista through Trees: Fontainebleau
Oil on wood, 12³/₄ × 17¹/₄ in.
(32.4 × 43.8 cm)
Signed and dated (lower left): N. Diaz. 73.
Mr. and Mrs. Isaac D. Fletcher Collection,
Bequest of Isaac D. Fletcher, 1917
17.120.230

The Forest of Fontainebleau
Oil on wood, 18⁵/₈ × 23⁵/₈ in.
(47.3 × 60 cm)
Signed and dated (lower left): N.Diaz.74.
Bequest of Collis P. Huntington, 1900
25.110.92

Hippolyte Flandrin
French, 1809–1864

Joshua
This is a study for a wall painting by
Flandrin in the nave of the church of
Saint-Germain-des-Prés, Paris.
Oil over pen and brown ink on thin paper,
laid down on wood, paper 13³/₈ × 5⁵/₈ in.
(34 × 14.3 cm)
Van Day Truex Fund, 1985
1985.246.2
DRAWINGS AND PRINTS

Hezekiah, King of Judah
This is a study for a wall painting by
Flandrin in the nave of the church of
Saint-Germain-des-Prés, Paris.
Oil over pen and brown ink on thin paper,
laid down on wood, paper 12 × 5⁵/₈ in.
(30.5 × 14.3 cm)
Van Day Truex Fund, 1985
1985.246.1
DRAWINGS AND PRINTS

Honoré Daumier
French, 1808–1879

The Drinkers
Oil on wood, 14³/₈ × 11 in.
(36.5 × 27.9 cm)
Signed (lower left): h.D.
Bequest of Margaret Seligman Lewisohn, in
memory of her husband, Sam A. Lewisohn,
1954
54.143.1

15.30.13

17.120.230

25.110.92

1985.246.2 1985.246.1

54.143.1

47.122

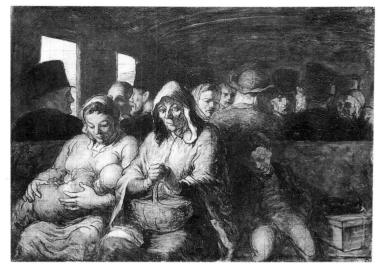

29.100.129

09.198

25.110.19

17.120.220

The Laundress
Oil on wood, 19¹/₄ × 13 in. (48.9 × 33 cm)
Signed and dated (lower left): h. Daumier /
186[3?]
Bequest of Lillie P. Bliss, 1931
47.122

The Third-Class Carriage
Oil on canvas, 25³/₄ × 35¹/₂ in.
(65.4 × 90.2 cm)
H. O. Havemeyer Collection, Bequest of Mrs.
H. O. Havemeyer, 1929
29.100.129

Don Quixote and the Dead Mule
Oil on wood, 9³/₄ × 18¹/₈ in.
(24.8 × 46 cm)
Signed (lower left): h.D.
Catharine Lorillard Wolfe Collection, Wolfe
Fund, 1909
09.198

Constant Troyon
French, 1810–1865

Road in the Woods
Oil on canvas, 22⁷/₈ × 19 in.
(58.1 × 48.3 cm)
Signed (lower left): C.TROYON.
Bequest of Collis P. Huntington, 1900
25.110.19

Going to Market
This is a smaller variant of a painting
exhibited at the Salon of 1859.
Oil on canvas, 16¹/₈ × 12⁷/₈ in.
(41 × 32.7 cm)
Signed and dated (lower right): C. TROYON.
1860.
Mr. and Mrs. Isaac D. Fletcher Collection,
Bequest of Isaac D. Fletcher, 1917
17.120.220

Jules Dupré

French, 1811–1889

Cows Crossing a Ford

Oil on canvas, 14¼ × 24⅝ in.
(36.2 × 62.5 cm)
Signed and dated (lower left): Jules Dupré. /
1836.
Gift of Mrs. Leon L. Watters, in memory of
Leon Laizer Watters, 1967
67.213

Landscape with Cattle

Oil on canvas, 31 × 51½ in.
(78.7 × 130.8 cm)
Signed and dated (lower left): J.Dupré / 1837
Robert Lehman Collection, 1975
1975.1.169
ROBERT LEHMAN COLLECTION

67.213

1975.1.169

Pierre-Étienne-Théodore Rousseau

French, 1812–1867

A Village in a Valley

Oil on canvas, 9⅛ × 16 in.
(23.2 × 40.6 cm)
Signed (lower left): TH. Rousseau.
The Friedsam Collection, Bequest of Michael
Friedsam, 1931
32.100.133

An Old Chapel in a Valley

Oil on wood, 10½ × 13⅞ in.
(26.7 × 35.2 cm)
Signed (lower left): TH.Rousseau.
Catharine Lorillard Wolfe Collection, Wolfe
Fund, 1903
03.28

32.100.133

03.28

A River in a Meadow

Oil on wood, 16¾ × 26⅛ in.
(42.5 × 66.4 cm)
Signed (lower left): Th. Rousseau
Bequest of Collis P. Huntington, 1900
25.110.52

A Meadow Bordered by Trees

Oil on wood, 16⅜ × 24⅜ in.
(41.6 × 61.9 cm)
Signed (lower left): TH.Rousseau.
Bequest of Robert Graham Dun, 1900
11.45.5

25.110.52

11.45.5

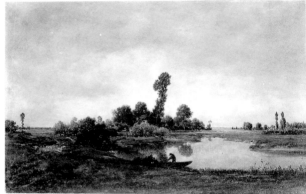

43.86.7

1975.1.204

1975.1.205

96.27

25.110.4

14.40.814

A River Landscape
Oil on wood, 16³/₈ × 24⁷/₈ in.
(41.6 × 63.2 cm)
Signed (lower left): Th.Rousseau.
Bequest of Richard De Wolfe Brixey, 1943
43.86.7

The Pool
Oil on wood, 12³/₄ × 16 in.
(32.4 × 40.6 cm)
Signed (lower left): Th. Rousseau.
Robert Lehman Collection, 1975
1975.1.204
ROBERT LEHMAN COLLECTION

Landscape
Oil on wood, 13¹/₂ × 20³/₈ in.
(34.3 × 51.8 cm)
Robert Lehman Collection, 1975
1975.1.205
ROBERT LEHMAN COLLECTION

The Edge of the Woods at Monts-Girard
Salon of 1855
Oil on wood, 31¹/₂ × 48 in. (80 × 121.9 cm)
Signed and dated (lower left): TH.Rousseau-
1854
Catharine Lorillard Wolfe Collection, Wolfe
Fund, 1896
96.27

Sunset near Arbonne
Oil on wood, 25¹/₄ × 39 in.
(64.1 × 99.1 cm)
Signed: (lower right) TH·R; (lower left) TH.
Rousseau-
Bequest of Collis P. Huntington, 1900
25.110.4

A Path among the Rocks
Oil on wood, 15 × 23⁵/₈ in. (38.1 × 60 cm)
Signed (lower left): TH.Rousseau.
Bequest of Benjamin Altman, 1913
14.40.814

Pierre-Étienne-Théodore Rousseau

French, 1812–1867

The Forest in Winter at Sunset

Oil on canvas, 64 × 102³/₈ in.
(162.6 × 260 cm)
Signed (lower left): TH.Rousseau.
Gift of P. A. B. Widener, 1911
11.4

Isidore Pils

French, 1813–1875

Minerva Combating Brute Force

This painting is a study for the decoration of
the grand staircase in the Paris Opéra.
Oil on paper, laid down on canvas,
11⁵/₈ × 27 in. (29.5 × 68.6 cm)
Signed (lower left): I.PILS
Purchase, Karen B. Cohen Gift, 1989
1989.53
DRAWINGS AND PRINTS

Charles-Émile Jacque

French, 1813–1894

The Sheepfold

Oil on wood, 18¹/₈ × 36¹/₈ in.
(46 × 91.8 cm)
Signed and dated (lower left): ch. Jacque /
1857.
Catharine Lorillard Wolfe Collection, Wolfe
Fund, 1897
97.40

A Shepherdess and Her Sheep

Oil on canvas, 32 × 25¹/₂ in.
(81.3 × 64.8 cm)
Signed (lower left): ch.Jacque
Bequest of Susan P. Colgate, in memory of
her husband, Romulus R. Colgate, 1936
36.162.3

Springtime

Oil on wood, 16 × 11¹/₂ in.
(40.6 × 29.2 cm)
Signed (lower left): ch. Jacque
Bequest of Lillian S. Timken, 1959
60.71.10

Jean-François Millet

French, 1814–1875

Garden Scene

Oil on canvas, 6³/₄ × 8³/₈ in.
(17.1 × 21.3 cm)
Signed (lower right): J. F. Millet.
Bequest of Maria DeWitt Jesup, from the
collection of her husband, Morris K. Jesup,
1914
15.30.24

11.4

1989.53

36.162.3

97.40

60.71.10

15.30.24

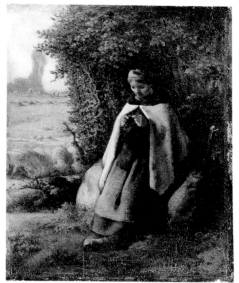

1983.446

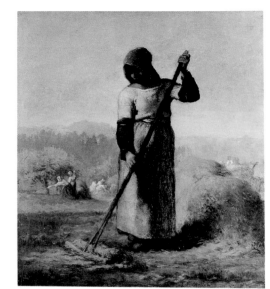

38.75

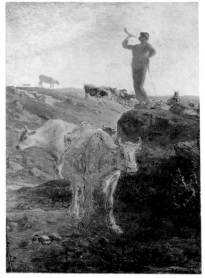

50.151

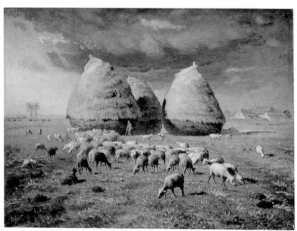

60.71.12

17.120.209

Shepherdess Seated on a Rock
This is one of two versions of the subject (the other is in the Cincinnati Art Museum) painted at the same time in 1856.
Oil on wood, 14¹/₈ × 11¹/₈ in. (35.9 × 28.3 cm)
Gift of Douglas Dillon, 1983
1983.446

Woman with a Rake
Oil on canvas, 15⁵/₈ × 13¹/₂ in. (39.7 × 34.3 cm)
Signed (lower right): J.F. Millet
Gift of Stephen C. Clark, 1938
38.75

Calling the Cows Home
Oil on wood, 37¹/₄ × 25¹/₂ in. (94.6 × 64.8 cm)
Signed (lower left): J·F·Millet·
Gift of Mrs. Arthur Whitney, 1950
50.151

Haystacks: Autumn
This is from a series commissioned in 1868 depicting the Seasons: Spring (Musée d'Orsay, Paris), Summer: Buckwheat Harvest (Museum of Fine Arts, Boston), and Winter: The Woodgatherers (National Museum of Wales, Cardiff).
Oil on canvas, 33¹/₂ × 43³/₈ in. (85.1 × 110.2 cm)
Signed (lower right): J.F. Millet
Bequest of Lillian S. Timken, 1959
60.71.12

Autumn Landscape with a Flock of Turkeys
Oil on canvas, 31⁷/₈ × 39 in. (81 × 99.1 cm)
Signed (lower right): J.F. Millet
Mr. and Mrs. Isaac D. Fletcher Collection, Bequest of Isaac D. Fletcher, 1917
17.120.209

Charles-Théodore Frère

French, 1814–1888

Jerusalem from the Environs

Oil on canvas, 29¹/₂ × 43¹/₂ in.
(74.9 × 110.5 cm)
Signed and inscribed (lower right): TH. FRÈRE.
/ JÉRUSALEM. TERRE SAINTE. (Holy Land)
Catharine Lorillard Wolfe Collection, Bequest
of Catharine Lorillard Wolfe, 1887
87.15.106

87.15.106

97.18

François-Louis Français

French, 1814–1897

Gathering Olives at Tivoli

Oil on canvas, 83³/₄ × 51⁵/₈ in.
(212.7 × 131.1 cm)
Signed and dated (lower right): Français 68
Gift of J. Montaignac, 1897
97.18

Thomas Couture

French, 1815–1879

Soap Bubbles

This is one of two versions of the subject; the
other (Walters Art Gallery, Baltimore) is
signed and dated 1859.
Oil on canvas, 51¹/₂ × 38⁵/₈ in. (130.8 × 98.1 cm)
Signed and inscribed: (lower left) T.C.; (on
paper) immortalité de l'un . . . (one's
immortality . . .)
Catharine Lorillard Wolfe Collection, Bequest
of Catharine Lorillard Wolfe, 1887
87.15.22

87.15.22

25.110.39

Jean-Louis-Ernest Meissonier

French, 1815–1891

The Card Players

Oil on wood, 13⁷/₈ × 10¹/₂ in.
(35.2 × 26.7 cm)
Signed and dated (lower left): EMeissonier
[initials in monogram] 1863
Bequest of Collis P. Huntington, 1900
25.110.39

Soldier Playing the Theorbo

Oil on wood, 11¹/₂ × 8⁵/₈ in. (29.2 × 21.9 cm)
Signed and dated (lower right): EMeissonier
[initials in monogram] 1865
Bequest of Martha T. Fiske Collord, in
memory of her first husband, Josiah M. Fiske,
1908
08.136.7

A General and His Aide-de-camp

Oil on wood, 7³/₄ × 10⁷/₈ in.
(19.7 × 27.6 cm)
Signed and dated (lower right): EMeissonier
[initials in monogram] 1869
Catharine Lorillard Wolfe Collection, Bequest
of Catharine Lorillard Wolfe, 1887
87.15.37

08.136.7

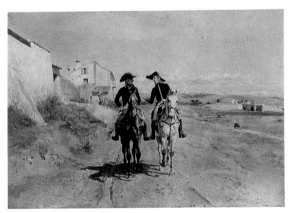

87.15.37

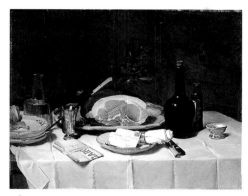

Friedland, 1807
Oil on canvas, 53¹/₂ × 95¹/₂ in.
(135.9 × 242.6 cm)
Signed and dated (lower left): EMeissonier
[initials in monogram] / 1875
Gift of Henry Hilton, 1887
87.20.1

Philippe Rousseau
French, 1816–1887

Still Life with Ham
Oil on canvas, 28³/₄ × 36¹/₄ in.
(73 × 92.1 cm)
Signed and inscribed: (on envelope) Monsieur
Ph. Rousseau. / à Acquigny / Eure ; (on
newspaper) [FI]GARO
Catharine Lorillard Wolfe Collection, Wolfe
Fund, 1982
1982.320

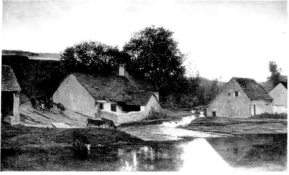

87.20.1

1982.320

Charles-François Daubigny
French, 1817–1878

Gobelle's Mill at Optevoz
Oil on canvas, 22³/₄ × 36¹/₂ in.
(57.8 × 92.7 cm)
Signed (lower left): C. Daubigny.
Bequest of Robert Graham Dun, 1900
11.45.3

Landscape on a River
Oil on wood, 8¹/₄ × 15 in. (21 × 38.1 cm)
Signed and dated (lower right): Daubigny
1863
Gift of Mary V. T. Eberstadt, 1964
64.149.7

64.149.7

11.45.3

The Banks of the Oise
Oil on wood, 14³/₄ × 26³/₈ in.
(37.5 × 67 cm)
Signed and dated (lower left): Daubigny. 1863.
Bequest of Benjamin Altman, 1913
14.40.815

A River Landscape with Storks
Oil on wood, 9¹/₂ × 17⁵/₈ in.
(24.1 × 44.8 cm)
Signed and dated (lower left): Daubigny 1864
Bequest of Benjamin Altman, 1913
14.40.818

14.40.815

14.40.818

Charles-François Daubigny
French, 1817–1878

On the Banks of the Oise
Oil on wood, 8³/₄ × 15¹/₂ in.
(22.2 × 39.4 cm)
Signed and dated (lower right): Daubigny
1864
Gift of Mary V. T. Eberstadt, 1964
64.149.6

Portejoie on the Seine
Oil on wood, 9⁵/₈ × 17³/₈ in.
(24.4 × 44.1 cm)
Signed and dated (lower left):
Daubigny.18[6?]8
Theodore M. Davis Collection, Bequest of
Theodore M. Davis, 1915
30.95.275

Boats on the Seacoast at Étaples
Oil on wood, 13¹/₂ × 22⁷/₈ in.
(34.3 × 58.1 cm)
Signed and dated (lower left): Daubigny 1871
Catharine Lorillard Wolfe Collection, Wolfe
Fund, 1903
03.29

Landscape with Ducks
Oil on wood, 15 × 26¹/₂ in.
(38.1 × 67.3 cm)
Signed and dated (lower left): Daubigny 1872
Robert Lehman Collection, 1975
1975.1.165
ROBERT LEHMAN COLLECTION

Apple Blossoms
Oil on canvas, 23¹/₈ × 33³/₈ in.
(58.7 × 84.8 cm)
Signed and dated (lower right): Daubigny
1873
Bequest of Collis P. Huntington, 1900
25.110.3

The Seine: Morning
Oil on wood, 15¹/₄ × 27¹/₄ in.
(38.7 × 69.2 cm)
Signed and dated (lower left): Daubigny 1874
Catharine Lorillard Wolfe Collection, Bequest
of Catharine Lorillard Wolfe, 1887
87.15.120

64.149.6

30.95.275

03.29

1975.1.165

25.110.3

87.15.120

43.86.6

08.136.4

The Pond of Gylieu
Oil on wood, 16 × 26¹/₂ in.
(40.6 × 67.3 cm)
Signed and dated (lower right): Daubigny
1876
Bequest of Richard De Wolfe Brixey, 1943
43.86.6

Landscape with a Sunlit Stream
Oil on canvas, 25¹/₈ × 18⁷/₈ in.
(63.8 × 47.9 cm)
Signed (lower left): Daubigny.
Bequest of Martha T. Fiske Collord, in
memory of her first husband, Josiah M. Fiske,
1908
08.136.4

Jean-Désiré-Gustave Courbet
French, 1819–1877

Young Women from the Village
The artist's sisters—Zélie, Juliette, and Zoë—
served as models for this painting, which was
exhibited at the Salon of 1852.
Oil on canvas, 76³/₄ × 102³/₄ in.
(194.9 × 261 cm)
Signed (lower left): G. Courbet.
Gift of Harry Payne Bingham, 1940
40.175

40.175

Jean-Désiré-Gustave Courbet
French, 1819–1877

Alphonse Promayet (1822–1872)
This painting served as the model for
Promayet's portrait in The Painter's Studio
(Musée d'Orsay, Paris) of 1855.
Oil on canvas, 42¹/₈ × 27⁵/₈ in.
(107 × 70.2 cm)
Inscribed (lower right): G. Courbet
H. O. Havemeyer Collection, Bequest of Mrs.
H. O. Havemeyer, 1929
29.100.132

Louis Gueymard (1822–1880) *as Robert le
Diable*
This portrait of the tenor Gueymard in the
title role in Meyerbeer's opera was exhibited at
the Salon of 1857.
Oil on canvas, 58¹/₂ × 42 in.
(148.6 × 106.7 cm)
Signed (lower left): G. Courbet.
Gift of Elizabeth Milbank Anderson, 1919
19.84

Woman in a Riding Habit (L'Amazone)
Oil on canvas, 45¹/₂ × 35¹/₈ in.
(115.6 × 89.2 cm)
Signed (lower left): G. Courbet.
H. O. Havemeyer Collection, Bequest of Mrs.
H. O. Havemeyer, 1929
29.100.59

Hunting Dogs with a Dead Hare
Oil on canvas, 36¹/₂ × 58¹/₂ in.
(92.7 × 148.6 cm)
Signed (lower right): G. Courbet.
H. O. Havemeyer Collection, Gift of Horace
Havemeyer, 1933
33.77

Madame Auguste Cuoq (Mathilde Desportes,
1827–1910)
Oil on canvas, 69¹/₂ × 42¹/₂ in.
(176.5 × 108 cm)
Signed (lower right): G. Courbet.
H. O. Havemeyer Collection, Bequest of Mrs.
H. O. Havemeyer, 1929
29.100.130

After the Hunt
Oil on canvas, 93 × 73¹/₄ in.
(236.2 × 186.1 cm)
Signed (lower left): G. Courbet.
H. O. Havemeyer Collection, Bequest of Mrs.
H. O. Havemeyer, 1929
29.100.61

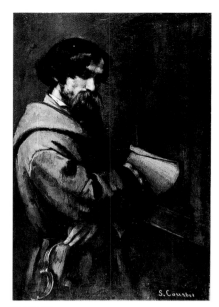

29.100.132

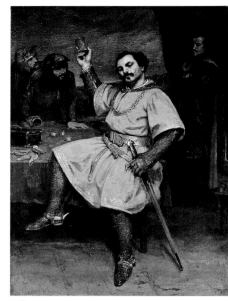

19.84

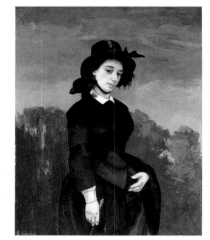

29.100.59

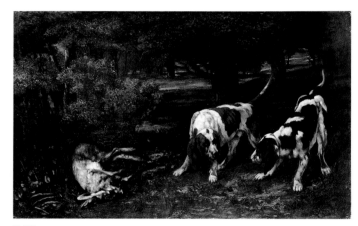

33.77

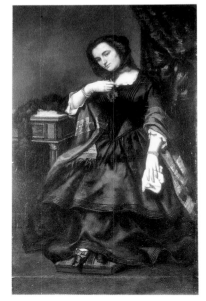

29.100.130

29.100.61

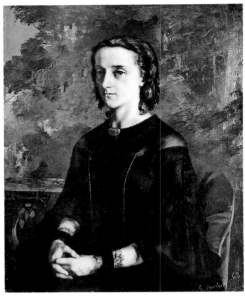

29.100.118

29.100.120

22.16.15

29.100.58

29.100.60

29.100.122

Madame de Brayer
Oil on canvas, 36 × 28⅝ in.
(91.4 × 72.7 cm)
Signed and dated (lower right): G. Courbet
. . 58
H. O. Havemeyer Collection, Bequest of Mrs.
H. O. Havemeyer, 1929
29.100.118

Monsieur Suisse
Oil on canvas, 23¼ × 19⅜ in.
(59.1 × 49.2 cm)
Signed (left edge): G. Courbet.
H. O. Havemeyer Collection, Bequest of Mrs.
H. O. Havemeyer, 1929
29.100.120

A Brook in a Clearing
Oil on canvas, 20¾ × 25½ in.
(52.7 × 64.8 cm)
Signed (lower left): G. Courbet.
From the Collection of James Stillman, Gift
of Dr. Ernest G. Stillman, 1922
22.16.15

The Source
Oil on canvas, 47¼ × 29¼ in.
(120 × 74.3 cm)
Signed (lower right): G. Courbet.
H. O. Havemeyer Collection, Bequest of Mrs.
H. O. Havemeyer, 1929
29.100.58

Nude with a Flowering Branch
Oil on canvas, 29½ × 24 in.
(74.9 × 61 cm)
H. O. Havemeyer Collection, Bequest of Mrs.
H. O. Havemeyer, 1929
29.100.60

The Source of the Loue
Oil on canvas, 39¼ × 56 in.
(99.7 × 142.2 cm)
Signed (bottom center): G. Courbet
H. O. Havemeyer Collection, Bequest of Mrs.
H. O. Havemeyer, 1929
29.100.122

Jean-Désiré-Gustave Courbet
French, 1819–1877

The Fishing Boat
Oil on canvas, 25^{1}/$_{2}$ × 32 in.
(64.8 × 81.3 cm)
Signed (lower left): Gustave Courbet.
Gift of Mary Goldenberg, 1899
99.11.3

The Hidden Brook
Oil on canvas, 23^{3}/$_{8}$ × 29^{3}/$_{4}$ in.
(59.4 × 75.6 cm)
Signed (lower right): G. Courbet
From the Collection of James Stillman, Gift
of Dr. Ernest G. Stillman, 1922
22.16.13

River and Rocks
Oil on canvas, 19^{5}/$_{8}$ × 23^{7}/$_{8}$ in.
(49.8 × 60.6 cm)
Signed (lower left): G. Courbet
From the Collection of James Stillman, Gift
of Dr. Ernest G. Stillman, 1922
22.16.14

The Deer
Oil on canvas, 29^{3}/$_{8}$ × 36^{3}/$_{8}$ in.
(74.6 × 92.4 cm)
Signed (lower left): G· Courbet·
H. O. Havemeyer Collection, Gift of Horace
Havemeyer, 1929
29.160.34

Portrait of a Man
Oil on canvas, 16^{1}/$_{4}$ × 13^{1}/$_{8}$ in.
(41.3 × 33.3 cm)
Signed (lower left): G·Courbet·
H. O. Havemeyer Collection, Bequest of Mrs.
H. O. Havemeyer, 1929
29.100.201

Woman with a Parrot
Salon of 1866
Oil on canvas, 51 × 77 in.
(129.5 × 195.6 cm)
Signed and dated (lower left): .66 /
Gustave.Courbet.
H. O. Havemeyer Collection, Bequest of Mrs.
H. O. Havemeyer, 1929
29.100.57

99.11.3

22.16.13

22.16.14

29.160.34

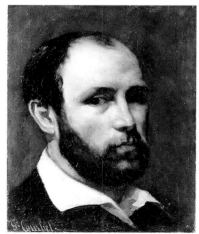

29.100.201

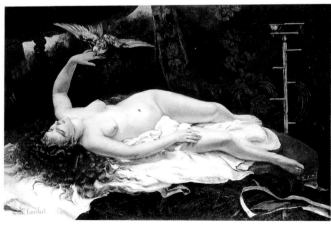

29.100.57

29.100.124

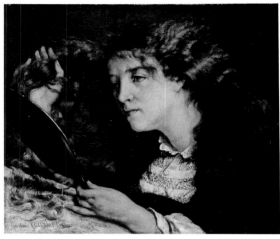

29.100.63

22.27.1

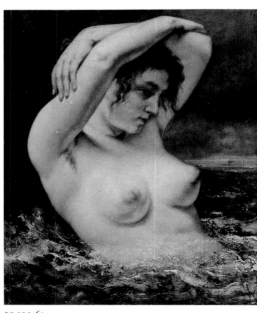

29.100.62

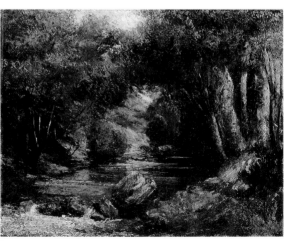

67.212

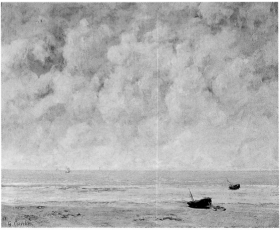

29.100.566

The Young Bather
Oil on canvas, 51¼ × 38¼ in.
(130.2 × 97.2 cm)
Signed and dated (lower left):
66 / G. Courbet.
H. O. Havemeyer Collection, Bequest of Mrs.
H. O. Havemeyer, 1929
29.100.124

Jo, La Belle Irlandaise
The model was Johanna Hiffernan (born
1842/43), Whistler's mistress. There are three
other versions (Nationalmuseum, Stockholm;
The Nelson-Atkins Museum, Kansas City;
and private collection).
Oil on canvas, 22 × 26 in. (55.9 × 66 cm)
Signed and dated (lower left): . . 66 /
Gustave.Courbet.
H. O. Havemeyer Collection, Bequest of Mrs.
H. O. Havemeyer, 1929
29.100.63

The Sea
Oil on canvas, 20 × 24 in. (50.8 × 61 cm)
Signed (lower right): G.Courbet.
Purchase, Dikran G. Kelekian Gift, 1922
22.27.1

The Woman in the Waves
Oil on canvas, 25¾ × 21¼ in.
(65.4 × 54 cm)
Signed and dated (lower left):
68 / G. Courbet
H. O. Havemeyer Collection, Bequest of Mrs.
H. O. Havemeyer, 1929
29.100.62

A Brook in the Forest
Oil on canvas, 19⅞ × 24⅛ in.
(50.5 × 61.3 cm)
Signed (lower right): G. Courbet.
Gift of Ralph Weiler, 1967
67.212

The Calm Sea
Oil on canvas, 23½ × 28¾ in.
(59.7 × 73 cm)
Signed and dated (lower left):
.69 / G.Courbet.
H. O. Havemeyer Collection, Bequest of Mrs.
H. O. Havemeyer, 1929
29.100.566

Jean-Désiré-Gustave Courbet

French, 1819–1877

Marine: The Waterspout

Oil on canvas, 27¹/₈ × 39¹/₄ in.
(68.9 × 99.7 cm)
Signed and dated (lower right):
G. Courbet / 70
H. O. Havemeyer Collection, Gift of Horace
Havemeyer, 1929
29.160.35

Style of Jean-Désiré-Gustave Courbet

French, second half 19th century

Portrait of a Woman, Called Héloïse Abélard

Oil on canvas, 25³/₈ × 21¹/₈ in.
(64.5 × 53.7 cm)
Inscribed (lower left, falsely): G. Courbet
H. O. Havemeyer Collection, Bequest of Mrs
H. O. Havemeyer, 1929
29.100.119

29.160.35

29.100.119

Apples

Oil on canvas, 13 × 17³/₈ in. (33 × 44.1 cm)
Inscribed (lower right, falsely): St. Pelagie /
G. Courbet.
H. O. Havemeyer Collection, Bequest of Mrs.
H. O. Havemeyer, 1929
29.100.123

Copy after Jean-Désiré-Gustave Courbet

French, second half 19th century

Spring Flowers

This is a copy of a painting (Kunsthalle,
Hamburg) signed and dated 1855.
Oil on canvas, 23³/₄ × 32¹/₄ in.
(60.3 × 81.9 cm)
Inscribed (lower left, falsely): G. Courbet / . . .
H. O. Havemeyer Collection, Bequest of Mrs.
H. O. Havemeyer, 1929
29.100.121

29.100.123

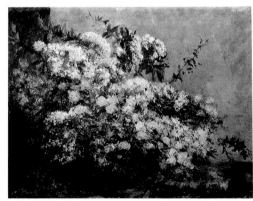

29.100.121

Antoine-Émile Plassan

French, 1817–1903

Mother and Child

Oil on wood, 10⁵/₈ × 8⁵/₈ in.
(27 × 21.9 cm)
Signed (lower left): PLASSAN.
Bequest of Margarette A. Jones, 1907
07.233.39

Théodore Chassériau

French, 1819–1856

Portrait of a Man

Oil on canvas, 21 × 18 in. (53.3 × 45.7 cm)
Signed and dated (lower right): Th·.
Chassériau / 1840
Victor Wilbour Memorial Fund, 1949
49.110

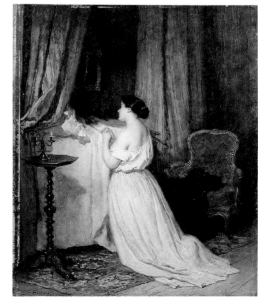

07.233.39

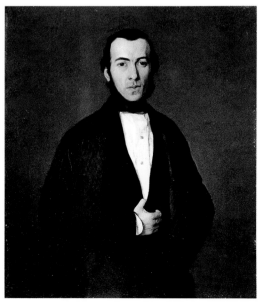

49.110

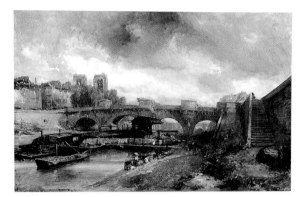

1980.203.3

06.1284

16.39

23.103.2

87.15.64

1975.1.183

Johan Barthold Jongkind
Dutch, 1819–1891

The Pont Neuf
Oil on canvas, 18 × 30 in. (45.7 × 76.2 cm)
Partial and Promised Gift of Mr. and Mrs. Walter Mendelsohn, 1980
1980.203.3

Sunset
Oil on canvas, 21¹/₄ × 28³/₄ in. (54 × 73 cm)
Signed and dated (lower right): Jongkind 1865
Gift of George A. Hearn, 1906
06.1284

Honfleur
Oil on canvas, 20¹/₂ × 32¹/₈ in. (52.1 × 81.6 cm)
Signed and dated (lower right): Jongkind 1865
Catharine Lorillard Wolfe Collection, Wolfe Fund, 1916
16.39

Eugène Fromentin
French, 1820–1876

The Arab Falconer
Oil on canvas, 42³/₄ × 28¹/₂ in. (108.6 × 72.4 cm)
Signed and dated: (lower left) -1864-; (lower right) Eug.Fromentin
The John Hobart Warren Bequest, 1923
23.103.2

Arabs Crossing a Ford
Oil on wood, 20 × 24¹/₂ in. (50.8 × 62.2 cm)
Signed and dated (lower right): -Eug.-Fromentin.-73-
Catharine Lorillard Wolfe Collection, Bequest of Catharine Lorillard Wolfe, 1887
87.15.64

Henri-Joseph Harpignies
French, 1819–1916

Landscape
Oil on wood, 16¹/₄ × 12⁵/₈ in. (41.3 × 32.1 cm)
Signed and dated (lower right): h harpignies. 1854
Robert Lehman Collection, 1975
1975.1.183
ROBERT LEHMAN COLLECTION

Henri-Joseph Harpignies
French, 1819–1916

Landscape
Oil on canvas, 37⁵/₈ × 63¹/₄ in.
(95.6 × 160.7 cm)
Signed and dated (lower left): hJharpignies
1869.
Robert Lehman Collection, 1975
1975.1.182
ROBERT LEHMAN COLLECTION

Moonrise
Oil on canvas, 34¹/₂ × 64¹/₄ in.
(87.6 × 163.2 cm)
Signed and dated (lower left): hjharpignies.
[hj in monogram] 1885.
Gift of Arnold and Tripp, 1886
86.6

1975.1.182 86.6

Eugène Lavieille
French, 1820–1889

The Village of La Celle-sous-Moret
Oil on wood, 13⁵/₈ × 23 in.
(34.6 × 58.4 cm)
Signed and inscribed: (lower right) Eugène
Lavieille; (verso) Le Village de la Celle Sˢ
Moret / Seine et Marne / Eugène Lavieille
Gift of Arthur Wiesenberger, 1960
60.155

Charles-Édouard de Beaumont
French, 1821–1888

In the Sun
Oil on canvas, 23¹/₂ × 37³/₄ in.
(59.7 × 95.9 cm)
Signed and dated (lower right): E. de
Beaumont 75
Gift of Estate of Marie L. Russell, 1946
46.150.2

60.155 46.150.2

Rosa Bonheur
French, 1822–1899

The Horse Fair
This painting, exhibited at the Salon of 1853,
was apparently retouched by the artist in 1855.
Oil on canvas, 96¹/₄ × 199¹/₂ in.
(244.5 × 506.7 cm)
Signed and dated (lower right): Rosa Bonheur
1853.5
Gift of Cornelius Vanderbilt, 1887
87.25

87.25

87.15.77

87.15.109

65.258.1

94.24.1

87.15.82

23.103.1

A Limier Briquet Hound
Oil on canvas, 14¹/₂ × 18 in.
(36.8 × 45.7 cm)
Signed (lower right): R B
Catharine Lorillard Wolfe Collection, Bequest
of Catharine Lorillard Wolfe, 1887
87.15.77

Weaning the Calves
Oil on canvas, 25⁵/₈ × 32 in.
(65.1 × 81.3 cm)
Signed and dated (lower left): Rosa Bonheur /
1879
Catharine Lorillard Wolfe Collection, Bequest
of Catharine Lorillard Wolfe, 1887
87.15.109

Alexandre Cabanel

French, 1823–1889

Echo
Oil on canvas, 38¹/₂ × 26¹/₄ in.
(97.8 × 66.7 cm)
Signed and dated (lower left): ALEX.
CABANEL. / 1874
Gift of Mary Phelps Smith, in memory of her
husband, Howard Caswell Smith, 1965
65.258.1

The Birth of Venus
This painting is an 1875 replica of a canvas
(Musée d'Orsay, Paris) that Cabanel showed
at the Salon of 1863.
Oil on canvas, 41³/₄ × 71⁷/₈ in.
(106 × 182.6 cm)
Signed (lower left): ALEX CABANEL
Gift of John Wolfe, 1893
94.24.1

Catharine Lorillard Wolfe (1828–1887)
Oil on canvas, 67¹/₂ × 42³/₄ in.
(171.5 × 108.6 cm)
Signed and dated (upper left): ALEX. CABANEL.
/ 1876
Catharine Lorillard Wolfe Collection, Bequest
of Catharine Lorillard Wolfe, 1887
87.15.82

Florentine Poet
Oil on wood, 12 × 19⁷/₈ in.
(30.5 × 50.5 cm)
Signed (lower right): ALEX-CABANEL.
The John Hobart Warren Bequest, 1923
23.103.1

Félix-François-Georges-Philibert Ziem

French, 1821–1911

Venetian Scene

Oil on canvas, 32¼ × 53¼ in.
(81.9 × 135.3 cm)
Signed (lower left): Ziem.
Gift of Mr. and Mrs. Malcolm P. Ripley, 1959
59.186

Augustin-Théodule Ribot

French, 1823–1891

Breton Fishermen and Their Families

Oil on canvas, 21¾ × 18¼ in.
(55.2 × 46.4 cm)
Signed (lower left): t Ribot.
Bequest of Catherine D. Wentworth, 1948
48.187.736

Auguste-François Bonheur

French, 1824–1884

Environs of Fontainebleau: Woodland and Cattle

Oil on canvas, 104½ × 157¼ in.
(265.4 × 399.4 cm)
Signed (lower left): Auguste Bonheur
Gift of James Clinch Smith and his sisters, in memory of their mother, 1890
90.25

Adolphe-Joseph-Thomas Monticelli

French, 1824–1886

The Court of the Princess

Oil on wood, 15 × 23⅜ in.
(38.1 × 59.4 cm)
Catharine Lorillard Wolfe Collection, Wolfe Fund, 1907
07.267

Flowers in a Blue Vase

Oil on wood; overall, with added strip at right, 26½ × 19¼ in. (67.3 × 48.9 cm)
Signed (lower right): Monticelli
Gift of Mr. and Mrs. Werner E. Josten, 1956
56.183

Four Figures

Oil on wood, 9¾ × 7¾ in.
(24.8 × 19.7 cm)
Signed (lower right): Monticelli
Bequest of Miss Adelaide Milton de Groot
(1876–1967), 1967
67.187.198

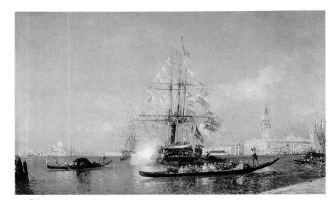

59.186

48.187.736

90.25

07.267

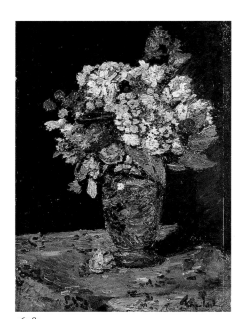

56.183

67.187.198

87.15.107

07.88.4

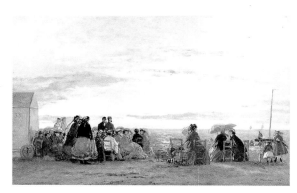

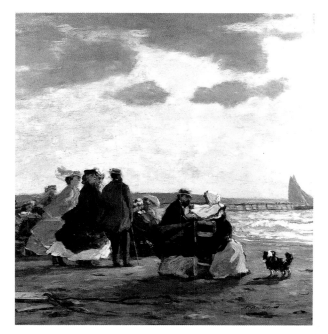

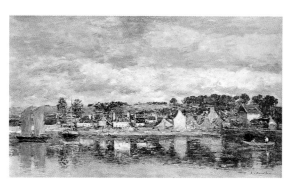

59.140

39.65.2

Hugues Merle
French, 1823–1881

Falling Leaves, Allegory of Autumn
Oil on canvas, 68⅞ × 43¼ in.
(174.9 × 109.9 cm)
Signed and dated (lower right): Hugues.Merle.
1872
Catharine Lorillard Wolfe Collection, Bequest
of Catharine Lorillard Wolfe, 1887
87.15.107

Eugène Boudin
French, 1824–1898

On the Beach at Trouville
Oil on wood, 10 × 18 in. (25.4 × 45.7 cm)
Signed and dated (lower right): E. Boudin.63
Bequest of Amelia B. Lazarus, 1907
07.88.4

On the Beach, Sunset
Oil on wood, 15 × 23 in. (38.1 × 58.4 cm)
Signed and dated (lower right): E. Boudin-65
Anticipated Bequest of Walter H. Annenberg

On the Beach, Dieppe
Oil on wood, 12½ × 11½ in.
(31.8 × 29.2 cm)
Signed and dated (lower right): E. Boudin
1864
Anticipated Bequest of Walter H. Annenberg

Village by a River
Oil on wood, 14 × 23 in. (35.6 × 58.4 cm)
Signed (lower right): E.Boudin.
Gift of Arthur J. Neumark, 1959
59.140

Beaulieu: The Bay of Fourmis
Salon of 1892
Oil on canvas, 21⅝ × 35½ in.
(54.9 × 90.2 cm)
Signed, dated, and inscribed (lower left):
[E].Boudin 92. / Beaulieu - Mars
Bequest of Jacob Ruppert, 1939
39.65.2

Eugène Boudin

French, 1824–1898

Princess Pauline Metternich (1836–1921)
on the Beach

Oil on cardboard, laid down on wood,
11⁵/₈ × 9¹/₄ in. (29.5 × 23.5 cm)
Anticipated Bequest of Walter H. Annenberg

Pierre Puvis de Chavannes

French, 1824–1898

Cider

This painting and the following (26.46.2) are
preparatory studies for the decoration of the
Musée de Picardie, Amiens (see also 58.15.1
below).
Oil on paper, laid down on canvas,
51 × 99¹/₄ in. (129.5 × 252.1 cm)
Signed (lower right): P.Puvis de Chavannes
Catharine Lorillard Wolfe Collection, Wolfe
Fund, 1926
26.46.1

The River

Oil on paper, laid down on canvas,
51 × 99¹/₄ in. (129.5 × 252.1 cm)
Signed (lower right): P.Puvis de Chavannes
Catharine Lorillard Wolfe Collection, Wolfe
Fund, 1926
26.46.2

Sleep

This is a reduced replica of a painting (Musée
des Beaux-Arts, Lille) exhibited at the Salon
of 1867.
Oil on canvas, 26¹/₈ × 41³/₄ in.
(66.4 × 106 cm)
Signed (lower left): P. Puvis de Chavannes.
Theodore M. Davis Collection, Bequest of
Theodore M. Davis, 1915
30.95.253

Tamaris

Oil on canvas, 10 × 15¹/₂ in.
(25.4 × 39.4 cm)
Signed (lower left): P. Puvis de Chavannes
H. O. Havemeyer Collection, Gift of Mrs.
J. Watson Webb, 1930
30.20

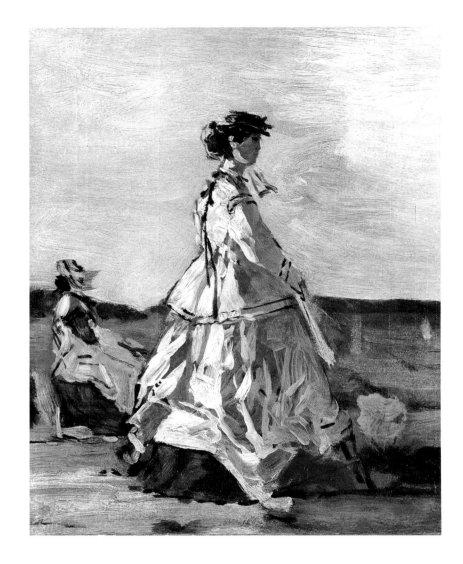

26.46.1

26.46.2

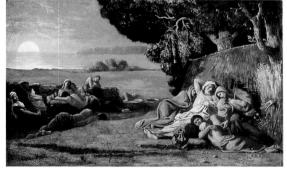

30.95.253

30.20

58.15.1

29.100.117

58.15.2

06.177

17.138.2

Ludus pro patria (Patriotic Games)
This painting is a reduced replica of a mural in the Musée de Picardie, Amiens (see also 26.46.1–2 above).
Oil on canvas, 13¹/₈ × 52⁷/₈ in.
(33.3 × 134.3 cm)
Signed (lower left): P. Puvis de Chavannes
Gift of Mrs. Harry Payne Bingham, 1958
58.15.1

The Allegory of the Sorbonne
This painting is a reduction of the decoration of the hemicycle in the amphitheater at the Sorbonne, Paris; the university is represented by the figure seated at the center.
Oil on canvas, 32⁵/₈ × 180¹/₄ in.
(82.9 × 457.8 cm)
Signed and dated (lower right): P.Puvis de Chavannes. 1889
H. O. Havemeyer Collection, Bequest of Mrs. H. O. Havemeyer, 1929
29.100.117

Inter artes et naturam (Between Art and Nature)
This painting is a reduced replica of the central part of a mural in the stairway of the Musée des Beaux-Arts et de la Céramique, Rouen.
Oil on canvas, 15⁷/₈ × 44³/₄ in.
(40.3 × 113.7 cm)
Signed (lower right): P.Puvis de Chavannes
Gift of Mrs. Harry Payne Bingham, 1958
58.15.2

The Shepherd's Song
Oil on canvas, 41¹/₈ × 43¹/₄ in.
(104.5 × 109.9 cm)
Signed and dated (lower left): P.Puvis de Chavannes / 1891
Rogers Fund, 1906
06.177

Charles-François Marchal
French, 1825–1877

Penelope
This painting and its pendant Phryne (location unknown) were exhibited at the Salon of 1868.
Oil on canvas, 43¹/₂ × 19¹/₂ in.
(110.5 × 49.5 cm)
Signed (upper right): Charles Marchal.
Gift of Mrs. Adolf Obrig, in memory of her husband, 1917
17.138.2

Jean-Léon Gérôme

French, 1824–1904

Prayer in the Mosque

Oil on canvas, 35 × 29¹⁄₂ in.
(88.9 × 74.9 cm)
Signed (upper right, on beam): J.L. GEROME
Catharine Lorillard Wolfe Collection, Bequest
of Catharine Lorillard Wolfe, 1887
87.15.130

Cafe House, Cairo (Casting Bullets)

Oil on canvas, 21¹⁄₂ × 24³⁄₄ in.
(54.6 × 62.9 cm)
Signed (center left): J.L. GEROME
Bequest of Henry H. Cook, 1905
05.13.4

Tiger and Cubs

Oil on canvas, 29 × 36 in. (73.7 × 91.4 cm)
Signed (lower left): J.L. GEROME
Bequest of Susan P. Colgate, in memory of
her husband, Romulus R. Colgate, 1936
36.162.4

Pygmalion and Galatea

Oil on canvas, 35 × 27 in. (88.9 × 68.6 cm)
Signed (on base of statue): J.L. GEROME.
Gift of Louis C. Raegner, 1927
27.200

Charles Bargue

French, 1825/26–1883

A Footman Sleeping

Oil on wood, 13³⁄₄ × 10¹⁄₄ in.
(34.9 × 26 cm)
Signed and dated (lower right): C.BARGVE 71
Bequest of Stephen Whitney Phoenix, 1881
81.1.656

A Bashi-Bazouk

Oil on canvas, 18¹⁄₄ × 13¹⁄₈ in.
(46.4 × 33.3 cm)
Signed and dated (right): BARGVE.75
Catharine Lorillard Wolfe Collection, Bequest
of Catharine Lorillard Wolfe, 1887
87.15.102

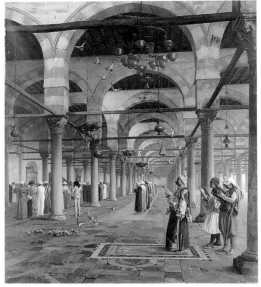

87.15.130

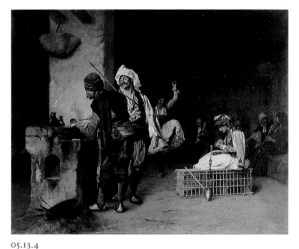

05.13.4

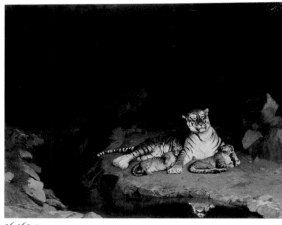

36.162.4

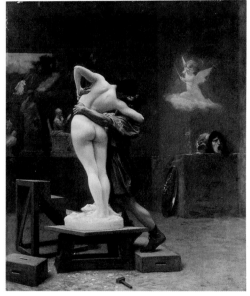

27.200

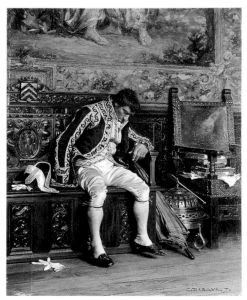

81.1.656

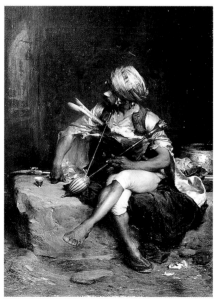

87.15.102

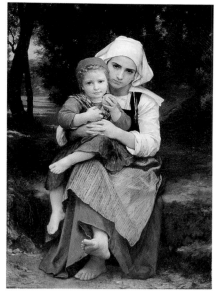

87.15.32

1993.402

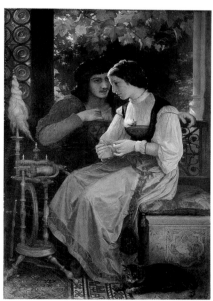

60.122

21.134.1

25.110.66

87.15.21

Adolphe-William Bouguereau
French, 1825–1905

Breton Brother and Sister
Oil on canvas, 50⁷/₈ × 35¹/₈ in.
(129.2 × 89.2 cm)
Catharine Lorillard Wolfe Collection, Bequest
of Catharine Lorillard Wolfe, 1887
87.15.32

Young Mother Gazing at Her Child
Oil on canvas, 56 × 40¹/₂ in.
(142.2 × 102.9 cm)
Signed and dated (lower right):
W-BOVGVEREAV-1871
Bequest of Zene Montgomery Pyle, 1993
1993.402

The Proposal
Oil on canvas, 64³/₈ × 44 in.
(163.5 × 111.8 cm)
Signed and dated (right, on pedestal):
W-BOVGVEREAV / 1872
Gift of Mrs. Elliot L. Kamen, in memory of
her father, Bernard R. Armour, 1960
60.122

Gustave Moreau
French, 1826–1898

Oedipus and the Sphinx
Salon of 1864
Oil on canvas, 81¹/₄ × 41¹/₄ in.
(206.4 × 104.8 cm)
Signed and dated (lower left): .Gustave
Moreau .64.
Bequest of William H. Herriman, 1920
21.134.1

Jules Breton
French, 1827–1906

The Weeders
This is a variant of a painting exhibited at the
Salon of 1861.
Oil on canvas, 28¹/₈ × 50¹/₄ in.
(71.4 × 127.6 cm)
Signed, dated, and inscribed (lower right):
Jules Breton/Courrières 1868
Bequest of Collis P. Huntington, 1900
25.110.66

A Peasant Girl Knitting
Oil on canvas, 22⁵/₈ × 18¹/₂ in.
(57.5 × 47 cm)
Signed (lower right): Jules Breton
Catharine Lorillard Wolfe Collection, Bequest
of Catharine Lorillard Wolfe, 1887
87.15.21

Paul-Désiré Trouillebert

French, 1829–1900

Early June Landscape

Oil on canvas, 21¹/₂ × 26 in.
(54.6 × 66 cm)
Signed (lower left): Trouillebert.
Robert Lehman Collection, 1975
1975.1.212
ROBERT LEHMAN COLLECTION

Blaise-Alexandre Desgoffe

French, 1830–1901

Objects of Art from the Louvre

Oil on canvas, 28³/₄ × 36¹/₄ in.
(73 × 92.1 cm)
Signed, dated, and inscribed: (lower left)
Blaise Desgoffe / -74; (on book) ALSACE
Catharine Lorillard Wolfe Collection, Bequest
of Catharine Lorillard Wolfe, 1887
87.15.119

Jean-Jacques Henner

French, 1829–1905

A Bather

This is a replica of a painting dated 1881
(Musée National Jean-Jacques Henner, Paris).
Oil on canvas, 38¹/₈ × 27³/₄ in.
(96.8 × 70.5 cm)
Signed (lower left): JJ HENNER
Catharine Lorillard Wolfe Collection, Bequest
of Catharine Lorillard Wolfe, 1887
87.15.54

Young Woman Praying

Oil on canvas, 24⁷/₈ × 17⁷/₈ in.
(63.2 × 45.4 cm)
Signed (lower left): JJ HENNER
Bequest of Emma T. Gary, 1937
37.20.2

Camille Pissarro

French, 1830–1903

Jallais Hill, Pontoise

Salon of 1868
Oil on canvas, 34¹/₄ × 45¹/₄ in.
(87 × 114.9 cm)
Signed and dated (lower right): C. Pissarro /
1867
Bequest of William Church Osborn, 1951
51.30.2

Still Life with Apples and Pitcher

Oil on canvas, 18¹/₄ × 22¹/₄ in.
(46.4 × 56.5 cm)
Signed (lower left): C. Pissarro
Purchase, Mr. and Mrs. Richard J. Bernhard
Gift, by exchange, 1983
1983.166

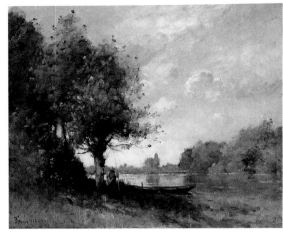

1975.1.212

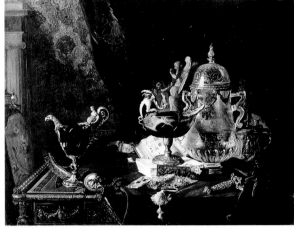

87.15.119

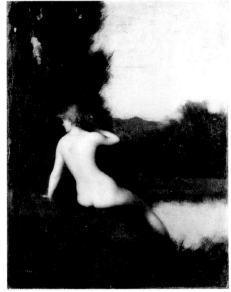

87.15.54

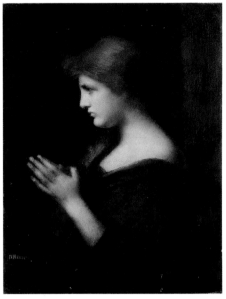

37.20.2

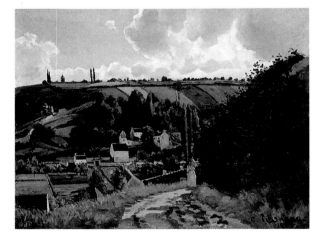

51.30.2

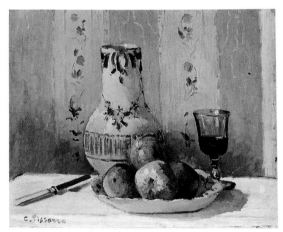

1983.166

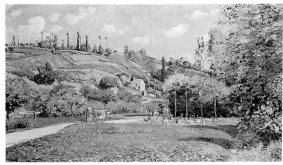

56.182

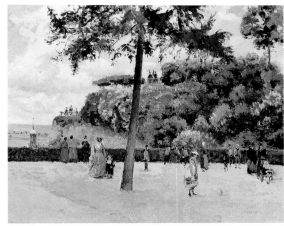

64.156

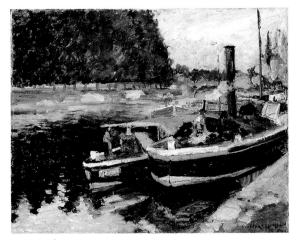

1979.135.16

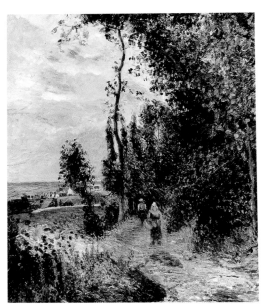

1991.277.2

1994.105

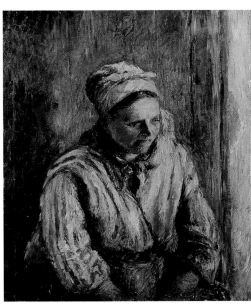

56.184.1

A Cowherd on the Route du Chou, Pontoise
Oil on canvas, 21⅝ × 36¼ in.
(54.9 × 92.1 cm)
Signed and dated (lower left): C. Pissarro.
1874
Gift of Edna H. Sachs, 1956
56.182

The Public Garden at Pontoise
Oil on canvas, 23⅝ × 28¾ in.
(60 × 73 cm)
Signed and dated (lower left): C.Pissarro.1874
Gift of Mr. and Mrs. Arthur Murray, 1964
(subject to a life estate)
64.156

Barges at Pontoise
Oil on canvas, 18⅛ × 21⅝ in.
(46 × 54.9 cm)
Signed and dated (lower right): C. Pissarro.
1876
Bequest of Mary Cushing Fosburgh, 1978
1979.135.16

Côte des Grouettes, near Pontoise
Oil on canvas, 29⅛ × 23⅝ in.
(74 × 60 cm)
Partial and Promised Gift of Janice H. Levin,
1991
1991.277.2

Fan Mount: The Cabbage Gatherers
Gouache on silk, 6½ × 20½ in.
(16.5 × 52.1 cm)
Signed (lower left): C. Pissarro
Purchase, Leonora Brenauer Bequest, in
memory of her father, Joseph B. Brenauer,
1994
1994.105

Washerwoman, Study
Impressionist exhibition of 1882
Oil on canvas, 28¾ × 23¼ in.
(73 × 59.1 cm)
Signed and dated (upper left): C. Pissarro 80
Gift of Mr. and Mrs. Nate B. Spingold, 1956
56.184.1

Camille Pissarro
French, 1830–1903

Potato Gatherers
Oil on canvas, 18¹/₈ × 21³/₄ in.
(46 × 55.2 cm)
Signed and dated (lower left): C.Pissarro.81.
Robert Lehman Collection, 1975
1975.1.197
ROBERT LEHMAN COLLECTION

Two Young Peasant Women
Oil on canvas, 35¹/₄ × 45⁷/₈ in.
(89.5 × 116.5 cm)
Signed and dated (lower right):
C.Pissarro.1892
Gift of Mr. and Mrs. Charles Wrightsman,
1973
1973.311.5

A Washerwoman at Eragny
Oil on canvas, 18 × 15 in. (45.7 × 38.1 cm)
Signed and dated (lower left): C.Pissarro.93
Gift of Mr. and Mrs. Richard Rodgers, 1964
64.154.1

Bather in the Woods
Oil on canvas, 23³/₄ × 28³/₄ in.
(60.3 × 73 cm)
Signed and dated (lower left): C. Pissarro.1895
H. O. Havemeyer Collection, Bequest of Mrs.
H. O. Havemeyer, 1929
29.100.126

Poplars, Eragny
Oil on canvas, 36¹/₂ × 25¹/₂ in.
(92.7 × 64.8 cm)
Signed and dated (lower right): C. Pissarro.95.
Bequest of Miss Adelaide Milton de Groot
(1876–1967), 1967
67.187.93

Steamboats in the Port of Rouen
Oil on canvas, 18 × 21¹/₂ in.
(45.7 × 54.6 cm)
Signed and dated (lower right): C.Pissarro. 96
Gift of Arthur J. Neumark, 1958
58.133

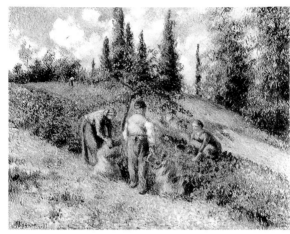

1975.1.197

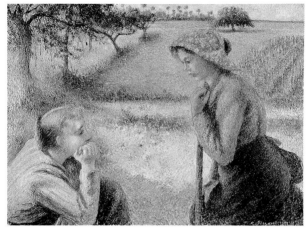

1973.311.5

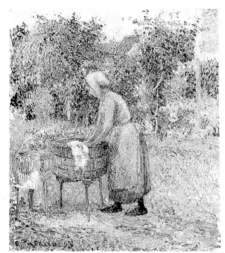

64.154.1

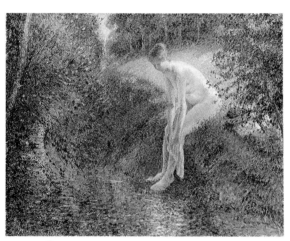

29.100.126

67.187.93

58.133

1980.21.1

60.174

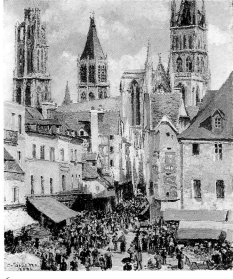

60.5

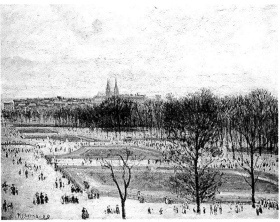

66.36

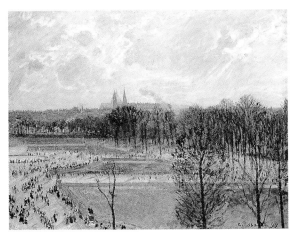

1979.414

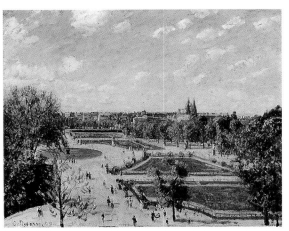

1992.103.3

Morning, An Overcast Day, Rouen
Oil on canvas, 21³/₈ × 25⁵/₈ in.
(54.3 × 65.1 cm)
Signed and dated (lower right): C.Pissarro.96
Bequest of Grégoire Tarnopol, 1979, and Gift
of Alexander Tarnopol, 1980
1980.21.1

*The Boulevard Montmartre on a Winter
Morning*
Oil on canvas, 25¹/₂ × 32 in.
(64.8 × 81.3 cm)
Signed and dated (lower left): C.Pissarro.97
Gift of Katrin S. Vietor, in loving memory of
Ernest G. Vietor, 1960
60.174

Rue de l'Épicerie, Rouen
Oil on canvas, 32 × 25⁵/₈ in.
(81.3 × 65.1 cm)
Signed and dated (lower left):
C.Pissarro. /1898
Purchase, Mr. and Mrs. Richard J. Bernhard
Gift, 1960
60.5

*The Garden of the Tuileries on a Winter
Afternoon*
Oil on canvas, 29 × 36¹/₄ in.
(73.7 × 92.1 cm)
Signed and dated (lower left): C.Pissarro.99
Gift of Katrin S. Vietor, in loving memory of
Ernest G. Vietor, 1966
66.36

*The Garden of the Tuileries on a Winter
Afternoon*
Oil on canvas, 28⁷/₈ × 36³/₈ in.
(73.3 × 92.4 cm)
Signed and dated (lower right): C.Pissarro.99
Gift from the Collection of Marshall Field
III, 1979
1979.414

*The Garden of the Tuileries on a Spring
Morning*
Oil on canvas, 28⁷/₈ × 36¹/₄ in.
(73.3 × 92.1 cm)
Signed and dated (lower left): C. Pissarro. 99
Partial and Promised Gift of Mr. and Mrs.
Douglas Dillon, 1992
1992.103.3

Édouard Manet

French, 1832–1883

Copy after Delacroix's "Bark of Dante"

The painting (Louvre, Paris) by Eugène
Delacroix (1798–1863) was exhibited at the
Salon of 1822.
Oil on canvas, 13 × 16¹/₈ in. (33 × 41 cm)
H. O. Havemeyer Collection, Bequest of Mrs.
H. O. Havemeyer, 1929
29.100.114

Still Life with Flowers, Fan, and Pearls

Oil on canvas, 18¹/₈ × 14¹/₂ in.
(46 × 36.8 cm)
Signed (lower right): Ed. M.
Partial and Promised Gift of Douglas Dillon,
1993
1993.399

Fishing

The figures at the lower right have the
features of the artist and his fiancée, Suzanne
Leenhoff (1830–1906).
Oil on canvas, transferred from the original
canvas, 30¹/₄ × 48¹/₂ in. (76.8 × 123.2 cm)
Signed (lower left): éd.Manet
Purchase, Mr. and Mrs. Richard J. Bernhard
Gift, 1957
57.10

The Spanish Singer

Salon of 1861
Oil on canvas, 58 × 45 in.
(147.3 × 114.3 cm)
Signed and dated (right, on bench): ed.
Manet 1860
Gift of William Church Osborn, 1949
49.58.2

Boy with a Sword

The model was Léon Koëlla-Leenhoff (1852–
1927).
Oil on canvas, 51⁵/₈ × 36³/₄ in.
(131.1 × 93.4 cm)
Signed (lower left): Manet
Gift of Erwin Davis, 1889
89.21.2

Mademoiselle V . . . in the Costume of an Espada

Salon des Refusés of 1863
The model was Victorine Meurent (1844–
1928).
Oil on canvas, 65 × 50¹/₄ in.
(165.1 × 127.6 cm)
Signed and dated (lower left): éd. Manet. /
1862
H. O. Havemeyer Collection, Bequest of Mrs.
H. O. Havemeyer, 1929
29.100.53

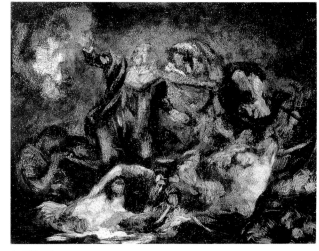

29.100.114

1993.399

57.10

49.58.2

89.21.2

29.100.53

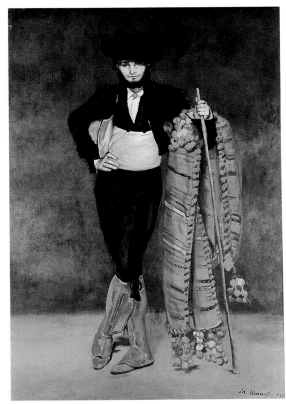

29.100.54

Édouard Manet
French, 1832–1883

Young Man in the Costume of a Majo
Salon des Refusés of 1863
The model has been identified as Manet's
younger brother Gustave (1835–1884).
Oil on canvas, 74 × 49⅛ in. (188 × 124.8 cm)
Signed and dated (lower right): éd. Manet. 1863
H. O. Havemeyer Collection, Bequest of Mrs.
H. O. Havemeyer, 1929
29.100.54

The Dead Christ and the Angels
Salon of 1864
Oil on canvas, 70⅝ × 59 in.
(179.4 × 149.9 cm)
Signed and inscribed: (lower left) Manet;
(lower right, on rock) évang[ile]. sel[on]. S.ͭ
Jean/chap[itre]. XXv.XII (Gospel according to
Saint John, chapter 20, verse 12)
H. O. Havemeyer Collection, Bequest of Mrs.
H. O. Havemeyer, 1929
29.100.51

Peonies
Oil on canvas, 23⅜ × 13⅞ in.
(59.4 × 35.2 cm)
Bequest of Joan Whitney Payson, 1975
1976.201.16

Young Lady in 1866
Salon of 1868
Oil on canvas, 72⅞ × 50⅝ in.
(185.1 × 128.6 cm)
Signed (lower left): Manet
Gift of Erwin Davis, 1889
89.21.3

A Matador
Oil on canvas, 67⅜ × 44½ in. (171.1 × 113 cm)
Signed (lower left): Manet
H. O. Havemeyer Collection, Bequest of Mrs.
H. O. Havemeyer, 1929
29.100.52

Madame Édouard Manet (Suzanne
Leenhoff, 1830–1906)
Oil on canvas, 39½ × 30⅞ in.
(100.3 × 78.4 cm)
Bequest of Miss Adelaide Milton de Groot
(1876–1967), 1967
67.187.81

The Funeral
Oil on canvas, 28⅝ × 35⅝ in. (72.7 × 90.5 cm)
Inscribed (lower right): Certifié d'Ed. Manet /
Vᵛᵉ Manet (Certified as by Ed. Manet /
Widow Manet)
Catharine Lorillard Wolfe Collection, Wolfe
Fund, 1909
10.36

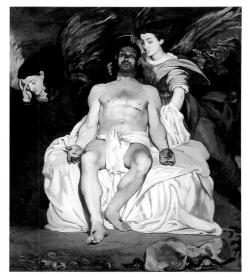

29.100.51

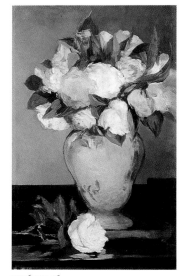

1976.201.16

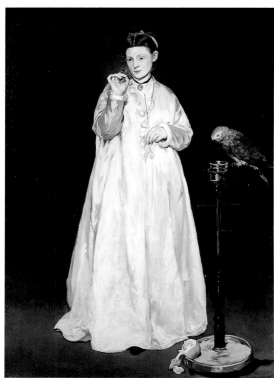

89.21.3

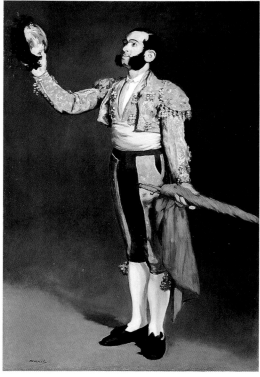

29.100.52

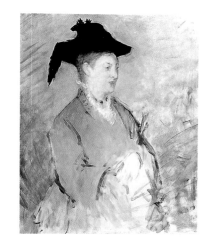

67.187.81

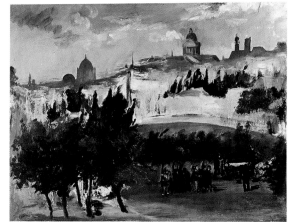

10.36

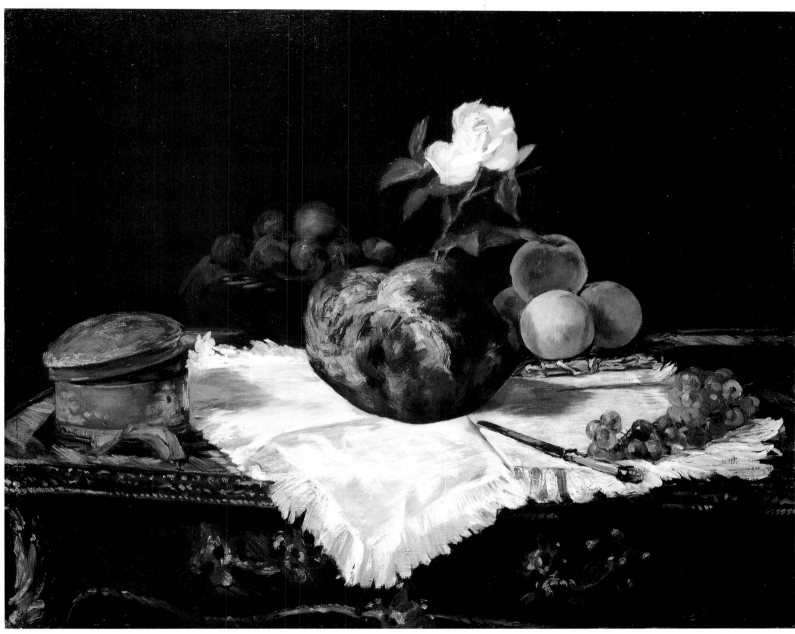

1991.287

The Brioche
Oil on canvas, 25⁵/₈ × 31⁷/₈ in.
(65.1 × 81 cm)
Signed and dated (lower right): Manet 1870
Partial and Promised Gift of an Anonymous
Donor, 1991
1991.287

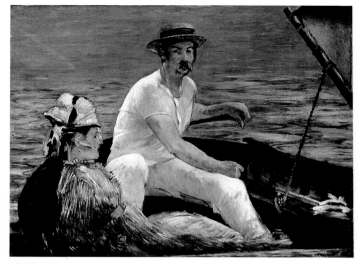

29.100.115

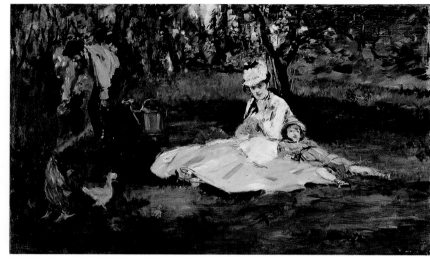

1976.201.14

55.193

29.100.55

Édouard Manet
French, 1832–1883

Boating
Salon of 1879
Oil on canvas, 38¼ × 51¼ in. (97.- × 130.2 cm)
Signed (lower right): Manet
H. O. Havemeyer Collection, Bequest of Mrs.
H. O. Havemeyer, 1929
29.100.115

The Monet Family in Their Garden at Argenteuil
This painting represents Claude Monet (1840–1926); his wife, Camille (1847–1879); and their son Jean (1867–1914) in the summer of 1874.
Oil on canvas, 24 × 39¼ in. (61 × 99.7 cm)
Signed (lower right): Manet
Bequest of Joan Whitney Payson, 1975
1976.201.14

George Moore at the Café
The sitter is the Irish critic and novelist
George Moore (1852–1933).
Oil on canvas, 25¾ × 32 in.
(65.4 × 81.3 cm)
Gift of Mrs. Ralph J. Hines, 1955
55.193

George Moore (1852–1933)
Pastel on canvas, 21¾ × 13⅞ in.
(55.2 × 35.2 cm)
Signed (lower left): Manet
H. O. Havemeyer Collection, Bequest of Mrs.
H. O. Havemeyer, 1929
29.100.55

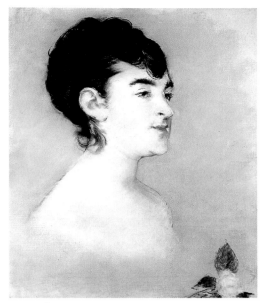

29.100.56

29.100.561

Mademoiselle Isabelle Lemonnier
Pastel on canvas, 22 × 18¼ in.
(55.9 × 46.4 cm)
H. O. Havemeyer Collection, Bequest of Mrs.
H. O. Havemeyer, 1929
29.100.56

Mademoiselle Lucie Delabigne (1859–1910),
Called Valtesse de la Bigne
Pastel on canvas, 21¾ × 14 in.
(55.2 × 35.6 cm)
Signed (right center): Manet
H. O. Havemeyer Collection, Bequest of Mrs.
H. O. Havemeyer, 1929
29.100.561

Madame Manet (Suzanne Leenhoff, 1830–
1906) ***at Bellevue***
Oil on canvas, 31¼ × 23¾ in.
(80.6 × 60.3 cm)
Anticipated Bequest of Walter H. Annenberg

Strawberries
Oil on canvas, 8⅜ × 10½ in.
(21.3 × 26.7 cm)
Signed (lower right): Manet
Gift of Mr. and Mrs. Nate B. Spingold, 1956
56.230.1

Jean-Baptiste Faure (1830–1914)
Oil on canvas, 23¼ × 19½ in.
(59.1 × 49.5 cm)
Gift of Mr. and Mrs. William B. Jaffe, 1950
50.71.1

Head of Jean-Baptiste Faure (1830–1914)
Oil on canvas, 18⅛ × 14⅞ in.
(46 × 37.8 cm)
Gift of Mrs. Ralph J. Hines, 1959
59.129

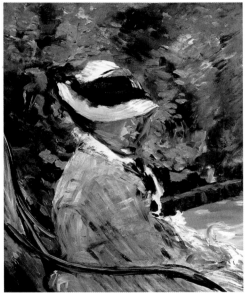

56.230.1

50.71.1

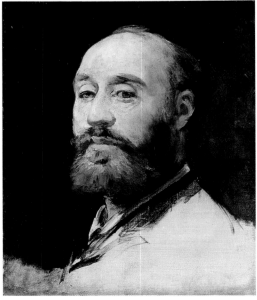

59.129

Léon Bonnat

French, 1833–1922

An Egyptian Peasant Woman and Her Child

Salon of 1870
Oil on canvas, 73¹/₂ × 41¹/₂ in.
(186.7 × 105.4 cm)
Signed (lower left): Lⁿ Bonnat
Catharine Lorillard Wolfe Collection, Bequest
of Catharine Lorillard Wolfe, 1887
87.15.97

Roman Girl at a Fountain

Oil on canvas, 67 × 39¹/₂ in.
(170.2 × 100.3 cm)
Signed and dated (lower right): Lⁿ Bonnat-75.
Catharine Lorillard Wolfe Collection, Bequest
of Catharine Lorillard Wolfe, 1887
87.15.137

John Taylor Johnston (1820–1893)

Johnston was a founding trustee (1870–93)
and first president (1870–89) of the
Metropolitan Museum. This portrait was
commissioned for presentation on the tenth
anniversary of his election.
Oil on canvas, 52¹/₂ × 44 in.
(133.4 × 111.8 cm)
Signed and dated (upper left): Lⁿ Bonnat- /
1880.
Gift of the Trustees, 1880
80.8

Marshall Orme Wilson (1860–1926)

Oil on canvas, 58¹/₂ × 40¹/₂ in.
(148.6 × 102.9 cm)
Signed and dated: (upper left) Lⁿ Bonnat.;
(upper right) 1894–
Gift of Orme Wilson, 1956
56.52

Gustave Doré

French, 1832–1883

***Don Quixote and Sancho Panza
Entertained by Basil and Quiteria***

Oil on canvas, 36¹/₄ × 28³/₄ in.
(92.1 × 73 cm)
Signed (lower left): Gᵛᵉ Doré
Gift of Mrs. William A. McFadden and Mrs.
Giles Whiting, 1928
28.113

Antoine Vollon

French, 1833–1900

Still Life with Cheese

Oil on canvas, 33³/₈ × 35³/₈ in.
(84.8 × 89.9 cm)
Signed (lower left): A Vollon
Bequest of William Hall Walker, 1917
18.22.1

87.15.97

87.15.137

80.8

56.52

28.113

18.22.1

61.101.6

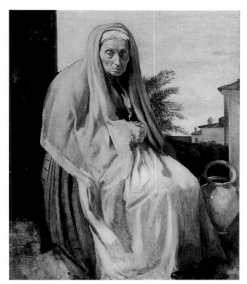

66.65.2

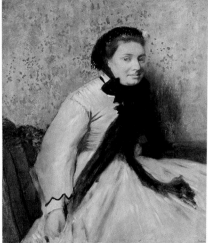

57.171

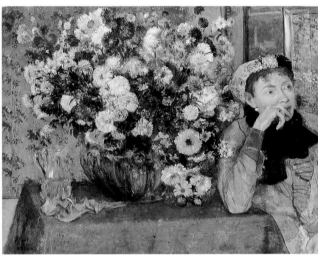

29.100.128

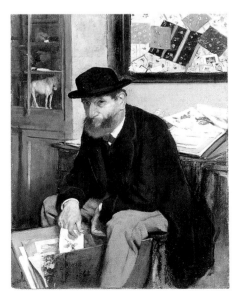

29.100.44

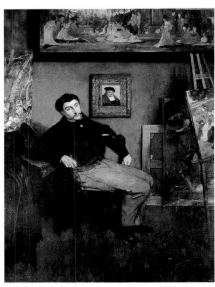

39.161

Hilaire-Germain-Edgar Degas
French, 1834–1917

Self-portrait
Oil on paper, laid down on canvas,
16 × 13¹/₂ in. (40.6 × 34.3 cm)
Bequest of Stephen C. Clark, 1960
61.101.6

The Old Italian Woman
Oil on canvas, 29¹/₂ × 24 in.
(74.9 × 61 cm)
Signed, dated, and inscribed (upper left):
Degas / Rome / 57
Bequest of Charles Goldman, 1966 (subject to
a life estate)
66.65.2

Portrait of a Woman in Gray
Oil on canvas, 36 × 28¹/₂ in.
(91.4 × 72.4 cm)
Stamped (lower right): Degas
Gift of Mr. and Mrs. Edwin C. Vogel, 1957
57.171

A Woman Seated Beside a Vase of Flowers
(Madame Paul Valpinçon?)
Oil on canvas, 29 × 36¹/₂ in.
(73.7 × 92.7 cm)
Signed and dated (lower left): Degas/1865
[partially legible]; 1865 / Degas
H. O. Havemeyer Collection, Bequest of Mrs.
H. O. Havemeyer, 1929
29.100.128

The Collector of Prints
Oil on canvas, 20⁷/₈ × 15³/₄ in.
(53 × 40 cm)
Signed and dated (lower left): Degas / 1866
H. O. Havemeyer Collection, Bequest of Mrs.
H. O. Havemeyer, 1929
29.100.44

James-Jacques-Joseph Tissot (1836–1902)
Oil on canvas, 59⁵/₈ × 44 in.
(151.4 × 111.8 cm)
Stamped (lower right): Degas
Rogers Fund, 1939
39.161

Hilaire-Germain-Edgar Degas
French, 1834–1917

Mademoiselle Marie Dihau (1843–1935)
Oil on canvas, 8³/₄ × 10³/₄ in.
(22.2 × 27.3 cm)
H. O. Havemeyer Collection, Bequest of Mrs.
H. O. Havemeyer, 1929
29.100.182

Two Men
It is possible that the figure at the right is the
painter Émile Lévy (1826–1890).
Oil on wood, 10⁵/₈ × 8¹/₈ in. (27 × 20.6 cm)
Stamped (lower right): Degas
Gift of Yvonne Lamon, 1992
1992.380

Joseph-Henri Altès (1826–1895)
Oil on canvas, 9⁷/₈ × 7⁷/₈ in.
(25.1 × 20 cm); with added strips
10⁵/₈ × 8¹/₂ in. (27 × 21.6 cm)
Signed (upper left): Degas
H. O. Havemeyer Collection, Bequest of Mrs.
H. O. Havemeyer, 1929
29.100.181

Madame Loubens
This study and the following (19.51.5) are for
a painting of about 1869 (The Art Institute of
Chicago).
Charcoal, heightened with pastel, with
indications of red and black chalk, on beige
paper, 9³/₈ × 8¹/₈ in. (23.8 × 20.6 cm)
Inscribed (lower right): Mᵉ Loubens
Stamped (lower left): Degas
Rogers Fund, 1918
19.51.4
DRAWINGS AND PRINTS

Madame Lisle
Charcoal, pastel, and traces of red and black
chalk on beige paper, 8⁵/₈ × 10¹/₈ in.
(21.9 × 25.7 cm)
Inscribed (upper right): Mᵐᵉ Lisle / oeil clair
et gris vert (light gray-green eye)
Stamped (lower left): Degas
Rogers Fund, 1918
19.51.5
DRAWINGS AND PRINTS

Madame Théodore Gobillard (Yves Morisot,
1838–1893)
This painting and the preparatory pastel
(1976.201.8) date to 1869. Related drawings
are in the Metropolitan Museum (1984.76 and
1985.48) and the Musée d'Orsay, Paris.
Oil on canvas, 21³/₄ × 25⁵/₈ in.
(55.2 × 65.1 cm)
Signed (lower left): Degas
H. O. Havemeyer Collection, Bequest of Mrs.
H. O. Havemeyer, 1929
29.100.45

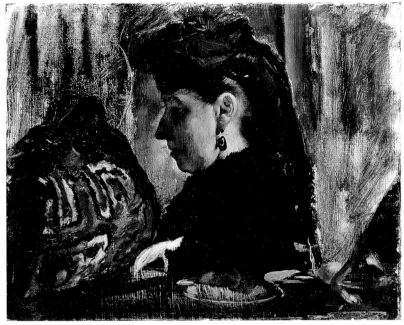

29.100.182

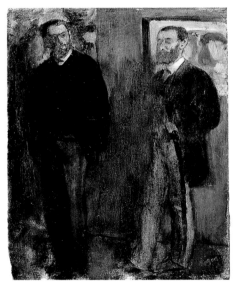

1992.380

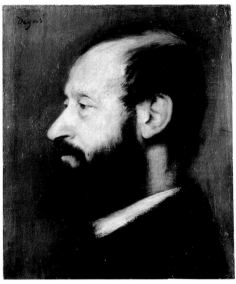

29.100.181

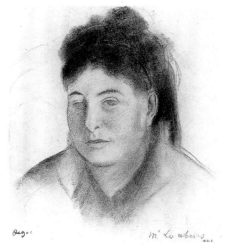

19.51.4

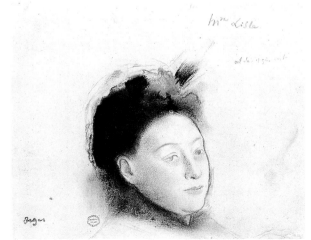

19.51.5

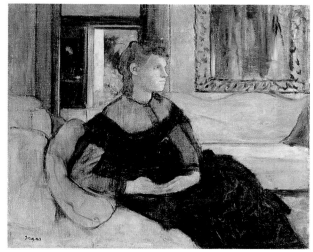

29.100.45

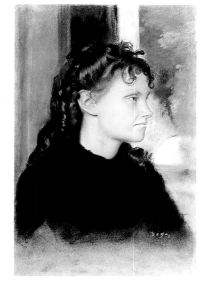

1976.201.8

29.100.43

29.100.552

29.100.184

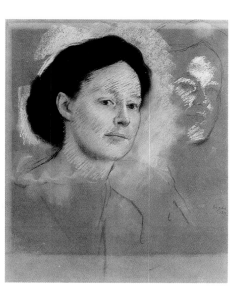

29.100.40

Madame Théodore Gobillard (Yves Morisot, 1838–1893)
Salon of 1870
Pastel on paper, 18⁷/₈ × 11³/₄ in.
(47.9 × 29.8 cm)
Signed (lower right): Degas
Bequest of Joan Whitney Payson, 1975
1976.201.8
DRAWINGS AND PRINTS

Sulking
Oil on canvas, 12³/₄ × 18¹/₄ in.
(32.4 × 46.4 cm)
Signed (lower right): E. Degas
H. O. Havemeyer Collection, Bequest of Mrs.
H. O. Havemeyer, 1929
29.100.43

The Ballet from "Robert le Diable"
Oil on canvas, 26 × 21³/₈ in.
(66 × 54.3 cm)
Signed and dated (lower right): Degas/1872
H. O. Havemeyer Collection, Bequest of Mrs.
H. O. Havemeyer, 1929
29.100.552

The Dancing Class
Oil on wood, 7³/₄ × 10⁵/₈ in.
(19.7 × 27 cm)
Signed (lower right): Degas
H. O. Havemeyer Collection, Bequest of Mrs.
H. O. Havemeyer, 1929
29.100.184

**The Artist's Cousin, Probably Mrs.
William Bell** (Mathilde Musson, 1841–1878)
Pastel on green wove paper, now darkened to
brown, 18⁵/₈ × 15¹/₈ in. (47.3 × 38.4 cm)
Signed and dated (lower right): Degas / 1873
H. O. Havemeyer Collection, Bequest of Mrs.
H. O. Havemeyer, 1929
29.100.40

A Woman Ironing
Impressionist exhibition of 1876
Oil on canvas, 21³/₈ × 15¹/₂ in.
(54.3 × 39.4 cm)
Signed (lower left): Degas
H. O. Havemeyer Collection, Bequest of Mrs.
H. O. Havemeyer, 1929
29.100.46

Hilaire-Germain-Edgar Degas
French, 1834–1917

Two Dancers
Dark brown wash and white gouache on
bright pink commercially coated wove paper,
now faded to pale pink, 24⅛ × 15½ in.
(61.3 × 39.4 cm)
Signed (lower right): Degas
H. O. Havemeyer Collection, Bequest of Mrs.
H. O. Havemeyer, 1929
29.100.187

The Rehearsal of the Ballet Onstage
One of three variants; the others are a grisaille
(Musée d'Orsay, Paris) and 29.100.39.
Oil colors freely mixed with turpentine, with
traces of watercolor and pastel over pen-and-
ink drawing on cream-colored wove paper,
laid down on bristol board and mounted on
canvas, 21⅜ × 28¾ in. (54.3 × 73 cm)
Signed (upper left): Degas
H. O. Havemeyer Collection, Gift of Horace
Havemeyer, 1929
29.160.26

The Rehearsal Onstage
Pastel over brush-and-ink drawing on thin
cream-colored wove paper, laid down on
bristol board and mounted on canvas,
21 × 28½ in. (53.3 × 72.4 cm)
Signed (upper left): Degas
H. O. Havemeyer Collection, Bequest of Mrs.
H. O. Havemeyer, 1929
29.100.39

Woman on a Sofa
Oil colors freely mixed with turpentine, with
touches of pastel, over graphite underdrawing,
on pink paper, 19⅛ × 16¾ in.
(48.6 × 42.5 cm)
Signed and dated (upper right): Degas 1875
H. O. Havemeyer Collection, Bequest of Mrs.
H. O. Havemeyer, 1929
29.100.185

Dancers Practicing at the Bar
Impressionist exhibition of 1877
Mixed media on canvas, 29¾ × 32 in.
(75.6 × 81.3 cm)
Signed (left center): Degas
H. O. Havemeyer Collection, Bequest of Mrs.
H. O. Havemeyer, 1929
29.100.34

The Dance Class
Impressionist exhibition of 1876
Oil on canvas, 32¾ × 30¼ in.
(83.2 × 76.8 cm)
Signed (lower left): Degas
Bequest of Mrs. Harry Payne Bingham, 1986
1987.47.1

29.100.46

29.100.187

29.160.26

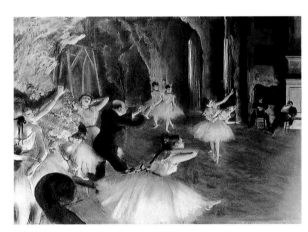

29.100.39

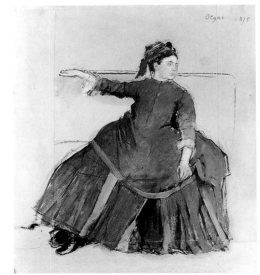

29.100.185

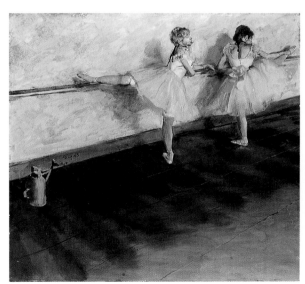

29.100.34

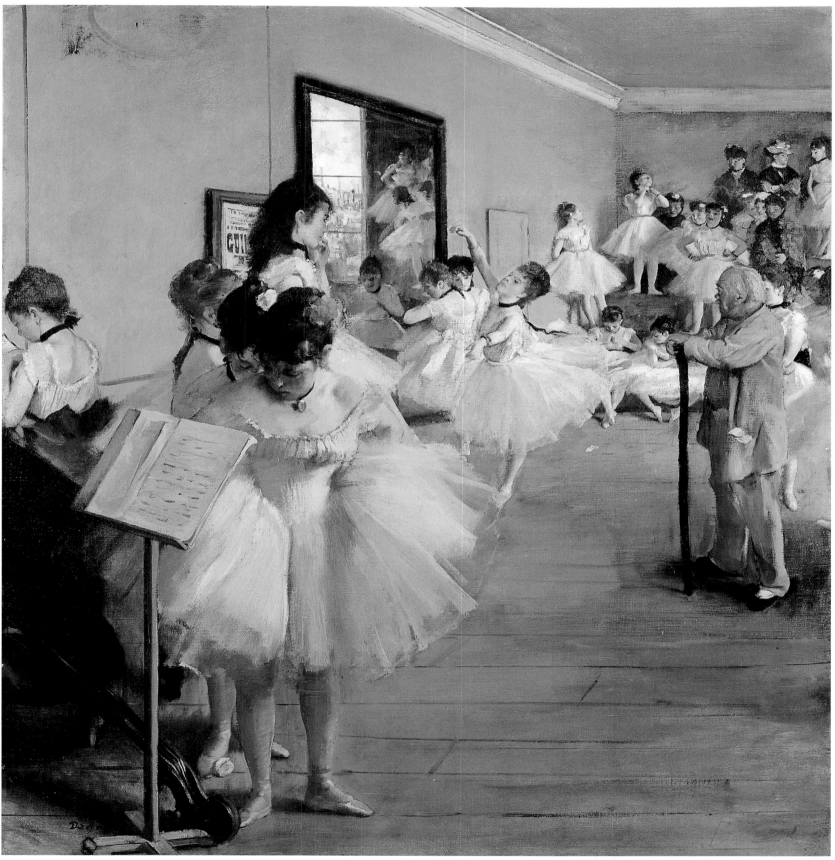

Hilaire-Germain-Edgar Degas
French, 1834–1917

Dancer Onstage
Gouache over graphite underdrawing on thin
wove commercially coated yellow paper, laid
down on board; paper 6³/₄ × 8³/₈ in.
(17.1 × 21.3 cm); board 7 × 9 in.
(17.8 × 22.9 cm)
Inscribed (lower left): à M[on?] ami A
Rouart / à Madame Al. Rouart (to my[?]
friend A Rouart / to Madame Al. Rouart)
Stamped (lower left): Degas
The Lesley and Emma Sheafer Collection,
Bequest of Emma A. Sheafer, 1973
1974.356.30

1974.356.30

19.51.1

Violinist Seated
This pastel served as a study for The Dance
Lesson (1971.185).
Pastel and charcoal on green paper (letterpress
printing on verso visible on recto),
15³/₈ × 11³/₄ in. (39.1 × 29.8 cm)
Stamped (lower left): Degas
Rogers Fund, 1918
19.51.1
DRAWINGS AND PRINTS

Portraits at the Stock Exchange
This study for a painting (Musée d'Orsay,
Paris) that was included in the Impressionist
exhibition of 1880 depicts the financier
Ernest May (1845–1925).
Pastel on paper, pieced and laid down on
canvas, 28³/₈ × 22⁷/₈ in. (72.1 × 58.1 cm)
Signed (lower right): Degas
Partial and Promised Gift of Janice H. Levin,
1991
1991.277.1

1991.277.1

29.100.189

Two Dancers
The model, Marie van Goethem, posed for
Degas's sculpture The Little Fourteen-Year-
Old Dancer.
Charcoal and white chalk on green
commercially coated wove paper,
25¹/₈ × 19¹/₄ in. (63.8 × 48.9 cm)
Signed (lower left): Degas
H. O. Havemeyer Collection, Bequest of Mrs.
H. O. Havemeyer, 1929
29.100.189

29.100.554

29.100.555

Fan Mount: The Ballet
Watercolor, India ink, silver, and gold on silk,
6¹/₈ × 21¹/₄ in. (15.6 × 54 cm)
H. O. Havemeyer Collection, Bequest of Mrs.
H. O. Havemeyer, 1929
29.100.554

Fan Mount: Ballet Girls
Watercolor, silver, and gold on silk,
7¹/₂ × 22³/₄ in. (19.1 × 57.8 cm)
Signed (center right): Degas
H. O. Havemeyer Collection, Bequest of Mrs.
H. O. Havemeyer, 1929
29.100.555

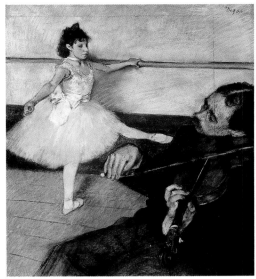

1971.185

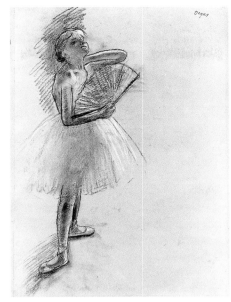

29.100.188

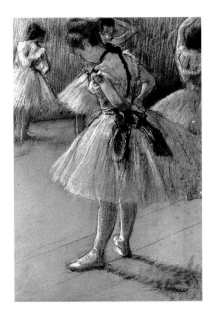

22.27.3

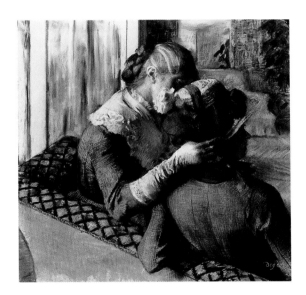

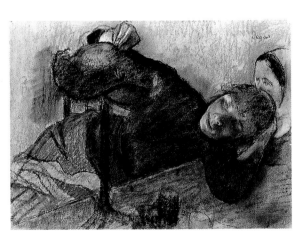

22.27.3

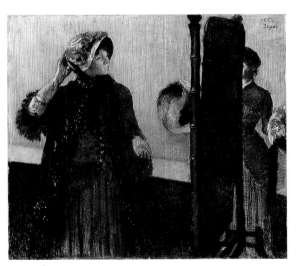

29.100.38

The Dance Lesson
Impressionist exhibition of 1879
Pastel and black chalk on three pieces of wove paper, joined together, 25³/₈ × 22¹/₈ in. (64.5 × 56.2 cm)
Signed (upper right): Degas
H. O. Havemeyer Collection, Gift of Adaline Havemeyer Perkins, in memory of her father, Horace Havemeyer, 1971
1971.185

Dancer with a Fan
This is a study for The Dancing Lesson (Sterling and Francine Clark Art Institute, Williamstown).
Pastel on gray-green laid paper,
24 × 16¹/₂ in. (61 × 41.9 cm)
Signed (upper right): Degas
H. O. Havemeyer Collection, Bequest of Mrs. H. O. Havemeyer, 1929
29.100.188

Dancer
Pastel, charcoal, and chalk on paper,
12¹/₂ × 19¹/₄ in. (31.8 × 48.9 cm)
Signed (lower right): Degas
Anticipated Bequest of Walter H. Annenberg

At the Milliner's
Pastel on five pieces of wove paper, backed with paper and laid down on canvas,
27¹/₄ × 27¹/₄ in. (69.2 × 69.2 cm)
Signed (lower right): Degas
Anticipated Bequest of Walter H. Annenberg

The Milliner
Pastel and charcoal on warm gray wove paper, now discolored to buff (watermark MICHALLET), laid down on dark brown wove paper, 18³/₄ × 24¹/₂ in. (47.6 × 62.2 cm)
Signed: (upper right) Degas; (lower right) Degas [obscured]
Purchase, Rogers Fund and Dikran G. Kelekian Gift, 1922
22.27.3

At the Milliner's
Impressionist exhibition of 1886
Mary Cassatt (1845–1926) was the model for the customer.
Pastel on pale gray wove paper (industrial wrapping paper, stamped on verso OLD RELIABLE BOLTING EXPRESSLY FOR MILLING), laid down on silk bolting, 30 × 34 in. (76.2 × 86.4 cm)
Signed and dated (upper right): 1882 / Degas
H. O. Havemeyer Collection, Bequest of Mrs. H. O. Havemeyer, 1929
29.100.38

Hilaire-Germain-Edgar Degas
French, 1834–1917

Dancer in Green
Pastel on paper, 28 × 15 in. (71.1 × 38.1 cm)
Signed (lower left): Degas
Bequest of Joan Whitney Payson, 1975
1976.201.7
Drawings and Prints

The Singer in Green
Pastel on light blue laid paper,
23³/₄ × 18¹/₄ in. (60.3 × 46.4 cm)
Signed (lower right): Degas
Bequest of Stephen C. Clark, 1960
61.101.7

Dancers in the Rehearsal Room with a Double Bass
Oil on canvas, 15³/₈ × 35¹/₄ in.
(39.1 × 89.5 cm)
Signed (lower left): Degas
H. O. Havemeyer Collection, Bequest of Mrs.
H. O. Havemeyer, 1929
29.100.127

Woman Drying Her Arm
Pastel and charcoal on off-white wove paper,
discolored at the edges, 12 × 17¹/₂ in.
(30.5 × 44.5 cm)
Signed (lower left): Degas
H. O. Havemeyer Collection, Bequest of Mrs.
H. O. Havemeyer, 1929
29.100.553

Three Dancers Preparing for Class
Pastel on buff-colored wove paper,
21¹/₂ × 20¹/₂ in. (54.6 × 52.1 cm)
Signed (lower left): Degas
H. O. Havemeyer Collection, Bequest of Mrs.
H. O. Havemeyer, 1929
29.100.558

Standing Bather
Charcoal, pastel, and watercolor on off-white
laid paper, 12¹/₈ × 9³/₈ in. (30.8 × 23.8 cm)
Stamped (lower right): Degas
Rogers Fund, 1918
19.51.3
Drawings and Prints

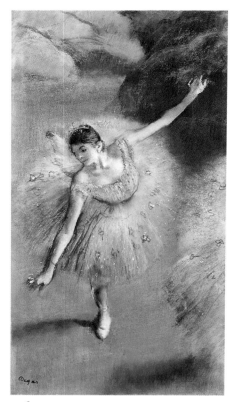

1976.201.7

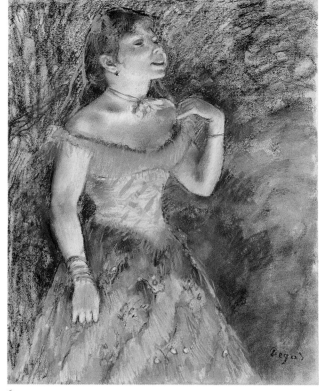

61.101.7

29.100.127

29.100.553

29.100.558

19.51.3

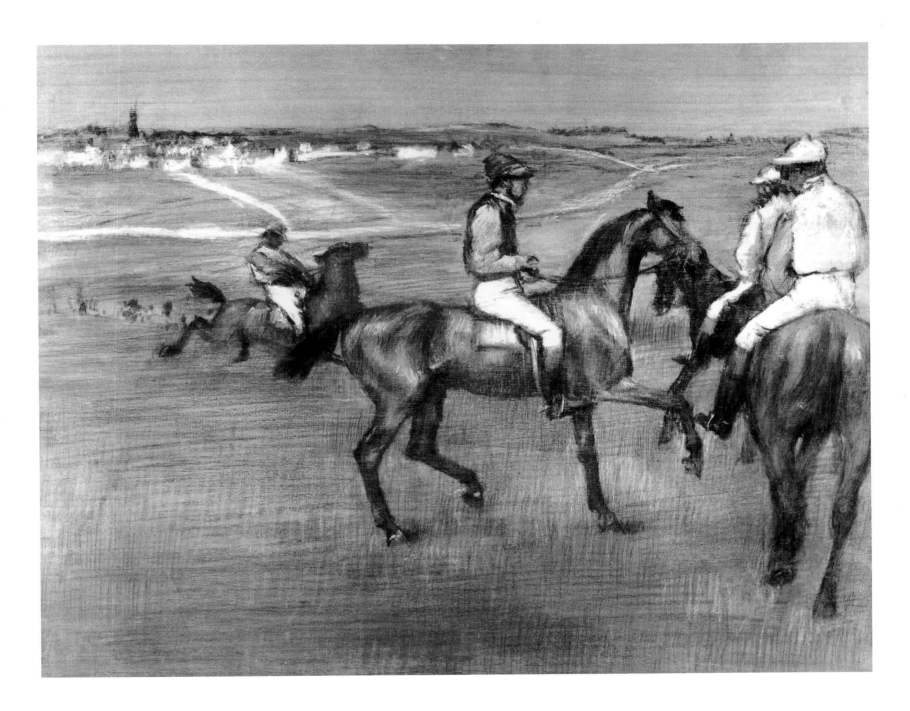

Race Horses
Pastel on wood, 11⁷/₈ × 16 in.
(30.2 × 40.6 cm)
Anticipated Bequest of Walter H. Annenberg

Hilaire-Germain-Edgar Degas

French, 1834–1917

Portrait of a Young Woman

Oil on canvas, 10³/₄ × 8³/₄ in.
(27.3 × 22.2 cm)
Signed (lower right): D
H. O. Havemeyer Collection, Bequest of Mrs.
H. O. Havemeyer, 1929
29.100.183

Woman Drying Her Foot

Pastel on buff wove paper, affixed to original
pulpboard mount, 19³/₄ × 21¹/₄ in.
(50.2 × 54 cm)
Signed (lower left): Degas
H. O. Havemeyer Collection, Bequest of Mrs.
H. O. Havemeyer, 1929
29.100.36

Woman Bathing in a Shallow Tub

Impressionist exhibition of 1886
Charcoal and pastel on light green wove
paper, now discolored to warm gray, laid
down on silk bolting, 32 × 22¹/₈ in.
(81.3 × 56.2 cm)
Signed and dated (upper left): Degas / 85
H. O. Havemeyer Collection, Bequest of Mrs.
H. O. Havemeyer, 1929
29.100.41

Woman Having Her Hair Combed

Pastel on light green wove paper, now
discolored to warm gray, affixed to original
pulpboard mount, 29¹/₈ × 23⁷/₈ in.
(74 × 60.6 cm)
Signed: (lower left) Degas; (lower right) Degas
[obscured by the artist]
H. O. Havemeyer Collection, Bequest of Mrs.
H. O. Havemeyer, 1929
29.100.35

Woman Combing Her Hair

Pastel on light green wove paper, now
discolored to warm gray, affixed to original
pulpboard mount, 24¹/₈ × 18¹/₈ in.
(61.3 × 46 cm)
Signed (lower left): Degas
Gift of Mr. and Mrs. Nate B. Spingold, 1956
56.231

The Dancers

Pastel and charcoal, heightened with white,
on paper, 28 × 23¹/₄ in. (71.1 × 59.1 cm)
Signed and inscribed (lower right): Degas
[g or 9?]
Gift of George N. and Helen M. Richard,
1964
64.165.1

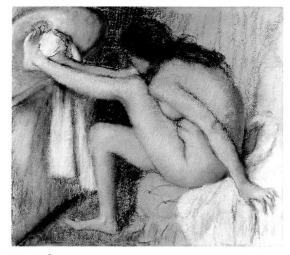

29.100.183

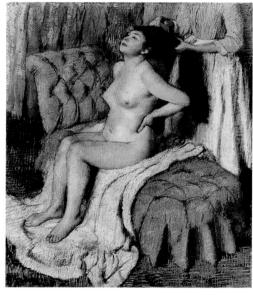

29.100.36

29.100.41

29.100.35

56.231

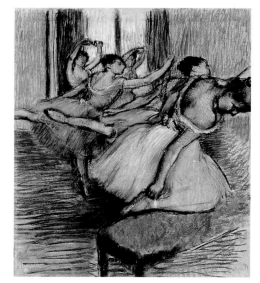

64.165.1

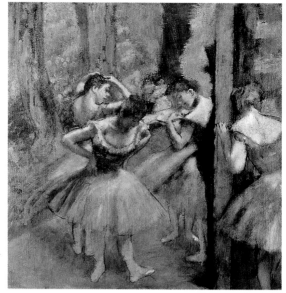

29.100.42

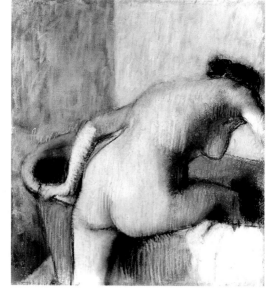

29.100.190

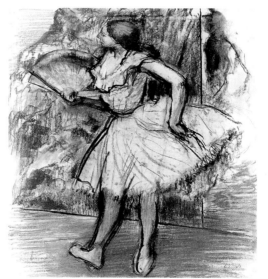

29.100.557

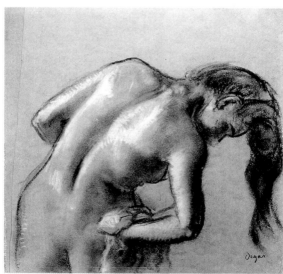

61.101.18

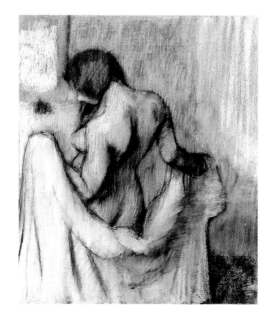

29.100.37

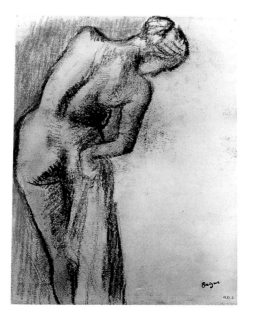

19.51.2

Dancers, Pink and Green
Oil on canvas, 32³/₈ × 29³/₄ in.
(82.2 × 75.6 cm)
Signed (lower right): Degas
H. O. Havemeyer Collection, Bequest of Mrs.
H. O. Havemeyer, 1929
29.100.42

Bather Stepping into a Tub
Pastel and charcoal on blue laid paper,
mounted at perimeter on backing board,
22 × 18³/₄ in. (55.9 × 47.6 cm)
Signed (upper left): Degas
H. O. Havemeyer Collection, Bequest of Mrs.
H. O. Havemeyer, 1929
29.100.190

Dancer with a Fan
This is a study for the pastel Dancer in the
Wings (Saint Louis Art Museum).
Pastel and charcoal on buff-colored wove
tracing paper, 21⁷/₈ × 19¹/₄ in.
(55.6 × 48.9 cm)
Signed (lower right): Degas
H. O. Havemeyer Collection, Bequest of Mrs.
H. O. Havemeyer, 1929
29.100.557

Bather Drying Herself
Pastel on paper, 10³/₈ × 10³/₈ in.
(26.4 × 26.4 cm)
Signed (lower right): Degas
Bequest of Stephen C. Clark, 1960
61.101.18
Drawings and Prints

Woman with a Towel
Pastel on cream-colored wove paper with red
and blue fibers throughout, 37³/₄ × 30 in.
(95.9 × 76.2 cm)
Signed and dated (upper right): Degas 94
H. O. Havemeyer Collection, Bequest of Mrs.
H. O. Havemeyer, 1929
29.100.37

Study of a Nude Female Figure
Charcoal and pastel on white paper,
12⁵/₈ × 9³/₄ in. (32.1 × 24.8 cm)
Stamped (lower right): Degas
Rogers Fund, 1918
19.51.2
Drawings and Prints

Hilaire-Germain-Edgar Degas

French, 1834–1917

Landscape

Oil on canvas, 20 × 24 in. (50.8 × 61 cm)
Robert Lehman Collection, 1975
1975.1.167
ROBERT LEHMAN COLLECTION

Two Dancers, Half-length

Pastel on paper, 18³/₈ × 21⁵/₈ in.
(46.7 × 54.9 cm)
Signed (lower left): Degas
The Lesley and Emma Sheafer Collection,
Bequest of Emma A. Sheafer, 1973
1974.356.31

Russian Dancer

This is a study for a pastel of 1899 (private
collection).
Pastel over charcoal on tracing paper,
24³/₈ × 18 in. (61.9 × 45.7 cm)
Signed (lower left): Degas
H. O. Havemeyer Collection, Bequest of Mrs.
H. O. Havemeyer, 1929
29.100.556

Dancing Peasant Girls

Pastel on paper, 24³/₄ × 25¹/₂ in.
(62.9 × 64.8 cm)
Robert Lehman Collection, 1975
1975.1.166
ROBERT LEHMAN COLLECTION

Three Jockeys

Pastel on tracing paper, laid down on board,
19¹/₄ × 24¹/₂ in. (48.9 × 62.2 cm)
Stamped (lower left): Degas
Partial and Promised Gift of Mr. and Mrs.
Douglas Dillon, 1992
1992.103.1

The Bath

Charcoal and pastel on paper,
12⁵/₈ × 10¹/₈ in. (32.1 × 25.7 cm)
Signed (upper left): Degas
H. O. Havemeyer Collection, Bequest of Mrs.
H. O. Havemeyer, 1929
29.100.186
DRAWINGS AND PRINTS

1975.1.167

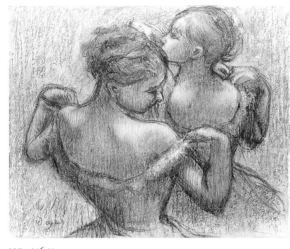

1974.356.31

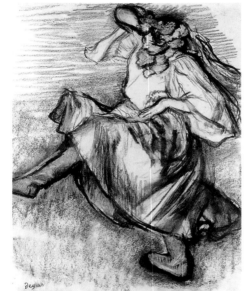

29.100.556

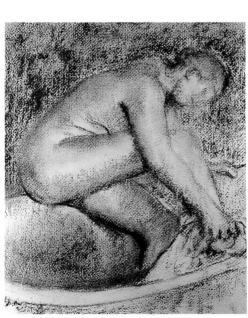

1975.1.166

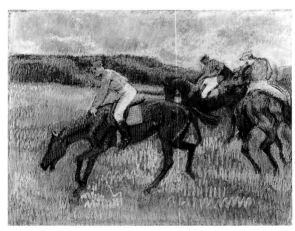

1992.103.1

29.100.186

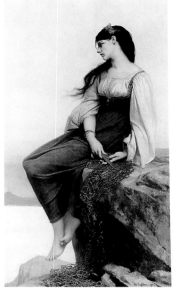

87.15.III

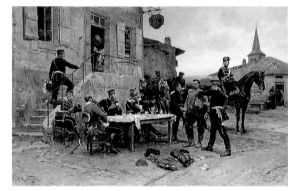

25.110.26

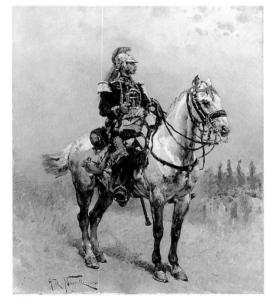

15.30.20

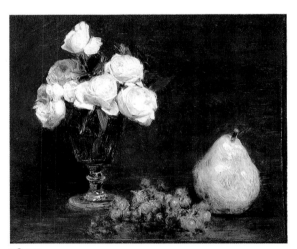

1987.119

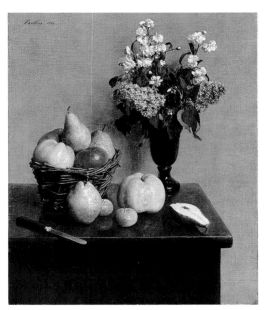

1980.3

Jules-Joseph Lefebvre

French, 1836–1912

Graziella

Oil on canvas, 78³/₄ × 44¹/₄ in.
(200 × 112.4 cm)
Signed and dated (lower right): Jules
LeFebvre. 1878.
Catharine Lorillard Wolfe Collection, Bequest
of Catharine Lorillard Wolfe, 1887
87.15.III

Alphonse-Marie-Adolphe de Neuville

French, 1835–1885

The Spy

Oil on canvas, 51¹/₄ × 84 in.
(130.2 × 213.4 cm)
Signed and dated (lower left): A de Neuville /
1880
Bequest of Collis P. Huntington, 1900
25.110.26

A Cavalryman

Oil on canvas, 18¹/₈ × 15 in. (46 × 38.1 cm)
Signed and dated (lower left): A de Neuville
1884
Bequest of Maria DeWitt Jesup, from the
collection of her husband, Morris K. Jesup,
1914
15.30.20

Ignace-Henri-Jean-Théodore Fantin-Latour

French, 1836–1904

Still Life with Roses and Fruit

Oil on canvas, 13⁵/₈ × 16³/₈ in.
(34.6 × 41.6 cm)
Signed and dated (upper right): Fantin. 1863.
Bequest of Alice A. Hay, 1987
1987.119

Still Life with Flowers and Fruit

Oil on canvas, 28³/₄ × 23⁵/₈ in.
(73 × 60 cm)
Signed and dated (upper left): Fantin. 1866.
Purchase, Mr. and Mrs. Richard J. Bernhard
Gift, by exchange, 1980
1980.3

Asters and Fruit on a Table

Oil on canvas, 22³/₈ × 21⁵/₈ in.
(56.8 × 54.9 cm)
Signed and dated (upper right): Fantin 68
Anticipated Bequest of Walter H. Annenberg

Ignace-Henri-Jean-Théodore Fantin-Latour

French, 1836–1904

Still Life with Pansies

Oil on canvas, 18½ × 22¼ in.
(47 × 56.5 cm)
Signed and dated (upper right): Fantin. 74
The Mr. and Mrs. Henry Ittleson Jr. Purchase
Fund, 1966
66.194

Roses in a Bowl

Oil on canvas, 11¾ × 16⅜ in.
(29.8 × 41.6 cm)
Signed and dated (lower left): Fantin 83
Anticipated Bequest of Walter H. Annenberg

66.194

Portrait of a Woman

Oil on canvas, 39½ × 32 in.
(100.3 × 81.3 cm)
Signed and dated (upper left): Fantin. 85
Catharine Lorillard Wolfe Collection, Wolfe
Fund, 1910
10.41

Roses and Lilies

Oil on canvas, 23½ × 18 in.
(59.7 × 45.7 cm)
Signed and dated (upper right): Fantin. 88
Anticipated Bequest of Walter H. Annenberg

The Palace of Aurora

Oil on canvas, 18⅛ × 15 in. (46 × 38.1 cm)
Signed (lower left): Fantin
Bequest of Anne D. Thomson, 1923
23.280.9

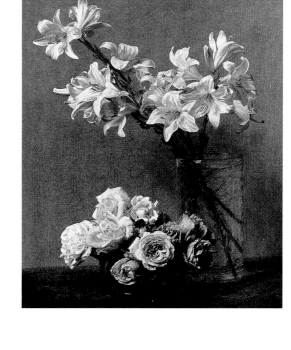

Jules Chéret

French, 1836–1933

Fantasia

Pastel on canvas, 25⅝ × 18¼ in.
(65.1 × 46.4 cm)
Bequest of Miss Adelaide Milton de Groot
(1876–1967), 1967
67.187.2

Pierre-Auguste Cot

French, 1837–1883

The Storm

Salon of 1880
Oil on canvas, 92¼ × 61¾ in.
(234.3 × 156.8 cm)
Signed and dated (lower left): P+A+COT+1880
Catharine Lorillard Wolfe Collection, Bequest
of Catharine Lorillard Wolfe, 1887
87.15.134

10.41

23.280.9

67.187.2

87.15.134

49.4

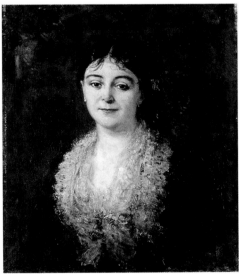

1981.366

87.24

67.187.103

1992.103.4

Charles-Émile-Auguste Carolus-Duran

French, 1838–1917

Mrs. William Astor (Caroline Webster
Schermerhorn, 1831–1908)
Oil on canvas, 83¹/₂ × 42¹/₄ in.
(212.1 × 107.3 cm)
Signed, dated, and inscribed (upper right):
Carolus-Duran. / Paris, 1890.
Gift of R. Thornton Wilson and Orme
Wilson, 1949
49.4

Portrait of a Woman
Oil on canvas, 28³/₄ × 23³/₄ in.
(73 × 60.3 cm)
Gift of Mr. and Mrs. Oscar Kolin, 1981
1981.366

Léon-Germain Pelouse

French, 1838–1891

January: Cernay, near Rambouillet
Oil on canvas, 35³/₈ × 46¹/₄ in.
(89.9 × 117.5 cm)
Signed (lower right): G. Pelouse.
Gift of Mabel Schaus, 1887
87.24

Alfred Sisley

British, 1839–1899

View of Marly-le-Roi from Coeur-Volant
Oil on canvas, 25³/₄ × 36³/₈ in.
(65.4 × 92.4 cm)
Signed and dated (lower right): Sisley.76
Bequest of Miss Adelaide Milton de Groot
(1876–1967), 1967
67.187.103

The Seine at Bougival
Oil on canvas, 18¹/₄ × 24¹/₈ in.
(46.4 × 61.3 cm)
Signed and dated (lower right): Sisley. 76
Partial and Promised Gift of Mr. and Mrs.
Douglas Dillon, 1992
1992.103.4

The Bridge at Villeneuve-la-Garenne
Oil on canvas, 19¹/₂ × 25³/₄ in.
(49.5 × 65.4 cm)
Signed and dated (lower left): Sisley. 1872
Gift of Mr. and Mrs. Henry Ittleson Jr., 1964
64.287

Alley of Chestnut Trees
Oil on canvas, 19³/₄ × 24 in.
(50.2 × 61 cm)
Signed and dated (lower right): Sisley.78
Robert Lehman Collection, 1975
1975.1.211
ROBERT LEHMAN COLLECTION

64.287

1975.1.211

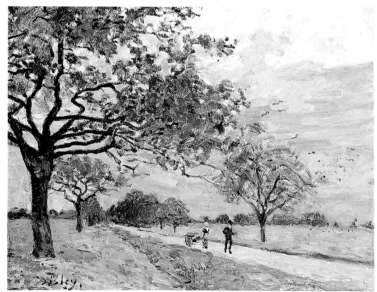

64.154.2

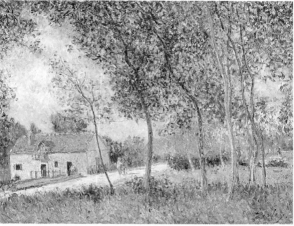

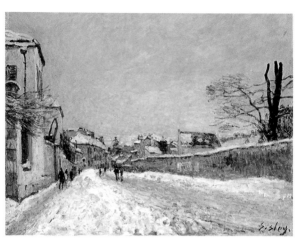

1976.201.18

1992.366

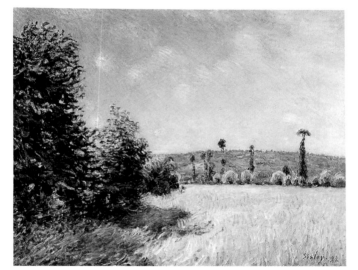

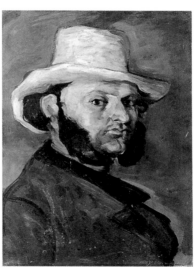

1991.277.3

29.100.65

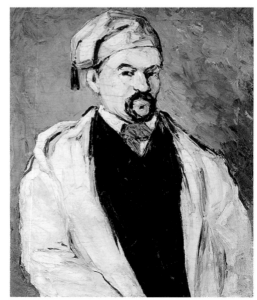

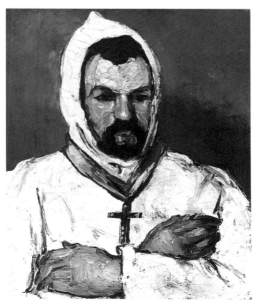

53.140.1

1993.400.1

Alfred Sisley

British, 1839–1899

The Road from Versailles to Louveciennes
Oil on canvas, 18 × 22 in. (45.7 × 55.9 cm)
Signed (lower left): · Sisley.
Gift of Mr. and Mrs. Richard Rodgers, 1964
64.154.2

The Road from Moret to Saint-Mammès
Oil on canvas, 19⁷/₈ × 24¹/₄ in.
(50.5 × 61.5 cm)
Signed (lower right): Sisley.
Bequest of Joan Whitney Payson, 1975
1976.201.18

Rue Eugène Moussoir at Moret: Winter
Oil on canvas, 18³/₈ × 22¹/₄ in.
(46.7 × 56.5 cm)
Signed (lower right): Sisley.
Bequest of Ralph Friedman, 1992
1992.366

Sahurs Meadows in Morning Sun
Oil on canvas, 28³/₄ × 36¹/₄ in.
(73 × 92.1 cm)
Signed and dated (lower right): Sisley 94
Partial and Promised Gift of Janice H. Levin,
1991
1991.277.3

Paul Cézanne

French, 1839–1906

Gustave Boyer in a Straw Hat
Oil on canvas, 21⁵/₈ × 15¹/₄ in.
(54.9 × 38.7 cm)
Signed (lower right): P. Cezanne
H. O. Havemeyer Collection, Bequest of Mrs.
H. O. Havemeyer, 1929
29.100.65

Dominique Aubert, the Artist's Uncle
Oil on canvas, 31³/₈ × 25¹/₄ in.
(79.7 × 64.1 cm)
Wolfe Fund, 1951; acquired from The
Museum of Modern Art, Lillie P. Bliss
Collection
53.140.1

***Dominique Aubert, the Artist's Uncle, as a
Monk***
Oil on canvas, 23⁷/₈ × 21¹/₂ in.
(60.6 × 54.6 cm)
The Walter H. and Leonore Annenberg
Collection, Partial Gift of Walter H. and
Leonore Annenberg, 1993
1993.400.1

Paul Cézanne
French, 1839–1906

Bathers
Oil on canvas, 15 × 18¹/₈ in. (38.1 × 46 cm)
Bequest of Joan Whitney Payson, 1975
1976.201.12

Dish of Apples
Oil on canvas, 18¹/₈ × 21³/₄ in.
(46 × 55.2 cm)
Signed (lower right): P Cezanne
Anticipated Bequest of Walter H. Annenberg

Still Life with Jar, Cup, and Apples
Oil on canvas, 23⁷/₈ × 29 in.
(60.6 × 73.7 cm)
H. O. Havemeyer Collection, Bequest of Mrs.
H. O. Havemeyer, 1929
29.100.66

Mont Sainte-Victoire and the Viaduct of the Arc River Valley
Oil on canvas, 25³/₄ × 32¹/₈ in.
(65.4 × 81.6 cm)
H. O. Havemeyer Collection, Bequest of Mrs.
H. O. Havemeyer, 1929
29.100.64

Apples
Oil on canvas, 9 × 13 in. (22.9 × 33 cm)
The Mr. and Mrs. Henry Ittleson Jr. Purchase
Fund, 1961
61.103

The Gulf of Marseilles Seen from L'Estaque
Oil on canvas, 28³/₄ × 39¹/₂ in.
(73 × 100.3 cm)
H. O. Havemeyer Collection, Bequest of Mrs.
H. O. Havemeyer, 1929
29.100.67

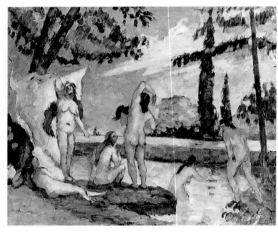

1976.201.12

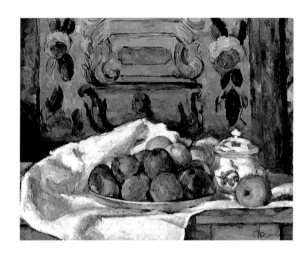

29.100.66

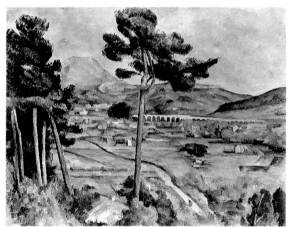

29.100.64

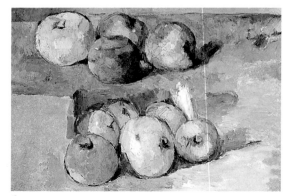

61.103

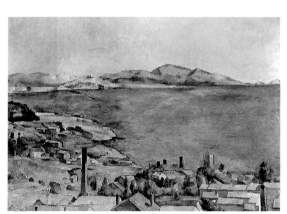

29.100.67

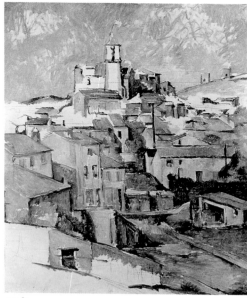

57.181

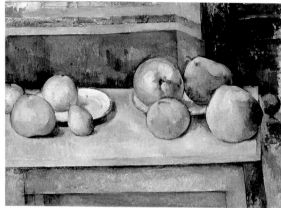

61.101.3

1975.1.160

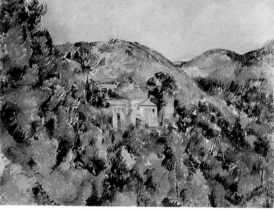

13.66

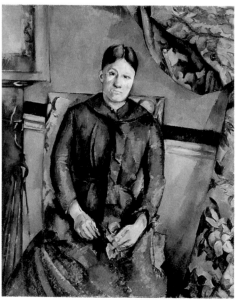

62.45

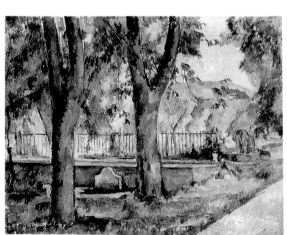

61.101.5

Gardanne
Oil on canvas, 31¹/₂ × 25¹/₄ in.
(80 × 64.1 cm)
Gift of Dr. and Mrs. Franz H. Hirschland,
1957
57.181

Still Life with Apples and Pears
Oil on canvas, 17⁵/₈ × 23¹/₈ in.
(44.8 × 58.7 cm)
Bequest of Stephen C. Clark, 1960
61.101.3

**House behind Trees on the Road to
Tholonet**
Oil on canvas, 26³/₄ × 36¹/₄ in.
(67.9 × 92.1 cm)
Robert Lehman Collection, 1975
1975.1.160
ROBERT LEHMAN COLLECTION

View of the Domaine Saint-Joseph
Oil on canvas, 25⁵/₈ × 32 in.
(65.1 × 81.3 cm)
Signed (lower right): P. Cézanne
Catharine Lorillard Wolfe Collection, Wolfe
Fund, 1913
13.66

Madame Cézanne (Hortense Fiquet, 1850–
1922) **in a Red Dress**
Oil on canvas, 45⁷/₈ × 35¹/₄ in.
(116.5 × 89.5 cm)
The Mr. and Mrs. Henry Ittleson Jr. Purchase
Fund, 1962
62.45

The Pool at the Jas de Bouffan
Oil on canvas, 25¹/₂ × 31⁷/₈ in.
(64.8 × 81 cm)
Bequest of Stephen C. Clark, 1960
61.101.5

Paul Cézanne

French, 1839–1906

Madame Cézanne (Hortense Fiquet, 1850–1922) *in the Conservatory*
Oil on canvas, 36¼ × 28¾ in.
(92.1 × 73 cm)
Bequest of Stephen C. Clark, 1960
61.101.2

The Card Players
Oil on canvas, 25¾ × 32¼ in.
(65.4 × 81.9 cm)
Bequest of Stephen C. Clark, 1960
61.101.1

The House with the Cracked Walls
Oil on canvas, 31½ × 23¾ in.
(80 × 60.3 cm)
The Walter H. and Leonore Annenberg
Collection, Partial Gift of Walter H. and
Leonore Annenberg, 1993
1993.400.2

Still Life with a Ginger Jar and Eggplants
Oil on canvas, 28½ × 36 in.
(72.4 × 91.4 cm)
Bequest of Stephen C. Clark, 1960
61.101.4

Rocks in the Forest
Oil on canvas, 28⅞ × 36⅜ in.
(73.3 × 92.4 cm)
H. O. Havemeyer Collection, Bequest of Mrs.
H. O. Havemeyer, 1929
29.100.194

Seated Peasant
Oil on canvas, 21½ × 17¾ in.
(54.6 × 45.1 cm)
Anticipated Bequest of Walter H. Annenberg

Still Life with Apples and a Pot of Primroses
Oil on canvas, 28¾ × 36⅜ in.
(73 × 92.4 cm)
Bequest of Sam A. Lewisohn, 1951
51.112.1

Mont Sainte-Victoire
Oil on canvas, 22¼ × 38⅛ in.
(56.5 × 96.8 cm)
The Walter H. and Leonore Annenberg
Collection, Partial Gift of Walter H. and
Leonore Annenberg, 1994
1994.420

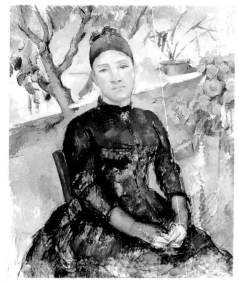

61.101.2

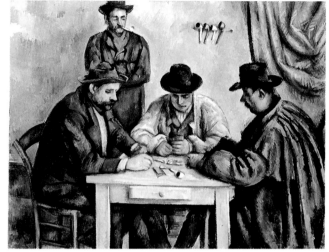

61.101.1

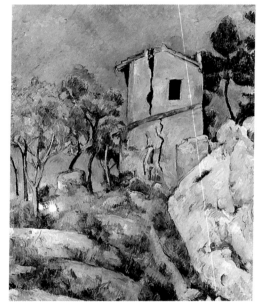

1993.400.2

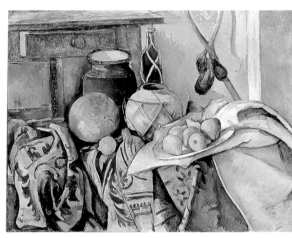

61.101.4

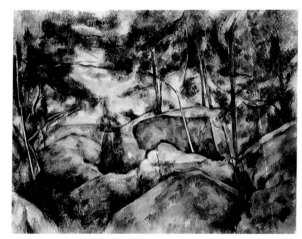

29.100.194

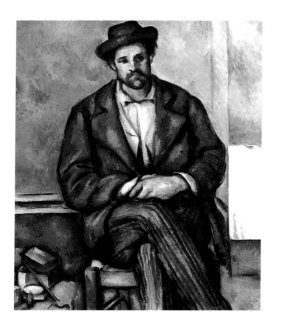

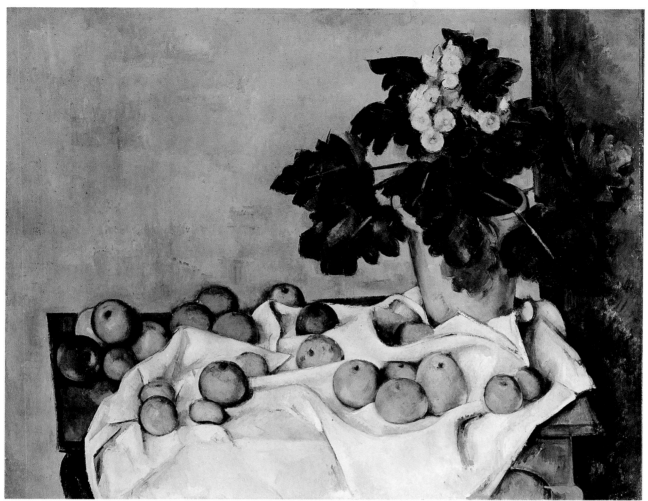

51.112.1

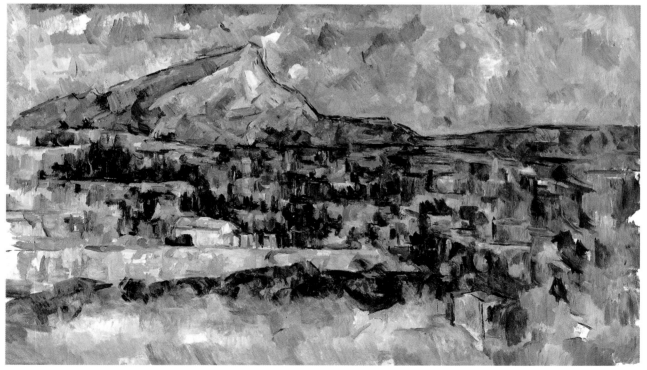

1994.420

Jehan-Georges Vibert

French, 1840–1902

The Reprimand

Oil on canvas, 20³/₈ × 33 in.
(51.8 × 83.8 cm)
Signed and dated (lower left): J.G.Vibert.
1874.
Catharine Lorillard Wolfe Collection, Bequest
of Catharine Lorillard Wolfe, 1887
87.15.101

The Missionary's Adventures

Oil on wood, 39 × 53 in. (99.1 × 134.6 cm)
Signed (lower left): J.G.Vibert.
Bequest of Collis P. Huntington, 1900
25.110.140

87.15.101

25.110.140

Odilon Redon

French, 1840–1916

Madame Arthur Fontaine (Marie Escudier)

Pastel on paper, 28¹/₂ × 22¹/₂ in.
(72.4 × 57.2 cm)
Signed, dated, and inscribed (upper left): fait
à St.-Georges-de-Didonne / Septembre-1901– /
ODILON REDON
The Mr. and Mrs. Henry Ittleson Jr. Purchase
Fund, 1960
60.54

Bouquet of Flowers

Pastel on paper, 31⁵/₈ × 25¹/₄ in.
(80.3 × 64.1 cm)
Signed (lower center): ODILON REDON
Gift of Mrs. George B. Post, 1956
56.50

Flowers in a Chinese Vase

Oil on canvas, 28⁵/₈ × 21¹/₄ in.
(72.7 × 54 cm)
Signed (lower left and at base of vase):
ODILON REDON
Bequest of Mabel Choate, in memory of her
father, Joseph Hodges Choate, 1958
59.16.3

Pandora

Oil on canvas, 56¹/₂ × 24¹/₂ in.
(143.5 × 62.2 cm)
Signed (lower right): ODILON REDON
Bequest of Alexander M. Bing, 1959
60.19.1

60.54

56.50

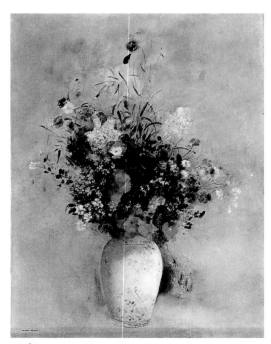

59.16.3

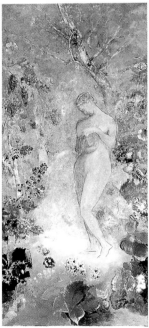

60.19.1

27.29

53.140.5

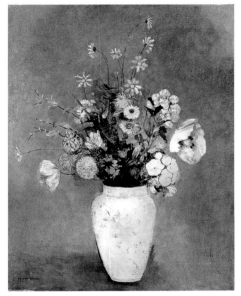

64.266

51.32

1988.221

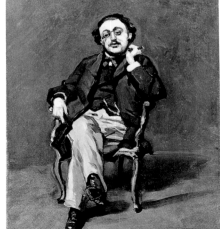

29.100.III

The Chariot of Apollo
Oil on canvas, 26 × 32 in. (66 × 81.3 cm)
Signed (lower left): ODILON REDON
Anonymous Gift, 1927
27.29

Etruscan Vase with Flowers
Tempera on canvas, 32 × 23¹/₄ in.
(81.3 × 59.1 cm)
Maria DeWitt Jesup Fund, 1951; acquired
from The Museum of Modern Art, Lillie
P. Bliss Collection
53.140.5

Bouquet in a Chinese Vase
Oil on canvas, 25¹/₂ × 19⁵/₈ in.
(64.8 × 49.8 cm)
Signed (lower left): ODILON REDON
The Mr. and Mrs. Henry Ittleson Jr. Purchase
Fund, 1964
64.266

Jean-Frédéric Bazille
French, 1841–1870
Porte de la Reine at Aigues-Mortes
Oil on canvas, 31³/₄ × 39¹/₄ in.
(80.6 × 99.7 cm)
Signed and dated (lower right): F. Bazille 1867
Purchase, Gift of Raymonde Paul, in memory
of her brother, C. Michael Paul, by exchange,
1988
1988.221

Claude Monet
French, 1840–1926
Dr. Leclenché
Oil on canvas, 18 × 12³/₄ in.
(45.7 × 32.4 cm)
Signed and dated (lower right): Claude Monet
/ 64
Gift of Mr. and Mrs. Edwin C. Vogel, 1951
51.32

The Green Wave
Oil on canvas, 19¹/₈ × 25¹/₂ in.
(48.6 × 64.8 cm)
Signed and dated (lower right): Cl. Monet 65
H. O. Havemeyer Collection, Bequest of Mrs.
H. O. Havemeyer, 1929
29.100.III

The Bodmer Oak, Fontainebleau Forest
Oil on canvas, 37⁷/₈ × 50⁷/₈ in.
(96.2 × 129.2 cm)
Signed (lower right): Claude Monet.
Gift of Sam Salz and Bequest of Julia W.
Emmons, by exchange, 1964
64.210

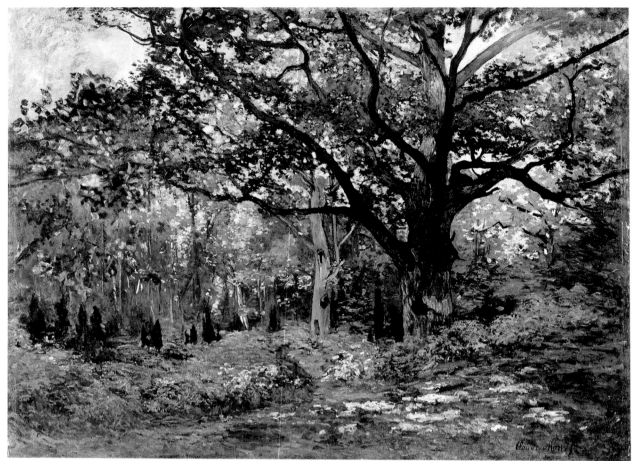

64.210

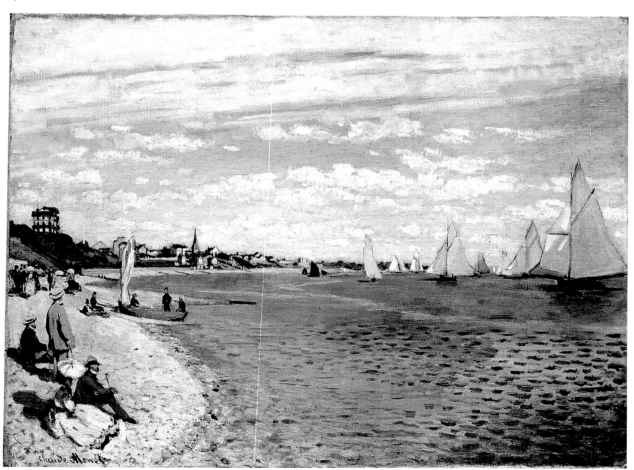

51.30.4

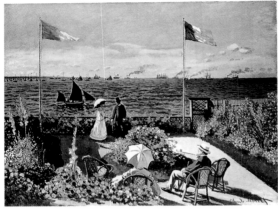

67.241

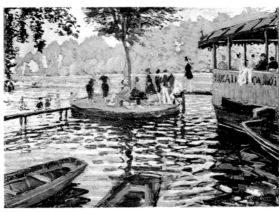

29.100.112

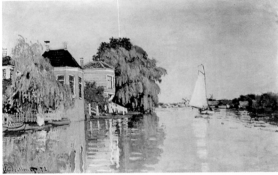

1975.1.196

26.186.1

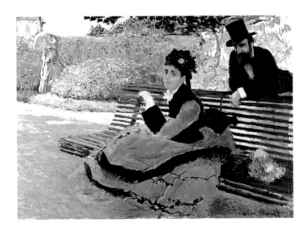

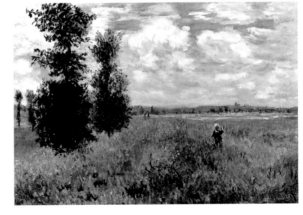

Claude Monet

French, 1840–1926

Regatta at Sainte-Adresse

Oil on canvas, 29⁵/₈ × 40 in.
(75.2 × 101.6 cm)
Signed (lower left): Claude Monet
Bequest of William Church Osborn, 1951
51.30.4

Garden at Sainte-Adresse

Impressionist exhibition of 1879
Oil on canvas, 38⁵/₈ × 51¹/₈ in.
(98.1 × 129.9 cm)
Signed (lower right): Claude Monet
Purchase, special contributions and funds
given or bequeathed by friends of the
Museum, 1967
67.241

La Grenouillère

Oil on canvas, 29³/₈ × 39¹/₄ in.
(74.6 × 99.7 cm)
Signed and inscribed: (lower right) Claude
Monet; (right) LOCATI[ON] CANOT[s] (boat
rental)
H. O. Havemeyer Collection, Bequest of Mrs.
H. O. Havemeyer, 1929
29.100.112

Landscape at Zaandam

Oil on canvas, 18 × 26³/₈ in.
(45.7 × 67 cm)
Signed and dated (lower left): Claude
Monet.72
Robert Lehman Collection, 1975
1975.1.196
ROBERT LEHMAN COLLECTION

Spring (Fruit Trees in Bloom)

Oil on canvas, 24¹/₂ × 39⁵/₈ in.
(62.2 × 100.6 cm)
Signed and dated (lower left): 73 Claude
Monet·
Bequest of Mary Livingston Willard, 1926
26.186.1

Camille Monet (1847–1879) ***on a Garden
Bench***

Oil on canvas, 23⁷/₈ × 31⁵/₈ in.
(60.6 × 80.3 cm)
Signed (lower right): Claude Monet
Anticipated Bequest of Walter H. Annenberg

Poppy Field, Argenteuil

Oil on canvas, 21¹/₄ × 29 in.
(54 × 73.7 cm)
Signed (lower right): Claude Monet
Anticipated Bequest of Walter H. Annenberg

Pierre-Auguste Renoir
French, 1841–1919

Madame Darras (Henriette Oudiette)
The pendant, a portrait of her husband, is in
the Gemäldegalerie Neue Meister, Dresden.
Oil on canvas, 30³/₄ × 24¹/₂ in.
(78.1 × 62.2 cm)
Signed and dated (lower right): A. Renoir .71.
Gift of Margaret Seligman Lewisohn, in
memory of her husband, Sam A. Lewisohn,
and of her sister-in-law, Adele Lewisohn
Lehman, 1951
51.200

A Road in Louveciennes
Oil on canvas, 15 × 18¹/₄ in.
(38.1 × 46.4 cm)
Signed (lower right): Renoir
The Lesley and Emma Sheafer Collection,
Bequest of Emma A. Sheafer, 1973
1974.356.32

A Waitress at Duval's Restaurant
Oil on canvas, 39¹/₂ × 28¹/₈ in.
(100.3 × 71.4 cm)
Signed (lower left): Renoir.
Bequest of Stephen C. Clark, 1960
61.101.14

Nini in the Garden (Nini Lopez)
Oil on canvas, 24³/₈ × 20 in.
(61.9 × 50.8 cm)
Signed (lower right): A Renoir
Anticipated Bequest of Walter H. Annenberg

Young Girl in a Pink-and-Black Hat
Oil on canvas, 16 × 12³/₄ in.
(40.6 × 32.4 cm)
Signed (lower left): Renoir
Gift of Kathryn B. Miller, 1964
64.150

The Milliner
Pastel on paper, 21 × 16¹/₄ in.
(53.3 × 41.3 cm)
Signed (lower right): Renoir
The Lesley and Emma Sheafer Collection,
Bequest of Emma A. Sheafer, 1973
1974.356.34

Madame Georges Charpentier (Marguerite
Lemonnier, died 1904) *and Her Children,
Georgette* (born 1872) *and Paul* (1875–1895)
Salon of 1879
Oil on canvas, 60¹/₂ × 74⁷/₈ in.
(153.7 × 190.2 cm)
Signed and dated (lower right): Renoir. 78.
Catharine Lorillard Wolfe Collection, Wolfe
Fund, 1907
07.122

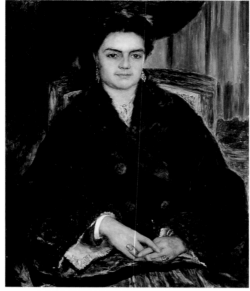

51.200

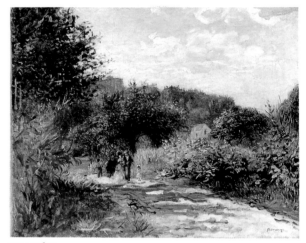

1974.356.32

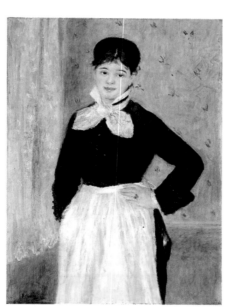

61.101.14

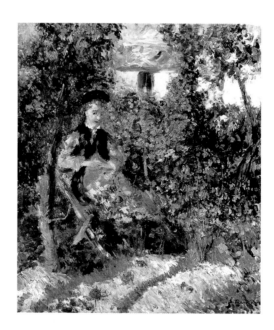

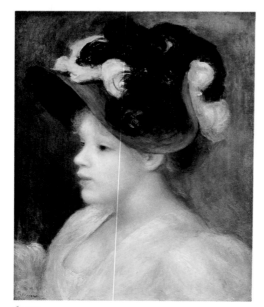

64.150

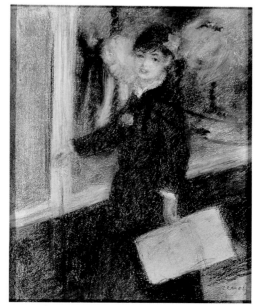

1974.356.34

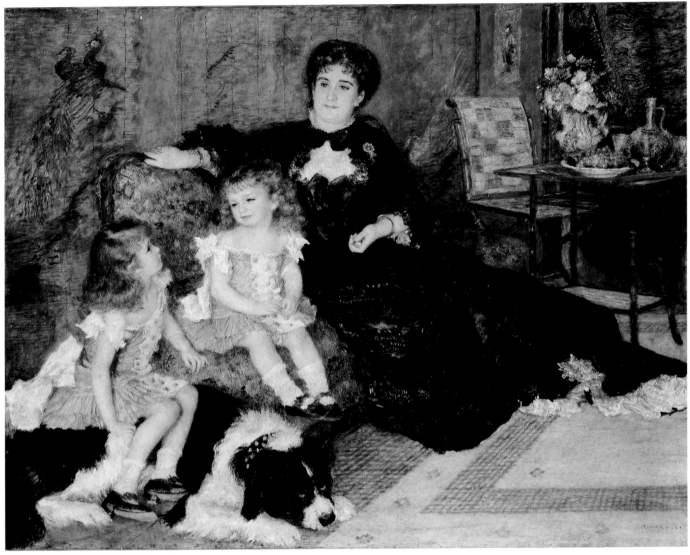

07.122

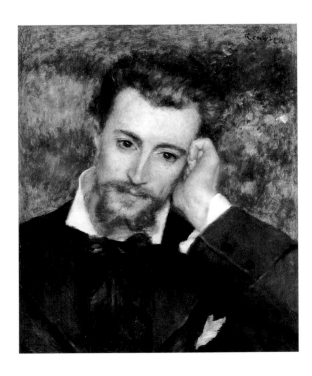

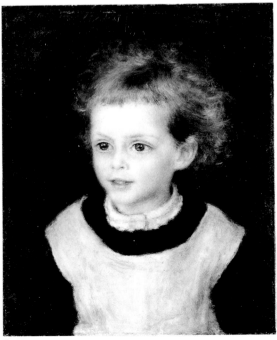

61.101.15

Pierre-Auguste Renoir
French, 1841–1919

Hyacinthe-Eugène Meunier (1841–1906),
Called Eugène Murer
Oil on canvas, 18¹/₂ × 15¹/₂ in.
(47 × 39.4 cm)
Signed (upper right): Renoir.
Anticipated Bequest of Walter H. Annenberg

Marguerite (Margot) Berard (1874–1956)
Oil on canvas, 16¹/₈ × 12³/₄ in.
(41 × 32.4 cm)
Signed and dated (upper left): Renoir 79.
Bequest of Stephen C. Clark, 1960
61.101.15

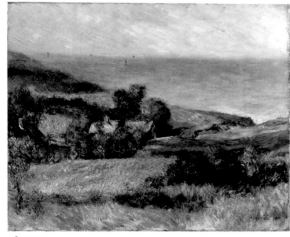 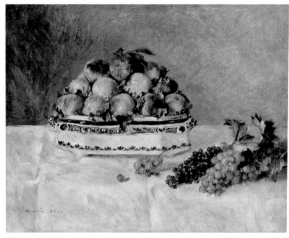

56.135.7 56.218

View of the Seacoast near Wargemont in
Normandy
Oil on canvas, 19⁷/₈ × 24¹/₂ in.
(50.5 × 62.2 cm)
Signed and dated (lower right): Renoir .80.
Bequest of Julia W. Emmons, 1956
56.135.7

Still Life with Peaches and Grapes
Oil on canvas, 21¹/₄ × 25⁵/₈ in.
(54 × 65.1 cm)
Signed and dated (lower left): Renoir. 81.
The Mr. and Mrs. Henry Ittleson Jr. Purchase
Fund, 1956
56.218

Still Life with Peaches
Oil on canvas, 21 × 25¹/₂ in.
(53.3 × 64.8 cm)
Signed and dated (lower right): Renoir. 81.
Bequest of Stephen C. Clark, 1960
61.101.12

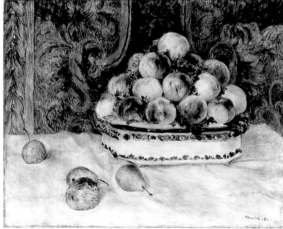 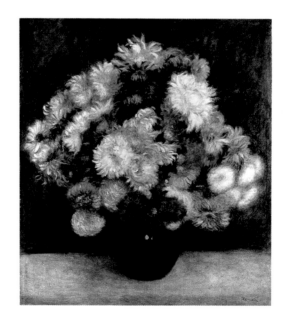

61.101.12

Bouquet of Chrysanthemums
Oil on canvas, 26 × 21⁷/₈ in.
(66 × 55.6 cm)
Signed (lower right): Renoir.
Anticipated Bequest of Walter H. Annenberg

The Bay of Naples
Oil on canvas, 23¹/₂ × 32 in.
(59.7 × 81.3 cm)
Signed and dated (lower right): Renoir. 81.
Bequest of Julia W. Emmons, 1956
56.135.8

Hills around the Bay of Moulin Huet,
Guernsey
Oil on canvas, 18¹/₈ × 25³/₄ in.
(46 × 65.4 cm)
Signed and dated (lower right): Renoir. 83.
Bequest of Julia W. Emmons, 1956
56.135.9

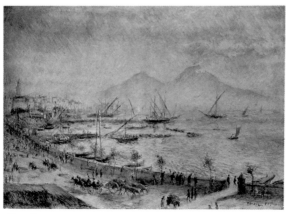 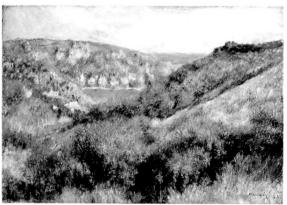

56.135.8 56.135.9

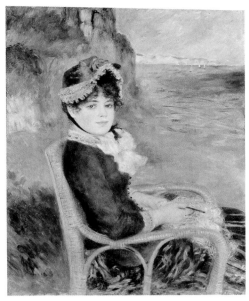

29.100.125

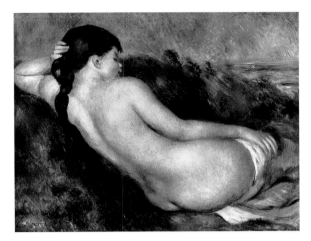

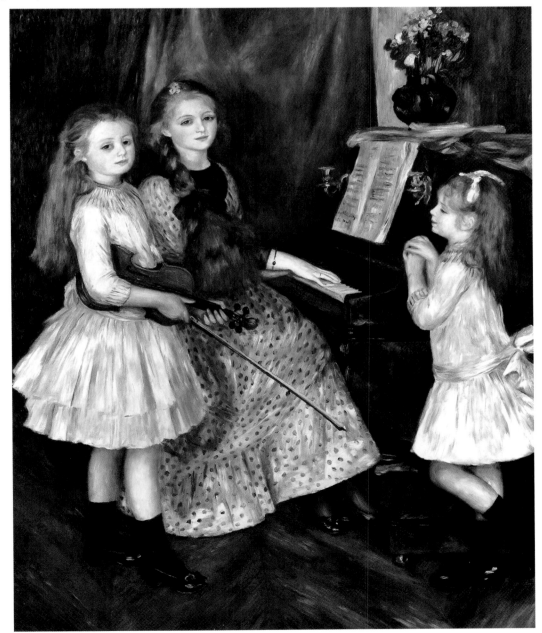

By the Seashore
Oil on canvas, 36¼ × 28½ in.
(92.1 × 72.4 cm)
Signed and dated (lower left): Renoir. 83.
H. O. Havemeyer Collection, Bequest of Mrs.
H. O. Havemeyer, 1929
29.100.125

Reclining Nude
Oil on canvas, 25⅝ × 32 in.
(65.1 × 81.3 cm)
Signed (lower left): Renoir
Anticipated Bequest of Walter H. Annenberg

The Daughters of Catulle Mendès
(Claudine; Huguette, 1871–1964; and
Helyonne)
Salon of 1890
Oil on canvas, 63¾ × 51⅛ in.
(161.9 × 129.9 cm)
Signed and dated (upper right): Renoir 88.
Anticipated Bequest of Walter H. Annenberg

Pierre-Auguste Renoir
1841–1919

Sea and Cliffs
Oil on canvas, 20¼ × 25 in. (51.4 × 63.5 cm)
Signed (lower right): Renoir.
Robert Lehman Collection, 1975
1975.1.200
ROBERT LEHMAN COLLECTION

A Young Girl with Daisies
Oil on canvas, 25⅝ × 21¼ in. (65.1 × 54 cm)
Signed (lower right): Renoir.
The Mr. and Mrs. Henry Ittleson Jr. Purchase
Fund, 1959
59.21

In the Meadow
Oil on canvas, 32 × 25¾ in. (81.3 × 65.4 cm)
Signed (lower left): Renoir.
Bequest of Sam A. Lewisohn, 1951
51.112.4

Young Girl Bathing
Oil on canvas, 32 × 25½ in. (81.3 × 64.8 cm)
Signed and dated (lower left): Renoir.92.
Robert Lehman Collection, 1975
1975.1.199
ROBERT LEHMAN COLLECTION

Two Young Girls at the Piano
Oil on canvas, 44 × 34 in.
(111.8 × 86.4 cm)
Signed and dated (lower left): Renoir.92
Robert Lehman Collection, 1975
1975.1.201
ROBERT LEHMAN COLLECTION

Figures on the Beach
Oil on canvas, 20¾ × 25¼ in.
(52.7 × 64.1 cm)
Signed (lower right): Renoir.
Robert Lehman Collection, 1975
1975.1.198
ROBERT LEHMAN COLLECTION

Versailles
Oil on canvas, 20½ × 24⅞ in.
(52.1 × 63.2 cm)
Signed (lower right): Renoir.
Robert Lehman Collection, 1975
1975.1.202
ROBERT LEHMAN COLLECTION

The Farm at Les Collettes, Cagnes
Oil on canvas, 21½ × 25¾ in.
(54.6 × 65.4 cm)
Signed (lower right): Renoir.
Bequest of Charlotte Gina Abrams, in
memory of her husband, Lucien Abrams, 1961
61.190

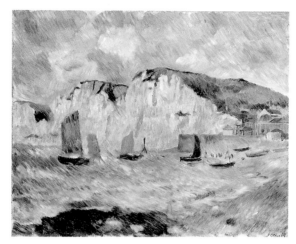

1975.1.200

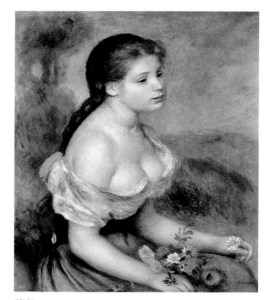

59.21

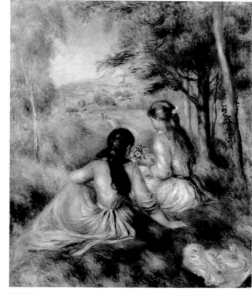

51.112.4

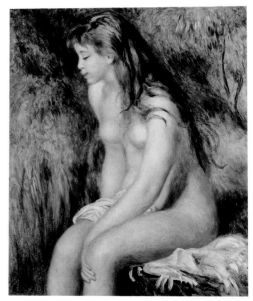

1975.1.199

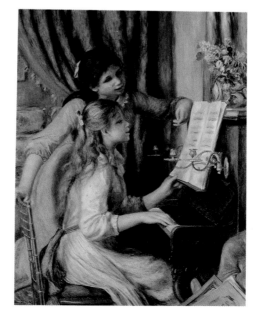

1975.1.201

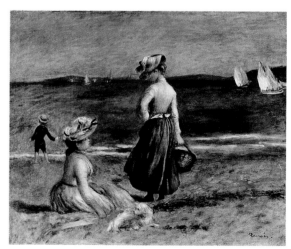

1975.1.198

1975.1.202

61.190

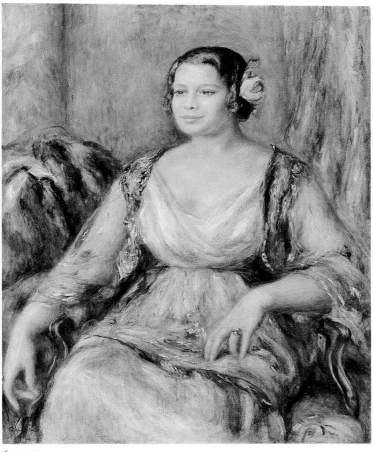

61.101.13

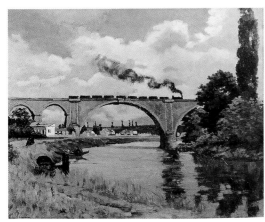

1975.1.180

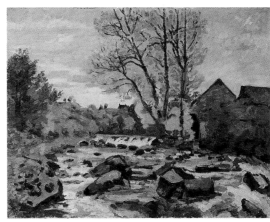

1975.1.181

Tilla Durieux (1880–1971)
Oil on canvas, 36¼ × 29 in.
(92.1 × 73.7 cm)
Signed and dated (lower left): Renoir / 1914
Bequest of Stephen C. Clark, 1960
61.101.13

Jean-Baptiste-Armand Guillaumin

French, 1841–1927

Bridge over the Marne at Joinville

Oil on canvas, 23⅛ × 28⅜ in.
(58.7 × 72.1 cm)
Signed and dated (lower left): AGuillaumin
[initials in monogram] / 1871
Robert Lehman Collection, 1975
1975.1.180
ROBERT LEHMAN COLLECTION

The Lock at Genetin

Oil on canvas, 25⅝ × 31⅞ in.
(65.1 × 81 cm)
Signed (lower left): Guillaumin
Robert Lehman Collection, 1975
1975.1.181
ROBERT LEHMAN COLLECTION

Berthe Morisot

French, 1841–1895

Young Woman Seated on a Sofa

Oil on canvas, 31¾ × 39¼ in.
(80.6 × 99.7 cm)
Signed (lower left): Berthe Morisot
Partial and Promised Gift of Mr. and Mrs.
Douglas Dillon, 1992
1992.103.2

The Pink Dress

The sitter was Marguerite Carré (1854–1935).
Oil on canvas, 21½ × 26½ in.
(54.6 × 67.3 cm)
Signed (lower right): Berthe Mor[isot]
Anticipated Bequest of Walter H. Annenberg

Young Woman Knitting

Oil on canvas, 19¾ × 23⅝ in. (50.2 × 60 cm)
Signed (lower left): Berthe Morisot
Bequest of Miss Adelaide Milton de Groot
(1876–1967), 1967
67.187.89

Jean-Charles Cazin

French, 1841–1901

The Route Nationale at Samer

Oil on canvas, 41½ × 48¼ in.
(105.4 × 122.6 cm)
Signed (lower left): J.C.CAZIN
Bequest of Maria DeWitt Jesup, from the
collection of her husband, Morris K. Jesup,
1914
15.30.26

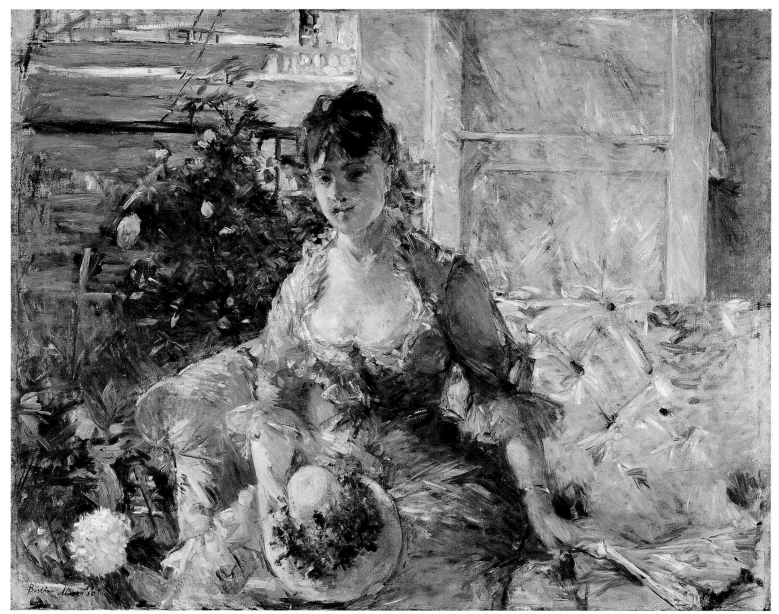

1992.103.2

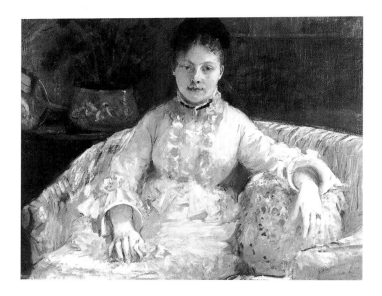

67.187.89

25.110.54

15.30.26

87.15.74

14.25.1878

16.95

87.15.90

Jean-Richard Goubie

French, 1842–1899

The Prize for the Hunt

Salon of 1872
Oil on canvas, 30 × 43¹⁄₂ in.
(76.2 × 110.5 cm)
Signed and dated (lower right): R Goubie
1872
Bequest of Collis P. Huntington, 1900
25.110.54

Pierre-Paul-Léon Glaize

French, 1842–1932

Before the Mirror

Oil on canvas, 39³⁄₄ × 29⁷⁄₈ in.
(101 × 75.9 cm)
Signed and dated (upper right): 1873
P.P.LÉON GLAIZE
Catharine Lorillard Wolfe Collection, Bequest
of Catharine Lorillard Wolfe, 1887
87.15.74

Ferdinand Humbert

French, 1842–1934

William H. Riggs (1837–1924) in Sixteenth-Century Half-Armor

The sitter was vice president of the
Metropolitan Museum, 1870–74.
Oil on canvas, 22 × 15 in.
(55.9 × 38.1 cm)
Signed and dated (lower right): F. Humbert 71
Gift of William H. Riggs, 1913
14.25.1878
ARMS AND ARMOR

Henri-Alexandre-Georges Regnault

French, 1843–1871

Salomé

Salon of 1870
Oil on canvas, 63 × 40¹⁄₂ in.
(160 × 102.9 cm)
Signed, dated, and inscribed (left center):
HRegnault [initials in monogram] / Rome
1870
Gift of George F. Baker, 1916
16.95

Alexandre-Louis Leloir

French, 1843–1884

Choosing the Dinner

Oil on canvas, 12¹⁄₄ × 18³⁄₈ in.
(31.1 × 46.7 cm)
Signed and dated (lower right): Louis Leloir
72.
Catharine Lorillard Wolfe Collection, Bequest
of Catharine Lorillard Wolfe, 1887
87.15.90

Paul Sébillot

French, 1843–1918

Spring in Brittany

Oil on wood, 14 × 10³/₄ in.
(35.6 × 27.3 cm)
Signed and dated (lower right): Sébillot 74
Gift of Paul-Yves Sébillot, 1949
49.114

Jean-Joseph Benjamin-Constant

French, 1845–1902

Judith

Oil on canvas, 47¹/₂ × 31¹/₂ in.
(120.7 × 80 cm)
Signed (upper left): Benj-Constant
Gift of J. E. Gombos, 1959
59.185

Léon-Augustin Lhermitte

French, 1844–1925

The Grape Harvest

Salon of 1884
Oil on canvas, 99 × 82⁵/₈ in.
(251.5 × 209.9 cm)
Signed and dated (lower left): L.Lhermitte /
1884
Gift of William Schaus Jr., 1887
87.22.2

Among the Humble

Salon of 1905
The models were Hortense and Louis Nourry
and their children.
Oil on canvas, arched top, 104³/₄ × 90 in.
(266.1 × 228.6 cm)
Signed and dated (lower left): L.Lhermitte /
1905
Catharine Lorillard Wolfe Collection, Wolfe
Fund, 1905
05.38

**Henri-Julien-Félix Rousseau
(le Douanier)**

French, 1844–1910

The Banks of the Bièvre near Bicêtre

Oil on canvas, 21¹/₂ × 18 in.
(54.6 × 45.7 cm)
Signed (lower right): H. Rousseau
Gift of Marshall Field, 1939
39.15

The Repast of the Lion

Oil on canvas, 44³/₄ × 63 in.
(113.7 × 160 cm)
Signed (lower right): Henri Rousseau
Bequest of Sam A. Lewisohn, 1951
51.112.5

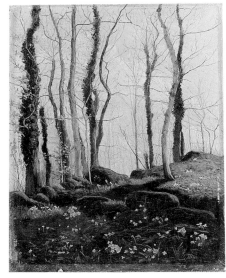

49.114

59.185

87.22.2

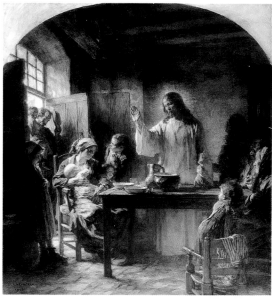

05.38

39.15

51.112.5

89.21.1

08.136.5

87.20.2

48.115

87.8.12

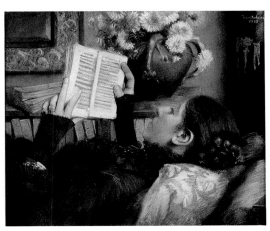

1990.117

Jules Bastien-Lepage
French, 1848–1884

Joan of Arc
Salon of 1880
Oil on canvas, 100 × 110 in.
(254 × 279.4 cm)
Signed, dated, and inscribed (lower right):
J.BASTIEN-LEPAGE / DAMVILLERS Meuse / 1879
Gift of Erwin Davis, 1889
89.21.1

Édouard Détaille
French, 1848–1912

A Dragoon on Horseback
Oil on wood, 9¹/₂ × 5³/₈ in.
(24.1 × 13.7 cm)
Signed and dated (lower left): EDOUARD
DETAILLE / 1876.
Bequest of Martha T. Fiske Collord, in
memory of her first husband, Josiah M. Fiske,
1908
08.136.5

The Defense of Champigny
Salon of 1879
Oil on canvas, 48 × 84³/₄ in.
(121.9 × 215.3 cm)
Signed and dated (lower right): EDOUARD
DETAILLE- / 1879.
Gift of Henry Hilton, 1887
87.20.2

Gendarmes d'Ordonnance
Oil on canvas, 22 × 16⁵/₈ in.
(55.9 × 42.2 cm)
Signed and dated (lower left): Edouard
Detaille. / 1894.
Gift of Estate of George Albert Draper, 1948
48.115

Henry Lerolle
French, 1848–1929

At the Organ
Salon of 1885
Oil on canvas, 88³/₄ × 143 in.
(225.4 × 363.2 cm)
Signed (lower right): h.Lerolle
Gift of George I. Seney, 1887
87.8.12

Albert Bartholomé
French, 1848–1928

The Artist's Wife (Périe, 1849–1887) *Reading*
Pastel and charcoal on wove paper, laid down
on blue wove paper, laid down on stretched
canvas, 19⁷/₈ × 24¹/₈ in. (50.5 × 61.3 cm)
Signed and dated (upper right): ABartholomé
/ 1883
Catharine Lorillard Wolfe Collection, Wolfe
Fund, 1990
1990.117

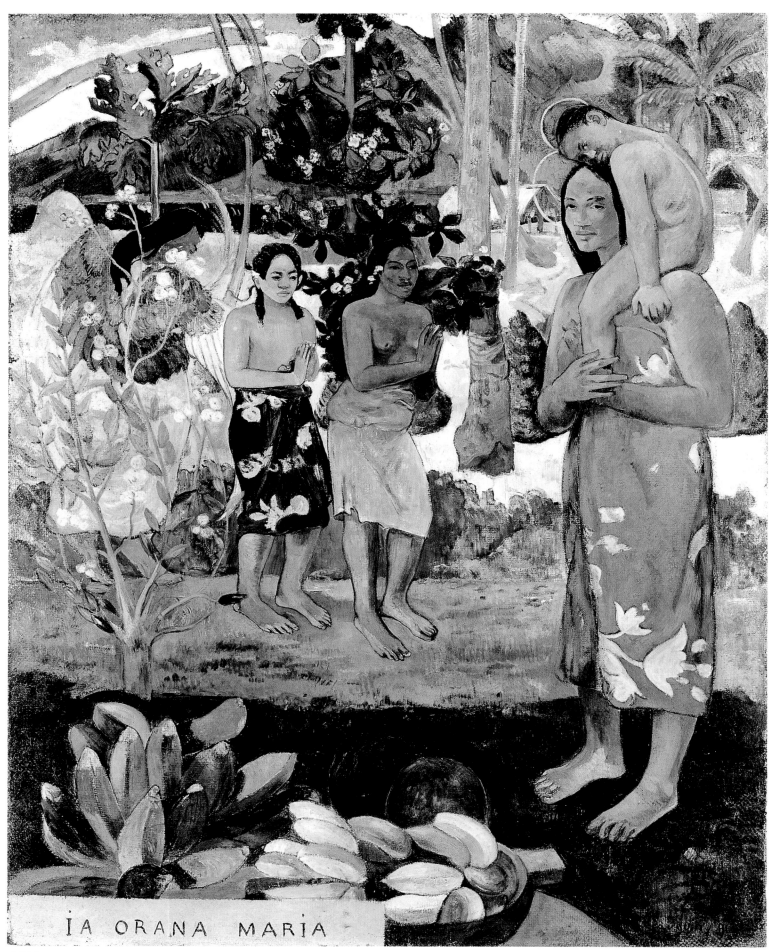

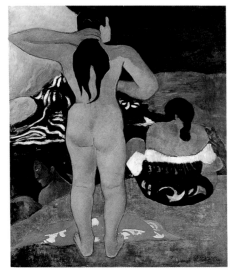

1975.1.179

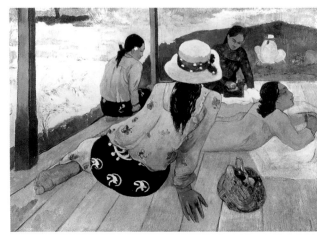

1993.400.3

54.143.2

49.58.1

Paul Gauguin
French, 1848–1903

Ia Orana Maria (Hail Mary)
Oil on canvas, 44³/₄ × 34¹/₂ in.
(113.7 × 87.6 cm)
Signed, dated, and inscribed: (lower right) P
Gauguin 91; (lower left) IA ORANA MARIA
(Hail Mary)
Bequest of Sam A. Lewisohn, 1951
51.112.2

Tahitian Women Bathing
Oil on canvas, 43¹/₄ × 35¹/₄ in.
(109.9 × 89.5 cm)
Signed (lower right): P.Gauguin / .
Robert Lehman Collection, 1975
1975.1.179
ROBERT LEHMAN COLLECTION

The Siesta
Oil on canvas, 34¹/₄ × 45⁵/₈ in.
(87 × 115.9 cm)
The Walter H. and Leonore Annenberg
Collection, Partial Gift of Walter H. and
Leonore Annenberg, 1993
1993.400.3

A Farm in Brittany
Oil on canvas, 28¹/₂ × 35⁵/₈ in.
(72.4 × 90.5 cm)
Signed (lower left): P.Gauguin
Bequest of Margaret Seligman Lewisohn, in
memory of her husband, Sam A. Lewisohn,
1954
54.143.2

Still Life with Teapot and Fruit
Oil on canvas, 18³/₄ × 26 in.
(47.6 × 66 cm)
Signed and dated (lower right): P Gauguin 96
Anticipated Bequest of Walter H. Annenberg

Three Tahitian Women
Oil on wood, 9⁵/₈ × 17 in.
(24.4 × 43.2 cm)
Signed and dated (lower right): P. Gauguin
96
Anticipated Bequest of Walter H. Annenberg

Two Tahitian Women
Oil on canvas, 37 × 28¹/₂ in.
(94 × 72.4 cm)
Signed and dated (lower left): 99 / PGauguin
Gift of William Church Osborn, 1949
49.58.1

Paul Gauguin

French, 1848–1903

Still Life with Sunflowers and Puvis de Chavannes's "Hope"

Oil on canvas, 25³/₄ × 30¹/₄ in.
(65.4 × 76.8 cm)
Signed and dated (lower right): Paul Gauguin / 1901
Partial Gift of Joanne Toor Cummings, 1984
1984.432

Two Women (Mother and Daughter)

Oil on canvas, 29 × 36¹/₄ in.
(73.7 × 92.1 cm)
Anticipated Bequest of Walter H. Annenberg

Style of Paul Gauguin

French, late 19th century

Still Life

Oil on canvas, 15¹/₈ × 18¹/₄ in.
(38.4 × 46.4 cm)
Inscribed (lower right): P.Gauguin.91.
Bequest of Miss Adelaide Milton de Groot
(1876–1967), 1967
67.187.69

Tahitian Landscape

Oil on canvas, 25³/₈ × 18⁵/₈ in.
(64.5 × 47.3 cm)
Inscribed (lower left): PGauguin–9[1]
Anonymous Gift, 1939
39.182

Attributed to Paulin Jénot

French, active by 1886, died after 1930

Captain Swaton

Oil on canvas, 16¹/₈ × 13 in. (41 × 33 cm)
Gift of Raymonde Paul, in memory of her brother, C. Michael Paul, 1982
1982.179.12

Eugène Carrière

French, 1849–1906

Self-portrait

Oil on canvas, 16¹/₄ × 12⁷/₈ in.
(41.3 × 32.7 cm)
Signed (lower left): Eugène Carrière
Purchase, Albert Otten Foundation Gift, 1979
1979.97

The First Communion

Oil on canvas, 25³/₄ × 21 in.
(65.4 × 53.3 cm)
Signed (lower right): Eugène Carrière
Gift of Chester Dale, 1963
63.138.5

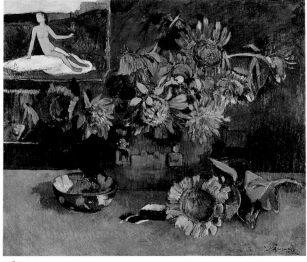

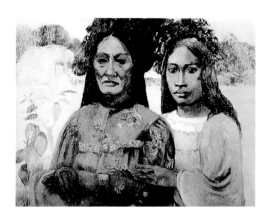

1984.432

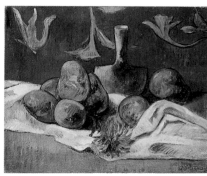

67.187.69

39.182

1982.179.12

1979.97

63.138.5

55.35

52.48.1

08.123

17.120.228

06.1233.2

31.132.34

Jean Béraud

French, 1849–1936

The Church of Saint-Philippe-du-Roule, Paris

Salon of 1877

Oil on canvas, 23³/₈ × 31⁷/₈ in.
(59.4 × 81 cm)

Signed (lower left): Jean Béraud—

Inscribed (on shop signs): [illegible]

Gift of Mr. and Mrs. William B. Jaffe, 1955

55.35

A Windy Day on the Pont des Arts

Oil on canvas, 15⁵/₈ × 22¹/₄ in.
(39.7 × 56.5 cm)

Signed and inscribed: (lower right)
JeanBéraud.; (center) FETE / DE SEVRES / . . .

Bequest of Eda K. Loeb, 1951

52.48.1

Jean-François Raffaëlli

French, 1850–1924

Place Saint-Germain-des-Prés, Paris

Oil on canvas, 27¹/₂ × 31¹/₂ in.
(69.9 × 80 cm)

Signed (lower right): JFRAFFAËLLI

Catharine Lorillard Wolfe Collection, Wolfe
Fund, 1908

08.123

The Fletcher Mansion, New York City

Oil on canvas, 23³/₄ × 32 in.
(60.3 × 81.3 cm)

Signed (lower right): JFRAFFAËLLI

Mr. and Mrs. Isaac D. Fletcher Collection,
Bequest of Isaac D. Fletcher, 1917

17.120.228

Pascal-Adolphe-Jean Dagnan-Bouveret

French, 1852–1929

Madonna of the Rose

Oil on canvas, 33³/₄ × 27 in.
(85.7 × 68.6 cm)

Signed, dated, and inscribed (lower right):
P.A.J. DAGNAN-B / PARIS 85.

Catharine Lorillard Wolfe Collection, Wolfe
Fund, 1906

06.1233.2

The Pardon in Brittany

Salon of 1887

Oil on canvas, 45¹/₈ × 33³/₈ in.
(114.6 × 84.8 cm)

Signed and dated (lower right): P.A.J.
DAGNAN-B / 1886

Gift of George F. Baker, 1931

31.132.34

Jean-Louis Forain
French, 1852–1931

Recess of the Court
Oil on canvas, 23⁷/₈ × 28⁷/₈ in.
(60.6 × 73.3 cm)
Signed (upper right): forain
Gift of Mr. and Mrs. Arthur Wiesenberger,
1966
66.217

Vincent van Gogh
Dutch, 1853–1890

Peasant Woman Cooking by a Fireplace
Oil on canvas, 17³/₈ × 15 in.
(44.1 × 38.1 cm)
Gift of Mr. and Mrs. Mortimer Hays, 1984
1984.393

Self-portrait with a Straw Hat; (verso) ***The Potato Peeler***
Oil on canvas, 16 × 12¹/₂ in.
(40.6 × 31.8 cm)
Bequest of Miss Adelaide Milton de Groot
(1876–1967), 1967
67.187.70ab

Sunflowers
Oil on canvas, 17 × 24 in. (43.2 × 61 cm)
Signed and dated (lower left): Vincent 87
Rogers Fund, 1949
49.41

The Flowering Orchard
Oil on canvas, 28¹/₂ × 21 in.
(72.4 × 53.3 cm)
Signed (lower left): Vincent
The Mr. and Mrs. Henry Ittleson Jr. Purchase
Fund, 1956
56.13

66.217

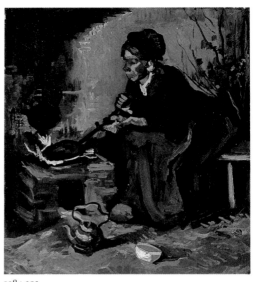

1984.393

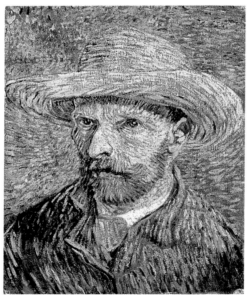

67.187.70a

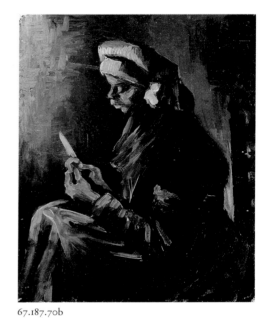

67.187.70b

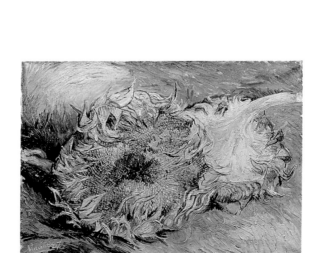

49.41

56.13

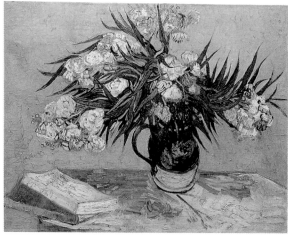

62.24

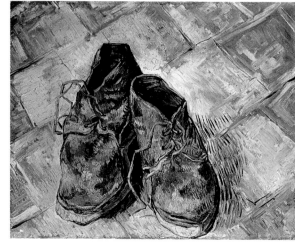

1992.374

Oleanders
Oil on canvas, 23³/₄ × 29 in.
(60.3 × 73.7 cm)
Inscribed: (on cover of book) EMILE ZOLA / LA
joie de / VIVRE; (on spine of book) Lajoie de /
vivre / Emile / Zola
Gift of Mr. and Mrs. John L. Loeb, 1962
62.24

Shoes
Oil on canvas, 17³/₈ × 20⁷/₈ in.
(44.1 × 53 cm)
Signed (lower left): Vincent
Purchase, The Annenberg Foundation Gift,
1992
1992.374

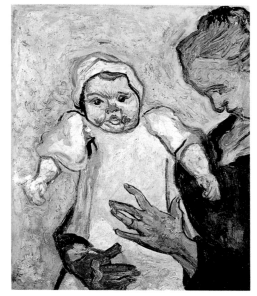

1975.1.231

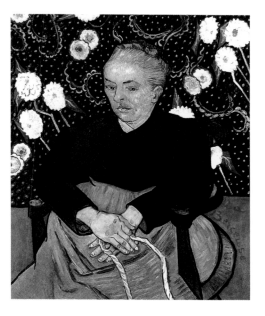

Madame Roulin (Augustine Roulin, 1851–
1930) **and Her Baby** (Marcelle, born 1888)
Oil on canvas, 25 × 20 in. (63.5 × 50.8 cm)
Robert Lehman Collection, 1975
1975.1.231
ROBERT LEHMAN COLLECTION

Woman Rocking a Cradle (Augustine
Roulin, 1851–1930)
This is one of five versions, possibly the first.
The other versions are in the Rijksmuseum
Kröller-Müller, Otterlo; the Museum of Fine
Arts, Boston; the Stedelijk Museum,
Amsterdam; and The Art Institute of
Chicago.
Oil on canvas, 36¹/₂ × 29 in.
(92.7 × 73.7 cm)
Signed, dated, and inscribed: (on arm of
chair) vincent / arles 89; (lower right) La /
Berceuse (Woman Rocking a Cradle)
Anticipated Bequest of Walter H. Annenberg

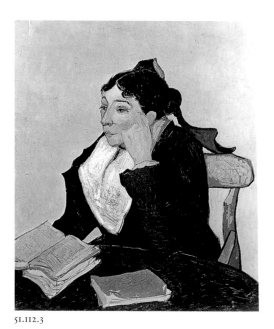

51.112.3

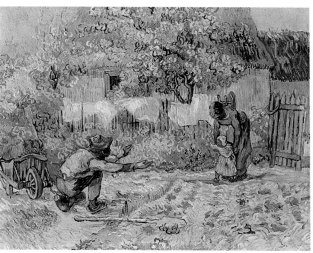

64.165.2

**L'Arlésienne: Madame Joseph-Michel
Ginoux** (Marie Julien, 1848–1911)
One of two versions; the other is in the
Musée d'Orsay, Paris.
Oil on canvas, 36 × 29 in. (91.4 × 73.7 cm)
Bequest of Sam A. Lewisohn, 1951
51.112.3

First Steps, after Millet
Oil on canvas, 28¹/₂ × 35⁷/₈ in.
(72.4 × 91.1 cm)
Gift of George N. and Helen M. Richard,
1964
64.165.2

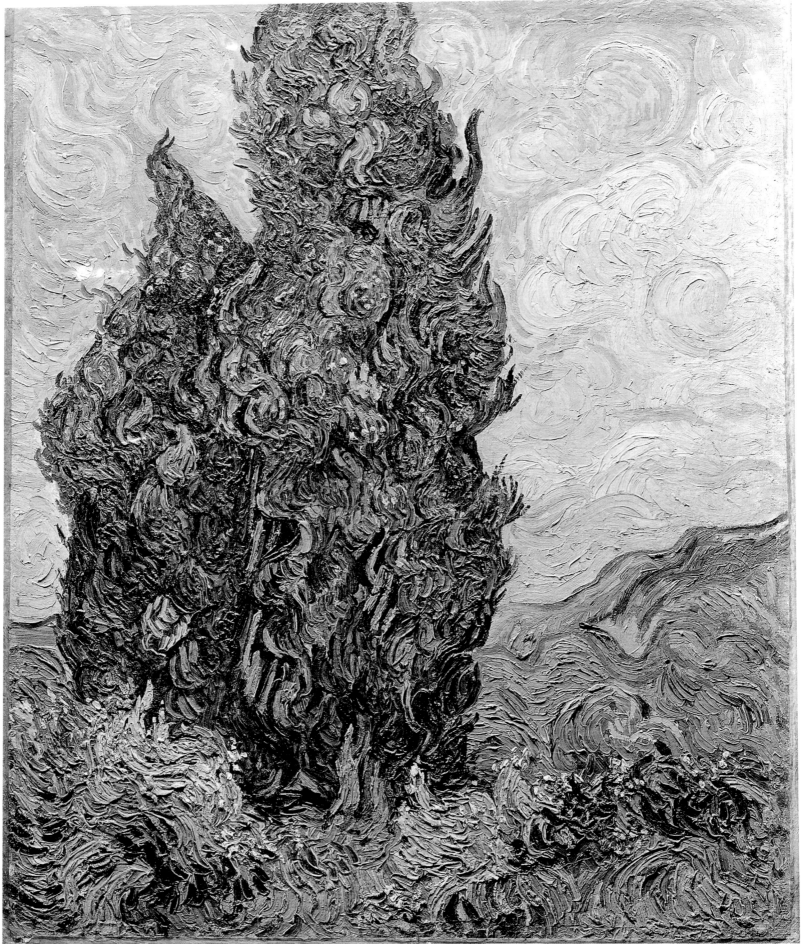

49.30

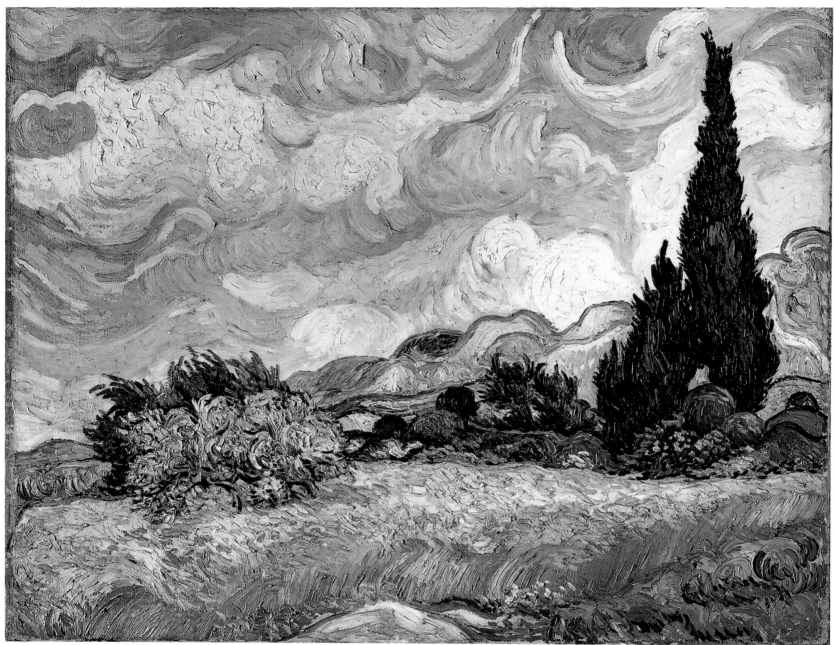

1993.132

Vincent van Gogh

Dutch, 1853–1890

Cypresses

Oil on canvas, 36³/₄ × 29¹/₈ in.
(93.4 × 74 cm)
Rogers Fund, 1949
49.30

Wheat Field with Cypresses

There are two repetitions of this
composition (National Gallery, London;
private collection).
Oil on canvas, 28³/₄ × 36³/₄ in.
(73 × 93.4 cm)
Purchase, The Annenberg Foundation Gift,
1993
1993.132

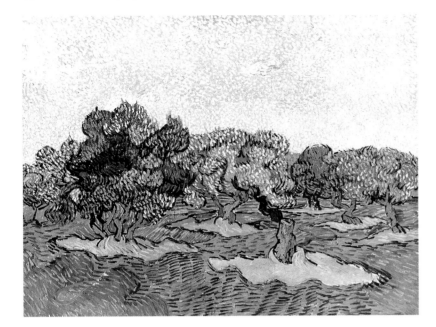

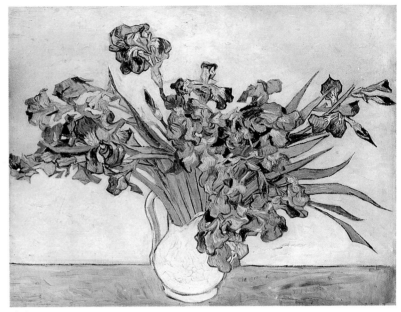

58.187

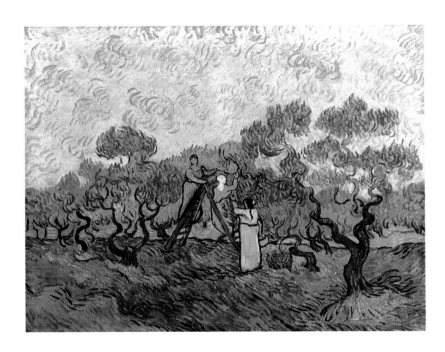

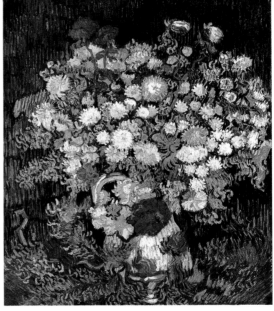

1993.400.4

Vincent van Gogh
Dutch, 1853–1890

Olive Orchard
Oil on canvas, 28⁵/₈ × 36¹/₄ in.
(72.7 × 92.1 cm)
Anticipated Bequest of Walter H. Annenberg

Irises
Oil on canvas, 29 × 36¹/₄ in.
(73.7 × 92.1 cm)
Gift of Adele R. Levy, 1958
58.187

Women Picking Olives
There are two other versions of the
composition (National Gallery of Art,
Washington, D.C., and private collection).
Oil on canvas, 28¹/₂ × 35⁷/₈ in.
(72.4 × 91.1 cm)
Anticipated Bequest of Walter H. Annenberg

Bouquet of Flowers in a Vase
Oil on canvas, 25¹/₂ × 21¹/₈ in.
(64.8 × 53.7 cm)
The Walter H. and Leonore Annenberg
Collection, Partial Gift of Walter H. and
Leonore Annenberg, 1993
1993.400.4

Vase of Roses
Oil on canvas, 36⁵/₈ × 29¹/₈ in.
(93 × 74 cm)
The Walter H. and Leonore Annenberg
Collection, Partial Gift of Walter H. and
Leonore Annenberg, 1993
1993.400.5

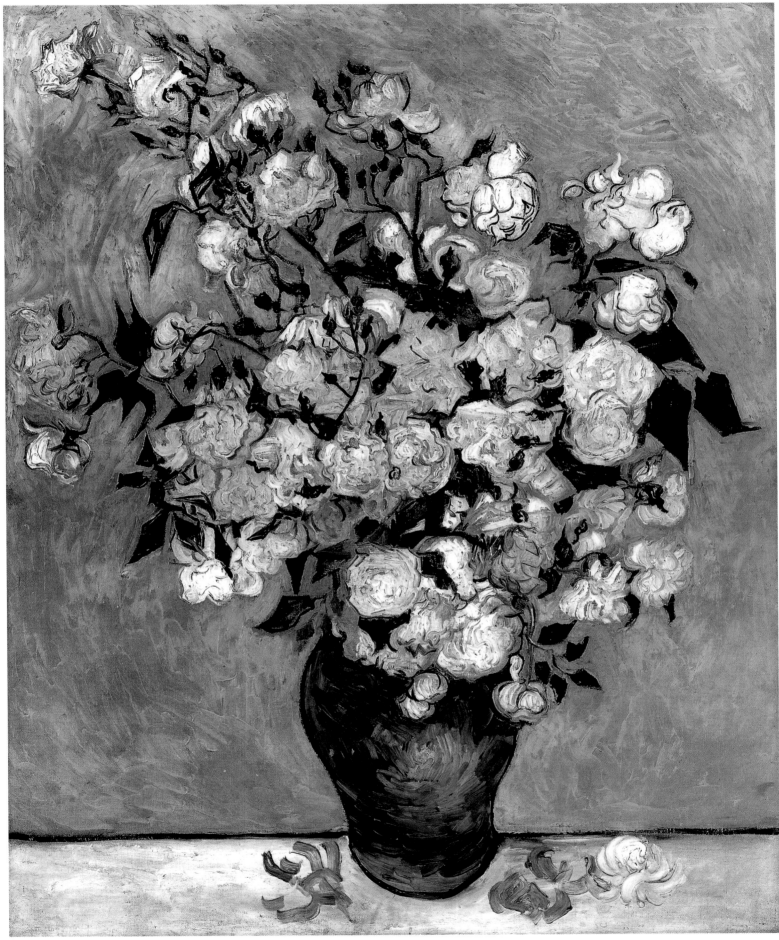

1993.400.5

Georges-Pierre Seurat

French, 1859–1891

Landscape at Saint-Ouen

The painting has been separated from its verso (private collection), a copy after the Pauvre Pêcheur by Puvis de Chavannes (1824–1898).
Oil on wood, mounted on wood; overall 6⁷/₈ × 10³/₈ in. (17.5 × 26.4 cm); painted surface 6⁵/₈ × 10 in. (16.8 × 25.4 cm)
Gift of Bernice Richard, 1980
1980.342

1980.342

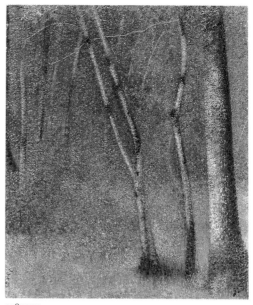

1985.237

The Forest at Pontaubert

Oil on canvas, 31¹/₈ × 24⁵/₈ in. (79.1 × 62.5 cm)
Purchase, Gift of Raymonde Paul, in memory of her brother, C. Michael Paul, by exchange, 1985
1985.237

The Mower

Oil on wood, 6¹/₂ × 9⁷/₈ in. (16.5 × 25.1 cm)
Robert Lehman Collection, 1975
1975.1.206
ROBERT LEHMAN COLLECTION

1975.1.206

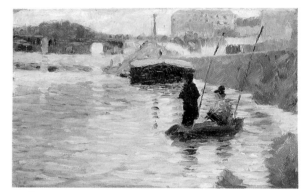

59.16.5

View of the Seine

Oil on wood, 6¹/₄ × 9³/₄ in. (15.9 × 24.8 cm)
Bequest of Mabel Choate, in memory of her father, Joseph Hodges Choate, 1958
59.16.5

The Gardener

Oil on wood, 6¹/₄ × 9³/₄ in. (15.9 × 24.8 cm)
Bequest of Miss Adelaide Milton de Groot (1876–1967), 1967
67.187.102

Study for "A Sunday on La Grande Jatte"

This painting and the following (51.112.6) are preparatory studies for the final canvas (The Art Institute of Chicago), which was first shown in the 1886 Impressionist exhibition.
Oil on wood, 6¹/₈ × 9¹/₂ in. (15.6 × 24.1 cm)
Inscribed (verso, by Paul Signac): Seurat #96
Robert Lehman Collection, 1975
1975.1.207
ROBERT LEHMAN COLLECTION

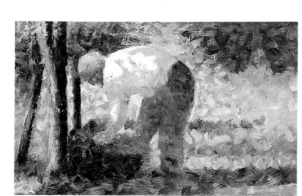

67.187.102

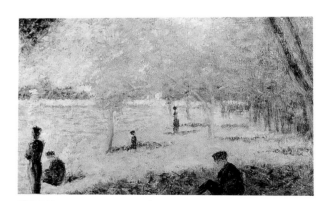

1975.1.207

Study for "A Sunday on La Grande Jatte"

Oil on canvas, 27³/₄ × 41 in. (70.5 × 104.1 cm)
Bequest of Sam A. Lewisohn, 1951
51.112.6

Gray Weather, Grande Jatte

Exposition des XX of 1889, Brussels
Oil on canvas, 27³/₄ × 34 in. (70.5 × 86.4 cm)
Signed (lower left): Seurat
Anticipated Bequest of Walter H. Annenberg

Circus Sideshow

Société des Artistes Indépendants of 1888
Oil on canvas, 39¹/₄ × 59 in. (99.7 × 149.9 cm)
Bequest of Stephen C. Clark, 1960
61.101.17

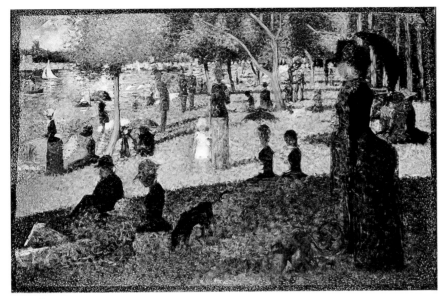

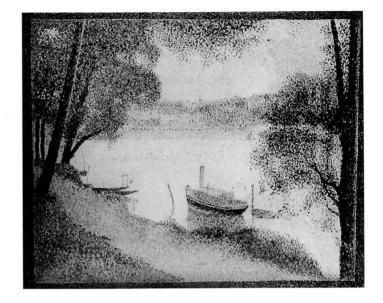

51.112.6

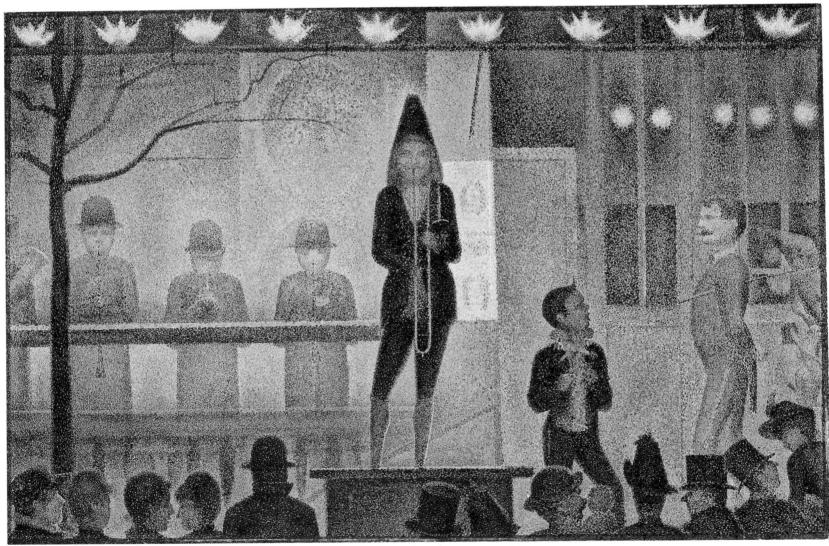

61.101.17

Maximilien Luce

French, 1858–1941

Morning, Interior

The painting represents Gustave Perrot (died 1891/92), a close friend of Luce's and a fellow Neo-Impressionist.

Oil on canvas, 25¹/₂ × 31⁷/₈ in.
(64.8 × 81 cm)
Signed and dated (lower right): Luce 90
Bequest of Miss Adelaide Milton de Groot
(1876–1967), 1967
67.187.80

Paul Signac

French, 1863–1935

View of Collioure

Oil on canvas, 24³/₄ × 31¹/₂ in.
(62.9 × 80 cm)
Signed, dated, and inscribed: (bottom left)
P.Signac.87; (bottom right) Op165
Robert Lehman Collection, 1975
1975.1.208
ROBERT LEHMAN COLLECTION

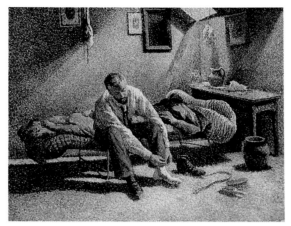

67.187.80

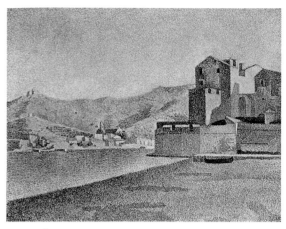

1975.1.208

The Jetty at Cassis

Oil on canvas, 18¹/₄ × 25⁵/₈ in.
(46.4 × 65.1 cm)
Signed, dated, and inscribed: (lower left)
P.Signac 89; (lower right) Op.198; (on stretcher) La Jetée de Cassis – PS [monogram]
Bequest of Joan Whitney Payson, 1975
1976.201.19

Paris: The Place Clichy

Oil on wood, 10³/₄ × 14 in.
(27.3 × 35.6 cm)
Signed and dated (lower right): Signac 89
Robert Lehman Collection, 1975
1975.1.210
ROBERT LEHMAN COLLECTION

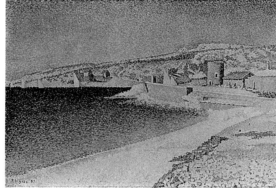

1976.201.19

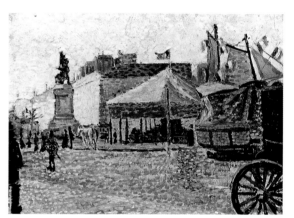

1975.1.210

Concarneau: Fishing Boats

Oil on canvas, 25¹/₂ × 32 in.
(64.8 × 81.3 cm)
Signed, dated, and inscribed: (bottom left)
P.Signac 91; (bottom right) Op. 220
Robert Lehman Collection, 1975
1975.1.209
ROBERT LEHMAN COLLECTION

View of the Port of Marseilles

Oil on canvas, 35 × 45³/₄ in.
(88.9 × 116.2 cm)
Signed and dated (lower right): P Signac /
1905
Gift of Robert Lehman, 1955
55.220.1

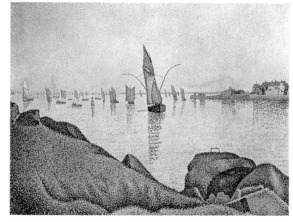

1975.1.209

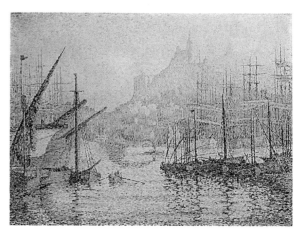

55.220.1

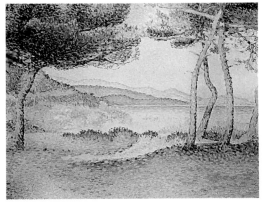

1975.1.164

1975.1.163

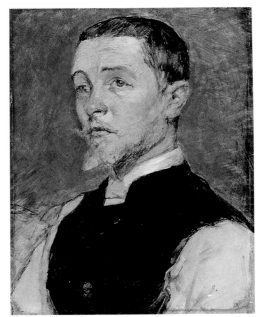

1979.135.14

1976.201.15

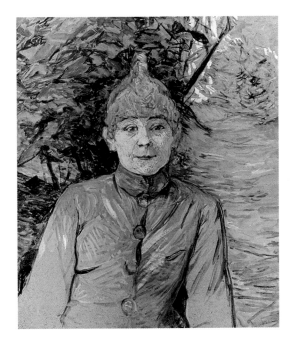

67.187.108

Henri-Edmond Cross (Henri-Edmond Delacroix)

French, 1856–1910

Landscape with Pine Trees
Oil on canvas, 21¼ × 25¾ in.
(54 × 65.4 cm)
Signed and dated (bottom left): henri
Edmond Cross 96.
Robert Lehman Collection, 1975
1975.1.164
ROBERT LEHMAN COLLECTION

Valley with a Fir Tree
Oil on canvas, 29 × 35½ in.
(73.7 × 90.2 cm)
Signed and dated (lower left): henri Edmond
Cross 09
Robert Lehman Collection, 1975
1975.1.163
ROBERT LEHMAN COLLECTION

Henri de Toulouse-Lautrec

French, 1864–1901

René Grenier (1861–1917)
Oil on wood, 13⅜ × 10 in. (34 × 25.4 cm)
Inscribed (verso): Mon portrait par / Toulouse
Lautrec / en 1887 / atelier rue Caulaincourt /
[Grenier?] (My portrait by Toulouse Lautrec
in 1887 studio rue Caulaincourt)
Bequest of Mary Cushing Fosburgh, 1978
1979.135.14

Woman in the Garden of Monsieur Forest
Oil on canvas, 21⅞ × 18¼ in.
(55.6 × 46.4 cm)
Signed (lower left): HTLautrec [HTL in
monogram]
Bequest of Joan Whitney Payson, 1975
1976.201.15

The Streetwalker
Oil on cardboard, 25½ × 21 in.
(64.8 × 53.3 cm)
Signed (lower right): [HT]Lautrec [initials in
monogram?]
Anticipated Bequest of Walter H. Annenberg

The Englishman (William Tom Warrener,
1861–1934) *at the Moulin Rouge*
This painting is a study for a color lithograph
commissioned in 1892.
Oil and gouache on cardboard,
33¾ × 26 in. (85.7 × 66 cm)
Signed (lower left): HTLautrec [HTL in
monogram]
Bequest of Miss Adelaide Milton de Groot
(1876–1967), 1967
67.187.108

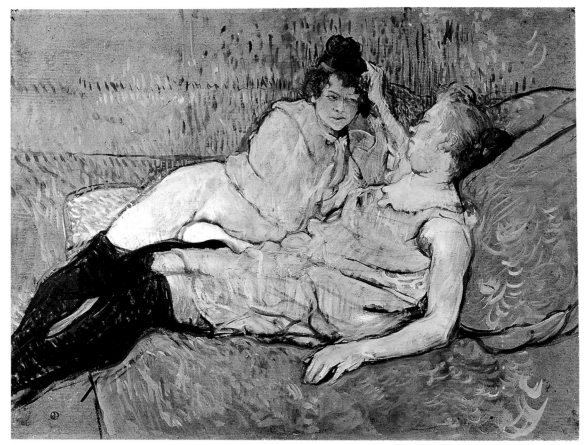

51.33.2

64.153

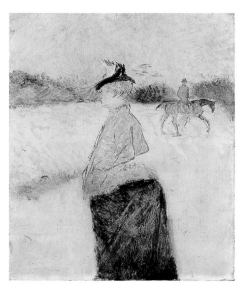

1974.356.35

1974.356.36

Henri de Toulouse-Lautrec
French, 1864–1901

The Sofa
Oil on cardboard, 24³/₄ × 31⁷/₈ in.
(62.9 × 81 cm)
Stamped (lower left): HTL [monogram]
Rogers Fund, 1951
51.33.2

Madame Thadée Natanson (Misia
Godebska, 1872–1950) ***at the Theater***
This is a study for the cover design of the
March 1895 issue of *L'Estampe originale*.
Gouache on cardboard, 24¹/₂ × 29¹/₂ in.
(62.2 × 74.9 cm)
Signed, dated, and inscribed (lower right): à
Mᵉth, Natanson / Hommages de / HTLautrec
[HTL in monogram] 95 (to Madame Thadée
Natanson / With the compliments of /
HTLautrec 95)
Gift of Mr. and Mrs. Richard Rodgers, 1964
64.153

Henri-Gabriel Ibels (1867–1936)
Gouache on paper, 20¹/₂ × 15¹/₂ in.
(52.1 × 39.4 cm)
Signed and inscribed (lower right): Pour (for)
/ H G IBELS / HTLautrec [HTL in
monogram]
Anticipated Bequest of Walter H. Annenberg

Woman before a Mirror
Oil on wood, 24¹/₂ × 18¹/₂ in. (62.2 × 47 cm)
Signed and dated (upper left): HTLautrec
[HTL in monogram] '97
Anticipated Bequest of Walter H. Annenberg

Émilie
Oil on wood, 16¹/₄ × 12³/₄ in. (41.3 × 32.4 cm)
Signed and inscribed (lower left): à (to)
Emilie / HTLautrec [HTL in monogram]
The Lesley and Emma Sheafer Collection,
Bequest of Emma A. Sheafer, 1973
1974.356.35

Mademoiselle Nys
Oil on unprimed wood, 10⁵/₈ × 8⁵/₈ in.
(27 × 21.9 cm)
Signed, dated, and inscribed (upper right): à
la famille / Nys (to the Nys family) /
HTLautrec [HTL in monogram] / 1899.
The Lesley and Emma Sheafer Collection,
Bequest of Emma A. Sheafer, 1973
1974.356.36

INDEX OF ACCESSION NUMBERS

INDEX OF ARTISTS